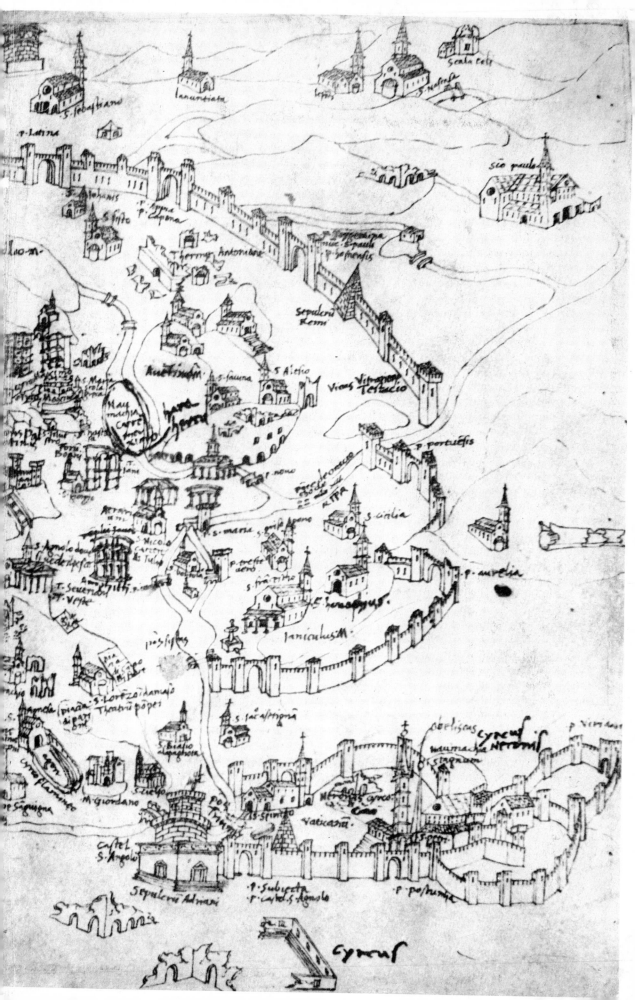

PHYLLIS PRAY BOBER & RUTH RUBINSTEIN

RENAISSANCE ARTISTS & ANTIQUE SCULPTURE

A HANDBOOK OF SOURCES

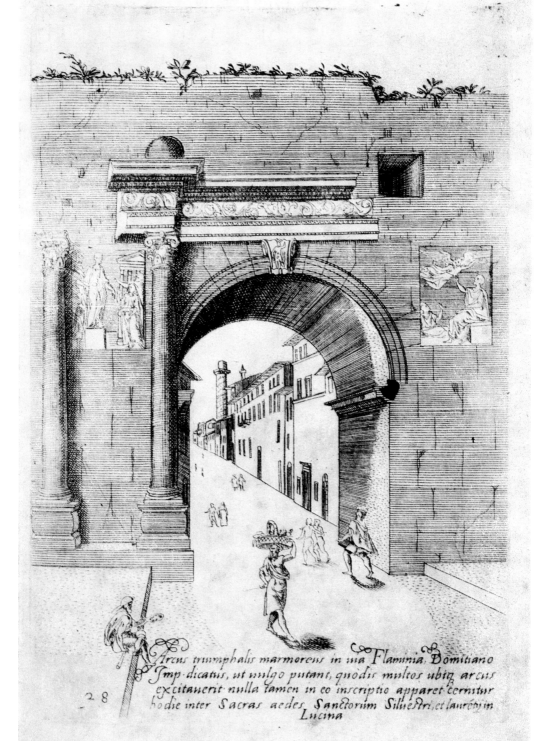

Arcus triumphalis marmoreus in uia Flaminia, *Domitiano Imp. dicatus, ut uulgo putant, quòd is multos ubiq; arcus excitauerit: nulla tamen in eo inscriptio apparet: cernitur hodie inter Sacras aedes Sanctorum Siluestri, et laurēdij in Lucina*

28

RENA
ARTISTS
& ANTIQUE
SCULPTURE

A Handbook of Sources
by Phyllis Pray Bober
and Ruth Rubinstein

with contributions by Susan Woodford
and 500 Illustrations

Published with the assistance of the J. Paul Getty Trust

HARVEY MILLER PUBLISHERS
OXFORD UNIVERSITY PRESS

© 1986 HARVEY MILLER PUBLISHERS
20 Marryat Road · London SW19 5BD · England

Published in conjunction with
OXFORD UNIVERSITY PRESS · Walton Street · Oxford OX2 6DP

London · Glasgow · New York
Toronto · Melbourne · Auckland
Kuala Lumpur · Singapore · Hong Kong · Tokyo
Delhi · Bombay · Calcutta · Madras · Karachi
Nairobi · Dar es Salaam · Cape Town
and associates in Beirut · Ibadan · Mexico City · Nicosia

Published in the United States by
OXFORD UNIVERSITY PRESS · NEW YORK

British Library Cataloguing in Publication Data

Bober, P.P.
 Renaissance artists & antique sculpture: a handbook of sources.
 1. Sculpture, Classical
 I. Title II. Rubinstein, R.O. III. Woodford, Susan
 733 NB85

ISBN 0-19-921029-2

Illustrations Originated by Quantock Studios · Sidcup · Kent
Printed and bound by Offizin Andersen Nexö · Leipzig · DDR

To Enriqueta Harris Frankfort

CONTENTS

LIST OF ILLUSTRATIONS

The illustrations are numbered in the same sequence as the catalogue. The antique work of art carries the catalogue number. Related representations and comparisons follow with an alphabetical suffix. The attributions to Renaissance artists and the approximate dates are based on recent art historical opinion.
For full identification of the illustrations, the reader is referred to the catalogue.
★ Illustrations marked with an asterisk will be found in the text.

PUBLISHERS' NOTE

We would like to express our thanks to all Museums, Libraries, Institutions, collectors and scholars who have helped with information and photographs in the preparation of this publication. We are particularly grateful to the Director and Staff of the Warburg Institute, University of London, for their encouraging support throughout the ten years of the book's conception, and for their practical help in allowing us the use of their photographs and access to all 'Census' material. And we wish to thank the J.Paul Getty Trust for their generous assistance towards the cost of this publication.

We would also like to acknowledge the contribution made by Dr.Susan Woodford, who wrote the introductory texts preceding the following catalogue entries: 106, 110, 111, 112, 119, 121–129, 131, 134, 136, 138, 160, 169, 173. All other entries are the work of Professor Bober or Dr.Rubinstein.

Finally we express the hope that our presentation of this complex source material will help students in many disciplines. Although the compilation of this Handbook was begun in 1976, and the final typescript completed in 1983, we have been aware of the need for incorporating the very latest research in the field, since the topics here dealt with are now very widely studied. The authors have therefore been able to include references to some of the most recent findings, and the most important relevant literature is cited up to the date of going to press.

PREFACE

ad fontes

THIS BOOK is intended as a reference guide to the ancient monuments which served Renaissance artists as a visual reservoir of sculptural styles, iconographic types, and expressive poses from an admired past. Here one may find more than 200 ancient statues and reliefs, and may learn–from text and illustration–something of what can be known of their history in the Renaissance: when they were discovered, where and how they were displayed, how their subject matter was interpreted, and which artists as well as antiquarians recorded them or otherwise profited by their presence.

There is a variety of ways in which the book may be used: to identify a drawing after the Antique; to see if a certain piece of sculpture could have been known to a particular artist, either directly or through a drawing, engraving or bronze, or through an adaptation; to study the varied responses of different artists to the Antique; or to survey the iconographic contents of Renaissance collections. And we hope it may also stimulate research into Renaissance interpretations of ancient works of art, an area still much in need of exploration.

Selection has not been easy. After decades of work on the 'Census of Antique Works of Art Known to Renaissance Artists'–an unpublished reference catalogue in progress since 1949–it was difficult to choose a fair representation, manageable in format. However, we were helped in the first instance by the period we covered: because the Census has concentrated on antiquities known during the 15th century and, in any case before the Sack of Rome in 1527, the same is true of our volume. Thus it notably complements the recent publication by Francis Haskell and Nicholas Penny, *Taste and the Antique* (1981) which places its emphasis upon the after-life of some of the same sculptures as 'touchstones' of taste in subsequent periods up to the 18th and early 19th centuries and deals almost exclusively with statuary. For earlier periods, narrative compositions *(istorie)* were of prime significance: our book is rich in sarcophagi, and Roman historical relief dominates the second part of the catalogue. We are fully aware that the attention of artists and humanists of the Renaissance was particularly engaged by small, portable antiquities and casts thereof–coins, gems, relief ceramics and bronze statuettes. However, except for the inclusion of a few outstanding examples, such material would lead us into antiquarian concerns best left for a different context.

The arrangement of antique sculpture in this Handbook is thematic, and it is divided into two sections: Greek and Roman Gods and Myths, and Roman History and Life. The arrangement of the catalogue entries is reflected in the illustrations, where the reader can see how theme leads into theme within the usual mythological sequence. And for those unfamiliar with this sequence, the Index guides the reader to each subject.

The book opens with the Olympian Gods and their Myths, continues with the lesser nature deities, among them personifications of Seasons and Rivers, and on to the Bacchic

and Nereid themes of which many examples survived in the Renaissance (for a list of the Gods, see p.50). The tragic themes based on ancient legend and dramatized by the great Greek tragedians and later poets begin a new section; these are followed by epic heroes celebrated by Homer and Virgil, and demi-gods whose deeds, including those of Hercules, lead on to scenes of combat, first in mythological battles (of Amazons or Centaurs), and then to the mingling of mythology and history, as in the dying warriors of the Attalid Dedication, and finally to historical battles of Trajan's army against the Dacians. The Trajanic battle reliefs provide the link to the second part of the book which deals with Roman themes such as Triumph and Victory, symbolic emblems, religious rites, and private life (for a list of Emperors, see p.190). The division between the first and second sections is therefore not clear-cut, but transitional.

The mythological and Roman subjects are each preceded by a short explanation of the theme in Antiquity, with indications of literary sources and other antique representations of the figure type or motif to be seen elsewhere in the book in other contexts, or known in the Renaissance in other examples or media. We have also briefly retold the story and given the standard classical interpretations of the subjects represented by the sculpture, so that the student can more easily read the plots, particularly of the mythological sarcophagus reliefs, and become familiar with the figure types. We have also tried to suggest in the catalogue entries, whenever evidence is available, how Renaissance writers and artists interpreted these frequently unrecognized themes.

The entries are numbered consecutively throughout and are intended to document the knowledge of each antique work of art as it was known in the Renaissance. All names are therefore given, where appropriate, in their Latinized form, according to Renaissance usage. The illustrations are numbered to correspond to the catalogue entries. (A note introducing the catalogue will be found on p.44).

Our main sources of visual documentation of the presence of antique works of art in the Renaissance are, of course, the Renaissance drawings. Comparatively few of those made in Rome in the 15th century survive. We have included many of these in our lists of representations and occasionally have added some made after the Sack of Rome which often add significant information on the history and condition of the antique object that may frequently have been restored later. We included also the relevant drawings, mostly of reliefs, collected in the Museum Chartaceum, the 'paper museum' compiled by Cassiano dal Pozzo in Rome in the 17th century (see Index of Artists and Sketchbooks: Pozzo). One reason for doing so is that readers may be interested in the influence of these antiques in a later period on artists such as Poussin.

The drawings, whether in sketchbooks or not, pose various problems which are beyond our scope. First, the attributions of drawings to artists affect our loosely chronological lists of representations of each of the antique works in our catalogue. We have avoided the often necessary revision of attributions; instead, we adhere as much as possible, for the convenience of our readers, to the attributions found in the most recent catalogues of the relevant collections, or in the standard literature. Accordingly, the names in the artists' index correspond to the attributions cited in our catalogue entries.

The second problem posed by the drawings and which also concerns our chronology of representations is that drawings after the Antique often fit into a tradition, just as manuscript copies of illuminated texts do. Whole series of drawings may be based on an

earlier drawing, now lost. The genesis of such copies still needs to be traced. We have avoided discussion of the relationships between the drawings, except occasionally to point them out.

Finally, in regard to Renaissance representations, we are primarily concerned with those which document the existence, condition, site and interpretation of the antique work of art in the Renaissance. But we also recognize that the adaptation or transformation of the antique prototype into a Renaissance creation is of art-historical interest. We have therefore included examples of such adaptations, and always noted them as such in our chronological lists. As these often conflate more than one source, or may come through the medium of another Renaissance artist's interpretation, the whole question of adaptations becomes speculative and depends to a great extent upon the knowledge or the imagination of the beholder. Because of this we have left aside many such connections with great works of Renaissance art and the Antique, while including enough examples to suggest valid possibilities of this pursuit.

It has become an axiom that the more creative the artist, the more difficult it is to trace his sources. Nevertheless, the measure of this creativity can often best be taken with the the knowledge of his sources. Once our eyes are open to the well-known examples and types of antique sculpture, we can recognize even the most gracefully disguised references to them in Renaissance and Baroque art. In this way we shall enrich not only our perception of the artists' heritage, but also our understanding of their own achievements.

Phyllis Pray Bober and Ruth Olitsky Rubinstein

ACKNOWLEDGEMENTS

The antique statues and reliefs catalogued and illustrated in this book are selected from the 'Census of Antique Works of Art Known to Renaissance Artists', an unpublished reference collection of documentation and photographs of over 1200 items which Phyllis Pray Bober began to compile in 1947 at the invitation of Fritz Saxl of the Warburg Institute, University of London. While she provided the documentation from published sources and from her own research in print rooms, the photographs of the antique works of art and relevant Renaissance drawings and engravings were collected over the years under the generous guidance of Enriqueta Harris Frankfort, Curator of the Photographic Collection of the Warburg Institute, until her retirement in 1970, with the initial collaboration of L. D. Ettlinger. Since 1957, Ruth Rubinstein has been helping the work of the 'Census' at

the Warburg Institute. From 1954 a duplicate set of the Census was installed at the Institute of Fine Arts, New York University where Phyllis Bober worked on it until she took up her appointement at Bryn Mawr in 1973. It was then that we first started to collaborate on this Handbook.

We should like to thank J. B. Trapp, Director of the Warburg Institute, and Jennifer Montagu, Curator of its Photographic Collection for their kindness in giving us permission to reproduce photographs from sketchbooks and drawings photographed over the years for the 'Census', and allowing us the use of other photographs from their files.

The staff of the Photographic Collection, of the Photographic Studio, Ian Bavington Jones and S. G. Parker-Ross, and the Librarians of the Warburg Institute are to be thanked for facilitating our work on the handbook. We are also grateful to readers using the 'Census' and contributing to it and the handbook through their own work, published or in progress. Among them are Ann Allison, John Bury, Virginia Bush, Norman Canedy, Nicole Dacos-Crifo, Gwendolyne Denhaene, Sylvie Deswarte, Doris Fienga, C. L. Frommel, Laurie Fusco, Arnold Nesselrath who has contributed photographs of drawings discovered by him in his travels, Marilyn Perry, Joseph Rushton, Annegrit Schmitt, Gunter Schweikhart, John Shearman, and Toby Yuen.

Among the friends to whom we have turned for advice, or who have offered information, we should like to thank Giovanni Agosti, Bruce Boucher, Howard Burns, Isabel Carlisle, D. R. Coffin, Peter Corbett, Daniela Gallo, Vincenzo Farinella, J. A. Gere, E. H. Gombrich, Elizabeth Gordon, Michael Greenhalgh, J. R. Hale, Denys and Sybille Haynes, Michael Hirst, Geoffrey House, Richard and Trude Krautheimer, Amanda Lillie, Margaret Lyttelton, Elizabeth McGrath, the late Ulrich Middeldorf, John Pope-Hennessy, Althea Schlenoff, C. H. Smyth, Peter Spring, Neil Stratford, Yvonne Tan Bunzl, Susan Walker, Roger Ward, Marian Wenzel, Matthias Winner, and R. P. Winnington Ingram.

Susan Woodford's knowledge of classical mythology has been a fortunate addition to the book in the final stage of its preparation. Her collaboration in writing some of the introductions to the classical subjects is deeply appreciated; her contribution begins with the tragic myths, and informs most of the Roman section. And these introductions are only part of the help and encouragement she has given us.

We should like to thank the staffs in charge of the drawings of the Louvre, the Uffizi, the Pierpont Morgan Library, the Metropolitan Museum of Art, and the Fogg Museum of Art, and Hans Mielke of the Kupferstichkabinett, Staatliche Museen der Stiftung Preussischer Kulturbesitz, Berlin-Dahlem, for their help during the checking of new acquisitions and inventory numbers for the handbook. Unfortunately it has not been possible to revisit the other print rooms.

Very special thanks go to Nicolai Rubinstein for his forebearance and support. John Shearman must be acknowledged for insisting on the desirability of a handbook for students of Renaissance art. Last but not least we thank our publisher Elly Miller, and our editors Isabel Hariades and Izabella Piestrzynska, for their intelligent and sympathetic efforts in making this book as useful as possible.

ABBREVIATIONS

AA	*Archäologischer Anzeiger*
Accad.	Accademia di Belle Arti (Perugia; Venice) Accademia Carrara (Bergamo)
AJA	*American Journal of Archaeology*
Albertina	Graphische Sammlung Albertina, Vienna
Annali Pisa	*Annali della R. Scuola Normale Superiore di Pisa, Sezione di Lettere*
Anon.	Anonymous
Ant. Gemmen	*Die antiken Gemmen* by A. Furtwängler (see Bibliography)
AQ	Art Quarterly
Arch.	Archaeology; Archeologico
ArtBull	*Art Bulletin*
ASA	*Annuario della R. Scuola Archeologica di Atene*
Ashmolean	Ashmolean Museum, Oxford
ASR	*Die Antiken Sarkophagreliefs* (see Bibliography)
attrib.	attributed; attribution
Bartsch	*Le peintre-graveur* (see Bibliography)
Beschreibung	*Beschreibung der Glyptothek König Ludwigs I. zu München* by A. Furtwängler (see Bibliography)
bibl.	bibliography
Bibl.	Bibliothèque; Biblioteca; Bibliothek
Bibl. Ambr.	Biblioteca Ambrosiana, Milan
Bibl. Hertz.	Biblioteca Hertziana, Rome
Bibl. Laur.	Biblioteca Laurenziana, Florence
Bibl. Marucel.	Biblioteca Marucelliana, Florence
Bibl. Mun.	Bibliothèque Municipale
Bibl. Triv.	Biblioteca dell'Archivio Storico Civico e Biblioteca Trivulziana, Milan
bk.	book
BM	British Museum, London The drawings referred to are all in the Department of Prints and Drawings, with the exception of the dal Pozzo Albums which are kept in the Department of Greek and Roman Antiquities but can be consulted in the Print Room.
BN	Bibliothèque Nationale; Biblioteca Nazionale; Biblioteca Nacional
Boll d'Arte	*Bollettino d'Arte*

BullBelge	*Bulletin de l'Institut historique belge de Rome*
BullComm	*Bullettino della Commissione archeologica comunale di Roma*
Burlington	*The Burlington Magazine*
BWpr	*Winckelmannsprogramm der Archäologischen Gesellschaft zu Berlin*
c.	circa
cat.; cats.	catalogue number; numbers
Cat.	Catalogue
Cat.	Catalogue (published)
ch.; chs.	chapter; chapters
CI	Courtauld Institute of Art, London
CIL	*Corpus Inscriptionum Latinarum* (see Bibliography)
Cod.	Codex
Cod.	Codex (published)
CTR	*Codice topografico della città di Roma* by R. Valentini and G. Zucchetti (see Bibliography)
d.	died
DAI	Deutsches Archäologisches Institut, Rome
DBI	*Dizionario Biografico degli Italiani* (see Bibliography)
Diss.	Dissertation
EAA	*Enciclopedia dell'arte antica*
École B-A	École des Beaux-Arts, Paris
ed.	edition; edited; editor
esp.	especially
exh.	exhibition
Exh. Cat.	Exhibition Catalogue
f.; ff.	folio; folios
fig.; figs.	figure; figures
Gab.	Gabinetto
Gal.; Gall.	Galerie; Gallery, Galleria
GazBA	*Gazette des Beaux-Arts*
Gernsheim	'Corpus Photographicum of Drawings' (see Bibliography)
GettyMusJ	*The J. Paul Getty Museum Journal*
ill.; ills.	illustration; illustrations
illus.	illustrated; illustrating
Inst.	Institute
Intro.	Introduction
inv.	inventory
Ist.	Istituto
JAK	*Jahrbuch der Kunsthistorischen Sammlungen des allerhöchsten Kaiserhauses*

Jb.	Jahrbuch
JBerlMus	*Jahrbuch der Berliner Museen*
JbKSWien	*Jahrbuch der Kunsthistorischen Sammlungen in Wien*
JdI	*Jahrbuch des k. deutschen archäologischen Instituts*
JHS	*Journal of Hellenic Studies*
JÖAI	*Jahreshefte des österreichischen archäologischen Instituts*
JpK	*Jahrbuch der preußischen Kunstsammlungen*
JRS	*Journal of Roman Studies*
JWI	*Journal of the Warburg Institute* (before 1945)
JWCI	*Journal of the Warburg and Courtauld Institutes*
Kat.	*Die Skulpturen des Vatikanischen Museums* by W. Amelung and G. Lippold (see Bibliography)
Kunsthist. Mus.	Kunsthistorisches Museum, Vienna
Lib.	Library
Louvre	Musée du Louvre, Paris
MA	Prefix for numbers of statues and reliefs in the Département des Antiquités in the Louvre as catalogued by Héron de Villefosse (1898) and revised by Michon (1922).
MAAR	*Memoirs of the American Academy in Rome*
MarbWPr	*Marburger Winckelmann-Programm*
Marsyas	*Marsyas. Studies in the History of Art* (New York)
MededRom	*Mededeelingen van het Nedererlands Historisch Instituut te Rome*
MemPontAcc	*Atti della Pontificia Accademia Romana di Archeologia. Memorie*
MFA	Museum of Fine Arts, Boston
MittFlor	*Mitteilungen des Kunsthistorischen Institutes in Florenz*
MJb	*Münchner Jahrbuch der bildenden Kunst*
MMA	Metropolitan Museum of Art, New York
Monuments Piot	*Monuments et Mémoires de la Fondation E. Piot*
MS; MSS	manuscript; manuscripts
Mus.	Museum; Musée; Museo
Mus. B-A	Musée des Beaux-Arts
n.	note
N. A.	Nuovi Acquisti
NACF	The National Art-Collections Fund, London
Naz.	Nazionale
n.d.	no date
neg.	negative
NG	National Gallery
NGA	National Gallery of Art, Washington, D.C.
n.l.	no location

no.; nos.	number; numbers
p.; pp.	page; pages
Pal.	Palazzo
Phil. Diss.	Philosophical Dissertation
phot.; phots.	photograph; photographs
pl.; pls.	plate; plates
PBSR	*Papers of the British School at Rome*
Pr. Staatsbibl.	Preussische Staatsbibliothek
r	recto
RA	Royal Academy of Arts, London
RA	*Revue archéologique*
RendPontAcc	*Atti della Pontificia Accademia Romana di Archeologia. Rendiconti*
Rép.Rel.	*Répertoire des reliefs grecs et romains* by S. Reinach (see Bibliography)
Rép.Stat.	*Répertoire de la statuaire grecque et romaine* by S. Reinach (see Bibliography)
RfKg	*Repertorium für Kunstgeschichte*
RfKw	*Repertorium für Kunstwissenschaft*
RIA	*Rivista del R. Istituto d'Archeologia e Storia dell' Arte*
RIBA	Royal Institute of British Architects
RIS	*Rerum Italicarum Scriptores (Muratori)*
RM	*Mitteilungen des Deutschen Archäologischen Instituts. Römische Abteilung*
RömJbKg	*Römisches Jahrbuch für Kunstgeschichte*
rpt.	reprint
S.; SS.	Saint; Saints
SBBerl	*Sitzungsberichte der Berliner Akademie*
ser.	series
SGS	Staatliche Graphische Sammlung, Munich
skb.	sketchbook (not published or incompletely published)
Skb.	sketchbook (published and fully illustrated)
St.; Sts.	saint; saints (in English and French)
Städel. Kunstinst.	Städelsches Kunstinstitut, Frankfurt-am-Main
Städt.	Städtische
Staatl. Mus.	Staatliche Museen, Berlin-Dahlem
Stat. Mus. for Konst	Statens Museum for Konst, Copenhagen
Studi Miscellanei	*Studi Miscellanei (Seminario di Archeologia e Storia dell' Università di Roma)*
TAPS	*Transactions of the American Philosophical Society* (Philadelphia)
transl.	translated; translation

Uffizi	Galleria degli Uffizi, Florence
	Unless otherwise specified, the drawings referred to are in the Gabinetto dei Disegni e Stampe. The Gabinetto catalogues them by a number which is followed by a letter referring to the relevant category or collection. These letters are as follows:
	A–Architettura
	E–Esposti
	F–Figura
	Horne–Horne Collection
	NA–Nuovi Acquisti
	Orn–Ornato
	S–Santarelli Collection
Univ.	University; Université; Univerersità; Universiteit
v	verso
V&A	Victoria and Albert Museum, London
Vat.	Vatican
Vat. Lat.	Biblioteca Apostolica Vaticana, Codices Vaticani Latini
vol.; vols.	volume; volumes
Windsor	Royal Library, Windsor Castle
ZfbK	*Zeitschrift für bildende Kunst*
ZfKg	*Zeitschrift für Kunstgeschichte*

INTRODUCTION

RENAISSANCE ARTISTS

AND THE USES OF ANTIQUITY

by Phyllis Pray Bober

A FAMOUS ANECDOTE concerning Filippo Brunelleschi crystallizes the excitement shared by a first generation of Renaissance artists in the presence of ancient art. Tradition has it that in Florence, one day in 1407, Donatello, Brunelleschi and companions were talking together when Donatello spoke in praise of the refinement and perfection of workmanship in an antique vessel he had stopped to admire at Cortona,[1] after passing on his way from Rome by way of Orvieto to see its Cathedral. Filippo was instantly inflamed with desire to see this 'basin' and set off just as he was dressed, with only wooden clogs on his feet, to walk the fifty or so miles, return before he was missed, and show his drawing of the piece.

The monument **(Fig. 1)** which aroused such enthusiasm may, if we anticipated a classical masterpiece, surprise at first acquaintance. It is a Roman sarcophagus of decent but not exceptional quality, a product of the mid 2nd century A.D., revealing a lively battle frieze of Bacchus and his retinue, including Centaurs, in combat with natives and Amazons encountered on their passage to India. Such sarcophagi, produced in masses for a burgeoning market in funerary art by highly organized ateliers, were scarcely created by major artists of their time. However, they did serve as storehouses of various motifs and styles from earlier Antiquity, frequently adapting narrative art by famous Greek painters and sculptors of 'classic' stature. Re-used during the Middle Ages as tombs, as fountain troughs, as holy-water basins, and the like, or simply incastrated for ornamental purpose, their sheer ubiquity made them the single most accessible class of ancient art to inspire subsequent artists. Everyone thinks of the sarcophagi of Pisa's Campo Santo and Nicola Pisano's profit therefrom. At Salerno, at Rome outside SS. Cosma and Damiano or lining the stairway to S. Maria in Aracoeli–almost every major church had its collection, and Florence had her own display at the Baptistry (see **11** for example).

Brunelleschi's drawing is not preserved, but we contemplate the Cortona *pilo* with Donatello's admiration in mind. We grasp immediately an intrinsic attraction of dramatic movement and emotional expressiveness in these figures; they are rendered with a clarity of design that keeps overlapping to a minimum in the mêlée and allows protagonists to stand out singly or in groups. We note the corner masks taken up by Donatello for his St. Louis tabernacle for Or San Michele, and we recognize that he would have been captivated by the frieze's planar discipline, the compression into one dominant relief layer of

complex poses conceived in exuberant three-dimensionality. Donatello especially, among his contemporaries, appreciated this sculptural principle; and he would not have missed the way angular surfaces and distortions of both facial expression and anatomy enhance psychological tensions by their very abruptness.

The Donatello-Brunelleschi anecdote is transmitted by Giorgio Vasari's *Lives of the Painters, Sculptors and Architects*, published almost a century and a half after the incident recorded. In his own life and work as an artist, Vasari was the beneficiary of intervening developments in the study of ancient art, begun by Donatello and Brunelleschi in the first years of the Quattrocento as they avidly measured ruins and drew antiquities in Rome. Study of the Antique in the course of the 15th century ended in transformed social and intellectual status for artists. It gave rise to antiquarian specialists, sought after as advisors and curators for collectors or the State. In 1515, the appointment of Raphael as Commissioner of the Antiquities of Rome by Leo X ratified this aspect of a new breed of artist-scholar to which Vasari also belongs. But it was Vasari and others like him who expanded upon the tradition of Early and High Renaissance predecessors by turning to systematized ideas of rules and canons by which to set criteria for discriminating valid taste in matters artistic.

In the Quattrocento, Leon Battista Alberti viewed his contemporaries as artists worthy of higher praise than the legendary masters of Antiquity because they forged a rebirth of the arts without benefit of teachers or models. By contrast, Vasari ascribed his own academic mentality to the same 15th-century masters. In his eyes, they had initiated a quest for the noblest and most beautiful ancient models; this quest culminated in Raphael's discovery of the best exemplars, just as, by Pliny's account, Zeuxis in the 4th century B.C. had anthologized ideal features for his 'portrait' of Helen of Troy. With a cultural self-confidence that is characteristic of the Renaissance, as well as a sense for classifying historical periods and styles that had developed in Raphael's circle, Vasari's writings established a long-lived conception–quite simply, a revival and comprehensive renewal of civilization after decay and barbarism in the Dark Ages. He drew the line where others before him had marked the break differentiating debased medieval culture from the Rinascimento: at Cimabue and Giotto. By analogy with the progress traced by ancient writers on art, the Renaissance might then be read as a culminating second Golden Age.[2]

Vasari's vision seemed made to order for 19th-century positivists who could identify with its concept of 'modern' man, confident in his own intellectual and physical power to control his destiny. Allowing themselves a certain romantic sympathy for passive medieval recipients of Divine Grace, Burckhardt, Symonds, and their peers vaunted the Renaissance as a pursuit of personal glory and an almost pagan rebirth of Antiquity in all spheres of life and thought–above all, in art. A generation ago this view still prevailed and made it less difficult than today to define the Renaissance. As far as the visual arts were concerned, Vasari's academic evaluation of the exemplary role of ancient sculpture in Quattrocento art, for example, was a handbook truth, although Berenson and Mather insisted, as had Wölfflin before them, on the purest originality of its painters (a new *paragone*). Mantegna's lithic figures were thought to be adequately explained by apprenticeship to ancient marbles in the workshop of his master, Squarcione.

Present-day historians of art who study the impact of classical Antiquity on Renaissance masters share a more sophisticated understanding of *imitatio*; the Dark Ages no longer

appear so dark; and the Italian renascence can be sited more justly among enduring survivals and punctuating revivals of the Antique throughout Western history. In comparison, the Middle Ages reveal equally strong 12th- and 13th-century humanist activity in the 'discovery' and dissemination of classical manuscripts; deep appreciation of the beauty and workmanship of ancient sculptures and minor arts; ethnic pride in mythological founders of dynasties and cities; avid collecting of *anticaglie*; and even a quite thoroughgoing influence of antique forms.[3] More important, sustained study of the Antique can now be recognized as a facet of late Gothic naturalism, as we shall see.

Such altered assumptions mean that to deal in the compass of an introduction with Renaissance artists' knowledge and use of works of ancient art is to simplify, perhaps falsify, an extremely complex reality. Not only are there distinctions to be drawn among antiquarian and humanist preoccupations, the motives of collectors and patrons of *arte all'antica*, and professional concerns of artists and craftsmen, but images of classical Antiquity, shaped from its relics, varied greatly from region to region of Italy, from period to period, and from individual eye to individual eye.

Few perceptions could differ more profoundly than the vision of a vanished antique world embodied in Florentine vis-à-vis Venetian art. We cannot hope to deal here with this neglected area of research in Antique-Renaissance relationships, but may note one determining factor. Most Florentines, before the late Quattrocento at least, sought in ancient art a reflection of their own compulsive *disegno* clarifying both pictorial void and substance. They also shared those genealogical and political motives, focused on an Etruscan or Republican Roman past, which galvanized Rome in its revival of *istorie*. Venice was without Roman civic history (although it did invent forebears), but it had been fed for generations by the ambiguities of Byzantine art–itself the direct heir of a dematerialized Hellenic classicism. This was the environment to nurture development of lyric *poesie*, shaping a romantic landscape of myth and pastoral eroticism exportable to lands beyond the Alps.[4]

It is possible to follow over the course of the 15th and 16th centuries changes in stylistic contexts that determined, generation by generation, artists' receptivity to ancient art. Differences in Quattrocento, High Renaissance and Mannerist orientations to the Antique may be characterized within a general evolution from surface borrowings of motifs of iconography and style to complete assimilation of underlying structures of meaning and form. But my theme addresses itself to the richness and diversity of historical reality in a way that transcends previous readings of affinities that bound Renaissance masters individually or collectively to specific phases of Greek and Roman works of art.[5]

Inevitably, the individual artist's 'eye' must be taken into account because it is not simply adoptive and adaptive, but absorptive in a totally creative act. In this book, the reader may contrast the reaction of Ghiberti to a statue of a sleeping Hermaphrodite with that of Alberti to a Meleager sarcophagus in passages quoted in **98** and **118**. The sculptor, trained originally as a goldsmith, marvels sensuously at differentiation of textures and at subtleties of surface that must be touched to be appreciated; the architect, humanist and art theorist shows a scientific appreciation of the way in which anatomy and motion (or absolute stillness) express inner states of being (or death). It is one thing for an artist to admire or to use an ancient model because he thinks it useful in meeting some problem of expressing what he has to say. It is quite another to select it because it is a paradigm

reinforcing a theoretical and conceptual context within which the normative synthesis of the High Renaissance could be attained.

A certain dichotomy still exists in the history of art between the heirs of Vasari, who stress as he did the antiquarian side of personalities like Mantegna, and those who emphasize in the great Paduan master and in other realists of the 15th century the boldness and innovation of their conquest not of Antiquity but of Nature. The former treat the artist as anthologist and ferret out ancient sources quoted in poses and iconographic details. Such findings may have a certain place in defining patronage in a society which appreciates classical erudition, rather like allusions in the poetry of T.S.Eliot or in Joyce's *Ulysses*. However, the Renaissance was not shaped by antiquarian lore, despite the artists' response to an ancestral quality evoked by humanists from Antiquity. The nature lovers, so to speak, carry on a perennial quarrel between two differing modes of representation, whether this is defined by Ancients versus Moderns, classicists versus romantics, or Poussinistes versus Rubenistes in controversies that developed during the 17th and 18th centuries. These led, once Winckelmann had shown a way to sort out *good* ancient art of Periclean Greece from contending styles, to academic neo-Classicism opposed to the work of realists and inspirationists.

If a particular crisis of the High Renaissance lies in the tension between Art and Nature, happily no such dualism existed for the Quattrocento. Systematic exploration of nature and passionate emulation of Antiquity were but two sides of the same coin, of identical value in shaping a more comprehensive view of the world and the richness of life than ever before. Ancient art *was* Nature rationalized and articulated, its creators having mined the raw ore of nature, transmuted and refined it. Artists collected casts of sculptures as well as gems, also fragments of antique statues which could hold a pose more effectively than apprentice-models.[6] It would take a century of humanist study and artistic theorizing to arrive at a stage when moral overtones would guide a quest for noble style and idealism. Until arbiters like Vasari began to discriminate the most worthy models among a bewildering array of ancient styles and periods, the 15th century accepted the most diverse phases of Antiquity insofar as these coincided with personal formal aims or generated novel categories of representation: portraiture, the 'art' statuette, the pastoral among them.

It is not difficult to show how ancient art served as Nature's surrogate or to pinpoint the historical moment when truth to visual reality dictated transformation of medieval workshop methods to include–as a matter of course–sketching after antique works of art. Here, the operative words are 'as a matter of course', applied to a characteristic feature of artistic practice in contrast to scattered occurrence in earlier pattern-books. Systematic compendia of ancient motifs, heirloom sketchbooks of details excerpted from the Antique, set side by side with renderings in exquisite veracity of animals, plants and costumes, are phenomena of late Gothic realism in the International Style of c.1400. In Florence their presence is reflected in the repertory *all'antica* displayed by masters responsible for sculpture of the Cathedral's *Porta della Mandorla* **(Fig.2)**. Whether or not such direct imitations of classical images of Hercules and other divinities are inspired by a contemporary treatise by Coluccio Salutati, the *de laboribus Herculis*, they mark the threshold of the Renaissance in the same way as his defence of poetry brings new legitimacy to pagan myth and allegory.[7]

From the studio of Gentile da Fabriano–whose Strozzi altarpiece of the *Adoration of the Magi* as vividly epitomizes late Gothic International Style as the Limbourg brothers' *Très Riches Heures* for the Duke of Berry–comes an astounding sketchbook inherited by Pisanello's workshop. Reconstructed from scattered leaves in many collections, it unfolds the first comprehensive series of drawings after the Antique preserved to us.[8] With lingering pattern-book mentality, its artists select and transcribe figures from a host of Roman sarcophagi and other reliefs as guides to solving representational problems. Gentile copies the murdered Clytemnestra from an Orestes sarcophagus **(25a)**, obviously fascinated by the utter lifelessness of total collapse, but his corpse is unclassically boneless, as meltingly soft and fluid as her Gothic folds of drapery. Pisanello's shop is just as devoted to continuity of line and total visibility of contour, revealing, however, more grasp of the modelling and three-dimensionality of units singled out for their extraordinary activity or unusual subject **(Fig.3)**. Still another North Italian hand (the 'Ambrosiana Anonymous') adds studies that seek to capture the formal response between figures, lending them more assertive tangibility in one instance than an original terracotta plaque **(23a)**.[9]

Two drawings sum up Quattrocento interplay between naturalistic observation and a study of ancient art. The first, attributed to Jacopo Bellini **(69a)**, is based upon three Roman sarcophagus reliefs.[10] A Bacchic procession reveals both his delight in agile, fine-boned figures and some degree of fidelity to a sculpture which is today in Berlin **(81)**; but he transposes the scene from myth to actuality by introducing a sharply rising groundline which realistically enhances strain in the action. A more finished rendering of one satyr carrying a huge wine-mixing bowl on his shoulders as an 'antique builder' in Bellini's Louvre sketchbook develops ideas gleaned from this notation in a way which reminds us that many Renaissance 'life drawings' have to be classified as 'after the Antique' by archaeologists. A variant of this ancient type also appears in decorative terracotta plaques called 'The Wedding of Peleus and Thetis' in a reveller carrying a sacrificial animal, feet up, upon his shoulders.[11] The same motif, representing Theseus carrying the Marathonian Bull, frequently attracted the eyes of Renaissance draughtsmen; it is reflected in a sketch **(Fig.4)** from the seismographic pen of Antonio Pollaiuolo (or, as some believe, the young Raphael), whose contemporaries thought him obsessed by scientific investigation of the muscles and tendons activating the human body. His is no less a study after the Antique, although creative synthesis reduces its dependence upon a specific prototype and a twist in space masks its relief origins. Metamorphoses such as these illustrate the manner in which Renaissance artists' search for the theoretical underpinnings of appearance might be equated with use of the Antique as a template for meaning and structure in nature.

Consequently, the Quattrocento pursuit after the principles of representation could move from surface imitation of an ancient motif to a full grasp of its organic integrity in a much shorter span of time than it had taken Greek artists of the past to arrive at postulates embodied in classical sculpture (*pace* Alberti). Andrea del Castagno, viewing a truncated statue fragment **(Fig.5)**, was able rationally to restore it and to place it in a different narrative context **(Fig.6)** long before a better preserved replica of the Niobid Paedagogue was discovered with the famous Florentine group in 1583 **(Fig.7)**.[12]

Though it may seem paradoxical to us, Early Renaissance visions of the Antique in terms of refined or enhanced Nature *(natura naturata)* even permitted certain artists to seize upon an anti-naturalistic aberration in classical art as a paraphrase for the breath of life in depicted (hence frozen) action. One of the most brilliant observations by Aby Warburg involved the impact of neo-Attic reliefs on Botticelli, Agostino di Duccio and artists who similarly exploited the possibilities of line.[13] He demonstrated that, under the aegis of Alberti's theories of the importance of agitated draperies and streaming hair to animate figures in momentary activity, these masters turned to mannered, anti-realist deformations of antique naturalism. What has been regarded as indicative of neo-Gothic trends, prefiguring their resurgence in *prima maniera* reaction to classicism of the High Renaissance, is actually one of the most thoroughly informed of classical revivals (e.g. **121**). Neo-Attic products wilfully manipulate weightless bodies flattened decoratively to fill their frames, encased in garments so clingingly rendered as to be appreciable only in isolated ridges or where artificially blown up into calligraphic arabesques beyond the outlines of a figure. The aesthetic preference of Filippino Lippi, Botticelli, Agostino and others in the second half of the 15th century settled upon this particular class of art created for sophisticated Romans of the early Empire; neo-Attic sculptors based their art in turn on good late 5th-century Athenian elaborations of the 'wet' drapery introduced in the Parthenon pediments. In wondrous consonance, that tripping, fragile 'Quattrocento' step of maidens carrying garlands (**59B–a**)[14] – or joining their billowing garments to the ornamental play of a cloak awaiting Venus wafted ashore from the sea – is directly inspired by visual and literary evidence from Antiquity. Under Medici patronage, neo-Attic artifice that once invested Ovid's poetry becomes the source for artists excited by Poliziano's verses reanimating lyric voices from Augustan Rome.

The Quattrocento quest for agility found other classicizing trends of the early Roman Empire to be overly subdued. Many artists were drawn to a Julio-Claudian historical relief displayed in Rome (**190**) by their interest in the subject matter portrayed (heightened by stubborn mis-reading of the *velatus* sacrificing as a female). Fritz Saxl highlighted Renaissance fascination with ancient scenes of sacrifice as prefigurations of the Christian mystery of the Mass.[15] However, to 'Bambaia', sketching it about 1514 in a manner linked still to the Quattrocento (**190c**), the solemn movement of this particular example seemed too restrained and self-contained, too dependent upon minute variations in repeated postures and parallel drapery folds; he was impelled to make the celebrants more nude and, by stressing their joints, more active – even jerky – in movement.

On the one hand, the neo-Attic influence put forward by Warburg represents merely what we could expect of Renaissance selection from an undifferentiated range of antique styles: any artist's elective affinity for works found sympathetic to his own vision. In some of the greatest masters such affinity embraced a wide variety of styles and periods. Donatello, for example, profited from Etruscan, Early Christian, neo-Attic, as well as Greek and Roman art from many stages.[16] Neo-Attic eclecticism, however – in different products dependent upon the inflated musculature and contorted postures of the Hellenistic 'baroque' – could not be translated gently enough to suit Quattrocento eyes. The Belvedere torso is the most famous ancient sculpture whose vocabulary and syntax, so to speak, could not be appreciated by the Early Renaissance, despite the challenge of reconstructing it (**132**). A large neo-Attic vessel embellished by reliefs of an erotic symposium (**92**) also

seems not to have been exploited before Michelangelo created his Medici Chapel giants and Giulio Romano his evocation of pagan divinities in love and at play.

On the other hand, the Florentine neo-Atticizing current in the late 15th century does illustrate a veritable *arte all'antica* because of its literary aspects and theoretical motivation. When supported by ancient treatises and criticism, contemporary theory was able to forge an even more powerful union of the perceptual with the cognitive that would prove pervasive and enduring. Such is the case with illusionistic wall decoration revived by painters of the Early Renaissance with the approval of Alberti's prescriptions derived from writings of the ancient Roman architect, Vitruvius. Quattrocento realists had a mathematician's devotion to constructing a convincing spatial milieu for their figures and relating it to the environment of the spectator. They could not but be excited by similar goals expressed in the pseudo-architecture and vistas of so-called Pompeian Second Style painting. This world-wide style was never confined to Pompeii nor did it originate in that middle-class town (only to be re-discovered in the 18th century); it was a style surely accessible to the Renaissance in Rome and in the Campagna. Quattrocento artists like Andrea del Castagno had direct experience of the kind of Second Style murals advocated by Vitruvius (and his interpreter, Alberti) for stately halls and public buildings. One cannot fail to be impressed by the similarities of aim and method when comparing Castagno's frescoes for the Villa at Legnaia **(Fig.8)** with a Pompeian painting he could certainly not have seen **(Fig.9)**. This is not brought about fortuitously because the painter revitalized a type of antique wall articulation that had survived throughout the Middle Ages–as palmette ornament and frieze of putti indeed confirm. It is rather the result of a rational synthesis: artistic predilection, study of a Roman model or models, and understanding the postulates of an ancient treatise, promulgated by the leading art theorist of the day, Alberti.[17]

A text like that of Vitruvius *On Architecture*, which bore the authority of canon for the Renaissance, added new dimensions to the influence of Antiquity; but it also introduced problems. The text was an academic survivor among many ancient formulations of art theory, fitted to an Augustan urge to assimilate 'proper' Hellenic achievement. As humanists resurrected such critical writings–all from late Antiquity, and dominated by Roman cultural inferiority beside the classic accomplishments of the Greeks–Renaissance artists came to discover discrepancies between antique theory and antique practice. In other words, universal principles congenial to their ambition did not coincide with individual realities: works primarily of Roman art. In each reconciliation of visual experience with literary testimony, artists had to come to terms with variations in the evidence preserved from the Antique.

To illustrate this in the very matter of painting: Quattrocento masters could never hope to recover lost easel paintings by Apelles and other famed Greek painters (although some did try to reconstruct them from literary descriptions like those of Philostratus), but they did have actual Roman frescoes as well as Vitruvian directives on wall decoration. Documented penetration of the buried 'grottoes' of the Golden House of Nero took place in the 1480s, opening a vast treasure house of antique painting. Yet Vitruvius made it clear that these Third and Fourth Style fantasies–*grottesche* reminiscent of Gothic inventions in the margins of manuscripts and thus abhorrent to the 'modern' eye turned on Nature–were less praiseworthy and noble than the projected colonnades and perspectives found elsewhere (and which we know today as an earlier Second Style). It would take that great harmonizer,

Raphael (and his School), to reconcile divergent lessons from the ancients. Vagaries and figments of imagination, which bothered Vasari subsequently as he looked back at the Quattrocento and Pinturicchio, were acceptable if confined to private *loggie* and bathrooms as painted by Raphael's workshop with archaeological exactitude for erudite patrons **(Fig.10)**. But artists of Raphael's circle discovered–among Third and especially Fourth Style 'monsters' which were deemed inappropriate for imitation in sacred surroundings–sparkling 'sacral landscape' vignettes. These had a revolutionary effect, bringing about pure rather than accessory landscape as a new category of art **(Figs.11 and 12)**.[18]

Such novel genres of representation, entirely new formal modes of expression, were brought about by Renaissance artists trying to systematize exemplary Antiquity from the conflicting testimony of literary as against visual sources. Discrepancies were reconciled gradually over the course of the Quattrocento by artists arriving at concepts of stylistic propriety to guide a choice of subject matter and the manner in which it should be expressed. Horace's *Ars Poetica* and other classical texts had already sparked emulation among humanists and reformers of written style in both Latin and the vernacular. For the visual arts, the process culminating in the High Renaissance synthesis took over a century to accomplish, with many shifts of direction and variant solutions to the fundamental problem of how to deal without a historical framework with so many different cultures and epochs under the single rubric of 'The Antique'. The Quattrocento artist, through his study and research into Nature and the Antique with the guidance of ancient texts interpreted by scholars, developed new theoretical and conceptual contexts for visual observation that are characteristic of the Renaissance. Only then could a Raphael–who, with his fellows, recognized that the sculptures on the Arch of Constantine represented contrasting period styles–or a Leonardo, gain access to and redefine a norm in ancient practice. At that point, if 'classical' antique style had not existed, they would have had to invent it.[19]

The Arch of Alfonso of Aragon at Naples **(Fig.13)** illustrates well the principle of stylistic congruence by which the Quattrocento selected contrasting ancient models to suit specific iconographic needs. As with the Emperor Frederick II Hohenstaufen in his South Italian realm more than two centuries earlier, historical monuments of Roman Imperial power–triumphal arches in general and the sculpture of the Arch of Trajan at Benevento **(179)** in particular–shape dynastic ambition expressed in the gate proper and its main frieze.[20] But striking differences in artistic 'dialect', over and above those brought about by date of execution and handling by diverse masters, demonstrate antique influence adapted to expressive purpose. The triumphal procession as well as later passage-way reliefs are executed in high relief and varying degrees of 'real' or stage space which may be filled to bursting by an anonymous, overlapping crowd, or emptied out around significant figures. Personifications of Peace, Prosperity and the Virtues of the ruler, or other abstract entities, present a more Hellenic, classicizing style and turn away from the descriptive textures and superabundant details of contemporary dress in the triumphal entry. Yet another style of carving is taken over in imitation of Hadrianic and Early Antonine Roman sarcophagi for minor socle friezes of symbolic intent (embracing cosmic and funerary significance in mythological terms). Here a subtle low relief, clarified on

neutral ground, ranges narrative figures in three-quarter view, though emblems are presented in frontal aspect. One element, an enwreathed 'Caesar' profile, through its imitation of Roman medals, recalls Alfonso's patronage of Pisanello as well as concepts that led to the rebirth of portraiture in the 15th century.

Portraiture, indeed, necessitated still another generic mode in the Renaissance union of practice and theory based on precepts from Antiquity. Originating in numismatic precedent and the vivid presence of late Gothic funerary images, Quattrocento portraits represented a new alliance between tangible relics of Antiquity and ancient texts conveying both physiognomic interpretation of character and congenial ideas of Latin ancestral pride.[21] Although the portrait bust took a form more readily associated with medieval reliquary tradition, it harked back in style to Roman prototypes of the Republic and early Empire. It was not until the Cinquecento that sculptured portraits came to absorb the heightened psychological tension and bravura colouristic effects of less static Antonine models. At any stage within this gradual evolution in the rendering of personality–likewise followed in the portrayal of Old Testament prophets made freshly 'real'–no single artistic or personal style coordinates portraiture with other types of sculpture. How unlike the Middle Ages when, at a given time and place, identical forms govern all media, linking a monumental *trumeau* figure to its miniscule relative executed in ivory, parcelgilt metal or wood.

Take for comparison another novel category of Quattrocento sculpture directly inspired by classical example: portable bronze statuettes. These express entirely different formal values from those of contemporary portraits, even if by the same hand. In place of sharply defined, static areas of shape and contour, or in-line relationships that make profile views particularly effective in the case of Early Renaissance portrait-busts, movement in space is exploited, as well as the kinetic involvement of the spectator, in the life of the object and its fluid, interpenetrating surfaces. Visual rhetoric suits the task: passive Roman *gravitas* in commemorative portraiture of monumental intent is set against an ideal of private, sensual art, the latter involving direct participation of the sort that is dramatized by Bellano's *David*, whose owner had the secret enjoyment of discovering the landscape setting of the hero's encounter subtly represented in relief on the underside of its base.[22] Sculptural problems worked out *all'antica* on a small scale, in bronze statuettes, led to similar concerns being addressed in large-scale statuary in the round and to classical statues and torsos being 'posed' in contrasting views **(Fig.14)**.

Many other genres of representation might be put forward to document the formation of a nascent concept of artistic modes, long before Lomazzo and Baroque theorists. To name but one: a pastoral and elegiac tone or idiom depended for its models on pictorial 'half-round' relief from ancient stuccoes, Arretine ware and gems.[23] It is possible to go on with other examples. But enough has been said both to indicate the complexities of the subject and at the same time to convey the knowledge Renaissance artists had–and the use they made–of the selected antiquities contained in this book. The Renaissance was born in the geographic heartland of Roman art. Greek Hellenistic culture had differentiated élite from popular art; it was left to the Romans to offer, for the first time in human history, a broad range of artistic standards, of contrasting styles–even for varying iconographic themes within one and the same monument. To cope with such diversity, the

Renaissance shaped two structures: that sense for the division of history into periods, which is rightly seen as its hallmark of self-awareness, and a new cognitive and theoretical process to regulate visual experience. The first is already apparent at the turn of the 14th century in Coluccio Salutati's discussion of the Florentine Baptistry when he argues that the original workmanship of this 'Temple of Mars' is not in the Greek nor the Tuscan mode but *more factum... plane Romano.*[24]

The second structure applies principles of rhetoric, inspired by abundant literary criticism from Aristotle and 'Demetrius' of Phaleron to Horace and Cicero, as well as a reform of language that gave fresh impetus to the study of ancient writers on linguistics and oratory. All of this has been recognized, but *ut pictura poesis*–equivalence of word and picture–represents merely one of the conceptual strands binding the Renaissance to Antiquity.[25] The tensile strength was Latin, and Roman art was exceptional in having created a comprehensive visual rhetoric to express every meaning. It is not surprising to find that Roman artists invented a sign language of gesture and symbol to encode abstract ideas and imponderables for the masses. For those who could appreciate subtler inflections, Imperial artists originated something much more significant for the Renaissance; an unexpected repertory of artistic languages of form, each a consolidated mode of expression fitted to a given theme.[26]

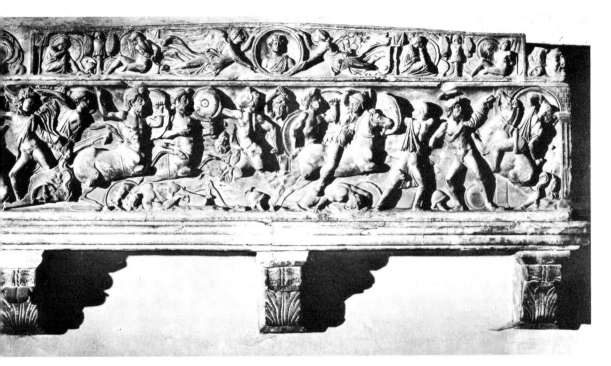

. 1 Battle of Bacchus and Retinue with Indians and Amazon. Roman
cophagus, c.160 A.D. Cortona, Museo Diocesano

Fig. 2 Hercules.
Detail on Porta della Mandorla,
c.1390–1400. Florence, Cathedral

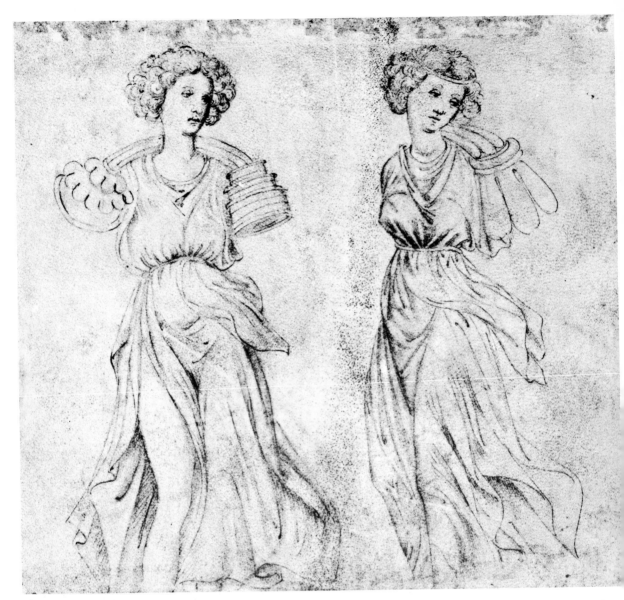

Fig. 3 Pisanello: Drawing of Horae or Maenads.
Rotterdam, Museum Boymans-van Beuningen

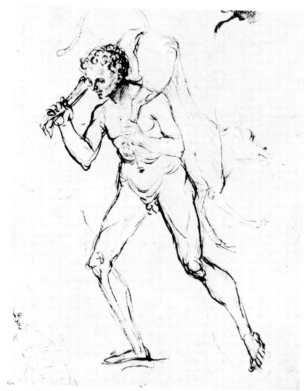

Fig. 4 Pollaiuolo (?): Drawing after the Antique.
Oxford, Ashmolean Museum

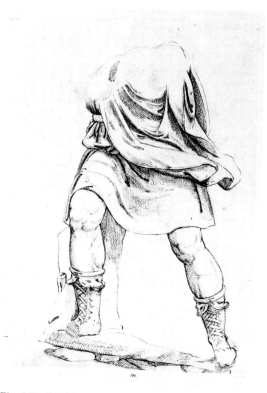

Fig. 5 Dosio: Drawing of Pedagogue from Niobid group.
Dosio Album, f. 54, no. 132. Berlin Staatliche Museen

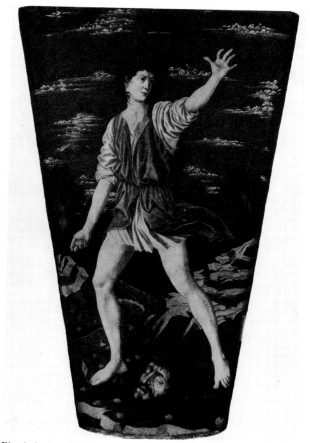

Fig. 6 Andrea del Castagno: Parade shield with David
and Goliath, c.1450. Washington, National Gallery of Art

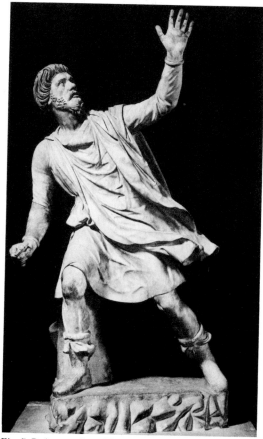

Fig. 7 Pedagogue from Niobid group.
Florence, Uffizi

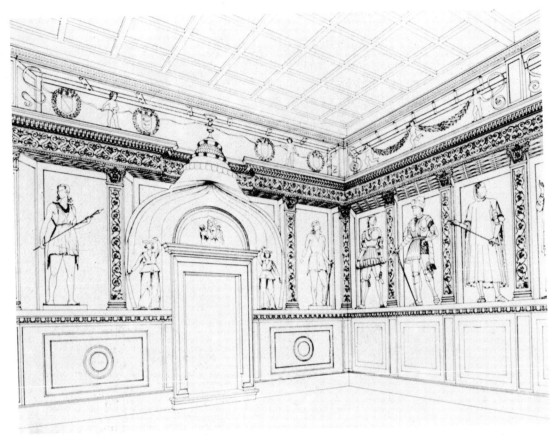

Fig. 8 Reconstruction of Andrea del Castagno's frescoes of
Famous Men and Women from the Villa Carducci, Legnaia

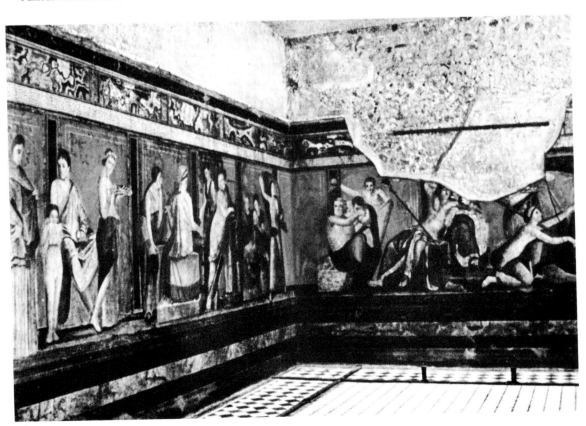

Fig. 9 Roman, Second Style wall decoration. Pompeii, Villa dei Mistere

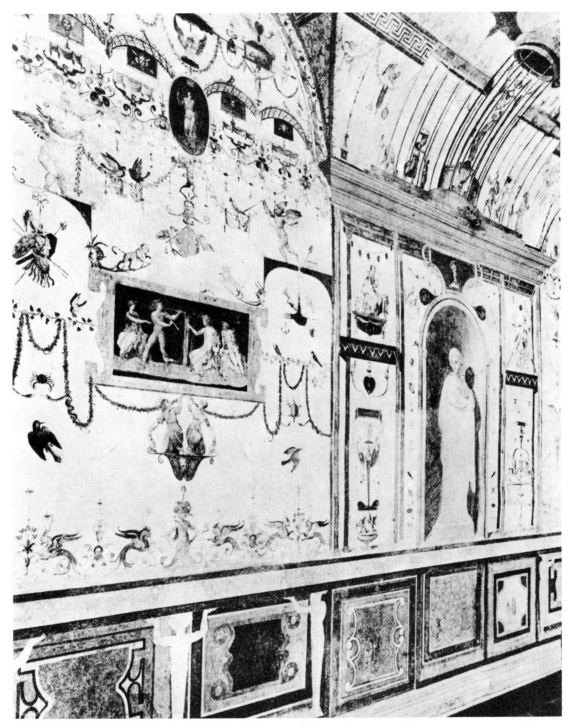

Fig. 10 Raphael and Giulio Romano:
Loggetta of Cardinal Bibbiena, Vatican Palace

Fig. 11 Roman idyllic landscape
from the House of Agrippa Postumus
at Boscotrecase. Naples, Museo Nazionale

Fig. 12 Polidoro da Caravaggio: Landscape with scenes from
the Life of St. Catherine, c.1524. Rome, S. Silvestro in Capite

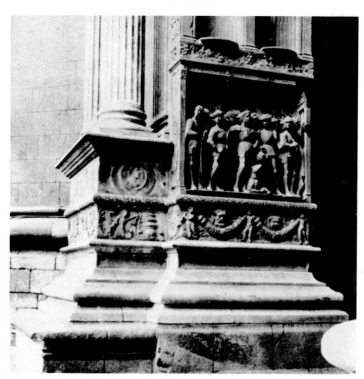

Fig. 13 Detail on the
Arch of Alfonso of Aragon, 1443–75.
Naples, Castello

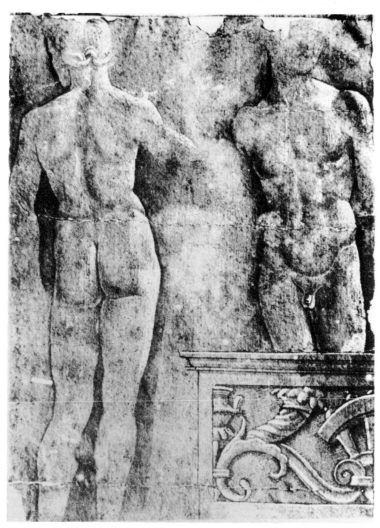

Fig. 14 Study after an antique torso.
Anonymous North Italian drawing,
15th century. Milan, Ambrosiana

Fig. 15 Attavante de Attavantibus: Miniature from the Missal for the
Bishop of Dol, 1483. Lyons, Bibl. Mun. MS 5, 123, f.6

NOTES TO THE INTRODUCTION

1. Vasari–Milanesi, 1906, II, p.340: '*un pilo antico bellissimo, dove era una storia di marmo, cosa allora rara, non essendosi disotterrata quella abbondanza che si è fatta ne' tempi nostri: e così seguendo Donato il modo che aveva usato quel maestro a condurre quell'opera, e la fine che vi era dentro insieme con la perfezione e bontà di magisterio, accessesi Filippo di una ardente volontà di vederlo…*' In Donatello's day the sarcophagus was in the Pieve, or parish church; today it is in the Diocesan Museum of Cortona. Minto, 1950, pp.1–22. See *144*.

2. On Renaissance concepts of rebirth, see Panofsky, 1960, esp. ch.I; and Gombrich, 1952, 'The Renaissance Concept of Artistic Progress and its Consequences', with earlier bibl. For Alberti and Quattrocento art theory, the study by Gadol, 1969, includes earlier literature; an important article by Baxandall, 1974, pp.143ff., reconstructs Alberti–an art criticism, as distinct from theory–through writings of Landino. The dependence on Pliny and relation to ancient art theory will be better understood by reference to Pollitt (1974).

3. A good summary, with bibl., of medieval studies and collecting is to be found in Weiss, 1969, chs.I–IV. For documents of the Mirabilia tradition, Magister Gregorius, John of Salisbury and other medieval visitors to Rome, see Valentini and Zucchetti, 1946, III (1953; IV covers the period from Petrarch through the 15th century). On the Augustan-inspired revival of Frederick II Hohenstaufen, the best work in English is Kantorowicz, 1957, and Haussherr *et al.*, 1977, Exh. Cat. illustrates it well.

4. On the concept of *istorie* as against *poesie*, see Howell, 1966, pp.374–90. In general, Venice moves from 'archaeological' concerns–inspired by Padua and clearly enunciated by Jacopo Bellini, for one–to a very free evocation of classical mythopoetics; cf. Saxl, 1957, I, pp.150ff.; Mitchell, 1960, pp.455–83; and Wittkower, 1963, pp.473–84. Rosand, 1972, pp.572ff., demonstrated what this means for Titian, although he does not always go beyond the literary to visual classical sources.

5. For differentiation of the preference for particular stages of ancient art felt by 15th century artists, High Renaissance masters and Mannerists, see Bober, 1957, Introduction; see Janson's review of Rowland, 1964, p.407 for unacknowledged citation of these passages.

6. Białostocki, 1963, pp.19–30, on a different meaning of *natura naturata* opposed to *natura naturans* as the passive and active aspects of the imitation of nature. The use of casts and fragments by artists is a topic that requires study; see Bober, 1957, p.21, n.5. Casts in lead and wax after gems, for example, circulated freely among artists and led to the art of reproductive plaquettes in bronze for collectors. For casts of sculptural torsos and *membra disiecta*, one thinks of Neroccio's testament or studios like that of Squarcione–also in Padua, the collection of Marco Mantova Benavides (Candida, 1967). See also Degenhart–Schmitt, 1968, I, pp.xxxii; Schmitt, 1970, p.103, and 1972, p.139 (Jacopo Bellini's will); Rosand, 1970, pp.5–53, on sculpture fragments as models for drawing. See now Fusco, 1979, pp.257–63, esp. p.259, n.7, for Pollaiuolo's use of sculptural models; Ost, 1975, pp.33–43, on 15th and 16th century plastic models used by artists.

7. On the significance of the *virtus* of Hercules in Florentine civic symbolism, see Ettlinger, 1972, pp.129ff., including earlier bibl. on the Porta della Mandorla and Coluccio Salutati. On Coluccio, see Ullman, 1963 and most recently Witt, 1983.

8. Degenhart and Schmitt, 1960, pp.59–151.

9. Folios in Milan by the 'Ambrosiana Anonymous' were first discussed by Vicenzi, 1910, pp.6ff., Schmitt, 1966, added two more Ambrosiana sheets by the same hand and modified the dating, attributing this group of drawings to a Milanese artist c.1460. On the identification of the antefix drawings, Schmitt, 1960, pp.123–4, figs.101–2. For the theory that Mantegna used the terracotta for his group of Mars and Venus in *Parnassus* as suggested by Bober, see Vickers, 1978, pp.151ff. (although he relates the figure also to Mars of the so-called Ahenobarbus altar).

10. For identification of this series of drawings, see Bober, 1963, pp.85–6, n.11; illus. and discussed by Degenhart and Schmitt, 1972, pp.154ff., figs.21–2, 25.

11. For this particular figure, see a plaque owned by Sodoma, '*una tegola di terra antiqua drentovi uno Hercole con uno toro et una donna con polli in uno bastone…*', discussed by G.F.Hill, 1906, *JHS*, XXVI, pp.288ff.

12. The process of assimilation at the hands of an individual artist like Giulio Romano is admirably set forth by Gombrich, 1963, pp.122ff. The dependence of Castagno's *David* (Washington, NGA, 640) on the Niobid Paedagogue was first noted by Aby Warburg, 1969, I, p.449, but denied subsequently by those who thought only of the replica in Florence, rather than a fragmentary copy now in Copenhagen which was his source.

13. 'Sandro Botticellis *Geburt der Venus* und *Frühling*' in Warburg, 1932, I, pp.6–22. F.Winter, 1890, pp.122ff.,

had earlier emphasized Agostino di Duccio's use of neo-Attic works, without relating this to Albertian theory.

14. Discussed by Dobrick, 1979.

15. Saxl, 1939, pp. 346ff.

16. The literature on Donatello and the Antique is vast. The most important bibl. is cited by Janson, 1968, pp. 77ff., and now Greenhalgh, 1982; both add many new Etruscan, Roman and Paleochristian sources to the repertory. See also Trachtenberg, 1968, pp. 268ff., for suggestion of an Etruscan prototype. For Etruscan influence in general, see Weege, 1921, Introduction; van Essen, 1939, pp. 497ff.; Chastel, 1959, pp. 165–80; Spencer, 1966, pp. 95ff. For a discussion of artistic affinity operative in the selection of models, including the lack of appreciation of the Belvedere torso, see Bober, 1957, pp. 19ff.

17. Similarly, Castagno's frescoes for the Bibl. Graeca of Nicholas V at the Vatican echo Second-Style wall decorations of a specific stage that marks a transition to IIIrd-Style work; cf. Yuen, 1970, pp. 725–36, although she relates Legnaia to Donatello and earlier Tuscan tradition. On the general topic, see Bergström, 1957, pp. 39ff.; Sandström, 1963, is one of the few comprehensive studies which recognize the influence of Antiquity. (See Horster, 1980, pls. 103–8 for good ills. of Castagno's frescoes in the Bibl. Graeca and pp. 41–4 for documentation.)

18. On the birth of landscape and antique precedent, see Gombrich, 1953, pp. 335–60. For Polidoro's S. Silvestro al Quirinale 'heroic Roman' landscapes, see Turner, 1974, ch. VIII. For the Golden House of Nero and all earlier literature, see Dacos, 1969.

19. Raphael and his creativity *all'antica* are discussed by Becatti, 1969, ch. V (Raphael and Antiquity). In the same volume, Castagnoli (ch. VI: Raphael and Ancient Rome), p. 582, n. 16, treats the famous letter to Leo X which his friend Castiglione helped Raphael compose. On the discussion of styles in the Arch of Constantine see **182.** Cf. Fontana, 1975, pp. 25ff., n. 2. In the older literature, Müntz, 1880, pp. 307–18, 453–64, is especially to be noted.

20. On the arch in general, see Hersey, 1973, although his study does not focus upon its classical borrowings;

for the latter, Driscoll, 1964, pp. 87–96, gives some idea of the range of sources contained in her unpublished thesis.

21. Cf. Lavin, 1970, pp. 207–26, for full consideration of the issues involved; see also Pope-Hennessy, 1966, esp. ch. II.

22. Jennifer Montagu, 1963, p. 33, makes this point about the 'intimate private quality' of the Bellano statuette and reproduces the Philadelphia Mus. version, figs. 21, 23.

23. Nicole Dacos is one of the few scholars to consistently and rightly stress the importance of small, portable works of art for the Renaissance; see 1977, pp. 51ff., and discussion of the influence of gems in her contribution to the Mus. Mediceo Exh. Cat., 1973, I, pp. 150ff. In the latter she points out that Vasari himself recognized the technical contribution of Arretine ware to the development of *stiacciato* relief. Yuen, 1979, pp. 263–72, signals a wider study of the topic.

24. *Invectiva in Antonium Luschum Vicentinum* (1403), ed. D. Moreni, Florence, 1826, p. 26. Coluccio Salutati's *de laboribus Herculis* (ed. by Ullman, 1951, together with an earlier epistolary version) was left incomplete at his death in 1406. The expanded commentary of the first book, a defence of poetry, carries forward Petrarch's and Boccaccio's contention against scholastic suspicions of pagan poetry with arguments which anticipate Ficino's Neo-Platonic doctrine of the unity of revelation through God's inspiration – whether of Homer and Virgil, of Moses and the author of the Song of Solomon, or of the Evangelists and St. Augustine. Salutati's allegorical interpretation of ancient myth and poetry announces the future just as surely as his characterization of the Baptistry (however erroneous) reveals a nascent historicism and consciousness of style.

25. The first formulation of what this concept meant for the Renaissance was made by Lee, 1940, pp. 197ff., also available in paperback, 1967. Cf. also Praz, 1970, with bibl.

26. On contrasting standards and the stylistic choices facing Roman artists, see Brendel's masterly historiographic overview, 1953, pp. 9–73. For the symbolic language of gesture which represents continuity in the diversity of styles, see Brilliant, 1963.

THE CATALOGUE

HOW TO USE THE CATALOGUE

The material assembled here attempts to show, in text and picture, how antique works of art were known and interpreted in the Renaissance. The catalogue entries are arranged by subject, each theme being introduced by brief narrative texts that re-tell the ancient myth or legend. The illustrations relevant to each entry follow the same sequence of numbering as the catalogue: Renaissance representations and comparisons can be recognized by the alphabetical suffix attached to the number of each antique work.

TITLE: Present identification of subject, approximate date according to recent authorities, and present location of the antique work with inventory, museum catalogue or standard reference number.

DESCRIPTION and INTERPRETATIONS: The appearance and condition of the antique subject; how it was described and interpreted in the literature, guidebooks and letters of the Renaissance.

HISTORY: How and where the subject was seen during the Renaissance. Further information on the major Renaissance Collections will be found in Appendix II.

REPRESENTATIONS: How and where the subject was recorded and used by artists of the Renaissance. Brief supplementary information on all artists and sketchbooks is given in Appendix I.

The representations documented and often illustrated, indicate the condition and location of the antique works of art in the Renaissance, and occasionally later. They are mostly drawn in sketchbooks, on sheets assembled later in albums, or on unbound sketchbook sheets. (When no other medium is cited, the entry always refers to a drawing. Published sketchbooks, albums and Codices are quoted in italics, abbreviated as *Skb., Cod.,* and those as yet unpublished are given as skb., cod.) Engravings, which greatly extend the knowledge of the antique objects, are also included, as are small bronze copies.

When reference is made to adaptations in Renaissance frescoes, sculpture and other media, 'adaptation' means that the antique sculpture is the basis for a free interpretation by the Renaissance artist; 'restored' means that the artist has not copied the damaged statue or relief exactly, but has added the missing parts in his drawing.

The representations are arranged in a roughly chronological order, but in most instances the ever-changing question of attribution has been left open. For the sake of the convenience of students working in print rooms, the inventory or catalogue numbers of the relevant collections of drawings are given whenever possible, as is the artist's name under which it is catalogued, even though that attribution may now be out of date.

LITERATURE: A short bibliography is given, relevant to the antique work of art and, when material exists, on its influence in the Renaissance. Bibliographic references are given in author's name and date of publication only, and all further information is to be found in the detailed Bibliography pp. 481–506.

PART ONE ~ GODS AND MYTHS: INTRODUCTION

Gods and Myths in Antiquity

The principal gods of the Greeks were so vividly characterized in Greek art and literature that the Romans could not resist borrowing Greek types for their own deities. Thus many of the images, personalities, and even myths of the Greeks were adopted by the Romans, often under Latinized names. As the Latin names were used in the Renaissance, so they are, where appropriate, used in this book.

In classical Antiquity, free-standing statues of gods and goddesses were mostly based on cult images and revealed deities in their most serious and dignified guises; but it was often forbidden to copy these exactly and statues were therefore shown with variations, though still recognizable by pose, dress and attributes. However, the stories told about the gods–the myths that arose to explain natural phenomena, clarify cult practices, or serve any number of other purposes–reveal a very different aspect of their personalities. In these myths, the gods are presented as active and passionate, very much like human beings in their behaviour and emotions. Jealousy, lust, pride and competitiveness were not unknown to these powerful deities.

Myths also tell of the gods' interaction with mortals, such as the love of Amor for Psyche or that of Jupiter for Leda, or else the concern of Minerva for Daedalus and Ulysses. In many myths heroic mortals become the protagonists, as for instance in the stories of Meleager's Calydonian Boar Hunt (p. 143), those of Paris or Achilles in the Trojan Legend (p. 148), or of the Labours of Hercules (p. 169–170). Such myths are often the subjects of works of narrative art on sarcophagus reliefs.

Artists in Antiquity knew myths from many sources. They must have heard them in childhood, as we hear Bible stories. Myths were not only disseminated in fine literary form, as in the tragedies of Euripides or the *Metamorphoses* of Ovid, but were also available in handy mythological manuals such as the *Fabulae* of Hyginus or the *Bibliotheke (The Library)* of Apollodorus. A great deal more material treating mythological topics existed in Antiquity than has survived; many poems that made up the epic cycle telling the story of the Trojan War may have been lost, but only the *Iliad* and the *Odyssey* of Homer remain and of some ninety tragedies of Aeschylus, only seven are preserved. Much can be pieced together from extant literature and ancient commentaries, but much is irretrievably lost.

Classical artists were not only verbally but also visually acquainted with myths. Representations of mythological themes decorated temples and public buildings; they were used to ornament clothing and implements for daily use; cycles of illustrations almost certainly appeared in book rolls, and pattern books for artists were evidently available. The Graeco-Roman artist carving a sarcophagus relief did not have to invent new narrative types, but rather had to adapt existing formulae to the front and ends of his sarcophagus. Certain themes lent themselves to long narrow reliefs particularly well–hunts for instance, and processions, both Bacchic and marine. The sarcophagus carvers estab-

lished their own compositional combinations which they repeated over and over again with slight variations, perhaps to accommodate the individual tastes of patrons.

This visual tradition was, however, broken in the Middle Ages. Images of gods came adrift from their antique figure types; the gods and heroes were shown in manuscripts illustrating Greek myths and legends dressed in the fashion of the day.

Gods and Myths in the Renaissance

Statues: The antique statues that survived or were discovered in the early Renaissance often proved difficult to identify, not only because the statues had lost arms, legs, heads, or attributes which might have revealed their identity, but because they were still too few in number to fall into categories of types. The colossal statues which survived through the Middle Ages in Rome on Monte Cavallo, the reclining river gods **(65 A–B)**, for example, or the 'Horse-Tamers' **(125)**, were still obscured by medieval legend, and in spite of the researches of scholars like Flavio Biondo, who drew upon a vast range of Latin texts which he knew from manuscripts available in Rome in the 1440s, their true identities were not revealed until much later.

However, there seem to have been several ways in which identifications could be attempted: it was possible to refer to literary sources such as the Greek and Latin poets and historians; or to consult a handbook of mythology, or a compilation such as Boccaccio's 14th century *Genealogy of the Gods* which, though available in manuscripts, was not printed until 1472. Such sources were not satisfactory, however, for visual descriptions of the gods as they appeared in marble and bronze. Better guides were the figures on the reverses of Roman coins–some had inscriptions which allowed the identification of analogous statues. Later on, this process could be extended by a comparison of statues of the same type.

With the increasing building activity in Rome, statues were discovered in the course of mending drains (cf. **98**), digging foundations, and in tilling vineyards amongst the ruins. Around 1500, statues began to be recorded in descriptions and drawings in private collections (see Appendix II). Outstanding discoveries were acquired by the popes for the statue court of the Belvedere in the Vatican, founded by Julius II in 1503; such statues were the Laocoon **(122)**, found in 1506, and the Hercules and Telephus **(131)**, discovered in 1507. And in the sculpture courts and private gardens, made in conscious imitation of the Antique, the newly-found antique sculpture could now be drawn by artists, and studied and discussed by the learned residents of Rome and their distinguished visitors and fellow collectors, such as Isabella d'Este.

In the early Cinquecento, the statues seem to have been identified from a study of classical texts rather than from comparison with other works of art. Particular excitement was caused when a statue was discovered which precisely answered a description by Pliny, such as the Laocoon, or the River God Nile **(67)**.

By the middle of the Cinquecento, thanks to the number of statues collected, identification by type had become easier and was further aided by the publication of mythological handbooks by Giraldi, Cartari and others who, unlike Boccaccio, were concerned with the visual appearance of the gods, as was the artist and antiquarian, Pirro Ligorio. His many

unpublished volumes of an illustrated encyclopedia of the ancient world were based on first-hand knowledge of antique sculpture, coins, gems and artefacts, as well as literary sources referred to by Cartari and other mythographers.

Soon after the middle of the 16th century, Aldrovandi published a description of statues in private and public collections in Rome, sometimes explaining the subjects, and comparing the statues with others of the type. Cavalieri's engraved plates of restored statues, which he began to publish at that time, are inscribed with the names by which the statues were generally known, and the collection to which they belonged; later editions included increasing numbers of statues, and show the progress made since the early Renaissance in the availability and identification of classical statues.

Mythological Reliefs: The extent to which Renaissance artists understood the subjects depicted on mythological sarcophagus reliefs is not fully known. It may well have been Manuel Chrysoloras, a learned and greatly admired Byzantine scholar who taught classical Greek in Florence, who opened the eyes not only of the humanists, but also of the artists, to the interest and beauty of these reliefs. He wrote from Rome, in 1411, in a much circulated letter:

'Walking through the streets one finds at every corner sculpted reliefs representing episodes from the ancient Greek myths – the story of Meleager (cf.**113–18**), Amphion (cf. p.139; **107**), Triptolemus, or if you prefer, of Pelops, Amphiaron, and Tantalus; these one can find on the sides of sarcophagi and even cemented into the walls of private houses; and each are the work of the very finest sculptors – a Phidias, a Praxiteles, or a Lysippus!' (Greek text in Baxandall, 1971, p.150; transl. David Thomason.)

When artists in the mid-Quattrocento illustrated the Greek myths, they looked to classical literature as a source, but did not seem to relate the themes they saw on the sarcophagi to those which they knew from Homer and Ovid. Leone Battista Alberti, the polymath humanist, architectural adviser and writer of treatises on painting, sculpture and architecture which were to provide guidance for generations of artists, advised his contemporaries in 1435 to study the *istorie* (sarcophagus reliefs) in order to learn how to express the movements of the mind by the movements of the body. He specifically draws attention to a Meleager sarcophagus, famous in Rome, for the dead weight of the whole body of Meleager (cf.**118**). He also advised the study of reliefs for the variety in the poses of the limited number of figures needed to tell a story clearly (Alberti–Grayson, 1972, II, chs.40–1).

Mythological reliefs, in fact, to judge from surviving drawings and the works of art of the early Renaissance masters, were not studied in terms of the original subject matter. The reliefs offered formal principles that could be applied in new works of art, and motifs and emotive gestures for use in a different context. Thus, as Peter Spring writes (1972): 'the Entombment echoes with the wild lamentation for Meleager'.

With the publication of Ovid's *Metamorphoses* and other classical texts in the last quarter of the Quattrocento, and of the mythological handbooks which appeared around the middle of the 16th century, there was an increasing tendency to draw entire reliefs rather than motifs from them. Although some reliefs were drawn and engraved by artists in Raphael's circle in the earlier part of the century, it is around 1550 that the drawings made for the German antiquary, Pighius, record whole sarcophagus reliefs accurately with no

attempt to supply missing parts. Dosio followed this archaeological approach, while Ligorio, who did not draw sarcophagus reliefs (see below) was able to supply missing parts from his knowledge of comparative material (gained in drawing funerary altars) often with an explanation in an accompanying text.

Quite a different approach to antique reliefs was adopted by artists of the anti-classical style which Vasari called 'Maniera', who took pleasure in virtuoso drawing, mixing elements from a variety of reliefs, so that the exact sources are consciously transformed in the new adaptation. This may explain why, for example, there are so few drawings in the Artists' Index (Appendix I) attributed to mannerist artists like Perino del Vaga, Francesco Salviati, and Polidoro, whom Vasari and Armenini reported as having made copious drawings after the antique. Girolamo da Carpi combines both trends, copying whole reliefs, but adding the missing parts and other embellishments, and Franco's drawings, while adapting to the antique model, often delight in an independent calligraphic line.

Pirro Ligorio, the artist most concerned with the subject matter of antique art, did not draw sarcophagus reliefs, but described them in words, and identified them with great precision (see for example, **110** and **121**). Yet his knowledge was not shared by the 17th century papal antiquarian Giovanni Pietro Bellori, who wrote the learned commentaries under the plates of antique sarcophagus reliefs that were first engraved by François Perrier in 1645 in reverse, then also in part copied correctly and augmented by Pietro Santi Bartoli in 1693. Bellori described a sarcophagus relief with the dead Meleager carried by his companions of the hunt to the funeral pyre **(118)** – perhaps the same one admired by Alberti– as the funeral procession of a huntsman. His inability to identify, in spite of his compendious knowledge, the reliefs of Orestes **(106)** and Medea (cf.**110**) show how the antique image and classical text had once more become divided even after a Chrysoloras or a Ligorio had temporarily brought them together.

Since then, thanks to archaeological research and philological study by such scholars as the 18th century Montfaucon, the early 19th century Visconti, and the German archaeologists Jahn, Matz and Robert in the late 19th century, art historians are better able to recognize the classical figure types and myths associated with the gods. As for the artists, the classical tradition in form and content is still alive, and they will continue to use it as they have through the centuries, selectively and for their own purposes.

Bibliographical Note

Sources of Classical Mythology: Ovid presents a splendid collection of myths in the *Metamorphoses* which is available in several English translations, some in paperback. Apollodorus' more complete but less amusing compendium in the *Bibliotheke (The Library)* and the *Epitome* is available in the Loeb Classical Library with English translation and illuminating notes by J. G. Fraser. The rich collection of myths told by Hyginus exists in an English Translation by Mary Grant under the title *The Myths of Hyginus* (University of Kansas Publications, Lawrence, 1960) and is extensively annotated. Of these sources, Ovid's graceful retelling of myths in the *Metamorphoses* circulated most freely in the Renaissance and was among the first books ever to be printed. The mythological manuals

of Hyginus and Apollodorus were first printed in 1523 and 1558 respectively, about the time when the first mythographers since Boccaccio, Giraldo (1548) and Vincenzo Cartari (1556) published their handbooks. Cartari's illustrated explanation of the gods and their myths was printed in several editions and became a reference book for artists and writers.

Modern reference works to consult on classical mythology are: Roscher, 1884–1937; *Der kleine Pauly Lexicon der Antike*, 1964 (in progress); *Lexicon Iconographicum Mythologiae Classicae*, 1981 (in progress, illustrated); as well as Graves, 1960, for sources; and Rose, 1964, for an excellent survey of myths with references and sources. *The Oxford Classical Dictionary*, 1970, offers authoritative short articles. Koch and Sichtermann, 1982, relate the myths to sarcophagus reliefs.

For classical mythology in the Renaissance, consult Seznec, 1953 (paperback, 1961), and Radice, 1973.

For the study of classical sculpture in other periods besides the Renaissance: Adhémar, 1939, (French medieval); Greenhalgh, 1978 (late Antiquity to Ingres); Potts, 1980 (18th century); Haskell and Penny, 1981 (1500–1900).

Listed below are the names of the principal Greek Gods,
Demi-Gods, Heroes and Personifications, with their Roman equivalents:

Greek	*Roman*
ZEUS	JUPITER/JOVE
HERA	JUNO
DEMETER	CERES
PERSEPHONE	PROSERPINA
HADES	PLUTO
HERMES	MERCURY
APHRODITE	VENUS
ARES	MARS
ARTEMIS	DIANA
SELENE	LUNA
APOLLO	APOLLO
ATHENA	MINERVA
HEPHAESTUS	VULCAN
EROS	AMOR/CUPID
DIONYSOS, BACCHUS	BACCHUS/LIBER
POSEIDON	NEPTUNE
ODYSSEUS	ULYSSES
HERAKLES	HERCULES
NIKE	VICTORIA/VICTORY
TYCHE/NEMESIS	FORTUNA

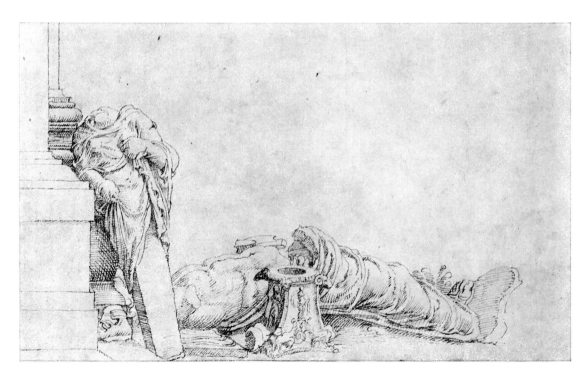

2a

PART ONE: GREEK AND ROMAN GODS AND MYTHS

JUPITER, JOVE (ZEUS)

Jupiter was the most powerful of the gods. His impressive figure was usually portrayed bearded with a nude torso, mantle over one shoulder, and legs draped. His attributes, the eagle, thunderbolt and sceptre show his dominion over the heavens.

The most famous classical image of Jupiter was the great gold and ivory statue that Phidias made for the god's temple at Olympia in Elis. Jupiter was shown seated, partially draped, holding a figure of Victory in one hand and a sceptre topped by an eagle in the other (Pausanias, V, 11, 1–2). This statue was considered one of the Seven Wonders of the Ancient World, not only because of its size and splendour, but also because of the spiritual power that it seemed to convey. So impressive was this that Quintilian (*Institutio Oratoria* XII, 10, 9) observed: 'its beauty can be said to have added something to traditional religion, so adequate to the divine nature is the majesty of the work'. Quintilian was much read in the Renaissance and Alberti cited this reference in the second book of his treatise *On Painting* (Alberti–Grayson, 1972, p.61).

The dignity and majesty of Phidias' statue was emulated in Antiquity, and Roman statues of the type were discovered in the Renaissance.

LITERATURE: A.B.Cook, 1914–40.

1. Jupiter Enthroned
Lower half of colossal Roman statue of Hellenistic type
Naples, Museo Nazionale (Ruesch, 1911, cat.643)

DESCRIPTION: In the early 16th century, according to the drawings, the statue was in two halves which were later united; now only the lower half remains.

The drawings showing the whole statue portray the god seated majestically on a throne, with right arm projecting to the side, but broken off at the biceps, and the other wrapped in a fold of drapery which falls between the knees, and the right foot extending forward. The torso is nude and only the left arm, loins and leg are draped. The throne is carved with lyre-shaped volutes and palmettes at the front of the sides, and the footstool is decorated with an ivy motif. The whole statue is set on a base which appears in all the drawings.

HISTORY: It was drawn in the Ciampolini Collection at the beginning of the 16th century (*Cod. Escurialensis*; Aspertini, *Cod. Wolfegg*). After Giovanni Ciampolini's death in 1518 it came to Cardinal Giulio de' Medici's Villa Madama, where both halves were assembled and drawn by Heemskerck in the *esedra* of the Villa which became Farnese property in 1538. There the statue remained until the 18th century. The lower half of a seated Jupiter now in Naples is generally associated with the Ciampolini-Madama-Farnese statue, although it does not appear in the Farnese inventories and Ruesch believed it to be from Herculaneum. There is a decisive record, however, that Albacini, the restorer, received only the lower fragment from the Villa Madama in his Roman studio in 1787, and sent it unrestored to Naples in 1800 (de Franciscis, 1946, p.109).

The suggestion that the missing top half could be the Jupiter of Versailles (2) is untenable, given the histories, measurements, and drawings of the two statues (for summary of this discussion, see Netto-Bol, 1976, p.45).

REPRESENTATIONS:
– North Italian, c.1500, Bayonne, Mus. Bonnat, inv. 704ᵛ (Bean, 1960, cat. and fig.225ᵛ): lower part enthroned from right frontal view.
– Aspertini, *Cod. Wolfegg*, f.46 (Robert, 1901, p.237): …'Zoano Canpolino'. 'Restored' as seated woman holding a mirror; cf. 'Prospettivo Milanese', c.1500, stanza 25: 'He (Ciampolini) has a nude that is seated/enveloped in a veil save for the left foot' (Fienga, 1970, p.43).
– *Cod. Escurialensis*, f.56: 'dianni ciampolin'. Lower part including left arm in drapery, throne, footstool and base, frontal right view (1a). According to Shearman (1977, p.130 and fig.6), it is after a lost drawing by Raphael probably made between 1505–1507, and he notes that the motif of 'mirrored lyres'

of the throne was used by Raphael in his *Madonna del Baldachino* (1508) and *Madonna del Pesce* (c. 1514).

- Raphael freely adapts the figure of Jupiter to his figures of Christ in the frescoes of the *Trinity*, 1505, S. Severo, Perugia and the *Disputà*, 1508–9, Vatican (Pope-Hennessy, 1971, figs. 77, 56–7).
- Sodoma, S. Benedetto fresco cycle, Monte Oliveto Maggiore, scene 2 (Carli, 1980, pl. on p. 29): adaptation as draped teacher on double voluted throne; scene 19 (*ibid.*, pl. on p. 91): double volute on balcony.
- Jacopo Sansovino, Florence, Uffizi, 4337AV: part of throne of Jupiter with inscription *'ianni campolino'*.
- Heemskerck, *Skb.* I, f. 24: whole figure from left at Villa Madama (**1b**).
- Giulio Romano, *Jupiter Enthroned*, fresco, c. 1545, Mantua, Casa di Giulio Romano (Gombrich, 1935, p. 125, fig. 83; Hartt, 1958, fig. 494): 'restored' and reversed (**1c**).
- 'Maarten de Vos' *Skb.*, f. VII (10): frontal view of whole statue.
- Pozzo Windsor, IX, f. 22, 8805 (Vermeule, 1966, p. 56, fig. 235): whole statue from front-right.
- Italian, 18th century, Vienna, Albertina, formerly Hofbibl., Sammlung Stosch (Egger, 1906, fig. 56): whole figure in *esedra* of Villa Madama.

LITERATURE: Netto-Bol, 1976, pp. 45–6. Pogány-Bàlas, 1978, for history of statue, ills. and further references.

2. Jupiter of Versailles

Colossal head and torso
Paris, Louvre (MA 78; Froehner, 1869, cat. 31)

DESCRIPTION: On its discovery in 1525 it was acclaimed as 'one of the largest and most beautiful statues to have been found in Rome'. The powerful torso with broken arms extending outwards, with windblown hair on a head 'with a beard so skilfully carved that it produces extreme wonder in whoever sees it' is all that remains of a statue which was broken on discovery. According to Francesco Gonzaga's report soon after the time of discovery, the head was separated from the body, it had no arms, and the legs were mutilated. In Heemskerck's drawing (**2a**) it appears in this condition lying on the ground at the Villa Madama, at least seven years after it was found.

HISTORY: First recorded in April 1525 in the newly acquired vineyard near the Porta del Popolo of Cardinal Francesco Armellini, who gave it to Clement VII at the Villa Madama. For letters describing the statue on its discovery, see Brown (1979,

pp. 57–8); and for letter of Francesco Gonzaga, May 17, 1525 (ASM, Busta 870), see Luzio (1908, pp. 14–15). In 1541 Margarita of Austria, widow of Alessandro de' Medici, and wife of Ottavio Farnese, sent the statue to Nicolas Perrenot de Granvelle in France who adapted it as a fountain figure on a column set up in the courtyard of his new palace in Besançon in 1546, as inscribed on its base. There it was described in 1575 (translations of documents in Brown, 1979, p. 49). It came into Louis XIV's collection at Versailles in 1686 when it was restored by Jean Droulli with new drapery and set up as a herm in the Park (Piganiol de la Force, 1728, p. 46). In the 19th century it was sent to the Louvre.

REPRESENTATIONS:
- Heemskerck, *Skb.* I, f. 46c: unrestored, lying on ground, at Villa Madama (**2a** on p. 50).
- Heemskerck, *The Good Samaritan*, c. 1550, Haarlem, Frans Hals Mus. (P. G. Hübner, 1911, *RM*, ('Jupiter') pl. xv; Preibisz, 1911, pl. x,a; Brown, 1979, fig. 9): in a view of Rome from Monte Mario, the site of the Villa Madama, the statue is shown prone, but 'restored', with an eagle beside it.
- Heemskerck adapted the colossus in other paintings reproduced in Brown (1979, figs. 2, 3, 5, 7).

LITERATURE: P. G. Hübner, 1911, *RM*, pp. 288–301; Brown, 1979.

JUPITER'S LOVES

To escape the notice of his jealous consort Juno, Jupiter (whose progeny contributed considerably to the number of the Olympian gods and heroes) generally pursued his loves in disguise. He courted Leda as a swan, and Europa as a bull; for Ganymede he sent his eagle. Certain of his loves, when discovered by Juno, suffered instant transformation into unappealing animals.

The transformations of Jupiter and his loves were celebrated by Ovid in his *Metamorphoses* (finished 7 A.D.), one of the chief literary sources for Renaissance artists. They were also illustrated in Graeco-Roman gems, reliefs, and statues of which the examples of Leda and Ganymede were the best known. What symbolism was given to these episodes in the Renaissance is beyond the scope of this book, but the Renaissance humanists' neo-Platonic interpretations of these themes are presented

by Panofsky (1939, pp. 214–16: Ganymede), and by Wind (1958, pp. 130–1), who demonstrates how the love of a divinity for a mortal, such as Jupiter's for Leda, is considered as a metaphor for death.

3. Leda and the Swan

Roman relief. Copy of a Hellenistic motif
Madrid, Medinaceli Collection, in 19th century, now in Seville (example of the type)

DESCRIPTION: Leda stands, bent forward to the swan's embrace, 'her thighs caressed/by the dark webs, her nape caught in his bill', unlike the statue in Venice (4) where they are face to face. The Madrid relief has a palm tree on the left and is assembled from many fragments.

A similar Hellenistic relief, with plain background, from Argos (London, BM; A. H. Smith, 1904, cat. 2199) was the inspiration for W. B. Yeats' poem 'Leda and the Swan' quoted above (3a). The motif also appears on Graeco-Roman gems.

HISTORY: A relief of the type known in the late 15th century probably in Rome, may have been among the sculpture given by Pius V to the de Ribera family in the early 17th century; it then came to the Medinaceli Collection in Madrid (E. Hübner, 1862, p. 237). From the drawings, it is evident that at least one other replica was known in the Renaissance.

REPRESENTATIONS:
– 'Mantegna' skb., Berlin, f. 91: swan with shorter wings, two figures added to foreground.
– Cesare da Sesto, Lombard *Skb.*, New York, Pierpont Morgan Lib., Fairfax Murray, 1910, II, pl. 35: adaptation; Leda's head turned outward.
– Raphael Workshop, Fossombrone skb., f. 88[v]: exact copy of Leda and Swan, but framed by a vine trellis.
– Italian, 16th century, from de Hévesy Collection (de Hévesy, 1931, p. 471, fig. 3) figures only, used for engraving by 'Episcopius' (Jan de Bisschop), 1669, pl. 83: 'Poel[enburgh]. d.'

LITERATURE: E. Hübner, 1862, no. 558.

4. Leda and the Swan

Roman statue. Copy of a Hellenistic statue or painting
Venice, Museo Archeologico (Forlati Tamaro, 1969, Sala VIII, 3)

DESCRIPTION: Leda stands with back curved forward, with weight on right foot, and right arm outstretched to push away the neck of the swan kissing her on the lips.

HISTORY: Possibly this or another replica was in Rome before 1523, but it is not listed in Domenico Grimani's inventory of 1523. It belonged to the Grimani donation of 1587 in Venice and was listed in the inventory of 1593 (C. A. Levi, 1900, II, p. 11).

REPRESENTATIONS:
– Lost drawing attrib. to Giulio Romano from Praun Collection, Nürnberg (not illus., Dollmayr, 1901, p. 183).
– Zanetti and Zanetti, 1743, II, pl. V (Perry, 1972, figs. 24–5).

LITERATURE: Dütschke, V, cat. 202 (description).

5. Leda and the Swan; Ganymede and the Eagle

Relief panels from a Roman sarcophagus
Lost. On the Quirinal ('Monte Cavallo') in the Renaissance (Robert, *ASR*. II, cat. 3, pp. 7 and 218; III, 2, p. 545)

DESCRIPTION: The Pighius drawing (5) reproduces a sarcophagus front with six panels. The outer panels show *genii* of death leaning on down-turned torches; the central panel contains a portrait bust of a man above confronting satyr masks. Left and right of centre are two scenes in large square panels. The left panel depicts Ganymede seated on the ground, facing left, leaning back and supported by his straight left arm. An eagle confronts him with wings outspread. There is an Amor in the left background and a spreading tree in the centre. The right panel shows Leda, lying on drapery on the ground looking right and embracing the swan. In the background, there is a cypress on the left, a tree in the centre, and Amor flying in from the right.

The Leda panel represents a well-known type in Hellenistic and Roman art and was widely copied in antique terracottas, gems, and statues, as Elfrida Knauer (1969) has pointed out. Without doubt, some of these antique replicas were known to Renaissance artists, although the objects themselves are not traceable. Knauer illustrates many Quattrocento and Cinquecento examples of works of art reflecting knowledge of this motif.

HISTORY: It can be assumed that the relief was visible in the 15th century in the ruins of the palace of the ancient Roman family of the Cornelii on the Quirinal near the River Gods (65), as described in the 1440s by Flavio Biondo (*Roma Instaurata* I, 97). For the house of the Cornelii see A. Strozzi's plan of Rome, 1472, Florence, Bibl. Laur. *(our end-papers)* (Frutaz, 1962, II, pl. 159). The sarcophagus was still there in the later 16th century, when it was drawn by Pierre Jacques '*sotto il fronton di Neron*', that is under the remains of the Temple of Serapis which dominated the Colonna gardens on Monte Cavallo (Scherer, 1955, fig. 175).

REPRESENTATIONS:

– Jacopo Bellini, follower, Paris, Louvre, R. F. 524 (Degenhart and Schmitt, 1972, fig. 21, p. 158, and pp. 155–6): sarcophagus at bottom of sketchbook-page (69a) in which panels of Ganymede and Leda and central portrait busts are very similar to the Pighius drawing, but with inscriptions instead of confronting masks, and no flanking *genii*. Degenhart and Schmitt nevertheless assume that the model was the same as the one drawn by Pighius.
– Ripanda, attrib., London, BM, 1946–7–13–210: free adaptation (5a).
– Rosso Fiorentino?, after Michelangelo's lost painting of *Leda*, London, NG, 1868 (Wilde, 1957, pl. 24): reversed adaptation (5c); one of many versions; cf. Cornelius Bos, engraving after Michelangelo, with the Dioscuri already hatched, and Helen visible in an egg (*ibid.*, pl. 28). For Michelangelo's painting of *Leda*, see Vasari–Barocchi (1962, III, pp. 1101–4, no. 528).
– Michelangelo, *Night*, statue on Medici tomb, Florence, S. Lorenzo, New Sacristy (Pope-Hennessy, 1970, pl. 28, pp. 333–4 for summary of literature): adaptation.
– Titian, *Danae*, 1545–6, Naples, Gall. Naz. di Capodimonte (Panofsky, 1969, fig. 150; Saxl, 1970, pl. 107, and p. 81): painted for Ottavio Farnese, first of many versions to show a relaxed adaptation of Leda.
– Girolamo da Carpi, Edinburgh, NG, Andrews, 1968, cat. 824ᵛ: Leda? Very free adaptation.
– Cod. Coburgensis, f. 4 (Matz, 1871, 150; Degenhart and Schmitt, 1972, fig. 24, p. 159 and n. 30): whole sarcophagus front, only damage to Leda relief is the outer leg and face of Amor; the figures seem to be modelled with detailed *musculatura*; cf. Cod. Pighianus, f. 301 (Jahn, 1868, 156): '*In domo Corneliorum*', see DESCRIPTION (5).
– 'Peruzzi' Siena *Skb.*, ('Hand B'), f. 54b: Leda and Swan.
– Luca Cambiaso, attrib., Hamburg, Kunsthalle, 38699: whole front very freely drawn.
– Pierre Jacques, '*Album*', f. 50ᵛ: '*Sotto il fronton di Neron*', Ganymede and Eagle.

LITERATURE: Wilde, 1957. Degenhart and Schmitt, 1972, esp. pp. 155–6, n. 30; figs. 21 and 24. Knauer, 1969, for antique type, Renaissance examples, and bibl.

ANOTHER SOURCE for Leda in the Renaissance is an onyx cameo (5b) of the same figure type of *Leda and the Swan* in Naples, Mus. Naz., 25967 (Dacos, *et al.*, 1973, cat. 48, fig. 53). Known at least since 1457 in Rome; then from 1471 in the collection of Lorenzo de' Medici in Florence, and later in the collections of Clement VII and the Farnese. It could thus have been known to Michelangelo.

JUNO (HERA)

Juno, the wife and sister of Jupiter, was the queen of the heavens, and the divine protectress of women. She was the patron goddess of marriage, and so was often shown veiled. The Greek Hera is frequently represented in Greek reliefs sitting beside Jupiter and lifting her veil, as would a bride (Parthenon frieze, Selinus metope). The Romans identified her with their early Italic goddess Juno, who also presided over marriages as Juno Pronuba.

The type of antique statue with which she was identified in the Renaissance is that of a majestic and austerely draped female figure, usually wearing a crown. Renaissance creations of Juno with her peacock depend on Roman literary sources, possibly reinforced by knowledge of Imperial medallion reverses which in turn reflected lost Roman wall paintings. According to Ovid (*Metamorphoses* I, 722), Juno preserved the hundred watchful eyes of Argus in her peacock's tail-feathers.

6. 'Juno Ludovisi'
Colossal neo-Attic head
Rome, Museo Nazionale (Helbig, III, cat. 2341)

DESCRIPTION: The goddess looks straight forward. Her crinkly hair, parted in the middle, waves over the ears and falls in two spirals along the neck. Her crown is carved with a border of small palmettes. The head is broken at the base of the neck, and the tip of the nose is restored.

Goethe bought a cast of the colossal head: 'She was my first Roman love and now I own her. No

words can give any idea of this work. It is like a canto by Homer' (*Italian Journey*, 6 January 1787, transl. Auden and Meyer, 1962, p. 143). That the head is now demonstrated to be a portrait of the younger Antonia shows how even the most time-honoured identifications of antique sculpture are still subject to change (Helbig, III, cat. 2341, H. v. Heintze).

HISTORY: From Cardinal Paolo Cesi's collection of antiquities, gathered from the 1520s, it passed to the Ludovisi Collection in 1622.

REPRESENTATION:
– Francisco de Hollanda, *Skb.*, f. 26.

LITERATURE: Hülsen, 1917, Cesi 149, p. 35. Schreiber, 1880, cat. 104.

7. Standing Female Figure, Draped (Juno Type)

Greek statue mounted in Augustan relief
Rome, Villa Medici (Cagiano de Azevedo, 1951, cat. 4)

DESCRIPTION: The female figure moves forward, her long robe is gathered loosely at the hips, and falls in parallel folds over her straight right leg, revealing the left leg bent at the knee. The top of the right sleeve is laced; the lower arm is a post-Renaissance addition. The statue was headless until given an antique head (Cagiano de Azevedo, 1951, cat. 5) when it was inserted in a relief representing the Temple of Mars Ultor flanked by six standing figures, one of the five della Valle reliefs from the Ara Pietatis Augustae probably acquired earlier in the 16th century.

Many replicas of the type exist, variants of the caryatids of the Erechtheion, made during the Hellenistic classical revival (for examples see below).

HISTORY: The drawings showing the statue headless indicate that it was known before the mid 1520s when it was restored and incorporated into the relief; but when it came into the della Valle Collection is not known. The reliefs from the Ara Pietatis were arranged on the upper walls of the della Valle courtyard, built c. 1525–36. Although invisible in Cock's engraving, the Mars Ultor relief is described by Waelscapple between the fourth and fifth niches on the left side of the courtyard as it appears in Cock's view after a lost drawing by

Heemskerck (Michaelis, 1891, [II], no. 90; Hülsen and Egger, 1913–16, II, pl. 128, no. 76, p. 66). It was first drawn in the relief in the mid 16th century in the Cod. Coburgensis. In 1584 it was sold to the Medici, and is still in the same relief in the garden façade of the Villa Medici.

REPRESENTATIONS:
– Italian, attrib. wrongly to Donatello, but first quarter of 16th century, Besançon, Mus. B–A, D. 3104 (Gernsheim, neg. no. 8349): unrestored, seen from front right. Cf. Peruzzi, Oxford, Ashmolean, Parker, 1956, II, cat. 466, now attributed to Raphael (Gere and Turner, 1983, no. 129), **7a**,
– Raphael Workshop, Fossombrone skb., f. 81ᵛ: unrestored; frontal view.
– Aspertini, London, BM *Skb.* I, f. 7 (Bober, 1957, p. 54 and fig. 24): with head; arms 'restored'.
– Girolamo da Carpi, after earlier drawings, Rosenbach *Album* (Canedy, 1976, R32): unrestored (*ibid.*, p. 42, as caryatid figure in Florence, Mus. Arch., see below).
– Girolamo da Carpi, Amsterdam, Rijksprentenkabinet, A 2163ᵛ: second from left on sheet of drawings. Restored with head, but no arms.
– Cod. Coburgensis, f. 129 (Matz, 1871, 38): drawn with head, in the relief of Mars Ultor.
– F. Salviati, Windsor, 6739 (Popham and Wilde, 1949, cat. 898): restored; engraved by Episcopius (Jan de Bisschop), 1669, pl. 100: 'F. Salviati del'.

LITERATURE: Matz and Duhn, III, cat. 3511.

OTHER EXAMPLES OF THE TYPE KNOWN IN THE RENAISSANCE:
– Florence, Mus. Arch. (DAI neg. no. 62.20): restored as Ceres. (Hülsen, 1927, pl. 16a.: Heemskerck.)
– Rome, Mus. Capitolino (Stuart Jones, 1912, pp. 290–291, Salone 24). Drawn by Dosio, Marucelliana *Skb.*, f. 66ᵛc (Hülsen, *Ausonia*, 1912, p. 44 with fig.): 'JUNONI PLACIDAE' inscribed on base; Cavalieri, I–II, pl. 8, engraved as an 'unknown goddess'.

8. 'Juno Cesi'

Roman copy of Hellenistic statue. Over life-size
Rome, Museo Capitolino (Stuart Jones, 1912, pp. 340–1, Stanza del Gladiatore, no. 2)

DESCRIPTION: According to Aldrovandi, Michelangelo praised this statue as 'the most beautiful thing there is in all of Rome' (1556, pp. 122–3). The figure stands with its weight on the left leg, the right thrust forward. The head with hair parted in the middle and caught up by a fillet, looks out with a distant but steady gaze. The long sleeveless *chiton* is tied under the breasts. The heavy stole (*himation*)

is draped over the left shoulder, crosses behind the goddess's back, and forms a roll above the waist at the top of a double apron of folds gathered on her left side, and then cascades down. Since the Renaissance, both arms have been restored from the shoulders.

INTERPRETATIONS: In the mid 16th century, it was thought to be an Amazon (Aldrovandi, 1556, p.123). More recently called Proserpina, or Ceres.

HISTORY: The statue was in the Cesi Collection by the 1530s (Hülsen, 1917, p.11, Cesi 2; P.G.Hübner, 1912, p.88; Aldrovandi, 1556, pp.122–3). If it had been one of Cardinal Paolo Emilio Cesi's early acquisitions, it could have been in Rome earlier. In the 18th century it went to the Villa Albani and to the Capitoline Museum in 1773.

REPRESENTATIONS (All show statue unrestored):
- Girolamo da Carpi or Franco, Pozzo London BM I, f.23ᵛ (Bober, 1957, fig.10; Vermeule, 1956, fig.4; 1960, p.10, no.25A).
- Girolamo da Carpi, Rosenbach *Album* (Canedy, 1976, R31, below): '*in giardino di Cesi*'.
- Pierre Jacques, '*Album*', f.14: two views.
- Italian, late 16th century, Madrid, BN, Barcia, 1906, cat.7848.
- Cavalieri, I–II, pl.24: '*Amazonis statua marmorea pulcherima*'.
- Franzini, woodcut, 1599, B2.

LITERATURE: Bieber, 1961, p.119; Haskell and Penny, 1981, cat.51: 'Juno Cesi'.

THE RAPE OF PROSERPINA

Proserpina was the daughter of Jupiter and of Ceres, the corn goddess. One day, when she was picking flowers with the daughters of Oceanus, she vanished mysteriously: the earth had opened up and Pluto, the god of the Underworld, had carried her off to be his bride.

Ceres, distraught, wandered the earth looking for her lost daughter. In her distress, she cared for nothing but Proserpina, and as she took no interest in the crops, they all failed.

Jupiter, out of compassion for starving mankind, sent Mercury to fetch Proserpina back for her mother, but since the girl had eaten some pomegranate seeds in the Underworld, she was doomed to return and spend some part of the year with her husband in the world below. Jupiter decreed that Proserpina, like the grain itself, could spend part of each year with her mother, but for the winter months must descend to her consort's dark realm of the dead.

The story was first told in extant literature in the Homeric Hymn to Demeter (7th century B.C.) and was later much embroidered by Ovid (*Fasti* IV, 393–620), and by Claudian in the 4th century A.D. *(De Raptu Proserpinae)*. Ceres and Proserpina were worshipped at Eleusis from early times. The Eleusinian Mysteries celebrated in their honour were much revered throughout Antiquity and initiation into the cult was sought down to late Roman times. The myth of the Rape of Proserpina was frequently illustrated on sarcophagi and other funerary reliefs from the second century A.D.

9. Rape of Proserpina
Roman sarcophagus, mid 2nd century A.D.
Rome, Palazzo Rospigliosi, Casino (Robert, *ASR*, III, 3, cat.363)

DESCRIPTION: *Front*-Terminal female figures with skirts full of flowers flank the scene. On the left, Ceres, carrying a torch, drives her snakedrawn chariot. A winged figure runs in the background, interpreted by Rubens as Night spreading her mantle. The two astonished Oceanides, their flower baskets overturned, sense the commotion, which is actually witnessed by Minerva. Pluto on his chariot has seized Proserpina who is stretched back and struggling as the four horses led by Mercury gallop back to the Underworld. Under their hooves lies Tellus (Earth) with a cornucopia **(9i)**. *Left end* **(9ii)** – The river god Oceanus with two daughters. *Right end* **(9iii)** – Mercury visits the veiled Proserpina and Pluto in the Underworld. Their throne is guarded by Pluto's three-headed watchdog, Cerberus.

HISTORY: The sarcophagus was known by the early 16th century (Falconetto), but its location in Rome was unknown until the early 17th century

when it changed ownership many times: Lelio Pasqualino (Rubens); Bentivoglio on the Quirinal and Francesco Piccolomini (Capitelli); Cardinal Mazarin's palace (Perrier); and finally, after the mid 17th century, it was acquired by the Rospigliosi.

REPRESENTATIONS:
- Falconetto, fresco decoration, c.1515?, Mantua, Pal. di Bagno, frieze above months of November and December (Fiocco, 1929): quotation of front, closer in detail to this than to the Uffizi sarcophagus (see below).
- Pozzo Windsor, X, f.96, 8089 (Vermeule, 1966, p.67): whole front, free interpretation.
- Italian, late 16th century, 'After Polidoro' (Sotheby Parke Bernet Italia, Florence sale, December 19, 1977, lot 11, ill.): whole front.
- Bernardino Capitelli, engraving, Bartsch, XX, undescribed: whole front. Inscription to Francesco Piccolomini saying that it had belonged to the Bentivoglio on the Quirinal and now belonged to Francesco.
- Perrier, 1645, pls.15–16: 'in aedibus Mazarinis' with both ends, in reverse; cf. P.Santi Bartoli (1693, pls.53–4) in correct sense.

LITERATURE: For Rubens' description (c.1606–8) of the sarcophagus and other antiquities in the collection of Lelio Pasqualino transcribed by Peiresc (Paris, BN, MS Fr.9530), see text of selections in van der Meulen-Schregardus (1975, p.206; see also Adonis, 22).

OTHER SARCOPHAGUS RELIEFS OF THE RAPE OF PROSERPINA KNOWN IN THE RENAISSANCE:
- Florence, Uffizi, Mansuelli, 1958, I, cat.257 (Robert, ASR, III, 3, cat.372): earliest evidence Rome, late 15th century.
- London, Soane Mus., Michaelis, 1882, no.26 (Robert, ASR, III, 3, cat.394): earliest evidence Rome, early 16th century.
- Milan, Torno Collection (Dütschke, II, cat.406): earliest evidence Florence, 15th century.
- Paris, Louvre, Froehner, 1869, cat.64; MA 409 (Robert, ASR, III, 3, cat.359): earliest evidence Rome, early 16th century at SS. Cosma e Damiano, then in the Galli Collection.
- Pisa, Campo Santo, Arias et al., 1977, A 10 int. (Robert, ASR, III, 3, cat.409): earliest evidence Pisa, Middle Ages.
- Rome, Villa Pamphili, Calza et al., 1977, cat.196 (Robert, ASR, III, 3, cat.376): earliest evidence Rome, early 16th century.
- Sarcophagus end, Mercury with Proserpina, Pluto and Hecate? in Underworld, Mantua, Pal. Ducale (9a), A.Levi, 1931, cat.188 (Robert, ASR, III, 3, cat.365): earliest evidence Rome, then to Mantua in

1524. (See Brown, 1976, pp.342–3 for description written in 1523 and evidence of expedition to Mantua in 1524; pl.18,6; see also Chambers and Martineau, 1981, cat.117).
- Funerary altar with Rape of Proserpina, Kent, Hever Castle, D.Strong, 1965, p.219, no.2 (CIL, VI, 8439): earliest evidence Rome, Via Appia, c.1484.

MERCURY (HERMES)

In most modern handbooks of mythology, Mercury appears as a minor Olympian, involved in many a tale as a messenger of the gods, but only rarely as a protagonist. For the Renaissance he represented much more. Medieval tradition–the mythographers and Martianus Capella's allegory of the liberal arts, *On the Heavenly Nuptials of Mercury with Philology*–conveyed his patronage of oratory and intellectual pursuits to match his protection of merchants, travellers and sly thieves; according to astrological texts, his power over the planet Earth was equal to that of Jupiter and Venus. Humanists could rationalize his many guises by quoting Cicero, who said there had been five Mercurys; one of these, Hermes Trismegistus, who reflected Hellenistic syncretism with the Egyptian god, Thoth, satisfied their leanings to hermetic texts and occult sciences. An arcane heritage sparked Renaissance love for exotic pre-classical manifestations of Mercury–from an archaistic type drawn by Ciriaco d'Ancona in Greece (Saxl, 1922, pp.252f.; 1957, pl.133b, copy; Seznec, 1953, pp.200–1) to feats of a prodigious infancy described in the Homeric Hymn, like the theft of the cattle of Apollo (Homeric Hymn IV, in Hesiod, 1914).

Mercury's attributes made him easy to recognize in narrative art (see the sarcophagi, **9**, for example), so that his ancient role as conductor of souls to the other world (*psychopompos*) was quite explicit (see **11**). Yet without *talaria* (wings on his sandals) or purse or *caduceus* (herald's staff entwined by snakes) or *petasus* (traveller's hat), statues of him were merely handsome nude youths. At least Mercury did not suffer the indignity met by Apollo and Bacchus when a statue's attributes

were broken away: athlete, yes, 'Antinous' (see **128**), even Hercules possibly, but not 'Hermaphrodite'. The Renaissance knew quite a number of statuettes of Mercury, both seated and standing, as well as statues variously restored, including two in Florence from the della Valle Collections (see Bober, 1957, fig. 16 and p. 52c for Pitti statue; Mansuelli, 1958, I, cat. 159 for the one in the Uffizi).

10. Mercury

Statue of the Praxitelean 'Hermes of Andros' type, called 'Antinous' and 'Milo' in the 16th century Vatican, Belvedere (Amelung, *Kat.*, II, pp. 132–8, no. 53)

DESCRIPTION: A well-developed youth with short, curly hair stands in a relaxed *contrapposto* with inclined head which gives a pensive appearance to the figure and accords well with the use of its most famous Andrian replica as a funerary image referring to Mercury *Psychopompos*. The right forearm is restored with wrist poised on hip; the left hand is lacking below a mantle wound round the forearm from the shoulder. The proportions of the figure were extravagantly admired by Baroque artists (there are measured drawings by Poussin and Duquesnoy); note Bernini's statement, quoted by Wittkower (1975, p. 105): 'when I was in difficulties with my first statue, I turned to the *Antinous* as to the Oracle'.

HISTORY: Following Michaelis' arguments (1890, p. 35), modern catalogues and writers cite the discovery of the statue in the Vigna Pallini near the Castel Sant'Angelo by Pope Paul III in 1543. According to Aldrovandi, however, and to Agostino Ferrucci's 1588 annotated edition of Andrea Fulvio, the figure was discovered at S. Martino in Monti, one of two statues of Antinous immediately acquired by Pope Leo X (Lanciani, 1902–12, I, p. 155). It is true that the Antinous-Hermes is not among the first Belvedere casts made by Primaticcio for Francis I c. 1540, but one was made for him in 1545 (Pressouyre, 1969, p. 225, n. 5). We have included it here because of the exaggerated admiration it elicited and because the same type, in an even finer replica was certainly known. This is the Hermes Farnese (**10a**) which passed from the Sassi Collection to the Farnese in 1546 and was acquired by the British

Museum in 1864, now on loan to the National Gallery, London (see Bober, 1957, p. 70), to which add a drawing published by Schmitt (1970, fig. 17; Umbrian *Skb.*, Calenzano, f. 4).

REPRESENTATIONS:
- Parmigianino drawing, formerly C. R. Rudolf Collection (Popham, 1971, cat. 758, dates it c. 1535–40).
- Bandinelli?, three-quarter view, Norfolk, Holkham Hall, Portfolio II.3 (CI neg. no. 245/9/3 as 'Italian, 16th century').
- Cavalieri, I–II, pl. 5 (Brummer, 1970, fig. 200): '*Milo alijs Antinous…*'.
- Cambridge *Skb.*, f. 12 (Dhanens, 1963, cats. 13–14, fig. 3): restored, front view from left.
- Vaccaria, 1584, pl. 11.
- Goltzius drawing, Haarlem, Teyler Mus. (Brummer, 1970, fig. 199).
- Franzini, woodcut (Ashby, 1920, A8): '*Antinous*'.
- 17th century, Florence, Uffizi, 16804F: unrestored.
- Bronze statuettes: Pietro da Barga, Florence, Mus. Naz. (Weihrauch, 1967, fig. 560); Duquesnoy (Gutman, 1940).

LITERATURE: Helbig, I, cat. 246; Brummer, 1970, pp. 212–14; Haskell and Penny, 1981, cat. 4: 'Antinous'.

11. Mercury Psychopompos emerging from the Gate of Hades

Sarcophagus. Roman, 3rd century A.D.
Florence, Museo dell'Opera del Duomo (from the Baptistry of S. Giovanni)

DESCRIPTION: The front of this sarcophagus is divided into three *aediculae* framed by pilasters supporting segmental arches over the lateral niches and a pediment over the central portal of the Underworld, one half of which opens here to an emerging figure of Mercury. He is in scale with the doors and, wearing both cape and *petasus*, carries a purse and *caduceus*. Symbols of victory over death fill every empty space: Victories on globes carrying trophies, lions' heads and Medusa masks ornamenting the portal of Hades; two more Victories flying in its pediment adorned with an eagle; and crouching lions and sheep serving as *acroteria* above the lateral *aediculae*. The latter niches contain large-scale figures of the deceased, a *togatus* at right accompanied by a child and *scrinium* filled with scrolls of books, and his wife, *velata* in the so-called *Pudicità* pose, at left.

HISTORY: The sarcophagus was among a group of Roman relics set up at the Florentine Baptistry in

the Middle Ages; they are mentioned at the site by Boccaccio, for example. In the 19th century this and certain companion pieces were removed to the Palazzo Medici-Riccardi for safe-keeping. Later restored to the Baptistry, this sculpture is now in the courtyard of the Museo dell'Opera del Duomo.

REPRESENTATIONS:
None, although various elements of the work, modest though it is, entered the visual repertory of Quattrocento artists. Donatello's prophets owe something to the *togatus*.

LITERATURE: Dütschke, II, cat. 122; Müntz, 1882, p. 45.

VENUS (APHRODITE)

In equating their own Venus with Aphrodite, the Greek goddess of beauty and love, Romans acquired a divinity of pre-Hellenic origin with as many different faces as another Near Eastern import, Bacchus-Dionysus. They also gained, thanks to her love for Anchises and the son named Aeneas born of their union (Homeric Hymn V, in Hesiod, 1914), a powerful progenitor of the *gens* Julia and that Trojan lineage celebrated by Virgil.

Greek mythology shaped two stories to explain the birth of this goddess who was in the beginning a fertility deity of cosmic force with a cult that absorbed the mysteries of the Carthaginian Astarte. In Homer's *Iliad*—where she obviously had to be committed to the side of Troy—she is the daughter of Jupiter and the nereid, Dione. For Hesiod and the author of Homeric Hymn VI, she arose in the sea-foam *(aphros)* from the seed of castrated Saturn-Uranus and was wafted over the waves by zephyrs to be greeted by the Seasons on the shores of Cyprus (alternatively Cythera). Her own offspring, besides Aeneas, include Eros and Anteros (see Amor) by Mars in unfaithfulness to Vulcan, the husband Jupiter arranged for her once he was received into Olympus; Hermaphrodite by Mercury; Eryx by Neptune; and Priapus by Bacchus. Plato speaks of two Venuses: Urania, the daughter of Uranus, and Venus *Pandemos* (or *Popularia*), goddess of all people, daughter of Jupiter and

Dione. For Cicero (*De Natura Deorum* ii, c. 27, iii, c. 23) there are four: one born at Tyre; one born from the sea; one the child of Jupiter and Dione; and one born from Caelus (Heaven) and Light. Predictably, the dualism of Plato's *Symposium* especially attracted Renaissance philosophers and literati, and depictions of Celestial as opposed to Profane Love created by Botticelli and Titian perpetuate the imagery for all of us.

In Antiquity Venus was not represented in her familiar nudity or beguiling semi-nudity before the 4th century B.C., when Praxiteles carved his famous statue for Cos. This was rejected for a more decorous image, while the people of Cnidos–who knew a good pilgrim attraction when they saw one–established a shrine for the first sculpture. The Cnidian Venus showed the goddess at her bath, caught at the moment she dropped (or was possibly about to raise) her drapery. Hellenistic and Roman artists improvised a rich series of variations on the theme; these and replicas of the Cnidia were accessible to Renaissance artists in many examples, but they could only read about the famous painting by Apelles which depicted Venus born glistening from the sea and wringing out her hair.

Venus *pudica* types, like the Cnidian, and its descendants, enjoy an almost continuous history in Medieval and Renaissance art. They evoked admiration as well as fear. Contrast Benvenuto Rambaldi d'Imola's reaction to a statue he knew in a private collection in Florence (his commentary on Dante, to *Purgatorio* X):

> … *statuam Veneris de marmore mirabilem in eo habitu in quo olim pingebatur Venus. Erat enim mulier speciosissima nuda tenens manum sinistram ad pudenda, dextram vero ad mamillas…* (… *a wondrous statue of Venus of marble in that guise in which Venus was depicted formerly: namely, as a supremely beautiful nude woman holding her left hand to the pubes, her right to her breasts…*)

with Ghiberti's story of a similar statue much admired in Trecento Siena, drawn by Ambrogio Lorenzetti, and set up in honour at a fountain, yet blamed for misfortune at the

hands of the Florentines and buried as an idol on the latter's territory to bring the enemy bad luck (*I Commentarii* III; Schlosser, 1910, I, pp. 61f.).

For Venus in mythology, see Introductions to the Graces and Seasons, as well as Adonis, Mars and the Judgement of Paris.

LITERATURE: Otto, transl. Hadas, 1954, ch. III, 3; Kraus, 1957; Wind, 1958, ch. IX; Panofsky, 1939, chs. VII–VIII, pp. 150ff.; Panofsky, 1969, ch. v.

12. Venus

Statue. Late Hellenistic variant on a 5th century B.C. source for the Venus Genetrix of Caesar's Forum
Mantua, Palazzo Ducale (A. Levi, 1931, cat. 74)

DESCRIPTION: The long-tressed goddess, with head and arms broken away, stands in an especially sinuous variant of Alkamenes' Aphrodite of the Gardens; her shoulders and upper body sway backward, while hips and thighs press forward and added torsion is set up by a disengaged leg thrust forward and to the side. She wears a clinging, transparent *chiton*, girdled high under her breasts; though she might as well be nude, one shoulder of her garment has fallen (pulled out by her missing left hand?) to uncover and frame her left breast.

HISTORY: The provenance is not recorded, but there is evidence that the statue was in Rome in the early 16th century. There is at least a possibility that it was among the antiquities Giulio Romano took to Mantua in 1524, some of which came from the collection of a dealer, Giovanni Ciampolini, who died in 1518.

REPRESENTATIONS:
– Giulio Romano, quoted in the Vatican Sala di Costantino as Diana (Amelung, 1909, *Ausonia*, III, p. 101, figs. 7–8).
– Sodoma, *Lucretia*, Budapest, private collection (Lederer, 1919–20, p. 51, as followed by Stechow, 1951, pp. 114f.): inspired by this Venus and not another variant in the Museo Nazionale delle Terme, Rome.
– Aspertini, London, BM *Skb.* I, f. 12V: 'restored'.
– Marcello Fogolino, engraving (Hind, 1948, V, p. 219, VII, pl. 803): head 'restored', reversed.

LITERATURE: Bober, 1957, p. 58.

13. Draped Female Figure in Pose of Venus of Capua

Roman copy of Hellenistic type
Vatican, Museo Chiaramonti, portico of Braccio Nuovo

DESCRIPTION: The figure leans forward, the weight on her right leg, the left foot raised. She wears a thin *chiton* tied under the breasts and gathered at the hips, with open sleeves fastened by three buttons on the upper arm and shoulder. A heavy stole surrounds her legs and left hip, one end falls across her raised left thigh. The arms below the sleeves, head and Amor are post-Renaissance additions.

The pose and drapery are similar to those of other statues and reliefs known in the Renaissance: Hygieia with Aesculapius, Turin (known in Rome from the late 15th century in the Maddaleni-Capodiferro Collection; drawn by an anonymous 16th century Netherlands artist, Munich, SGS, 1962, 30v) a Muse, third from left, in the Muse sarcophagus, Vienna (**38**), and the Victory from the column of Trajan (**170**). Thus the type was well known and many adaptations of it in the 15th and 16th centuries are listed and illustrated by Buddensieg (1968).

HISTORY: Although drawn earlier in Rome, it is first located specifically in the garden of the Ferrarese cardinal, Ippolito d'Este on the Quirinal, restored as Hygieia (Cavalieri). After 1568 it was transferred to the Cardinal's gardens of the Villa d'Este in Tivoli where it was grouped with a statue of Aesculapius, now in the Louvre (Buddensieg, 1968, p. 51; Lamb, 1966, fig. 51). In the 19th century it went to the Giardino della Pigna, Vatican.

REPRESENTATIONS:
– *Cod. Escurialensis*, f. 31 (Michaelis in Egger *et al.*, 1906, pp. 94–5, as conflated with the Victory writing on a shield from Trajan's column, **170A–a**; Buddensieg, 1968, fig. 38).
– Lorenzetto, marble statue, Raphael's tomb, 1520, Rome, Pantheon (Buddensieg, 1968, figs. 30–4): adaptation as Madonna and Child.
– Cavalieri, I–II, pl. 44 (Buddensieg, 1968, fig. 37): restored, holding a snake as *Hygieia*, still in the garden of the Cardinal of Ferrara in Rome.

LITERATURE: Not in Vatican catalogues. Reinach, *Rép. Stat.*, II, 1, p. 338, no. 2. Hülsen, 1917, p. 107, Este 109. For type see Robertson, 1975, on Venus of Capua (fig. 174e and p. 553); Haskell and Penny, 1981, cat. 89 and fig. 176 for the similar Venus de Milo. Buddensieg, 1968, p. 49, n. 19 for Renaissance drawings.

14. Venus Pudica of Cnidian Type

Torso. Roman copy of a Praxitelean, 4th century type
Munich, Glyptothek (Furtwängler, 1900, *Beschreibung*, no. 237)

DESCRIPTION: The ancient torso, restored by Pacetti, was preserved to just below the knees, through the bracelet on the left arm, and down to the right wrist at the *pudenda*.

HISTORY: Documented for Prospero Santacroce's Collection in Rome at the end of the Quattrocento. Acquired from the Santacroce in the 18th century by Pacetti; sold to Ludwig of Bavaria in Munich in 1810 (Furtwängler).

REPRESENTATIONS:
- Umbrian *Skb.*, Calenzano, f. 9ᵛ (Schmitt, 1970, p. 116, fig. 11): 'misier prospero', with head 'restored'; f. 8ᵛ (*ibid.*, fig. 19): an accurate study, without locale **(14a)**.
- Holkham Album, f. 34ᵛ (Schmitt, 1970, fig. 20): 'questa femina sta in chasa queste di santa chrocie e (una) bella chosa e tonda' ('this female figure is in the house of Santacroce and is a beautiful thing and fully rounded'), unrestored **(14b)**.
- Raphael Circle, Oxford, Ashmolean, Parker, 1956, II, cat. 628ᵛ: a closely related drawing, although it shows a restored figure reversed.
- Engraved by Clarac, 1826–53, pl. 618, no. 1375.

LITERATURE: Schmitt, 1970, p. 116 (where it is incorrectly identified as a statue in the Torlonia Collection, which belongs to the Medici-Capitoline variants of the Cnidian Venus).

15. Venus at her Bath (the Mazarin Venus)

Statue. Roman copy of a late Hellenistic variant of 4th century Greek types
Malibu, California, J. Paul Getty Museum (Vermeule and Neuerberg, 1973, cat. 32)

DESCRIPTION: Venus stands bending slightly forward and looking to her left as if surprised in the act of taking up her mantle. With her left hand she clasps one end of this fringed drapery to her *pubes* so that it covers the left leg on which her weight rests; the drapery then passes behind her and is held up with her right arm (restored, as is her head–although the long locks on her shoulder are original). The support is in the form of a dolphin with a cuttlefish in its mouth; marks on its back indicate that it may once have been ridden by a little Amor.

HISTORY: Discovered in Rome c. 1509 (Giovanantonio da Brescia engraving, see below), although its history is obscure until it was purchased c. 1643 in Rome for the collection in Paris of Cardinal Mazarin, who is supposed to have presented it to the King. Alleged hammer marks on the back of the statue which would reflect the manic assault of Mazarin's heir, the Duc de Mazarin, in 1670, have also been attributed to bullets at the time of the French Revolution when the statue was in the hands of a M. Beaujon in the Champs Elysées; there seems little reason to credit either story. Beaujon is also said to have buried the figure in his garden for safekeeping, where it was forgotten until about 1855 and soon after was purchased by Sir Francis Cook for his estate in Richmond. It was sold back to France at the dispersal of the Cook collection in 1917 and purchased for the Getty Museum in 1954.

REPRESENTATIONS:
- Giovanni Antonio da Brescia, engraving, (Hind, 1948, V, no. 14; VI, pl. 536, with incorrect types put forward for identification; Sheard, 1979, cat. 37 supplement as c. 1513): 'ROMAE NOVITER REPERTVM', set in a landscape without dolphin and with right arm wrongly 'restored'.
- 'Raphael School', Oxford, Ashmolean, Parker, 1956, II, cat. 626 on sheet with drawings of the much drawn Venus torso belonging to Giovanni Ciampolini **(15b)** (for this torso, also drawn in Umbrian *Skb.*, Calenzano, f. 8, see Schmitt, 1970, p. 114, figs. 9–10: unrestored).
- Marcantonio, attrib., Vienna, Albertina (Oberhuber, 1970, fig. 4): a related drawing by the same hand. The verso shows the figure threequarters left and lightly sketches in the missing right arm in the scheme of the Cnidian Venus of Praxiteles, but wrapped across her torso below the breasts **(15a)**.
- Florentine, 16th century, Budapest, Mus. of Fine Arts, inv. 2551: unrestored but with indication of the dolphin.

LITERATURE: Michaelis, 1882, pp. 620f., no. 2.

16. Venus Felix and Amor

Statue. Roman portrait of the 2nd century A.D. (Early Antonine), as Venus
Vatican, Belvedere (Amelung, *Kat.*, II, pp. 112–15, no. 42)

DESCRIPTION: An Antonine princess, identified by some as Faustina the Younger, wears a typical hairdress with a huge chignon that contrasts oddly with the long shoulder locks which belong to the conception of the original; the Amor standing on tiptoe to reach up to something his mother once held is also a portrait. The motif reverses the pose of the Mazarin Venus (15), although her head again turns to her left. As in the Renaissance, her left forearm and his arms have been left unrestored. Inscribed with a dedication to Venus Felix by Sallustia and Helpidus.

HISTORY: Placed by Pope Julius II in the Belvedere by 1509; there is no supporting evidence for an assertion that the statue was found near S. Croce in Gerusalemme (Ficoroni, 1744, p. 121). Albertini's description of the Belvedere, published in 1510, already includes the Venus Felix.

REPRESENTATIONS:
- Antico, bronze statuettes, including a spectacular example heightened with silver and gilt, Vienna, Kunsthist. Mus. (Planiscig, 1924, cat. 100; Brummer, 1970, fig. 109).
- Aspertini, London, BM *Skb.* I, ff. 14ᵛ–15c (Bober, 1957, p. 60).
- Girolamo da Carpi, Rosenbach *Album* (Canedy, 1976, R 68).
- Dosio, Berlin *Skb.*, f. 77a.
- Goltzius, Haarlem, Teyler Mus. (Brummer, 1970, fig. 107).
- Perrier, 1638, pl. 86.

LITERATURE: *CIL*, VI, 782; Albertini, 1510, 45ᵛ and all later descriptions of the Belvedere; see Michaelis, 1890, p. 14 for the history of the Vatican collections; Helbig, I, cat. 241; Brummer, 1970, pp. 122–9 and pp. 227–34, on the statue's importance in the 'thematic fabric' of the garden; Haskell and Penny, 1981, cat. 87.

17. Venus Seated

Roman variant of Hellenistic type
Vatican, Museo Chiaramonti (Amelung, *Kat.*, I, pp. 540–2, no. 353)

DESCRIPTION: The semi-nude figure is seated with her right foot back and left leg forward. The drapery around her hips and legs is rolled back to reveal the left knee and lower leg. The unrestored statue represented in Marcantonio Raimondi's drawing (17a) shows that c. 1516 it lacked the head, right arm, left forearm and left foot. The two

Amors ('Anteros and Eros') were added in 1565. While Eros symbolizes love, Anteros, son of Nox (Night) and Erebus (Hell) symbolizes hatred and avenges slighted love.

Perhaps the original Hellenistic type portrayed a nymph (cf. 61), but with an addition of an Amor, the figure could be adapted as a Venus. Amelung (*ibid.*, p. 542) gives other examples of this non-Venus type.

HISTORY: Known in Rome by 1516. From the 1550s it was in the garden of Ippolito d'Este's Villa on the Quirinal. In 1565 Andrea Caselli restored it with the two Amors (Hülsen, 1917, p. 99, no. 12). Later it was in the garden of the papal palace on the Quirinal, and is now in the Vatican on a new base, without the Amors.

REPRESENTATIONS:
- Marcantonio Raimondi, attrib., Vienna, Albertina (Oberhuber, 1970, fig. 3): unrestored (17a).
- After Raphael's design, fresco in bathroom of Cardinal Bibbiena, Vatican Palace (Marabottini, 1969, fig. 46): adaptation with an Amor leaning back on Venus' knee.
- Giulio Romano, Windsor, 12757 (Popham and Wilde, 1949, cat. 810; Oberhuber, 1972, fig. 54, cat. 454): after a drawing for a fresco (17b). Both Popham and Oberhuber refer to a copy in Vienna (Stix and Fröhlich-Bum, 1932, inv. 215, cat. 82). Cf. Agostino Veneziano, engraving, Bartsch, XIV, no. 286 (Oberhuber, 1972, fig. 147): '1516'. With addition of landscape with distant town.
- Italian, after 1565, Madrid, BN, Barcia, 1906, cat. 7757: badly damaged sheet. Adaptation of restored group; Venus and Amor, left, in landscape.
- Cavalieri, I–II, pl. 51: restored group. 'Anteros, Venus, Heros', in d'Este garden (17c). Cf. Vaccaria, 1621, pl. 58.

18. Venus Crouching

Roman copy of Hellenistic bronze statue ('Doidalsas type')
London, British Museum, on loan from the Royal Collection

DESCRIPTION: Known as 'Lely's Venus', this large life-size figure is elegant in comparison with many stocky replicas and variants of the type which crouch on one heel with arms adapted to the pose of the Venus Pudica. The variant here is that the left buttock rests on an overturned water jar. The compact and sinuous balance of the pose can be

explained by a relief in the British Museum **(19)** which shows Venus crouching low so that a small Amor can empty a bowl of water down her back during her bath.

The statue is unique in having its original head; heads of other extant copies have been lost or replaced. The statue showed no damage when it was drawn in Italy, where it was praised as 'the finest statue of all' by Charles I's agent when he listed the statues in Mantua to be sent to London in 1631 (Scott-Elliott, 1959, p.220). Restorations include the replacing of the right foot, toes, fingers, parts of arms, crown of head, and nose.

HISTORY: The early history of the statue in Mantua was put in doubt by Nicole Dacos' observation (1977, p.198) that a statue in Isabella d'Este's collection was only a '*Venere antiqua de marmo piccola*'; but the letter in which this description occurs (Gaye, 1839–40, II, p.53) does not describe the pose. If it were the model for Marcantonio's engraving (Holo, 1978–9), it would probably have been in Rome c.1510–27, although it could later have been in Mantua for some time before it was sold in 1625 to Charles I. In fact, a statue of a crouching Venus appears in a drawing of 1567–8 of the Loggia dei Marmi in the Palazzo Ducale (see REPRESENTATIONS, Andreasi). Before it left Mantua, Rubens drew it, and the pose appears in several of his paintings. After its arrival in England, it was set up in Whitehall Gardens, London, and in the mid 17th century was bought by the painter Sir Peter Lely. In 1682 it returned to the Royal Collection in Kensington Palace; in 1902 it was in the Orangery of Windsor Castle. Since 1963, it has been on loan to the British Museum.

REPRESENTATIONS:
– Marcantonio Raimondi, engraving, Bartsch, XIV, no.313 (Holo, 1978–9, fig.4): body in profile to right, head turned, in landscape with Amor behind.
– Paduan bronze, Berlin-Dahlem, Skulpturengal., inv.2166 (Bode, 1930, pl.36, cat.213).
– Venetian or Paduan, mid 16th century, bronze statuette, private collection (Sheard, 1979, cat. and fig.42): the head turned more towards the back, but pose and hair style are similar.
– Andreasi, unpublished drawing of Loggia dei Marmi, Mantua, Pal. Ducale, 1567–8, Düsseldorf, Kunstmus., Kupferstichkabinett (to be published by Jacqueline Burckhardt).
– Album of Busts and Statues in Whitehall Gardens, 17th century, Windsor, 8911 (Scott-Elliott, 1959, fig.13, p.220, cat.88; Chambers and Martineau, 1981, cat. and fig.246): '*elena di troia*'.

LITERATURE: Lullies, 1954; reviewed by Vermeule, 1956, pp.460–2, esp. p.461. Vermeule, 1955, pp.149f., pl.46, figs.29–30. Dacos, 1977, p.198 for discussion of history. Holo, 1978–9, pp.23–36.

For most recent studies of the type: Robertson, 1975, pp.556–7, and notes 139–40 on p.726; Brinkerhoff, 1978–9, pp.83–96. Both refer to Linfert, 1969, pp.158–64, who demolishes Doidalsas as the Bithynian artist whose name is merely the result of corrections of a corrupt passage in Pliny, *Natural History* XXXVI, 35; M.Lyttelton in Chambers and Martineau, 1981, cat.249. For the Uffizi example of the type with reference to **18**, see Haskell and Penny, 1981, cat.86, fig.171.

OTHER STATUES OF THE CROUCHING VENUS TYPE KNOWN IN THE RENAISSANCE:
– Naples, Mus. Naz., inv.6297. Known in Rome in Medici-Madama and Farnese collections in 16th century. 'Doidalsas' type, of ampler proportions and more compressed.
– Rome, Mus. Naz. delle Terme, inv.8564 (Lullies, 1954, pl.9, cat.8; Reinach, *Rép. Stat.*, II, p.372, no.1): Rome, Cesarini Collection, early 16th century; later Ludovisi Collection. Torso more erect, restored head looks forward; dolphin on left, Amor behind, holding out garment.
– Madrid, Prado (Blanco, 1957, cat.33E; Reinach, *Rép. Stat.*, I, p.348, no.2). Venus kneels on tortoise, head and torso turned, back and arms raised to hair; a variant related to the type of a statue in Rhodes (Bieber, 1961, fig.294). The statue now in Madrid was well known in Rome from early in the 16th century (Allison, 1974, pp.375–84, figs.5–6).

19. Venus Crouching at her Bath with Two Amoretti
Roman funerary relief
London, British Museum (A.H.Smith, 1904, cat.2360)

DESCRIPTION: The relief from the funerary urn of M.Coelius Superstes (*CIL* VI, 33018), shows Venus crouching in profile to right, head turned to left to look at an Amor emptying a bowl of water over her back. In front of her a swan rests its head on her outstretched hand while another Amor is about to douse it with water from a shell. On the right stands a pedestal fountain with water flowing down from a lion's mask. The sides are decorated with acanthus scrolls.

HISTORY: In the church of S.Trinità dei Monti, probably from the Middle Ages until the 1550s

when it was recorded in the Villa of Cardinal Ridolfo Pio da Carpi on the Quirinal. In the 17th century it was in the Villa Montalto on the Esquiline, where Thomas Jenkins bought it in the 18th century in Rome and shipped it to the Townley Collection, London. It came to the British Museum in the early 19th century, where it is now in the Wolfson Galleries.

REPRESENTATIONS:
- Cod. Coburgensis, f. 144, 1 (Matz, 1871, 116): front and right side, showing no damage.
- Boissard, Stockholm skb., f. 49ᵛ: quick sketch of front and left side; cf. Boissard, 1598, II, pl. 73.
- Ligorio, Naples, BN, MS XIII, B. 8.200: whole urn from right, graceful adaptation.
- Pierre Jacques, 'Album', f. 52ᵛ (19a).

LITERATURE: Altmann, 1905, p. 161, no. 203, fig. 131. Hülsen, 1917, p. 72, Carpi 66.

20. Venus binding her Sandal
Type of Hellenistic bronze statuette
London, British Museum, 280

DESCRIPTION: The type, also represented in gems, has been called 'Venus binding her sandal', but in the example drawn by Heemskerck, she stands next to a pedestal with her weight on one leg while bending to clasp the raised shin of the left leg with the opposite hand. The left arm is held out for balance, with the forearm up, a sinuous pose shown in Heemskerck's sketchbook in three views. Heemskerck's model has not been traced, but the antique type inspired many Renaissance adaptations, such as a Paduan bronze statuette and Giambologna's influential bronze statuette later in the 16th century.

REPRESENTATIONS:
- Paduan bronze statuette, first half of 16th century, Berlin-Dahlem, Staatl. Mus., inv. 1821 (Bode, 1930, pl. 36, cat. 237; cf. ibid., cat. 212): similar balance, but arm held out, not up.
- Heemskerck, Skb. I, f. 25ᵛ (20a).
- Giambologna, bronze statuette, Florence, Mus. Naz., 71 (Avery and Radcliffe, 1978, cat. 6 by Keutner as c. 1555–61, with further examples and bibl.): adaptation of the type; left foot raised on a pedestal; left hand towards head.

LITERATURE: For Hellenistic type, see Reinach, Rép. Stat., II, pp. 347–9; III, p. 107. Bieber, 1961, p. 144, figs. 606–7, and bibl. for type of which over seventy examples exist in various mediums.

ADONIS

A remarkably beautiful youth whom Venus, accidentally grazed by Amor's arrow, loved helplessly. Adonis, in turn, was enamoured only of boar hunting. According to Ovid (*Metamorphoses* X), Adonis' blood, drawn by the fatal lunge of a boar, was transformed by Venus into the shortlived scarlet anemone. It is the Hellenistic 'Lament for Adonis' attributed to Bion (in *Greek Bucolic Poets*, Loeb ed., 1950, pp. 387–95) which, however, provides motifs for Roman sarcophagus reliefs: the amoretti binding the wound in Adonis' thigh, Venus shrieking through the woods, and her plea to her lover for a last kiss 'till thou give up thy breath into my mouth...', a passage well known to Rubens (see 22).

As a cult figure, Adonis, like Proserpina, was worshipped in connection with the returning spring; he was believed to spend part of the year in the Underworld, and return to earth with the new vegetation (see Frankfort, 1958, esp. p. 748).

For mythological sarcophagi with other boar hunts, see Meleager's Calydonian Hunt (113), and Hippolytus and Phaedra (111).

21. Adonis
Roman sarcophagus, 2nd century A.D.
Mantua, Palazzo Ducale (A. Levi, 1931, cat. 190)

DESCRIPTION: The first scene on the left follows the formula for the Departure for the Hunt (cf. 22), but the artist has turned it into the Death of Adonis. Venus, now faceless, kisses Adonis; both are seated on the left before a curtain. His companions, stand behind him, while two amoretti bind his thigh with drapery; his dog sits at his feet. A pilaster separates this scene from the forest setting to the right. *Centre and right*–Venus 'flies through the long glades shrieking amain' guided by amoretti to the dying Adonis. He has been wounded by the boar which the hunters and dogs are attacking.

HISTORY: At the beginning of the 16th century, the sarcophagus was in Rome in the collection of the sculptor Andrea Bregno (d. 1503). After the mid 16th century it went to the Gonzaga Collection in Sabbioneta; in 1771 to Mantua.

REPRESENTATIONS:
- Gentile da Fabriano, Paris, Louvre, 2397 (Degenhart and Schmitt, 1968, I, cat. and fig. 130): Venus rushing, 'restored'.
- Pisanello, Berlin-Dahlem, Kupferstichkabinett, 1358 (Schmitt, 1966, cat. 16B): detail of boar hunt.
- Ambrosiana Anon., Milan, Bibl. Ambr., F265, inf. 91 (Schmitt, 1966, cat. and fig. 30ᵛ): figures from both scenes, 'unrestored'.
- Aspertini, Cod. Wolfegg, ff. 34ᵛ–35 (Bober, 1957, fig. 45): *'andare in monte chavallo in chasa de mestro andrea scarpelino'*. Both scenes **(21a)**.
- Franco, 'Contraffazione', Turin, Bibl. Reale, cart. 33, no. 34: freely 'restored', from group on left including figure of Adonis wounded (noted and photographed by A. Nesselrath, Rome, Bibl. Hertz.). Cf. Franco, lost drawing in the 18th century Praun Collection, Nürnberg, as Giulio Romano (Robert, *ASR*, III, 3, fig. 20ᴵᴵᴵ on p. 564): reversed.
- Cod. Pighianus, f. 258 (Jahn, 1868, 157; Schmitt, 1960, fig. 50): unrestored. Both figures of Adonis headless, as well as Venus, and the hunter behind the wounded Adonis; records other breakages.

LITERATURE: Robert, *ASR*, III, 1, cat. 20; *ASR*, III, 3, p. 564 (Appendix listing drawings). See also Schmitt, 1960, pp. 122–3, cat. 7, and figs. 48, 54 and 56 also illus. the Quattrocento drawings listed above. For Titian's moving adaptation **(21b)**, see Saxl, 1957, p. 173 and pls. 113–14 (*Pietà*, Venice, Accad.).

22. Adonis

Roman sarcophagus relief, late 2nd century A.D.
Rome, Palazzo Rospigliosi (Robert, *ASR*, III, 1, cat. 15)

DESCRIPTION: One of the poses of Venus, and of the seated Adonis facing right, were adapted in Quattrocento works of art, but no early drawings survive. Rubens described the relief in the early 17th century with Bion's *Lament for Adonis* in mind:

The whole relief of ADONIS, first dissuaded by Venus from the hunt, to which he goes in the company of hunters (*petasari* – with broad brimmed hats), he is armed with the *jaculum venatorium* (hunters' lance). The combat against the boar. His wound on the thigh is treated with a sponge, Venus supporting his head. His death while Cupid again applies a sponge to his wound. He expires and gives up his soul almost in the mouth of Venus who approaches him to receive it. (From Peiresc's transcription of Rubens' Roman Itinerary, Paris, BN, MS Fr. 9530; quoted by van der Meulen-Schregardus, 1975, p. 205.)

HISTORY: Its early history is obscure but it was known to artists in the Quattrocento. It is first recorded at the end of the 16th century in the collection of Tiberio Cevoli (Ceuli) on the Via Giulia in Rome. By the early 17th century it was described by Rubens in the collection of Lelio Pasqualino; later in the Palazzo Rospigliosi.

REPRESENTATIONS:
- Ghiberti, *Moses on Mt. Sinai*, bronze relief, Florence, Baptistry, East Doors (Krautheimer, 1956, pl. 103): the figure of Venus following the hunters adapted for figure of the dancing daughter of Israel on the left.
- Ghiberti, *Creation of Adam*, bronze relief, Florence, Baptistry, East Doors (Krautheimer, 1956, pl. 83a): seated Adonis facing right adapted as Adam; Krautheimer (*ibid.*, p. 343) notes the evolution of a Trecento type revitalized by an antique, possibly this relief; **22a**.
- Uccello, *Creation of Adam*, fresco, Florence, S. Maria Novella, Chiostro Verde (Krautheimer, 1956, fig. 70): figure of Adonis seated on ground, reversed as Adam (*ibid.*, fig. 71: *sinopia*, or preparatory drawing on the wall).
- Cesare da Sesto, Lombard *Skb.*, New York, Pierpont Morgan Lib., Fairfax Murray, 1910, II, cat. 50ᵛ: possible adaptation of group of Venus and Adonis on right **(22b)**.
- Pozzo Windsor, X, f. 53, 8046 (Vermeule, 1966, p. 64; Italian, late 16th century): 'Cevoli' on verso; see above, HISTORY.

LITERATURE: Matz and Duhn, II, cat. 2211. Krautheimer, 1956, pp. 343–4; p. 348; for Rubens, van der Meulen-Schregardus, 1975, p. 205.

MARS (ARES)

The Olympian god of war is described by Homer in the *Iliad* (V, 30) as a mindless bruiser, given to brute force rather than to subtle strategy on the battlefield. He was also the lover of Venus **(23)**. He is always portrayed as a virile warrior with crested helmet, spear and shield, whether cuirassed **(24)** or nude, as when found netted with Venus in her husband Vulcan's bed, to the amusement of the other gods (Homer, *Odyssey* VII). A sarcophagus in Grottaferrata, known to Raphael's circle, records the scene (Robert, *ASR*, II, cat. 195 as lost; Dacos, 1977, p. 209).

The Romans conflated the Greek Ares with the Etruscan war-god, Mars. Apart from

Greek mythology, he is important in the legend of the founding of Rome. He made love to the sleeping Vestal Virgin, Rhea Silvia; their offspring were said to be Romulus, founder of Rome, and his twin, Remus (25, 184). Mars was worshipped second only to Jupiter in the early Roman official religion (Livy, I, 20).

In the Renaissance, the neo-Platonists and artists delighted in contemplating the relationship between Mars and Venus; how the god of war could be vanquished by the goddess of love, and the harmony resulting from the union of opposites (Wind, 1958, pp. 85-96). Indeed, the daughter of Mars and Venus was called Harmonia.

23. Venus and Mars

Roman terracotta antefix
New York, Metropolitan Museum, 96.18.162
(See also example in Paris, Louvre, reserve collection CP 3747, Schmitt, 1960, fig. 102)

DESCRIPTION: The figures of Venus and Mars conform to the shape of the round-headed architectural antefix, used to conceal the ends of roof tiles. Venus sways towards the left in a long clinging *chiton* and drapes her mantle over her right shoulder while turning to gaze at Mars who is seated to the right, leaning on his shield and holding his spear. He is nude except for a helmet and drapery which falls over his left shoulder and right thigh. He turns to look towards Venus' eyes which are on the same level.

A similar rhythmical response between Venus and Mars is suggested by Mantegna's *Parnassus* of the 1490s in the Louvre (59A-b).

HISTORY: At least two examples of this type were known in the 15th century (see above), but their location then is not known.

REPRESENTATIONS:
- Ambrosiana Anon., Milan, Bibl. Ambr., F. 265, inf. 91 (23a): upper three-quarters of the two figures without props, on sketchbook sheet with draped legs of Venus and her left foot drawn twice above. (A figure of Vulcan standing beside her is discussed by Bielefeld, 1968, p. 49, fig. 7; Schmitt, 1960, fig. 101 related to the Louvre replica; and 1966, cat. and fig. 30.)
- Marcantonio Raimondi, Bartsch, XIV, no. 288: adaptation of the type.

LITERATURE: Winnefeld and von Rohden, 1911, IV, pp. 247-8, pl. XVII (example in Louvre). Bielefeld, 1968, pp. 47-51.

24. Mars in Cuirass ('Pyrrhus')

Roman statue, possibly after Augustan cult statue in Temple of Mars Ultor (the Avenger)
Rome, Museo Capitolino (Stuart Jones, 1912, pp. 39 to 40, Atrium 40)

DESCRIPTION: The statue was first known in the 16th century as a torso with elaborate cuirass carved with Medusa's head, a pair of griffins turning their heads away from the candelabrum they flank, an inverted palmette below them. The three layers of carved lappets must also have been preserved, at least in part, as shown in the Heemskerck drawing. It was restored with helmeted head and legs with buskins, similar to those of the colossal Genius (188), but without arms, by the end of the 1530s (Francisco de Hollanda), when it became known as 'Pyrrhus'. Aldrovandi, who saw it in 1550, described it on a base in the Massimi courtyard with cuirass and helmet 'all'antica', with a mantle hanging behind and wrapping both arms, and with a shield supported with the left hand, 'a most beautiful statue'.

HISTORY: It could have come into the Galli Collection in the late 15th century, or the time of Pope Julius II. By the late 1530s, the figure was restored in the possession of Angelo Massimi. It was brought to the Capitol in the time of Clement XII (c. 1735). The tradition that it was found in the mid 16th century in the Forum of Nerva is based on a false statement written on a drawing by Sallustio Peruzzi (Uffizi, 687A[V]; A. Bartoli, 1914-22, IV, fig. 653 and text vol. p. 116).

REPRESENTATIONS:
- Heemskerck, *Skb.* I, f. 27: torso, lying in upper garden of the Galli (62a).
- Francisco de Hollanda, *Skb.*, f. 27: 'PIRRHI REGIS'; restored with head and legs, no arms, but the bottom of the shield; installed in round-headed niche (24a).
- Jacob Bos, engraving, 1562, for Lafréry's *Speculum* (Hülsen, 1921, cat. 67a): 'Pyrrhi Molossorum Regis Imperatorum… simulachrum. quod Romae in porticu domus Maximi Archiepiscopi Amalphitanorum situm… MDLXII…' Restored in niche; right hand raised; left resting on shield.
- Cavalieri, I-II, pl. 96: 'Pyrrhi regis… in aedibus Maximorum'; restored, with staff in right hand.

sisters, the Heliades, who turned into poplar trees, and whose tears became drops of amber (for the story, see Ovid, *Metamorphoses* II, 1–366). From classical times the moral was clear. *Hubris* is followed by *Nemesis*: '*terret ambustus Phaëton avaras/spes*' ('scorched Phaeton serves as a warning to ambitious hopes', Horace, *Odes* IV, XI).

Another literary source which appealed to later painters was the colourful description of Phaeton's fall in Philostratus the Elder's *Imagines* (Loeb ed., 1969, I, 11, pp. 45–9).

27. Phaeton
Roman sarcophagus, 2nd century A.D.
Florence, Uffizi (Mansuelli, 1958, I, cat. 251)

DESCRIPTION: Victories hold garlands at the corners. The central scene shows the bolting horses of the Sun's *quadriga*, and Phaeton falling headlong from the chariot into the River Po, represented by a reclining river god. To the right of Phaeton stands a bearded man, thought to be his pedagogue. Above to the right is a seated mountain god.

To the left are Phaeton's sisters, the mourning Heliades; the youth with a torch on a horse is identified as Phosphorus by Robert. Under the confronting pair of horses is Cycnus, a relation of Phaeton, already transformed into a swan. The two standing figures to the right are Mercury and Phoebus.

In the Renaissance the sarcophagus front was badly damaged. Phaeton's arms and legs were missing, as well as legs of horses, and arms and heads of some of the figures. One of the Dioscuri with his horse is carved on each end. On the back is a third century carving of a circus race (Robert, *ASR*, III, 3, p. 425, fig. 343c).

HISTORY: The sarcophagus was recorded at S. Maria in Aracoeli around 1500 (*Cod. Escurialensis*) and was probably known there in the 15th century. Pirro Ligorio, who was architect, antiquarian, mythologist and artist, described it to the right of the main entrance, where it was used as a tomb (Dessau, 1883, p. 1094, no. 17). Later in the 16th century, it was recorded by Panvinio in the garden of the Palazzo Colonna near SS. Apostoli (Robert); it was then acquired by the Medici. The sarcophagus was in the Villa Pratolino near Florence before it was taken to the Uffizi c. 1779. It was probably restored before the end of the 18th century.

REPRESENTATIONS:
- Ambrosiana Anon., Milan, Bibl. Ambr., F.265 inf. 92V (Schmitt, 1960, fig. 103): centre of front.
- Aspertini, separate sketchbook sheet, c. 1500–3, New York, MMA, Rogers Fund 19.151.6 (Sheard, 1979, fig. 22): middle section 'restored'.
- *Cod. Escurialensis*, f. 40: '*oraceli*'. Whole front, partly 'restored'.
- Italian, c. 1500?, Pozzo London BM I, f. 77, no. 86 (Vermeule, 1960, not illus., p. 14): centre of front, unrestored (27c).
- 'Maarten de Vos' *Skb.*, f. VIIIV (Netto-Bol, 1976, pl. 71; Robert, *ASR*, III, 3, fig. 342III): front.
- Lambert Lombard, Album, D. 230: three standing figures on right.
- Girolamo da Carpi, follower of, London, BM, 1950–8–16–13 (Gere and Pouncey, 1983, cat. 185): left half of front, 'restored'.
- Cod. Coburgensis, f. 33 (Matz, 1871, 158; Schmitt, 1960, fig. 104; Robert, *ASR*, III, 3, fig. 342II): front; cf. Cod. Pighianus, f. 246V (Jahn, 1868, 164).
- Taddeo Zuccaro, London, BM, 1859–8–6–78 (Gere and Pouncey, 1983, cat. 323; Robert, *ASR*, III, 3, fig. 342I as Giulio Romano): 'Phosphorus', three horses of the Sun, and swan; unrestored (27a).
- Pozzo London BM I, f. 32, no. 38 (Vermeule, 1960, p. 11): whole front 'restored'. Old attribution to 'Andrea del Sarto'.
- Pozzo London BM I, f. 90, no. 98 (Vermeule, 1960, p. 15): 'restored'. Right part including Phaeton.

ADAPTATIONS:
- A 15th century gem of the Fall of Phaeton in Florence, Palazzo Pitti (Kris, 1929, I, cat. 43; II, pl. 14).
- For Leonardo's adaptation in the *Battle of Anghiari*, see Ost (1975, pp. 111–12).
- Sebastiano del Piombo, *Fall of Phaeton*, fresco in lunette of Sala di Galatea in Villa Farnesina, Rome (Hirst, 1981, fig. 39).
- Michelangelo, drawings of the *Fall of Phaeton*: London, BM, 1895–9–517 (27d; Wilde, 1953, cat. 55, noting the further study in Venice, Accad., and the final presentation drawing for Tommaso dei Cavalieri, Windsor, 12766; Popham and Wilde, 1949, cat. 430, pl. 29).
Note: although these have been associated with the Uffizi relief, Michelangelo may have had in mind the clearer figure clusters and the challenge of the damaged figure of Phaeton falling to the left in another Phaeton sarcophagus, also known in the 16th century, and now restored in the Louvre (MA 1017; Robert, *ASR*, III, 3, fig. 337I illustrating Cod. Coburgensis, f. 209; Matz, 1871, 159, unrestored, 27b, as Michelangelo would have seen it).

LITERATURE: Robert, *ASR*, III, 3, cat. 342; Schmitt, 1960, pp. 118–9, cat. 2 with list of drawings.

personification of the Breeze. On the right a sleeping shepherd closes the scene; he sits on a ledge, head on hand supported by a raised knee. The relief is flanked by a pair of large amoretti, out of scale with the other figures, and not part of the narrative. Other Endymion sarcophagi are flanked by similar figures in the same pose, with heads bowed, cross-legged, and leaning on down-turned torches. They represent the spirits *(genii)* of sleep or death.

HISTORY: The sarcophagus was probably at S. Giovanni in Laterano as early as the 15th century as Florentine reliefs reflect motifs from this or a similar Endymion sarcophagus (Pope-Hennessy, 1980, pp. 37–8). It was first recorded as a 'Triumph of Venus', by Fabricius (1587, p. 223), who saw it c. 1530 at S. Giovanni, where there was another Endymion sarcophagus. It was walled into the Rospigliosi Casino façade, which was completed in 1613.

REPRESENTATION:
– Pozzo Windsor, X, f. 93, 8086 (Vermeule, 1966, p. 67; Robert, *ASR*, III, 1, fig. 47[1]): 'a san giovanni', with lid (26a).

LITERATURE: Robert, *ASR*, III, 1, cat. 47.

OTHER EXAMPLES: Many examples of this basic theme exist, as it was one of the most popular myths to be adapted for sarcophagus reliefs from the mid second to the 4th century A.D. Other versions add more figures: a river god under the horses, shepherds with mountain goats etc. The following examples known before 1527 are illustrated in Robert, *ASR*, III, 1:

80[1]	Assisi, tomb of S. Rufino, known from c. 1050 A.D.
53	Pisa, Campo Santo, Middle Ages (Arias *et al.*, 1977, A 7 est).
55	Rome, Pal. Rospigliosi (also at S. Giovanni where it may have been re-used as a sepulchre in the Middle Ages).
86	Lost. 'Ripanda' skb., f. 50, Oxford, Ashmolean; Dosio, Berlin *Skb.*, f. 9 (26b). In Rome, c. 1500; mid 16th century in the house of Livia Colonna (Aldrovandi, 1556, p. 266).

APOLLO*, PHOEBUS, SOL (HELIOS), SUN GOD

The Hellenistic interpretation of Apollo (Phoebus) as Sun God explains his inclusion here, for as his sister Diana (Phoebe) was identified by the Romans with the Moon (Luna) in one of her guises, so Apollo was identified with the Sun. As the Sun God, he was often portrayed with rays of light around his head. In his chariot drawn by four horses *(quadriga)*, the all-seeing god surveys the activities in a variety of Roman reliefs (cf. 25). He ascends with his *quadriga* on Mithras reliefs (46), in a Constantinian tondo on the east side of the Arch of Constantine (182c) and on the lid of a marriage sarcophagus (196), always as the counterpart of the Moon with her descending team. He was powerless to save his headstrong son, Phaeton (27).

* See also p. 71.

PHAETON

Ovid's description of the speed and terror of Phaeton's wild ride, forsaking the pathways of the skies, inspired the Renaissance artists who studied the Roman sarcophagus reliefs. When Phaeton, a vain and handsome youth, asked his father, Phoebus, the Sun God, to reassure him that he was indeed his father by granting him a wish, Phoebus agreed. But to his father's horror, Phaeton chose to drive the chariot of the Sun for one day. Having sworn by the River Styx, Phoebus was bound to his promise, and when Phaeton refused to make another choice, his father gave him detailed instructions on the route and handling of the horses. Phaeton's wish proved to be catastrophic. The horses, used to the mastery of Phoebus, completely lost their heads as Phaeton panicked, and careered madly off their course, scorching the earth by coming too close, turning the sea into a desert, the mountain tops into flames, and all but setting Olympus on fire. Jupiter, at the request of the burning Earth (Tellus), flung his thunderbolt at Phaeton, who plunged from his chariot in flames. The naiads found the scattered fragments of his body and buried them beside the River Po (Eridanus). His mother, Clymene, wandered the earth until she found the remains of her son, and mourned him with his

POST-RENAISSANCE INTERPRETATIONS:
- P. Santi Bartoli, 1693, pl. 22: restored. Bellori, in his commentary to the plate, considers the scene in terms of the Emperor Gallienus, because of the sun-god which also appears on Gallienic coins.
- Montfaucon, 1719, I, 1, pl. XLVIII and p. 99 as the Adultery of Mars and Venus, although he finds it difficult to relate the other gods to Homer's text.

Earlier interpretations not known.

LITERATURE: Matz and Duhn, II, cat. 2235; Schmitt, 1960, pp. 128–9, cat. 19.

DIANA (ARTEMIS)

Of the different roles of Diana known through antique sculpture in the Renaissance, the most familiar was Diana as huntress, chaste and fair. In this guise she wore buskins and a short *chiton*, and carried a bow and arrows (189), and when not hunting, she bathed and danced with her band of nymphs in the woods, as described by Ovid and other classical poets.

DIANA LUNA (SELENE, THE GREEK MOON GODDESS)

Just as the Romans identified Apollo with the sun god Sol (Helios), driving his *quadriga*, they identified his sister Diana with the Moon, who drove her chariot and two horses across the sky at night (196). Diana is therefore often shown wearing a crescent moon over her brow. Through this assimilation Diana came to be the lover of Endymion, although in the Hellenistic myth it was Selene, the Moon Goddess, who fell in love with Endymion, the beautiful young shepherd whom she saw sleeping on Mount Latmos in Caria. She stopped there on her nightly round to gaze at his unfading beauty, for he was endowed with perpetual youth, in endless sleep.

In these words, the Moon described her passion for Endymion to Venus:

'...you should see him when he has spread out his cloak on the rock and is asleep; his javelin in his left hand just slipping from his grasp, the right arm bent upwards, making a bright frame to the face, and he is breathing softly in helpless slumber. Then I came noiselessly down, treading on tiptoe not to wake and startle him–but there, you know all about it; why tell you the rest? I am dying of love, that is all.' (According to the satirist, Lucian, in his *Dialogues of the Gods* XI, transl. H. W. Fowler.)

Endymion's eternal sleep served as a graceful metaphor for death and consequently was frequently illustrated on sarcophagi.

'Endymion, if we are inclined to listen to fairy-tales, once upon a time fell asleep on Latmos, a mountain in Caria, and has not yet awoke I fancy. You do not think then that he is anxious about the worries of the moon, by whom it is thought he was lulled to sleep, that she might kiss him in his slumber. Nay, why should he be anxious who has not so much as the power of sensation? You have sleep, death's counterfeit...' (Cicero, *Tusculan Disputations* I, XXXVIII, 92, Loeb Library, 1927, p. 111, transl. J. E. King.)

LITERATURE: Catullus, 'Hymn to Diana', *Carmen* xxxiv, line 16; Wind, 1967, p. 154, for Diana as Luna.

For the oriental cult statue of Diana of Ephesus, see 48.

26. Endymion
Roman sarcophagus, c. 150 A.D.
Rome, Palazzo Rospigliosi, Casino

DESCRIPTION: In rocky country where trees grow like strange flowers, Somnus, the winged, bearded god of Sleep, sits supporting the sleeping Endymion, who lies with his arm raised to his head and one knee bent. A distant fountain nymph looks down on them from the ledge on which she lies. Endymion's dog wakes as the Moon Goddess, her veil billowing, and a crescent moon in her hair, steps down from her chariot to the sleeping Endymion, guided by three amoretti, while two other amoretti are left to manage the abandoned horses as best they can. A female figure dressed like Diana the huntress, but with wings, carries a torch and guides the horses. She is thought to be Aura,

LITERATURE: Vermeule, 1956, *ArtBull*, p.37, n.21; 1959, cat.78 (as Flavian); Helbig, II, cat.1198 (E. Simon); P.G. Hübner, 1911, *RM*, pp.310f; Aldrovandi, 1556, pp.173-4: bought by Angelo Massimi *poco tempo fa*.

MARS AND RHEA SILVIA

Rhea Silvia, or Ilia, daughter of King Numitor of Alba Longa, was forced to be a Vestal Virgin by the usurper of the throne, Numitor's brother Amulius, to prevent her from producing offspring who could contest the crown. According to legend, Amulius' plan was foiled when the war-god, Mars, seduced Rhea Silvia while she slept. Their offspring were the twins Romulus and Remus. Amulius had Rhea Silvia imprisoned and the twins exposed. They were suckled by a she-wolf (**184**) and were later found and reared by the royal shepherd, Faustulus. They grew up to restore Numitor to his throne and to found the city of Rome, of which Romulus was the first king.

Although the story belongs to the founding of Rome, the imminent seduction of Rhea Silvia is depicted in terms of Greek mythology, and is visually akin to the Endymion sarcophagi (**26**), which is why it is included here and not in the Roman section. We may be tempted to see the personifications on the sarcophagus (**25**) in terms of the Roman legend, but they are interpreted according to their traditional Greek mythological types by modern archaeologists.

LITERATURE: Livy, I, iii-iv; Ovid, *Fasti* III, 11-86; Strabo, *Geographia* V, 3.2; Plutarch, *Life of Romulus*.

25. Mars and Rhea Silvia

Roman sarcophagus relief, 190 A.D.
Rome, Palazzo Mattei: Front (Robert, *ASR*, III, 2, cat.188)
Rome, Vatican, Belvedere: Ends (Robert, *ASR*, III, 2, cat.188a-b; Amelung, *Kat.*, II, p.92, no.37b, pl.9; p.130, no.52b, pl.14)

DESCRIPTION: According to Robert, and Sichtermann and Koch (1975, cat.71), Somnus, in the centre, pours a sleeping draught over the breast of the slumbering Rhea Silvia, as Mars approaches from the left, stepping over the reclining river god, Oceanus, a sea dragon and various amoretti. Tellus (Earth), Oceanus' counterpart, also reclines with her back towards us, on the right. On the extreme left are two seasons, Autumn, restored with a bearded head, and Summer, leaning with crossed, draped legs. In the background, from left to right, are the Sun God in his chariot; Lucifer, striding with his back towards us; and a bearded wind-god in frontal pose. To the right of Mars is Vulcan, seated, with goats on the hill and a temple at his back. The large, draped, enthroned, female figure is Venus, presiding over the scene crowded with her scattered amoretti.

Left end–Mars and Rhea Silvia with personifications of the River Tiber and the Aventine Hill. *Right end*–Romulus and Remus with Wolf; two shepherds (Dulière, 1979, cat.125; Reinach, *Rép. Rel.*, III, p.339, 1-2).

HISTORY: Known at least from first half of the 15th century, the relief was probably at the Lateran: '*a s. giovanni*' (Pozzo Windsor, IX, f.105, 8098). By 1613 it was walled, already restored, into the Palazzo Mattei.

REPRESENTATIONS:
- 'Gentile da Fabriano', Milan, Bibl. Ambr., F.214, inf.13 (Degenhart and Schmitt, 1968, I, cat.129. pl.175a; Schmitt, 1960, fig.44 and discussion pp.94-95; Schmitt, 1966, cat.9): river god and Rhea Silvia, each with a putto. Below is Clytemnestra slain, from **106 (25a)**.
- Raphael School (Biagio Pupini?), Chatsworth, 907A: selection of figures, 'restored' with rhetorical gestures. Somnus lifts Rhea Silvia's veil.
- Marcantonio Raimondi School, engraving, Bartsch, XV, p.53, no.10: figures in a wide landscape with flying Victory holding two crowns over central group.
- Franco, Paris, Louvre, 4965: central group 'restored'.
- Cod. Coburgensis, f.9 (Matz, 1871, 168; Schmitt, 1960, fig.47): whole front unrestored (**25**); cf. Cod. Pighianus, f.271 (Jahn, 1868, 180).

THE FOLLOWING 17TH CENTURY DRAWINGS SHOW THE RELIEF RESTORED:
- Pozzo Windsor, VIII, f.15, 8716 (Vermeule, 1966, fig.208): accurate.
- Pozzo Windsor, IX, f.105, 8098 (Vermeule, 1966, fig.209, p.68): less exact; on verso: '*a s. giovanni*'.
- Pozzo London BM I, f.80, no.89 (Vermeule, 1960, pp.14f.).

APOLLO

The most venerated son and oracle of Jupiter, Apollo has many roles in Antiquity*. The celebrated Apollo Belvedere was for the Renaissance the supreme example of a graceful Hellenistic type.

Apollo and Diana (Artemis) were the twins of Latona (Leto). They delighted in arrows and were quick to use them; by their arrows the children of Niobe fell (107).

A most familiar image of Apollo for Renaissance artists was Apollo with a *cithara* (Apollo *Citharoedos*), the young god of poetic and musical inspiration, known from Graeco-Roman gems and sculpture. As such he appears with Marsyas (29, 30), alone (35, 36), or in the company of the Muses (38). While Minerva could be said to be the patroness of the Arts and Crafts, Apollo and the Muses were givers of inspiration.

The Renaissance artists tend to portray Apollo with his crown of laurel, although it is not generally evident in antique representations. They were enchanted by Ovid's story of the love of Apollo for Daphne who, pursued by him, prayed to her father, the River God Peneus, for deliverance, and was transformed into a laurel, Apollo's sacred tree (*Metamorphoses* I, 452–67).

LITERATURE: Heissmeyer, 1967.

* For Apollo as Sun God, see p.69.

28. Apollo Belvedere
Roman copy of lost Hellenistic bronze
Vatican Museums, Cortile del Belvedere (Amelung, *Kat.*, I, pp.256–69, no.92)

DESCRIPTION: The motivation of the pose of this most famous statue has not yet been determined. If the original bronze is connected with the Greek celebration of victory over the Gauls at Delphi in 278 B.C., the god might be thought to be stepping elegantly forth, bow in hand, to repel the barbarians from his temple. The triumph of Hellenic reason, light and order over 'barbarian' violence was, after all, a central theme of Greek art and literature.

Vasari saw the statue, together with the others in the Belvedere, as providing the lessons of ease and grace in rendering the human figure, lessons which inspired the styles of Leonardo, Raphael, Michelangelo and the other 16th century masters (Preface to Part III of the *Lives*). Bernini's *Apollo and Daphne* (1622–5) in the Villa Borghese is perhaps the most breathtaking transformation of this statue. To Winckelmann in 1755, the statue was the 'consummation of the best that nature, art and the human mind can produce' (Holt, 1958, II, p.344) and his appreciation influenced Neo-Classical artists.

As it was the duty of every artist and tourist to visit the Apollo in the Vatican Belvedere, countless modern replicas and engravings were made up to this century. Only a few of the earliest drawings are listed below.

HISTORY: The location of discovery is not known; it was wrongly supposed to have come from Grottaferrata or Anzio (for literature, see Bober, 1957, p.59). In the late 1490s it was in the garden of Cardinal Giuliano della Rovere at S.Pietro in Vincoli (*Cod.* Escurialensis, f.53); after the Cardinal became Julius II in 1503, it was installed in the new Cortile del Belvedere and eventually placed in a niche. The existing right arm was replaced with a new one by Montorsoli in 1532–3, and both hands were then restored (Vasari–Milanesi, 1906, VI, p.633; Winner, 1968, p.199). It was among the famous statues cast in bronze for Francis I at Fontainebleau from the moulds made by Primaticcio in 1540 (Pressouyre, 1969, pp.223–4).

REPRESENTATIONS:
The following show the original arm without the strut:

- *Cod.* Escurialensis, f.53 (Brummer, 1970, fig.38): profile to right 'nel orto disapiero invinhola' (28a); f.64 (*ibid.*, fig.39): frontal, on square base.
- Marcantonio Raimondi, engraving, Bartsch, XIV, p.249, no.331 (Brummer, 1970, fig.43); cf. *Cod.* Escurialensis, f.53, and engraving, 1552, for Lafréry's *Speculum* (*ibid.*, fig.37).
- Agostino Veneziano, engraving, Bartsch, XIV, p.148, nos.328–9 (Brummer, 1970, fig.44); cf. *Cod.* Escurialensis, f.64.

The following show the antique strut which connected the right wrist to the hip:

- North Italian?, c.1500, London, BM, 1946-7-13-1262 (Popham and Pouncey, 1950, cat.352; Brummer, 1970, fig.40): towards left on a square base.

Note: Winner (1968, p.198) suggests that it was drawn while at S.Pietro in Vincoli, but it is represented as it was in the Vatican, on a squared base, which may indicate that the drawing was made after 1503.

– Bolognese, 16th century, Berlin-Dahlem, Kupferstichkabinett, KdZ 26135 (Winner, 1968, fig.11 as Francia?, c.1510; Brummer, 1970, fig.41; Sheard, 1979, cat.53).

– Bandinelli, Milan, Bibl. Ambr., F.269, inf.108 (**28b**; Winner, 1968, fig.17; Brummer, 1970, fig.42; for Bandinelli's adaptation in his statue of *Orpheus*, c.1516–17, Florence, Pal. Medici, see Langedijk, 1976).

– Giulio Romano, Vienna, Albertina (Oberhuber, 1972, fig.26).

– Two bronzes by Antico reconstruct original hands before restoration: Frankfurt, Liebieghaus (Brummer, 1970, fig.45); Venice, Ca' d'Oro (*ibid.*, fig.46; Radcliffe in Chambers and Martineau, 1981, cat.57; Sheard, 1979, cat.89 Supplement; Candida, 1981, cat.2); cf. adaptations in drawings by 'Filippino Lippi', Paris, Louvre, 9877 (Brummer, 1970, fig.53) and Dürer's Sol-Apollo, London, BM, R 95 (*ibid.*, fig.54; Sheard, 1979, cat.50 Supplement).

Drawings after Montorsoli's restorations are:

– Heemskerck, *Skb.* II, f.23 (Brummer, 1970, fig.48); I, f.36$^\mathrm{v}$: shows only two views of head.

– Aspertini, London, BM *Skb.* I, f.15 (Bober, 1957, fig.44; Brummer, 1970, fig.47).

– Francisco de Hollanda, *Skb.*, f.9 (**28c**): restored in niche (Brummer, 1970, fig.36); f.16$^\mathrm{v}$: sandal.

– Cambridge *Skb.*, f.1 (Brummer, 1970, fig.49).

– Goltzius, Haarlem, Teyler Mus., K III 23 (Reznicek, 1961, cat.208; Brummer, 1970, fig.59; Sheard, 1979, cat.55).

LITERATURE: Robertson, 1975, pp.547–8; Helbig, I, cat.226; Winner, 1968, pp.181–99; Brummer, 1970, pp.44–71 with ills., early descriptions and bibl.; Haskell and Penny, 1981, cat.8. A Vatican publication on the 1981 restoration of the statue, which will illustrate all the drawings, is planned by G.Daltrop and A.Nesselrath.

MARSYAS

In Greek mythology, Marsyas was sometimes thought to be the inventor of the flute *(aulos)*, but, according to certain versions of the myth, he only became a flautist when Athena discarded her instrument because blowing distorted her cheeks. It is the latter version, popular in Athens for obvious reasons, that was represented in the famous group by Myron preserved in numerous copies. Through coarse and rustic associations of the flute or oboe, Phrygian Marsyas was assimilated by the Greeks into Bacchic troops of satyrs and silenes. Ovid, Apollodorus and Hyginus tell the story of his *hubris* in challenging Apollo to a musical contest of flute against *cithara*, and– following the adverse judgement of the Muses–his grisly forfeit: being flayed alive. This was the subject of one of the most famous paintings of Antiquity by the 4th century B.C. master, Zeuxis; in Roman times it was displayed in the Temple of Concord in the Roman Forum not far from the spot where a statue of Marsyas and a sacred tree symbolized civic liberty (according to Servius' late-antique commentary on Virgil's *Aeneid* III, 20).

Two traditions prevail in classical art, subdivided by archaeologists into 'White' and 'Red' series, according to the colour of the marble used. In one, Marsyas is strung up against a tree, suspended by his wrists tied over his head; in the other he is seated with hands fastened behind his back. In well-known Renaissance documents, including Vasari's *Lives* of Donatello and Verrocchio (Vasari-Milanesi, 1906, II, 407 and III, 366), we are told of two statues of Marsyas flanking the door to Lorenzo de' Medici's garden at S. Marco where the young Michelangelo was said to have studied ancient sculpture. One of these two statues, now lost, had been worked in *marmo rosso* so that the veins stood out very realistically, as they do today in a hanging Marsyas of the 'Red' type (**32a**) preserved in the Uffizi (Mansuelli, 1958, I, cat.57). The Uffizi sculpture was known c.1500 (drawn, unrestored, in an Umbrian *Skb.* published by Schmitt, 1970, fig.24). Parronchi (1968, pp.3ff.), believes that its restored head is one of Michelangelo's youthful works, but the work came to Florence as a gift to the Medici in the late 16th century. The Medici 'White' Marsyas (**32**) was long assumed to be a fine replica likewise in the Uffizi, although its provenance can be traced back to the della Valle Collection in 16th century Rome. The Belvedere torso (**132**) was not recognized as a Marsyas

figure before certain modern archaeologists advanced that theory.

Renaissance artists and antiquarians could also study reliefs and at least one painting that depicts the contest between Marsyas and Apollo, and Olympus begging for the life of his master (copied by Giulio Romano from the same source recorded in the Cod. Pighianus, see Bober, 1963, II, p.85, pl.XXIII, figs.5–6), not to mention the famous Medici gem (31).

LITERATURE: Schauenburg, 1958, pp.42–66 and 1972, pp.317–22 (vase paintings); Borbein, 1973, pp.37–52; Weis, 1976.

29. Marsyas: the Contest with Apollo
Sarcophagus. Roman, late 2nd–early
3rd century A.D.
Formerly Kent, Hever Castle, (Robert, *ASR*, III, 2, cat.201)

DESCRIPTIONS: Considerably worn by long exposure, the face of the sarcophagus depicts Marsyas' challenge to Apollo and the punishment exacted when he loses the verdict of the Muses. The contest itself occupies the central position, while flanking scenes represent subsequent events in the narrative: Olympus' plea for mercy on the left and the flaying of Marsyas on the right. From left to right appear Apollo seated with Victory behind him and accompanied by his griffin, while Olympus, in Phrygian dress, kneels before him in an eloquent gesture of pleading for the life of his master; in the background stand three of the nine Muses who serve as judges of the central action. The partisans of Marsyas are gathered on the left of the central scene: Bacchus with his arm around a young satyr and accompanied by an old Silenus; Cybele (in whose company Marsyas travelled to Nysa) with *tympanon* and lion; and Athena (Minerva), inventor of the flute, directly behind Marsyas. The latter is actively piping (in a pose not unlike the Mantineia base, see **30**), while Apollo, seated with his *cithara* on his left knee, thrusts himself back as if recoiling from the sound. On Apollo's side Latona (Leto) is seated as pendant to Cybele; Mercury, inventor of the *cithara*, appears behind her; and Diana in hunting garb moves in rapidly from the right, although she turns to look at the final episode where Marsyas hangs from a tree and the trousered Scythian kneels, sharpening his knife. The left end shows a seated elder with scroll; the right depicts a Muse–

probably Euterpe–standing with crossed legs against a pillar, in disputation (dramatized by her right index finger) with a seated Apollo, who leans upon his *cithara* and also gesticulates.

HISTORY: The history of the piece is obscure, although it was certainly exposed in Rome from at least the first half of the 15th century. At the end of the 19th century, it was in the hands of a dealer in Rome who obtained it from the Palazzo Altobelli-Zinsler. Purchased by Lord Astor after 1904.

REPRESENTATIONS:
- Gentile da Fabriano, Paris, Louvre, 2397 (Schmitt, 1960, fig.48): Olympus kneeling.
- 'Ripanda' skb., Oxford, Ashmolean, f.26ᵛ left half up to Marsyas.
- Biagio Pupini, Edinburgh, NG, D2978 (Andrews, 1968, fig.700): left two-thirds, adapted.
- Franco, Paris, Louvre, 4938.
- Cod. Coburgensis, f.10 (Matz, 1871, 154).
- Cod. Pighianus, f.247 (Jahn, 1868, 161).

LITERATURE: D.Strong, 1965, p.224, pl.20, and Sotheby Sale, 12 July 1983, lot 364.

30. Marsyas Piping
Marble or limestone statue or statuette. South Italian or Etruscan, 4th–3rd century B.C.
Lost

DESCRIPTION: A youthful Marsyas, legs spread wide and elbows out, in the act of piping a tune, is shown in a number of Quattrocento bronze statuettes so convincingly rendered *all'antica*, that variant replicas passed as ancient in museums in the 19th century (see, for example, Reinach, *Rép. Stat.*, I, p.407; *Rép.Stat.*, III, p.38, no.6; p.120, no.6). Bode (1922, p.73, pl.83) speaks of four examples in Florence, formerly attributed to Pollaiuolo, and others in Modena, Berlin and the Frick Collection, comparing an ancient relief (Athens, Mus.Nat.215) found at Mantineia in Greece and often related to Praxiteles (although the pose is reversed). Explicit evidence that Renaissance artists knew an antique example of Marsyas fluting is found in a rare antiquarian detail: in several bronzes the satyr wears a *phorbeia*, a sort of leather mask over the lower part of the face used by Greek *aulos* players to achieve a round, pure tone. J.P.Small informs us that there is no extant representation of Marsyas wearing a *phorbeia* included in the *Lexicon Iconographicum Mythologiae Classicae* (in progress). However, a statue or statuette of the type was drawn in

the 15th century by a Florentine artist and is clearly the source of inspiration for the popular Renaissance bronzes (see the drawing in Copenhagen, below; **30a**). The figure wears a *phorbeia*, fastened over his pointed ears; the caught activity of his pose with the right leg thrust forward and to the side is reduced by the profile view and the fact that the marble or stone figure is broken below the knees and above the right elbow. Anne Weis (1976) tells us that such a beardless Marsyas type, which does not emphasize the satyr-quality of Marsyas, is to be found in Etruscan art; the angular forms and reduced buttocks of the sculpture shown in the drawing suggest South Italian stylistic characteristics.

HISTORY: Unknown, but apparently accessible in the second half of the 15th century.

REPRESENTATION:
- Florentine, 15th century, Copenhagen, Stat. Mus. for Kunst, Box 4, 4a (Gernsheim, neg. no. 72 885); **30a.**

OTHER REPRESENTATIONS WHICH MAY DERIVE FROM THE STATUETTES:
- Umbrian *Skb.*, Venice, f. 14 (Fischel, 1917, fig. 184; Middeldorf, 1958, pl. VII, 2).
- Loschi, fresco, 1508, Carpi, Castello dei Pio, Sala dei Mori.

LITERATURE: Bode, 1922, for various Renaissance bronzes of the type. For illustrations also see Bode, 1930, pl. 15, cat. 40 (Berlin); Ciardi-Dupré, 1966, colour pl. 5 (Modena); Pope-Hennessy, 1970, pp. 30–6 (New York, Frick Collection); Candida, 1981, cat. 1 (Venice, Ca' d'Oro). Middeldorf, 1958, pp. 170–2; for examples owned by the Medici, see *Firenze e la Toscana dei Medici*; *Pal. Vecchio*, Exh. Cat., 1980, cat. 643a–b (A. Conti).

31. Marsyas, Apollo and Olympus
Gem. Carnelian intaglio, attributed to Dioskourides, period of Augustus
Naples, Museo Nazionale (inv. 26051)

DESCRIPTION: Apollo stands at left in graceful *contrapposto*, clasping his *cithara* against his outthrust right hip, as he draws his left leg from the importuning hands of Olympus (in diminutive scale), who kneels naked before him to plead for the life of Marsyas. Marsyas is seated on the right against a barren tree with his hands bound to it behind his back; his panther-skin is visible beneath

him and the double flutes hang from the tree. The gem is inscribed 'LAV. R. MED.'. Early Renaissance artists and collectors did not recognize the scene, which was taken to be the seal of Nero. Ghiberti took Olympus to be a child (*'infans'*) in keeping with interpretations which saw it as a representation of the Three Ages of Man.

HISTORY: According to Vasari's chronology, Cosimo de' Medici had the gem mounted by Ghiberti c. 1428 for his son Giovanni, then a child. It is not recognizable in the Medici inventories of gems until that of Lorenzo the Magnificent in 1492. Piero took it with him on his flight in 1494, but it was restored to Florence on the Medici's return in 1512. When Duke Alessandro was murdered in 1537, the intaglio was among the collection of precious gems which his young widow, Margarita of Austria, took with her into Farnese possession through her marriage in 1538 to Ottavio Farnese. It journeyed with her to the Palazzo Madama and the Palazzo Farnese in Rome; to Flanders where she was Regent from 1559–67, and into retirement in Ortona. After Margarita's death in 1586, this gem and its companions passed from one heir to another down to the early 18th century, when the Bourbons inherited them. In the 18th century the Farnese collections were transported to Naples.

REPRESENTATIONS:
This gem was frequently copied. Pesce (1935) and Dacos (1973, 1977), among others, have listed replicas in Renaissance gems, plaquettes, medals, miniature illuminations, majolica ware and other media. These include:
- Italian, 15th century, bronze cast, Berlin-Dahlem, Staatl. Mus. (**31a**), present inv. no. 490 (Bange, 1922, pl. 22, cat. 66): shows Ghiberti's inscription *all'antica* with the name of Nero (see Dacos, 1973, p. 158; Pope-Hennessy, 1965, cat. 246 for this and other plaquettes).
- Botticelli Workshop, *Portrait of a Woman*, c. 1483–6?, Frankfurt, Städel. Inst. (Lightbown, 1978, cat. C 3): the gem worn as a pendant (**31b**).
- Gerard David, *Judgement of Cambyses*, 1498, Bruges, Groeningen Mus. (von Simon, 1981, figs. 1 and 3): as a medallion on the wall.
- Marcantonio Raimondi?, or Bolognese, early 16th century, Oxford, Ashmolean, Parker, 1956, II, cat. 500: figure of Marsyas as 'a youthful captive'.
- Raphael Workshop, Vatican, Loggie (Dacos, 1977, pl. CXXXIIC).
- Florentine School, late 15th – early 16th century, marble relief, Washington, D.C., NGA, K 1600 (Middeldorf, 1976, pp. 68–9, fig. 120); figures of Marsyas and Apollo.

– Parmigianino, Windsor 597V (Popham and Wilde, 1949, pl.133): sketches based on an impression of the three figures.

Because it has been stated in so much of the literature that this Apollo inspired Raphael's *grisaille* in the School of Athens, it should be noted that the artist borrowed from a quite different source (120).

LITERATURE: Ghiberti, *I Commentari* II, 20; *Filarete* – von Oettingen, 1890, p.658; Vasari – Milanesi, 1906, II, pp.235–6; Pesce, 1935, pp.5off.; Dacos *et al.*, 1973, pp.155–7, cat.25 (with the theory that the gem may be an allegory of the Battle of Actium with Apollo representing Augustus and Marsyas the 'Dionysiac' character of Mark Antony), and pp.158–60, Scheda 8 with list of representations; Dacos, 1977, pp.290–1.

32. Marsyas
Statue of 'White' type. Roman copy of a Greek original of the 3rd century B.C.
Florence, Uffizi (Mansuelli, 1958, I, cat.56)

DESCRIPTION: Marsyas is shown hanging, the full weight of his body suspended from his lashed wrists which are pinned high above his head to a tree. The motif exploits a painful dislocation of the satyr's shoulders and stretches the lean musculature of his body as if it were already laid bare by the Scythian's knife (archaeologists are divided on the question of whether the 'Arrotino', 33, belongs to *this* Marsyas type). Marsyas' shaggy head, squeezed between his taut arms, is distorted by anguish in anticipation of the torment to come. The lower part of the tree, both feet and half of the lower right leg, parts of the arms and other bits are restored, although not, as has been suggested, by Donatello (cf. Vasari–Milanesi, 1906, II, p.407). For 'Red' type see 32a and p.72.

HISTORY: A view of the court of the Palace built and installed by c.1520 by Cardinal Andrea della Valle was drawn by Heemskerck in the 1530s and engraved by Hieronymus Cock; this shows the statue, unrestored, at the right hand side of the entrance portico (P.G.Hübner, 1912, pl.V; Hülsen and Egger, 1913–16, II, pl.128, p.58, no.1). From the Palazzo della Valle-Capranica it passed with the other sculpture of the collection to the Villa Medici in 1584. It appears in an inventory of 1780 of works about to be transferred to Florence.

REPRESENTATIONS:
– Umbrian *Skb.*, Venice, f.6V (Fischel, 1917, p.91): torso and legs only.

– Raphael Circle, Turin, Bibl. Reale (Bertini, 1958, cat.374).
– Anon., 16th century, Florence, Uffizi, 18730F (Jacobsen, 1904, p.253, n.336 as Michelangelo): part of torso.
– Anon. Italian School, 16th century, Haarlem, Teyler Mus., K II, 41: '*nel Palazzo (d)ella Valle*'. Three views (32b).
– Girolamo da Carpi, Budapest, Mus. of Fine Arts, no.1952, formerly Esterhazy Collection, attrib. to Giulio Romano: unrestored.
– Girolamo da Carpi, Rosenbach *Album* (Canedy, 1976, R42 and R72).
– Cambridge *Skb.*, f.13 (Michaelis, 1892, p.95; Dhanens, 1963, cat. and fig.15): '*la Valle … marsilus di him varmat met apolo te spalen*'.

Engravings:
– Cock engraving of the della Valle sculpture court (see above, HISTORY).
– Cavalieri, I–II, pl.85: unrestored.
– Vaccaria, 1584, pl.69.
– Franzini, woodcut, 1599, G 7.
– Perrier, 1638, pl.18, and others.
The usefulness of the figure for Crucifixion scenes is to be noted.

LITERATURE: Aldrovandi, 1558, p.217: '*un Marsia legato con le braccia alte ad una colonna…*'; Bieber, 1961, pp.110f.; Haskell and Penny, 1981, cat.59.

33. Scythian Slave sharpening a Knife ('Knife Grinder')
Statue. Roman copy of a Hellenistic Pergamene original of the 3rd century B.C.
Florence, Uffizi, Tribuna (Mansuelli, 1958, I, cat.55)

DESCRIPTION: The sculpture belongs to a three-dimensional group which depicted the punishment of Marsyas, although in the Renaissance it was generally referred to as 'the peasant sharpening his knife', or given more learned interpretations: Manlius, for example, or Attius Naevius, the Augur, among others. The 'Arrotino' crouches above the whetstone, his right knee almost touching the ground and his arms stretched forward; at the same time he glances upward and to his left at his hapless victim. His low estate and barbarous nature are emphasized by the figure's nudity, save for a stiffly-textured mantle (probably meant to represent leather) framing his bent back from his left shoulder, as well as the coarse and distorted features of his leering face and curled-back lips.

HISTORY: Although the statue was discovered before 1534-6 (Heemskerck; P. Santi Bartoli, 1790, p. 251, no. 102), the earliest literary documentation is Aldrovandi's description (of 1550) of the '*Aguzza coltelli*' in the house of Niccolò Guisa in Rome: '*dove hora sta il Signor Duca di Melfi, al di là del Tevere*'. Guisa's domicile seems to have been in the Palazzo Capodiferro, subsequently Mignanelli, then Spada (see Index to Collections). Boissard (I, 39) describes Cardinal Capodiferro's statue of 'Aetius Naevius, the Augur, sharpening his razor', making it clear that the Scythian had already received in the mid 16th century a designation popular in the 18th. Unsuccessful negotiations by the Medici to acquire the statue in 1566 and 1571 are recorded, but Ferdinando de' Medici received it from the Mignanelli as a gift, according to Bartoli. It was transferred to Florence in 1677 from the Villa Medici and installed in the Tribuna in 1680.

REPRESENTATIONS:
- Ghirlandaio, *Baptism of Christ*, Florence, S. Maria Novella (Dacos, 1962, fig. 34, p. 447): adaptation in the nude young man kneeling to take off his shoe (**33a**).
- Giovanni da Udine, fresco, *Sacrifice of Noah*, Vatican Loggie (Dacos, 1977, pl. XVIIIa): the son sacrificing a ram may be an adaptation (as first suggested by von Pulszky, 1887, pp. 37f.).
- Heemskerck, *Skb.* I, f. 57: frontal view.
- The Master of the Die, engraving, Bartsch, XV, no. 206: an analogous figure in a Marsyas scene is the only evidence that the statue's true identity was recognized before Agostini in the 17th century.
- Bandinelli, drawing, Florence, Uffizi, 531F.
- Franco, Budapest, Mus. of Fine Arts, 1869[V] (Fenyö, 1965, pl. 20): free adaptation on left with two groups of agitated men; cf. engraving of 1763 in London, BM, Print Room by W. W. Ryland as described by Rogers (1778, no. 16). Franco's drawing cited by Weigel (1865, p. 224, no. 66) as from the collection of Sir Joshua Reynolds.
- Florentine, 2nd half of 16th century, bronze statuette, Vienna, Kunsthist. Mus. (Planiscig, 1924, cat. and fig. 247).
- Cavalieri, III-IV, pl. 90: '*Manlius Capitoli propugnator...*'.
- Pozzo Windsor, IX, f. 16, 8799.
- Perrier, 1638, pl. 17.

NOTE: Numerous 17th and 18th century representations. Decorative bronzes often paired with a crouching Venus (cf. **18**).

LITERATURE: Aldrovandi, 1558, p. 162; Ladendorf, 1958, p. 169; Bieber, 1961, p. 111, figs. 441f. On the

theory that Ghirlandaio knew the statue: Egger–Michaelis, 1906, p. 25; Parronchi, 1971, in which it is attrib. to Michelangelo; Dacos, 1977, p. 164; Haskell and Penny, 1981, cat. 11: 'Arrotino'.

34. Flaying of Marsyas
Sarcophagus end. Roman, late 3rd century A.D.
Rome, S. Paolo fuori le mura, at the crossing

DESCRIPTION: On the right end of a sarcophagus of the Muses, two Scythians prepare to flay Marsyas as Mercury hurries off in the left background after having brought Apollo's command to proceed with the forfeit. Both Scythians are fully clothed in native dress; one binds Marsyas (in miniature scale resulting from the late antique artist's insistence on the conceptual importance of making the tree recognizable as a palm) to a tree, while the other sharpens his knife; a goat reclines at the foot of the tree.

HISTORY: Re-used in 1128 for the burial of Pietro di Leone, father of the anti-Pope, Anacletus II, although weathering of the Muses on the front reveals long use previously as a water basin.

REPRESENTATION:
- Pozzo Windsor, VIII, f. 7, 8708: the front (Vermeule, 1966, p. 48). Robert cites in connection with this sarcophagus Pozzo Windsor, VIII, f. 33, a drawing of Apollo, a Scythian and Marsyas tied to a tree; but this is the end of a different unidentified sarcophagus, as noted by Vermeule.

LITERATURE: Robert, *ASR*, III, 2, cat. 212; cf. Wegner, 1966, *ASR*, V, 3, cat. 184.

35. Apollo Citharoedos
Roman copy of Hellenistic type
Florence, Villa Poggio Imperiale, façade (Capecchi et al., 1979, cat. 2)

DESCRIPTION: Several replicas exist of the type derived from Praxiteles' lost original of a nude Apollo standing with one arm over his head, draped legs, and a *cithara* beside him. In this example the left foot is raised on a block to give a languid *contrapposto* to the torso which the Renaissance restorations of head and arms emphasize. Its influences may be seen at work, although indirectly, in Raphael's fictive statue in the *School of Athens*, and in Michelangelo's *Dying Slave* (1513) in the Louvre.

The representations are sometimes confused in art-historical literature with those of the similar Sassi-Farnese Apollo *Citharoedos* now in Naples (see below for OTHER EXAMPLES).

HISTORY: The early history is not certain, but an '*Apollo Cythera modulans carmen*' was recorded in the della Valle Collections in a letter by Giovanni da Tolentino of 1490 (Schofield, 1980, p.255), and an Apollo was on the triumphal arch decorated with della Valle statues for the *possessio* of Leo X in 1513 (Bober, 1957, p.48, for G.G.Penni's contemporary description). By the 1520s it was restored in a niche in the new courtyard of Cardinal Andrea della Valle (see below, Cock engraving after Heemskerck; Francisco de Hollanda). In 1584 it was sold to the Medici, and remained in the Villa Medici in Rome until the 18th century, when it was sent to Florence; since the early 19th century it has been in the Neo-Classical façade of the former Medici Villa, Poggio Imperiale.

REPRESENTATIONS:
- Raphael School, Oxford, Ashmolean, Parker, 1956, cat.627 (**35b**): before restoration, with a statue of Hercules also from the della Valle Collection cf.**130**; also Parker, cat.628, **35a**: after restoration).
- Peruzzi, fresco, Rome, Villa Farnesina, Sala di Galatea, *Sol in Sagittarius* (Freedberg, 1961, fig.190): 'restored', with lyre in right hand, drapery over raised leg.
- Cock, engraving after lost drawing by Heemskerck of the della Valle courtyard (Hülsen and Egger, 1913–16, Heemskerck, *Skb.* II, pl.128, pp.58f., no.40) in first niche on right of right wall, below; cf. Francisco de Hollanda, *Skb.*, f.54: same position on right wall.
- A.Allori, *Portrait of a Young Man*, dated 1561, Oxford, Ashmolean (Sotheby and Co., London, *Old Master Paintings*, 21 April, 1982, lot 85 with colour pl.): small replica seen from right in background of the painting.

LITERATURE: On Hellenistic type, Robertson, 1975, p.550 (fig.174c: BM, 1380); Dütschke, II, cat.90; Michaelis, 1891, *JdI*, (II), no.52.

OTHER EXAMPLES OF STANDING APOLLO CITHAROEDES STATUES KNOWN IN THE RENAISSANCE:
- Naples, Mus. Naz., black basalt from Sassi and Farnese Collections, Cavalieri, I–II, pl.37: 'Hermaphroditus'; (Bober, 1957, fig.88 and p.71 for history and drawings).
- Venice, Mus. Arch., another type with *cithara* resting on raised knee; in Rome as 'torso' in Domenico Grimani's Collection before 1523; restored by T.Aspetti in 1587 (Perry, 1978, pl.24e).

36. Apollo, Draped and Seated
Colossal porphyry Roman statue, 2nd century A.D.
Naples, Museo Nazionale (inv.6281)

DESCRIPTION: Until the late 18th century, this statue was considered to be of a female figure and was called 'Roma' or 'Vesta' in the 16th century; 'Cleopatra' or a Muse in the 18th century. In the late 18th century, the bronze hands and feet, with which it had been restored in the mid 16th century, were replaced by Albacini with white marble, and the statue was interpreted correctly for the first time as an Apollo with the addition of a laurel crown and lyre.

Aldrovandi (1556, p.150) described it in the mid 16th century in the Palazzo Farnese with its original head, and recent bronze restorations:

> One finds … a most beautiful statue of a seated *Roma* in triumph, larger than life, and its head, feet, and hands and a part of the arms are bronze, almost the colour of brass (*auricalcho*), then the rest is of porphyry, made with marvellous skill. It was found in Parrione in the house of M. Fabio Sasso.

The high-belted, draped figure with feminine head resembles a type of seated Muse and was so described in the inventory of 1796 shortly before it was restored. For a similarly draped standing Apollo, see the Bacchic puteal with Apollo *Citharoedos*, Paris, Louvre (Froehner, 1869, cat.88; Clarac, 1826–1853, II, pl.139, no.141).

HISTORY: The statue was probably in the Sassi Collection by 1510, when Albertini writes of its porphyry statues (p.Q iiv). In 1546 it was sold, with the Sassi Collection, to Ottavio Farnese, and was restored by 1550 (Aldrovandi). It remained in the Palazzo Farnese until 1790 when it was restored by Albacini and sent to Naples as Apollo *Citharoedos*.

REPRESENTATIONS:
- Jacopo Sansovino, marble statue, Rome, S. Agostino (Garrard, 1975, pl.50a): adaptation as *Madonna and Child* (**36b**), for Child, cf.**200** reversed.
- Cf. the Virgin in Heemskerck's painting, *St. Luke Painting the Virgin*, before 1553?, Rennes, Mus. B–A (Garrard, 1975, pl.51c; Hülsen and Egger, 1913–16, I, fig. on p.45).
- Heemskerck, Berlin-Dahlem, Kupferstichkabinett, KdZ 2783 (Garrard, 1975, pl.50c; Hülsen and Egger, 1913–16, I, pl.81; Canedy, 1976, pl.52a): in Sassi courtyard, statue with head, but forearms and feet missing.
- Aspertini, London, BM *Skb.* I, f.41 (Bober, 1957, p.71, fig.90): 'restored' left arm with hand lifted.

- 'Passarotti', Chatsworth, 25 (Garrard, 1975, fig. 51a; Hülsen and Egger, 1913–16, I, fig. on p. 44): from front right at foot of stairs in Sassi courtyard, unrestored.
- Girolamo da Carpi, attrib., New York, J. Scholz Collection (Oberhuber and Walker, 1973, cat. 53 with pl.; Canedy, 1976, pl. 51c as Parmigianino): from front left, restored.
- Girolamo da Carpi, Rosenbach *Album*, f. 113 (Canedy, 1976, p. 63, pl. 15): suggested as copy of 'Parmigianino' drawing above.
- Lambert Lombard, Album, D. 269–70 (Delbrueck, 1932, fig. 15): restored, from right.
- Italian, 16th century, small bronze of seated female figure, as restored, London, V & A, A 142–1910 **(36a)**, related by Canedy (1976, p. 63) to Lombard drawing.
- Cavalieri, I–II, pl. 34: '*Roma e lapide porphirite, capite tamen brachiijs et pedibus aeneis*'. With 16th century restorations, in Farnese Collection.

LITERATURE: Delbrueck, 1932, pp. 62–6, with drawings, descriptions and documents; Bober, 1957, p. 71, with list of drawings; Garrard, 1975, pp. 333–8.

THE MUSES

The Muses are the nine daughters of Jupiter and Mnemosyne (Memory), 'goddesses of heavenly song'. In Antiquity, divine inspiration came to mortals through the goodwill of the Muses who presided over the Liberal Arts, led by Apollo *(Musagetes)* and sometimes Athena-Minerva. How indispensable the Muses were to the creative process is attested by Alcman's invocation (mid 7th century B.C.):

> Hither, Muse, Calliope, daughter of Zeus, begin the lovely songs, set desire on our hymn, and make our dance graceful. (Fr. 67 D in C. M. Bowra, *Greek Lyric Poetry*, Oxford, 1961, p. 29).

Hesiod names the Muses in his *Theogony* (77–9). Later, in the Roman period, each Muse was identified with one of the arts and sciences. They were represented with their attributes: Clio = History (scroll); Euterpe = Music (flute); Thalia = Comedy (comic mask); Melpomene = Tragedy (tragic mask); Terpsichore = Dance; Erato = Erotic Poetry *(cithara)*; Polyhymnia = Hymns; Urania = Astronomy (globe); and Calliope = Heroic Epic. The allocation of attributes, however, is flexible, both in Antiquity and in the Renaissance, and indeed, even now.

In the Renaissance their images were identified from sarcophagus reliefs where they appeared together, by themselves, or with Apollo and Minerva **(38)**, or with an author or philosopher **(37)**. Statues of them were known, but could be confused with draped female figures of similar type. Thus serious Calliope and Clio, well-wrapped, might pass for mourning women or for Demeter, except that their heads are uncovered, while the more lightly clad and graceful Muses resemble their companions, the Hours.

LITERATURE: Wegner, *ASR*, V, 3. For the Muses in the Middle Ages and the Renaissance, see Schröter, 1977.

37. Muses in Niches (front); Muses inspiring Authors (ends)

Asiatic sarcophagus of Sidamara type, early 3rd century A.D.
Rome, Museo Nazionale delle Terme (Helbig, III, cat. 2133)

DESCRIPTION: Column and niche type with five Muses with their attributes on the front **(37i)**. *Left to right*, according to Wegner–Erato, Melpomene, Euterpe, Thalia, Terpsichore (but, according to Winternitz, Erato is the last muse on the right, cf. Erato in **38**). *Left end* **(37ii)**–Clio and Calliope; *Right end* **(37iii)**–Urania and Polyhymnia. Both pairs flank an author. The influence of the sarcophagus on Raphael's fresco, *Parnassus*, is illustrated by Winternitz (1967).

HISTORY: In the 15th and early 16th centuries, the sarcophagus was in Rome at S. Paolo fuori le mura. In the late 16th century, it was transferred to the garden of Ciriaco Mattei.

REPRESENTATIONS:
- Francesco di Giorgio Martini, Florence, Uffizi, 326Aᵛ (Winternitz, 1967, pl. 88b, detail of Erato): '*a san pavolo*'. Full length figure of Erato on right, and heads of four other Muses from front.
- Giuliano da Sangallo, *Cod.* Barberinianus, f. 70g (Hülsen, 1910, p. 73): attributes only.

– Aspertini, Cod. Wolfegg, ff.45ᵛ–46 (Winternitz, 1967, pl.89c): 'in santo paolo'. Terpsichore and Euterpe.
– Cod. Coburgensis, ff.92 and 185 (Matz, 1871, 165; Wegner, *ASR*, V, 3, pl.88a): left end, and four Muses of front, intact with heads and attributes.
– Cod. Pighianus, f.23 (Jahn, 1868, 175): left end, author with Polyhymnia.
– Pozzo Windsor, VIII, ff.4–6, 8705, 8707: ends; 8706: front. Another hand, X, ff.87–8, 8080: on verso, 'al Giardino del sig. Ciriaco Mattei'; 8081: both sides (Vermeule, 1966, pp.48 and 67, figs.199–203).
– Rubens, after, Chicago, Art Inst. (Held, 1960, pl.169, cat.160): right end.

LITERATURE: Wegner, *ASR*, V, 3, cat.128 and figs.84, 87, 89, 91b, 92, 99 and list of drawings, p.50; Winternitz, 1967, pp.185–201, esp.192–7 with other adaptations.

38. Muses with Minerva and Apollo

Roman sarcophagus front, 2nd century A.D.
Vienna, Kunsthistorisches Museum (Wegner, *ASR*, V, 3, cat.228)

DESCRIPTION: The nine Muses stand in a row with Minerva in their midst; on the right, Apollo, nude, with quiver on his back, and with lyre. *Left to right* – (1) Polyhymnia, (2) Clio, (3) Erato, (4) Thalia, (5) Terpsichore, (6) Minerva, (7) Urania, (8) Melpomene, (9) Euterpe, (10) Calliope, (11) Apollo.

The figure of Erato, conflated with a Venus in the Vatican **(13)**, inspired many Renaissance works of art, listed and partly illustrated by Buddensieg (1968, esp. pp.52–3).

HISTORY: The sarcophagus was evidently in Rome at S.Maria Maggiore in the 15th and 16th centuries (Cod. Pighianus). In the 17th century it was in the Villa Giustiniani in Rome; it went to Vienna in 1815.

REPRESENTATIONS:
– Ambrosiana Anon., Milan, Bibl. Ambr., F.214, inf.2ᵛ (Schmitt, 1966, fig.97, no.26, p.133; Wegner, *ASR*, V, 3, pl.9a): separate figures. Above: Muses 6, 5, 3 and 4; below: Muses 1, 2 and 10. Unrestored with parts of arms missing.
– Filippino Lippi, fresco, Florence, S.Maria Novella, Cappella Strozzi, right lower window wall (Winternitz, 1967, pls.72 and 74c): Muses 3 and 1, reversed; cf. anon. 16th century drawing of Filippino Lippi's fresco, Florence, Uffizi, 14587F (*ibid.*, fig.75b). Filippino Lippi, *Allegory of Music*, Berlin-Dahlem, Staatl. Mus. (Panofsky, 1960, fig.150, p.203, as adaptation of **50**, but more likely a conflation): Muse 3.

– Marcantonio Raimondi, engravings on separate sheets, Bartsch, XIV, p.211, nos.236–7, 269, 271, 277–8: Athena, Apollo and eight Muses, the missing parts freely 'restored' (Wickhoff, 1899, p.184, for theory that Marcantonio's engravings were based on drawings by Peruzzi or Ripanda?); cf. Marcantonio, Florence, Uffizi, 394S: Apollo, Muses 2 and 9; verso: Muses 5, 4 and 3.
– Franco, Melbourne, NG (Wegner, *ASR*, V, 3, pl.8a): all eleven figures freely 'restored'; Apollo trimmed on right **(38a)**.
– Girolamo da Carpi, Rosenbach *Album* = R; Turin, Bibl. Reale = T. The following drawings with reference to figures numbered as above in DESCRIPTION are illustrated in Canedy (1976): R27:8; R32:4 armless; T24:9; T38:10; T62:2; T121:1.
– Cod. Coburgensis, f.61 (Matz, 1871, 163a): whole front, unrestored, some arms broken (Wegner, *ASR*, V, 3, pl.10); cf. Cod. Pighianus, f.287 (Jahn, 1868, 172): 'S. Mar. Maior'. Front with eleven figures; Apollo drawn again clearly below.

LITERATURE: Wegner, *ASR*, V, 3, cat.228; list of drawings, pp.88f.; Buddensieg, 1968, esp. pp.52–3. Winternitz, 1969, pp.166–84, with discussion of Renaissance interpretations of Muses in the Cappella Strozzi.

OTHER MUSE SARCOPHAGI KNOWN IN THE RENAISSANCE:
(References to Wegner, *ASR*, V, 3)
– Rome, Villa Borghese: ends; Paris, Louvre: front (Wegner, cat.206).
– Rome, S.Crisogono (Wegner, cat.180).
– Rome, S.Maria in Aventino (Wegner, cat.183).
– Rome, Villa Medici (Wegner, cat.214; Cagiano de Azevedo, 1951, cat.57).
– Rome, S.Paolo fuori le mura (Robert, *ASR*, III, 2, cat.212; Wegner, cat.184).
– Woburn Abbey, Bedfordshire (Wegner, cat.231).
– Lost. Muses and Apollo (Matz and Duhn, II, 3269; one of eight reliefs, described by Pirro Ligorio in Dessau, 1883, no.11, walled into staircase of S.Maria in Aracoeli).

39. Muse Melpomene

Colossal Roman copy of a Greek statue
Paris, Louvre (Froehner, 1869, cat.368; MA 411)

DESCRIPTION: The grave Muse of Tragedy holds low the tragic mask (restoration). Her left hand (fingers restored) is opened downwards; the long tunic is belted beneath the breasts; the heavy vertical folds increase her monumentality. She was not recognized as a Muse in the Renaissance, but thought perhaps to be Minerva or Ops (associated with the Greek Rhea, a Mother goddess).

HISTORY: The Muse was set up with the colossal 'Ceres' (Juno, Vatican, Sala Rotonda, Lippold, *Kat.*. III, 1, p.542) in the 1490s in the court of Cardinal Raffaello Riario's Palazzo S.Giorgio (Cancelleria). Both statues were later in the Museo Pio Clementino in the Vatican (Visconti, 1885, II, 171 and 176). The statue of Melpomene was ceded to the Louvre in 1797.

REPRESENTATIONS:
– Raphael Workshop, Fossombrone skb., f.32: statue unrestored, *in situ* in *cortile* of Cancelleria (39b); f.33: left profile, fingers of left hand missing.
– Peruzzi, fresco, Rome, Villa Farnesina, Sala della Prospettiva (Frommel, 1967–8, cat.51, pl.xxxvii a): possibly free adaptation as fictive statue in niche, in window embrasure.
– Antonio da Sangallo the Younger, Florence, Uffizi, 993A (Schiavo, 1964, fig.107): groundplan of Cancelleria showing bases of the two colossi in the portico of the Cortile.
– Francisco de Hollanda, *Skb.*, f.10: '*in palatio C.S.Giorgii*', unrestored, with small figure to give scale (39a). (Tormo, 1940, p.65, wrongly identifies it with a similar statue, the Urania Farnese in Naples; Reinach, *Rép.Stat.* I, p.282, no.1.)
– Lambert Lombard, Album, D.306, by another artist: frontal, unrestored, drawing cut off at head.
– Girolamo da Carpi, Rosenbach *Album*, f.140 (Canedy, 1976, R140, p.69, as Urania Farnese, Naples): seen almost in right profile, drapery floating behind, lower right arm missing, left hand sketched lightly.

LITERATURE: For provenance, Lanciani, 1902–12, I, p.94; P.G.Hübner, 1912, p.112.

40. Muse 'Erato' Seated

Roman statue, 2nd century A.D.
Madrid, Museo del Prado (Blanco, 1957, cat.61E)

DESCRIPTION: The graceful Muse of lyric poetry sits lightly on a rock, her thin *chiton* tied under the breasts; the heavy mantle (*himation*) falls from her left arm, cascades down to the ground by her left side, and part of the fold encircling the thighs falls diagonally between the knees and winds around the lower right leg.

As can be seen from Heemskerck's drawing (40a) the statue lacked a head, lower right arm, left hand and lower left leg, and both feet, as well as the lyre.

'Erato' was one of a group of seated Muses in Hadrian's Villa at Tivoli which, in the Renaissance, were more damaged, having lost their heads and attributes. They were restored in the 17th century.

HISTORY: According to Pirro Ligorio, the statues were found in Tivoli in the time of Alexander VI (1492–1503). They were later sent to Clement VII's Villa Madama, where four were drawn by Heemskerck. In the 17th century they belonged to Queen Christina of Sweden, who probably had them restored by Francesco Maria Nocchieri; they were then arranged in her Stanza delle Muse, Palazzo Riario, Rome, with Nocchieri's Apollo. They were acquired by Livio Odescalchi in Rome, 1704, and by Philip V of Spain, c.1724. In the Palace of S.Ildefonso at La Granja until 1840, when they went to the Prado (*Christina Queen of Sweden*, Exh. Cat., 1966, p.576).

REPRESENTATIONS:
– Heemskerck, *Skb.* I, f.34$^{\mathrm{v}}$a (40a): unrestored; cf. 'Maarten de Vos' *Skb.*, VII$^{\mathrm{v}}$, f.4: reversed; f.5: from left (Netto-Bol, 1976, p.44).

LITERATURE: Türr, 1971, p.67, cat.VII, 3, for early documentation, and type (Thalia restored as Erato).

MINERVA (ATHENA)

The Roman Minerva, descended from an Etruscan Mother Goddess, is identified with the Greek Athena, goddess of Wisdom and War, and protectress of the arts which include the Liberal Arts of the Muses, crafts (pottery and goldsmith's work), and the arts of the household, such as spinning and weaving. She invented the flute (*aulos*) with which Marsyas challenged Apollo (29), and built the ship Argo.

She was born from the head of the almighty Jupiter; her mother was Metis, personification of Good Counsel. In early cults, Athena was worshipped as a protector of palaces. Her cult was strongest in Athens, and there, in the 5th century B.C., Pericles commissioned the Parthenon in her honour. The theme of the relief on the West Pediment is Athena and Poseidon (Minerva and Neptune, as they were called by the Romans) disputing for Attica, a theme known to the Renaissance artists from a cameo (41).

Aspects of Athena's wisdom and humanity were celebrated by the poets and artists. She protected the heroes Ulysses and Hercules in their adventures, helping them to outwit their

enemies. With matchless reason, she changed the terrifying Furies into the Eumenides ('the kindly ones'), responsible benefactors of Mankind (Aeschylus, *Eumenides*; **106**, right end).

Minerva is usually represented as a wise war-goddess, unlike brutal Mars. She holds a spear and shield, wearing, for protection, a helmet and the *aegis* (a goatskin with a border of snakes and a Medusa's head on it) over long straight robes **(42)**. The owl, symbol of her wisdom, often accompanies her. She sometimes is seen holding an olive branch, symbol of peace.

She was familiar to Renaissance artists through coins and gems, and statues mainly derived from classical prototypes known by descriptions, and from sarcophagus reliefs. She appears with the Muses and Apollo **(38)**, with Daedalus **(45)**, with Juno and Venus in the Judgement of Paris **(119)**, and she was present when Pluto seized Proserpina **(9)**. The reliefs which show her patronage of the household arts, have survived in the Forum of Nerva (P. Santi Bartoli, 1693, pls. 35–41; Brilliant, 1967, pls. 16–7).

LITERATURE: Wittkower, 1977, pp. 129–42.

41. Athena and Poseidon (Minerva and Neptune) disputing for Attica

Hellenistic onyx-sardonyx cameo (cm 5,1 × 5,2).
Mid 1st century A.D.
Naples, Museo Nazionale (inv. 25837)

DESCRIPTION: The gem represents the ancient legend of the founding of Attica. Zeus promised the dominion of Attica to Poseidon, god of the sea, or to Athena, depending on which of them could produce the most useful offering. The winner was Athena who caused the olive tree, the symbol of peace, to grow, while the salt spring which had been conjured up by Poseidon was rejected.

Here Poseidon, a dolphin behind him, leans forward, a foot raised on a rock to dispute with Athena, who holds a branch of her olive tree. The snake which coils from the ground and rears up behind Athena, symbolizes Erechtheos, a legendary

ruler of Athens, associated with snakes, and worshipped with Athena on the Acropolis. Under the ledge is carved the monogram of Lorenzo de' Medici: 'LAV. R. MED'.

HISTORY: The cameo was in the Medici Collection in Florence in the Quattrocento, from the time of Piero (inventory of 1465) to the death of Lorenzo in 1492. In 1495, it was taken to Rome. It was acquired by Alessandro de' Medici (d. 1537); and through his widow, Margarita of Austria, it passed by her marriage in 1538 to Ottavio Farnese to that family and went to Naples in the 18th century.

REPRESENTATIONS:
– School of Donatello, large marble tondo, courtyard of Palazzo Medici, Florence (Wester and Simon, 1965, fig. 14; Dacos *et al.*, 1973, fig. 81): one of the twelve tondi copying antique gems and sculpture built into the courtyard above the arches **(41a)**.

LITERATURE: Wester and Simon, 1965, pp. 78–83, as Minerva and Argus; Dacos *et al.*, 1973, pp. 42–4, cat. 6 and p. 157, *scheda* 2.

42. Minerva

Roman copy of Greek statue of 4th century B.C.
Florence, Palazzo Pitti (Dütschke, II, cat. 28)

DESCRIPTION: The statue has been restored with oratorical gestures, and without reference to its celebrated prototype, discovered later, the majestic 'Minerva Giustiniani' much admired by Goethe and now in the Vatican (Amelung, *Kat.* I, p. 138, no. 114, pl. 18; Haskell and Penny, 1981, cat. 63, fig. 140: representing Minerva with a snake, and the right hand curving around a spear, the left turned in to hold the mantle to her chest). The Pitti replica in the Renaissance lacked arms, and although the helmeted head is a restoration, it was already represented in 16th century drawings. As in other statues of this type of a standing Minerva, the heavy mantle falls from the left shoulder across the body, partly covering the small *aegis* worn over a layered garment with fine vertical folds.

HISTORY: The statue was installed in the della Valle-Capranica courtyard in the 1520s or 1530s. At first shown free-standing in the courtyard, it was described in the 1584 inventory as standing in a niche on the side. It was sold to the Medici in 1584.

REPRESENTATIONS:

- Cock, engraving after lost Heemskerck drawing of della Valle-Capranica court, showing statue to right of centre, at back of the open courtyard (Hülsen and Egger, 1913–16, II, pls. 128–9, pp. 56ff., no. 91; Michaelis, 1891, *JdI*, (II), p. 233, no. 100: not related by these scholars to the Vico engraving nor to the statue now at the Pitti).

- E. Vico, engraving of 1541, Bartsch, XV, p. 302, no. 44: '*Rome. in edib. car. valle*'; armless standing figure seen from right, head and helmet not identical to present restoration. Cf. Girolamo da Carpi, New York, Cooper-Hewitt Mus., 1958–143–4: '*in la vala*', seen from front, no arms; helmet similar to Vico's. Canedy (1976, p. 61, R106) discusses the Cooper-Hewitt drawing in relation to the torso of Minerva, also in the della Valle Collection, symmetrically draped, with large *aegis*, belted at the waist, and now restored as a standing figure, in the Boboli Gardens, Florence (Reinach, *Rép. Stat.*, VI, p. 67, 1).

VULCAN (HEPHAESTUS)

The divine smith (God of Fire), originally a Near Eastern deity of volcanoes, presents a rather comic figure in Graeco-Roman mythology: a crippled, sly cuckold (see Mars and Venus, **23**). The son of Jupiter and Juno, Hephaestus (Vulcan) seems the original victim of child abuse: he was thrown out of Olympus, and thus crippled, by Jupiter who was enraged by the child's defence of his mother (Homer, *Iliad* I, 590ff.). Juno tried to do away with him because he was lame (*ibid.* XVIII, 395). Coming to rest on the island of Lemnos, Vulcan taught its inhabitants and all mankind the arts of civilization; it was as patron of craftsmen that he was worshipped with Athena (Minerva) at Athens. His forges under Mount Aetna (where Cyclopes were lay his assistants) and under other rifts in the earth's crust. Here he fashioned–for he was something of a magician–marvels such as Jupiter's thunderbolts, the golden sun-chariot of Apollo, the weapons of other divinities and illustrious heroes (Hercules, Achilles and Aeneas), and the thread Ariadne gave Theseus to find his way in the Labyrinth. It is the Hephaestus of Hesiodic tradition, the creator of Pandora (*Works and Days*, 57ff.) who was most popular in the Renaissance, in line with neo-Platonic interpretations of the reconciliation of opposites in the union of Mars and Venus; Renaissance artists also exploited the imagery of Venus (Beauty) wedded to Craftsmanship and Vulcan's role as the father of Amor (an early 16th century drawing attributed to the Venetian School in Copenhagen, Mag IX, 17, represents the god punishing Amor).

For the importance of Vulcan-Hephaestus in the early history of mankind and interpretations of a painting by Piero di Cosimo in the Wadsworth Athenaeum in Hartford of *Vulcan Falling Among the Nymphs on Lemnos*, see Panofsky (1939, ch. II), Delcourt (1957), and Brommer (1978).

43. Vulcan forging the Weapons of Achilles

Sarcophagus cover? fragment. Roman, early 3rd century A.D.
Rome, Museo Capitolino (Stuart Jones, 1912, pp. 332–3, no. 30, pl. 83)

DESCRIPTION: Three separate episodes, derived from book illustrations, read from left to right–(1) three figures move towards the right where a missing figure would have been Vulcan (Hephaestus) approached by Thetis, Antilochus and Achilles, who is unarmed and naked save for a *chlamys*, or short cloak, on his shoulders and is coming to ask for weapons; (2) in the centre is shown the forge in which Vulcan sits steadying a shield on his anvil while three Cyclopes hammer it in rhythm; two stand behind and are naked, while the third is seen from the back wearing an *exomis* (or vest), and standing before an oven; (3) Achilles faces the spectator while Athena hands him his sword and a mature man adjusts a shield on his arm; at the right of the group the hero–or a companion beckoning him–runs off, looking back; on the ground between Athena and Achilles is a large *cista*, or basket, and the warriors' greaves fill the space under Achilles' shield.

HISTORY: The location of this fragment during the early 16th century is not known, but it was influential in Raphael's circle; from the second half of the 16th century there is evidence that it was owned by the della Valle. Subsequently it passed to the Albani Collection and thence to the Capitoline Museum.

REPRESENTATIONS:
- Cod. Coburgensis, f.18 (Matz, 1871, 153) and f.216,2: right portion.
- Cod. Pighianus, f.262 (43; Jahn, 1868, 160).
- Pierre Jacques, 'Album', f.47ᵛ: inscribed 'Valle'. Cf. Michaelis (1891, JdI, (II), no.116), although he wonders whether the relief might not have been in the della Valle house with the Pan statues (75).
- Pozzo Windsor, X, f.63, 8056; VIII, f.75, 8780.
- Pozzo London BM I, f.4, no.4: (Vermeule, 1960 fig.5) two scenes on left.

NOTE: It is this relief of Vulcan's forge, rather than a classicizing one illus. by Veldman (Heemskerck, 1977, pp.28f.) which inspired Peruzzi (43a; Farnesina, Sala delle Prospettive), Marcantonio (Bartsch, XIV, no.326), Giulio Romano and Heemskerck, among others.

LITERATURE: Robert, ASR, II, cat.43, pl.XXI as 'Achilles before Troy'; Helbig, II, cat.1418.

DAEDALUS

Daedalus, although not a god, is classified here with the arts because of his inventive craftsmanship. He was trained by Athena (Minerva) in Athens, where he made toys with moving limbs. He killed his nephew out of jealousy for excelling him in skill, and fled from Athens to Crete with his son, Icarus. King Minos of Crete welcomed him as a gifted craftsman.

DAEDALUS AND PASIPHAE

To confirm his right to rule, Minos prayed to Neptune to send him a bull to sacrifice (44, right end), but the bull sent by the sea-god was of such beauty that Minos kept it, and sacrificed another instead. Neptune, to punish this deceit, caused Minos' wife, Pasiphae, to fall in love with the bull. She confided her passion to Daedalus who designed a life-size hollow wooden cow for her. In this way, she could climb inside the cow and the bull could mount it. The offspring of this strange union was the Minotaur, a monster with a bull's head and human body. It was kept in the Labyrinth designed by Daedalus.

44. Daedalus and Pasiphae

Roman sarcophagus relief, end of 1st century A.D.
Paris, Louvre (front and left end, MA 1033)
Rome, Villa Borghese (right end, Helbig, II, cat.1955)

DESCRIPTION: The front (44i) has three scenes. *Left*–Daedalus stands before Pasiphae, who is seated with an amor at her knee. *Centre*–the wooden cow is almost finished and workmen fit it with a hind hoof. *Right*–an amor emerges from an opening in the cow's back. The cow is finished and stands on a platform with wheels; a flight of steps leads to its belly. Daedalus shows the waiting cow to Pasiphae who is led towards it by an amor. The relief is flanked by a pair of amoretti holding garlands.

Left end–The three sons of Minos before an altar laden with fruit. *Right end* (44ii)–Minos and an old woman (his mother, Europa?) prepare to make a sacrifice to Neptune in front of his temple, with a relief of a triton in the pediment, and two amoretti standing in front of columns on the flank (the right end has been cut off since the 16th century).

HISTORY: The relief was known in Rome in the early 16th century; it may have gone to the Vatican Belvedere c.1560; c.1575 it was in Trastevere. In 1615, the front and ends were separated: the front was walled into the façade of the Casino of the Villa Borghese; the front and left end went to Paris in 1807; the right end remains in the Villa Borghese, in Sala I.

REPRESENTATIONS:
- Falconetto, painted decoration of a house façade, Verona (Schweikhart, 1968, p.335, figs.8–10; 1973, figs.108 and 112): adaptation with Daedalus, Pasiphae and cow with amor emerging from cow's back.
- Girolamo da Carpi, London, BM, 1946.7-13-1351 (Gere and Pouncey, 1983, cat.157): detail of amor on the cow's back.
- Dosio, Berlin Skb., f.10 (Hülsen, 1933, no.24, pl.XIII): unrestored (44a) with inscription identifying subject and locating it in the Vatican Belvedere c.1559–65; f.4 (ibid., no.9, pl.V): right end; f.28 (ibid., no.76, pl.XLI): left end.
- Pierre Jacques, 'Album', f.6: 'trastevere'; both ends.
- Pozzo London BM I, f.23, no.25 (attrib. by Popham to Girolamo da Carpi on mount; Vermeule, 1960, fig.18, p.10): front.
- Pozzo Windsor, III, f.69, 8399 (Vermeule, 1960, fig.19; 1966, pp.25-6): whole front; X, f.9, 8002 (Vermeule, 1966, p.61): ends; X, f.61, 8054 (ibid., pp.25-26): front.

– Topham Albums, Eton College Lib., BM I, 22: whole front.

LITERATURE: Robert, *ASR*, III, 1, cat. 35, pls. X–XI, illus. Dosio, Pozzo and Topham drawings.

DAEDALUS AND ICARUS

When Minos discovered Daedalus' role in accommodating Pasiphae's passion for the bull, he imprisoned Daedalus and Icarus in the Labyrinth, but they escaped from Crete by flying with the wings Daedalus made from feathers held together with wax. Icarus disobeyed his father and flew so high that the sun melted the wax and he plunged into the sea **(45)**.

In the Renaissance, Daedalus was known through Ovid's *Metamorphoses* VIII; Diodorus Siculus' synthesis of world history, *Bibliotheca Historica* IV; Virgil's *Aeneid* VI, and other literary sources. The Medici, in an inventory of 1456, correctly identified their cameo of Icarus standing on a block and being fitted out with wings by Pasiphae and Daedalus on the left, and a female figure identified as Diana seated on the right (Dacos *et al.*, 1973, pl. III, cat. 2, fig. 35; and for Renaissance copies, figs. 78–9; and Schmitt, 1970, fig. 8).

LITERATURE: Waźbiński, 1968, pp. 98–114, in Polish, with English synopsis on pp. 113–14: Daedalus is seen by humanists as an ideal of moderation, while Icarus is the 'hero of the unlimited deed'.

45. Daedalus and Icarus

Roman sarcophagus relief, 2nd century A.D.
Lost. In Renaissance at S. Paolo fuori le mura
(Robert, *ASR*, III, 3, cat. 440)

DESCRIPTION: In three scenes. *Left*–Athena seated on the left, and Daedalus on right, making a mechanical toy. A winged youth stands before him, and an ominous figure (Fury?) appears in the background. *Centre*–a bearded man (King Minos of Crete?) sits on right, watching Daedalus build the labyrinth. *Right*–the fall of Icarus into the sea personified by a sea god and a water nymph. A figure with a cap stands on left, and a winged figure sits behind the nymph.

HISTORY: Known in the early 16th century (Agostino Veneziano), and it is likely that the relief was at S. Paolo fuori le mura long before it was recorded there in the mid 16th century, possibly already in medieval times.

REPRESENTATIONS:
– Agostino Veneziano, engraving after Raphael, Bartsch, XIV, p. 192, no. 239: motif of reclining nymph with billowing veil, reversed **(45a)**.
– Cod. Coburgensis, f. 2 (Matz, 1871, 211): whole relief; cf. Cod. Pighianus, f. 31V (Jahn, 1868, 208): '*In S. Paulo extra muros*' **(45)**.

LITERATURE: See Robert, who cautiously listed the sarcophagus under unidentified subjects.

MITHRAS

Mithras was an Indo-Persian god of the sky and protector of herds. He was not adopted into the Greek religions, but his mystery cult flourished in Rome and in the outposts of the Roman Empire, and became the dominant religion of Roman soldiers in the 2nd–4th centuries A.D. In his Roman image, the original protector of herds sacrifices a bull in a cave, which symbolizes the world, to ensure the fertility of the crops which the Sun and Moon help to grow. In the late Roman reliefs, Mithras wears tunic, leggings and Phrygian cap–the Phrygian garb of Attis **(47)** and Paris **(119)**–to show his Eastern origin. His characteristic profile as he slays the bull, with one knee pressed on its back, the other leg outstretched with his foot on the bull's extended hind leg, and with one hand grasping its nose or a horn to pull its head back, while thrusting a dagger into its neck, had a long tradition in classical art. Modifications of this pose can be found in the Centaur metopes from the Parthenon (London, BM) and Roman Battle of the Centaurs sarcophagi **(145)**; in the Hellenistic Victories sacrificing bulls **(171)**, and in certain reliefs of Hercules and the Hind from sarcophagi of Hercules' Labours **(134)**, the pose is more vertical and compressed.

In the 15th and early 16th centuries, damaged reliefs and statues of Mithras killing the bull, and the accompanying chariots of

the Sun and Moon were used by artists as formal motifs without the Mithraic trappings which they did not fully understand. It was not until the mid 16th century and later that Pirro Ligorio and his archaeologically-minded contemporaries faithfully recorded the reliefs and statues with all their symbols as found in caves in the hills of Rome but, according to Panofsky, Lorenzo Pignoria in 1606 seems to have been the first to identify the Mithras reliefs correctly (see below).

LITERATURE: Toynbee, *s. v. Mithras*, in *The Oxford Classical Dictionary*, 1970, pp.694–5, with bibl. Saxl, 1931, pp.108–10, on Renaissance interpretations; Saxl, 1957: the first three lectures deal with the history of Mithras in European art. Mandowsky and Mitchell, 1963, esp. p.60, n.1 for Ligorio's account of examples of Mithraic reliefs known to him, and his attempt to interpret their symbolism. Lanciani, 1902–12, IV, p.209 for other Renaissance notices of Mithraic temple-caves. Panofsky, 1964, pp.97f., esp. p.98, n.1 for mis-interpretations of the Mithras reliefs in the Renaissance. Pignoria's discovery made in 1606 was first published in his edition of Cartari, 1615.

46. Mithras slaying a Bull
Roman relief, 3rd century A.D.
Paris, Louvre (MA 1023)

DESCRIPTION: The entrance of a cave in a hillside frames Mithras killing the bull, assisted by the symbolic scorpion, snake and dog. Two attendant torch-bearers, Cautes and Catophates, flank the mouth of the cave. The Sun in his chariot climbs the hill on left, the Moon descends on right, both led by *genii* with torches. In the Renaissance the figure of Mithras was headless and armless; the attendants lacked arms and torches.

INTERPRETATIONS: Although the cave was called 'Lo Perso' after the Persian god in the Middle Ages and early Renaissance (Cola di Rienzo, Signorili, Ciriaco, cited by Lanciani below), artists in the 15th and 16th centuries often restored the figure of Mithras as Hercules alone with the bull. 'Prospettivo Milanese' (c. 1500) described Mithras as a nymph slaying a bull (stanza 131). In the mid 16th century, Vincenzo de' Rossi interpreted Mithras on the bull as The Rape of Europa (Flaminio Vacca, 1594, 19; in Lanciani, 1901, pp.193–5). Although Pirro Ligorio understood the inscriptions of the relief, the

type was considered to represent the personification of Agriculture (Ferrucci in Fulvio, 1588, pp.308 to 309).

HISTORY: The subterranean Mithraeum under the hill of the Aracoeli near the Capitol which contained this relief was known in the Middle Ages and to Ciriaco d'Ancona before the middle of the 15th century (*CIL*, VI, 507). The cave collapsed after the mid 16th century and the relief was brought to the Campidoglio by 1594. It was later in the Villa Borghese, and was sent to the Louvre in 1808.

REPRESENTATIONS:
- A. Rossellino, relief on base of tomb of the Cardinal of Portugal, Florence, S. Miniato (Hartt *et al.*, 1964, pl.84): adaptation as Hercules, or youth with flying mantle.
- Woodcut ill to Ovid. *Metamorphoses*, Venice, 1513; 1522: adaptation as Hercules and the bull.
- Peruzzi, fresco, Sala del Fregio, Farnesina (Alinari neg. no.40843): adaptation as Hercules grabbing bull by the horns.
- Raphael Workshop, stucco relief, Vatican Loggie (Dacos, 1977, pl.LXVIa): adaptation.
- Aspertini, London, BM *Skb*. I, f.40 (Bober, 1957, fig.89, p.69): figures of whole relief, Mithras 'restored' as Hercules astride the bull.
- Cod. Coburgensis, f.178 (Matz, 1871, 53; Mandowsky and Mitchell, 1963, pl.10a): unrestored, whole relief (**46a**).
- Ligorio, Naples, BN, MS XIII, B.7, p.22 (Mandowsky and Mitchell, 1963, pl.9a, cat.9): 'restored'.
- Pozzo London BM II, f.34, no.347 (Vermeule, 1960, pp.25–6): figure on left and Mithras and bull in mouth of cave.

LITERATURE: Saxl, 1931, pp.108–10, for discussion of Renaissance interpretation, and conflation of the figures of the Sun and Moon in their chariots from the same relief. Froehner, 1869, pp.495f., no.569. Dacos, 1977, p.225 with list of Renaissance drawings and adaptations.
 Another example known in the Renaissance: Mithras slaying bull, statue, London, BM (A.H.Smith, 1904, cat.1720, from S.Croce Collection where it was drawn by Heemskerck, *Skb*. I, f.29ᵛg; Saxl, 1931, fig.138).

MAGNA MATER (CYBELE)

The Great Mother, the female element of nature and earth, has the most ancient origins. She is a goddess of many names (the Mother

of Gods, the Idaean or Berecynthian Deity), and in Greece was identified with local goddesses, such as Rhea and Demeter. The Roman Magna Mater is identified with the Phrygian Cybele whose cult was brought to Rome in 204 B.C. from Pessinus in Asia Minor on the advice of the Sibylline Books consulted during the Punic Wars. The Eastern cult of Cybele became established as an official Roman religion as soon as the symbolic meteoric stone, which was sent from Asia to represent her, was brought to the Palatine, but the rituals were at first not performed by Roman priests, but by Phrygian eunuchs known as Galli or Curetes. The festival of the cult of Cybele commemorated the death of her beloved Attis, a young Phrygian prince or shepherd who, according to versions of the myth, was driven to madness owing to his infidelity to her, and castrated himself in the wilderness. The eunuch priests re-enacted the search for Attis, wailing, pounding hand drums, and playing raucous music until at last an image of the youth was found and carried in joyous procession. Thus the festival, performed at the Spring Equinox, commemorated the mourning and resurrection of Attis who, like Proserpina and Adonis, symbolizes the return of spring and the fertility of the earth.

In Rome the cult thrived particularly in the reigns of Claudius and of Antoninus Pius whose wife, Faustina, was portrayed as Cybele. It was still flourishing in late Antiquity, when Attis came to be worshipped, like Mithras, as a sky god.

Cybele, in the Roman art known in the Renaissance, is portrayed in her Hellenistic image, draped, wearing the turreted crown as a protectress of fortresses and cities (cf. Roma, **168**; Tyche, **196**) and is nearly always accompanied by lions, for she was also mistress of wild beasts. She holds in her hand a tambourine, which is used in processions. Other musical instruments of the cult, the curved Phrygian horn, double pipes, and castanets often appear on Roman funerary altars. Elements of the Eastern cults of Cybele and of Bacchus can be seen together in Hellenistic reliefs.

The image of Attis, as it was known in the Renaissance through Roman funerary reliefs, is also based on the Hellenistic type. Attis wears the Phrygian cap, tunic and leggings (cf. Mithras, **46** and Paris, **119**), and leans cross-legged on his sacred pine tree, holding a tambourine, or shepherd's crook (pedum).

The earlier Renaissance artists' sources for Cybele were more literary and historical than visual. Mantegna's painting The Introduction of the Cult of Cybele in Rome (London, NG; Illustrated Catalogue, 1973, cat. 902) is based on Ovid and Livy rather than on any known relief (Braham, 1973, p. 458). Flavio Biondo, in his treatise on Roman life and institutions, Roma triumphans (completed in 1459), refers in Book I on pagan religions to a version of the myth which omits Attis' castration, but refers to the gory sacrifices of the cult. A century later, Pirro Ligorio investigated the Near-Eastern mystery cults including that of Cybele and Attis. In the Casino he designed for Pope Pius IV (1564) in the Vatican Gardens, he gives a prominent place to a seated female statue restored as Cybele with a turreted crown (Heemskerck, Skb. I, f. 52b: unrestored without a head; Cavalieri, I–II, pl. 12: restored).

LITERATURE: Vermaseren, 1977.

47. Cybele and Attis
Roman funerary altar, 3rd century A.D.
Rome, Villa Albani (Helbig, IV, cat. 3313)

DESCRIPTION: Dedicated to the Magna Mater by L. C. Scipio Orfitus. Front–Cybele wearing turreted crown, holding flower and tympanum, sits in a chariot drawn by two lions. Attis, dressed as a Phrygian shepherd, stands cross-legged under a pine tree and holds a tympanum. The pedum is next to him. Left side–crossed torches. Right side–cluster of musical instruments used in cult festivals. Back–sacred tree hung with objects; a sacrificial ram and bull under it.

HISTORY: According to the records of epigraphers (CIL, VI, 505), it was known in the 15th century near S. Sebastiano on the Via Appia where it had been since Antiquity on the land which belonged to Orfitus (Vermaseren, 1977, p. 59). From at least the mid 16th century it was in the Cesi Collection;

towards the end of the 17th century, it was acquired by the Massimi and in the 18th century it came to the Villa Albani.

REPRESENTATIONS:
- B.Brunelleschi, Epigraphical skb., 1509, Florence, Bibl. Marucel., Cod. A 78, f.39v. Cf. Woodcut in Mazochius, 1521, p.clxxiv: front (47a). (See also Du Choul, 1556, fig. on p.89.)
- Cod. Coburgensis, f.179 (Matz, 1871, 59; Mandowsky and Mitchell, 1963, pl.18b): front and motifs from sides; cf. Cod. Pighianus, f.2v (Jahn, 1868, 78).
- Giovanni Colonna, Cod. Vat. Lat., 7721, f.25: front; f.24: details of sides.
- Boissard, Stockholm skb., f.36 (Mandowsky and Mitchell, 1963, pl.18a): front and right side; cf. Boissard, 1597, III, pl.47.
- Ligorio, Naples, MS XIII, B7, f.57 (Mandowsky and Mitchell, 1963, pl.17a, cat.27): front and right side.
- Dosio Circle, Florence, BN, MS N.A. 1159, f.1: 'Nel cortile di Ciesis'; front, both sides in projection.
- 'Peruzzi' Siena Skb., f.57: details of figures from front and right side.
- Pierre Jacques, 'Album', f.4v (Hülsen, 1917, fig.8): figures from sides.
- Dupérac, Louvre Album, inv.26452: front and right side; back and left side (only drawing to show the back).

LITERATURE: Hülsen, 1917, p.11, Cesi 8.

48. Diana of Ephesus
Roman copy of Hellenistic type
Rome, Museo Capitolino (Stuart Jones, 1912, pp.158 to 159, Sala delle Colonne, 49)

DESCRIPTION: The cult statue, representing the fecundity of nature, stands rigidly facing front with hands outstretched. The head, hands and feet are of black marble, the rest is white as described by Claude Bellièvre in 1514–15. The goddess wears a tower on top of her head which holds down a billowing, symmetrical veil. Below the collar are animals' forequarters in high relief and three rows of udders. The skirt is like a heavy sheath, divided into square fields, each of which has a relief of an animal's head, or bees, or rosettes. At the ankles, the underskirts fan out over the bare feet.

This type of cult statue developed after the rebuilding of the Temple of Ephesus in the 4th century B.C., one of the Seven Wonders of the Ancient World. A temple of Diana of Ephesus existed on the Aventine in Rome.

HISTORY: The statue was in the Rossi (Roscia) Collection in Rome, in the early 16th century, where it was described by Claude Bellièvre in 1514 (passage quoted by Dacos, 1977, p.253).

REPRESENTATIONS:
- This statue, as well as images of the type, such as coins, were probably known to Raphael and his Workshop, and are reflected in the decoration of the Vatican Loggie (Dacos, 1977, pp.252–3, pl.XCb).
- Giulio Clovio?, Colonna Missal, I, f.79, Manchester, John Rylands Lib. (Pevsner, 1968, I, fig.28).

LITERATURE: Dacos, 1977, pp.252–3.

FORTUNA/DESTINY (TYCHE/NEMESIS)

The Greek concept of Tyche represents the good fortune bestowed by gods on men. As a guardian deity, personifying cities, Tyche is sometimes represented wearing a turreted crown, like Cybele's, and holding a cornucopia representing the fertility of the earth (cf. 196, left).

Another aspect of the Goddess of Fortune is the Greek concept of Nemesis, seen at work in many of the myths: if a man or god boasts of his luck or demonstrates hubris he may be sure that Nemesis, personification of divine vengeance, will bring about his humiliation. Nemesis, Fate or Fortuna is portrayed in various ways in Antiquity. The standing draped female figure with her foot on a wheel (49ii, 114, 116) is a common type.

In the Renaissance, Fortuna is often nude with a billowing veil, and balances on a globe to indicate her instability. She is blindfolded to show that her gifts are bestowed by chance, and may hold a rudder or sail to catch the currents or winds of change. The concept of Fortuna was of great interest to unfatalistic Renaissance humanists who sought to control her fortuitous gifts by the exercise of human will (cf. Giovanni Rucellai's emblem, a concept of great interest to Warburg; Gombrich, 1970, pp.172–3; Gilbert, 1949, pp.103–4 with political interpretation).

LITERATURE: Schweitzer, 1931. Doren, 1922–3.

49. (i) Genius of Sleep ('Somnus') leaning on an inverted Torch
(ii) Nemesis ('Fate') with Foot on Wheel

Reliefs from a Roman funerary altar, 1st century A.D.
Rome, Villa Albani (Helbig, IV, cat. 3322)

DESCRIPTION: Dedication to Q. Caecilius Ferox inscribed on framed panel on front of altar. Figures on sides each stand in a round-headed niche framed by pilasters. *Right side* (ii) – female figure stands in a well-known attitude of *Victory writing on a Shield* (**170**), but is wingless, and rests one foot on the wheel associated with Nemesis. Her inscription identifies her with Fate ('FATIS'). A similar figure attends the doom of Meleager (**114, 116**). *Left side* (i) – an amor-like winged *genius* stands frontally, nude, with a mantle over his left shoulder, leaning his hands on the top of an inverted torch, legs crossed, in an attitude of mourning or sleep which is associated with the *genius* of death. The inscription on the cornice above ('SOMNUS') identifies the figure (cf. the flanking figures of the Endymion sarcophagus, **26**).

HISTORY: In various private collections in Rome in the 15th century (*CIL*, VI, 2188–9). By 1553 it was in the Cesi Collection. In the late 17th century it was in the Palazzo Massimi-Albani, and came to the Villa Albani in the 18th century.

REPRESENTATIONS:
– Heemskerck, *Skb.* II, f.62: side A without inscription.
– 'Maarten de Vos' *Skb.*, f. VIII: figure (i) only.
– Girolamo da Carpi, Rosenbach *Album* (Canedy, 1976, R. 51): figure (ii) only.
– Boissard, Stockholm skb., f.33V: front and both sides of whole altar; cf. Boissard, 1597, III, pl.48, below.
– Cod. Coburgensis, f.100a: front and figures only (not in Matz) cf. Cod. Pighianus, f.93 (Jahn, 1868, 135).
– Dosio Circle, Florence, BN, MS N.A. 1159, f.22b: '*nel Cortile del Cardinale di Ciesis*'; front with side projections.
– Pierre Jacques, '*Album*', f.1V (Hülsen, 1917, fig.7): side (ii).
– Pozzo London BM II, f. 35V, no. 348 (Vermeule, 1960, p.26): both sides with inscription between them.
– Claude, attrib., Florence, Uffizi, 5834V Horne: front and side (ii) showing breakages and lid.

LITERATURE: Hülsen, 1917, p.12, Cesi 9. Altmann, 1905, p.149. Hartmann, 1969, pp.11–26.

AMOR (EROS, CUPID)
For Amor and Psyche, see pp.125–126

'...fairest among the deathless gods, who unnerves the limbs and overcomes the mind...' so Hesiod described Amor's power in the *Theogony*; in classical Greek art he is portrayed as a winged youth. The Amor which prevails in Roman and Renaissance art is the Hellenistic winged putto, Venus' playful son, often armed with bow and arrows to wound his random victims with love. As cause and symbol of love, he attends not only Venus and her lovers, but also the loves of other gods, often not appearing singly, but in numbers (see Amoretti–Cupids). Statues known in the Renaissance show him bending a bow (**50**), or asleep on a lion's skin, holding poppies or bow and arrows, or with a flaming torch laid aside (**51**). A winged *genius* (spirit), looking very much like Amor, and leaning on a downturned torch, often appears on Roman funerary altars (**49i**) and, in a pair, terminates mythological sarcophagus reliefs (e.g. **26**), in order to represent the Genius of Sleep or Death.

LITERATURE: For antique type – Stuveras, 1969; Schauenburg and Strocka, *ASR*, V, 2: *Die Erotensarkophage*.

50. Amor stringing a Bow
Roman copy of a 4th century B.C. Lysippan statue. (Example of a type known in the Renaissance)
Rome, Museo Capitolino (Stuart Jones, 1912, Gall. 5, p.87; pl.18)

DESCRIPTION: Amor, a boy of about eight years, bends forward to string his bow, the parallel arms outstretched to one side, taut with pull and thrust. The stance is wide, the main weight is on his left foot. Restorations include the right arm, top of left arm, legs below knees and feet, bow and wings.

There is no evidence that any of the many extant copies of this type were known in the early Renaissance, but such a model was certainly available from the 15th century. Another fragment to be considered is in Venice, Museo Archeologico (inv. 121: original torso with antique head not its own; from Grimani bequest of 1586).

HISTORY: Tivoli, Villa d'Este in 1572; 1753 to Capitoline Museum.

REPRESENTATIONS:
- Mantegna, *Triumphs of Caesar*, Hampton Court, Canvas IX (Martindale, 1979, p.160, fig.42): adapted as the youth carrying a banner.
- Dürer, c.1495, Vienna, Albertina, 3062 (illus. in Koschatzky and Strobl, 1971, cat.13): with pose reversed.
- Filippino Lippi, *Allegory of Music*, c.1500, Berlin-Dahlem, Staatl. Mus. (Panofsky, 1960, p.203, n.3 and fig.150): pose of the Muse Erato, **38** (Muse 3) is conflated with **50** reversed.

LITERATURE: Döhl, 1968, illus. replicas; Robertson, 1975, pp.466f.

51. Amor Sleeping
Greek marble statue
Florence, Uffizi (Mansuelli, 1958, I, cat.108)

DESCRIPTION: Amor sleeps on his back, with his head on his left arm, legs apart, and chest turned by the weight of his right arm falling across it. Two poppies are in the right hand which rests on drapery, rather than the usual lion skin, which covers the rising ground beneath him. His hair is finely carved in waves ending in ringlets.

Of the examples catalogued by Mansuelli (see LITERATURE), we illustrate the one which seems to have had the earliest history in the Renaissance and to have been, possibly, the model for Michelangelo's lost *Sleeping Cupid*.

HISTORY: According to Dütschke (III, cat.544), the statue was traditionally thought to be the one Vasari (Vasari–Milanesi, 1906, IV, p.273) describes as the marble Sleeping Cupid given by the King of Naples to Lorenzo de' Medici, and brought from Naples to Florence by Giuliano da Sangallo together with 'a bust of Hadrian (and) an over life-size nude female, all of them (carved) in the round *(tutti tondi)*' (Parronchi, 1981).

Mansuelli, however, gives no Renaissance provenance for our **51**. If it was indeed the statue sent from Naples, it could have influenced Michelangelo's lost 'forgery' of a sleeping cupid, a much admired early work, later acquired by Isabella d'Este (Vasari–Milanesi, 1906, VII, pp.147–8, and n.2; Chambers and Martineau, 1981, pp.54–5, and cats.246 and 279 citing Norton, 1957).

REPRESENTATION:
- Album of Statues and Busts in Whitehall Gardens, Windsor, A 49, 8914 (Norton, 1957, fig.5): considered by Norton to be the only representation of Michelangelo's lost *Sleeping Cupid* (**51a**).

OTHER SIMILAR STATUES exist in the Uffizi, and may also have been known in the Renaissance. One large black marble statue, uncatalogued by Mansuelli, and now on view in the East Gallery, was found in the store-room after the flood of 1966, and exactly answers the description by Vasari of 'a putto of black stone, sleeping, a personification of Sleep, and has wings, and a *cornetto* (small horn) in his hand, and in the other a poppy, and the skin of a lion underneath' (Bloch, 1892, p.82; illus. in Parronchi, 1981, figs.24a–b, 25 etc. as Michelangelo's model for his lost *Sleeping Cupid*). Vasari also describes in the Palazzo Pitti, another sleeping putto with wings and the skin underneath, but no other attributes (Mansuelli, 1958, I, cat.109?).

A lost Sleeping Amor holding poppies was drawn in the Cesi Collection by Francisco de Hollanda, *Skb.*, f.17ᵛ, and Girolamo da Carpi (Canedy, 1976, R4 and p.33 for other replicas and drawings).

LITERATURE: Dütschke, III, cat.544. For type see Robertson, 1975, p.553 with further literature, and for other examples, Mansuelli, 1958, I, cats.106–7, 109 (figs.107–10).

AMORETTI (EROTES, CUPIDS)

Hellenistic amoretti swarm over Roman reliefs and proliferate increasingly in Renaissance, Baroque, Rococo and Neo-Classical art. The antique reliefs best known in the Renaissance show them up to every trick: imitating charioteers or hunters, riding on goats or sea animals, and even enacting Meleager's tragedy. On Bacchic sarcophagi they play with cult objects or wear satyrs' masks. On sarcophagus reliefs they escort the cortèges of Bacchus and Ariadne, and of the Nereids and Tritons. They never fail to swarm around lovers such as Diana (Luna) and Endymion, Mars and Rhea Silvia, and the unrequited Phaedra. They help Vulcan at his forge, Venus at her bath, and Pasiphae into the wooden cow. The reliefs of the Ravenna thrones represent them playing with the attributes of the gods, to show that even the gods are subject to love, just as described in

the Hellenistic *Greek Anthology* (1918, Vol. V, 214–15)

For foliate amoretti or *genii*, see below, pp. 92 and **55**.

LITERATURE: See Amor, p. 88.

52A. Amoretti with Attributes of Neptune ('Throne of Neptune')

Probably from the frieze of an Augustan temple or large altar
Ravenna, S. Vitale

DESCRIPTION: The 'Throne of Neptune' is the most complete fragment from a series of reliefs of the thrones of the gods. Neptune's throne, guarded by a sea monster, and covered in drapery, is set before a wall articulated by Corinthian pilasters on a high base. Above runs a cornice and frieze with a relief of pairs of dolphins, tails entwined, over scallop shells, the motifs divided by Neptune's trident vertically related to the pilasters below. In the foreground flanking the throne, are three large amoretti, two to the left, and one to the right, lifting the attributes of the sea god: the conch shell and the trident.

INTERPRETATIONS: In the Renaissance, the Thrones were thought to be the work of one of the great Greek sculptors, Praxiteles or Polyclitus (Francesco Sansovino, 1581, p. 63).

HISTORY: The original monument decorated by the reliefs is not known, nor when the reliefs came to S. Vitale in Ravenna in the Middle Ages. The Neptune reliefs remained in S. Vitale, and were first drawn in the first half of the 15th century and were described in Ravenna c. 1461 by Desiderio Spreti (1489, f. a5; Weiss, 1969, pp. 124–5). The reliefs in Venice (**52B**) were taken from Ravenna by 1335.

REPRESENTATIONS:
- Gentile da Fabriano, Paris, École B–A, M. 2342 (1369) (Schmitt, 1960, fig. 75; Degenhart and Schmitt, 1968, I, cat. 126; Sheard, 1979, cat. 16): the three amoretti **(52A–a).**
- Adaptation by L. Laurana of dolphin frieze, Urbino, Pal. Ducale, Library Portal (Rotondi, 1969, fig. 95; cf. figs. 266, 268).
- Marco Dente, engraving, 1519, Bartsch, XIV, no. 242: whole fragment reversed (**52A–b**). The engraving inspired the border of Giulio Romano's tapestry of *The Battle of Tessino*, woven at the Gobe-

lins factory in the 17th century (Jestaz, 1978, p. 30 with ills.).
- Aspertini, London, BM *Skb.* I, f. 31 (Bober, 1957, fig. 119): two amoretti on left.

LITERATURE: Bober, 1957, p. 86; Schmitt, 1960, p. 124, cat. 10. For other reliefs from the Thrones and their literature, see below, p. **52B**.

52B. Amoretti with Attributes ('Throne of Saturn')

Two fragments from the series of 'Ravenna Thrones'
Venice, Museo Archeologico (Forlati Tamaro, 1969, p. 24, Sala XI, 1 and 2)

DESCRIPTION: The fragments in Venice are identical with the Throne in Paris (see below as in **52B–b**). The pilastered wall runs behind as in **52A**. (i) Two amoretti take the poses assumed by amoretti holding garlands on sarcophagus reliefs (**54**), only they carry Saturn's attribute, the sickle. (ii) Another similar pair carry Saturn's sceptre.

HISTORY: The reliefs were recorded in Venice in the famous 'shopping list' of the collector, Oliviero Forzetta, who made a note to acquire them in 1355 (Gargan, 1978, p. 38, no. 13). In 1532, the reliefs were broken and taken to S. Maria dei Miracoli in Venice. At the instance of Canova, they were brought into the Venetian Public Collection *(Statuario Publico)* in 1811.

REPRESENTATIONS:
- Tuscan, last quarter of 15th century, Milan, Bibl. Ambr., F. 237, inf. 1702 (Schmitt, 1966, cat. and pl. 35): an amor and putto carry not a sickle, but a winnowing tray (**52B–a**).

LITERATURE: Dütschke, V, cats. 257 and 263; Ricci, 1909, pp. 247–58 for ills.; Bober, 1957, p. 86; Saxl, 1970, pp. 57–8; Perry, 1972, p. 107; Gargan, 1978, p. 45.

OTHER FRAGMENTS OF THE RAVENNA THRONES KNOWN IN THE RENAISSANCE:
All the known fragments were copied and adapted, particularly by artists working in North Italy in the Quattrocento, including Donatello and Mantegna.
- Amoretti with attributes of Saturn, Paris, Louvre (Clarac, 1826–53, pls. 218, 10, 156). Counterpart to reliefs in Venice (**52B–b**). Probably taken from Venice to Paris (de Nicola, 1916, pp. 218ff., connects plaquettes and other works of Donatello and his school with this relief). Cf. 'Ripanda' skb., Oxford, Ashmolean, f. 57.

- Thrones of Jupiter and Mars, Florence, Uffizi (Mansuelli, 1958, I, cat.151, fig.155; cat.152, fig.152).
- Throne of Ceres, Ravenna, Pal. Arcivescovile: one fragment consists of two amoretti flanking a large vase heaped with fruit, and another an amor falling over backwards (DAI neg. no.38.1212). The pair of amoretti with the vase has been related to one of the two relief panels in the lower zone of Donatello's Cantoria (Colosanti, 1934, figs.6–7; Janson, 1963, pl.51a and p.125, n.6).

NOTE: Throne of Diana, Milan, Mus. Arch., is not of the same series (Colasanti, 1934, fig.8, for its relation to the other panel by Donatello in the Cantoria; Janson, 1963, pl.51d).

LITERATURE: Bibl. for whole series in Gargan, 1978, pp.42–3, n.35; and for the influence of the Thrones on Renaissance art, see *ibid.*, pp.43–4, n.36.

53. Amoretti playing with Bacchic Cult Objects

Fragments of a Roman sarcophagus relief
Paris, Louvre (MA 1570 and MA 1593)

DESCRIPTION: On the left, a herm of Priapus, draped and bearded, holding a two-handled wine cup in one hand and a rod in the other, faces five amoretti who climb around a voluted and gadrooned wine jar. One lifts his drapery to urinate, and steadies himself by leaning a hand on a small altar.

More of the relief was known in the Renaissance: in the Pozzo drawing (17th century) the fragment continued to the right with three more amoretti, one bending, one crouching, and the third playing a flute, all turned to the right, with a large quiver of arrows in the background.

HISTORY: This sarcophagus, or an almost identical one, was known as early as the end of the 14th century (cf. urinating putto in Florence, Duomo, Porta della Mandorla), but its history is obscure. In the 17th century it was in the Villa Borghese.

REPRESENTATIONS:
- Pozzo London BM I, f.21 (**53a**; Vermuele, 1960, p.10, no.23 and fig.16): shows the three amoretti on right, now identified by M. O. Jentel.
- The type of the urinating amor quoted by Titian and by Michelangelo (see Panofsky, 1939, p.221, with notes on the use of such amoretti by Donatello).

LITERATURE: Jentel, RACAR, II, 1975, pp.45–50.

OTHER EXAMPLES OF THE TYPE KNOWN IN THE RENAISSANCE:
- Child's sarcophagus, Pisa, Campo Santo (**53b**; Dütschke, I, cat.33; Arias *et al.*, 1977, C 11 int.; Lasinio, 1814, tav. L, XXIV; DAI neg. no.65.2250).
- Child's sarcophagus, Florence, Uffizi, from della Valle Collection (Mansuelli, 1958, I, cat.242, pl.242a, b, c).
- Lost sarcophagus drawn in Cod. Pighianus, f.94 (Jahn, 1868, 189; not in Cod. Coburgensis).

54. Amoretti holding Garlands

Roman sarcophagus, 2nd century A.D.
Lost

DESCRIPTION: One of the many sarcophagus reliefs in which at least one pair of amoretti moves vigorously forward, holding up a garland with the far side elbow towards the ear. The garlands often frame mythological vignettes, portrait busts, satyr masks etc. The pose of the amoretti was frequently used in Antiquity and was repeated in Quattrocento decorative reliefs on tombs and architectural friezes. A particularly fine example is Raphael's putto holding the Medici ring and feathers in the Vatican Stanza d'Eliodoro, with a drawing for it in the Teyler Museum, Haarlem (van Regteren Altena and Ward-Jackson, 1970, cat.76).

This lost relief was drawn with the garlands framing two vignettes, both representing a nereid on a triton. The arm of the nereid on the left was evidently broken in the Renaissance as it appears hatched, and is variously 'restored' by the artists in their drawings.

HISTORY: On Monte Cavallo c.1500 (*Cod. Escurialensis*).

REPRESENTATIONS:
The following drawings also include the foliate amoretti and griffins of the Forum of Trajan (**55**):
- *Cod. Escurialensis*, f.34, (2) '*inchavagli*' (Monte Cavallo); **54**.
- 'Francesco di Simone', London, Kaufman Collection, 181; cf. *Cod. Escurialensis* with variations.
- Francesco da Sangallo, Florence, Uffizi, 1694 Orn (Hülsen, 1910, *JÖAI*, fig.123): variant 'restorations' in left vignette.
- Jacopo Zucchi, formerly 'Pontormo', skb., Paris, Louvre, 960 (Monbeig-Goguel, 1972, cat.375): transposition of left and right vignettes.

LITERATURE: Rumpf, *ASR*, V, 1, cat.8. Rumpf does not take into account that the variations of the drawings may be due to the artists' reconstructions, and assumes that two different sarcophagi were drawn.

FOLIATE AMORETTI, 'GENII' OR WINGED PUTTI

As a common decorative motif, winged putti emerge from acanthus scrolls as foliate amoretti or *genii*, much used by Renaissance artists, craftsmen, and manuscript illuminators, particularly in the late Quattrocento. Various specific examples from antique architectural decoration were recorded in the Renaissance. A frontal foliate amor in vigorous *contrapposto* terminated the acanthus frieze of the gigantic 'Frontispizio di Nerone' on Monte Cavallo (Temple of Serapis), and was drawn by Giuliano da Sangallo (*Cod. Barberinianus*, f.68v); Francisco de Hollanda (*Skb.*, f.20v); Dosio, Uffizi, 2025A (Borsi *et al.*, 1976, cat.116); Pirro Ligorio *in situ*, Oxford, Ashmolean (Parker, 1956, II, cat.281); and also in the 'Pietro da Cortona' Toronto skb. Another frieze was drawn in the Forum of Trajan **(55)**.

Well known were the reliefs of foliate amoretti on the candelabra bases in Sant' Agnese fuori le mura, admired by Giovanni Rucellai in 1450 (Rucellai-Perosa, 1960, p.74: '*be' candelabri in sul coro con fogliame et figure. Cose molte notabili...*). Of these, two pairs are now in the Vatican (Helbig, I, cat.526; Lippold, *Kat.*, III, cat.2, pls.88–91 and 115, nos.44, 51; 24–5) and one is still in Sant'Agnese. A figured capital with a foliate Amor, drawn by Francesco di Giorgio, was re-used in the 5th century church of Sant'Angelo in Perugia (Weller, 1943, p.267).

Foliate amoretti and other foliate creatures could also be seen in the grotteschi decorations of the Golden House of Nero. They inspired lively variations in the Renaissance (Dacos, 1969, *passim*).

55. Foliate Amoretti or 'Genii' in Acanthus Scrolls

Reliefs from an architectural frieze in Trajan's Forum

Lost; similar fragments from same frieze in Vatican, Museo Lateranense, inv.9760, 9648 (Helbig, I, cat.1023)

DESCRIPTION: One of the two Vatican fragments, similar to those drawn in the Renaissance, is a foliate amor seen in profile, pouring a drink for a horned griffin which stands with a forepaw raised above the far-side rim of the cup. The other fragment, also much restored, preserves two smiling winged putti ending in acanthus scrolls in place of legs, pouring wine from a jug raised above a bowl. They flank, back to back, a large amphora decorated with a relief of Bacchic dancers. The third fragment of this frieze, a foliate amor in profile to right, outer arm broken, in pose of pouring, is in Berlin (DDR), Antikensammlung (Furtwängler, *Beschreibung*, 1891, cat.903).

HISTORY: The extant fragments were only found in the late 16th century, but similar reliefs from the same frieze showing the foliate amor pouring a drink for a griffin were drawn *in situ* in the Renaissance. The frieze was on a giant cornice on the south precinct wall of Trajan's Forum by the small church of S.Maria in Spoglia Cristo, so-called in the Renaissance for its image of the Disrobing of Christ; later it came to be called S.Maria in Campo Carleo. The church was destroyed in the 19th century (A.Bartoli, 1924). Drawings of the cornice *in situ* show the church bells attached.

REPRESENTATIONS:
A group of related drawings of the frieze with foliate amoretti and griffins or separate figures from it are drawn on the same sheet with the lost sarcophagus **(54)** on Monte Cavallo and all seem to be based on a common lost prototype:
- 'Francesco di Simone', London, Kaufman Collection, 181.
- F. or GB.Sangallo, Florence, Uffizi, 1694 Orn (Hülsen, 1910, *JÖAI*, fig.123).
- A.Barili, attrib., Florence, Uffizi, 560 S.
- Jacopo Zucchi, formerly 'Pontormo', skb., Paris, Louvre, 960 and 974v (Monbeig-Goguel, 1972, cats.375 and 389v, with bibl.).

Of the many architectural drawings of the cornice at 'Spoglia Cristo' listed by A.Bartoli (1924), only two indicate the carved reliefs:
- Cronaca, attrib., Florence, BN, Cod. II, 1, 429, f.50v (A.Bartoli, 1924, pl.37, 2 and 1): cornice with one griffin sketched in; f.50: cornice *in situ*, frieze blank.
- Cod. Escurialensis, f.46, above **(55a)**: '*a spoglia Christo*'. Cornice with frontal foliate amor in frieze (short side), amor in profile pouring drink for griffin (long side). The cornice is seen *in situ* as part of wall, with church behind it; cf. Cronaca, f.50.
- Heemskerck, *Skb.* I, f.50a: foliate amoretti flanking a candelabrum. Hülsen (1913–16, p.27) thought the drawing represented a part of the frieze, but the

fragment drawn by Heemskerck may come from the Temple of Venus Genetrix (cf. D. Strong, 1961, fig. 65).

LITERATURE: A. Bartoli, 1924, pp. 177–94; Leon, 1971, pp. 67–9. For the significance of the griffin's drink, see Simon, 1962.

SEASONS
(HORAE–THE HOURS)

The Seasons in Greek mythology are the daughters of Themis (Justice) by Zeus and are named Eunomia (Good Counsel or Government), Dike (Right) and Eirene (Peace). They evolved from gatekeepers of Olympus and the abstract Horae of Hesiod's *Theogony* (901) into popular spirits of growth and the blessings of nature allied with the Graces, and finally into the three or four goddesses regulating the eternal change of season. They underwent an even more radical metamorphosis in Roman times. At first they were Neo-Attic types representing young maidens in fluttering garments, bearing appropriate attributes, but in the course of the second century A.D., Spring, Summer, Autumn and Winter came to be depicted as seasonal Amoretti or winged *Genii*, symbolizing the constant renewal of time and of life. On sarcophagi of the later Empire and on triumphal arches, as well as in individual statues, their associated fruits or game made them easily identifiable for Renaissance artists and poets.

LITERATURE: Hanfmann, 1951; Toynbee, 1971; Nilsson, 1920.

56. Seasonal 'Genii'

Sarcophagus front. Roman, 249–50 A.D.
Rome, Palazzo dei Conservatori, Sala dei Trionfi, no. 4 (Stuart Jones, 1926, p. 49, pl. 17)

DESCRIPTION: A column sarcophagus which divides the relief into three sections by architectural elements: at either side colonnettes bearing segmental arches enclose Seasonal *Genii*, chiastically arranged so that (left to right) Winter follows Spring (left) and Summer succeeds Autumn (right).

Thus Spring and Summer, reflecting each other's balance with baskets of flowers held in their outermost arms, set up a confining rhythm that is passed on to mirror-postures of Winter and Autumn. The centre is filled by an elaborate tomb structure with one valve of its doors standing partially open, a door to the Underworld as well as to the house of the dead. The pediment of this building replaces the pediment one would expect in the architectural façade which articulates the relief; tritons and sea-animals are fitted into spandrels of this 'arcade'–again a double reading–while they also serve as *acroteria* for tomb and flanking *aediculae*. The doors of the tomb are elaborately decorated with reliefs of funerary symbolism: *gorgoneia*, lion-heads, and miniature variants of the four Seasons. The large Seasons in the *aediculae* are separated by low postaments with Bacchic masks. Spring has a small kid at his feet; Winter a boar, while he carries two ducks and a bundle of reeds; Autumn (hands restored) is crowned with vine-leaves and now holds grapes, with a little Bacchic panther at his feet; and Summer is crowned with wheat and has an indeterminate animal attribute. The deceased couple is shown in modest scale but with symbols indicating their prospective triumph: at either side of the door to the next world their *Genii*, standing as Victories, hover above them, he with *patera* in sacrificing pose at left, and she as Fortuna with a rudder. The relief was restored by Algardi in the 17th century (according to J. Montagu, 1985, Cat. 122).

HISTORY: With another sarcophagus front, this was already set into the vestibule of the Palazzo dei Conservatori by the early 16th century; Albertini (1510, f. 61ᵛ) mentions the two slabs of relief. Aldrovandi's description identifies them, making it plain that the second showed Achilles and Penthesilea (a sarcophagus now in the Villa Doria Pamphili, Calza *et al.*, 1977, cat. 168, pl. cvii). This puts to rest the notion that the second sarcophagus was also of the Seasons (usually equated with a related sculpture in the Vatican Belvedere, Amelung, *Kat.*, II, pp. 153–8, no. 60, pl. 17, which Panofsky brought forward as the inspiration for the lower story of Michelangelo's 1505 project for the Tomb of Julius II; see Panofsky, 1964, pp. 37f., fig. 135).

REPRESENTATIONS:
– Anon., 16th century, Pennsylvania, Swarthmore College Collection (unpublished drawing): the wife and Victories.

– 'Ripanda' skb., Oxford, Ashmolean, f.25v, below.
– Cod. Coburgensis, f.34 (Matz, 1871, 179).
– Cod. Pighianus, f.245 (Jahn, 1868, 190).

LITERATURE: Haight, 1952, pp.25ff.; Hanfmann, 1951; Helbig, II, cat.1451 (Andreae); Kranz, 1984, Cat. 16.

57. Seasons (Horae)

Reliefs on a candelabrum base
Roman, Neo-Attic. 1st century B.C.–
1st century A.D.
Chantilly, Musée Condé

DESCRIPTION: On each face of a square base ornamented by sphinxes below and rams' heads at the upper corners, a Season of Neo-Attic type is displayed. The movement is to the right. Winter has her feminine charm disguised in heavy garments: leggings, a hunting tunic and a scarf draped over one shoulder; she carries a shepherd's crook on her shoulder with game (three birds and a hare) balanced at either end and dangles a little boar from her right hand. Autumn wears a *chiton* and mantle and holds a little animal in her right hand which seems to be a hare; grapes are grasped by her left hand which also supports the folds of her cloak. Summer wears only a mantle covering her legs and blown up in a deliberate foil for the nude torso; on a similar base in the Villa Albani, Renaissance commentators took her to be Venus. Spring is given in the type of Pomona, holding, with both hands, a fold of her mantle filled with fruit; the breezes of the season have wafted out a delightful swallow-tail flutter of drapery.

HISTORY: In the early 16th century, the candelabrum was at the Villa Madama, Rome (Heemskerck). Later it went to the Palazzo Farnese and by Piranesi's day it was in the Villa Farnesina (inventories of 1767 and 1775, *Documenti inediti* III, pp.192f.). Its path to Chantilly has not been traced.

REPRESENTATIONS:
– Holkham Album, f.20: one whole face of the base, showing Winter.
– Raphael Circle (style of Giulio Romano, c.1527?), Cambridge, Mass., Fogg. Mus., 1938.53 (Mongan and Sachs, 1940, I, cat.155; II, fig.87): Spring, Autumn and Winter (**57b**).
– Heemskerck, *Skb.* I, f.46d (**2a**).
– Cod. Coburgensis, f.134 (Matz, 1871, 64); **57a**.
– Cod. Pighianus, f.244 (Jahn, 1868, 90).
– Piranesi, 1778, pl.89: '*nel palazzo detto La Farnesina alla Longara*' (see HISTORY for inventories).

LITERATURE: Herrmann, 1901, p.38; Hauser, 1889, no.37, p.104 (as 'lost').

58. Season, the Hora of Autumn ('Pomona')

Statue. Roman copy of a neo-Attic sculpture of 1st century B.C.–1st century A.D.
Florence, Uffizi (Mansuelli, 1958, I, cat.124)

DESCRIPTION: Clad in diaphanous, windswept draperies–an under-*chiton* and mantle which reveal her figure and at the same time decoratively frame its contours–'Pomona' (as she was called from the Renaissance up to the 18th century) steps lightly forward with her left foot. Before her, caught up in an apron-like swag of drapery, she holds the fruits of the season. The wreathed head, forearms, edges of drapery, feet and base are (Renaissance?) restorations. Similar antique bronze statuettes, of which many exist, may also have been known in the Renaissance.

HISTORY: Earliest certain reference to the piece appears in Bocchi's description of the Uffizi (1591, p.46), but it seems to be among the Medici statues mentioned by Vasari at mid century in the Palazzo Pitti: '*una femmina con certi panni sottili, con un grembo pleno di varij frutti, la quale è fatta per una Pomona*' (1568 ed.; because the passage is often omitted by editors of Vasari's *Lives*, it is cited in full by Bloch, 1892, pp.81f.). A similar Pomona was owned in mid 16th century Rome by Francesco Lisca and subsequently by Girolamo Garimberti, as a study by C.M.Brown affirms (Art Bull., Sept. 1984; cf. Bober, 1967, p.122, n.18).

REPRESENTATIONS:
– A mid 16th century drawing by a central-Italian artist (formerly attrib. to 'Maturino') in Port Sunlight, Lady Lever Art Gall., inv. no.3024, seems to 'restore' the Uffizi replica (**58a**).
– Cavalieri, III–IV, pl.54 (Bober, 1967, fig.6) engraved the Garimberti statue.

NOTE: Extant drawings after the Uffizi replica, cited by Mansuelli, are late, but Warburg believed that it served as a prototype for Botticelli's *Primavera*. Many Quattrocento works reflect such Neo-Attic draperies (see Introduction, p.36).

LITERATURE: Warburg, 1932, I, pp.38f., notes 2f., fig.15; Aldrovandi, 1558, p.174 (for the statue in the Lisca Collection).

59A. Dancing Maidens
59B. Maidens decorating a Candelabrum

Reliefs. Roman, neo-Attic, 1st century B.C.–
1st century A.D.

Paris, Louvre (MA 1612 and 1641)

DESCRIPTION: *Relief* **A**–Before a precinct wall articulated by Corinthian pilasters, five maidens dance with solemn ritual tread, holding hands as dancers still do today in Greece. Since three move to the left and two to the right in a calculated rhythm of profile, back and front views, they are to be thought of as dancing in a circle. Each is dressed in the 'wet' draperies beloved of Neo-Attic artists exploiting ornamental possibilites of patterned and fluttering folds. Heads and most free-standing portions of arms are restored.

Relief **B**–A companion slab, with a similar precinct wall or portico, shows three maidens in even more decorative draperies of filmy material with windswept mantles. Before a small Corinthian temple they bring garlands and a basket of flowers to ornament a flaming candelabrum that has Bacchic figures on its triangular base. Heads, projecting arms and other details are restored.

HISTORY: Both reliefs came to the Louvre from the Villa Borghese in Rome, part of the collection assembled at the beginning of the 17th century by Cardinal Scipio Borghese and sold to the Louvre by Napoleon's brother-in-law, Camillo Borghese. The location of the 'Borghese Dancers' during the Renaissance is not recorded, but the second slab **(B)** was in the 'piazza' (or atrium?) of Old St. Peter's at the end of the Quattrocento.

REPRESENTATIONS:
Relief **A** –
– It has been suggested that the Borghese Dancers influenced Mantegna's rendering of the Muses in his *Parnassus* **(59A–b)**, and indeed their formal correspondence is greater than with the Ciriaco d'Ancona tradition which gave the painter's creations authenticity (cf. Lehmann, 1973, pp.98ff.).
– Particularly popular in Raphael's circle, several figures and groups are quoted directly in paintings and stuccoes of the Vatican Loggie (Dacos, 1977, esp. pp.47f., 147f., 231f., 268f., indices, and a fine colour pl. of a stucco detail from Vault VII, pl.2).
– Several figures are taken over directly in Lorenzetto's bronze relief of *Christ and the Adulteress* **(59A–a)** for the Cappella Chigi in S.Maria del Popolo, Rome (Dacos, 1977, pl.CXLVII, figs.3–4).

– Raphael Workshop, Fossombrone skb., ff.85ᵛ, 86ᵛ, 87ᵛ: individual figures carefully drawn **(59A–c)**.
– Pozzo Windsor, V, f.20, 8503 (Vermeule, 1966, p.33; Blunt, 1971, cat.180 as Franco): whole relief wrongly reassembled on restored sheet.

Relief **B** –
– *Cod.* Escurialensis, f.51ᵛ: 'in sulla piaza di santo piero'; the maiden approaching with flowers, is understood by the editors of the Codex to be after a Quattrocento fresco, though the rendering is quite accurate. This drawing was adapted in the sculptural decoration of the courtyard in La Calahorra, Spain, by a Genoese sculptor.
– The right-hand figure with billowing drapery is recorded in Florence, Uffizi, 336E, attrib. Giuliano da Sangallo **(59B–a)**. Berenson (1938, cat.2514A) attributes it to Sogliani, 'undoubtedly inspired by the antique'.
– The central figure may stand behind one maiden in a Ghirlandaio drawing in Stockholm, Nationalmus., no.109/1863 (Bjürstrom, 1969, cat.5).
– Adapted as angels in reliefs by Andrea Bregno, Piccolomini monument, Siena, Duomo. Cf. frescoes by Peruzzi in the Chapel of the Castello di Belcaro outside Siena.

LITERATURE: Clarac, 1826–53, pls.163, 259 = Reinach, *Rép. Stat.*, I, p.58; Bober, 1963, pp.88–9; Loewy, 1896, pp.247ff. Haskell and Penny, 1981, cat.29 **(59A)**: 'The Borghese Dancers'; on p.195 they note adaptations in two *chiaroscuro* vases painted on the façade of the Pal. Milesi by Polidoro da Carravaggio (c.1524–7) preserved in prints and drawings recording the façade (see Galestruzzi after Polidoro, Bartsch, XXI, nos.47 and 61).

THE GRACES ('GRATIAE'–CHARITES)

We tend to think of the Graces as a trinity among Graeco-Roman minor divinities, although they may have been more numerous and more potent spirits of fertility. In historical Greek times they were united in cult with the Horae, or Seasons. They are the daughters of Zeus (Jupiter) and Eurynome and personify every aspect of grace, beauty and beneficence–*charisma*, in the original sense of the word. Their physical charms made them fitting attendants of Aphrodite (Venus), while their intellectual graces linked them to the Muses. Their names reflecting powers in

fecundity and love, Kale (The Beautiful), Auxo (The Grower), Thaleia (The Flowerer), by later Greek times gave place to the three we emphasize today: Thaleia, Aglaia (The Radiant) and Euphrosyne (Delight), with Peitho (Persuasion) a favourite Hellenistic alternative. For some later Christian apologists, they became Faith, Hope and Charity.

Hellenistic also is the imagery that supplanted all others in Roman times to be revived in the Renaissance. Archaeologists have not yet been able to settle the question whether the inventor of the canonic nude, interlaced triad was painter or a sculptor. (For example, Orlandini, 1959, favours an initial painting of the early third century B.C., whereas Havelock, 1969, commenting on a Pompeian painting on colour pl. XIX, feels the debate is now on the side of an original sculpture in the round, possibly from the School of Pasiteles in the 1st century.) Whoever created the original, it was as famous afterwards as the Mona Lisa is today. In Roman art the intertwined group, seen always from the side which displays the middle figure from the back, is represented in every medium: painting and mosaic, sculpture in the round as well as relief, medals, terracotta lamps and other minor arts.

If the Three Graces' most typical shape and their personification of the social arts were familiar to every Roman, it was among intellectuals that more subtle connotations matched the intricate responses of their pose. From Seneca, Pliny and Servius, the joys of giving and receiving could then be allegorized by neo-Platonists of the Renaissance, investing the group with ingenious trinitarian meanings; not only Pulchritudo-Amor-Voluptas or Castitas subsumed in the unity of Venus, but as qualities of the Divine Mind.

LITERATURE: Becatti, 1937, pls. I–IV, figs. 1–3; Borda, 1953, pp. 79ff.; Merot, 1958. Influence and interpretation in the Renaissance: Tea, 1914, pp. 41–8; Warburg, 1932, I, pp. 29, 327; Panofsky, Torchbook ed. 1962, pp. 168–9, fig. 124; Wind, 1958, ch. II, Seneca's Graces; von Salis, 1947, pp. 153–64; Ladendorf, 1958, p. 30, pls. 12–15 up to and including Maillol. See Cristofani, 1979, pp. 126–34 with further bibl.

60. Three Graces

Statue group. Roman copy of a Hellenistic original
Siena Cathedral, Piccolomini Library

DESCRIPTION: An understated grace of pose, the interwined design of the motif in one plane, as well as the dewy youthfulness of their bodies all contrive to lend a chaste air to the nudity of these figures, probably enhanced by their slight forms and the fact that the sculpture is under life-size. Two Graces face forward; each is self-contained in classicizing ways, above all through a modest inclination of head toward the weight-bearing outer leg. At the same time, the composition of the whole, closed by a firm arc of engaged leg and hip, is opened again by that very tilt of head and extended arm (already broken away at the time of the Renaissance). The middle Grace is just as subtly formed, with even more intricate harmonies demanded of this member of the triune chorus. It does not really matter that she has lost her head or that the interlace of arms on shoulders is interrupted (her left arm is quite clear, though her right shows some variation in other renderings: clutching the outside shoulder or gently touching the outstretched hand of her companion, if not holding some attribute), so lucid is the rhythm of response.

HISTORY: Thanks to epigraphers who learned early the importance of citing sources, we can trace the group from the collection of Cardinal Prospero Colonna to that of the Cardinal of Siena, Francesco Piccolomini. Fra Giocondo, recording an inscription which had been invented for the base (CIL, VI, 5. 3*b, Falsae: 'Sunt nudae charites niveo de marmore at illas/diva columna suis aedibus intus habet'...), states that it had remained at the Colonna Palace when the Graces came to Cardinal Piccolomini (Vat. Cod. Reg. 2064, f. 111, cited by Lanciani, 1902–1912, I, p. 114). Marcanova and others cite these verses owned by the Colonna, and they turn up again or were imitated for other representations of the Three Graces in Cinquecento collections (a group owned by Ludovico Podacattaro, engraved by Lafréry, for example, see below). By 1502, Piccolomini had transferred the sculpture to his native city, Siena, well before his election as Pope Pius III and precipitous death in 1503.

REPRESENTATIONS:
– On Ghiberti's use and Botticelli's dependence on him, see Krautheimer (1956, p. 346 and cat. 37).
– Italian, late 15th century, formerly attrib. to Antonio Federighi, Munich, SGS, 36909 (Degenhart,

1939, p.135, fig.48; Schmitt, 1970, fig.6, as related to an artist of the Holkham Album group): the best drawing, showing both sides of the group (60a).

- Umbrian *Skb.*, Venice, f.28 (Fischel, 1917, p.106): two Graces at left and centre.
- Raphael Workshop, Vatican Loggie stuccoes, see Dacos (1977, p.231, the middle Grace in VI C; pl.LXXIIIa), although she notes the possibility of derivation from other antique examples known in the Renaissance, or from medals attributed to Niccolò Spinelli Fiorentino for several Quattrocento belles, including Giovanna Tornabuoni (Hill, 1930, p.998, cats.1008, 1021). Cf. the medal for Pico della Mirandola, (Hill and Pollard, 1967, cat.277).

NOTE: Raphael's painting in Chantilly, Mus. Condé of the *Three Graces*, Correggio's frescoes in the Camera di S.Paolo, Parma, and other representations may be modelled on antique representations in various media. Cf. discussion of the Marcantonio engraving, Bartsch, XIV, no.340, in Crelly (1965), as well as a Pontormo drawing, Florence, Uffizi, 6748 F, which may derive from the print. See also the relief belonging to Ludovico Podacattaro with the dedication of Batinia Priscilla to the nymphs (Mazochius, 1521, p.CV^V: '*In domo Ludovicii Apodocatharii Caprii Card. Caputaquenensis*), and the Graces in the collection of the del Bufalo family (Cod. Pighianus, f.292a; Jahn, 1868, 13).

LITERATURE: *CIL*, VI, 5, 3*b; Deonna, 1930, pp.274–332; Cristofani, 1979, cat.134.

NYMPHS

Nymphs were worshipped from early times in Greece as spirits of benevolent forces of nature, particularly those of life-giving springs–although there were many categories of nymphs: of forests, of meadows, of mountains, and of the sea (Nereids). They were given divine honours as daughters of Zeus, linked with the Muses in inspiring poetry and dance; yet even as agents of translation to a happy afterlife, they were not themselves immortal. Re-awakened interest in nymphs and their patronage characterized a growth of neo-Platonism in the Renaissance, fed by ancient interpretations of Homer's description of the cave of the nymphs, such as Porphyry's *De antro nympharum*. Humanists gained visual inspiration in this regard from a particular

statue type invented in the early Hellenistic period for slumbering maenads (or compare Ariadne abandoned on Naxos, **79–80**). From it Romans had created apt imagery for fountain sculpture: a naiad, *en négligée*, lulled to sleep by the murmuring waters over which she presided. The same beguiling conceit created a pseudo-antique inscription in the Roman Academy of Pomponius Laetus in the late Quattrocento as well as genuine or forged statues in the gardens of poets and collectors. A Christianized allegiance to a fountain nymph spread in the Curia of Julius II and of Leo X, to surface again in the neo-classicism of Alexander Pope and Thomas Jefferson.

LITERATURE: Ballentine, 1904, pp.77–119; Roscher, *Lexicon*, pp.1527ff., *Nymphai*; Kapossy, 1969; Kurz, 1953; Meiss, 1966; MacDougall, 1975; Bober, 1977.

61. Nymph 'alla Spina'
Statue. Roman copy of a Hellenistic bronze original of 2nd century B.C.
Florence, Uffizi (Mansuelli, 1958, I, cat.52)

DESCRIPTION: The nymph, nude above the waist, sits next to a tree-stump support, her left leg crossed over her right at the knee in the pose of one who puts on or adjusts a sandal with a right hand while reaching back to steady the action with the left (major restorations include the right hand and both feet, as well as head and neck). The connection of this figure and its replicas has long been established (Klein, 1921, pp.45, cat.86, and 1909) with a nude satyr dancing and beating out time with a foot-clapper (*kroupezion*); the best copy of the latter figure is also in the Uffizi Tribuna and seems to have been in Rome in the late 15th and early 16th centuries (drawings by Giuliano da Sangallo, Uffizi, 1799^V Orn; and Jacopo Zucchi, Louvre, 965, Monbeig-Goguel, 1972, cat.380). Together the group is known as 'Invitation to the Dance', representing in Klein's stylistic phases of Hellenistic art an antique 'Rococo' of the second half of the second century B.C.

HISTORY: At the end of the Quattrocento, the statue was owned by the Caffarelli in Rome, at the site of the present S.Andrea della Valle. Possibly it

came from there to the neighbouring Palazzo della Valle, but transfer to Florence is obscure. It was already in the Uffizi by 1704.

REPRESENTATIONS:
- Holkham Album, f.34 **(61a)**: '*questa femina ista in chasa questi chafaregli dirimpetto messer Lello della Valle*' ('this female figure is in the house of these Caffarelli opposite Messer Lello della Valle').
- Giovanni Fonduli da Cremona, bronze statuette, London, Wallace Collection (Mann, 1931, cat.72, pl.19, with reference to less appropriate sources; Radcliffe, 1966, p.13 for attrib. and colour pl.I, back-view pl.1).

LITERATURE: 'Prospettivo Milanese', c.1500, stanza 23: '*I chafarellan un asisa nuda/ che per strache*ʒ*e tien so capo chino...*' ('The Caffarelli have a seated nude bowed from care seemingly more penitent than Judas'; transl. Fienga, 1970, p.42). Cf. Michaelis, 1891, *JdI*, (I), p.238. Mansuelli, 1958, I (the *kroupe*ʒ*iast*, cat.51). Bieber, 1961, p.139, fig.563. D.K.Hill, 1974, pp.107ff., on the group as a fountain sculpture.

62. Nymph of a Fountain or Spring, Sleeping

Statue. Roman, 2nd century A.D.
Lost? A similar replica is in the Vatican (Amelung, *Kat.*, II, p.82, no.30)

DESCRIPTION: A Naiad reclines on her left side with the upper part of her body propped on a water-jug by the left arm, her head cradled on that shoulder; the left wrist is wrapped in an end of the mantle drawn under the nymph from its decorous draping about her legs. To complicate the rhythms of her supple form, the right leg is crossed over the left at the ankles and the right arm, decorated by a biceps 'Cleopatra' bracelet, is cast across her chest to grasp the opposite shoulder.

HISTORY: The statue was among the antiquities to be seen at the Casa Galli in Parione in the early 16th century, although the collection seems to have been acquired by Quattrocento members of the Galli family. Heemskerck's views of the 1530s show the sculpture installed on a truncated column as centrepiece for the upper garden, above the area where Michelangelo's Bacchus for Jacopo Gallo stands amidst ancient reliefs and torsi (one of which, apparently male, seems a more active though recumbent counterpart to the nymph). In mid century, Aldrovandi does not mention any of

the works drawn by Heemskerck, save the Michelangelo, as the old collection was evidently being dispersed. The history of this piece is obscure; the Vatican figure shows significant differences from Heemskerck's study, but is closer than Hülsen's suggestion (Vatican, Giardino della Pigna, no.100, Amelung, *Kat.*I, p.848, pl.101).

REPRESENTATION:
- Heemskerck, *Skb.* I, f.27a **(62a)**, also in the background of f.72.

LITERATURE: as above, p.97; Brummer, 1970, fig.162; Kurz, 1953, p.174, pl.23c; on example of the type, Kapossy, 1969, p.18.

63. Nymph of a Fountain or a Sea-Goddess (so-called 'Amymone' Type)

Statue. Roman, Antonine copy of a late Hellenistic restrospective type based on an early 4th century B.C. prototype
Rome, Villa Borghese (Helbig, II, cat.1971)

DESCRIPTION: In this replica, head and right forearm are restored; the support at the side is a dolphin spouting water and the figure's restored hand grasps its tail, although in the original the nymph leaned this right hand upon a low pilaster. Such a downwards shift to her right would have heightened the complex rhythms set up in the statue as the left hand is planted vigorously on the hip and right leg is thrust out to the side and forward, pulling against a mantle which is cast about her hips with one fold over the upper left arm and the other hanging in a deep triangular fold of Phidian inspiration. The nymph's locks fall over her shoulders and we know from many replicas of this statue so popular among the Romans, particularly in seafaring Ostia, that her torso was nude in the original; in the Borghese copy she wears a decorous *chiton*, thin and clinging though it may be. The Renaissance knew several variants of the type (see below).

HISTORY: At the end of the Quattrocento the statue stood either in SS. Apostoli or in the adjacent Palazzo of the Colonna family, according to the evidence of the *Cod.* Escurialensis. Its subsequent history is obscure, although we know that it came to the Borghese from the Villa Mandragone at Frascati (constructed 1572–85).

REPRESENTATIONS:
- *Cod.* Escurialensis, f. 54ᵛ: '*asanto apostolo*', 'restored' **(63a)**. Copy of this drawing by Fra Bartolommeo, Windsor (Popham and Wilde, 1949, cat. 118, fig. 35).
- Jacopo Francia, engraving (Hind, V, pl. 811, no. 3).
- Heemskerck, attrib., Paris, Louvre, 22634: restored.
- Melchior Lorch, on a sheet with eighteen statues, signed and dated in Rome, 1551 (H. Poulsen, 1933, pp. 104ff.): unrestored.

NOTE: A version of the statue with naked torso, drawn in the Maffei Courtyard, by Heemskerck, *Skb.* I, f. 3ᵛ (cf. late 15th century Florentine drawing in the Prado, see **109a**) is perhaps a replica formerly in the Hope Collection, Deepdene, now in the Lady Lever Gallery, Port Sunlight (catalogue by G. B. Waywell in progress). Drawings related to the Maffei type include: Fra Bartolommeo?, Oxford, Christ Church, Byam Shaw, 1976, cat. 56, pl. 54; Raphael School, Oxford, Ashmolean, Parker, 1956, II, p. 333, no. 623; Girolamo da Carpi, Rosenbach *Album* (Canedy, 1976, R37) as 'Venus of Arles' type, comparing Biagio Pupini, Uffizi 14790F; Pierre Jacques, '*Album*', f. 13.

LITERATURE: Becatti, 1971, discusses the antecedents of this and all other replicas; note that he reproduces the Borghese statue in fig. 44 and the Escurialensis drawing in fig. 45, labelled incorrectly as M. Lorck.

RIVER GODS

In Greek mythology they were the sons of the river god Oceanus, the most ancient of Titans who fought Jupiter for the supremacy of the world. Because they irrigated the land, rivers were worshipped in local Greek cults as fertility gods. As rivers were sacred, particularly in dry lands, so were fountains and springs, represented by nymphs, the female counterparts of river gods. Although in classical times a river could change into the shape of a bull or some other animal and often appeared as a human-headed bull in vase paintings, its principal representation in Hellenistic sculpture was as a powerful bearded old man reclining or sitting up and leaning on a symbol of his country. This Hellenistic type was the one which was favoured in the Renaissance.

Three colossal statues of river gods **(64, 65A and B)** survived in Rome from Antiquity, although they were not generally regarded as river gods until the 16th century when others **(66, 67)**, with well-preserved attributes, were discovered. This made it possible to identify and re-assess the existing *colossi*. Even in the Quattrocento many mythological sarcophagi could be seen with river gods, sometimes reclining beneath the hooves of horses to suggest the setting. Their attributes: the cornucopia, to indicate the abundance of crops they made to grow; the rudder, symbol of navigation; or simply a handful of water reeds could help to identify them (e.g. **9, 25, 27**). River gods were also known from coin reverses and from gems **(68)**. Their reclining pose was used for the female Tellus (Earth; E. Strong, 1937, 'Terra Mater or Italia?') who often accompanied Oceanus on sarcophagi **(25)**, and for Hercules **(133)**.

LITERATURE: A mid 16th century explanation of river gods is given by Aldrovandi, 1556, pp. 115ff. (see also Brummer, 1970, p. 268 for text). Sichtermann, 1960. Du Jardin, 1932–3. Gais, 1978. Rubinstein, 1984.

64. River God Marforio
Colossal Roman statue
Rome, Museo Capitolino (Stuart Jones, 1912, p. 21, Cortile, no. 1)

DESCRIPTION: The god lies lower than the *colossi* from the Quirinal **(65)**, and turns his head to left, his beard resting on his collar bone. The legs are draped from hips down to ankles. Before Bescapè restored the statue in 1594 as Oceanus, there was no right arm below the biceps, no left hand, nor a right foot. Parts of the head were also restored. Lafréry's engraving shows the statue unrestored on a marble plinth studded with oval stones, and no attributes by which the statue could be identified.

INTERPRETATIONS: The statue was described as the Tiber by the Anon. Einsidlensis in his itinerary of Rome in the year 800 (*CTR*, II, p. 177) based on a lost earlier text which seems to have preserved the original identification. By the mid 12th century this early tradition was lost, and the followers of the *Mirabilia* took the statue to be Mars until the

16th century. Biondo (1440s) referred to a view he did not hold, namely that it was dedicated to Jupiter the Baker, because the marble bed on which the statue lay seemed covered with bread (rolls) (*Roma Instaurata* III, 56; cf. Ovid, *Fasti* VI, 349–94).

Andrea Fulvio, who studied the antiquities of Rome with Raphael under Pope Leo X, explained in the dedication of his book to Clement VII in 1527, that he saw it as a river god, lying not on a bed but on a stony reef (*scoglia*). He compared it with the *colossi* on the Campidoglio (**65**), smaller river gods on arches, and one on the reverse of a medal of Trajan. He thought the name Marforio was a corruption of *Nar Fluvius*, a tributary of the Tiber (*Antiquitates Urbis*, Rome, 1527; 1588, Italian transl., bk. IV, ch. XLV, pp. 156f.; cf. Aldrovandi, 1556, p. 311).

The name Marforio was generally accepted for the statue, and made to stand for others of the type, according to the Codex Escurialensis (f. 58ᵛ) which refers to the river god Nile (**65B**) on Monte Cavallo (Quirinal) near the colossal horses of the Dioscuri (*Cavalli*) as *Marfurio di Chavagli*. (Cf. Baccio Bandinelli's earliest statue, a snowman of 'a fine giant like Marforio, lying down'; Vasari–Milanesi, 1906, VI, p. 135).

In the 16th century, the Marforio was one of the 'talking statues' of Rome, together with the Pasquino (**155**). Next to both statues outspoken criticisms of the unacceptable behaviour of public authorities were posted in the form of verse dialogues, as though written by the statues themselves. An engraving by Bonasone (1547) shows Pasquino in a boat on the Tiber with Marforio in the Forum, lampoons on the wall behind him (Bartsch, XV, p. 173, no. 352). The Lafréry engraving of Marforio (1550) includes a poem (**64a**):

This is a noble citizen of Rome
Who (let no one think I harm by saying this)
Was born with this beard and in these rags
And was as big as this since he was little
He never eats nor drinks, and is near to
And perhaps more than One Thousand and Two
 Hundred years old
And nevertheless he doesn's care a farthing
for all discomforts and worldly losses
Always, and one can say naked, to the rain, the
 sun,
the wind, and on the ground he stays without
 shelter
He hasn't even a tooth, not even one that hurts
 him,

Quiet of nature, serious plain speaking
Candid of few words
Both apt and adept at many things
Already certain traitors have mutilated him out
 of disrespect
As you see, and he is called Marfuori.

HISTORY: One of the colossal statues known throughout the Middle Ages, it remained visible until 1588 in the Forum near the Arch of Septimus Severus, and next to S. Martina just below the Capitoline Hill as drawn by Heemskerck (*Skb.* II, pl. 125). In 1588, it was moved first to the Piazza S. Marco, and then in 1594, it was restored by Bescapè and installed in the niche in the terrace wall of S. Maria in Aracoeli on the Campidoglio opposite the Palazzo dei Conservatori, its *aedicula* and fountain built by Giacomo della Porta after the designs of Michelangelo, according to Baglione (1642, p. 61), incorporating the colossal marble head of Constantine which Innocent VIII brought to the Capitol in 1486 as 'Commodus', restored as Apollo by Bescapè also in 1594. This installation was engraved by Nicolaus van Aelst in 1600 (Buddensieg, 1969, pp. 210–11; figs. 31–32). The statue remained there until 1644 and, in the same year, it was in the *cortile* of the new Museo Capitolino still as a fountain. The niche was restored under Clement XII in 1734 and flanked by the famous pair of Pan statues (**75**). (See Rossi, 1928, for a more detailed account.)

REPRESENTATIONS:
– Heemskerck, *Skb.* I, f. 19: '*Marfoelge*' (**64b**). Unrestored figure; *Skb.* II, pl. 125: view of Forum with Marforio *in situ*. Cf. *Skb.* II, ff. 79ᵛ–80.
– A. Sangallo the Younger, Florence, Uffizi, 896A (d'Onofrio, 1957, fig. 113): *aedicula* for Marforio.
– Bonasone, engraving, 1547, Bartsch XV, p. 173, no. 352: Pasquino and Marforio as *statue parlanti* (for pasquinades or lampoons, see **155**).
– Girolamo da Carpi, Florence, Uffizi, 1688E (Horster, 1975, p. 417): 'restored'. Horster identifies this drawing with the river god, 'Tigris', in the Vatican. It is very similar, but the hair is closer to Marforio's.
– Girolamo da Carpi, Turin *Portfolio*, f. 23 (Canedy, 1976, T 135): right arm 'restored', left incompletely drawn; two small figures seated on Marforio's leg give an exaggerated scale.
– Lafréry, *Speculum*, 1550 (Scherer, 1955, pl. 122): unrestored in Forum, with poem (see above). Many copies after the engraving were printed in the 16th century with and without poem and *cippi* (funeral stones) in foreground.
– Cavalieri, I–II, pl. 94: '*Aqua Traiana, vulgo Marphorius in foro boario*' (unrestored).

– Goltzius, *Skb.*, Haarlem, Teyler Mus. (Reznicek, 1961, I, cat.233; II, pl.155): before restoration.

LITERATURE: Stuart Jones, 1912, as above, for history and bibl. Helbig, II, cat.1193. Michaelis, 1891, *RM*, pp.49ff. Du Jardin, 1932–3, pp.66–72. Siebenhüner, 1954, pp.104–5. Haskell and Penny, 1981, cat.57.

For the niche and fountain projects, see d'Onofrio, 1957, pp.131ff; Buddensieg, 1969, p.211 and figs.31–2. See also Margaret Scherer, 1955, p.139, pls.221–2.

65. River Gods:
(A) Tigris [Tiber] and (B) Nile
Colossal Roman statues c. 5 × 3 metres,
2nd century A.D.
Rome, Campidoglio (Helbig, II, cat.1162)

DESCRIPTION: In their present installation by Michelangelo (**65A** and **B**), they sit back to back, framed by the triangular panel of the double staircase; unlike the pair from the Belvedere (**66, 67**), they sit heraldically, and their legs are draped.

The Tigris (**A**), main profile to the right, leans his right elbow on what was in the Renaissance perhaps a badly damaged tiger, thought by 'Prospettivo Milanese' (c. 1500) to be a crocodile (stanza 118). It was reworked after the mid 16th century into the Wolf suckling Romulus and Remus, thus transforming the statue into the river god Tiber, symbolic of Rome. In his other hand he holds out a cornucopia supported by his raised knee.

The Nile (**B**), profile to left, leans his left elbow on the original sphinx, cradling the cornucopia in the bend of the same arm, while extending his other arm (16th century restoration) before him.

INTERPRETATIONS: According to the Mirabilia tradition still current in the Quattrocento, the *colossi* were thought to be Saturn and Bacchus. Pomponio Leto, whose notes on Roman antiquities were not published until 1510, knew them to be river gods already in the 1480s (*CTR* IV, p.428) and was followed by 'Prospettivo Milanese' (stanze 117–118), although Albertini (1510, II, p.60) called them Neptunes. Fulvio finally established their identities (Nile and Tigris) in *Antiquitatis Urbis* (1527, p.xxxi), although in 1513 (*Antiquaria Urbis*, p.G ivv) he had named them Ister (Danube) and Achelous (the longest river in Greece). (See also Bush, 1976, pp.56–7.)

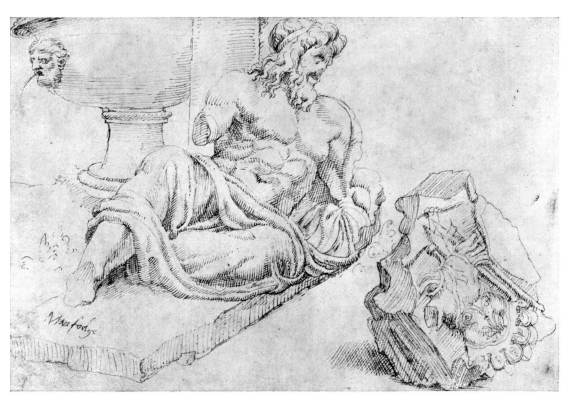

64b

HISTORY: In the Middle Ages and early Renaissance they were on the Quirinal (Monte Cavallo) with the Horse-tamers or Dioscuri (125), where they were mentioned in most of the itineraries and descriptions of Rome. They were moved to the Capitol in 1517 (Lanciani, 1902–12, I, p.183 with document) and drawn in front of the old Palazzo dei Conservatori (Heemskerck, *Skb.*, I, ff.45 and 61). By 1552, they had been moved to their present location, framed by Michelangelo's two flights of steps to the Palazzo dei Senatori. Between 1565–68 the damaged attributes of the Tigris were restored as the Tiber's Wolf suckling Romulus and Remus. Vasari seems first to have called it 'Tiber' in 1568 (Vasari–Milanesi, 1906, VII, p.222).

REPRESENTATIONS:
Both river gods in Campidoglio:
– Heemskerck, *Skb.* II, f.72: in front of Pal. dei Conservatori; *Skb.* I, f.61: A and B seen from behind, from portico of palace (65a); *Skb.* I, f.45: with bronze colossal head of 'Commodus'.
– Francisco de Hollanda, *Skb.*, f.7ᵛ (176b).
– H. Cock, engraving, 1547: Nile (B) newly installed; Tigris (A) still in front of Pal. dei Conservatori (Siebenhüner, 1954, fig.29).
– Two anonymous Italian? drawings of c.1554–60 show the Piazza unfinished with both river gods installed, Paris, Louvre, 11028 (Siebenhüner, 1954, fig.33); Brunswick, Kupferstichkabinett (*ibid.*, fig.28; Egger, 1911–31, II, cat.3).

Tigris (A):
– Pisanello, Berlin-Dahlem, Kupferstichkabinett, 1359ᵛ (Schmitt, 1960, cat.12, fig.79; Winner, 1967, cat.5, pl.6): figure without attribute, but with cornucopia.
– Fra Bartolommeo, Florence, Uffizi, 14543F (65A–a).
– Cavalieri, I–II, pl.69: '*Antiqua statua Tygridis Fluvii marmorea quam recentiores statuarii Tiberi accomodarunt in Capitolio*'.
– Perrier, 1638, pl.96: reversed.

Nile (B):
– Umbrian, late 15th century, New York, Pierpont Morgan Lib., Fairfax Murray, 1910, IV, pl.5 (Schmitt 1960, fig.80 and cat.13 as North Italian): profile to left, unrestored, without hand and foot, but with sphinx and cornucopia; sketch of top part of one of the Dioscuri on left (65B–a).
– Filippino Lippi, fresco, Florence, S. Maria Novella, Cappella Strozzi (Halm, 1931, pp.418–19, fig.14): figure of Noah.
– Pinturicchio, fresco, c.1490, Rome, Pal. Colonna formerly Pal. of Giuliano della Rovere (Dacos, 1969, fig.93 and p.67, n.4): as pair in grotesque decoration of vault.
 Cod. Escurialensis, f.58ᵛ: '*Marfurio di cavagli*'. Un-

restored, no right arm. Leans on sphinx? Man on its head exaggerates its colossal size; cf. *Cod. Escurialensis*, f.39.
– Girolamo da Carpi, London, BM, Payne Knight, Pp.2–121ᵛ (Gere and Pouncey, 1983, cat.121ᵛ): torso only, faint outline of cornucopia.
– Cavalieri, I–II, pl.70: restored with rudder.
– Perrier, 1638, pl.97: reversed.

LITERATURE: Michaelis, 1891, *RM*, pp.25–30. Siebenhüner, 1954, pp.46–53 and ills. Scherer, 1955, p.137 with text from *Mirabilia*, and pls.216 and 218 (Heemskerck, *Skb.* I, ff.45 and 61); pl.214 (Lafréry engraving of Campidoglio in 1565). Schmitt, 1960, pp.124–26, fig.79, cat.12 (Tigris); p.126, fig.80, cat.13 (Nile), with reference to early descriptions, lists of drawings and bibl. Winner, 1967, pp.20–1, no.5, pl.6, with discussion and further bibl., also nos.2–4 and 7 illustrating the river gods on the Capitol.

66. River God Tiber
Graeco-Roman colossal statue
Paris, Louvre (MA 593; Froehner, 1869, cat.449)

DESCRIPTION: In a pose much admired by 16th century artists for its apparent ease, the nude and bearded god sits with one leg stretched out before him, and slightly bent, with the weight on the heel; the other leg is bent inward and the knee rests on the ground. He leans back with his right wrist on the back of the Wolf while holding in the right hand a brimming cornucopia. He turns his head towards his right and in his left hand he holds a rudder (partly restored). His thick wavy hair is garlanded with leaves, the ends of the fillet which binds them ripple over his shoulders. The flowing drapery beneath him covers his forearms, and the base on which he lies is carved as if covered with water, 'the bed of the river Tiber' as it was described at the time of discovery. River scenes and animals of the Roman Campagna are carved in relief on the sides and back of the base as engraved by Beatrizet. When discovered in 1512, only a little of the nose was missing, but most of the rudder, parts of the Wolf and Romulus and Remus, and a leg was broken, according to Grossino's description (1512, in Brummer, 1970, pp.191–2). Although some restorations were made in 1524–5, it was fully restored only in the 18th century.

HISTORY: In the 1440s Poggio Bracciolini reported the discovery, near S. Maria sopra Minerva in Rome, of an enormous head of a statue, unidenti-

fied, which attracted such crowds that the owner of the property who had found it while digging a trench to plant a row of trees, covered it all up again for the sake of peace and quiet (*De varietate fortunae* in *CTR*, IV, 1953, p. 235).

In January 1512 the colossal statue of the Tiber was excavated near the south flank of S. Maria sopra Minerva towards S. Stefano del Cacco, on the site of the temple of the Egyptian gods Isis and Serapis. The statue was recognized at once as the river god Tiber (Grossino), and Pope Julius II had it brought to the statue court in the Vatican Belvedere on 2 February, 1512 (Luzio, 1886, p. 535) where it was joined by its counterpart, the river god Nile **(67)** apparently found soon after 1513? on the same site, but not described there until 1523 (Brummer, 1970, p. 266). Both river gods were set up as fountains in the middle of the court (Brummer, 1970, Appendix I, 3–8; see below, LITERATURE). Both their bases had the Medici arms (Cavalieri, I–II, pls. 2–3). The Tiber was ceded to France in 1797, reaching Paris in 1803, and installed in the Louvre in 1811 with the Nile, which was returned to Rome the following year (Haskell and Penny, 1981, p. 310). Both **66** and **67** were among the famous statues from the Belvedere cast in bronze by Primaticcio and Vignola for Francis I at Fontainebleau in the mid 16th century.

REPRESENTATIONS:
- B. Peruzzi, London, BM, 1946-7-13-15 (**66a**; Pouncey and Gere, 1962, cat. 244, pl. 218; Brummer, 1970, fig. 176): 'restored' frontal view showing curve of torso, profile to left. Pouncey and Gere suggest that the drawing was possibly a study for a house façade near the site of the discovery of the statues, and that the drawing is datable 1512–20.
- Franciabigio, *Triumph of Cicero*, fresco, 1521, Poggio a Caiano, Villa Medici (McKillop, 1970, fig. 85): statue in foreground with other antiquities.
- E. Vico?, New York, Pierpont Morgan Lib., Fairfax Murray, 1910, IV, cat. 50A not illus. (Brummer, 1970, fig. 177): partially restored, cf. Goltzius drawing below.
- Giulio Romano, drawing for a tondo of triumphal arch? celebrating Charles V, 1530, Haarlem, Teyler Mus. (van Regteren Altena, 1972, cat. and pl. 17): adaptation.
- Aspertini, London, BM *Skb.* I, ff. 16ᵛ–17 (Bober, 1957. p. 61, fig. 49): 'restored' Tiber seated with extended leg sloping off plinth.
- Frans Floris, lost skb., f. 47 (Dansaert and Bautier, 1911; Brummer, 1970, fig. 187): partly restored; extended leg resting on lower level.
- Girolamo da Carpi, New York, MMA, 34.114.1:

Romulus and Remus on a skb. page (cf. Kemp and Smart, 1980, fig. 15).
- Beatrizet, engraving for Lafréry's *Speculum*, Bartsch, XV, p. 257 no. 96 (Brummer, 1970, fig. 178): 'restored', holds bamboo cane. River and animal reliefs from sides of plinth frame top and sides of plate.
- 'Maarten de Vos' *Skb.*, f. VIII, 8 (Netto-Bol, 1976, p. 47, pl. 71): torso frontal, head in profile to left, 'restored'.
- Cavalieri, I–II, pl. 2 (Brummer, 1970, fig. 184): restored, holds curved rudder. Base with Medici coat of arms.
- Cambridge *Skb.*, f. 19 (Dhanens, 1963, fig. 13, cat. 18; Brummer, 1970, fig. 191): restored, holding rudder.
- Goltzius, Haarlem, Teyler Mus. (Reznicek, 1961, cat. 204; Brummer, 1970, fig. 179): incompletely restored and showing the mending lines of breakages. Holds broken rudder. Exaggerated turn of head and gaze.

LITERATURE: Amelung, *Kat.*, I, pp. 124–34, no. 109 (Nile, **67**), with reference to Tiber. Brummer, 1970, pp. 191–204; pp. 281–2; for Grossino's detailed description, see Brummer, pp. 191–2, and those by Fulvio, 1513, Anon. Venetian ambassador, 1523, Fichard, 1536, Aldrovandi, 1556, and others in Brummer, Appendix I, nos. 3–8. Haskell and Penny, 1981, cat. 79.

67. River God Nile
Colossal statue, copy of 2nd century B.C. bronze original? (Robertson, 1975, pp. 547–8)
Vatican, Braccio Nuovo (Amelung, *Kat.*, I, pp. 124–134, no. 109)

DESCRIPTION: In the same manner as his nude counterpart, the Tiber **(66)**, the Nile holds a cornucopia and rests his lower left arm on the back of his local attribute, the sphinx. The drapery underneath him covers his left wrist and raised right thigh. Sixteen small putti, now restored, swarm over statue, sphinx, cornucopia and plinth. The vertical sides of the plinth are carved with Nilotic scenes, as drawn by Francisco de Hollanda and engraved in Lafréry's *Speculum* in projection.

The statue is thought to be a copy of the famous Alexandrian statue of Egyptian stone looted by Nero and placed by Vespasian in the Templum Pacis and there described by Pliny (*Natural History* XXXVI, 58): 'playing around the Nile were sixteen figures of children, through which are conveyed the total number of cubits which the river rises at its

high flood point'. (A Nile flood less than sixteen cubits would not irrigate the land and the result would be famine.) The putti were restored under Pope Clement XIV (1769–74) by G. Sibilla (Amelung, *Kat.*, I, p. 133).

HISTORY: See Tiber (66).

REPRESENTATIONS:
(As listed by Bober, 1957, and Brummer, 1970.)
- Heemskerck, *Skb.* I, f. 54 (Brummer, fig. 188): from back, partly restored; f. 59ᵛ: frontal, head only; f. 74ᵛ: leg and back (for discussion of restorations, Hülsen and Egger, 1913–16, I, p. 30).
- Aspertini, London, BM *Skb.* I, ff. 14ᵛ–15 (Bober, p. 59 and fig. 44): front and back, partly restored.
- Francisco de Hollanda, *Skb.*, f. 50 (Brummer, fig. 192): 'restored', animals on plinth, in grotto.
- Frans Floris, lost skb. (Dansaert and Bautier, 1911, p. 320, fig. 1).
- E. Vico?, New York, Pierpont Morgan Lib., Fairfax Murray, 1910, IV, cat. 50 (Brummer, fig. 181); unrestored, **67a**; cf. Goltzius, below.
- Girolamo da Carpi, Turin *Portfolio* (Canedy, 1976, T 138, pl. 41): head and torso; child.
- Beatrizet, engraving for Lafréry's *Speculum*, Bartsch, XV, p. 266, no. 95 (Brummer, fig. 182): partly restored; borders on three sides of plate represent the Nilotic reliefs on three sides of the plinth; with explanatory inscription.
- 'Maarten de Vos' *Skb.*, f. XIᵛ (Brummer, fig. 189; Netto-Bol, 1976, pp. 57–8): mostly 'restored'.
- Dupérac, Louvre *Album*, inv. 26409 (Guiffrey and Marcel, 1910, V, pl. 66, cat. 3870): 'restored', borders in three rows beneath.
- Cavalieri, I–II, pl. 3 (Brummer, fig. 185): 'restored' not without some fantasy.
- Cambridge *Skb.*, ff. 16ᵛ–17 (Brummer, fig. 190; Dhanens, 1963, fig. 14, cat. 17): front, 'restored'; f. 18 (Brummer, fig. 191; Dhanens, 1963, fig. 13 below, cat. 19): back, 'restored' with detail of two animals from plinth relief.
- Cherubino Alberti, engraving, Bartsch, XVII, p. 107 no. 155; cf. drawing, Y. Tan Bunzl at Somerville and Simpson (London art market, Exh. Cat., 1978, no. 4, no ill.).
- Goltzius, Haarlem, Teyler Mus., K III 21 (Brummer, fig. 183): unrestored, showing breakage in foot and legs. Exaggerated incline of head. In court with lemon trees, masks and doorway sketched in background. Cf. Vico, above.
- Pozzo Windsor, X, f. 119, 8112 (Brummer, fig. 186; Vermeule, 1966, p. 69, fig. 269): partly restored, on Medici base, with Nilotic reliefs framing borders of sheet on three sides.
- Pozzo Windsor, VIII, f. 39, 8740 (Vermeule, 1966, p. 51): Nilotic scenes from plinth reliefs.

LITERATURE: Helbig, I, cat. 440; Michaelis, 1890, *JdI*, pp. 24, 38, 70–1. Bober, 1957, p. 59. Brummer, 1970, pp. 191–204; pp. 280–1, and appendix I, 3–8 for 16th century descriptions (see **66**, LITERATURE). Haskell and Penny, 1981, cat. 65.

68. 'The Fertility of Egypt' (the Tazza Farnese)

Agate-sardonyx shallow bowl, 20 cm diameter. Alexandrian, 2nd–1st century B.C.?
Naples, Museo Nazionale, inv. 27611 (Furtwängler, *Ant. Gemmen*, 1900, II, pp. 253–6)

DESCRIPTION: An unusually large and magnificent example of Hellenistic gem carving, in which the lighter upper layers of the agate contrast with the warm ambers of the background. Carved on both surfaces.
Inside ('The Fertility of Egypt'): The allegorical figures were thought to be the bearded river god, Nile, the goddess Isis leaning on a sphinx, the young Horus, her son, and the two Etesian winds which bring the summer rains that flood the Nile, while the seated goddesses on the right could be the Seasons.

Furtwängler called attention to the juxtaposition of the agricultural symbols held by the three figures to the right, finding them the key to the allegory of the Fertility of Egypt caused by the waters of the Nile, with the help of the winds and seasons. The interpretation is now related to Augustan imagery following the battle of Actium (La Rocca, 1984).
Outside: A cameo of the frontal head of Medusa, with hair alive with snakes, and knotted under her chin, fills the convex circular field. The Medusa or Gorgon's head, an object of terror, had the power of turning whoever looked at it to stone. It was worn by Athena-Minerva to confound her enemies, after she helped Perseus to behead the monster.

INTERPRETATIONS: In Renaissance inventories, the Tazza had been described as an agate cup carved with eight figures, and a Medusa's head. In the 16th century the figures were thought to represent the Apotheosis of Alexander the Great, a view most acceptable to Alessandro Farnese, Paul III– whose nephew's wife owned the Tazza – as he identified himself with that great Hellenistic king (Buddensieg, 1969, p. 223, n. 60; Harprath, 1978; work in

progress by A. Schlenoff). Later interpretations and opinions on dating the Tazza are in Furtwängler (1900, p. 254; Havelock, 1971, p. 238).

HISTORY: According to Blanck (1964), the Tazza was drawn in Persia in the early 15th century. It is not known how it came to Rome, where it was in Paul II's collection. Lorenzo de' Medici acquired it from Sixtus IV in 1471 and brought it to the Palazzo Medici, Florence, where it was the most valued object in his collection (Gombrich, 1960, pp. 303–4). It remained in Florence until 1495. Its location from 1495–1536 is unknown but in 1495, the Tazza was entrusted to Lorenzo Tornabuoni by the Florentine Commune to repay Medici debts (Heikamp and Grote, 1974, pp. 170–1, doc. vii). Later it belonged to Alessandro de' Medici when he married Margarita of Austria in 1536. (For subsequent history of the Medici-Farnese gems see 31, and Pannuti in Dacos et al., 1973, pp. 5–9; Heikamp and Grote, 1974, pp. 19 and 25.)

REPRESENTATIONS:

Whole compostion inside the Tazza:

- Mohammed al Khayyam, attrib., Berlin, Pr. Staatsbibl., Album, Diez A, f. 72 (Blanck, 1964, fig. 1; Dacos et al., 1973, fig. 41): fine outline drawing; the faces with Persian features.
- Italian, 16th century, bronze plaquette, Vienna, Lederer Collection (Kris, 1929, fig. 65, no. 18).

Adaptations of the Etesian Winds:

- Botticelli, *Birth of Venus*, Florence, Uffizi, inv. 878 (Yuen, 1969, p. 177, fig. 2; Dacos et al., 1973, fig. 91; **68a**).
- Piero di Cosimo, *Myth of Prometheus*, Munich, Pinakothek, 8973 (Yuen, 1969, p. 177, fig. 3; Dacos et al., 1973, fig. 92).
- Raphael, SS. Peter and Paul from the *Expulsion of Attila*, Vatican, Palace, Stanza di Eliodoro (Dacos et al., 1973, fig. 93, **68b**).

Medusa's Head:

- Bronze plaquettes, Italian, 16th century, Berlin-Dahlem, Staatl. Mus. (Bange, 1922, II, 710, 711).

LITERATURE: Havelock, 1971, p. 238 and colour pl. iv. Dacos et al., 1973, cat. 43 (Pannuti), colour pl. i, figs. 39, 43; *scheda* 13, p. 161, figs. 91–3 (Dacos); pp. 5–9; p. 129 (Pannuti, for history). Heikamp and Grote, 1974, pp. 19, 25, 170–1 (for history). Yuen, 1969, pp. 175–8. La Rocca, 1984.

BACCHUS ('LIBER PATER'; THE GREEK DIONYSUS, EQUATED WITH EGYPTIAN OSIRIS)

Bacchus, god of vegetation and above all of the grape-vine, represents a fusion of age-old ecstatic folk religion with worship of the noble Olympian pantheon. His cult, unimportant to Homeric heroes after its Minoan origins, was reintroduced to Greece by way of Phrygia and Thrace. Hesiod already knows the myth of his birth from the thigh of Zeus, rescued from the womb of his mother, Semele, who was consumed to ashes by the blazing majesty of Zeus when she challenged him to prove his love. The infant Bacchus (Dionysus) was carried off by Mercury (think of the Hermes of Praxiteles at Olympia) to be raised by the nymphs of Nysa (69) and instructed by Silenus. Bacchus' later adventures, as related in Homeric Hymn VII, include being captured by pirates (confounded by being turned into dolphins – so engagingly rendered in the famous cup in Munich, painted by Exekias); bestowing the golden touch on Midas; discovering his bride, Ariadne, abandoned by Theseus on the island of Naxos (80); and undertaking campaigns of conquest in India and the East which mirror those of Alexander the Great. But his most famous exploit was bringing the cultivation of the vine to Greece from the realm of the Great Mother Goddess, Cybele; Euripides' *Bacchae* tells what orgiastic rituals meant to his birthplace of Thebes, and to Pentheus (87).

In Dionysus' welcome by Apollo to share the sanctuary at Delphi lies the creative opposition between Apollonian and Dionysiac (today's cognitive vs. affective) established by Nietzsche in *The Birth of Tragedy*: clarity and light set against dark forms of irrationality. Drama and tragedy, it is true, arose from Dionysiac rituals at Athens, where he has also been assimilated into the Eleusinian mysteries. Seasonal decay and rebirth of fruit-bearing plants; pruning of the vine and crushing of its grapes seen as metaphors for the passion of the god in another guise (and

ancestor of Christian communion); probably also the tale of his descent into Hades (Pausanias, II, 37, 5) to lead Semele up to Olympus (Pindar, *Olympian Ode* 2); all these resurrection motifs assured Bacchus' place in Orphic religion and the prevalence of his own mysteries in Hellenistic and Roman times.

For the Renaissance, it is this mystical Bacchus and divine madness that reverberates in the neo-Platonic interpretations of Marsilio Ficino and Pico della Mirandola (see Wind, 1958, ch.4 and *passim*; cf. Bober, 1977, pp.234ff.), absorbed at popular level through delight in unfettered abandon and fascination with the animal spirits of Pans and satyrs who share the god's revels and triumph. Roman sarcophagi depicting a Bacchic *thiasos*, or procession of dancing and singing Bacchantes **(81–3, 86)**, were especially numerous in Italian cities and churches. Scenes were often expanded to include the entire train in Bacchus' triumphal return from India **(76–8)**, known to Renaissance *literati* through Nonnus' *Dionysiaca*; and these sarcophagi were frequently re-used as fountain basins, and, robbed of their pagan sting, also for Christian burial with their symbolic values of wine and vintage.

Statues of Bacchus were also known, but easily confused among his various aspects unless attributes such as vine-leaves in the hair, pine-cone tipped staff *(thyrsos)*, or accompanying panther were preserved. An aged, bearded Bacchus in long theatrical garb **(90, 91)** did not fare as badly as the youthful type: sensually fleshed, with long locks falling over his shoulders; as torsi these were generally taken to be Hermaphrodites *(Ermafroditi)*. Among his entourage, satyrs, Pans and fauns were confused as indiscriminately as they are today, while plump old Silenus seemed to fit ancient literary descriptions of another educator, Socrates (so that statues of Bacchus leaning upon Silenus or satyr became 'Socrates and Alcibiades' in the Renaissance).

LITERATURE: Cumont, 1942; Lehmann-Hartleben and Olsen, 1942; Nilsson, 1957; Matz, *ASR*, IV, 1–4; Kekule von Stradonitz, 1908; Wind, 1958, chs.XII–

XIII. Two recent exhibition catalogues dedicated to Dionysus and his myth in Western art contain interesting observations and further bibl.: Essers, 1974; Houser, 1979.

69. Childhood of Bacchus

Sarcophagus. Roman, early Antonine replica of lost relief known in the Renaissance
Rome, Museo delle Terme (Aurigemma, 1958, Aula VI, no.88, inv.124736)

DESCRIPTION: The scene in the left section of the front depicts Silenus and a satyr playing with the infant Bacchus. Against a cloth *(parapetasma)* backdrop, hung between a herm of Priapus at the corner, which is being wreathed by a maiden, and a barren tree, Silenus is seated to the right; leaning far back, he swings the child up in the air, steadied by a satyr standing behind him, who dangles a cluster of grapes for the baby to clutch at.

HISTORY: This particular example was brought to the Museum in 1946 from the eighth kilometre of the Via Casilina (Labicana), but the same composition was recorded in the 15th century.

REPRESENTATIONS:
- Jacopo Bellini follower, variant drawing, Paris, Louvre, R.F.524 **(69a**; Degenhart and Schmitt, 1972, fig.21).
- Master of the Barberini Triptych (Fra Carnevale?), *Birth of the Virgin*, New York, MMA, 35.121 (Wehle, 1940, pp.105f.; Christiansen, 1979, as FraCarnevale): Silenus tossing infant Bacchus, reversed, as one of the Bacchic reliefs on the building **(69b)**.

LITERATURE: Degenhart and Schmitt, 1972, pp.154–5, figs.21 and 23; Matz, *ASR*, IV, 3, cat.206.

70. Bacchic Revels ('Pannychis')

Sarcophagus. Roman, mid 2nd century A.D.
Naples, Museo Nazionale, Gabinetto segreto (Matz, *ASR*, IV, 3, cat.176)

DESCRIPTION: The front face of the sarcophagus represents a night-long Bacchic festival *(Pannychis)* in honour of Priapus, who occupies the centre of the relief, bearded and vine-crowned, wearing a

long *chiton*. He lurches unsteadily to his right, held up by two satyrs around whose shoulders he has flung both arms – without relinquishing a wine-jug in his right hand and a wreath in his left; one of the satyrs wears an animal-skin, the other is naked. This central group is framed by a satyr carrying a burning torch and a cymbal-playing maenad who dances so vigorously that she is turned in two directions at once within the plane of the relief; a small satyr-child holding a torch and a branch looks at her in admiration. In the background is glimpsed a maenad carrying a *thyrsos* and a *liknon* (winnowing basket) balanced on her head. To the left, before a shrine of Pan, a maenad lies overcome by wine and the orgy in a pose usually associated with Ariadne **(79; 80)**, while a female satyr tries to play erotically with a Pan herm. Her counterpart on the right is revealed in a more clamorous sexual encounter, lit by a satyr-child holding a torch behind one of the shielding curtains hung from trees which punctuate all the scenes of this sarcophagus; this satyress kneels screaming, apparently suppliant before a satyr-herm where a shouting, live Pan assaults her. Objects of the Bacchic cult are scattered throughout, and the trees (plane, pine, palm and fig) all have symbolic meaning in its rituals. The continuation of each corner tree on the ends of the sarcophagus indicate that these are to be read as part of the action. *Right end* – two satyrs with torches are bringing up the child Bacchus in a *liknon* **(70a)**; *left end* – a satyr hangs another curtain near a rustic rock altar (which must be in the garden of the Pan-shrine on the front face) on which a nymph (one of Bacchus' nurses?) sprinkles incense before a herm of Pan.

HISTORY: At the end of the Quattrocento the sarcophagus was recorded in the garden of S. Marco (the Pal. Venezia) in Rome; weathering and holes bored through it show its long use as a fountain. Apparently it was not among the antiquities belonging to Cardinal Domenico Grimani, for it did not go to Venice with his collection, but was acquired by the Farnese sometime before the middle of the century (Aldrovandi, 1556, p. 165). With Farnese possessions it was transferred to Naples in the 18th century.

REPRESENTATIONS:
– Mantegna School, Paduan drawing of the satyress, Ottawa, NG, no. 14798 (Meller, 1976, fig. 6).
– Aspertini, Cod. Wolfegg, f. 47ᵛ, (Bober, 1957, p. 69, fig. 86): '*in logardino de santo marco*'. Right end.

– Raphael Workshop, stucco, Vatican Loggie (Dacos, 1977, p. 213, pl. LVIIb): satyress and herm.
– Aspertini, London, BM *Skb.* I, f. 3ᵛ (Bober, 1957, fig. 17): below, left two-thirds of front with variations; f. 40 (*ibid.*, fig. 89): right end.
– Engravings in reverse by and after Marcantonio, Bartsch, XIV, p. 217, no. 284, **70a**: satyress with herm; no. 230 **(70b)**: right end; nos. 248–9: front, '*Romae Ad S. Mar*'; E. Vico, Bartsch, XV, p. 298, no. 33: satyress and herm after Marcantonio; cf. Jacob Binck, c. 1529 (Pauli, 1909, no. 18, p. 41).
– Venetian, 16th century, Paris, Louvre, RF 531: front face after Marcantonio. Cf. 'Falconetto', decorative ceiling panel, Padua, Odeo Cornaro (Schweikhart, 1968, fig. 5).
– Andrea Riccio, bronze relief, Cleveland, Mus. of Art (Meller, 1976, fig. 1): variant of the satyress on the left, probably after Marcantonio.
– Pozzo Windsor, X, f. 14, 8007 and 'lost' 8116 (Vermeule, 1966, p. 62).

LITERATURE: Bober, 1957, pp. 51 and 69; Meller, 1976, pp. 324–34; Dacos, 1977, pp. 213–14.

71. 'Bacchus' (Satyr in Human Guise)
Statue. Roman copy adapting a Greek 5th century B.C. original
Copenhagen, Ny Carlsberg Glyptotek (F. Poulsen, 1951, cat. 158)

DESCRIPTION: The Doryphorus of Polyclitus modified by a Roman copyist to represent a Bacchic figure, is seen caught in his stride, in classical Greek *contrapposto* which turns the head slightly down towards the right supporting leg; he once carried a staff (*pedum*, or shepherd's crook) against his left shoulder; the head and both forearms are restored. The figure wears an entire goat's skin, tied at his right shoulder; the right arm hangs down above a support where the pipes of Pan are hung.

HISTORY: From the late Quattrocento, at least, the statue was owned by the Santacroce; it was acquired in the 16th century for the Villa of Pope Julius III and subsequently for the Villa Martinori. It was purchased for the Glyptothek in 1900.

REPRESENTATIONS:
– Heemskerck, *Skb.* I, f. 29ᵛ: unrestored, in view of the Santacroce court.
– 'Passarotti', London art market (Peel, 1972, pl. 1): unrestored **(71a)**.
– Girolamo da Carpi, Rosenbach *Album* (Canedy, 1976, R 132): restored.

- Cavalieri, I–II, pl.62: '*Pastoris signum marmoreum Romae in villa Iulij III...*', restored; and cf. copies thereafter.
- Franzini, unnumbered woodcut, 1599: '*Pastoris signum marmoreum Romae in villa Iulij III*'.

LITERATURE: 'Prospettivo Milanese', stanza 35: '*Et ecci in casa dun di santa croce/ un nudo et tiene un zappo scorticato...*'; Aldrovandi, 1558, p.236: '*Pane Dio de' Pastori...*' in the House of Valerio Santacroce; P.G. Hübner, 1912, p.113, pl.IVb.

72. Satyr Resting (type)
Roman copy of statue by Praxiteles
Rome, Museo Capitolino (Stuart Jones, 1912, pp.350–1, Stanza del Gladiatore, 10)

DESCRIPTION: The satyr stands with weight on his left leg in hip-shot pose, left arm akimbo with back of hand on hip, sweeping aside the goatskin which is draped over his right shoulder and which falls down across his chest. He rests his right hand on a tree trunk.

The example in the Capitoline Museum is the best known of at least forty replicas of the celebrated Praxitelean Marble Faun. One such replica, at least, was known in the late 15th century. Haskell and Penny (1981, pp.209–10) discuss the uncertainty attached to this statue's provenance and the great fame it enjoyed as a result of Hawthorne's novel, *The Marble Faun*, published in 1860.

HISTORY: This replica was probably acquired in 1568 by Cardinal Ippolito d'Este in Rome from the Palatine; it came to the Museo Capitolino in 1753.

REPRESENTATION OF THE TYPE:
- Antico, bronze, Vienna, Kunsthist. Mus. (Planiscig, 1924, cat.102; Bode, 1922, pl.31, right): adaptation without drapery; arm resting on knotted staff, wearing cap (as Mercury?).
- Italian, 16th century, London, N. & J. Stratford Collection (**72a**).

ANOTHER REPLICA known in the late 16th century was drawn in the Cevoli collection by Andrea Boscoli (Rome, Gab. Naz. delle Stampe: 130644) cf. Episcopius (Jan de Bisschop), *Paradigmata*, 1671, pl.37. The statue is now in the Galleria Borghese (see Di Castro and Fox, 1983, cat 47b).

LITERATURE: Robertson, 1975, p.468, pl.147d (illustrating replica in Louvre, MA 595). Haskell and Penny, 1981, cat.36: 'The Marble Faun'.

73. Satyr holding up Grapes, with Panther
Roman adaptation of Greek statue
Florence, Uffizi (Mansuelli, 1958, I, cat.98)

DESCRIPTION: The satyr balances on tiptoe, one foot ahead of the other. He clutches a bent club in his left hand, and a winesack over his left shoulder; a *nebris*, heavy with fruit, pulls his upper body down to one side. Main restorations are the head, neck and whole right arm. In the restoration his right hand holds a bunch of grapes and he looks up at them. The panther gnaws the grapes which grow from the vine next to him.

The Uffizi statue is one of three satyrs with fruit and holding up grapes for a panther which came to Florence from the della Valle collection. The other two are in the Pitti (see below). Renaissance drawings sometimes conflated the statues, but there may have been other similar examples known. The many antique replicas of the type are discussed by Mansuelli (1958, p.134).

HISTORY: The statue was in Rome, first in the Maffei Collection, c.1500, then in the della Valle Collection; in 1584 it went to the Villa Medici, but it is not in the Villa Medici inventory of 1670. It is not known when it came to Florence.

REPRESENTATIONS:
- Umbrian *Skb.*, Calenzano, f.6ᵛ (Schmitt, 1970, pp.114, 122 and fig.12): '*in chaxa di manfei*', unrestored, with raised right arm suggested; no head.
- Aspertini, London, BM *Skb.* I, f.2ᵛ (Bober, 1957, fig.11): seen from left; without panther, on sheet with other statues in the della Valle-Rustici Collection.
- Lambert Lombard, Album, D.442, by another hand? (Bober, 1957, p.50 and fig.8): conflation of Uffizi satyr and Pitti variant. Possibly derives from still another variant known in the Renaissance.
- Pietro da Barga, bronze statuette, 1576, Florence, Mus. Naz. (de Nicola, *Burlington*, 1916, pl.I, fig.C).
- Perrier, 1638, pl.43.

LITERATURE: Mansuelli, as above. Bober, 1957, pp.49 to 50.

OTHER EXAMPLES OF THE TYPE KNOWN IN THE RENAISSANCE:
- Pitti, Dütschke, II, cat.31 = Reinach, *Rép. Stat.*, II, p.137, no.8 = Michaelis, 1891, *JdI*, (I), no.155.
- Pitti, Dütschke, II, cat.32 = Reinach, *Rép. Stat.*, II, p.137, no.7 = Michaelis, 1891, *JdI*, (I), no.153.

74. Daphnis Seated, playing Pan Pipes

Roman copy from Hellenistic group
Florence, Uffizi (Mansuelli, 1958, I, cat. 102)

DESCRIPTION: Figure from an erotic group, of which there are many replicas, showing Pan teaching a youth, Daphnis (sometimes called Olympus) how to play the pan-pipes. Daphnis sits on a rock with his left leg tucked behind the right, his head turns to the pan-pipes which he holds before him in both hands, and his torso leans back. The usual figure of Pan is missing from his side, but the statue's base shows that it was carved as an independent figure. The major restoration is the head, considered 'modern' in the 1584 inventory, and included in all 16th century representations. The left arm, part of pan-pipes, and right hand are also restored.

HISTORY: In della Valle-Rustici courtyard; to Medici Collections in 1584; in 1787 to Florence.

REPRESENTATIONS:
- Marco Dente, engraving, Bartsch, XIV, p. 283, no. 309: seen from left in niche; flying hair.
- Aspertini, London, BM *Skb.* I, f. 2V (Bober, 1957, fig. 11, p. 49): in niche in della Valle Collection, seen from left.
- Heemskerck, *Skb.* I, f. 26V (P. G. Hübner, 1911, *RM*, p. 310): from right below, emphasizing the backward lean of the pose.
- Francisco de Hollanda, *Skb.*, f. 28V (Bober, 1957, fig. 12): two views, from left and right, in niche.
- Pietro da Barga, bronze statuette, 1576, Florence, Mus. Naz. (de Nicola, *Burlington*, 1916, pl. 1, fig. E): with reconstruction of damaged Pan pipes.
- Vaccaria, pl. 41, dated 1577, and inscribed '*Cherubinus Albertus fe*', but inscription evidently added later which places it in Medici Collection: '*in Viridario Cardinalis de Medicis*' (Bober, 1957, p. 49; cf. Lafréry, *Speculum* Q 271: '*Apolinis in viridario Magni Ducis* Etruriae').
- Perrier, 1638, pl. 40: as Apollo.

LITERATURE: Michaelis, 1891, *JdI* (II), pp. 235–6, no. 158. Bober, 1957, p. 49: other drawings and display in della Valle Rustici court.

OTHER EXAMPLES OF PAN AND DAPHNIS GROUPS KNOWN IN THE RENAISSANCE (see also Bober, 1957, p. 49):
- Naples, Mus. Naz. (Reinach, *Rép. Stat.* II, 1, p. 70, no. 5). In Chigi Garden, Rome, described by Pietro Aretino in 1537, then to the Farnese Collection (Cavalieri, III–IV, pl. 81).

- Rome, Mus. Naz. delle Terme (Paribeni, 1932, no. 161; bibl. in Winner, 1967, cat. 65; Haskell and Penny, 1981, cat. 70, fig. 151: 'Pan and Apollo'). From the Cesi Collection.
- For a relief of a satyr piping in a somewhat similar pose, see **85ii**.

75. Pair of Pan Statues

Rome, Museo Capitolino (Stuart Jones, 1912, p. 22, Cortile 5, and p. 25, Cortile 23)

DESCRIPTION: The vigorous pair of horned and goat-legged Pans of heroic size stand as if mirroring each other's pose and drapery. In Antiquity they must have been telamon figures (male caryatids) serving as doorposts to support a lintel. Each raises the outer arm to balance a basket of grapes on his head, while the inner arm hangs down alongside the advancing leg. Their goatskins are worn diagonally across their chests from the shoulders of the lowered arm. The arms, restored in the 18th century, were missing during the Renaissance, but the original positions were clear from the truncated upper arms and the hands still attached to the baskets. In some representations of the Quattrocento the missing arms are supplied, and the figures are usually shown freestanding, but they are still united to piers (Heemskerck, *Skb.* II, f. 20; Perrier, 1638, pl. 19).

Other statues of the type were evidently known in the later 16th century (see below, Cavalieri, I–II, pl. 87). For Pan in Antiquity, see 'Pan' in *The Oxford Classical Dictionary* (1970), where he is described as half goatish, with a human body to the loins, goats' legs and horns.

CONTEMPORARY DESCRIPTIONS: The statues were first described as 'glittering with gold' in the entrance of a private collection (della Valle) by Giovanni da Tolentino, a Milanese who recounted his visit to Rome in a letter of 1490 (Schofield, 1980, p. 254 and n. 62). 'Prospettivo Milanese' (stanza 15; text in Bober, 1957, p. 74; transl. Fienga, 1970, p. 41) also describes them. G. G. Penni praised them as *phauni* (fauns) in the triumphal arch of 1513 (text in Bober, 1957, p. 48). Described in the house of Lello della Valle as *fantacciatissimi* in the Holkham Album, f. 34 (**61a**; but not drawn; text in Bober, 1957, p. 74).

HISTORY: The Pans were known in Rome at least from the end of the 15th century. They were first recorded in the della Valle Collection in 1490. In

1513 they were used by Bishop Andrea della Valle to decorate, with other della Valle statues, a temporary triumphal arch for Pope Leo X's *possessio*. They were later incorporated into the portico of a courtyard of one of the della Valle houses (Heemskerck, *Skb.* II, f. 20; **75b**) where they remained until acquired by Cardinal Albani. They were installed in the court of the new Museo Capitolino in 1734, flanking the fountain of the Marforio **(64)**.

REPRESENTATIONS:

The Pans, often called fauns or satyrs in the Renaissance, possessed an unusual attraction for Renaissance artists and patrons, not only reflected in sketchbook drawings, but in many of the visual arts. 15th and 16th century descriptions praise their pagan vitality almost as though they were living creatures straight from Antiquity; indeed in his *Triumph of Silenus* in Vienna, Heemskerck paints one of them leaving his companions as statues on a triumphal arch to walk away with the Bacchic procession. Reflections of the Pans can be found far beyond the boundaries of Rome and of Italy. The only antique statues from a Roman private collection to be copied for Francis I, their bronze casts in Fontainebleau inspired generations of new admirers north of the Alps. They also appear in tapestry and manuscript borders, intarsie, and frescoed grotesques, as well as in small bronzes.

Many recent art-historical studies list the sketchbook drawings and works of art inspired by the Pans– an entire study could be dedicated to the genesis of these lists–but no list can ever be complete.

Our selection is of some of the earlier representations, those drawings which best show how they appeared in their 16th century installation, and a few works of art which indicate the range of their diffusion.

– Anon., after Ciriaco d'Ancona's lost drawing of c. 1432? in a letter by Bartolomeo Fonzio, Florence, Bibl. Laur., Cod. Ashburnham, 1174,

75b

ff. 136ᵛ–137: Pans separate, frontal, 'restored' arms, the lower hands dangling bunch of new carrots at end of a ribbon (**75a**; cf. Bober, 1957, p. 74).

- Girolamo da Cremona, attrib., illuminated frontispiece to printed book (Latin transl. of Aristotle's *Works* I, Venice, 1483) New York, Pierpont Morgan Lib., E. 41 A (Alexander, 1977), colour pl. 17, p. 72): free adaptation of a 'restored' Pan leaning an arm on a carved base, supporting a basket of fruit on his head.

- Francesco di Giorgio Martini Circle, *Bacchic procession*, c. 1480s, Berlin-Dahlem, Kupferstichkabinett, KdZ 613 (Winner, 1967, cat. 63. pl. 35): Pans facing each other, one seen from the back, both arms raised to baskets; adaptation.

- 'Mantegna' skb., Berlin, f. 81 (Pressouyre, 1969, fig. 15): freestanding, unrestored.

- Heemskerck, *Skb.* II, f. 20 (Pressouyre, 1969, fig. 16): installed in a della Valle courtyard, **75b**.

- Heemskerck, *Triumph of Silenus*, painting, c. 1536-7, Vienna, Kunsthist. Mus., Gemäldegal., Cat. 1972, no. 519: adaptation. Fanciful reference to triumphal arch of 1513 with unrestored Pans, three on the arch, the fourth walking into the distance (this painting also noted by Netto-Bol, 1976, p. 29. n. 5).

- Francisco de Hollanda, *Skb.*, f. 28 (Pressouyre, 1969, fig. 10): statues drawn at angles in relation to piers of portico.

- 'Maarten de Vos' Skb., f. 1ᵛ (Netto-Bol, 1976, p. 29, no. 4): Pan on right seen from right.

- Primaticcio and Vignola, lifesize bronze casts, 1540-1550, Fontainebleau, Salle de Bal (Pressouyre, 1969, fig. 17): unrestored; 16th century casts destroyed in 18th century; replaced by modern ones made from restored statues. Pressouyre (*ibid.*, p. 238) gives references to the influence of the casts in France.

- Pirro Ligorio, Casino of Pius IV, Vatican Gardens: two pairs of Pan statues adapted as herms on the façade (noted by Netto-Bol, 1976, p. 24, n. 7).

- Pietro da Barga, small bronze, parcel gilt, 1576, Florence, Mus. Naz. (Weihrauch, 1967, fig. 213): Pan on left.

- Cavalieri, I-II, pl. 87: '*Satyrii effigies Romae in aedibus familiae à Valle, huic similis varij in Vrbe conspiciuntur*'. Single Pan (right), ithyphallic, unrestored, crack in base and damage to right foot; freestanding.

- Pozzo Windsor, IX, f. 33, 8816 (Vermeule, 1956, fig. 20; 1966, pp. 57-8; Blunt, 1971, fig. 52, pp. 121f. as Pietro Testa): Pan, right, unrestored.

- Perrier, 1638, pl. 19: unrestored; with bases and piers, showing pilaster strips still attached to statues.

LITERATURE: See Stuart Jones, 1912, for history and bibl., and Helbig, II, cat. 1192, for recent studies on Hellenistic type and function. Bober, 1957, pp. 74-5 for history, discussion of conjectured place of discovery, list of 15th and 16th century drawings and works of art, with bibl. and texts of Renaissance descriptions of the Pan statues (see also p. 48 for Arch of 1513). Pressouyre, 1969, esp. pp. 237-9 on the Pan statues, and figs. 10-16 for ills. of the skb. drawings of them (omitting only Aspertini's drawing, Bober, 1957, fig. 98). Netto-Bol, 1976, p. 29. Dacos, 1977, pp. 260-1: most complete of the many published lists giving Cinquecento drawings and works in several mediums. See her colour pl. 19 for Giovanni da Udine's transformation (1519) of the unrestored Pans into grotesque decorations for a pilaster. Haskell and Penny, 1981, cat. 75: Della Valle Satyrs'.

76. Indian Triumph of Bacchus

Sarcophagus front. Roman, mid 2nd century A.D. Rome, Villa Medici, garden façade (Cagiano de Azevedo, 1951, cat. 59)

DESCRIPTION: The triumphal procession moves at a brisk pace across the face of this sarcophagus, with many elements based on actual Roman military triumphs: two satyr 'commanders' on horseback once brought up the rear of the train, shown in Renaissance drawings at the missing left edge of the relief; another–Silenus-like, riding a mule–is at the head, leading a contingent of prisoners and their satyr-guards; a satyr *tubicen* blows a trumpet in the backgound just behind the prisoners, who consist of three men and two women and a pathetic naked child clinging to his mother's *chiton*; and a welcoming male figure emerges from an arched gateway at right that had its counterpart at the left edge in a manner which corresponds formally to Roma greeting a triumphant Emperor. Bacchus, wearing a *nebris* and seemingly crowned by two satyrs behind him, stands with his near arm about the shoulders of a young satyr in a serpent-ornamented chariot drawn by two garlanded elephants with amoretti perched like mahouts on their backs; in the foreground old Silenus, still carrying a shield, gestures back from his seat on a lioness whose mate appears farther on, guided by a satyr and a gambolling Pan. A camel is added to this menagerie of exotic beasts, his long neck emerging in the background with his keeper behind the group with the lion. Details visible here, despite abrasion, help to sort out elements in the tumultuous welter of the third century triumph sarcophagi which follow.

HISTORY: At the end of the Quattrocento the sarcophagus was in the collection of the art dealer, Giovanni Ciampolini, at Rome, which came into the hands of Giulio Romano in 1520, many of the

works going to Mantua with the artist. This sarcophagus, however, seems to have been acquired by the della Valle and passed in 1584 to the Medici.

REPRESENTATIONS:
- Benozzo Gozzoli, formerly attrib. to Fra Angelico, Stockholm, Nationalmus., Printroom (Berenson, 1938, cat. 545B): satyr and lion; cf. Benozzo Gozzoli, Dresden, Kupferstichkabinett, C6ᵛ (76b; Degenhart and Schmitt, 1968, I, cat. 399, pl. 314b).
- *Cod.* Escurialensis, f. 39ᵛ: '*in chasa el campolino*', includes the chariot and prisoners (76a).
- Aspertini, single sheet, c. 1500–3, London, BM, 1905.11.10.2 (Bober, 1957, fig. 4): complete face.
- Perino del Vaga?, catalogued under anon., 16th century drawings, Princeton Univ., 56.29, 59.20 (Gibbons, 1977, cats. 796 and 798).
- Girolamo da Carpi, follower of, London, BM, 1950.8.16.4 recto and verso (Gere and Pouncey, 1983, cat. 176); also Florence, Uffizi, 1699E, wrongly identified by Serafini (1915, figs. 108–9) as Villa Albani-del Drago sarcophagus.
- Franco, Turin, Bibl. Reale, 14760 (Bertini, 1958, cat. 182): prisoner from back and the satyr, horse from the head of the procession.
- Anon. drawing in 1957 in private collection, Rhode Island (Matz, *ASR*, IV, 2, cat. 130, no. 7).
- Cod. Coburgensis, f. 26 (Matz, 1871, 134): complete front.

NOTE: Blum (1936, p. 80) derives the youth on an elephant in Mantegna's *Triumphs of Caesar* (Hampton Court, Canvas V; Martindale, 1979, figs. 28–9) from this sarcophagus, but other examples of an Indian Triumph known in the Renaissance might have served as a source; on the other hand, Pope-Hennessy's comparison of Fra Angelico's Berlin *Last Judgement* (the damned at lower right) with the prisoners seen from the back on a sarcophagus in the Uffizi (Matz, *ASR*, IV, 2, cat. 115), also from della Valle provenance, seems to be correct despite the similar motive here (Pope-Hennessy, 1952, p. 196; see 1974 ed., p. 221 as possibly by Zanobi Strozzi, c. 1448–50).

LITERATURE: Matz, *ASR*, IV, 2, cat. 130 and Beilage 60, nos. 2–3: illus. drawings by Aspertini and in the *Cod.* Escurialensis.

77. Indian Triumph of Bacchus

Sarcophagus front. Roman, end of 2nd century A.D. Rome, Palazzo Rospigliosi, Casino of Aurora (Matz, *ASR*, IV, 2, cat. 96)

DESCRIPTION: The sarcophagus belongs to a group which includes the example at Woburn Abbey (78); the group about Bacchus standing in his panther–drawn chariot is particularly closely related. However, there is no second *biga* (two-horse chariot) for Hercules and less of a tendency to iconic presentation; as a result, the procession maintains its momentum to culminate at a small altar on the extreme right edge of the relief. There are even more 'Indian' animals than at Woburn Abbey (78), and the elephant in the foreground is exploited for his full presence. Particularly to be noted are inventions of strong *contrapposto*: a kneeling satyr in front of the elephants who pours into a vessel held against his chest from a wineskin on his left shoulder; the camel and rider at the head of the cavalcade; and a female figure in closely wrapped garments above the altar at far right, seen from the back as she twists about to look left. There are numerous small restorations: heads, arms, and other projections.

HISTORY: At the end of the Quattrocento it was in a church of S. Lorenzo (Aspertini, Cod. Wolfegg) which is generally taken to have been S. Lorenzo fuori le mura, although there were at the time at least six churches dedicated to the saint in Rome. It was walled into the Casino Rospigliosi with other ancient reliefs in 1611–13.

REPRESENTATIONS:
- Aspertini, Cod. Wolfegg, ff. 36ᵛ–37, above (Matz, *ASR*, IV, 2, Beilage 43, 1): '*a Santo Lorientio*'.
- Perino del Vaga, Florence, Uffizi, 1494E (Matz, *ASR*, IV, 2, Beilage 44, 2): most of front from left.
- After Giulio Romano, Montpellier, Mus. Fabre, no. 3303 (photographed by A. Nesselrath).
- E. Vico?, London, BM, 1946–7–13–582 (Bober, 1964, fig. 3).
- E. Vico, engraving, Bartsch, XV, p. 297, no. 32.
 Roman, mid 16th century, Oxford, Christ Church, 0827 (Byam Shaw, 1976, cat. 524, no ill.; Matz, *ASR*, IV, 2, Beilage 45, 2): right portion, transformed by addition of Bacchus at head of procession.
- Late 16th century drawing, New York, MMA, Lehmann Collection (Matz, *ASR*, IV, 2, Beilage 43, 3): whole front.
- Pozzo Windsor, VII, ff. 6–7, 8634–5 (Vermeule, 1966, figs. 172–3, p. 43; Matz, *ASR*, IV, 2, Beilagen 44, 1; 45, 1; Blunt, 1971, cats. 184–5); cf. Girolamo da Carpi, Munich, SGS, 3142 (phot. A. Nesselrath).
- Pozzo Windsor, X, f. 23, 8016 (Matz, *ASR*, IV, 2, Beilage 43, 2): front.
- Annibale Carracci, studio copy, Paris, Louvre, 7184 (Tietze, 1905–6, fig. 71; Martin, 1965, fig. 272): unexecuted sketch for Farnese ceiling of a Bacchic procession including an elephant.

ADAPTATIONS:

– Krautheimer (1956, Appendix A, no.32) connects the elephant, with its diamond-patterned incision representing a net, with Ghiberti's *Noah's Ark* of the Baptistry Doors, and also cites examples of the woman seen from the back in Ghiberti's work (*ibid.*, no.39).
– Antal (1948, p.93f., fig.15) has pointed out Garofalo's inspiration from this sarcophagus for his late *Triumph of Bacchus* in Dresden, Gemäldegal., inv. 138.
– There are numerous borrowings among the stuccoes of the Vatican Loggie (Dacos, 1977, p.219, 237), including a Triumph of Bacchus on one soffit (*ibid.*, pl.LXIIIb) which combines elements from the Woburn Abbey example (78).

LITERATURE: Matz, *ASR*, IV, 2, cat.96, Beilage 43–45 (ills. of drawings).

78. Indian Triumph of Bacchus and Hercules

Sarcophagus front. Roman, early 3rd century A.D. (c.210–20)
Bedfordshire, Woburn Abbey (Michaelis, 1882, p.739, no.144)

DESCRIPTION: Like the related sarcophagus at the Casino Rospigliosi (77), this differs from the Villa Medici Triumph (76) in its third–century format with very high proportions permitting two tiers of figures and an exuberance of Bacchic detail, as well as more exotic animals (a giraffe's head is added in the background and there is a considerable variety of felines). Yet the swift forward movement is countered by the densely packed mass and by the frontality which governs major protagonists, despite the frenetic activity of individual figures. Bacchus is clothed in a long garment, standing in a panther-drawn chariot (Matz: 'Tiger'), a satyr behind him and a maenad carrying a *Tropaion* (restored as a *lagobolon*–a curved stick for throwing at rabbits) in front, while a Victory alights to crown him. Before the chariot a woman holds a burning lamp and a *tympanon*-playing maenad (restored as a trumpeter) dances ahead in ecstasy. The central portion of the relief is taken up with an especially shaggy Pan, who leads the panthers, and by a large elephant carrying two bound prisoners on its back (they are characterized by corkscrew locks and trousered legs as alien, but their traits would better suit Mauretanians than Indians); a lion peers from beneath the elephant, as a young pard bites playfully at the ponderous beast's forelegs. Hercules, in a cart pulled by a lyre-playing centaur and his mate, dominates the right-hand third of the scene, with old Silenus appearing behind him. In a sort of *horror vacui*, small figures of putti, female satyrs, a minute Pan and a mountain-god at upper right are squeezed in everywhere, playing with animals, with Bacchic cult objects and generally adding to the almost suffocating air of activity. Restorations are numerous, but immediately recognizable since they were carried out in white Italian marble that contrasts with the original.

HISTORY: The provenance is the Villa Aldrobandini at Frascati where collected antiquities were installed in 1603, among them an Achilles sarcophagus (also now at Woburn Abbey, 121) from the staircase of Aracoeli. Apparently the Triumph of Bacchus was also exposed in some public location in the Quattrocento.

REPRESENTATIONS:

– Neroccio, formerly attrib. to Francesco di Giorgio, Paris, Louvre, R.F.459 (Degenhart, 1939, pp.142f., fig.59): the chariot group including the camel, the elephant and captives below.
– Aspertini, London, BM *Skb*. I, ff. 37ᵛ–38 (Bober, 1957, fig.81): left portion freely transformed.
– Pozzo Windsor, VII, f.8, 8636 (Vermeule, 1966, p.62; attrib. to Franco?, see Vermeule, 1956, p.34; cf. Blunt, 1971, cat.217 as studio of Giulio Romano).
– Cod. Coburgensis, f.51 (Matz, 1871, 132): unrestored.
– Pozzo Windsor, X, f.24, 8017 (Vermeule, 1966, p.62): early drawing; VII, f.8, 8636 (*ibid.*, p.43).

LITERATURE: Matz, *ASR*, IV, 2, cat.100, Beilagen with ills. – 47: Aspertini; 48: Cod. Coburgensis; 49: Neroccio and Pozzo Windsor.

79. Ariadne Sleeping

Statue. Roman, 2nd century A. D. Copy of a Hellenistic Pergamene original, c.200 B.C.
Vatican, Galleria delle Statue (Amelung, *Kat.*, II, pp.636–43, no.414)

DESCRIPTION: Ariadne lies in uneasy slumber on a rocky support (restored much too steeply so that the figure's upper body is more upright than in the original pose and also turned too far forward on her left side) where she has spread a mantle which is

then folded over her crossed legs from either side. The sculptor has managed to capture both the pathos of her situation, exhausted and abandoned by Theseus on the island of Naxos, and the salvation that awaits her, awakening to the epiphany of Bacchus (Dionysus), who will take her as his bride. Although a thin under-*chiton*, girdled high beneath the breasts, sensuously unveils her left breast and part of her abdomen, it seems by its tattered quality to testify to the rigours of the sea-passage from Crete. Her head is propped on the hand of a left arm with elbow uncomfortably set on the ground, while the right arm streches back to grasp (originally) the mantle drawn up over the back of her hair. All this makes for a restless composition of strain, angles and, perhaps, even an allusion to conventional ancient gestures of mourning. In contrast, the majestic thighs and legs, calmly disposed and wrapped in grandiose folds that recall sculptures in the Parthenon pediments, seem to speak of the divine honours to come. A snake bracelet is coiled about Ariadne's left upper arm, a detail which led to the Renaissance identification of her as the dying Cleopatra, an interpretation that persisted until the days of Winckelmann. The fountain settings designed for the sculpture at the Vatican in the 16th century, together with the metaphors of sleep induced by soporific murmurings of water in poetic tribute to Ariadne, make it clear, however, that her kinship with sleeping nymphs was never far from mind, creating a 'second identity', as Brummer (1970, p.168) has termed it.

HISTORY: The date and site of discovery is not known, but at some time in the first decade of the 16th century the statue was in the possession of the Maffei family in Parione. Early in 1512 it was acquired by Julius II and placed in his Belvedere as the centrepiece of a fountain in the northeast corner, above a sarcophagus of a Roman general believed to represent the Emperor Trajan showing Clemency to subject barbarians (160). Under Julius III, a new installation was planned in a nymphaeum in the 'Stanza della Cleopatra' at the end of a corridor leading to the Belvedere (Canedy, 1967). The statue was among the famous antiques at the Belvedere, cast in bronze from Primaticcio's moulds c.1540 for Francis I.

REPRESENTATIONS:
Drawings and engravings include:
– Leonardo, Cod. Atlanticus, Milan, Bibl. Ambr., f.283V (Brummer, 1970, fig.135).
– Raphael Circle, Oxford, Ashmolean, Parker, 1956,

II, p.331, cat.620 (Brummer, 1970, fig.143): unrestored (**79c**).
– Aspertini, London, BM *Skb.* I, f.16V: unrestored.
– 'Aspertini', former attrib., London, BM, 1905-11-10-1 (Bober, 1957, fig.47): unrestored.
– Francisco de Hollanda, *Skb.*, f.8V (Brummer, 1970, fig.136): showing the installation in Julius II's fountain setting, although only the corner barbarians from the sarcophagus (**160**) are rendered in order to leave room for an inscription (**79a**).
– Girolamo da Carpi, Turin, Bibl. Reale, in 'Franco', 'Contraffazione', Cod.14760, no.1B (Brummer, 1970, fig.141; Canedy, 1976, T5).
– Cavalieri, I–II, pl.6 (Brummer, 1970, fig.216): '*nymphae cuiusdam dormientis simulacrum ... quidam propter adiectum serpentem Cleopatrae imaginem putant*'.
– Franzini, woodcut (Ashby, 1920, A 6): reversed.
– Goltzius, Haarlem, Teyler Mus. (Brummer, 1970, fig.144).

ADAPTATIONS:
– Master of 1515 (Bambaia), prints representing Cleopatra: Bartsch, XIII, p.415, no.16 (Brummer, 1970, figs.156 and 158); Hind, V, 2, p.283, no.2 (Brummer, 1970, fig.157).
– Marcantonio, Bartsch, XIV, p.162, nos.199-200 (Brummer, 1970, fig.160).
– Raphael, drawing for the Muse Calliope in *Parnassus*, Vienna, Albertina, inv.219 (Stix and Fröhlich-Bum, 1932, cat.65; **79b**). As Brummer (1970, p.154, n.4) points out, there was no need for this to be executed after the figure entered the Belvedere, since Raphael was already a member of a close circle of humanists which included members of the Maffei family, as well as group of a nymph devotees (cf. Bober, 1977, pp.230f.).
– Rinaldo Mantovano, painting of the spring, *Castalia*, Mantua, Pal. del Tè (Brummer, 1970, fig.150).
– Note that a drawing attrib. to Giulio Romano does not adapt the Ariadne, but is based on the Sleeping Hermaphrodite type (**98**; Brummer, 1970, fig.161), as comparison with Rubens' drawing of that sculpture from above (listed in **98**) makes clear (cf. Parronchi, 1968, fig.71).

LITERATURE: Helbig, I, cat.144 (W.Fuchs); on restoration problems, Müller, 1938, pp.164-74; Havelock, 1971, cat.122 with plate taken from a cast in order to partially correct the inaccurate placement of the figure on the rock; Ladendorf, 1958, pp.53, 65, 172; Brummer, 1970, pp.158-84, 220-2, 254-64, reprinting sources and poems of praise. Haskell and Penny, 1981, cat.24 ('Cleopatra'), with reference (p.187) to another much-admired antique statue of Cleopatra-Ariadne formerly in the Villa Medici (cf. Harris, 1981, for Velázquez' view of it there), now in Florence, Mus. Arch. (Laviosa, 1958).

80. Discovery of Ariadne

Sarcophagus. Roman, early 3rd century A.D.
Oxfordshire, Blenheim Palace (Michaelis, 1882, p.215, n.3)

DESCRIPTION: A large oval sarcophagus, the rear side destroyed by incastration as a fountain basin; it is much weathered and many parts of the figures have broken away. Two lion-headed masks divide the composition into compartments. In the centre stands Bacchus, nude except for a mantle draped around his crossed legs; his left arm is flung about the shoulders of a nude satyr who props his unbalanced pose; at the god's right side another satyr dances and plays the double-flute. This central group is flanked by two ecstatic maenads, clad in clinging garments, with mantles blown into arcs above their heads (velificatio), who carry the action toward figures disposed under the lion-heads. On the left, drunken Hercules reclines on a lion's skin, attended by little Pans who hold up his garlanded shoulders and pour wine into a cup he extends with his left hand; another dancing maenad follows. To the right, Ariadne lies in abandon, her upper body eased into the lap of the personification of Sleep (Somnus). Pan clambers over her from the left, looking back to see if the god is heedful as he pulls back her cloak to reveal her nudity; at Ariadne's feet a little Amor plays, while a sea-monster (Ketos) creeps out from beneath her hip; another dancing satyr follows.

HISTORY: If the inscription on one drawing is not in error (Carpio Album), the sarcophagus belonged at one time to the Massimi; from the 1540s, at least, it stood in the Palazzo della Valle and was among eleven sarcophagi reserved for the Capranica at the sale of the collection to Cardinal Medici in 1584. It was still in the Palace in the 17th century; acquired by the Dukes of Marlborough at the beginning of the 18th century.

REPRESENTATIONS:
- Mantuan, c.1480, Berlin-Dahlem, Kupferstichkabinett, KdZ.20717 (Winner, 1967, cat.68, cf.69): whole front, Somnus as female.
- Jacopo Francia, engraving, c.1506 (Bartsch XV, 460, 7), Washington, D.C., NGA (Levenson et al., 1973, no.179): Bacchus and Ariadne, reversed, 'restored' and varied (80a).
- 'Falconetto', adaptation of right section in ceiling decoration, Padua, Odeo Cornaro (Schweikhart, 1968, figs.13 and 15).
- Lambert Lombard, Album, D.515, by another artist.
- Franco, Städel. Kunstinst., inv.5594 (Malke, 1980, cat. and ill.83): whole front.
- Girolamo da Carpi?, Turin, Bibl. Reale, 16015ᵛ (Bertini, 1958, cat.173ᵛ, not illus.): several figures, maenads and Ariadne.
- Girolamo da Carpi, earlier attrib. to Baccio Bandinelli, Florence, Uffizi, 14781F.
- Girolamo da Carpi, London, Sotheby-Ellesmere Sales Cat., Dec. 5 1972, II, lot 86: the maenad left of Bacchus and reclining Hercules.
- Cod. Coburgensis, f.119 (Matz, 1871, 142).
- Cambridge Skb., f.23 (Dhanens, 1963, fig.24, cats.24-5).
- Drawing in Carpio Album, London, Society of Antiquaries, f.103: 'fue del Cavˡ de Massimis'.
- Pozzo Windsor, VII, f.22, 8650 (Vermeule, 1966, p.44); X, f.20, 8013 (ibid., p.62).
- Pozzo London, BM I, f.56, no.64 (Vermeule, 1960, p.13).

ALSO TO BE NOTED:
- Robert's suggested identification of two drawings in the Cod. Wolfegg (ff.30ᵛ-31; 1901, RM, p.229) with this work is erroneous. See the Borghese reliefs (85) and Bober (1957, p.45).

LITERATURE: Matz, ASR, IV, 1, cat.45, Beilage 18-19, illus. the last five drawings in our list.

81. Bacchic Procession

Sarcophagus fragment. Roman,
late 2nd century A.D.
Berlin, (DDR), Staatliche Museen (Matz, ASR, IV, 2, cat.157)

DESCRIPTION: The incomplete left-hand portion of a sarcophagus front depicts a rollicking Bacchanalian procession moving left which once served as the vanguard for Bacchus in a centaur-drawn chariot. An intoxicated crew of old satyrs (sileni) carrying sacrificial animals, fruits and wine, conduct two women in a cart pulled by stumbling donkeys driven by Pan. One donkey has collapsed in a drunken manner and Pan bends far forward trying to prod him up again with a thyrsos; two maenads loll in the car in a swaying embrace, arms linked around shoulders, and one holds a huge satyr-mask. Behind them dance two figures: a silene with a vessel of fruits held high and a maenad balancing on her head a liknon, the sacred winnowing-basket of Bacchus. A naked satyr in the foreground, signalling with his left arm to Pan, tries to help the faltering team, while behind them another

satyr is bent under the weight of a bullock upturned on his shoulders and a cymbal-playing maenad turns back to look at the hitch in the parade. Farther left appear two more satyrs, one in the background twisting back, a goat on his shoulder; the other dancing forward still with a large *krater* of wine on his shoulders. Originally, at least one more figure would have completed the scene to the left.

HISTORY: Unknown; purchased in Rome in 1846.

REPRESENTATIONS:
- Jacopo Bellini Circle, Paris, Louvre, R.F. 524, above (Degenhart and Schmitt, 1972, fig. 53; **69a**).
- Jacopo Bellini, Paris, Louvre *Skb.*, f. 79: the *krater*-bearing satyr reworked for an 'antique builder' carrying a capital, moving right (see Introduction, p. 35).
- Mazzolino, *Massacre of the Innocents*, c. 1515–20, Rome, Pal. Doria, inv. 120 (Matz, *ASR*, IV, 2, pl. 184, 3, detail): background setting reproducing the composition intact with Bacchus' chariot or a good approximation.
- Polidoro da Caravaggio, attrib., London, CI, Witt Collection, no. 762 (Matz, *ASR*, IV, 2, pl. 184, 2): condensed, but including the lead centaur of Bacchus' chariot in the lost portion of the relief.

LITERATURE: Bober, 1963, p. 85, pl. 24; Degenhart and Schmitt, 1972, p. 154, figs. 21, 25.

82. Bacchic Procession (Triumph of Bacchus and Ariadne)

Sarcophagus front. Roman, Antonine (170–80 A.D.) Bedfordshire, Woburn Abbey (Michaelis, 1882, p. 724, no. 61)

DESCRIPTION: Bacchus and Ariadne semi-reclined, embrace on a low cart drawn by a team of panthers in the midst of a dancing throng of satyrs—one bearded oldster clashing cymbals—and a maenad carrying a *liknon* (winnowing basket) on her head. A little amor, perched on the forepart of the cart, holds its reins, while a second amor rides the lead animal, playing a lyre. A prancing figure of Pan, next to a mystic *cista* from which a snake emerges, heads the entourage around the god. Before him, in the right half of the panel, a satyr has dropped his full wine-skin on the ground in order to help a companion prop up drunken Silenus who is slipping off his precarious seat on a donkey; an apprehensive panther crouches beneath him. On the

right, three maenads dance on at the head of this *thiasos*, one with another sacred *liknon* on her head, her companions playing a pair of pipes and *tympanon*.

HISTORY: Alleged provenance from Sicily is manifestly false; the piece stood in Rome during the 16th and 17th centuries. It was purchased for Woburn Abbey in 1800.

REPRESENTATIONS:
- 'Ripanda' skb., Oxford, Ashmolean, ff. 30ᵛ–31.
- Matteo Balducci, attrib., cassone painting, Gubbio, Pinacoteca (**82a**) (Schubring, 1923, no. 518, pl. CXX).
- Italian, mid 16th century, London, V & A, 9092 (Ward-Jackson, 1979, cat. 523): whole relief.
- Italian School, 16th century, Chatsworth, 955 A and C (Matz, *ASR*, IV, 2, cat. 80, Beilage 31, 2–3): unrestored, with less damage than the relief shows now.
- Girolamo da Carpi, Pozzo Windsor VII, f. 4, 8632 (Vermeule, 1966, p. 43 and fig. 170): left half, reversed.
- Pozzo Windsor, VII, f. 10, 8638 (Vermeule, 1966, p. 44 and fig. 171): left half in proper direction. Cf. Windsor, 0489 (Popham and Wilde, 1949, cat. 196, fig. 46 as Girolamo da Carpi).

LITERATURE: Matz, *ASR*, IV, 2, cat. 80.

83. Triumphal Procession of Bacchus and Ariadne

Roman sarcophagus. Mid 2nd century A.D. London, British Museum (A. H. Smith, 1904, cat. 2298)

DESCRIPTION: This sarcophagus was a major attraction for artists visiting Rome who drew single figures or groups from its long low front and ends for the best part of two centuries. The rejoicing figures, damaged as they were before restoration, marvellously demonstrated a gamut of Hellenistic Bacchic poses, from utter relaxation to wild abandon. Their ecstatic attitudes are inspired by the wine, music and presence of the god, whose marriage to Ariadne will be consummated in the heavens at the end of this festive journey (Propertius, *Elegiae* iii, xvii, 7–9; Ovid, *Fasti* iii, 510).

Front (83i), left to right:
(1) The bridal chariot of Bacchus and Ariadne drawn by two musical centaurs; beyond, a woman with a winnowing basket *(liknon)* on her head.

(2) The dance of Pan, satyr with a winesack, maenad with swirling *chiton* (hands missing in Renaissance) and satyr (restoration; the original figure seems to have been a piping satyr seen from back, cf. Matz, *ASR*, IV, 2, cat. 89, and as in Louvre, 5611 and on the *Camino della Iole*, Pal. Ducale, Urbino). Such a satyr appears on two similar sarcophagi in Pisa and Lucca (see below).

(3) Drunken Silenus lolling on a donkey, attended by two satyrs, with a dancing maenad in the background. This group is often confused by art historians with a similar one at Woburn Abbey (82), in which the supporting satyr does not step with one foot on a stone.

(4) Nude maenad dancing, with a veil, accompanied by an ithyphallic satyr in profile to left.

(5) Satyr with child on his shoulders; child on ground (restoration). In the background stands a soberly draped woman, and originally, a panther (restored as a dwarf elephant).

(6) The two satyrs on the right, missing in most Renaissance representations, are restorations, but their original *pedum* (shepherd's crook) hung with a winesack is preserved.

Left end (83ii) – Somnolent, drunken Pan carried by two amoretti and a satyr; Pan's lower right leg is broken and variously reconstructed in drawings.

Right end (83iii) – Pan is carried on the back of a satyr to an altar heaped with fruit under a tree. To the left a satyr, in a lunging pose, pulls Pan's tail and is about to thrash him. His hand, holding the flail (squills?), was broken and was variously interpreted by the artists.

The present restorations are reflected first in Perrier's engravings (1645) and were probably made when the sarcophagus was at the Villa Montalto after 1585. The main additions, apart from arms, legs and noses, are the figures of the three satyrs, one in the centre, and two on the right, as well as a child on the ground and the forequarters of a dwarf elephant. The new satyrs are derived from figures in a Bacchic relief also originally at the Villa Montalto (90, cf. 91).

HISTORY: The only indication of its location in the Renaissance is the notation on the Aspertini, Cod. Wolfegg drawing: '*a santa maria maggiore*'. It is probable that it was first drawn there when Pope Martin V had his residence there in the early 1420s. The sarcophagus was probably moved in the time of Sixtus V to his Villa Montalto next door to S. Maria Maggiore (c. 1585-90) and was there restored before 1645. It was bought from the Villa Montalto-Negroni in 1786 by Thomas Jenkins for Charles Townley, and sent to London, where it entered the British Museum in 1805. It is now in the Wolfson Galleries.

REPRESENTATIONS:
Whole front:
– Michele di Giovanni di Bartolo, attrib., *Camino della Iole*, marble chimney piece relief, c. 1460s, Urbino, Pal. Ducale (Degenhart, 1950, fig. 10; Rubinstein, 1976, fig. 169): simplified version including the three satyrs later missing (or reconstruction?).
– Aspertini, Cod. Wolfegg, ff. 31v–32 (Bober, 1957, p. 29, fig. 2; Degenhart and Schmitt, 1968, I, fig. 352; Rubinstein, 1976, fig. 192): '*a santa maria maggiore*', muddled sequence.
– North Italian, c. 1520-30, Dresden, Kupferstich-kabinett, Platte 28–29 II Garnitur (Schweikhart, 1976, figs. 5–6 and p. 358, n. 28): with both ends 'restored', and includes child on ground, the panther, and two satyrs at the right, but not the lost satyr in the centre.
– Franco, engraving, 1549, Bartsch, XVI, p. 134, no. 45 (Rubinstein, 1976, fig. 173): reversed, 'restored', includes right end, scene 3 modified, lacks the figures later restored.
– Italian, mid 16th century, formerly attrib. to Polidoro, Munich, SGS, 2536, 83a (Degenhart and Schmitt, 1968, I, fig. 353; Rubinstein, 1976, fig. 162): front and ends unrestored and without the figures later restored. Shows traces of the missing satyr's hand and pipe (2) as pointed out by Degenhart and Schmitt.
– Naldini, 1560, Oxford, Christ Church, 0836 (Byam Shaw, 1976, cat. 199): left half of front, unrestored (scenes 1–2); Sotheby, London, 24 May 1966, lot 18 (Rubinstein, 1976, figs. 205–6): right half (scenes 3–5), records the hindquarters of the panther.
– Perrier, 1645, pls. 8–9 (Rubinstein, 1976, figs. 178–9): reversed, and showing for the first time the present restorations. Cf. P. Santi Bartoli, 1693, pls. 48–9 in correct sense.

Details of front:
Scene 1. Bacchus and Ariadne drawn by centaurs
– 'Ripanda' skb., Oxford, Ashmolean, f. 59 (Rubinstein, 1976, fig. 190): 'restored'.
– Giovanni da Udine, stuccoes in the Vatican Loggie (Dacos, 1977, pls. LXVd, LXVIIa and d; pp. 224–5): vignettes of centaur and Pan, two centaurs, and Bacchus and Ariadne.
– Fogolino, fresco frieze from Ca' Impenta, Venice, Ca' d'Oro (Schweikhart, 1976, fig. 18): Bacchus and Ariadne; (*ibid.*, figs. 8b, 23, 28): centaurs.
– Italian, first half of 16th century, Lyons, Mus. B–A, B 1264 (noted by A. Nesselrath).
– Jan de Bisschop, Album, London, V & A, D1212-60–1889: chariot, reversed (after Perrier).

Scene 2. Dancers with Pan
- Central Italian, c.1420–30, Paris, Louvre, 5611 recto and verso (Degenhart and Schmitt, 1968, I, cat.136; Rubinstein, 1976, figs.182–3): piping satyr from centre, later missing, seen in three-quarter view from back, turned towards left and holding up a pair of pipes, on sheet with left and right ends of the sarcophagus, see below.
- Ambrosiana Anon., Milan, Bibl. Ambr., 1707 (Schmitt, 1966, no.33ʳ; Degenhart and Schmitt, 1968, I, fig.354; Rubinstein, 1976, fig.186): the maenad in the *chiton*, together with scene 4. Unrestored.
- North Italian, 15th century, Cambridge, Fitzwilliam Mus., PD 35–1956 (Rubinstein, 1976, fig.188 as 'Mantegna School', owner unknown): unrestored.
- Marcantonio Raimondi or his school, engraving of an allegory, Bartsch, XIV, no.397 (Rubinstein, 1976, fig.172): adaptation of maenad in *chiton*.
- Raphael Workshop, Fossombrone skb., f.89: unrestored.
- Girolamo da Carpi, Düsseldorf, Kunstmus., FP.126 (Rubinstein, 1976, fig.201): maenad in *chiton* and scenes 3–5.
- Jan de Bisschop, Album, London, V & A, D1212-180–1889: reversed (after Perrier).

Scene 3. Silenus Group
- Falconetto, attrib., stucco relief, c.1524, Padua, Odeo Cornaro, Loggia (Schweikhart, 1975, fig.2): free variation of front borrowed from the Urbino *Camino* (see above *Whole front*). Recognizable are scenes 3–4, and the piping satyr, interspersed with other figures.
- Cartari, 1615, p.559 (after Franco's engraving, see above, *Whole front;* Rubinstein, 1976, fig.174): the satyr supporting Silenus is dressed; the satyr urging them forward holds a curved horn like a cornucopia. Cf. *Camino*, Urbino (see *Whole front*); Falconetto, Odeo Cornaro relief (above) and Titian, *Bacchus and Ariadne*, London, NG, 35 (Goodgal, 1978, fig.25, and p.125, n.60 for further use of motif).

Scene 4. Dance of the nude Maenad and ithyphallic satyr
- See above, *Scene 2:* Ambrosiana Anon., and Girolamo da Carpi, Düsseldorf.
- Vittorio Ghiberti Workshop, c.1456–64, Florence, Baptistry, bronze frames of Andrea Pisano's Doors (Degenhart, 1950, fig.19; Rubinstein, 1976, fig.168): adaptation of a maenad as Eve.
- Marcantonio Raimondi, engraving, Bartsch, XIV, p.207, no.258: adaptation. Cf. Giovanni da Udine, Vatican Loggie, stucco medallion (Dacos, 1977, pl.Ca): maenad, adaptation with basket on head; cf. *ibid.* (pl.LXXIXd): ithyphallic satyr as one of the dancing youths; Dacos relates the group to an antique gem.

- Giulio Romano follower, in Heemskerck, *Skb.* II, f.65ᵛ, **83b** (Rubinstein, 1976, fig.196): maenad, unrestored, on sheet with left end; f.65ʳ (*ibid.*, fig.197): ithyphallic satyr drawn alone, as if a statue, on sheet with two others.

Scene 5. Satyr with child on shoulders
- Central Italian, c.1420–30, Paris, Louvre, R.F.38 (Degenhart and Schmitt, 1968, I, cat.137, pl.179a; Rubinstein, 1976, fig.184).
- Vittorio Ghiberti Workshop, Florence, Baptistry, bronze frame of Andrea Pisano's Doors (Degenhart, 1950, fig.19; Rubinstein, 1976, fig.167): adaptation, reversed, as Adam.

Left end. Drunken Pan carried by amoretti and a satyr:
- Central Italian, c.1420–30, Paris, Louvre, 5611 (Degenhart and Schmitt, 1968, I, cat.136, pl.178c; Rubinstein, 1976, fig.182): restored; on sheet with 'missing' satyr piping.
- Ambrosiana Anon., Milan, Bibl. Ambr., 1707ᵛ (Schmitt, 1966, no.33ᵛ; Rubinstein, 1976, fig.185): unrestored.
- Domenico Ghirlandaio, *Judith*, c.1489, Berlin-Dahlem, Staatl. Mus., Gemäldegal., *Cat.*, 1975, no.21 (Egger, 1906, fig.3; Dacos, 1962, p.449): detail of Pan's head as fictive relief with others **(103, 158)** in background.
- 'Ripanda' skb., Oxford, Ashmolean, f.58 (Rubinstein, 1976, fig.189): 'restored'.
- Aspertini, Cod. Wolfegg, f.48ᵛ, below (Rubinstein, 1976, fig.191): *'a santa maria magiore'*. Pan restless and precariously carried.
- Fogolino, fresco frieze from Ca' Impenta, Venice, Ca' d'Oro (Schweikhart, 1976, fig.30).
- Giulio Romano follower, in Heemskerck, *Skb.* II, f.65ᵛ (Rubinstein, 1976, fig.196): unrestored. Pan's expression is to be noted **(83b)**.
- Lambert Lombard, Album, D.695 (Rubinstein, 1976, fig.198): quick sketch, 'restored'.
- Frans Floris Workshop, Basel *Skb.*, f.26ᵛ (Rubinstein, 1976, fig.199): unrestored.
- Franco, Chatsworth, Devonshire Collection, 292 (Rubinstein, 1976, fig.200): 'restored'.
- 'Ligorio', Florence, Uffizi, 383S.
- Naldini, Oxford, Christ Church, 0832 (Byam Shaw, 1976, cat.195, pl.127; Rubinstein, 1976, fig.204): unrestored.

Right end. The flagellation of Pan:
- Central Italian, c.1420–30, Paris, Louvre, 5611ᵛ (Degenhart and Schmitt, 1968, I, cat.136ᵛ, pl.178d; Rubinstein, 1976, fig.183).
- Ambrosiana Anon., Milan, Bibl. Ambr., F.214 inf.2 (Schmitt, 1966, no.29; Rubinstein, 1976, fig.187).
- Aspertini, Cod. Wolfegg, f.47ᵛ (Bober, 1957, fig.86; Rubinstein, 1976, fig.193).
- Marcantonio Raimondi, engraving, Bartsch, XIV,

p.231, no.305: adaptation with the satyr carrying a female Pan; cf. Taddeo Zuccaro, *Triumph of Bacchus*, fresco, Caprarola, Pal. Farnese, Camerino del Autunno (Gere, 1969, fig.139).

- Fogolino, frieze from Ca' Impenta, Venice, Ca' d'Oro (Schweikhart, 1976, figs.10,24).
- Aspertini, London, BM *Skb.* I, f.2 (Bober, 1957, fig.6; Rubinstein, 1976, fig.195).
- Girolamo da Carpi, Providence, Mus. of Art, Rhode Island School of Design, 22.229ᵛ (Rubinstein, 1976, fig.202).
- Girolamo da Carpi, Rosenbach *Album* (Canedy, 1976, R144).
- Luzio Romano, or assistant, fresco, 1547, Rome, Castel Sant'Angelo (E.Gaudioso, 1976, fig.57; noted by Yuen).
- Naldini, c.1560. Florence, Uffizi, 14443Fᵛ (Barrochi, 1965, fig.92b; Rubinstein, 1976, fig.207).
- Jan de Bisschop, Album, London, V & A, D212-4-1889: motif of Pan on satyr's back reversed (after Perrier).

LITERATURE: Matz, *ASR*, IV, 2, cat.88 with list of drawings; Bober, 1957, p.47; Degenhart and Schmitt, 1968, I, cat.136; Rubinstein, 1976, illus. all skb. drawings and 13 adaptations; Schweikhart, 1976, p.357, n.25, and Dacos, 1977, pp.224–5 with further representations and adaptations. Work in progress by Dorothea Schmitt, Munich.

OTHER SARCOPHAGI OF THE TYPE KNOWN IN THE RENAISSANCE:
- Pisa (Matz, *ASR*, IV, 2, cat.89; Degenhart and Schmitt, 1968, I, fig.349a). Fragment includes satyr piping seen from back.
- Lucca, Pal. dell'Arcivescovado (Matz, *ASR*, IV, 2, cat.90). With piping satyr.
- Variant of Silenus group in Woburn Abbey, Bedfordshire (Matz, *ASR*, IV, s. cat.80; **82**); Genoa, S.Agostino (Matz, *ASR*, IV, 2, cat.116).

84. Amor and Psyche on Musical Centaurs

Funerary Cippus (detail). 1st century A.D.
Paris, Louvre, (MA 488)

DESCRIPTION: The Cippus of Amemptus must have been much admired in the Renaissance for its elegance and grace and crisp carving. The corner torches, the garlands and ribbons and hanging beads, the palmette mouldings, the beautifully proportioned letters, and the two charming winged infants on the backs of confronting male and female centaurs playing the lyre and the double pipes with

an overturned vase and horn on the ground between them should prove to have reflections in Renaissance reliefs and particularly in MS illuminations, but so far no direct analogies seem to have been noted in works of art.

HISTORY: It was first recorded by Fra Giocondo in the 1480s in the house of Bernardino de' Franceschi, Rome, and then in the della Valle Collection by the beginning of the 16th century; in the mid 16th century it was in the house of Bruto della Valle. Later it went to the Villa Borghese and to Paris in the early 18th century (*CIL*, VI, 2, 11 541).

REPRESENTATIONS:
- *Cod.* Escurialensis, f.36 (see Michaelis in Egger 1906, pp.103–4): front, '*inchisa lavalle*'.
- Cod. Coburgensis, f.197 (Matz, 1871, 104): four sides of altar; cf. Cod. Pighianus, f.84 (Jahn, 1868, 127): '*Bruti dela Valle*'.
- Boissard, Stockholm skb., f.44ᵛ: left side and front; cf. Boissard, 1597, III, pl.144.
- E.Vico, 1557, frontispiece (**84a**): front reversed.
- Circle of Dosio, skb., Florence, BN, NA 1159, f.27: front; f.30: back and left side.
- Pozzo London BM II, f.279 (Vermeule, 1960, p.25).

LITERATURE: Collignon, 1877, p.432, cat.184; Michaelis, 1891, *JdI*, (I), p.237, no.188 (della Valle); Altmann, 1905, cat.111, pls.I–II (front and sides).

85. Bacchic Subjects

Reliefs in four segments. Graeco-Roman
Rome, Villa Borghese (Helbig, II, cat.nos. 1944, 1947, 1950 and 1964.

DESCRIPTION: The pieces are understood to be dismembered sections of a rectangular base, either end of which **i** and **iv** would have shown the single repeated motif: a lively Pan leaping up to cast the head of a ram on a burning altar (the dead ram in the foreground and the whole set in a hilly landscape before a herm of Bacchus, i.e. a rustic shrine). **(i)** A young nude satyr leads a small amor on a goat. On the long faces, **(ii)** a satyr pipes for an older companion who is dancing; a satyr and a half-clad nymph wash a herm of bearded Dionysus; then two scenes **(iii)** show nymphs being importuned by a satyr and old Silenus; and **(iv)** a satyr boxing another amor perched on a goat.

HISTORY: The provenance is unknown, although the reliefs, all or in part, were visible in the Quat-

trocento, apparently in some public location, to judge by the popularity of the various motifs.

REPRESENTATIONS:

- Aspertini, Cod. Wolfegg, ff. 31ᵛ–32, below (Bober, 1957, p. 33, fig. 2): Pan sacrifice.
- Aspertini, London, BM *Skb.* I, ff. 1ᵛ–2a: Pan sacrifice (Bober, 1957, p. 45, fig. 6).
- Italian, 16th century, Florence, Uffizi, 14848F (Bober, 1957, fig. 3): from piping satyr through the putto led on a goat and including one Pan sacrifice.
- Cod. Coburgensis, f. 85 (Matz, 1871, 40).
- Dosio, Berlin *Skb.*, f. 14.
- Naldini, Oxford, Christ Church, Byam Shaw, 1976, cats. 196 and 201, pl. 121: Pan sacrifice and three satyrs **(85a)**.
- Lambert Lombard, Album, D. 720: cut sketch of left end, inscribed 'lato sinistro'; D514: including satyr piping.
- Pozzo Windsor, X, f. 25, 8018: including Pan sacrifice; also f. 29, no. 8022.

Engravings include:

- Woodcut, title-page of Valla's Latin transl. of Herodotus, *Historiae*, Venice, I. and G. de Gregoriis, 1494 (Hülsen, 1912, *JÖAI*, ill. on p. 123): free adaptation of a figure of Pan.
- Marcantonio, Bartsch, XIV, p. 284, no. 373: the nymph sponging (without the herm) and satyr pouring water, reversed.
- Giovanni Antonio da Brescia? (Hind, VI, pl. 589, 19a): Amor on goat with two satyrs in landscape. Cf. a reversed version by Zoan Andrea? (Hind, VI, pl. 589, 19).
- For adaptations by Fogolino, see Bober (1957, p. 45) and Schweikhart (1976, p. 364, fig. 15).
- For adaptations in works by Pinturicchio, and in paintings and stuccoes of the Vatican Loggie, see Bober (1957, p. 45) and Dacos (1977, *indices* and esp. pp. 154–5, pl. XIIa, *Creation of Eve*: satyr piping).

LITERATURE: Amelung, 1909, p. 181–8; Hülsen, 1912 and 1913, *JÖAI*, with ills. of seven of the representations.

86. Bacchic Thiasos

Oval sarcophagus with lions' heads, c. 200 A.D.
Formerly Hever Castle, Kent (Matz, *ASR*, IV, 1, cat. 44), now Amsterdam, University, Allard Pierson Museum

DESCRIPTION: The continuous high relief offers a wonderful variety of nude or lightly draped male and female figures in the frenzied movements of the Bacchic dancing procession or *thiasos*. In the centre of the front, Bacchus leans (legless) on a satyr; the principal scene on the back is a maenad

sacrificing at an altar on which there is a goat's head; a ram's head is on a pedestal. Although much worn now, and more damaged than it was in the Renaissance, the Pighius drawings show that the minor figures include a satyr herm, a seated satyr holding a rearing goat by the horn at arm's length, another satyr enjoying a supine goat, a panther drinking from a vase, and a satyr strapped with bells, with a goat under one arm.

HISTORY: Although the sarcophagus was in Rome from at least the first half of the Quattrocento, its precise location there is unknown. Brought by Lord Astor from Rome to Hever Castle in 1905.

REPRESENTATIONS:

- Pisanello Workshop, Oxford, Ashmolean, Parker, 1956, II, cat. 41ᵛ as Pisanello (Schmitt, 1960, fig. 73; Degenhart and Schmitt, 1968, I, cat. 132 as Gentile da Fabriano): two maenads with *tympani* **(86a)**.
- Central Italian artist, 1420–30, Paris, Louvre, RF38 (Degenhart and Schmitt, 1968, I, cat. 137: maenad on right.
- B. Peruzzi, *Bacchic Procession*, fresco, Rome, Farnesina, Sala de' Fregi (Frommel, 1967–8, fig. XXXVIb): detail of seated satyr holding goat by horns.
- E. Vico, engraving, Bartsch, XV, p. 321, no. 111 (12): back, to the left, maenad dancing. Cf. Franco, engraving, Bartsch, XVI, p. 151, no. 86: 'camei antichi', reversed.
- Girolamo da Carpi, Turin *Portfolio*, f. 27 (Canedy, 1976, T159): front right maenad; satyr in jerkin hung with bells from right.
- Cod. Coburgensis, f. 53 (Matz, 1871, 145; Matz, *ASR*, IV, 1, Beilage, pl. 16, 2; Schmitt, 1960, fig. 74): right end and back including satyr herm, excluding maenad at altar.
- Pozzo Windsor, II, f. 3, 8631 (Vermeule, 1966, p. 43, fig. 169; Matz, *ASR*, IV, 1, cat. 44, Beilage, pl. 17, 1 as copy of Cod. Coburgensis, f. 53).
- Pozzo London BM I, f. 58, no. 66 (Matz, *ASR*, IV, 1, cat. 44, Beilage, pl. 17, 2).

LITERATURE: See above, Matz, *ASR*, and Sotheby Sale. 12 July 1983, lot 371.

87. The Death of Pentheus

Relief panel from a sarcophagus cover.
2nd century A.D.
Pisa, Campo Santo (Arias *et al.*, 1977, C18 est)

DESCRIPTION: The cover, with crouching lionesses on the sides, and masks on the corners, consists of two relief panels on the front, flanking the inscrip-

tion: 'T.CAMUREN/MYRONIS'. *Left*–Infant Bacchus reared by the nymph, Nysa; *Right*–Death of Pentheus.

Pentheus, King of Thebes, fanatically disapproved of the Bacchic cult which, nevertheless, aroused his curiosity. When he was caught spying on their Bacchic rites, his two maternal aunts (left) attacked him, and his mother, Agave (right), dismembered him.

> 'Possessed of Bacchus … his left arm she clutched in both her hands, and set against the wretch's ribs her foot,
> and tore his shoulder out …' (Euripides, *Bacchae*, Loeb ed., 1919; see also Ovid, *Metamorphoses* III, 708–32).

A maenad with flying drapery rushes to the fray from the right.

HISTORY: The sarcophagus cover must have been known in the Campo Santo as early as the end of the 13th century, as the torn figure of Pentheus is reflected in works by Nicola Pisano. Ciriaco d'Ancona copied the inscription in 1442 (*CIL* XI, 1463, and p.271).

INTERPRETATION: Dosio (c.1560–70) wrote on a drawing of the cover (Berlin *Skb.*, f.48): 'it is thought to be the death of Orpheus'. The musician, Orpheus, was also mutilated by crazed maenads (Ovid, *Metamorphoses* XI, 1–43).

REPRESENTATIONS:
– Nicola and Giovanni Pisano. The Pentheus figure stands behind the recurring figure (reversed) of a man torn by demons (one of which develops from an amor wearing a satyr's mask from another sarcophagus) in the scene from *The Last Judgement* in the various pulpit reliefs: Nicola Pisano, Pisa, Baptistry, 1260 (Seidel, 1975, fig.75); Pistoia, Sant'Andrea, 1301 (*ibid.*, fig.76); Giovanni Pisano, Pisa, Duomo, 1311 (*ibid.*, fig.77).
– Donatello, *The Miracle of the Irascible Son*, bronze relief on altar, Padua, Santo (Janson, 1963, pl.87a, p.186, n.16): adaptation. Gombrich (1963, pp.123–4) prefers as a possible source a detail of Trajan's Column, his fig.156.
– Pollaiuolo, Florentine, 15th century, copy of lost drawing, Cologny (Geneva), Bibl. Bodmer, as Hercules and Cacus (Fusco, 1979, pl.56f): Hercules nude with arms bent. A variant weaker copy is in Turin, Bibl. Reale (Bertini, 1958, cat.17; Fusco, 1979, pl.56c, pp.261–2, n.21 for literature).
– Dosio, Berlin *Skb.*, f.9 (Hülsen, 1933, pl.XI): whole cover; f.48 (*ibid.*, pl.LXV): '*in campo santo di Pisa et si pensa sia la morte d'orpheo*'; left side of cover with lionesses flanking ram's head; corner mask.

LITERATURE: Hülsen, 1933, p.7, 23; p.24, 119; also see Matz, *ASR*, IV, 3, cat.230A, for further bibl. Seidel, 1975, esp. pp.379–84.

88. Maenads Dancing

Funerary altar. Provincial Roman, 1st–2nd century A.D.
Padua, Museo Civico, inv.248 (Ghedini, 1980, cat.35)

DESCRIPTION: On a round altar that is much worn, three orgiastic maenads abandon themselves to the dance. The half-nude types bearing *tympanon*, *thyrsos* and *krotales* (castanets), reflect neo-Attic models created originally by Callimachus at the end of the 5th century B.C.

HISTORY: Visible in or around Padua in the Quattrocento, but its history is obscure.

REPRESENTATION:
– Jacopo Bellini, Louvre *Skb.*, f.44: two maenads copied directly for crowning figures atop an invented monument (**88a**).

LITERATURE: Degenhart and Schmitt, 1972, p.149, figs.12–13 (the *ara*) and fig.8 (Bellini); their note 11 indicates that Röthlisberger (1958/9, p.70) independently noted these reliefs as Bellini's prototype.

89. Bacchic Dancers

Candelabrum base. Roman, neo-Attic, 1st century A.D.
Venice, Museo Archeologico, inv.122 (Anti, 1930, p.30, 11)

DESCRIPTION: The triangular base, one of a pair, was in a church at Tivoli. The lower moulding is decorated with bucrania and garlands; the upper with grape-vines and Pan-masks, with projecting Ammon-heads at the corners. The vertical edge of each face with its dancer is shaped plastically in a sequence of ram's head, sphinx and Victory. Two dancers are Spartiate types, clad in short, clinging *chitons* and wearing *kalathiskoi* (a sort of open basketwork) on their heads; they dance on tiptoe in ballet-like poses. The third, a maenad, wears a long garment and *nebris*; her dance is a rapid stomp with head cast back in rapture and arms flung wide holding the ends of a mantle that passes behind her.

A closely related base in the Louvre (MA 239) was also known in the Renaissance (89a). Here the Spartiate dancers are the same, but the maenad is partially nude and dances with a *tympanon* (Reinach–Clarac, *Rép.Stat.* I, p.61, 2 [1], and p.62, 1; drawn in Fossombrone skb., f.30 recto and verso; Raphael's circle, *Holy Family*, Madrid, Prado, no.371, as part of the setting, although shown broken, without its upper and lower terminations, and with one *kalathiskos* dancer visible; Cod. Coburgensis, f.150, 1, Matz, 1871, 73; Girolamo da Carpi, London, BM 1950.8-16-10ᵛ, Gere and Pouncey, 1983, cat.182; Rosenbach *Album*, Canedy, 1976, R41 and Turin *Portfolio, ibid.*, T17, T126).

HISTORY: In the Quattrocento both bases were preserved and drawn in one of the churches at Tivoli. Later they entered the collection of Cardinal Domenico Grimani (d.1523) and went with his bequest to Venice, where there is another base, a Renaissance copy. The one taken to Paris in the time of Napoleon remains in the Louvre.

REPRESENTATIONS:
– Tuscan drawing, c.1430, London, BM, 1845-9-15-439ᵛ (Popham and Pouncey, 1950, cat.273ᵛ, pl.CCXXXVI): nude dancer with *kalathiskos* hair-dress inspired by these dancers. (Degenhart and Schmitt, 1968, I, cat.194, as 'Ghiberti's circle'; cf. a similar base once in Darmstadt, private collection, *ibid.*, fig.398).
– Giuliano da Sangallo, *Cod. Barberinianus*, f.30ᵛ: '*a Tigholi... Intriandolo*', compound and inaccurate.
– Cod. Zichy, Budapest, City Lib., f.56: free adaptation.
– *Cod.* Escurialensis, f.32: '*attibolj*', (freely).
– B.Brunelleschi, Epigraphical skb., Florence, Bibl. Marucel., A 78, I, f.33: '*in Tivoli in Santo Laurenzo*'.
– Antonio da Sangallo, the Younger, Florence, Uffizi, 1208A.
– Cod. Coburgensis, f.63 (Matz, 1871, 72).
– Cod. Pighianus f.308 (Jahn, 1868, 97).

LITERATURE: Hülsen, 1910 (*Cod. Barberinianus*, f.30ᵛ); Becatti, 1969, pp.519f., figs.13–14; S.Haynes, 1979, on *Kalathiskos*-dancers, with reference to BM 15th century drawing, fig.54.

90. Bacchus visiting the Poet Icarius ('Triclinium')

Roman copy after Greek neo-Attic relief or painting, c.100 B.C.? (Robertson, 1975)
London, British Museum (A.H.Smith, 1904, act.2190)

DESCRIPTION: The relief was much admired for its description of architecture and furniture, and is of great interest for historians of Greek drama. It is, however, mutilated, worn and restored; only by comparing it with complete versions of the same type (e.g. 90c; Naples, Mus.Naz.), as some Renaissance artists did, can we reconstruct its original appearance.

In its present state, the dramatic poet Icarius of Athens reclines alone on a couch (originally there was a reclining woman leaning on an elbow on the couch, looking towards him). With outstretched arm Icarius hails his divine visitor, Bacchus, who leads his retinue, now consisting of three tipsy satyrs with fat Silenus, playing a flute, in their midst. The last satyr on the right has three legs and seems to carry an odd bundle; this is all that is left of a drunken maenad who once accompanied him.

The figure of bearded Bacchus with one small satyr bending towards him to take off his sandals, and another, enveloped in his master's robe and supporting him from behind was a motif often used in Renaissance art, and is repeated in the Bacchic *krater* in Pisa (91), as are several of the satyrs (cf. 91b).

The scene takes place in front of a curtain attached to a low house with tiled roof and a wall. In the background is a long building, also with a tiled roof, running almost the width of the relief in perspective. The combination of decorative details, which distinguishes this relief from all the other thirteen known ones (Watzinger, 1946), consists of the satyr on the wall who decorates the long building with a garland, the Medusa's head flanked by tritons on the gable, the relief of a charioteer driving two horses and the four masks on the (restored) footstool.

The condition of the relief in the Renaissance is best understood from Dosio's drawing (Berlin *Skb.*, f.26; 90b), which shows vague areas to left and right, where the women should have been, reflecting damage. The diagonal line running from left to right might be thought to correspond to a mended crack in the relief, but turns out to be a tear in the paper.

HISTORY: The relief was known in Rome from at least the beginning of the 16th century in the Maffei Collection (Aspertini, Cod. Wolfegg; Heemskerck, *Skb.*, I, f.3ᵛ: *in situ*). Probably around 1600 it went to the Villa Montalto-Negroni, and was acquired by Charles Townley of London in the later 18th century. Entered the British Museum in 1805.

INTERPRETATIONS: Aspertini (Cod. Wolfegg, ff. 46ᵛ-7), 'Ripanda' (skb., Oxford, Ashmolean, f. 57ᵛ) and Falconetto (Vienna, Albertina, 13247; **90a**) are the first to interpret the solitary figure of the poet as a woman. Falconetto's adaptation suggests a matrimonial couch, presided over by a herm of Priapus, and a satyr with the torch of Hymen, god of weddings, while a noisy band of wedding guests approach (Buddensieg and Schweikhart, 1970, fig. 8, and p. 6, n. 25). Later, around the mid 16th century, interest centres on the *triclinium* (a room designated for three dining couches), as in the Lafréry engraving of 1548 **(90d)**.

REPRESENTATIONS: The large number of contradictory drawings after the relief fall into two major groups: the first shows it as it is now, without the two women; the second shows all the distinguishing details of the relief in common with the first group, but includes the two women, the reclining poetess with hair bound in a snood on the couch with the poet, and the drunken maenad supported by the last satyr on the right, and holding a tortoise-shell lyre.

The reasons for these major differences in drawings throughout the 16th century may be that the figures of the women were so badly damaged, as shown by

Dosio, that some artists preferred to ignore them and freely interpreted the poet alone on the bed as a woman (see INTERPRETATIONS above; Pozzo Windsor, 8488: Blunt, [1971], pl. 12, attrib. to Franco; and Pozzo Windsor, 8060: Vermeule, 1966, fig. 102, cf. figs. 100-1). It is thought that other more archaeologically-minded artists seem to have referred for the missing figure to the relief of the same subject now in Naples (**90c**), which had been well known in the early 16th century in the Sassi Collection, and was sold to the Farnese in 1546. In the Naples relief both women were intact, but parts of the retinue were also damaged.

REPRESENTATIONS WHICH CONFLATE THE LONDON AND NAPLES RELIEFS ARE:
- Fra Bartolomeo, sketch, Florence, Uffizi, 14544Fᵛ: concentrates on the central figures; no women.
- Roman, anon., second quarter of 16th century, London, BM, 1901-6-19-2 (Gere and Pouncey, 1983, cat. 348).
- Francisco de Hollanda, *Skb.*, f. 17.
- Anon., engraving for Lafréry's *Speculum* (Hülsen, 1921, cat. 46a; **90d**): '*Triclinarium Lectorum tripedis Mensae ...ex marmoreis tabulis graphica deformatio*'.
- Cod. Pighianus, f. 322ᵛ (Jahn, 1868, 59).
- Franco, Turin, Bibl. Reale, 14760, 31 B (Bertini, 1958, cat. 155): left side of relief, no retinue.

90b

LITERATURE: Robertson, 1975, fig.172b. For lists of representations, see Hülsen, 1933, p.6; and for 16th century adaptations, see Dacos, 1977, p.155 and index for the many stucchi and frescoes in the Vatican Loggie using individual figures. Watzinger, 1946, pp.78 and 82f. for types, interpretations and bibl. Schreiber, 1894, pl.xxxviiA, showing restorations superimposed on phot. Hauser, 1889, pp.189–99: 'Die sog. Ikarios-Reliefs', esp. pp.190–2, no.3 (BM); no.4 (Naples version). Flavio Biondo, *Roma triumphans* (Italian transl., Venice, 1544, II, p.73) on the *triclinium* in Antiquity; definitions. Blunt, 1939, pp.271–6 for later 16th century treatises on the *triclinium*. C.Picard, 1960–1. Handley, 1973.

91. Bacchic Thiasos

Relief on neo-Attic marble *krater*
Pisa, Campo Santo (Arias *et al.*, 1977, C24 est, pp.155–6, figs.207–11)

DESCRIPTION AND INTERPRETATION: Under a grape vine, dancing satyrs and maenads, and Silenus wield the *thyrsos*, play pipes, and a small satyr supports the heavily draped, bearded Bacchus, the celebrated figure which inspired Nicola Pisano. The figure types resemble some of those on the Icarius relief (90).

The vase had a 14th century inscription, removed in the mid 18th century, saying that it had been sent by Caesar for Pisan tribute money to the Romans (Vasari–Milanesi, 1906, I, p.32; Hülsen, 1933, p.43 and pl.xxiv). As if to illustrate the inscription, Francisco de Hollanda drew it with coins inside. The inscription added that Giovanni Rossi set it up on a column on top of a lion in March 1319, and it was he who made the Gothic lid, all of which was drawn by Dosio (91a). The lid was replaced with a classical one by Cosimo Cioli in 1604 (documents published by Morrone, 1812, II, p.276, no.20).

HISTORY: From 1319, it was in front of the Porta S.Ranieri on a column, resting on the back of a lion on a porphyry pedestal, standing on the steps of the Cathedral of Pisa (Dosio). The lid and vase were restored in 1604. It was taken to the Campo Santo in 1810.

REPRESENTATIONS:
– Nicola Pisano, marble pulpit, Pisa, Baptistry (Seidel, 1975, fig.2): Bacchus group as Patriach on right, supported by a boy.
– Francisco de Hollanda, *Skb.*, f.23ᵛ: vase with legendary tribute money inside, according to inscription.

– Dosio, Berlin *Skb.*, f.17 (91a): vase on lion and porphyry column, with inscription and Gothic lid drawn separately on same sheet.
– Lasinio, 1814, pl.LXI (91b).

LITERATURE: Dütschke, I, cat.132. Hülsen, 1933, p.12, no.43 with inscription and history. Seidel, 1975, esp. pp.379–84.

92. Bacchic Symposium ('The Torlonia Vase')

Large marble vessel adapting a Hellenistic frieze. 2nd century A.D.
Rome, Museo Torlonia (C.L.Visconti, 1884–5, cat.297)

DESCRIPTION: The heads and figures of the frieze and the base have undergone a series of restorations. The frieze consists of a reclining Bacchic company in a connected series of groups. A grapevine (modern addition) swings above their heads, their drinking bowls fill them with sensuous abandon, and inspire them to make music and love. Like a figure in a *triclinium* or banqueting scene (90), Bacchus raises his right arm to welcome and encourage the revellers; a maenad gives suck to a kid (now headless), and amorous couples brandish *thyrsoi*. An exhausted nymph is discovered, like Ariadne (80), by a satyr; Hercules, seen from behind on a lion's skin, offers his bowl to a reclining satyr. These advanced revelries are accompanied by music from double pipes, horn and lyre, played by satyrs.

The vase has an egg-and-dart rim; below the frieze, the gadrooned bowl curves under. Two pairs of satyrs' heads form the bases of the handles. The vase is supported on three mighty lions' legs and a central acanthus pedestal, all resting on a curved tripodal base, but this is a modern restoration.

HISTORY: At the beginning of the 16th century, it was in Trastevere in S.Francesco, according to Aspertini (Cod. Wolfegg). By the 1530s, it was in the Cesi gardens as a fountain, with a statue of Silenus pouring water from a winesack in to the bowl (Aldrovandi, 1556, p.124; Girolamo da Carpi, Cambridge, Mass., Fogg Mus., inv.1957, 188; Houser, 1979, pl. and cat.43; and see below, Heemskerck; Francisco de Hollanda). In the early 18th century it went to the collection of Cardinal Albani; c.1760 in Villa Albani; 1869 to Museo Torlonia.

REPRESENTATIONS:
- *Cod.* Escurialensis, f.49(3): vase, frieze with sleeping nymph.
- Aspertini, *Cod.* Wolfegg, ff.43ᵛ–44 (Bober, 1957, fig.55): *'a santo francesco in trastevaro'*. Figures reconstructed freely and out of sequence.
- Giovanni da Udine, Vatican, Loggie (Dacos, 1977, pl.LXXIXa): stucco of sleeping nymph.
- Raphael Workshop, Fossombrone skb., f.14: vase seen with frieze and satyr-head consoles.
- Heemskerck, *Skb.* I, f.25 (Hülsen, 1917, p.21, Cesi 66, fig.1): *in situ*, Cesi gardens.
- Francisco de Hollanda, *Skb.*, f.34 (Hülsen, 1917, fig.10): as Cesi fountain.
- Frans Floris Workshop, Basel *Skb.*, f.25 (Van de Velde, 1969, pl.12b): *'Back dat fonteynken'*.
- Cod. Coburgensis, ff.170 and 98 (Matz, 1871, 97; **92a and b**): whole sequence of frieze in the two drawings unrestored; f.189, 3 (*ibid.*, 96): whole vase with statue of Silenus in left profile; f.84, 2 (*ibid.*, 97).
- Naldini, c.1560, whole sequence of frieze 'restored' in three drawings, two in Oxford, Christ Church, Byam Shaw, 1976, cats.200 and 203, pl.125 (**92c**); and one in London, V&A (Ward-Jackson, 1979, cat.202ᵛ).
- Cambridge *Skb.*, f.52 (Dhanens, 1963, cat.46, fig.23) and f.98, not illus.
- Netherlands, second half of 16th century, Oxford, Christ Church, inv.1324, Byam Shaw, 1976, cat.1340: sleeping nymph, and satyr.

Engravings:
- F.Perret, 1581, for Lafréry's *Speculum* (Hülsen, 1917, fig.11).
- Franzini, 1587, pl.G14.
- Cavalieri, III–IV, pl.97.

LITERATURE: Hülsen, 1917, p.21, no.66 (Cesi) for history, list of representations, and literature. Dacos, 1977, pp.235–6 (list). The restorations will be discussed in detail by A.Nesselrath in his forthcoming edition of the Fossombrone skb.

93. Bacchic Symposium ('Ara Grimani')

Four late Hellenistic reliefs on sides of a Greek altar or candelabrum base. Greek, 2nd century B.C. Venice, Museo Archeologico, inv.263, Sala VI.21

DESCRIPTION: **(i)** Satyr kissing seated maenad. **(ii)** Maenad and satyr on bed covered with lion skin, another satyr with raised arm and wine cup on right. **(iii)** Maenad playing musical instrument *(trigonon)* on bed with satyr lying on lion skin, beating time to the music with a *thyrsos*. **(iv)** Maenad

seated, playing lyre, with standing satyr listening behind her.

There was an inscription on the altar in the Renaissance, by now illegible: 'HIC LOCUS SACER EST' ('This place is sacred'); Mommsen reported traces of it (Forlati Tamaro, 1969, p.15).

HISTORY: The 'Ara Grimani' was in the 1587 Grimani bequest to the city of Venice; no earlier documentation exists, but if it were known earlier to Correggio in Rome before 1523, it may have belonged to Domenico Grimani. It is, however, not recognizable in Domenico Grimani's inventory of 1523 (Perry, 1978, pp.241–2).

REPRESENTATION:
- Correggio, *The Rape of Ganymede: Jupiter and Io*, Vienna, Kunsthist. Mus., Gemäldegal., *Cat.* 1965, p.40f. Knauer suggests that the altar was known to Correggio in Rome and that the satyr from side **i** can be seen in *Ganymede*, and both this satyr and the maenad in *Io and Jupiter* (Knauer, 1970, figs.1–2).

LITERATURE: Knauer, 1970, pp.61–7 with bibl. and further examples of indirect borrowings; illustrates sides 1 and 2; all four sides illus. by D.Strong, 1976, pl.22.

AMOR AND PSYCHE

Amor's love affair with Psyche was celebrated in delightful and intricate detail by the second century A.D. writer, Lucius Apuleius, in *The Golden Ass* or *Metamorphoses*, in which the tale of Amor and Psyche is one of several within a longer narrative. It was much read and illustrated in the Renaissance.

Amor fell in love at first sight with Psyche, a mortal, the youngest daughter of a king. Amor did not reveal his identity to Psyche because his mother, Venus, was jealous of the girl's great beauty, and had given Amor orders to make her fall in love with the most hideous husband possible. Instead, Psyche was wafted to a magnificent palace where she lived in great luxury, attended by unseen servants, and was visited only at night by Amor, also unseen, who came to her as her mysterious husband. He forbade her to let her two prying sisters visit her. Psyche persuaded him to let them come, and listened to the jealous

sisters' advice to find out who her unknown husband was and to kill him, as Apollo's oracle had previously declared to the king that Psyche would marry 'a dire mischief, vigorous and fierce/… great Jupiter himself fears this winged pest'.

One night, overcome by curiosity, Psyche lit a candle as Amor lay sleeping, and was so dazzled by his beauty that her hand trembled, and a drop of hot wax fell on his shoulder, and he flew away. Psyche, who had pricked her finger on one of his arrows with which she had planned to kill him, had by then fallen in love.

The rest of the story concerns Psyche's search for Amor, impeded by cruel tasks imposed by Venus, which took her even into the Underworld. She received no help from the other gods who kept her very well informed but preferred not to get too involved. Only Amor, unseen, helped her out of one seemingly insurmountable difficulty after another, until at last she had accomplished Venus' orders. When Amor and Psyche were finally reunited, their wedding was splendidly celebrated on Olympus by all the gods. Jupiter decreed Psyche to be immortal and Amor to be her husband forever. The daughter born to them was called Voluptas (Pleasure).

The figures of Amor and Psyche appear frequently on Roman funerary monuments, conceivably as a promise of the divine love sought and found by the soul, only after the obstacles imposed on mortals have been overcome by death.

On a first century altar, Amor and Psyche appear as small children, each riding a musical centaur (**84**). On some sarcophagi they embrace as children (**96**), while on others they are shown as adolescents. In the relief known in the Renaissance as the *Bed of Polyclitus (Letto di Policleto; 94)*, the adolescents are tentatively called 'Amor and Psyche', but in Antiquity these figures may have had another identity.

In the Quattrocento, Apuleius' story could have been known from manuscripts of Boccaccio's 14th century *Genealogy of the Gods* (first printed in 1472) in a corrupt and moral-

ized version, owing not a little to the 5th century A.D. mythographers, Martianus Capella and Fulgentius, who imposed an elaborate symbolism on every aspect of the tale. Even before Apuleius' work first appeared in a Latin edition in 1469, the story of Amor and Psyche was painted on Florentine wedding chests *(cassone)* and panels (Vertova, 1979).

With Beroaldus' commentary on Apuleius (first edition Bologna, 1500) and the Italian translations of *The Golden Ass* which began to appear from early in the 16th century, the story of Psyche began to enjoy its greatest popularity with artists, and inspired many works of art, among them Raphael's incomplete cycle of frescoes (c. 1517 to 1519) in the Loggia of the Villa Farnesina for Agostino Chigi in Rome (Dussler, 1971, pp. 96–9, figs. 158–70); a widely circulated series of engravings (1530s) by the Master of the Die, who illustrated every scene with passages from the story as captions (Bartsch, XV, nos. 39–70); Giulio Romano's frescoes (1527–8) in the Sala di Psiche, Palazzo del Tè, Mantua (Hartt, 1958, figs. 226–52; Yuen, 1979); and Perino del Vaga's cycle (1544–5) in the Sala di Amore e Psiche, Castel Sant'Angelo, Rome (F. M. A. Gaudioso, 1981, I, pl. 10 and figs. 82–97; II, pp. 87–103 with drawings: figs. 54–66).

Renaissance artists, in depicting the story of Amor and Psyche, relied primarily on the text by Apuleius for their source. They naturally also drew on a wide range of visual sources from Antiquity without restricting themselves to the few examples known to them of this subject. While Raphael, Giulio Romano and Titian used the pose of 'Psyche' in the *Letto di Policleto* (**94**) for such figures as Hebe, Ariadne or Venus, it would seem that Amor and Psyche first appear together in the *Bed of Polyclitus* only around 1600 in a Florentine fresco cycle of the story of Psyche in the Villa Corsini at Mezzomonte near Florence.

LITERATURE: Collignon, 1877, for symbolism and a catalogue of antique monuments representing Psyche. Apuleius, 1950. Vertova, 1979, for ills. of Apuleius' story of Psyche in the Renaissance before Raphael and for the available texts, versions and interpretations in a Quattrocento and Medicean context.

94. Amor and Psyche
('il Letto di Policleto')
Roman relief with Hellenistic figure types
16th century copy, owner unknown (formerly
J. Hewitt)

DESCRIPTION: A much-admired relief, coveted by
collectors, which inspired figures in great works
of art, but was not copied in the usual sketch-
books.

Pirro Ligorio's description, perhaps of another
copy, interprets the figures as Vulcan and Ve-
nus:

This relief contains the old god Vulcan in bed,
with his arms and head relaxed, he shows him-
self to be overcome with sleep, and Venus, all
nude, is seated, turning her shoulders to us. She
twists and turns towards her consort, and with
her left hand uncovers him, and leans with the
right hand on the bed as if she wanted to enter it
by his side, and at the foot of the bed is a draped
figure who sleeps sitting up in a low chair, and
because of this it is called 'the bed of Polyclitus'.
('Libro di Antichità di Pirro Ligorio', Turin,
Archivio di Stato, vol. XIV; for full text see
Schlosser, 1941, p. 127, n. 55.)

The first use of the relief as Amor and Psyche seems
to come in the 17th century, with a fresco cycle of
their story in the Villa Corsini at Mezzomonte,
Florence.

HISTORY: The original owned by Lorenzo Ghiberti
is lost, but it still seems to have belonged to his
heirs when Raphael was sent to acquire it for Al-
fonso d'Este of Ferrara in 1517, without success
(Golzio, 1936, p. 54). Thereafter the history be-
comes obscure, owing to the number of bronze
copies, casts and marble variants recorded in the
literature. Either the original, or a copy, or both,
belonged to Giovanni Gaddi in Rome, and it may
have been the original which was then acquired by
Cardinal Ridolfo Pio da Carpi in Rome which later
passed to Cardinal Ippolito II d'Este of Ferrara.
Emperor Rudolf II bought it in 1603 from the
d'Este (inventory of 1607–11, no. 1805 G; Bauer and
Haupt, 1976, p. 95 with Renaissance inscription).
Lost in the Sack of Prague of 1630.

A bronze replica belonged to Pietro Bembo of
Padua, and a marble one to Cardinal de Granvelle,
which was later lost in Prague.

Two replicas exist, one in Rome in the Palazzo
Mattei, and the one illustrated here without know-

ledge of its present location. For a summary of the
history and literature, see Dacos (1977, p. 210).

REPRESENTATIONS:
– Michelangelo, Windsor, 12763 (Wilde in Popham
and Wilde, 1949, pl. 23, cat. 422 for evidence of in-
fluence of relief on Michelangelo's work): studies of
head and arms of sleeping 'Amor'.
– Tribolo, Florence, Bibl. Laur., floor mosaic (94b;
Goldscheider, 1951, fig. 146); cf. Michelangelo
School, Florence, Casa Buonarroti (Weihrauch,
1967, fig. 19): sketched on sheet with bronze
foundry model of a statue.
– Titian, Florence, Uffizi, 12907F^V (Rosand, 1975,
fig. 75, p. 245): 'Amor' (94a). See below, Titian's
Venus and Adonis.
– Bandinelli, Paris, Louvre, 129 (Beck, 1973, fig. 8):
head and arms of 'Amor'. The figure of 'Amor' was
frequently adapted in Bandinelli's work, as noted
by Roger Ward.

ADAPTATIONS:
(For fuller coverage see Dacos, 1977, pp. 210–12.)
– Ghiberti Workshop, Resurrection, bronze relief,
Florence, Baptistry, North Door (Krautheimer,
1956, pl. 53): soldier on right in pose of 'Amor', as
noted by Roger Ward.
– Giovanni Bellini, attrib., Orpheus, Washington D.C.,
NGA 598 (Shapley, 1979, II, pl. 27): female figure in
background, cf. 'Psyche'.
– Raphael, Rome, Villa Farnesina, Loggia di Psyche
(Camesasca, 1963, II, pls. 110 and 127): 'Psyche'
reversed as one of the Three Graces; and as Hebe in
The Banquet of the Gods; Raphael or Giulio Romano,
study for Hebe, Haarlem, Teyler Mus., A62 (van
Regteren Altena, 1972, cat. 12).
– Giulio Romano, Mantua, Pal. del Tè, Sala di Psyche,
fresco of Bacchus and Ariadne (Gombrich, 1966,
fig. 175): 'Psyche' reversed as Ariadne.
– Giulio Romano, The Infancy of Jupiter, London, NG
(Gombrich, 1966, fig. 172 and p. 126): 'Psyche' re-
versed and twisted around so that 'the nose turns in
the opposite direction of the toes'.
– Rosso Fiorentino, Dead Christ, Boston, MFA (Shear-
man, 1966, p. 156 and n. 29 for bibl. on the 'Letto'):
angle of head and hanging arm of Christ, cf.
'Amor's'. The same pose is adapted frontally for
Barocci's Deposition of Christ, Perugia, Duomo (ibid.,
fig. 51).
– Titian, Venus and Adonis, Madrid, Prado (Panofsky,
1969, fig. 159; pp. 150–1): 'Psyche' as Venus (94c).
See Rosand (1972, esp. pp. 538–9) for Adonis' hang-
ing arm.

LITERATURE: Schlosser, 1941, pp. 123–40; Dacos, 1977,
pp. 210–12 and pl. LV^b for adaption in the Vatican
Loggie.

95. 'Psyche' Crouching

Roman copy of a Hellenistic retrospective statue based on a Greek 4th century work

Rome, Museo Capitolino (Stuart Jones, 1912, pp. 98–9, Galleria 20)

DESCRIPTION: The winged, draped female figure turns and looks up as she crouches forward, fearfully clutching something to her breast with her right hand (both arms and right breast restored). The head is original, and although the pose is that of a Niobid (Schwarzenberg, 1977, fig. 122: replica in the Museo Bardini, Florence), the original attachments for the wings remain.

HISTORY: The statue was in the garden of Agostino Chigi's Villa Farnesina in Trastevere from the second decade of the 16th century; after the mid 16th century it was in the Villa d'Este in Tivoli and came to the Museo Capitolino in 1753 (see Canedy, 1976, p. 50).

INTERPRETATION: The pose was adapted in the engravings of the story of Psyche, illustrating Apuleius' *The Golden Ass* (Master of the Die, 1530s, Bartsch, XV, nos. 39–70). The statue of Psyche appears to have participated 'in person' in a sequence of the Psyche story ('The Opening of the Fatal Bottle'?) missing in the unfinished frescoed cycle in the Loggia di Psyche in the Villa Farnesina (Shearman, 1964, pp. 70–1).

REPRESENTATIONS:
– Italian, 16th century before 1520, Vienna, Albertina, inv. 111 (Stix and Fröhlich-Bum, 1932, III, cat. 137v; Schwarzenberg, 1977, fig. 110): 'nel orto agostino chigi', with wings (95a).
– Raphael, Rome, S. Maria del Popolo, Chigi Chapel, frescoed segment of soffit (Shearman, 1961, pl. 23a): adaptation.
– Girolamo da Carpi, Rosenbach *Album* (Canedy, 1976, R59, R60, R102).

Engravings:
– Master of the Die (Maestro del Dado), after Raphael, Bartsch, XV, p. 222, no. 64: free adaptation; cf. figure of Psyche in other episodes of the series.
– Cavalieri, III–IV, pl. 46: as in Farnese Collection. Schwarzenberg notes in the Warburg Census (1977) that Cavalieri's drawing must date from 1586, when Alessandro Farnese temporarily removed some of the antique statues out of the Villa d'Este.

LITERATURE: Schwarzenberg, 1977; Collignon, 1877, cat. 15, pp. 374–5 (description).

96. Amor and Psyche Embracing

Roman sarcophagus relief, 3rd century A.D.
Rome, Sant'Agnese fuori le mura (Matz and Duhn, II, cat. 2508)

DESCRIPTION: Two large flying amoretti hold a central shield with the portrait of Sant'Agnese, added in the 4th century. Below them lie Oceanus, the original Greek river god, holding a water reed, and Tellus (Gaia), the female personification of Earth, with a cornucopia. Between them are small figures of two children, a woman and a cock. Large figures of Amor and Psyche as children embrace at either end.

All the motifs of the sarcophagus were commonly known in the Renaissance from this and other examples. The flying amoretti holding a *clipeus* (or round shield) were often adapted in the Renaissance for holding *stemmae* (coats of arms) on marble friezes, doorways, tombs, or in the lower border of illuminated manuscripts. Oceanus and Tellus, or their types, inspired the reclining figures in the upper and lower frames of Ghiberti's East Doors for the Baptistry in Florence. The figures of Amor and Psyche appear frequently on late Roman sarcophagi. A famous statue of the pair now in the Museo Capitolino was not discovered until 1749 (Stuart Jones, 1912, pp. 185–6; Haskell and Penny, 1981, cat. 26, fig. 98).

HISTORY: Evidently known since Antiquity, the sarcophagus was altered to a Christian monument in the 4th century, and was later used as the antependium for the main altar of Sant' Agnese.

REPRESENTATION:
– Pozzo Windsor, X, f. 39, 8032 (Vermeule, 1966, p. 21): whole relief.

LITERATURE: Collignon, 1877, cat. 194, pp. 438–9.

HERMAPHRODITE

The cult of Hermaphroditus flourished in the Hellenistic period, particularly on Cos and Rhodes.

Ovid (*Metamorphoses* IV, 285–388) spins out the events with charming embellishments, but briefly the story is this: Hermaphroditus

was the son of Mercury and Venus (Hermes and Aphrodite). When he was fifteen, he wandered off from Mount Ida, where he had been brought up by the Naiads, and became enchanted by a transparent pool in Caria. It was the haunt of an unusually languid nymph, Salmacis, who longed to possess him. Unable to control herself, she plunged into the pool while he was innocently bathing, and embraced him. In the course of the struggle, for he did not know what love was, she prayed that they might never be separated. Thus their two bodies were joined in one and they became both man and woman. In Antiquity the waters of the spring of Salmacis, near the Mausoleum of Halicarnassus on the mainland opposite Cos, were known to have an ennervating effect.

See Dacos (1977, p.236) for the widespread diffusion of the motif, on a Medici gem, of a reclining hermaphrodite with amoretti.

LITERATURE: Delcourt, 1958.

97. Hermaphrodite Standing

Roman copy of a Greek-Hellenistic statue
Rome, Villa Doria-Pamphili (Calza *et al.*. 1977, cat.75)

DESCRIPTION: The pose, drapery and figure type are probably derived from a late Hellenistic variant of a figure of Venus (cf. **15, 16**). In the Renaissance the Hermaphrodite lacked head and arms, and the drapery which billowed behind, clung to the right thigh, leaving the entire torso exposed. It was later restored as a Venus, with the drapery covering the genitals.

HISTORY: Either this or another replica was known c. 1500 in the collection of Mariano Astalli in Rome, and described by 'Prospettivo Milanese' (stanza 18):

> Ecci un inclita po hermafrodita
> producta fu dalli superni dei
> e parte un sottil velo ha circuita...

('Here is a famous hermaphrodite, offspring of the eternal gods, and surrounded in part by a thin veil...')

Recorded near S.Marco, c. 1540 (Floris), it was in the Villa Pamphili by the early 17th century.

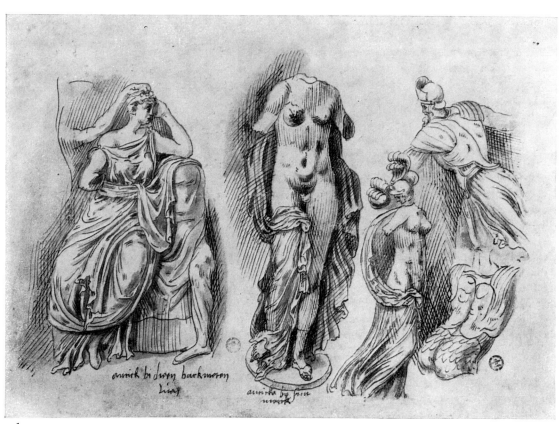

97b

REPRESENTATIONS:
- North Italian, c.1503?, London, BM, 1946-7-13-1262V (Popham and Pouncey, 1950, cat.352V): left frontal view, unrestored (97a). For recto and probable date, see Apollo Belvedere, 28.
- Frans Floris' Workshop, Basel *Skb.*, f.29V (Van de Velde, 1969, pl.13a): '*anticka by sint marck*'. Two views, unrestored: frontal and right profile with veil billowing out behind (97b).
- G.G. dei Rossi, 1649, pl.I: unrestored.

LITERATURE: Matz and Duhn, I, cat.845.

98. Hermaphrodite Sleeping

Roman copy of a late Hellenistic statue
Rome, Villa Borghese (Helbig, II, cat.1978)

DESCRIPTION: This late replica, restored in the 18th century (head, mattress, right elbow and left leg), is one of several which have come to light since the Renaissance; the others are in the Louvre, and in the Terme Museum, Rome. In any case, it serves as an example of a lost statue described by Ghiberti, who saw it when it was discovered in a drain in Rome. In his *Commentaries* III, 1, he describes it as being the size of a thirteen-year-old girl:

> The figure was represented on a mound of earth over which a small sheet was thrown. The figure was lying on the sheet and was turned in a way to show both the masculine and feminine characteristics. The arms rested on the ground and the hands were crossed one over the other. One of the legs was stretched out and the big toe had caught the cloth, and the pulling of the cloth was shown with admirable skill. It was without a head, it lacked nothing else. There were many subtleties in it, the eye discovered nothing unless with the touch the hand revealed it.

HISTORY: All that is known from Ghiberti's report is that it was found in a drain near S.Celso (between the Ponte Sant'Angelo and the Medici Bank), and that a sculptor (unidentified) had it brought to S.Cecilia in Trastevere where he was working on the tomb of a cardinal, and he had some marble removed from it the better to transport it to Florence. Julian Gardner notes that the only surviving Cardinal's tomb in S.Cecilia of relevant date is Adam of Easton's (d.1398; see Krautheimer, 1956, pp.357-8, n.27).

According to Ghiberti's calendar *all'antica*, the Hermaphrodite was discovered 'in Olympiad 440' which has been variously interpreted as 1420 (Lanciani, *Scavi* I, p.46); 1425-30, probably 1429 (Krautheimer, 1956, pp.357-8); and 1445 (Schlosser, 1912, II, pp.187-8).

REPRESENTATIONS: No direct influence of the statue has been noted so far in Renaissance art or drawings, but the type was influential in the 17th century. A drawing attributed to Rubens shows it from above (98a; London, BM, 1895-9-15-1055; Rowlands, 1977, cat.18; and New York, MMA: Jaffé, 1977, fig.290); Velázquez adapted it in the Rokeby Venus (London, NG, 2057); Susini copied it in a bronze statuette (New York, MMA; Avery and Radcliffe, 1978, cat.189); and Canova's *Sleeping Nymph* (1823-4) in London, V&A, is based on the replica in the Terme (Pope-Hennessy, *V&A Cat.*, 1964, cat.701).

LITERATURE: On the antique type, see Havelock, 1971, cat.89 (Terme example illus.). Robertson, 1975, with later evocations, pp.551ff. and fig.176, illus. the Louvre example; cf. Haskell and Penny, 1981, cat.48, fig.120; for our 98 see their p.235, no.2. On Ghiberti's replica: Schlosser, 1912, I, pp.61f.; II, pp.187ff.; (Ghiberti's MS in Florence, BN, Cod. Maglibecchiano XVII, n.33). Holt, 1958, I, pp.163-4, (transl. of Ghiberti's whole passage on which the transl. here is based).

NEREIDS

These alluring nymphs of the sea, fathered by a primeval marine deity, Nereus (himself a son of Pontus and Tellus) with an Oceanid named Doris, held a special popularity in Greek and Roman funerary art. And there were enough of them to create happy throngs in marine *thiasoi* (processions) disporting themselves on Roman sarcophagi; classical mythographers number them optimistically at one hundred, though fifty is their usual number (Hesiod, *Theogony*, 240ff., for example, cf. Virgil, *Georgics* iv, 334ff.). Some Nereids enter handbooks of myth in their own right: Thetis (mother of Achilles); Galatea, Amphitrite, among others. But an anonymous crew is borne over the ocean waves–they are scarcely 'abducted', no one has ever navigated with such nonchalance and sensuous abandon–on the backs of tritons who are engagingly

humanoid, or riding sea-animals of every description, accompanied by amoretti representing, like themselves, the souls of the departed carried off to eternal happiness in the Isles of the Blessed. The Renaissance could not help but grasp underlying meanings of such assemblies which flooded Italian sepulchral art from the Greek colony of Tarantum (which Horace calls 'Neptune's colony') by the 4th and third centuries B.C. Jan Białostocki has shown the penetration of funereal symbolism during the Renaissance in regions remote from classical tradition like Poland, while Kenneth Clark has brought out nereids' universal formal, not to mention erotic, attraction as nudes in artfully contrived poses.

LITERATURE: Białostocki, 1967; Clark, 1955; Rumpf, 1939.

99. Nereids and Tritons: the Marriage of Neptune and Amphitrite?

Sarcophagus front. Roman, early 3rd century A.D. Vatican, Giardino della Pigna (Amelung, *Kat.*. I, p.828, no.34)

DESCRIPTION: A sea *thiasos* is centered on an almost heraldic presentation of Neptune in his *quadriga*, viewed frontally with the steeds fanned out to either side, the flukes of their tails waving above their heads in sprightly accompaniment to the ends of the god's mantle which is blown up into an arch from his upcast arms; the god is otherwise nude. Among the waves, where dolphins and amoretti play in response to a swarm of amoretti scattered through the air, two tritons flank the chariot bearing semi-clad nereids and amoretti on their tails (the left-hand nereid engagingly presented from the back in marked *contrapposto*). At either edge the nereids are borne along by sea-bulls. Because the one at left sits sedately and pulls her veil aside in a gesture with nuptial connotations, she may represent Amphitrite escorted into Neptune's presence. The right-hand figure has grasped the neck of her mount and is seen in profile, floating upward, her full nudity in relief against her welling drapery in a pose of striking sensuality.

HISTORY: Abrasion of the surface speaks of centuries of exposure to the elements. At the end of the Quattrocento, if not earlier, the sarcophagus

was at S.Maria in Aracoeli (Aspertini, Cod. Wolfegg). By the 18th century it was in the Palazzo Lancellotti and was acquired by the Vatican from there between 1834–42.

REPRESENTATIONS:
Drawings include:
- Italian, 15th century, London, BM, 1946-7-13-2*ᵛ: the chariot, and recto: the triton at right and group left of chariot.
- Aspertini, Cod. Wolfegg, ff.29ᵛ-30, above (with transposed inscription of locale, see **103**): '*a Larecielo su a campodoio*'.
- Pupini, Edinburgh, NG, Andrews, 1968, RSA 258, fig.703: central and two flanking groups.
- Cod. Coburgensis, f.120 (Matz, 1871, 176).
- Pozzo Windsor, VI, f.48, 8602.

ADAPTATIONS:
- The nereid of the right edge apparently used by Ghiberti for the figure of Eve created from Adam's rib on his East Doors, Baptistry, Florence (Krautheimer, 1956, pls.82, 83b).
- North Italian, late 15th-early 16th century, bronze plaquette, *Neptune in his Chariot*, c.1480, Washington D.C., NGA, Kress Collection (Pope-Hennessy, 1965, fig.294, no.354): the use of the sarcophagus image illustrates the application of such models for plaquettes, in addition to casts and adaptations of ancient gems.
- Falconetto, frieze, c.1500, from Casa Vignola, Verona (Schweikhart, 1975, *Arte Veneta*, fig.5): tritons hold *clipeus* in centre instead of Neptune's *quadriga*; conflation with other reliefs.
- Leonardo, Windsor (Clark–Pedretti, 1968-9, I-II, cat.12570; Clark, 1969, fig.28): adaptation of central group (**99a**).
- Raphael Workshop, Vatican Loggie (Dacos, 1977, pilaster XIb, pl.CXVIIIb): adaptation.

LITERATURE: Robert, 1901, *RM*, pp.211, 228, pl.IX; Rumpf, *ASR*, V, 1, pp.45f., cat.116, p.276; Krautheimer, 1956, Appendix A, no.25; Dacos, 1977, p.276.

100. Nereids and Tritons with the Triumph of Neptune

Sarcophagus front, in two fragments. Roman, second half of 2nd century A.D.
(i) Berlin, Schloß Klein-Glienicke (Goethert, 1972, cat.114, pl.48); **(ii)** Rome, Villa Medici (Cagiano de Azevedo, 1951, cat.37);

DESCRIPTION: The sarcophagus was already fragmentary during the Renaissance; only a piece showing foreparts of Neptune's team and the two tritons who guide it (Schloß Klein-Glienicke) and part of

the right corner (Villa Medici) seem to be preserved. The Codex Coburgensis (**100b**) documents it in the 16th century: a joyous train of marine beings rollicks across the front of the sarcophagus from left to right (only the left-hand group of a sea-centaur carrying a nereid seen from the back counters with movement toward the left) in the vanguard and wake of Neptune in his chariot drawn by hippocamps conducted by two tritons. The god is nude except for a scarf tossed over his left shoulder; in his right hand he probably brandished a trident, as he is shown restored in several Quattrocento adaptations. Four sea-centaurs, including a youthful one just before the chariot group who holds a little amor on his shoulder, bear as many nereids in various poses (one completely nude with the garment that usually masks the lower body welling in an arch over her head, another seen in profile at the right edge) all accompanied by amoretti flying about or perched like gulls at rest. The sea-centaur immediately behind Neptune seems to have carried a large *krater* for wine on his shoulder. The way in which the dolphin-infested waters swirl about the finny legs of this marine horde was particularly appreciated by Quattrocento artists.

HISTORY: The extraordinary popularity this relief enjoyed during the 15th century, despite its fragmentary condition, indicates that it must have been displayed in some public location. By the 16th century it had come into the possession of the della Valle family. After the Medici purchased the bulk of the della Valle-Capranica antiquities in 1584, one piece was made into a *pasticcio* with other della Valle nereid fragments and used to ornament the exterior of the Villa Medici. Prince Karl of Prussia assembled his antiquities for Schloß Klein-Glienicke near Potsdam in the period 1830–50.

REPRESENTATIONS:
Drawings and engravings include:
– 'Ambrosiana Anon.', Milan, Bibl. Ambr., F 265, inf.92 (Schmitt, 1960, fig.99): left and right of chariot transposed, figures only, unrestored.
– Miniature by Attavante de Attavantibus, 1483, in a Missal for Bishop James of Dol, Lyons, Bibl. Mun., MS 5, 123, f.6ᵛ (Bober, 1964, fig.5): 'restored'. **(Fig. 15).**
– Early 16th century drawing, formerly attrib. to Mantegna School, (Bellini?), Paris, Ecole B–A, 190: group of hippocamps and tritons, reversed.
– Anon., early 16th century, formerly attrib. to Giulio Romano, Eton College Lib., Topham Albums, B.N.9, 38: unrestored, chariot group and left half **(100a).**

– Roman School, early 16th century, Windsor, 323, 324 (Popham and Wilde, 1949, cats.1137–8): left portion and the hippocamps and their grooms.
– 'Enea Vico', London, BM, 1946–7–13–582 (Bober, 1964, fig.3): 'restored'.
– 'Maarten de Vos' Skb., f.XII (Rumpf, *ASR*, V, 1, cat.117, fig.72; Netto-Bol, 1976, p.59, no.1).
– Franco, London, BM, 1946–7–13–346 (Bober, 1964, fig.4; Gere and Pouncey, 1983, cat.140): left two-thirds.
– Girolamo da Carpi, follower of, London, BM, 1956–2–16–5, above (Gere and Pouncey, 1983, cat.170): detail.
– Girolamo da Carpi, Rosenbach *Album* (Canedy, 1976, R110, R144, R146?): left two-thirds and details.
– Cod. Coburgensis, f.136 (Matz, 1871, 177; Rumpf, *ASR*, V, 1, cat.117, fig.31; Schmitt, 1960, fig.100) **100b**: whole damaged relief.
– Pozzo Windsor, VI, f.53, 8607: already in a *pasticcio*, together with two other fragments of nereid sarcophagi: Rumpf, *ASR*, V, 1, cat.102 (drawn by G.F.Penni and Pierre Jacques) and cat.201 (drawn by Gentile da Fabriano, Rotterdam, Mus. Boymans van Beuningen, J 523ᵛ; Schmitt, 1960, fig.57, cat.23) from the della Valle Collection.
– Engraved in 'Marcantonio School' print, the chariot group (Bober, 1964, fig.8).
– Bernardino Campi, Oxford, Christ Church, 1354 (Byam Shaw, 1976, cat.1117, pl.682): 'restored' and adapted.

ADAPTATIONS INCLUDE:
– Miniature for frontispiece of the *Trionfi* in Petrarch edition, 1472, of *Sonetti, Canzoni e Trionfi*, Milan, Bibl. Triv., Petr.2, (Bober, 1964, p.48) attrib. to the Master of the Putti (Canova, 1966, fig.87; Armstrong, 1981, cat.21), see also initials in his Pliny. Canova's theory that this Maestro is Marco Zoppo is supported by a drawing, formerly in the Loeser Collection, Florence, attrib. to Zoppo, of Neptune and tritons given musical instruments, dependent on the relief, although figures move to the left (Berenson Archives phot.).
– Giuliano da Sangallo, fireplace of the Pal. Gondi, Florence (Bober, 1964, fig.5; fine phots. in Bocci and Bencini, 1971, pls.24–25).
– Falconetto, Aquarius fresco, Mantua, Pal. di Bagno, Salone del Zodiaco (Bober, 1964, fig.7).
– Mantegna, engraving, Battle of the Tritons (cf. Bober, 1964, p.48; Hind, 1948, VI, pls.494–5).
– Venetian, late 15th-early 16th century, bronze plaquette, related to Mantegna style, Washington, NGA, Kress Collection (Pope-Hennessy, 1965, no.339, fig.270): chariot group reversed.
– Leopardi, bronze reliefs on Standard bases, 1505, Piazza S.Marco, Venice (Jestaz, 1982, fig. on pp.28–9): adaptations.

– Falconetto, chiaroscuro frieze, Verona, Casa Vignola (Schweikhart, 1975, *Arte Veneta*, fig.1): symmetrical adaptation.

LITERATURE: Rumpf, *ASR*, V, 1, cat.117; Schmidt, 1968; Bober, 1964; Schmitt, 1960, pp.131–2, no.24.

101. Nereid mounted on a Hippocamp

Statue. Roman copy of a Greek 4th century or early Hellenistic Muse, adapted as a nereid
Florence, Uffizi (Mansuelli, 1958, I, cat.97)

DESCRIPTION: A spirited hippocamp prances to our right, his body shaped in serpentine coils (the flukes of his tail, finny forelegs and muzzle with its reins all restored). Upon his back a semi-draped sea-goddess, her head and right arm with attribute restored, sits placidly in a pose originally created for a Muse, legs crossed at the ankles, steadying herself with left arm braced upon her mount's back.

HISTORY: At the beginning of the 16th century, the statue was in the collection of Angelo Colocci at Rome. Following his death in 1549, it still stood in one of his houses then owned by a nephew (Aldrovandi), while Cavalieri engraved it at the Villa Medici before 1594. Variously known as Doris or

Galatea or Cymothoe, the Nereid rode her hippocamp in the Medici gardens until the group was removed to Florence in 1780.

REPRESENTATIONS:
– North Italian, c.1500, (Mocetto?), Cambridge, Mass., Harvard, Fogg Art Mus., 1932.303 (mis-identified in Mongan and Sachs, 1940, p.70): 'restored' **(101a)**.
– Frans Floris Workshop, Basel *Skb.*, f.25 (Van de Velde, 1969, pl.13b): unrestored **(101b)**.
– Cavalieri, III–IV, pl.53: '*Cymothoe in Palatio M.Ducis Etruriae*'.

LITERATURE: Aldrovandi, 1558, p.285: '*una donna mezza ignuda assisa sopra un mostro marino*' (in an annotated edition of the text P.P.Bober deals with earlier evidence that the group was interpreted in connection with myths of Proteus, or Arion). Bober, 1977, p.225, n.14. For antique gems which copy the motif, see Kurz, 1973.

102. Nereid embraced by a Triton

Sarcophagus fragment. Roman,
mid 2nd century A.D.
Grottaferrata, Museum of the Abbey (Rumpf, *ASR*, V, 1, cat.151)

DESCRIPTION: In this fragment, which may be the vignette of a garland sarcophagus (cf. **54**) or part of

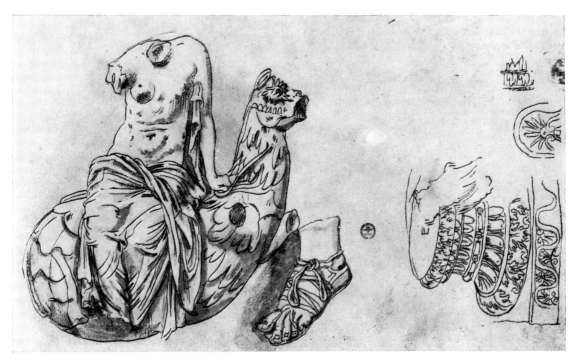

101b

a cover, a triton is presented in back view as he clasps a nereid whose cloak is cast back as a frame about her nudity. A little amor perched at right on one of the coils of the triton, makes a contrast to the sinuous *contrapposto* of these figures as he eagerly reaches forward to help unveil the half-yielding, half-resistant captive.

HISTORY: The sarcophagus fragment was visible in the second half of the Quattrocento on the Quirinal in Rome, presumably in the gardens of the Colonna family who lived on the slope adjacent to SS. Apostoli. It is uncertain when the piece was removed to the Badia at Grottaferrata which was reconstructed under Pope Pius V.

REPRESENTATIONS:
- Ambrosiana Anon., Milan, Bibl. Ambr., F.214 inf.2 (Schmitt, 1966, cat. and pl.29).
- Venetian, early 16th century, formerly attrib. to Jacopo de' Barbari, Oxford, Christ Church, Byam Shaw, 1976, cat.713, pl.407.
- *Cod. Escurialensis*, f.34 (**102a**): 'in chavagli', another drawing on the verso is its reverse, apparently traced through the folio.
- Pinturicchio, ceiling coffer, Pal. dei Cavalieri del Santo Sepolcro, formerly of Domenico della Rovere (Redig de Campos, 1962, fig.9).
- Jean Goujon, relief on his Fountain of the Innocents in Paris (du Colombier, 1930, fig.1, pp.27f.): reversed motif.

LITERATURE: Dacos, 1961, pp.143–50, with pls. of all representations above.

103. Nereids and Sea-Centaurs with Sea-Creatures

Sarcophagus. Roman, early Antonine
(mid 2nd century A.D.)
Paris, Louvre (Froehner, 1869, cat.438; MA 342)

DESCRIPTION: Converging towards the centre of the front face, a marine *thiasos* (procession) moves over a sea peopled with dolphins and amoretti at play, four half-nude nereids, one holding a *cithara*, on a sea-goat and three sea-centaurs, two of whom are old and bearded. The youthful sea-centaur balances a little amor on his shoulder and clasps an anchor; his companion at the right leads a sea-bull and carries a chest on his head. Tritons in the background help to control the procession, while more amoretti fly above the happy throng of nereids disposing themselves in sinuous poses – the second

from the left twisted about to show off her back – with heads moving in alternating rhythm from outward-facing to inward-facing.

HISTORY: From some indeterminate date the sarcophagus was visible in the church of S. Francesco a Ripa in Trastevere where its presence is documented at the end of the Quattrocento. It remained in the church well into the 17th century (P. Santi Bartoli, 1693, pls.31–2), but was removed to the Capitoline Museum in the 18th century; it was ceded to France in the Treaty of Tolentino, 1797.

REPRESENTATIONS:
- *Cod. Escurialensis*, f.5v: 'Insanfra(n)ceschoi(n) testeverj'.
- Ghirlandaio, *Judith*, Berlin-Dahlem, Staatl. Mus., Gemäldegal., no.21: the central group is reproduced in grisaille in the background (see **83**, left end).
- Aspertini, Cod. Wolfegg, ff.29v–30, below (Rumpf, *ASR*, V, 1, fig.68).
- 'Bambaia' Berlin *Skb*. f.5v (Dreyer and Winner, 1964, fig.38): right half.
- Girolamo da Carpi, Rosenbach *Album* (Canedy, 1976, R 85, below): detail of right-hand group.
- Cod. Coburgensis, f.25 (Matz, 1871, 175): unrestored.
- Pozzo Windsor, VI, ff.44–44v, 8598 (Vermeule, 1966, p.40) and f.52, 8606 (*ibid.*, p.41, fig.153); X, f.111, 8104 (*ibid.*, p.69).
- Perrier, 1645, pls.12–3: reversed, 'restored'.

LITERATURE: Rumpf, *ASR*, V, 1, pp.56f., cat.132, pl.XXXIX.

104. Nereids and Sea-Centaurs: Marine Thiasos

Sarcophagus front. Roman,
end 2nd–early 3rd century A.D.
Siena, Museo dell' Opera del Duomo, inv.136
(Rumpf, *ASR*, V, 1, cat.67)

DESCRIPTION: In the centre a bust of the deceased is displayed in a shell-medallion; beneath it three putti are at play. Two nereids riding on ichthyocentaurs contrive to hold up the shell, flanked in turn by further groups and sea-creatures. The nereid at far right is seen from the back, as is one young triton holding up a sea-panther.

HISTORY: Exposed in Siena since the Middle Ages, the whole sarcophagus was used as a basin in the sacristy of the Duomo in the early 16th century according to Sigismondo Tizio writing at the time

(Cristofani, 1979, p.114). Later the front was sawn off and at the time of Gori it was incorporated in a portal leading to the Piazza alla Bottega degli Scultori (*Inscriptiones Etruriae* III, 1743, pl.43).

REPRESENTATIONS: No Renaissance drawings seem to exist. The sarcophagus is included here because it has become a handbook illustration of Nicola Pisano's borrowings from antiquities at hand; several figures, including the nereid seen from the back, were taken over in his reliefs for the Siena pulpit.

LITERATURE: Nicco Fasola, 1941, pl.7; Seidel, 1975, pp 343–4, n.120; Cristofani, 1979, cat.132.

TRAGIC MYTHS

Tragic myths adapted by the Greek dramatists of the 5th century B.C. appear on Roman sarcophagus reliefs of the second and third centuries A.D. These provided important sources for Renaissance artists. Aeschylus, Sophocles and Euripides freely interpreted the traditional myths and imparted a noble grandeur to the human problems embodied in them. Their works, or adaptations of them by later writers, form the literary sources of the stories depicted on the sarcophagi. The plots involved the legendary heroes and royal families of ancient Greece, whose destinies were controlled by the gods, the result of whose interference could be good or bad. Their sagas were performed in plays with few actors and with such gravity that the audience left the theatre with a profound sense of shared emotions akin to religious experience.

Scenes from the plays, most of which are now lost to us, were illustrated in Antiquity on vases and perhaps in illuminated bookrolls which do not survive but may have been available to the craftsmen who carved the sarcophagi. Other formal sources for the sarcophagus reliefs may have included reliefs on silver and clay cups, and on Etruscan cinerary urns.

On the front of a sarcophagus two or more scenes from a tragedy would be represented, uniting, often in arbitrary sequence, the most dramatic moments from a well-known plot.

Supplementary episodes, often from other plays or myths, would occupy the short ends and cover.

LITERATURE: Sichtermann and Koch, 1975, pp.9–13, for use of Greek themes on Roman sarcophagus reliefs; bibl.; and also Froning, 1980, pp.322–41, for the iconographical tradition. Brilliant, 1984.

IPHIGENIA

When the Greek troops under the leadership of Agamemnon were mustered at Aulis, the goddess Artemis (Diana) sent an unfavourable wind that prevented them from setting sail for Troy. The soothsayers declared that a good wind could be obtained only if Agamemnon sacrificed his daughter, Iphigenia, to appease the wrath of the goddess whom he had offended. Despite his great reluctance, Agamemnon was at last forced to agree to do this and summoned Iphigenia to Aulis on the pretext that she was to be married to Achilles. When the girl was just about to be killed, Artemis took pity on her and carried her off to be her priestess in Tauris, leaving a deer on the altar in her place. The story was movingly dramatized by Euripides in his *Iphigenia in Aulis* (see below, p.136).

Events turn out quite differently in Aeschylus' *Agamemnon*, for here Artemis does not intervene at the sacrifice and Iphigenia's death adds to Clytemnestra's motives for killing her husband.

105. Iphigenia prepared for Sacrifice

Relief on a small round altar: 'The Ara of Cleomenes'

Roman, 1st century B.C. after Greek 4th century prototype by Cleomenes?

Florence, Uffizi (Mansuelli, 1958, I, cat. 116).

DESCRIPTION: The group which moves around the sacrificial altar is described by Euripides at the end of *Iphigenia in Aulis*. The soothsayer Calchas who conveyed the fatal oracle from Diana (Artemis) is dressed as a *victimarius* at the sacrifice with his robe tied around his waist. He approaches Iphigenia to cut a lock of her hair thereby consecrating her for sacrifice. Iphigenia comes towards him, resigned, head veiled and arms in the attitude of mourning (cf. **116**) with one hand to chin and lower arm (restored) across her waist (**105i**). She is followed by a nude youth supporting her left elbow. Turning away from the scene, supporting his arm on a staff with hand raised to head, is Agamemnon (**105ii**): 'not having any way in which to show his grief … he threw a drape over his head and let his most bitter grief be imagined even though it was not seen' (Alberti-Grayson, 1972, II, no. 42; cf. Quintilian, *Institutio oratoria* II, xiii, 13 and Pliny, *Natural History* XXXV, 73). A plane tree separates Agamemnon from Achilles who stands behind Calchas, with a foot on a rock, holding a cup and basket of fruit.

HISTORY: In the 18th century it was found in the *cortile* of the Villa Medici at Castello, which was rebuilt in the 16th century for Cosimo I, but which had been in Medici possession since 1477. The early history of the altar is not documented, although it appears that the figure type of Iphigenia was known to Ghiberti, and that of Agamemnon to Donatello. The altar entered the Uffizi in 1772 (Dütschke, III, cat. 165; Mansuelli, 1958, I, cat. 116).

REPRESENTATIONS:
- Ghiberti, Florence Baptistry, East Doors, Isaac panel, bronze relief, figure of Rebecca mourning, **105a** (Krautheimer, 1970, pls. 94, 97b, pp. 347, no. 41b; cf. no. 41a (**116**)).
- Donatello, Florence, S. Lorenzo, bronze pulpit, Mary Magdalene at the Tomb with drapery over her head (Janson, 1963, pl. 112): possible adaptation of the figure of mourning Agamemnon (**105b**).

ALSO TO BE NOTED: Although not taken from this altar, it is interesting to see the diffusion of the motif of the four figures of Achilles, Calchas, Iphigenia and the nude youth in the Byzantine ivory 'Veroli Casket' of the 10th or 11th centuries, London, V&A, inv. 216-1865 (Weitzmann, 1951, fig. 214 and pp. 169–74).

LITERATURE: For the antique altar and the literary source: Loewy, 1929, pp. 1–41, esp. p. 4, figs. 1, 6, 9. For references to the altar and for the use of antique motifs of covering the head in sorrow in the Renaissance and later, see McGrath, 1978, pp. 256–9.

ORESTES

Orestes was the son of Clytemnestra and Agamemnon, the leader of the Greek expedition against Troy. When Agamemnon returned victorious from Troy, Clytemnestra at first appeared to receive him warmly, but then, with the help of her lover, Aegisthus, treacherously slew him. This murder proved critical for Orestes, whose life was henceforth to be dominated by the need for revenge, expiation and redemption.

Orestes, only a child at the time, was smuggled out of Mycenae when his father was murdered. It was his duty to avenge his father's death and the god Apollo insisted that he fulfil it. The burden lay heavily upon him as he grew up in exile.

When he was fully grown, Orestes set out to accomplish his revenge. Clytemnestra now ruled Mycenae with her paramour, Aegisthus. They lived in daily fear of Orestes' return.

Finally Orestes arrived, accompanied by his loyal friend, Pylades. He slew his father's murderers and so accomplished the mission that Apollo had laid upon him. But in order to do so, he had been obliged to slay his own mother and this roused the Furies, terrifying spirits devoted to persecuting those guilty of shedding kindred blood. Orestes fled and they pursued him. He came to the sanctuary of Apollo at Delphi and implored the god to help him, for he had been obeying Apollo's command when he incurred the stain of blood-guilt. Apollo purified him and, according to Aeschylus (*Eumenides*), sent him to Athens, where Athena appeased the outraged Furies so that Orestes was released from their terrors.

According to the tradition embodied in Euripides' *Iphigenia in Tauris*, Orestes had to perform one further task: he had to fetch the idol of Artemis from the Taurians. Traditionally, all strangers were sacrificed to this statue, and Orestes and Pylades were in mortal danger until they discovered that the priestess who was about to slay them was in fact Orestes' long-lost sister, Iphigenia. With her help all three made their escape taking the idol with them. Thus finally Orestes achieved redemption.

The terrible retribution claimed by Orestes from his own mother provided the theme for many Greek tragedies. Three of them have survived: the *Libation Bearers* of Aeschylus, the *Electra* of Euripides and the *Electra* of Sophocles. Aeschylus' *Eumenides* and Euripides' *Iphigenia in Tauris* and *Orestes* deal with later episodes in Orestes' story.

LITERATURE: Scherer, 1963, pp.132–40.

106. Orestes

Roman sarcophagus, 2nd century A.D.
Rome, Palazzo Giustiniani (Robert, *ASR*, II, cat.156)

DESCRIPTION: The relief was greatly admired by Renaissance artists not for the story of Orestes' revenge, as the subject seemed to be a mystery to them, but for the inspiring poses of the figures. The sleeping Furies, the recoiling or cowering servants, Pylades on the left and two nude figures of Orestes: in the middle with his arm crossing his chest in a backhand swipe of the sword, and on the right leaping over a sleeping Fury as he comes from Apollo's altar to execute his revenge; and the bodies of Aegisthus and Clytemnestra in the foreground violently slain–these were drawn separately, or used by generations of artists who transposed the figures, freed from their original emotional context, into new works of art. Raphael and his circle, and Titian, were most deeply moved by the figures on this relief.

The snakes which identify the Furies in other sarcophagi of the type, in the group on the left and behind the curtain, are missing here.

The ends show other episodes in Orestes' story. The left end shows Iphigenia facing Orestes and Pylades with a water jar on the ground. This is a scene from Euripides' *Iphigenia in Tauris*, often represented on Orestes sarcophagi. The right end shows a Fury and Athena with a ballot jar between them, from the last scene of Aeschylus' *Eumenides*. Both end reliefs are illustrated by Robert, and by Rizzo (1905, pp.25–6); see also Pozzo Windsor.

INTERPRETATION: A lost fragment of a similar type of sarcophagus, known at S. Marco in the Renaissance and representing the group of sleeping Furies on the left, was thought by Aldrovandi to be 'Cleopatra with the serpent at her breast, the other women crying and sorrowful' (Bober, 1957, p.87; fig.105: Ripanda). The subject of the Giustiniani sarcophagus was not identified even by the celebrated antiquarian Bellori who could not name the figures in his commentary to Pietro Santi Bartoli's engraving in *Admiranda* (1693, pl.52) even though he compared it with the nearly identical Barberini sarcophagus now in the Vatican (see below: OTHER SARCOPHAGI) which includes the Furies' identifying snakes.

HISTORY: In front of S. Stefano in Cacco, according to Fabricius who visited Rome in 1530. Evidently known earlier to Quattrocento artists.

REPRESENTATIONS:
– Gentile da Fabriano, attrib., Milan, Bibl. Ambr. F.214, inf.13 (Schmitt, 1966, cat. and pl.9; Schmitt, 1960, cat.18, 1; fig.44): Clytemnestra 'restored' **(25a)**.
– Pisanello Workshop, Cod. Vallardi, Paris, Louvre, 2397 (Schmitt, 1960, cat.18, 2; fig.48 as Gentile da Fabriano): figure of Orestes (centre) with Hercules' club, instead of sword.
– Raphael, *Freeing of St.Peter*, fresco, Vatican, Stanza of Heliodorus (Pope-Hennessy, 1971, pl.139): adaptation. St.Peter sitting in pose of Fury lower left.
– Giovanni da Udine, frescoes after Raphael's designs in Vatican Loggie (Dacos, 1977, pl.LXVIc): Pylades or Orestes, left, with corpse of Aegisthus; (*ibid.*, pl.LXVId) Orestes and Fury, right, adaptation; (*ibid.*, pl.LXXVId) Fury left, below; (*ibid.*, pls.LVIa, CXb, cf.CXXIIb) Fury left, middle, reversed; (*ibid.*, pl.LXXVc) Fury, right, below. See Dacos (*ibid.*, p.47) for assessment of Giovanni's use of the sleeping Furies and (*ibid.*, pl.LXXIIIb and d): middle Fury left, Fury lower right.
– Giovanni da Udine, stucco decoration, Rome, Villa Lante, Loggia (Lilius, 1975, p.xxiii, fig.9): Furies rearranged decoratively in front of and behind curtain supported by three herms.

- Titian, *David and Goliath*, Venice, S.Maria della Salute, Sacristy (Brendel, 1955, fig.19; Panofsky, 1969, pl.35): the falling corpse of Aegisthus may be adapted for Goliath.
- Titian, *St.Margaret*, paintings, Escorial, and Madrid, Prado (Panofsky, 1969, pls.55-6): the pose may be based on a conflation of the centre and right figures of Orestes.
- Titian, *Bacchus and Ariadne*, London, NG, 35 (Panofsky, 1969, pl.115): the figure of Bacchus may conflate the same two figures of Orestes (106b).
- Other examples of such 'borrowings' by Titian are given by Brendel and Panofsky, and more can be found in his works. Both Brendel and Panofsky, as Dacos (1977, p.212) points out, refer to a sarcophagus in the Lateran Mus., now in the Vatican which was not known until the 19th century (Robert *ASR*, II, cat.155), but the figure types are the same. For a discussion, see Perry (1980).
- Girolamo da Carpi, attrib., London, Christie's, Old Master Drawings Sale Cat., December 8, 1981, Lot 23, ill.
- Cod. Pighianus, f.252 (106a) (Jahn, 1868, 204; Schmitt, 1960, cat.18, 3, fig.49): unrestored, but fairly well preserved. Break in Orestes' right wrist (centre); Clytemnestra's left hand missing. Lack of snakes identifies drawing with this, not the Barberini-Vatican relief.
- Taddeo Zuccaro, Florence, Uffizi, 11216F (Gere, 1969, pl.15, cat.72): adaptations of two figures of Orestes (centre and right) on a sheet with a third not from sarcophagus.
- Pozzo Windsor, II, f.21, 8276 (Schmitt, 1960, cat.18, 4; Vermeule, 1966, p.16, not illus.): front flanked by ends.
- Poussin, *Judgement of Solomon*, 1649, Paris, Louvre (Wittkower, 1975, p.109 and fig.154): the recoiling woman near Aegisthus could be the model for the woman on the right in the painting; preparatory drawing, Paris, École B–A (*ibid.*, fig.155). Wittkower compares the pose with that of Althaea in the Meleager sarcophagus, Villa Albani (116).

LITERATURE: Toynbee, 1934, pp.180-4 on this and similar sarcophagus reliefs; Dacos, 1977, p.212 for list of drawings, and summary of influence of the sarcophagus on Titian, Poussin and other artists.

OTHER SARCOPHAGI WITH THE STORY OF ORESTES KNOWN IN THE RENAISSANCE:
- The one closest to this type is in the Vatican (Lippold, *Kat.*, III, p.2, no.28, pl.83; Robert, *ASR*, II, cat.158) and was in the Barberini Collection in the 17th century; cf. Dacos, 1969 (*Découverte*), p.48 for a stucco relief in the Colosseum.
- Lost; at S.Marco c.1500. 'Ripanda' skb., Oxford, Ashmolean, f.52 (Bober, 1957, p.87, fig.105).
- Two of another type with different scenes of

Orestes, Pylades, Iphigenia, and Thoas in Tauris are in the Staatl. Kunstsammlungen, Weimar, and were earlier in the Grimani Collection (Robert, *ASR*, II, cats.172 and 178; Schmitt, 1960, cat.25, fig.78), and another is divided between the Villa Albani and the Vatican (Robert, *ASR*, II, cats.168 and 168a).

NIOBIDS

Niobe, daughter of Tantalus (whose eternal punishment in Hades has given us the verb 'tantalize') is the mythic incarnation of *hubris*, pride and insolence towards the gods. Her marriage with Amphion of Thebes having produced a bevy of sons and daughters–six of each in Homer, in Ovid seven, while Hesiod and others give different counts–she boasted of this accomplishment, at the same time denigrating Latona (Leto), mother of Apollo and Artemis, for merely having given birth to two. The wrath of the goddess was swift, spurring her children to slaughter the Niobids with their deadly arrows. In heart-rending grief, Niobe turned into a rock on Mount Sipylon, her tears forming a crystalline spring.

The great Greek dramatists wrote tragedies on the theme which survive in fragments by Aeschylus and Sophocles. According to archaeological tradition, the massacre was treated by the most famous 5th century artists; Polygnotus in painting, and Phidias in reliefs for the throne of his cult image of Zeus at Olympia, created types for the dead and dying children which echo through post-classical art of all media from the 4th to the eclectic first century B.C. (Simon, 1963).

Hellenistic sculptors of the latter century were responsible, according to modern scholarship, for the group of fourteen or fifteen statues discovered in the spring of 1583 in the Vigna Tommasini on the Esquiline. These were immediately recognized as the Niobids Pliny described (*Natural History* XXXVI, 28), in the Temple of Apollo Sosianus in Rome. Other replicas of individual figures had been known long before this discovery *en masse*,

but went under quite different names; a Pedagogue of the Niobids in Copenhagen, drawn by several artists as a topless trunk and legs (see Dosio, Hülsen, 1933, no.132) inspired Castagno's *David* (Introduction, **Fig.6**); the Maffei family's dead Niobid, now in Munich, was merely sleeping ('Endymion', the Bevilacqua family later named him); and Aldrovandi took a youth fallen on one knee to be one of the sons of Laocoon. A mixture of retrospective elements of style which led Pliny to report conflicting attributions to either Scopas or Praxiteles, has vexed more recent authors; on the most recent speculation as to date, see Havelock (1971, cats.137–8). The replicas of 1583 were sold to the Medici and transported to Florence by 1770, together with duplicate copies in two cases from della Valle provenance.

LITERATURE: Mandowsky, 1953; Mansuelli, 1958, I, pp.101–10; cf. Haskell and Penny, 1981, cat.66, figs.10–11, 143–7 of the group in the Uffizi, found in 1583; in general, Cook, 1964. Simon, 1963.

107. Death of the Niobids

Sarcophagus front. Roman, early 3rd century A.D. Wiltshire, Wilton House (Michaelis, 1882, pp.706f., no.163)

DESCRIPTION: Rocky landscape distributes the figures on two levels, enclosed between larger-scaled parents who vainly attempt to protect their youngest children. Amphion on the left grasps a sinking son with his right arm as he raises his shield protectively; Niobe tightly clasps two terrified daughters while her windswept mantle billows like a pathetic shelter above them. Both Amphion and Niobe–as well as every person who is not already dead or dying–look up sharply to the centre of the scene; evidently, on analogy with intact sarcophagi of related type, the avenging deities, Apollo and Artemis, appeared in small scale on the lid, launching their arrows. The portrayal follows one version of the story best exemplified in Apollodorus' *Bibliotheke* which has the sons slaughtered while hunting on Mt.Cithaeron rather than at home with the daughters (the bearded mountain-god is represented at the upper right border of the

relief, tucked in above Niobe's veil). Across the uppermost tier gallop three fleeing sons on horseback; two are already stricken and fall backwards or forwards on their mounts. In the left-hand interval between these equestrians, an old, bearded retainer supports the collapsing half-clad body of an adult daughter; at their feet kneels a sister shrinking in terror. In the right-hand space a draped maiden, her head and extremities destroyed, turns her back in flight into the background. In the lower or foreground level, reading from Amphion at left to Niobe at right: a bearded Pedagogue kneels to support one of the youngest boys who is falling forward; a daughter lies stretched out on the ground; a son has fallen from his rearing horse, though he still holds the reins in his left hand while he tries to pull out an arrow with his right; just over him an old nurse clasps the sinking figure of a half-clad girl; and another youth still sits his fallen horse, pulling his *chlamys* (cloak) up over his head in vain caricature of a shield.

HISTORY: From perhaps the early Quattrocento, the relief was exposed in the wall of a private house at the foot of the Capitol in Rome (cf. Chrysoloras, p.47). In the 17th century, it was acquired by Cardinal Mazarin for his *hôtel* in Paris (no.124 XVII in the Colbert inventory of 1653). Thomas Herbert, Eighth Earl of Pembroke (1654–1732) acquired it about 1720 with other marbles from the Mazarin Collection.

REPRESENTATIONS:
– *Cod.* Escurialensis, f.65[V] (Robert, *ASR*, III, 3, fig.317[I]): '*a pie di chanpidoglio*', with minor 'restorations' and misreadings **(107a)**.
– Drawing attrib. to Giulio Romano by Stark (1836, p.11, n.3) which was in Dresden in 1861.
– Aspertini,[1] London, BM *Skb.* I, ff.19[V]–20 (Bober, 1957, fig.56 below, p.64b).
– Girolamo da Carpi, attrib., Pozzo London BM I, f.63, no.72 (Robert, *ASR*, III, 3, fig.317[IIII]; Vermeule, 1960, p.13): the left two-thirds of the relief through the nurse-daughter group, some 'restorations' in the drawing.
– Cod. Pighianus, f.248[V], (Jahn, 1868, 163; Robert, *ASR*, III, 3, fig.317[II]): '*sub capitolio in pariete privatae domus*', unrestored.
– Pozzo London BM I, f.142, no.159 (Vermeule, 1960, p.20, fig.63): restored.
– Robert (*ASR*, III, 3, ill. on p.384) reproduces an engraving by Galestruzzi of a destroyed fresco by Polidoro da Caravaggio painted for no.7, Via della Maschera d'Oro, which is based on this particular sarcophagus.

LITERATURE: Robert, *ASR*, III, 3, pp.383f., cat.317, pls.CI, CIII; Sichtermann, 1968, discusses the Wilton example among related sarcophagi and their sources.

108. Niobid

Statue. Roman copy of a figure in a Hellenistic group created either c.300 B.C. (Bieber, 1961, p.75) or, more likely, in the 1st century B.C.
Florence, Uffizi (inv.289)

DESCRIPTION: One of the sons of Niobe has fallen on his left knee, his right leg thrust out to the left before him; in strong *contrapposto* he turns his torso and drastically raises his head to our right – as in the sarcophagi all protagonists look up at their divine executioners.

HISTORY: Part of the della Valle-Rustici Collection; sold to the Medici in 1584 and exchanged for the same figure in the Niobid group discovered in 1583 (Mandowsky, 1953, p.262, n.16). Another figure of a son clambering up a rock also belonged to the della Valle before the 1583 discovery.

REPRESENTATIONS:
- Girolamo da Carpi, Florence, Uffizi, 1700E (Serafini, 1915, fig.138).
- Cavalieri, III–IV, pl.12.

ALSO TO BE NOTED:
- On Ghiberti's suggested use of the figure for Isaac in the Competition Relief, Florence, Mus. Naz., see Krautheimer (1956, pls.2b, 26a, p.339).

LITERATURE: Mansuelli, 1958, I, pp.101f., and cat.78, with bibl.

109. Dead Niobid

Statue. Roman copy (as in **108**) of a figure in a Hellenistic group created either c.300 B.C. (Bieber, 1961, p.75) or, more likely, in the 1st century B.C.
Munich, Glyptothek, 269 (Vierneisel-Schlörb, 1979, cat.43, pls.233–6)

DESCRIPTION: The naked corpse of one of the youngest sons lies stretched out in death, the right arm flung over his head, with the left hanging life-less from the hand at his waist. He lies on his *chlamys,* mouth hanging open, on a plinth (mostly restored) which represents uneven ground made higher under the torso so the body arches up through the rib cage, the feet – crossed right over left at the ankles – and head much lower.

HISTORY: The statue was first documented in the Maffei Collection c.1500 by 'Prospettivo Milanese'. By 1589 it belonged to Conte Mario Bevilacqua, who collected antique sculpture from various sources in Rome and elsewhere from 1570–90 (Franzoni, 1970, p.100, n.7 and p.164: inventory of 1589, no.17). From that collection in Verona it was purchased for Bavaria in 1811.

REPRESENTATIONS:
- Florentine, late 15th century, Madrid, Prado, inv. F.D.149, **109a** (Pérez Sánchez, 1978, cat.I): on sheet with statue of semi-draped nymph (cf. **63**) also in Maffei Collection (cf. Oxford, Christ Church, Byam Shaw, 1976, cat.56, pl.34).
- Umbrian *Skb.*, Calenzano, f.9 (Schmitt, 1970, fig.14).
- Aspertini, Cod. Wolfegg, ff.33ᵛ–34 (Robert, 1901, pl.X): '*in casa dei mafei*'.
- Aspertini, London, BM I, ff.18ᵛ–19c (Bober, 1957, fig.53).
- Heemskerck, *Skb.* I, f.3ᵛk (view of the Pal. Maffei court), **ill.** on p.476.
- Perino del Vaga?, London, private collection (Goldscheider, 1951, App., figs.162–3).
- The arched body, though upright and reversed, is unmistakable in the figure hanging down from the wall in Raphael and Giulio Romano's fresco of the *Fire in the Borgo*, Vatican, Stanza dell'Incendio; Raphael was a good friend of the Maffei and surely knew the figure well.
- Aspertini adapts the pose for a decapitated saint in his fresco of *The Burial of Sts. Valerian and Tiburtius*, Bologna, Oratorio of S. Cecilia (Bober, 1957, fig.132).

LITERATURE: Furtwängler, 1900, *Beschreibung*, no.269; 'Prospettivo Milanese', c.1500, stanza 19:
Han molte cose poi certi maphei
giaquato un nudo vinto dal sopore
ve che colar fa spesso gliochi mei…
('The Maffei have many things/a nude male reclined overcome by slumber,/which induces my eyes to droop' …; Fienga, 1970, p.42). 'Prospettivo Milanese's' description shows that the figure was not recognized as a Niobid, and the Bevilacqua family later thought of it as Endymion, sleeping (Franzoni, 1970, p.165: inventory of 1593); Hülsen and Egger, 1913–16, I, p.4, k; Bober, 1957, p.63. Vierneisel-Schlörb, 1979, II, pp.472ff.

MEDEA

Jason's unscrupulous and ambitious uncle, Pelias, usurped the throne of Iolcus and, in order to eliminate Jason, set him the seeming-

ly impossible task of fetching the Golden Fleece from distant Colchis. Jason, therefore, gathered together a crew of heroes gifted with a variety of talents and set sail on the perilous voyage in the miraculous ship, Argo.

After many adventures, Jason arrived in Colchis, where even more trials awaited him, and he would not have been able to complete his mission had he not been helped by the goddess Juno. She persuaded Venus to make Medea, the daughter of the king of Colchis and a sorceress of great power and ingenuity, fall in love with Jason. The enamoured Medea enabled Jason to obtain and carry off the Golden Fleece. Having betrayed her home and family, Medea joined Jason in his flight and, back in Iolcus, contrived a hideous death for Pelias (he was murdered unwittingly by his own daughters). Then she and Jason fled to Corinth.

As the years passed, Medea's charms began to pall for Jason and although he had two children by her, he was more than ready to give her up when he saw an opportunity to ally himself with the royal house of Corinth.

Medea, now homeless, hated, despised and abandoned, sought desperately for means by which she could revenge herself upon the perfidious Jason. She decided to pretend submission, and as a gesture of reconciliation, sent a beautiful robe and crown to Jason's new bride, Creusa. The gifts were poisoned and the Corinthian princess was consumed in flames as soon as she put them on, along with her father, Creon, who rushed to help her.

Driven on by her destructive rage and heedless of any pain to herself, Medea next murdered her own beloved children in order to injure Jason further and to blast his hopes once and for all. She then escaped to Athens in a dragon-drawn chariot, leaving Jason behind, a broken man.

The adventures of the Argonauts and the early stages of Medea's infatuation with Jason are vividly recounted by Apollonios of Rhodes in the *Argonautica* (translated as *The Voyage of the Argo*, Penguin, 1959), and the anguish and passion of Medea are unforgettably portrayed in Euripides' *Medea*.

110. Medea

Roman sarcophagus, mid 2nd century A.D.
Ancona, Museo Nazionale (Robert, *ASR*, II, cat. 199)

DESCRIPTION: The surface of the relief is very weathered, having spent centuries out of doors or in open courtyards. The damages recorded in the Pighius drawings correspond to its present state.

Front–Four scenes from Euripides' *Medea*. (i) Left, in front of curtain, Jason with his two little sons, accompanied by their tutor, innocently offer Medea's poisoned presents to Jason's bride, Creusa, who is seated with her father, King Creon, before her and a servant behind. A warrior with a shield (Jason?) divides this from the next scene. (ii) Creusa has put on the robe and crown sent by Medea:

> ... the stuff was eating her clear flesh. She leapt up from her chair, On fire, and ran shaking her head and her long hair this way and that...
> (transl. Vellacott, 1963, p. 54).

Creon follows her over a *scamnum* (stool), which is decorated with a relief of Jason taming the Bull at Colchis. (iii) Medea about to murder her children who play or run away. (iv) Medea with the body of child flung over her shoulder escapes on a chariot drawn by winged snake-dragons.

Ends–Griffins.

HISTORY: The sarcophagus was known in the 15th century, probably in front of SS. Cosma and Damiano in the Roman Forum where it was recorded in the mid 16th century by Pirro Ligorio: '*Di Medea et Iasone... A destra del'entrar della medisima chiesa...*' (Dessau, 1883, p. 1085, no. 2). After 1560 it was in the Vatican Belvedere; in the early 19th century, in the courtyard of the Lateran; and before 1842 it went to the Stamperia Reale. For a while it was at the Museo Nazionale delle Terme, often confused with a similar sarcophagus which came to the Terme in 1911 and is still there (Robert, *ASR*, II, cat. 201; inv. 222). It was sent to Ancona in the 20th century. Another similar relief was sent from Rome to the Gonzaga Villa La Favorita near Mantua in the 17th century (Robert, *ASR*, II, cat. 196); its earlier history is unknown.

INTERPRETATIONS: Pirro Ligorio recognized the subject, but see Master of the Die below. Bellori (P. Santi Bartoli, 1693, pl. 55) thought a similar relief (now in the Louvre, Robert, *ASR*, II, cat. 195) depicted the story of Proserpina.

(Bold roman numbers in parentheses refer to scenes in DESCRIPTION.)

- Gentile da Fabriano, Rotterdam, Mus. Boymans van Beuningen, J.523 (Schmitt, 1960, fig.63; Degenhart and Schmitt, 1968, I, pl.178a–b as Gentile; Fossi Todorow, 1966, cat. and fig.204 as Pisanello's Workshop): isolated figures (110c) – Jason (i); Medea (iv); Creusa (i).
- Ambrosiana Anon., Milan, Bibl. Ambr., F.237, inf.1707ᵛ (Schmitt, 1960, fig.63; Schmitt, 1966, cat. and pl.33ᵛ): two children (i); Creon and Creusa (ii); children fleeing (iii).
- 'Ripanda' skb., Oxford, Ashmolean, f.26 recto and verso.
- Michelangelo, *Madonna and Child with St.John*, 'The Taddeo Tondo', London, RA: Christ child, adaptation of Medea's son stepping over stool (iii). (Panofsky, 1939, p.172, n.3 gives further adaptations of this Medea relief by Michelangelo and Bandinelli).
- Giovanni da Udine, stucco reliefs, Vatican Loggie (Dacos, 1977, pls.LIIIb, LXXIb, LXXIVd, LXXVIIa, CVIIa): Creusa (i); (*ibid.*, pls.LXIVb, LXIXb): Medea (iv).
- Master of the Die, engraving, Bartsch, XV, p.204, no.28 (Robert, *ASR*, II, fig.199ⁱⁱ): reversed and freely interpreted. '*Androgenede poenas exolvere caedis Cecropidae iussi*' (interpreted as Minos' penalty exacted from the Athenians for his son's death; see Catullus, *Carmina* LXIV, 77).
- Falconetto, attrib., two fresco panels in ceiling of Odeo Cornaro, Padua (Schweikhart, 1968, figs.7, 9–10): two scenes from front.
- Bandinelli, *Descent from the Cross*, Paris, École B–A (Antal, 1937, pl.9d): burning Creusa (ii) reversed. Antal (*ibid.*, p.71) saw it as a Neo-Attic dancing maenad.
- Franco, Florence, Uffizi, 7973S: muddled sequence.
- Frans Floris Workshop, Basel *Skb.*, f.18ᵛ (Van de Velde, 1969, pl.8b and p.270): '*ANTICK by tempelum pacis an dat cleijn kercke dat gy gescuetsert hebt*'; scene (i) including standing warrior to right of Creusa.
- Bonasone, engraving, Bartsch, XV, p.138, no.98 (Robert, *ASR*, II, fig.193ⁱⁱⁱ): reversed figures of the relief in Roman setting with SS. Cosma and Damiano in the background (110b).
- Italian, 16th century, Florence, Uffizi, 5943 Horne: sheet with four other sarcophagi at SS. Cosma e Damiano (110a).
- Girolamo da Carpi, Turin *Portfolio* (Canedy, 1976, 146T): seated Creusa, children (i).
- Cod. Coburgensis, f.42 (Matz, 1871, 216; Robert *ASR*, II, fig.199ⁱ; Schmitt, 1960, fig.61): whole front unrestored in present condition.
- Cod. Pighianus, f.250b (Jahn, 1868, 212): '*in foro romano Cosmi et Damiani ante aedem*', and in the left corner, '*Androginis*' referring to the interpretation

given by the Master of the Die. Cf. Cod. Coburgensis above.
- 'Peruzzi' Siena *Skb.*, f.55ᵛ: Medea (iv); f.56ᵛ: left half of front through (ii), without figure on left.

LITERATURE: Dacos, 1977, pp.207–8, with list of the drawings and engravings included here, and with reference to dim reflections of the relief seen by others in works by Ghiberti, Titian and Poussin.

HIPPOLYTUS

Hippolytus was the son of Theseus and the Amazon, Hippolyta. After the Amazon's death, Theseus married the Cretan princess, Phaedra.

While Theseus was absent, Phaedra fell hopelessly in love with her stepson. Hippolytus, being devoted to the chaste goddess of the hunt, Diana, was not only shocked but disgusted when Phaedra's passion was revealed to him. Phaedra, rejected and despairing, accused Hippolytus of having made advances to her. Theseus, on his return, believed her story and cursed his son, imploring Neptune to bring disaster upon the youth.

Hippolytus fled, and as he drove his chariot along the shore, a huge bull, sent by Neptune, rose out of the sea and terrified his horses, which ran wild, dragging their hapless master behind them.

Phaedra committed suicide; Theseus, grief-stricken, learned, too late, to recognize his error and to regret his haste.

The story was twice treated dramatically by Euripides (his second tragedy on the theme, *Hippolytus*, is preserved) and by Seneca in his *Phaedra*.

111. Hippolytus and Phaedra
Roman sarcophagus relief, end of 2nd century A.D.
Pisa, Campo Santo (Robert, *ASR*, III, 2, cat.164; Arias *et al.*, 1977, cat.C9 est)

DESCRIPTION: Although very worn, and damaged in the Second World War, the sarcophagus relief still justifies Vasari's description of it in his *Life* of Nicola Pisano as one of the most beautiful of the

sarcophagi in the Campo Santo: '... the nudes and draped figures on it (are) carved with great skill and perfect composition...'. Its condition in the Renaissance can be judged by the Pozzo and Topham drawings.

Like Adonis sarcophagi (e.g. **21**), the relief is divided by a pilaster into two scenes: Hippolytus' departure for the hunt on the left, and boar hunt on the right. A boar hunt which also appears in sarcophagus reliefs of Adonis and Meleager, caused Vasari to call the relief 'the hunt of Meleager and the Calydonian boar'.

On the left, Phaedra is seated before a temple, probably of Venus, for she was under the sway of the goddess of Love, as shown by the two amoretti standing by her, one cross-legged and leaning an elbow on her knee, head to hand, a much-repeated motif given a greater intimacy by Michelangelo in his Pitti tondo (Florence, Mus. Naz.; **111a**). Phaedra is also attended by two female servants and by her old nurse who, with her gesticulation, seems to be giving away Phaedra's secret to Hippolytus, whose hand is raised in alarm as he looks at Phaedra before rushing off to the hunt.

A typical boar hunt scene takes place on the right. Hippolytus, nude, accompanied by a mounted companion and dogs, rides towards the boar. The female figure dressed like Diana in a short hunting *chiton* with buskins, but with the type of helmet worn by personifications of Roma, is thought to be *Virtus*, who often accompanies the hero of hunts (cf. **199**).

Left end–two hunters, one with net.
Right end–hunter with dog, and Hippolytus leaning on a spear, hand on hip.

INTERPRETATIONS: Vasari thought it represented Meleager's Calydonian Hunt. Seidel (1975, pp.334ff.) discusses the historical and iconographical significance of the sarcophagus in the Middle Ages.

HISTORY: According to Vasari, it was brought with other sarcophagi and marbles from Rome as ballast by the Pisan fleet. According to the inscription, it was used as the tomb for Countess Beatrice, mother of Countess Mathilda of Tuscany (d. 1076). It was set into the south exterior wall of the choir when the Cathedral of Pisa was built (Pozzo drawing), and remained there until 1810.

REPRESENTATIONS:
– Nicola Pisano, *Presentation in the Temple*, marble relief, 1260, Pisa, Baptistry, Pulpit (Seidel, 1975,

figs. 2 and 16): Mary's head, cf. head of Phaedra; (*ibid.*, figs. 8 and 13): Elizabeth's head, cf. head of old nurse; (*ibid.*, fig. 9): cf. Hannah's head. See also Seidel (*ibid.*, figs. 10–11) for influence of nurse's head on reliefs on pulpit in the Duomo of Siena. Vasari commented on the influence of this sarcophagus on Nicola:

> Nicola considering the excellence of this work which much pleased him, began with such study and diligence to imitate the style ... that before long he was judged the best sculptor of his time. (Vasari–Milanesi, *Life of Nicola Pisano* I, p.295.)

– Ghiberti, bronze head of Prophetess in door frame, Florence, Baptistry, North Door (Krautheimer, 1956, pl. 62a): head of nurse. For less striking adaptations by Ghiberti of heads from this sarcophagus, see Krautheimer (*ibid.*, pls. 58a, 62, 62b, 63b; pp. 340–1, nos. 7–10).
– Pozzo London BM I, f. 78, no. 87 (Vermeule, 1960, p. 14, not illus.): relief *in situ* in frontal view. Mounted on projecting wall brackets with inscription on tablet below.
– Topham Albums, Windsor, Eton College Lib., BM IV, 114–7.

LITERATURE: Vasari–Milanesi, 1906, I, pp. 293–5; English transl., Hind, rev. ed. 1963, I, p. 40. Seidel, 1975, esp. pp. 325–7 for significance of sarcophagus in Middle Ages, and use made of relief by Nicola Pisano; phots. of details. Sichtermann and Koch, 1975, cat. 26, pls. 55,2; 56–7, for recent interpretation; phots. of details. Froning, 1980, for sources of the type of seated Phaedra.

MELEAGER

Oeneus, king of Calydon, once forgot Diana when sacrificing to the gods. This omission brought dire consequences: Diana, enraged, sent a huge boar to ravage the land. So large and fierce was it that Meleager, the son of Oeneus, had to invite a band of heroes to help to hunt it. They were joined by the virgin huntress, Atalanta. Atalanta drew the first blood from the Calydonian Boar and Meleager slew it. By rights the boar's skin belonged to him, but he gallantly awarded it to Atalanta. This angered Meleager's uncles, the brothers of Meleager's mother, Althaea. In the course of the hostilities that then broke out, Meleager killed his uncles. Althaea was so grieved by the death of her brothers that she took

vengeance on her own son. When Meleager was a baby, the Fates had appeared to his mother and warned her that her son would live only so long as the brand then on the fire was preserved. Althaea had snatched the brand off the flames and hidden it in a chest. When she received the news of the death of her brothers, she took it from its hiding place and threw it on the flames. Meleager, though far away, died when the brand was consumed; Althaea, overwhelmed with sorrow, killed herself and all Calydon mourned for the fallen hero.

Homer (*Iliad* IX, 529–99) tells the story of Meleager, but omits any mention of Atalanta or the fatal brand. Althaea curses her son for killing her brothers in a dispute over the spoils of the Calydonian boar, but he is not said to have died from her curse.

Ovid (*Metamorphoses* VIII, 270–545) recounts the whole tale, vividly depicting Althaea's anguish as she dooms her son. He also tells of the excessive grief of Meleager's sisters, all but two of whom were turned into birds.

Meleager's death and the lamentation at his bier were probably most eloquently portrayed in Euripides' lost tragedy, *Meleager*.

Romans addicted to hunting could find a heroic parallel to their pursuits in the story of Meleager. The hunt was, therefore, a popular subject for sarcophagi. Scenes showing the dying hero carried home and those which portray him lying in state piteously mourned by those who loved and admired him are imbued with a tenderness and humanity that not only made them appealing to Roman customers choosing themes for their carved coffins, but also inspired Renaissance artists seeking formulae to convey the pathos of the entombment of Christ.

LITERATURE: Brilliant, 1984, pp. 145–65; E. Paribene, 1975, for the Meleager theme in Renaissance art.

112. Meleager
Roman statue
Destroyed by fire. Formerly Florence, Uffizi (Mansuelli, 1958, I, cat. 50 and App. 4, p. 264)

DESCRIPTION: The statue represents Meleager charging the boar with a spear, as he appears in sarcophagus reliefs of the Calydonian hunt.

In 1638 the figure was grouped with the famous boar still in the Uffizi (Mansuelli, 1958, I, cat. 50; Haskell and Penny, 1981, cat. 13, fig. 83).

INTERPRETATION: In the Medici inventories of the 17th century (1638 and 1676) the figure was thought to be a peasant (*contadino* or *villano*).

HISTORY: Known to Antico when he visited Rome in 1497? Antico later returned to Rome to study the statues of the Belvedere which he copied in small bronzes for the Gonzaga court. The statue was first mentioned in the Medici inventories in 1638, and was destroyed in the fire in the Uffizi in 1762.

REPRESENTATIONS:
– Antico, bronze parcel gilt statuette, before 1496, London, V&A, A 27–1960 (**112a**; Radcliffe, 1966, colour pl. III; Chambers and Martineau, 1981, fig. 44).
– A. F. Gori, 1740, III, pl. LXXVIII (**112**; Mansuelli, 1958, I, fig. 324).

LITERATURE: Keutner, 1962, p. 172; Radcliffe, cat. 54 in Chambers and Martineau, 1981.

113. Meleager. Calydonian Hunt
Roman sarcophagus, late 3rd century A.D.
Bedfordshire, Woburn Abbey (Michaelis, 1882, no. 110)

DESCRIPTION: Meleager, nude, in lunging pose with cape flying, strikes the boar's snout with his spear at the moment that Atalanta, by his side, shoots the boar with her bow (restored), and a horseman clubs it while excited dogs join the attack. On the right, Atalanta has been given the boar's head as a trophy; a *genius* of death with inverted torch reaches towards the boar's head, while the hero stands proudly on the right, still unaware of his fate. The badly damaged condition of the relief in the Renaissance is shown in mid 16th century drawings.

HISTORY: About 1550 Aldrovandi describes it (1556, p. 242) over the entrance portal on the exterior of the house of Giulio Porcari in Rome. Both its position, and the fact that the collection of this

branch of the Porcari family, founded by Giulio's grandfather, was rich in inscriptions and other antiquities known to the 15th century epigraphers and antiquarians, suggest that it had been immured in the Quattrocento long before the specific documentation of the mid 16th century.

REPRESENTATIONS:
- Cod. Coburgensis, f. 54 (Matz, 1871, 218; Robert, *ASR*, III, 2, fig. 224¹): heads missing from all but three figures; Meleager without head, right arm and left leg (**113a**). Cf. Cod. Pighianus, f. 255 (Jahn, 1868, 214).
- Pozzo Windsor, X, f. 47, 8040 (Vermeule, 1966, p. 64): '*ai porcari*'.

LITERATURE: Robert, *ASR*, III, 2, cat. 224; Koch, *ASR*, XII, 6, cat. 71; Vermeule, 1956, *AJA*, 60, p. 348.

OTHER MELEAGER SARCOPHAGI KNOWN IN THE RENAISSANCE:
Calydonian Hunt
- Chiusi, Vescovato (Robert, *ASR*, III, 2, cat. 225; Koch, *ASR*, XII, 6, cat. 155): drawn by Francesco di Giorgio.
- Florence, Baptistry: used as 14th century tomb.
- Palermo, Duomo (Robert, *ASR*, III, 2, cat. 247; Koch, *ASR*, XII, 6, cat. 154): in crypt since Middle Ages.
- Pisa, Campo Santo (Robert, *ASR*, III, 2, cat. 250; Koch, *ASR*, XII, 6, cat. 27): used in 13th century as a tomb.
- Pisa, Campo Santo (Robert, *ASR*, III, 2, cat. 223; Koch, *ASR*, XII, 6, cat. 69): used on exterior of Duomo in the Middle Ages as fountain basin.
- Rome, Mus. Capitolino (Robert, *ASR*, III, 2, cat. 237; Koch, *ASR*, XII, 6, cat. 1): walled into staircase of Aracoeli since end of 14th century.
- Rome, Pal. Rospigliosi (Robert, *ASR*, III, 2, cat. 251; Koch, *ASR*, XII, 6, cat. 28): in S. Maria Monticelli in 16th century.
- Salerno, Duomo (Robert, *ASR*, III, 2, cat. 239; Koch, *ASR*, XII, 6, cat. 151): used as tomb in 12th century.
- Split (Spalato), Mus. Arch. (Robert, *ASR*, III, 2, cat. 220; Koch, *ASR*, XII, 6, cat. 178): earliest evidence in 15th century at Salona, near Split; to Split mid 15th century.

114. Meleager (Death Scene)
Roman sarcophagus relief, 2nd century A.D.
Milan, Torno Collecton (formerly Florence, Palazzo Montalvo; Robert, *ASR*, III, 2, cat. 282; Koch, *ASR*, XII, 6, cat. 117)

DESCRIPTION: The figure of Nemesis with her foot on a wheel, holds an open book roll in one hand, with statuette of Diana in background. Atalanta mourns, seated on a rock. Five mourners surround the dying Meleager on his bed. On the right is Meleager confronting his uncles, one of whom lies slain. A Fury with a lash stands in the background.

Two ends in the Museo Archeologico, Florence, have been associated with this sarcophagus, but Koch (*ASR*, XII, 6, cat. 118) argues that the measurements do not correspond to the front. They represent two sisters of Meleager mourning at his tomb Althaea thrusting the brand into the fire, with a Fury behind the altar.

HISTORY: The location of the relief in the Renaissance is unknown, but it was evidently available to artists in the 15th century.

REPRESENTATION:
- Giuliano da Sangallo?, attrib., stone frieze on funerary monument of Francesco Sassetti, Florence, S. Trinita (Gombrich, 1970, pl. 25; Borsook and Offerhaus, 1981, figs. 47 and 49): close adaptation of figures from seated woman on left to nude men on right; fallen figure, replaced by a dog; addition of old man on right in toga supported by putti.

NOTE: This, rather than the often cited Albani example (**116**), may have been in Donatello's mind when he made the bronze relief of the *Entombment* on the altar of the Santo, Padua (Janson, 1963, pl. 88a).

LITERATURE: Warburg, 1932, I, pp. 154f., from his article on Francesco Sassetti's last Will and Testament first published in 1907; see Gombrich, 1970, pp. 170–7 for English summary, and particularly pp. 174–5 for the harmonization of Christian and pagan ideas in Sassetti's tomb. Borsook and Offerhaus, 1981, p. 25 and n. 82 for further bibl.

115. Death of Meleager
Roman sarcophagus front, mid 2nd century A.D.
Wiltshire, Wilton House (Michaelis, 1882, no. 61)

DESCRIPTION: Left to right–Meleager kills his uncles; Althaea holds the brand low as she thrusts it into the flames, as if she were lighting a funeral pyre in ancestral fashion with averted eyes (Virgil, *Aeneid* VI, 23–4). She is attended by Fate (Nemesis) and a Fury with a sickle; mourners surround the couch of Meleager; Atalanta, standing, turns aside to mourn. Unrestored.

HISTORY: It was certainly known in Rome at S. Angelo in Pescheria in the beginning of the 16th century (Aspertini, Wolfegg) but was probably also there in the 15th century. In the 17th century it was in the collection of Cardinal Mazarin, and probably went from there to Wilton.

REPRESENTATIONS:
– Donatello, *Entombment*, marble relief on tabernacle, 1432–3, Rome, St. Peter's, Sagrestia dei Beneficiati (Janson, 1963, p.98, pl.42a): adaptation. Robert suggests Donatello's use of the relief, but Janson points out that only the standing figure of Atalanta, turned aside to the right, is related to Donatello's comparable figure of St. John.
– Donatello, *Lamentation*, bronze relief, London, V&A (Pope-Hennessy, *V&A Cat.*, 1964, cat.63, pl.79; Janson, 1963, pl.101, p.206): figure of St. John standing aside with hand to cheek in the pose of Atalanta.
– Aspertini, Cod. Wolfegg, ff.34ᵛ–35, above (Bober, 1957, fig.45; p.35, n.2): 'in lepescari' (S. Angelo in Pescheria). Whole front 'restored'. Figures and objects arranged in depth.
– 'Bambaia' Berlin *Skb.*, f.11 (Dreyer and Winner, 1964, fig.39): first two scenes on left.
– M. Accursius, *Diatribae*, 1524, title-page.
– Cod. Coburgensis, f.12 (Matz, 1871, 222; Robert, *ASR*, III, 2, fig.275ᴵ): whole front unrestored.
– Pozzo London BM I, f.136, no.153 (Robert, *ASR*, III, 2, fig.275ᴵᴵ; Vermeule, 1960, p.19): whole front unrestored.

LITERATURE: Robert, *ASR*, III, 2, cat.275; III, 3, pp.574f.; Koch, *ASR*, XII, 6, cat.122.

116. Death of Meleager

Roman sarcophagus relief, end of 2nd century A.D.
Rome, Villa Albani (Robert, *ASR*, III, 2, cat.278; Koch, *ASR*, XII, 6, cat.114)

DESCRIPTION: Nemesis or Fate, stands on the left with her foot on a wheel; Althaea thrusts the brand into the fire; mourners bend over the deathbed of Meleager in varying attitudes of profound grief; Atalanta, seated, mourns alone.

The figures represent well-known types encountered on other Meleager sarcophagi and in other contexts, and were particulary rich sources for Renaissance artists.

HISTORY: The sarcophagus was in the collection of the della Valle as Perrier's engraving indicates

(1645), but when it entered the collection is not known. Use was made of the motifs in the Quattrocento, but as many of them were common to other sarcophagi of the type, such evidence remains inconclusive.

REPRESENTATIONS:
– Ghiberti, *Rebecca*, bronze relief, Florence, Baptistry, East Doors (Krautheimer, 1956, pl.97b, p.347, 41a): the female figure standing with hand to head has been suggested as a possible source, together with Iphigenia (see 105a).
– Donatello, *Resurrected Christ*, bronze relief, Florence, S. Lorenzo, south pulpit (Lavin, 1959, p.30, fig.26; Janson, 1957, pl.448; 1963, pl.116 and p.218): cf. old man in profile with knee up, leaning on staff, adaptation.
– Falconetto, Marriage Scene, Vienna, Albertina, inv.13247 (Buddensieg and Schweikhart, 1970, fig.8; 90a): adaptation of death bed scene in the relief on the column.
– Falconetto, drawing of a funerary monument, Paris, Louvre, RF1075 (Buddensieg and Schweikhart, 1970, figs.14 and 20).
– Michelangelo, *Sacrifice of Noah*, fresco, Vatican, Sistine Chapel Ceiling (Gombrich, 1937, pl.8a, p.69): woman kindling flame, adaptation of Althaea.
– Cod. Coburgensis, f.99 (Matz, 1871, 224; Robert, *ASR*, III, 2, fig.278ᴵ): 116, cf. Cod. Pighianus, f.267 (Jahn, 1868, 218).
– Pozzo Windsor, X, f.103, 8096 (Vermeule, 1966, p.68): whole front freely drawn.
– Pozzo Windsor, VIII, f.16, 8717 (Vermeule, 1966, p.49).
– Pozzo London BM I, f.117, no.130 (Vermeule, 1966, p.178): finished drawing simulating the marble relief against a dark background and heightened with white; verso: old man on right centre of relief.
– Perrier, 1645, pl.21: reversed; cf. P. Santi Bartoli, 1693, pl.69 in correct sense.

LITERATURE: See above, Koch. Not in Helbig, IV.

117. Meleager: Carrying the Body

Roman sarcophagus relief, 2nd century A.D.
Rome, Villa Doria Pamphili, Casino del Belrespiro (Calza, *et al.*, 1977, cat.191)

DESCRIPTION: Meleager slays an uncle in the midst of the battle scene on the left. On the right is the procession and the carrying of Meleager's body back to Calydon.

The relief was badly damaged on the left and Meleager's dangling arm was missing in the Renaissance. It seems not to have been restored until

after it was built into one of the façades of the Casino.

HISTORY: Known at least since the Quattrocento (Ghiberti), but location unknown until it was incastrated on the Casino 1644–50.

REPRESENTATIONS:
- Ghiberti, Florence, Baptistry, East Doors, details from Moses panel (Krautheimer, 1956, pl. 104b, p. 348, no. 46): adaptations – figure covering face with hand; detail from Joshua panel (ibid., pl. 108b, p. 349, no. 50): man carrying rock on shoulders, cf. man carrying Meleager's feet. And see also ibid., no. 49.
- Girolamo da Carpi?, Florence, Uffizi, 1712E (Robert, ASR, III, 2, fig. 283¹): front, unrestored.
- Pozzo London BM I, f. 81, no. 90 (Vermeule, 1960, p. 15, fig. 36; Robert, ASR, III, 2, fig. 278ᴵᴵ): incastrated, unrestored.
- Pozzo Windsor, VIII, f. 17, 8718 (Robert, ASR, III, 2, fig. 283ᴵᴵ; Vermeule, 1966, p. 49 with further reference): whole front.
- Poussin, New York, Pierpont Morgan Lib., Fairfax Murray, 1912, III, pl. 73 (Friedlaender and Blunt, 1974, cat. 300, pl. 244, dateable to mid 1630s): unrestored, much damage on left, Meleager's dangling arm missing.

LITERATURE: Robert, ASR, III, 2, cat. 283; Koch, ASR, XII, 6, cat. 84.

118. Meleager: Carrying the Body

Sarcophagus cover. Late Antonine
Lost. Formerly Rome, Palazzo Sciarra (Robert, ASR, III, 2, cat. 230a; Koch, ASR, XII, 6, cat. 80)

DESCRIPTION: Four scenes–(i) a procession of mourners follows the group of Meleager's companions carrying his body; (ii) Meleager's three sisters in attitudes of grief rush towards them; (iii) the legs of Meleager are seen on the pyre; the last scene (iv) is the suicide of Althaea. The figure of Meleager remarkably fits Alberti's description:

They praise a historia in Rome, in which the dead Meleager is being carried away, because those who are bearing the burden appear to be distressed and to strain with every limb, while in the dead man there is no member that does not seem completely lifeless; they all hang loose; hands, fingers, neck, all droop inertly down, all combine together to represent death. (Alberti–Grayson, 1972, p. 75).

The relief seems to have been well preserved in the Renaissance (118a).

Robert believed it to be the cover of a Meleager sarcophagus in the Villa Medici (Cagiano de Azevedo, 1951, cat. 63) from the della Valle Collection.

HISTORY: Probably known in the 15th century. Robert compares Donatello's figure leaning on a shield to the left of the Entombment in the S. Lorenzo Pulpit (Janson, 1963, pl. 109) with a figure on the relief which occurs on no other preserved Meleager sarcophagus.

According to Robert, it was in the Palazzo della Valle-Capranica in the 16th century; and in the 17th century it was in the Palazzo Barberini (Perrier).

REPRESENTATIONS:
- Aspertini, London, BM Skb. I, ff. 6ᵛ–7 (Bober, 1957, pp. 53–4 and fig. 24): free adaptation and transposition of figures with the addition on f. 7 of a statue of a woman (7) in the della Valle Collection who appears to take part in the scene.
- Cod. Coburgensis, f. 160 (Matz, 1871, 228; 118a).
- Dosio, Berlin Skb., f. 2: whole sequence in two rows; cf. f. 3ᵛ: sketch, not by Dosio, of death of Althaea; f. 10: copy of f. 2, not by Dosio.
- Pozzo Windsor, V, f. 70, 8474 (Vermeule, 1966, p. 30): finished drawing of complete relief, restored, simulating the marble, on dark background.
- Perrier, 1645, pls. 21–2: reversed.
- P. Santi Bartoli, 1693, pls. 70–1. Bellori, the 17th century antiquarian, commenting on the Perrier and Bartoli plates, considered the subject to be of an unspecified funeral cortège.

LITERATURE: Matz and Duhn, II, cat. 3262; von Salis, 1947, p. 71, pl. 11b, c.

OTHER MELEAGER SARCOPHAGI KNOWN IN THE RENAISSANCE:
Meleager Dead
- Castelgandolfo, Villa Barberini (Robert, ASR, III, 2, cat. 276; Koch, ASR, XII, 6, cat. 121): earliest evidence early 16th century.
- Genoa, S. Lorenzo (Robert, ASR, III, 2, cat. 302; III, 3, p. 580; Koch, ASR, XII, 6, cat. 78): in façade since Middle Ages.
- Rome, Pal. Barberini (Robert, ASR, III, 2, cat. 287; Koch, ASR, XII, 6, cat. 76): used as medieval tomb in S. Maria in Monticelli.
- Rome, Villa Medici (Robert, ASR, III, 2, cat. 301; Koch, ASR, XII, 6, cat. 91): earliest evidence early 16th century.

THE TROJAN LEGENDS

The Trojan legends are stories by Greek and Roman authors who used as source material ancient legends which now exist mostly in fragments, recorded by later writers (see below, LITERATURE). Homer used part of the ancient legends in the resounding poetry of the *Iliad*, and in the *Odyssey*. Like other authors who drew freely on, and developed these ancient legends, he limited himself to certain heroes and their deeds and the gods who controlled their destinies.

Of the many episodes of the Trojan legends described by various authors, the ones illustrated in this section, and elsewhere in the book, are referred to here in their chronological sequence in the legend: the preparation for the Trojan War, the War, the Fall of Troy, and the homecoming of the Greek heroes.

The Trojan legends are introduced by the Judgement of Paris (**119-20**). The Trojan War was the result of Paris' abduction of the Greek Helen from her husband, Menelaus, who, with the help of his brother, Agamemnon, rallied the Greek forces to his aid. Achilles, who was needed to win the war, was recruited by Ulysses (Odysseus) and Diomedes who found him on the island of Scyros, disguised as a girl (**121**). The fleet after a long delay set out for Troy (Ilium) from Aulis, where Agamemnon had been told to sacrifice his daughter, Iphigenia (**105**).

Homer immortalizes in the *Iliad* a late phase of the fighting, ten years after the start of the war. Menelaus supporting the lifeless body of Achilles' friend, Patroclus (*Iliad XVII*) is represented in a fragmentary statue group (**155**, cf. the same motif in a Roman battle sarcophagus, **154**). Not included by Homer in the *Iliad*, but in a later sequence of the war, is the episode in which Achilles kills Penthesilea, an Amazon who had come to the aid of the Trojans, and killing her, fell in love (**139**). Still later, the concluding events of the war include the ordeal of Laocoon and his sons (**122**), magnificently described by Virgil; and

to secure the fall of Troy, Diomedes and Ulysses had to steal the Palladium (**123**).

The homecomings of the Greek heroes provided themes for many masterpieces of literature, among them Aeschylus' dramatic trilogy, the *Oresteia*. Agamemnon's tragic return resulted in Orestes' revenge against his mother (**106**). Homer's *Odyssey* follows Ulysses' adventures on his long voyage home; we illustrate one, possibly two, episodes related to Ulysses and the Cyclops (**124** and **147**).

LITERATURE: Fragments of *The Cypria, Aethiopis, The Little Iliad, The Sack of Ilium* and *The Returns (Nostoi), The Telegony* survive. These are included in Hesiod (Loeb ed.) 1914, see introduction by H.G.Evelyn-White. For further literature and works of art inspired by the Trojan Legends, see Scherer, 1963; and for legends concerning Ulysses, see Stanford and Luce, 1974.

THE JUDGEMENT OF PARIS

When Peleus and Thetis were married, all the gods and goddesses were invited to celebrate the wedding–except Eris (Discord), an understandable omission from the guest list. But Eris did not understand and was offended. Angrily she intruded on the festivities and tossed a golden apple into the midst of the gathering: on it were written the words, 'For the Fairest'.

Juno, Minerva and Venus each instantly claimed the apple as her own. Jupiter was loth to choose between them and so sent the three quarrelling goddesses off to be judged by a man who had a reputation for impartiality. That man was Paris, the son of the king of Troy.

Paris was at that time living rather humbly as a shepherd. This was because his mother, just before he was born, had dreamed that she had given birth to a fire-brand that had ignited and burned the whole city of Troy. On the advice of the soothsayers, the baby was

immediately exposed and left to die. He was, however, rescued by shepherds and brought up among them, which was why he was minding his herds and flocks when he was approached by Mercury (the messenger of the gods) leading the three contending goddesses. Mercury instructed Paris to decide which one of them was the fairest and to award her the golden apple.

Each of the three goddesses enticed Paris with a bribe. Juno offered a vast empire; Minerva offered a glorious military career; Venus offered the most beautiful woman in the world. This Paris could not resist and he gave Venus the apple.

True to her word, Venus presented Paris with the most beautiful of women, Helen, the wife of King Menelaus of Sparta. Paris carried her away to Troy, and thus provoked the war that ended in the destruction and burning of that city, for the Greeks were determined to recover Helen and were ready to fight for her.

The story provides the starting point and motivation for the Trojan war and explains the alignment of the goddesses on the Greek and Trojan sides–for the two slighted goddesses never forgave Paris and, on his account, conceived an undying hatred for his city.

The tale is told wittily and cynically by Lucian (*Dialogues of the Gods* XX) and is described vividly in the form of a pantomime by Apuleius (*The Golden Ass* XVII).

119. The Judgement of Paris

Roman sarcophagus, 2nd century A.D.
Rome, Villa Medici (Cagiano de Azevedo, 1951, cat. 54)

DESCRIPTION: One of the best loved sarcophagi in Raphael's circle, the whole relief inspired other compositions, while individual figures, and particularly the river god group, were copied or used in new works of art.

Paris as a Phrygian shepherd is seen seated in a landscape with his flock on the ledge above him; two semi-draped nymphs on the left. Paris gives the apple to Venus while Minerva and Juno look on. Mars, with shield raised, divides the two scenes. On the right the goddesses, escorted by Mercury,

return to Olympus, where Jupiter is seated above Caelus (Heaven), whose head and shoulders emerge from clouds and who holds a veil arching above his head. Below is a group of two chiastically reclining river gods flanked by nymphs. The relief was already much damaged in the Renaissance, many figures lacking heads and arms.

HISTORY: The sarcophagus was known at least from the early 16th century. From the della Valle Capranica Collection, it went in 1584 to the Villa Medici.

REPRESENTATIONS:
- 'Ripanda' skb., Oxford, Ashmolean, f. 53: freely 'restored' (**119a**).
- Raphael, study for tapestry cartoon of S. Peter in Prison, New York, Janos Scholz Collection (Shearman, 1972, fig. 70): adaptation of Uranus.
- Raphael, *The Vision of Ezechiel*, c. 1518, Florence, Pal. Pitti (Camesasca, 1963, pl. 125): Jupiter adapted as Ezechiel.
- Marcantonio Raimondi, engraving after Raphael, Bartsch, XIV, p. 106, no. 245 (Pope-Hennessy, 1971, fig. 20; Loewy, 1896, pp. 241–5; Vermeule, 1966, fig. 210a; Sheard, 1979, cat. 90): adaptation, conflated with **120**; cf. Marcantonio Raimondi School, engraving, not in Bartsch: reversed, 'restored'.
- Bonasone, engraving, Bartsch, XV, no. 112 (Bober, 1957, fig. 82): narrative unfolds in hilly landscape with sky.
- Giovanni da Udine, stucco relief, Vatican Loggie, 1st bay (Dacos, 1977, pl. LIVb): figure of Jupiter with eagle.
- Perino del Vaga, Besançon, Mus. B-A, D3009 (Gernsheim neg. no. 8364): whole relief, 'restored'.
- Aspertini, London, BM *Skb*. I, ff. 38ᵛ–39 (Bober, 1957, fig. 84 and pp. 68–9): right part from Venus standing before Paris, 'restored'.
- Franco, attrib., Cologne, Wallraf-Richartz Mus., Z-1956: right half with goddesses returning to Olympus, 'restored'.
- Girolamo da Carpi studio, Pozzo London BM I, f. 137ᵛ, no. 154 (Vermeule, 1966, p. 19): left and centre of front including Victory, unrestored.
- Girolamo da Carpi, follower of, London, BM, Sloane 5226–138 (Gere and Pouncey, 1983, cat. 167): right portion of front from figure of Mars, freely interpreted and 'restored'.
- Italian, 16th century, Bowdoin, Maine, College of Fine Arts, 18.11.134: unrestored. Fragment. Left side, including half the figure of Venus before Paris; animals.
- Cod. Coburgensis, f. 58 (Matz, 1871, 99): unrestored (Robert. *ASR*, II, fig. 11¹); cf. Cod. Pighianus, f. 259 (Jahn, 1868, 203).
- Cambridge *Skb*., f. 35 (Dhanens, 1963, fig. 26, not re-

cognized in cat. 33): headless figure of Mars seen as a statue in three-quarter view.

- Pozzo London BM I, f.20, no.22 (Vermeule, 1960, p.10): 'restored' (British, 18th century); f.137ᵛ (ibid., p.19): left half, unrestored (Girolamo da Carpi?).
- Pozzo Windsor, VIII, f.22, 8723 (Vermeule, 1966, p.50; fig.210): 'restored' in Villa Medici.

LITERATURE: Robert, *ASR*, II, cat.11. Dacos, 1977, pp.208–9: with list of further representations and derivations in works by Raphael–such as the *Ezechiel*–and by his circle. Gombrich, 1970, pp.273–7, for Warburg's interpretations of the relief as symbolic of an ancient concept of nature, transformed in the engraving by Marcantonio, and again in the painting, *Déjeuner sur l'herbe*, by Manet. See also Vermeule, 1964, p.8 on the value of this relief as a source for artists of all periods.

120. **The Judgement of Paris**

Roman sarcophagus relief
Rome, Villa Doria Pamphili (Calza *et al.*, 1977, cat.194; Robert, *ASR*, II, cat.10)

DESCRIPTION: The graceful poses of the figures in rhythmic groupings give the relief an idyllic serenity. On the left, two nymphs leaning on amphoras flank a seated nymph seen from the back in a much-admired pose often repeated in Renaissance and later works of art, finding favour with both Rubens and Ingres. Paris, seen towards the centre facing right, is approached by Mercury. Nude Venus with a billowing veil stands before him, followed by Juno and Minerva. On the right are Jupiter with nymphs above, and Tellus (Earth) below with a cornucopia. For its condition before restoration, see Cod. Coburgensis.

The short ends may be now in Liverpool County Museum, from Ince: Paris as shepherd; Venus and Amor (Ashmole, 1929, nos.262–3, pl.47; Robert, *ASR*, II, cat.10a–b).

HISTORY: At end of 15th century it was at S. Maria a Monterone in Rome. In the 16th century it was perhaps in the house of Girolamo Frangipane behind S.Maria in Via (Aldrovandi, 1556, p.284; Hülsen, 1933, p.6).

REPRESENTATIONS:
- *Cod.* Escurialensis, f.8ᵛ: 'restored'.
- Raphael, *School of Athens*, fresco, Vatican: the pose of Raphael's fictive statue of Apollo is similar to that of the nymph behind Paris.
- Agostino Veneziano, engravings, Bartsch, XIV, nos.474–5, 478: three nymphs on left.

- After Raphael, engraving, Bartsch, XV, no.25: Jupiter and Ganymede.
- 'Bambaia' Berlin *Skb.*, f.13 (Dreyer and Winner, 1964, cat.13, fig.29): free adaptation.
- For Marcantonio's engravings after Raphael, see **119** with which this relief is conflated.
- Girolamo da Carpi, Turin, Bibl. Reale, 'Contraffazione', 12A (Canedy, 1976, p.4): left half.
- Lambert Lombard, Album, D508: transposition of figures, 'restored'.
- Cod.Coburgensis, f.59 (Matz, 1871, 200): unrestored; f.102ᵛ (Matz, 1871, 202): ends, Paris as shepherd and Venus and Amor.
- Dosio, Berlin *Skb.*, f.8: restored. (Also reproduced in Dreyer and Winner, 1964, fig.24).
- Pozzo London BM I, f.20, no.22 (Vermeule, 1960, p.10): 18th century inserted sheet.
- Pozzo Windsor, X, fig.18, 8011 (Vermeule, 1966, p.62).
- Topham Albums, Windsor, Eton College Lib., B.M. 10.30 bis: ends.

LITERATURE: Clairmont, 1951, cat.242.

ACHILLES ON SCYROS

Achilles' mother, Thetis, knew that her son was fated to have either a long inglorious life or a short and glorious one.

Preparations were being made for the Trojan war while Achilles was still a beardless youth. The Greek leaders were eager to number Achilles among their forces, for there was a prophecy that Troy could not be taken without his help. Thetis, fearing that the glory Achilles would win in such a war would condemn him to an early death, hid him among the daughters of Lycomedes on the island of Scyros, dressed as a girl.

Ulysses and Diomedes, who were recruiting on behalf of the Greek chieftains, discovered that Achilles was on Scyros, but at first were at a loss as to how to detect him in his disguise. Ulysses eventually devised the following stratagem: he and Diomedes arrived pretending to be merchants. They offered an array of feminine articles, but also included a complete set of arms and armour. While the daughters of Lycomedes (and Achilles among them) were inspecting the goods, Ulysses had someone blow a trumpet to sound the alarm. Achilles, his true nature rushing irrepressibly

to the surface, immediately seized the spear and shield. Having thus revealed himself, Achilles was easily persuaded to join the expedition against Troy. His departure from Scyros was particularly lamented by Lycomedes' eldest daughter (Deidamia), the mother of his son, Neoptolemus (or Pyrrhus), whom he hastily married before leaving.

The story is told at length by Statius (*Achilleid* I, 207 ff.) and a painting of it is described by the younger Philostratos (*Imagines* I). The Greeks, Polygnotus (Pausanias I, xxii.6) and Athenion (Pliny, *Natural History* XXXV, 134) painted the subject, and among the Romans it was not only painted on the walls of Pompeian houses but also carved on sarcophagi.

121. Achilles on Scyros

Roman sarcophagus relief
Bedfordshire, Woburn Abbey (Michaelis, 1882, cat. 117)

DESCRIPTION: Achilles disguised as a girl (centre left) with the daughters of Lycomedes seizes a spear and shield from the otherwise maidenly trinkets brought by the bearded Ulysses with his characteristic cap (*pilos*), watching in the background with his warriors. The kneeling girl with amoretti must be the princess Deidamia with whom Achilles had fallen in love. Pirro Ligorio described the six maidens:

'like lovely nymphs dressed in thinnest veils, some of them seem to dance and swirl their veils, with the cloth so light and transparent that they seem almost nude' (Dessau, 1883, p. 1093, no. 16).

For an amusing description of the scene in a relief in Cambridge which preserves the trumpet, see Budde and Nichols (1964, cat. 162, pl. 56).

See REPRESENTATIONS below, Cod. Coburgensis, for condition of the relief in the Renaissance.

HISTORY: Among the eight reliefs walled into the staircase of S. Maria in Aracoeli in the 14th century, it was there described by Pirro Ligorio. In the early 17th century? it went to the Villa Aldobrandini in Frascati.

INTERPRETATIONS: Pirro Ligorio described the scene as 'Achilles and Ulysses' (in Dessau, *op. cit.*),

diverging from the present interpretation only in the identifications of some of the figures.

REPRESENTATIONS:
- Florentine?, 15th century, Chantilly, Mus. Condé (Gombrich, 1970, pl. 6b): on right of sheet, maiden with lyre, maiden in background, and unfinished figure of Achilles **(121a)**. The maiden with the lyre illustrates Warburg's example of *ninfa* with movement of draperies, hair etc. as 'the touchstone of the "influence of antiquity"' (*ibid.*, p. 61). Cf. Alberti's *Della Pittura* II, in which he recommends to artists the graceful movement of draperies blown by the wind to reveal a figure (Alberti–Grayson, 1972, p. 87; see also Dobrick, 1979, for ills. of Botticelli's use of the device. The motif is discussed in the Introduction, p. 36.)
- Heemskerck *Skb.* I, f. 76: detail of helmet decorated with battle scene (not by Heemskerck).
- Girolamo da Carpi, follower of, London, BM, 1950–8–16–13ᵛ (Gere and Pouncey, 1983, cat. 185): central group, Achilles with daughters **(121b)**.
- Cod. Coburgensis, f. 60 (Matz, 1871, 203): whole front unrestored. Missing: Achilles' arms, Deidamia's head, all but three torsos of amoretti, right arm and left hand of bearded trumpet blower (Diomedes?), head and arms of female figure in background right of shield (Robert, *ASR*, II, fig. 34¹).
- Pozzo Windsor, III, f. 11, 8334 (Vermeule, 1966,
- p. 21): restored.
 Pozzo Windsor, X, f. 93. 8086 (Vermeule, 1966, p. 66): 'Aracoeli'. very free interpretation of front, and lid (now lost).

LITERATURE: Robert. *ASR*, II, cat. 34. Warburg. 1932, I, p. 20 n. 2 figs. 6–7 for drawing in Chantilly and 'Nympha'.

OTHER SARCOPHAGUS RELIEFS WITH ACHILLES ON SCYROS KNOWN IN THE RENAISSANCE:
- Paris. Louvre (Robert, *ASR*, II, cat. 26): known to Raphael *(Parnassus)*.
- Lost (Robert, *ASR*, II, cat. 29): if, as thought, it was in the Porcari Collection, it could have been known in Rome at the end of the 15th century.

LAOCOON

Laocoon, the only clear-sighted man left in Troy, feared and distrusted the great wooden horse that the Greeks had placed outside the walls of the city. He even dared to heave a spear into the horse's side and set the armour of the warriors concealed inside it rattling.

But Troy was doomed to fall and the warning was not heeded. The gods moreover discredited Laocoon by visiting a terrible fate upon him. He had been chosen by lot to be the priest of Neptune, and as he was about to sacrifice a bull at the altar of the god on the shore by the sea, two monstrous snakes came swimming towards him.

'And now, with blazing and blood-shot eyes and tongues which flickered and licked their hissing mouths, they were on the beach ... they forged straight at Laocoon. First each snake took one of his two little sons, twined round him, tightening, and bit, and devoured the tiny limbs. Next they seized Laocoon, who had armed himself and was hastening to the rescue; they bound him in the giant spirals of their scaly length, twice round his middle, twice round his throat; and still their heads and necks towered above him. His hands strove frantically to wrench the knots apart. Filth and black venom drenched his priestly bands. His shrieks were horrible and filled the sky...'

Such is the terrifying word-picture that Virgil paints of the fate of Laocoon (*Aeneid* II, 203ff., Jackson-Knight, transl. Penguin).

Another stunning image of Laocoon's death was produced by three Greek sculptors, who probably drew their inspiration from sources similar to Virgil's. The Roman polymath Pliny (d.79 A.D.) says this about their work:

'...the Laocoon which stands in the palace of the Emperor Titus, is a work to be preferred to all that the arts of painting and sculpture have produced. Out of one block of stone, the consummate artists, Hagesandros, Polydorus, and Athenodorus of Rhodes made, after careful planning, Laocoon, his sons and the snakes marvellously entwined about them.' (*Natural History* XXXVI, 37, Bieber, transl.)

LITERATURE: Bieber, 1942.

122. Laocoon

Roman copy, 1st century A.D., group
Vatican, Belvedere (Amelung, *Kat.*, II, pp.181–205, no.74; Helbig, I, cat.219)

FAME IN THE RENAISSANCE: From its momentous discovery in 1506 (see HISTORY) the Laocoon was universally admired, the most moving of the statues in the Vatican Belvedere Statue Court. It immediately inspired many detailed descriptions and humanist poems (see Brummer, 1970 and Winner, 1974). It was particularly treasured by Michelangelo who was reported by Boissard (1559) to have said that it was 'a singular miracle of art in which we should grasp the divine genius of the craftsman rather than try to make an imitation of it' (quoted in Latin by Brummer, 1970, p.271). Even so it was copied for eager collectors by Sansovino, Bandinelli and others, and it was cast in bronze from Primaticcio's mould of 1540 for Francis I at Fontainebleau.

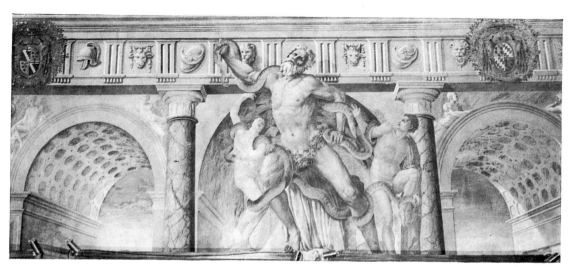

122e

Its liberating baroque rhythms, and sensitive carving were also greatly admired by Titian, El Greco, Bernini and Rubens. Lessing, in the 18th century, however, found in it the ideal of classical restraint. For the Neo-Classical sculptor, Canova, 'the first two statues in the world' were the Apollo Belvedere and the Laocoon.

DESCRIPTION: Michelangelo identified this group with Pliny's description. Although Pliny thought the group was carved from a single block, in 1506 Michelangelo and Gian Cristoforo Romano were able to see that it was skilfully fitted together in four parts (Brummer, 1970, pp. 81–2); Filippo Magi (1960, pp. 13ff.) discovered that it is in fact composed of seven or eight parts.

When the statue was discovered, according to the earliest representations, there were missing Laocoon's right arm, and that of his eldest son (left); this son's lower leg, but with the toes still preserved against the inner left heel; the fingers on the right hand of the younger son and some toes. Various attempts were made to restore the group (see REPRESENTATIONS), one by Bandinelli in the early 1520s (122b), and another by Montorsoli in 1532–3. The representations from about 1540 show the right arm of Laocoon diagonally outstretched. The outstretched arm was replaced in marble c. 1725–7 by Cornacchini. Recently Magi reconstructed the group by removing the restorations of arms and replacing the fragment of Laocoon's original arm discovered in a mason's yard in the early 20th century (see 122d). The antique arm, bending towards the head, is closer to Bandinelli's reconstruction in his marble copy of 1520–5, than to the outstretched arm thought to be Montorsoli's.

HISTORY: The statue was discovered on 14 January 1506 on the Esquiline near the so-called Baths of Titus in a vineyard. It was brought to the Belvedere where the statue court was still under construction, and installed in a specially planned niche (capella; see Brummer, 1970, pp. 75–8 for contemporary reports). It was taken to Paris in 1797–8 and returned to the Vatican in 1815 (Prandi, 1954).

INTERPRETATIONS: The statue was recognized as Laocoon at once. When the architect and antiquarian Giuliano da Sangallo was summoned by Pope Julius II to see the group still in the ground, he took Michelangelo with him, together with his small son, Francesco, who remembered many years later the moment when they first peered down at the statues, and his father saying, 'This is the Laocoon of which Pliny writes' (Brummer, 1970, p. 75).

Its literary associations first determined the interpretations of the group. Cavalcanti in 1506 wrote that the missing right arms were intended to be raised, according to the signs of attachment (spiccatura) and 'it is believed that the father must have had a spear in his hand, or some other weapon' (cf. Virgil, Aeneid II, 216: 'tela ferentem'. See Winner, 1974, pp. 106–7, n. 63 for Cavalcanti's description.) The missing arm of Laocoon was interpreted in a humanist poem to be the result of divine retribution for hurling the spear against the wooden horse (Brummer, 1970, pp. 118–19).

The Laocoon was known as an exemplar of suffering, and was considered a suitable model in the Counter-Reformation period for representing Christian martyrs (Brummer, 1970, pp. 117–18; Ettlinger, 1961, pp. 121–6).

SOME PROBLEMS REGARDING REPRESENTATIONS: The sequence of representations of the Laocoon in the 16th century is almost as intricate as the coils of its serpents. The tentativeness of dating or attributing some of the drawings, the uncertainty as to whether they refer to the copies made by Sansovino and Bandinelli, and by others, or if they reflect the wax arm restored by Bandinelli in the early 1520s or that by Montorsoli in 1532–3, is compounded by the draughtsmen's own inventiveness in 'restoring' the group, and by lack of evidence that the restorations of the right arm were actually attached to the figure and if so, for how long. These problems apply to representations before 1540.

In 1540 Primaticcio made a cast of the unrestored group for Francis I, king of France. It was after this that part of Laocoon's right shoulder was cut away to accomodate an unfinished terracotta arm which exactly fits. Can this be Bandinelli's? It is similar to the bent one in his marble copy.

The only thing that seems perfectly clear is that from the mid 16th century, all representations are unanimous in showing Laocoon's right arm outstretched diagonally upward, the hand grasping a doubled coil of snake. They are thought to be based on Montorsoli's terracotta restoration, but Heemskerck, who drew figure studies of the group between 1532 and 1535, during or just after Montorsoli's restoration, does not record the right arm of Laocoon. Francisco de Hollanda (1539–40) in a drawing of the restored statue in its redecorated niche shows an outstretched arm, but with a slightly more decorative system of snake coils.

Brummer suggests that Montorsoli's outstretched terracotta arm was removed for the cast made by Primaticcio in 1540; that then the shoulder was mutilated to accomodate an unfinished terracotta bent right arm; that later it was removed, and the outstretched arm by Montorsoli was replaced (Brummer, 1970, pp. 89, 100–1).

The representations are listed in chronological order which must still be partly tentative, according to the current literature, with the caution that in spite of the vast amount of work done on this famous group, we still do not know its complete history in the Renaissance.

REPRESENTATIONS:

– Italian, 1506, Düsseldorf, Kunstmus., FP7032 (Winner, 1974, fig. 14 and pp. 99–102): unrestored. Makeshift blocks under left foot of Laocoon and the right foot of the elder son (122a).
– Giovanni Antonio da Brescia, 1509, engraving, Bartsch, XIII, p. 326, no. 15 (Brummer, 1970, fig. 68): reversed, unrestored. Makeshift blocks under feet.
– Marco Dente, engraving, Bartsch, XIV, p. 268, no. 353 (Brummer, 1970, fig. 61; Sheard, 1979, cat. 60): the group against a wall with ruins behind. Figures and altar rest on a base; younger son's foot restored.
– Italian, early 16th century, bronze plaquette, Washington, D.C., NGA, Kress Collection (Pope-Hennessy, 1965, fig. 316, cat. 383): 'restored' with Laocoon's hand to head, and snake over head. Pope-Hennessy suggests that it may have been inspired by an antique gem.
– Roman, 16th century, detail of fresco in Vatican, Appartamento delle Guardie Nobili (Brummer, 1970, fig. 71): unrestored on base at foot of Esquiline with 'Trophies of Marius' (174) on top of hill.
– Jacopo Sansovino, wax copy (c. 1506–8, according to Shearman, 1977, pp. 136–7), lost; cast in bronze without sons, or sons cast separately, in Rome for Cardinal Domenico Grimani (Perry, 1978, pp. 221–3; 242, no. 28); given to the Cardinal in Lorraine in 1534 (Vasari–Milanesi, 1906, VII, p. 489; cf. Brummer, 1970, fig. 88, left, for bronze in Florence, Mus. Naz. of unrestored group, and p. 103, n. 39 for discussion of appearance of Jacopo's model). A stucco copy was sent to Federigo Gonzaga (letter from Pietro Aretino quoted by Brummer, 1970, p. 102).
– Florentine, early 16th century, Paris, Louvre, 2712 (Berenson, 1938, cat. 2379A as Puligo): younger son 'restored' with right arm behind head.
– Andrea or Jacopo Sansovino, attrib., Florence, Uffizi, 14535F (Brummer, 1970, fig. 90 and addendum after p. 275; Winner, 1974, pp. 111–2 as probably after Montorsoli's restorations): study of 'restored'? Laocoon with right arm outstretched, no snakes.

– Raphael, study for Homer's head in *Parnassus*, 1511, Windsor, 12760 (Popham and Wilde, 1949, cat 796, pl. 48): based on head of Laocoon.
– Andrea del Sarto, c. 1520, Florence, Uffizi, 339F (Shearman, 1965, pl. 73b): studies of leg of older son.
– Bandinelli, marble copy, 1520–5, Florence, Uffizi (122b; Brummer, 1970, fig. 96): right arm bent up at the elbow, the snake knotted around the biceps. See Vasari–Milanesi (1906, VI, p. 146) and report of Venetian ambassador in time of Adrian VI (1522–3):

 'The king of France asked Pope Leo in Bologna for the gift of this work (the original Laocoon group). The Pope promised it to him, but in order not to deprive the Belvedere, he decided to have a copy made to give him, and already the boys are made which are there in a room...' (Brummer, 1970, p. 266.)

Bandinelli's wax right arm for the Laocoon was made for Clement VII and was presumably bent and with knotted snakes as in his marble replica (Vasari–Milanesi, 1906, VI, p. 146).
– Bandinelli, Florence, Uffizi, 14785F; 14786F: Laocoon without right arm, studies of torso, etc.
– Parmigianino, c. 1524?, Florence, Uffizi, 743E (Popham, 1971, pl. 212, cat. 71): study of head of elder son; Chatsworth, 347b (*ibid.*, pl. 212, cat. 694): head of Laocoon.
– Tomaso Bernabei, ('il Papacello'), *Laocoon*, fresco, 1525–27, Cortona, villa of Cardinal Silvio Passerini (d. 1529) (Magi, 1967–8, fig. 2): inscription on base: 'LAOCOON / CVIVS VETVSTISSIMA IMA / GO ROMAE INVENTA ET / IN PALATIO PONTIFICO QVOD VVLGO DICITVR BEL / VEDE / RE PO- SITA / EST. In Cardinal's room frescoed with scenes from Roman history (122e). The right arm, closer to Bandinelli's reconstruction than to the outstretched arm attrib. to Montorsoli. Winner (1974, p. 103, n. 55; p. 117, n. 102) thinks the fresco follows Beatrizet's engraving, Bartsch, XV, no. 264, p. 90, see below.
– Aspertini, London, BM *Skb.* I, f. 17 (Bober, 1957, fig. 49; Brummer, 1970, fig. 97): right arm bent with hand on head, no snakes. Either an exaggeration of the pose created by Bandinelli's wax arm, or an independent 'restoration' which anticipates the modern restoration of Magi with the original arm illus. in Brummer's (1970) fig. 67. Bober (1957, p. 14) dates Aspertini's drawing before Montorsoli's restoration of 1532–3.
– Michelangelo, attrib., large mural drawing discovered 1975, c. 1530?, Florence, S. Lorenzo, crypt under New Sacristy (dal Pogetto, 1979, fig. 108; Elam, 1981, fig. 24 as by perhaps Montorsoli?): recollected head of Laocoon.
– Montorsoli, terracotta arm for Laocoon, 1532–4. Montorsoli was summoned from the Sacrestia Nuova of S. Lorenzo, Florence, where he had been assisting Michelangelo, to Rome to restore the Lao-

coon, the Apollo Belvedere and other statues in the Belvedere for Clement VII (Vasari–Milanesi, 1906, VI, p.633).

- Heemskerck, *Skb.* I, f.39: head; f.23ᵛ: right side of Laocoon from neck to top of thigh, without right arm; back of left foot with ankle; f.74: back of Laocoon, snakes suggested, no arm, see also ff.67ᵛa–b and 74ᵛb (details of left leg and arm, left thigh; copies after another artist).
- Lambert Lombard, Album, f.85, by another hand: restored, reversed sketch (Denhaene, 1983, cat.264).
- Francisco de Hollanda, *Skb.*, f.9ᵛ (Brummer, 1970, fig.62): restored? group in redecorated niche in Belvedere **(122c)**.
- Primaticcio, mould, 1540, for cast in bronze for Fontainebleau: unrestored, without right arm. Later some of Laocoon's right shoulder was cut away to receive another arm much like the arm in Bandinelli's marble replica in the Uffizi. (See Brummer, 1970, fig.72 of the bronze cast now back in Fontainebleau; fig.73 of unfinished terracotta right arm; fig.74 of Laocoon's right shoulder cut away; fig.75, Laocoon with unfinished terracotta arm attached.) This arm was attributed to Michelangelo by Magi (1960, pp.64ff.).

All the subsequent drawings and engravings, of which the following are a selection, record the statue with an arm outstretched, and the snake a taut loop:
- Marliani, 1544 (Brummer, 1970, fig.80).
- Beatrizet, engravings for Lafréry's *Speculum*, Bartsch XV, p.264, no.90: group restored in niche; Bartsch, XV, p.264, no.91 (Brummer, 1970, figs.81–2): close-up of group. Right arm of younger son missing and fingers of right hand of elder son, but Laocoon's arm restored.
- Cambridge *Skb.*, f.2 (Dhanens, 1963, fig.17, cat.2; Brummer, 1970, fig.76): shows join at right shoulder of Laocoon.
- Figino, Windsor Album, c.1570s (Brummer, 1970, fig.77, Popham and Wilde, 1949, cat.326, no.51): detail of Laocoon from below right. (Cf. *ibid.*, nos.36–8; 52–3).
- Cavalieri, I–II, pl.1: group restored. Isolated.

ADAPTATION:
- N.Boldrini, undated woodcut after Titian's lost caricature (Clark, 1960, fig.298): father and sons as monkeys in a landscape; reversed, and 'restored' with 'Laocoon's' hand towards head.

LITERATURE: Helbig, I, cat.219 (Fuchs). Conticello and Andreae, 1974. Von Blanckenhagen, 1969; *id.*, 1976, p.103; and Robertson, 1975, pp.541–2 with controversial theory on basis of Sperlonga discoveries. Prandi, 1954; Bober, 1957, pp.61–2; Brummer, 1970, pp.75–119, and appendices for early descriptions; Winner, 1974; Sheard, 1979, cat 61; Haskell and Penny, 1981, cat.52.

OTHER ANTIQUE REPRESENTATIONS OF LAOCOON KNOWN IN THE RENAISSANCE:
- Hellenistic head of Laocoon (Pisanello, Paris, Louvre, 2315ᵛ); for various heads, some antique? see Forster (1891, pl.I; 1906, pp.8ff., figs.2–5). Also cf. the Maffei head *somigliantissima* to that in the Belvedere (Aldrovandi, 1558, p.241).
- Manuscript illumination, Vatican Virgil, Vat. Lat. 3225, f.18ᵛ (de Mely, 1909, pp.209ff., pls.22–3; Winner, 1974, fig.9; Brummer, 1970, fig.104).

DIOMEDES AND THE PALLADIUM

An oracle revealed that Troy could never be taken as long as it possessed the Palladium. According to Apollodorus (*Bibliotheke*, III, xii, 3), the Palladium (a statue sacred to Athena-Minerva), which had fallen from heaven, 'was three cubits in height, its feet joined together; in its right hand it held a spear aloft, and in the other hand a distaff and a spindle'.

On learning of the oracle, Ulysses and Diomedes crept into Troy one night and stole the statue.

The theft of the Palladium was frequently illustrated in classical art. Sometimes Ulysses was shown carrying the image and sometimes Diomedes. Ancient writers were as divided on this point as the artists. In the literary tradition, which goes back as far as the 7th century B.C. epic cycle, it was usually supposed that the two heroes acted in concert, but there was no unanimity as to which one actually carried the statue.

Several gems show Diomedes alone holding the Palladium; one such was well-known in the Renaissance.

123. Diomedes and the Palladium
Gem (Chalcedony intaglio).
Roman copy of 1st century A.D. after Greek original of 1st century B.C. (4.5 × 3.3 cm.)
Lost. Illustration from cast in Cades Collection, III, E283 (Dacos *et al.*. 1973, cat.26 and *scheda* 9)

FAME IN THE RENAISSANCE: The Chalcedony was greatly praised by artists and humanists; Filarete and Vespasiano da Bisticci attributed it to the hand of 'Pulicreto' (Policleto). Originally discovered around the neck of a little boy on the streets of Florence and bought for five florins, its value in-

creased with successive owners to 500 florins by 1492. The appreciation it received in humanist circles is reflected in Quattrocento works of art, in manuscript illuminations, in plaquettes and in medals, and in a large marble tondo in the courtyard of the Palazzo Medici. When it was in the collection of Lorenzo de' Medici, Leonardo and Michelangelo studied it.

DESCRIPTION:

c. 1450–Ghiberti, *Commentarii*:

'... among the other antique things he (Niccolò Niccoli) had this chalcedony, which is the most perfect thing I ever saw. Oval in form, it had on it the figure of a youth with a knife in his hand. He was almost kneeling with one foot on an altar; the right leg was resting on the altar and the foot placed on the ground was foreshortened with such art and mastery that it was a wonderful thing to see. In his left hand he had a cloth with which he held a small idol. It seemed that the youth was threatening the idol with his knife. By all those skilled and expert in sculpture or painting, without the disagreement of a single person, this carving was said to be a marvellous work, having all the measurements and proportions any carving or sculpture should have ... One could not see it well in a strong light. The reason is this: that when fine polished stones are carved, the strong light and the reflections conceal the carving. This carving could best be seen by turning the carved part against a strong light; then one may see it perfectly ...' (Ghiberti, *Commentarii* III, 4, English transl. by Holt, 1958, pp. 166–7; Dacos *et al.*, 1973, p. 160 in Italian.)

1457–from inventory of collection of Pietro Barbo (Paul II, 1464–71), Palazzo, S. Marco, Rome:

'A large chalcedony in which is a figure of a nude male seated and having in his right hand a sword, but in the left hand he holds the god Mars, and the left arm is covered with drapery, and this figure is surrounded by a large laurel *(et circumdatur ipsa figura laurea magna)*, and is of the value of 80 ducats.' (Latin text of entry in Dacos *et al.*, 1973, cat. 26, p. 57, *Notizie*).

1492–from inventory of Lorenzo de' Medici's collection:

'A chalcedony with a figure engraved half sitting on an altar with a foot underneath and the left *(sic)* leg extended, an arm behind with a knife in the hand, a drapery over the shoulder and outstretched arm and in the hand an armed figure in gold (?), engraved transparent without a backing *(in chavo trasparente sanza fondo)*, 500 florins.' (Italian text in Dacos *et al.*. 1973, App. Doc. XI, p. 122, f. 20.)

The side of the altar is carved with Lorenzo's abbreviated name: 'LAV. R. MED.' in reverse. The high quality of the intaglio and certain details distinguish it from other antique and modern intaglios of Diomedes. For a seated Diomedes and standing figure of Ulysses on the 'Felix gem' known in the 15th century, see Pollard (1977, pls. 54–5, p. 574; Sheard, 1979, cat. 8); for the motif in antique sculpture, see Reinach (*Rép. Stat.*, III, p. 80, no. 2; *Rép. Rel.*, III, p. 36, no. 2: lost sarcophagus relief known in the Renaissance). Other antique replicas in Wester and Simon (1965, p. 28, n. 17).

HISTORY: Found by the Florentine humanist and collector, Niccolò Niccoli around the neck of a small boy and bought from the father (Vespasiano da Bisticci, Italian text in Dacos *et al.*, 1973, p. 86, Doc. III). By 1437 bought from Niccoli in Florence by the Patriach of Aquileia (Ludovico Trevisan), Testament of Niccoli, *ibid.*, p. 85, n. 2). By 1457 in collection of Pietro Barbo, later Pope Paul II (*ibid.*, cat. 26, p. 57); acquired by Lorenzo de' Medici in September 1471 (Lorenzo's *Ricordi*, *ibid.*, pp. 119–120; inventory of 1492, *ibid.*, p. 122). Untraced after 1494? (*ibid.*, pp. 6–10).

INTERPRETATIONS: Diomedes was not identified in the Quattrocento. The Palladium was thought to be a male figure, armed, and is called Mars in the inventory of 1457. A quattrocento medal reverse shows Diomedes incribed as 'Mercurio'. By the 18th century, similar figures were correctly identified (Gori, 1732, II, pl. XXVIII, figs. 2–3 with reference to passages in Virgil, Ovid etc.; fig. 1 cf. 'Felix gem', Pollard, 1977).

REPRESENTATIONS:

– Italian, 15th century, bronze plaquettes, Washington, D.C., NGA (Pope-Hennessy, 1965, cat. 256, fig. 44; Dacos *et al.*, 1973, fig. 69; and Pope-Hennessy, *ibid.*, cat. 257, fig. 47): variants, not casts, based on the gem. Both plaquettes omit Lorenzo's mark and could therefore be considered to be copied from the gem before it came into Lorenzo's collection; Pope-Hennessy, 1964, 'The Italian Plaquette', p. 67.
– Donatello School, large marble tondo, Florence, Pal. Medici courtyard (Dacos *et al.*, 1973, fig. 83; Wester and Simon, 1965, fig. 2, pp. 27–8): adaptation of figure to circular frame (**123a**).
– Cicero, *Orationes*, Florence, Bibl. Laur., Plut. 48, cod. 8, f. 2, MS illumination (detail, Pollak, 1951, pl. 51d).
– Breviary of Ercole I d'Este, now lost, MS illumination (Hermann, 1900, pl. XXVII).

Niccolò Fiorentino, (Spinelli), reverse of medal of Antonio della Lecia (d. 1510) (Hill, 1930, cat. 925, pl. 150): figure copied from gem with inscription, 'Mercurio'.

- Leonarda da Vinci, Windsor, 12540 (Clark–Pedretti, 1968–9, II, cat. 12540 as possibly a study for St. John the Baptist; Pollak, 1951, pl. 51a, pp. 303–4; Dacos et al., 1973, fig. 95): nude male figure in more comfortable pose without accessories.
- Michelangelo, Vatican, Sistine Chapel Ceiling, fresco (de Tolnay, 1945–9, II, fig. 366): pose adapted in reverse for one of the *ignudi* above right of the Erythraean Sybil.

LITERATURE: All the sources and representations used in this entry unless otherwise stated, can be found, as indicated in Dacos et al., 1973. Their catalogue is itself a treasury of source material and an invaluable reference for the study of antique gems in the Renaissance.

ULYSSES AND POLYPHEMUS

In Book IX of the *Odyssey*, Homer tells how when Ulysses was sailing home after the sack of Troy, he and some of his men came to the cave that was the home of a giant, the one-eyed Cyclops, Polyphemus. They hoped to be given fine presents by the monster, since at that time hosts customarily sent their guests off mightily enriched, but, discourteously, Polyphemus decided he would rather eat them.

Polyphemus trapped the men within his cave by blocking the entrance with an enormous boulder, too large and heavy for Ulysses and his men to dislodge. Ulysses realised that he could not hope to escape if he killed the Cyclops outright and that he had to find some way to induce the monster to remove the boulder himself. So, after Polyphemus had finished one of his grisly meals, Ulysses offered him copious draughts of strong wine. When the Cyclops had fallen into a drunken stupor, Ulysses and his men drove a firehardened stake into his single eye to blind him.

Next morning, though he was himself in dreadful pain, Polyphemus was touched with compassion for his sheep who bleated piteously because they could not get out of the cave. He heaved the great boulder aside, but spread his huge hands across the opening in order to make sure that no men slipped out along with the sheep. Clever Ulysses, however, had tied his men up under the bellies of the sheep and himself clung on underneath the biggest ram. Thus did the Greeks make good their escape.

The relief **(124)** illustrates the moment when Polyphemus, having finished ministering to his flocks for the night, has seized a pair of Ulysses' men and prepared them for his supper by dashing their brains out on the floor. Ulysses reports:

Then came my chance. With an ivy-bowl of my dark wine in my hands, I went up to him and said: 'Here, Cyclops, have some wine to wash down that meal of human flesh…' (*Odyssey* IX, 347–9).

124. Ulysses with Polyphemus
Roman relief, copied from a late Hellenistic Odyssey cycle
Paris, Louvre (MA 3456)

DESCRIPTION: The very high relief is extremely damaged, and unrestored.

Ulysses is shown at the far left looking ingratiatingly at Polyphemus seated to the right in the pose of the famous Lysippian bronze of a seated Hercules *Epitrapezios*. The Cyclops holds the wrist of a crumpled companion of Ulysses (no doubt part of his intended feast) in his left hand; his right would have been free to accept the cup that Ulysses was holding out to him, but both arms are damaged or missing. Another companion appears head and shoulders above Ulysses.

Another relief illustrating this passage in the Museo Capitolino, Rome (Stuart Jones, 1912, pp. 36–37, Atrio 35), was also known in the Renaissance at the Palazzo S. Marco **(143a)**.

HISTORY: An early drawing indicates that it was known in Rome in the first half of the 15th century, but the location and later history are not known.

REPRESENTATION:
- Central Italian, c. 1420–30, Paris, Louvre, R.F. 38 **(124a**; Degenhart and Schmitt, 1968, I, cat. 137, p. 179): the figure of Polyphemus and the Greek kneeling below him, undamaged ('restored'?), on a sheet with other figures from Roman reliefs (see **83**, **86** and **139**).

LITERATURE: See Sichtermann and Koch, 1975, pl. 129, cat. 50 on another sarcophagus relief of this subject in Naples.

DEMIGODS AND HEROES

The Greek heroes in the following section (125–138) are grouped together here not only because they are men of athletic build, capable of mighty deeds, but also because they were worshipped as gods, or honoured as civic heroes, as in the case of the Tyrannicides.

The Dioscuri (125) were demigods, offspring of a mortal and a god, and were hatched from Leda's egg (see 3–5); although Castor was thought to have a mortal father, he shared, in a limited way, his twin Pollux's immortality. Hercules (129–138) was also born of Jupiter and a mortal. He became a god through his Labours (134–8) and was worshipped as a saviour in many local cults throughout the Mediterranean world.

On the other hand, the Tyrannicides and Antinous were not mythological, but historical figures. The Tyrannicides (127) were honoured by the citizens of Athens for their patriotic efforts, and their commemorative statues show them as athletes in challenging poses. Antinous (128) was a Greek youth from Bithynia in Asia Minor, living some six centuries later, in the second century A.D. He was loved by the Emperor Hadrian, who deified him after his early death, not because of his heroic deeds, but to preserve the image of his outstanding beauty. He is included here, and not in the Roman section of the book, because some of his cult statues, of which 128 is one, show him as a classical Greek hero or divinity.

Literature: Farnell, 1921.

THE DIOSCURI (CASTOR AND POLLUX/ POLYDEUCES)

Castor and Pollux were usually referred to as the Dioscuri, the sons of Jupiter, even though only Pollux was the offspring of the god, and Castor was the son of the mortal, Tyndareus, according to Pindar (*Nemean Ode* X, 55ff.).

The mother of both Dioscuri was indisputably Leda, who had been embraced by Jupiter disguised as a swan (3, 4, 5), and who in consequence produced either a single egg or a pair of eggs from which her children (Castor and Pollux, Clytemnestra and Helen) were hatched (*First Vatican Mythographer*, 78 and 204; see Frazer's notes in Apollodorus, *The Library*, 1956, II, p. 23, n. 7). In the second century A.D., according to Pausanias (III, xvi, 1), an egg hanging from the roof of a sanctuary in Laconia was said to have been the famous one that Leda brought forth. The sanctuary belonged to the daughters of Leucippus, Hilaeira and Phoebe, who were carried off by the Dioscuri (126) and this fact may well explain why such a remarkable object was associated with them.

As youthful heroes, the Dioscuri participated in the great legendary expeditions of their day; they joined in the voyage of the Argo and helped with the hunt of the Calydonian Boar (cf. 113). They were thought of as warriors and athletes and from early times were associated with horses.

Many cults in Greece were devoted to the worship of the Dioscuri, and from the third century B.C. the Romans began to revere them as well.

The Romans cherished the legend of the aid they were given by the Dioscuri when they were fighting the Latins at the Battle of Lake Regillus (Dionysus of Halicarnassus, VI, xiii, 1–5), which prompted the erection of many monuments in honour of the pair. Pliny (*Natural History* XXXIV, 79) mentions statues of the Dioscuri that stood in front of the temple of Jupiter the Thunderer.

Pirro Ligorio identified a pair discovered in the time of Pius IV (1559–65) with those referred to by Pliny. They were later placed on the parapet above the Capitoline ramp where they are still to be found.

But the gigantic Dioscuri of Monte Cavallo (125) were not known as such in the Renais-

sance. In spite of their horses, they do not wear the short capes and round caps by which the Dioscuri are identified in Roman reliefs, coins and statues.

Because Castor and Pollux were thought to spend alternate days in the heavens, they came to symbolize immortality and salvation on Roman sarcophagus reliefs (**196**, lid).

125. The Dioscuri (the Horse-Tamers of Monte Cavallo)

Colossal group. 2nd century after Greek 5th century B.C. prototypes
Rome, Piazza del Quirinale (Matz and Duhn, I, cat.959)

FAME IN THE RENAISSANCE: 'The Horse-Tamers' were among the few colossal statues visible throughout the Middle Ages in Rome. 'Monte Cavallo' was the name their presence gave the Quirinal. While their neighbours, the reclining colossal river gods (**65**), offered models of dignified repose, the pair of nude giants, eighteen feet high, dominating their rearing horses, provided artists with powerful examples of controlled energy and grandiose scale.

Renaissance artists studied them in their topographical surroundings, drew them singly and as a pair in sketchbooks, and made detailed studies of their dynamic anatomy.

Later, in their new installations (see HISTORY) in which they could be seen frontally as a whole, they appealed to the imaginations of Domenico Fontana, Bernini, Juvarra and Canova, who drew unexecuted monumental schemes in which to incorporate them (Hoffman, 1960).

Their fame was to spread far beyond Rome through large-scale copies in marble, and through bronzes, engravings, and painted views.

DESCRIPTION: The inscriptions on their bases, thought to have been carved in the 4th century A.D., are, left–'OPUS FIDIAE'; right–'OPUS PRAXITELIS', as recorded in the Renaissance.

The two pairs, each with man and horse, stood on separate bases united in the Middle Ages by a small house built between them forming a high continuous platform recorded in Renaissance maps and views.

The men flank their horses, striding outwards while looking back to pull the unruly heads, as if they held tight reins in their raised nearside hands. The men are nude; both have a drapery around the left arm which falls behind as a support to the left leg. A Roman cuirass stands behind each man as a strut to the outside leg (Kleiner, 1975, pp. 264–265). The horses rear back on folded hind legs, the lower part invisible in the drawings, and with existing forelegs bent in the air, they turn their raised heads away from their tamers, mouths open and nostrils flaring.

The condition of the statues in the Renaissance can be seen in the views. *Left*–horse's neck propped on brick support, no forelegs, back repaired with bricks. *Right*–horse's neck cracked all the way round, damaged but whole. Left front leg broken off at top. Left hand of man missing.

HISTORY: Their location between the ruins of the Baths of Constantine and the Temple of Serapis ('Frontizpizio di Nerone') on the narrow *vicus Corneliorum* (Bufalini map of 1551; Frutaz, 1962, pl. 197), has suggested that originally they may have belonged to one or the other of these buildings, but of their original position nothing is known from antique sources. A recent reconstruction incorporates the river gods (**65**; Lorenz, 1979, pp. 43–57).

They remained in their medieval installation with minor restorations to the figures of the 'horse tamers' in the time of Pope Paul II (Lanciani, 1902–12, I, p. 74), and with new stone suports under the horses, signed by Antico (Nesselrath, 1982, figs. 38–9), until 1589; they were restored with new bases in the time of Sixtus V by Flaminio Vacca and others in 1589–90 (Egger, 1931, II, pls. 81–3). Under Pius VI's directions they were moved again, their bases splayed to accomodate an Obelisk from the Mausoleum of Augustus which was set between them in 1786. In 1817, Pope Pius VII completed the monument by installing in front the large granite basin seen in 17th and 18th century views of the 'Campo Vaccino' (Haskell and Penny, 1981, p. 136).

INTERPRETATIONS: Always known as the *cavalli* (or *caballi*), the group was considered in the 12th century *Mirabilia* (Scherer, 1955, p. 138) to represent two philosophers, Phidias and Praxiteles. Flavio Biondo followed a catalogue of the Roman regions which referred to the horses as gifts from Tiridates, King of Armenia, to the Emperor Nero (Biondo, *Roma instaurata* I, 99); the group thus became known as 'the horses of Tiridates' in 16th century guidebooks, including Fulvio's (1527; 1588).

Soon after 1550 the antiquaries Pirro Ligorio and Onofrio Panvinio identified both groups as Alexander the Great and his horse Bucephalus (Buddensieg, 1969, p. 222, notes 52 and 55), and this inter-

pretation prevailed through the 18th century (Piranesi). Although Perrier (1638, pls. 23–55) had already suggested that some people thought the groups might represent Castor and Pollux, it was Donati in a late edition of his *Roma vetus ac recens* (1665, III, ch. XV, p. 363) who actually illustrated the reverse of a coin of Maxentius showing Castor and Pollux flanking their horses as a comparison.

The many representations of the Dioscuri on sarcophagus reliefs confirm Donati's identification, which was finally accepted in the 19th century (Bendinelli, 1962).

REPRESENTATIONS:
- Giovanni Pisano, marble horse, Siena, Duomo façade (Seidel, 1969, fig. 61): adaptation?.
- Pisanello, Milan, Bibl. Ambr., vol. 214, inf. 10V (Schmitt, 1960, fig. 81; Degenhart and Schmitt, 1968, I, fig. 607): man on left, frontal, baton in right hand.
- Studio of Filippo Lippi, London, BM, Pp. 1–18 (Popham and Pouncey, 1950, cat. 152, pl. 112; Degenhart and Schmitt, 1968, I, pl. 308c, cat. 373 as Fra Angelico; Sheard, 1979, cat. 47): adaptation of group on left, seen from left.
- Mantegna, Altarpiece, 1457–60, Verona, S. Zeno (Puppi, 1972, fig. 51): group on right 'restored' in tondo relief on pier to right of throne (125b).
- Umbrian School?, late 15th century, New York, Pierpont Morgan Lib., Fairfax Murray, 1912, V, pl. 5: group to left, head of horse with upper part of man lightly sketched; with river god Nile (65B–a; and see Schmitt, 1960, p. 128, fig. 80 as North Italian).
- Gozzoli follower?, Florence, Uffizi, 125EV (Berenson, 1938, no. 1868V: Degenhart and Schmitt, 1968, I, p. 501, fig. 710): upper half of man on left, drawn on a sheet with landscape and figures (previously attributed to Verrocchio and to Francesco di Giorgio).
- Cronaca, (Simone Pollaiuolo), Florence, Uffizi, 163SV (A. Bartoli, 1914, I, pl. 18): reconstruction of both groups on fanciful 'Temple of the Sun'.

A group of three drawings, variants of a lost prototype attrib. to the Ghirlandaio workshop, share the following features: both groups *in situ* from left; inscription on right base 'IPVS PRXIB'; one of cuirassed statues of Constantine and his sons (Michaelis, 1898, pp. 252–4) standing on wall to right. Examples:

- 'Ghirlandaio School, c. 1500', Cambridge, Mass., B. Rowland Jr. Collection (Rowland, 1967, fig. 2, cf. fig. 1 also in his Collection, attrib. to Heemskerck; Sheard, 1979, cat. 48; inscription illegible).
- Heemskerck Circle, Dresden, Kupferstichkabinett, 100183 (Egger, 1931, II, pl. 79 with useful commentary; Degenhart and Schmitt, 1968, I, fig. 609).
- A. Sangallo the Younger, Florence, Uffizi 1158AV (A. Bartoli, 1917, III, pl. 235): the same viewpoint.

- Sodoma, Monte Oliveto Maggiore, fresco cycle of S. Benedetto, first scene, c. 1505 (Carli, 1980, pl. on p. 23): adaptation of horse and one of the Dioscuri.
- Raphael, Chatsworth, 657 (Byam Shaw, 1969–70, cat. 56; Nesselrath, 1982, fig. 37): measured drawing of horse on right, seen from left showing repairs, and Antico's support (125a).
- Among the many adaptations of the right-hand group by Raphael, is his tapestry, *The Conversion of Saul*, Vatican Mus. (Shearman, 1972, fig. 20 and p. 121; for others see Grimm, 1882; Nesselrath, 1982): as runaway horse and groom.
- Giulio Romano, Vienna, Albertina (Stix and Fröhlich-Bum, 1932, III, cat. 92): head and right leg of right horse.
- B. Peruzzi, *Adoration of the Magi*, cartoon, London, NG, 167 (Frommel, 1967–8, cat. 96, pl. LVI): adaptation as horse and groom of an Eastern king (cf. INTERPRETATIONS: Horses of Tiridates?).
- 'Maturino', Florence, Uffizi, 700F: sketch, plus detail of head of one horse and one of the Dioscuri.
- Parmigianino, London, CI, Witt Collection (Popham, 1971, pl. 19, cat. 265): adaptation. Curvaceous version of horse on right, seen from back, 'restored'.
- Aspertini, London, BM *Skb.* I, ff. 42V–43 (Bober, 1957, fig. 92): both groups from left; cuirasses.
- Heemskerck, *Skb.* I, f. 17: back of man on right; f. 22V: arm of man on right; f. 35V: hind quarters of horse on right seen from left; f. 43V: hind quarters of horse and back view of man on left; f. 56: left leg of horse on right; ff. 64–64V: other figure studies.
- Francisco de Hollanda, *Skb.* f. 10V: left group seen from left. Inscription on base and 'SIC. ROMAE' in background. One of the figures of Constantine (see after 183) sketched in rear view of background; f. 11V: right group seen from right. Inscription on base and in background: 'IN EXQUILIS' (because the Quirinal was known as Monte Cavallo, Biondo and others confused it with the neighbouring hill to the south, the Esquiline).
- Girolamo da Carpi, Rosenbach *Album* (Canedy, 1976, R31): right man, frontal; Turin *Portfolio* (ibid., T23): right man from right.
- Franco, Turin, Bibl. Reale, 'Contraffazione', 14760, f. 5B: left man with cuirass, from left, horse barely indicated.
- Engraving, published by Salamanca before 1546: both groups *in situ*, from left.
- Beatrizet, engraving, 1546, for Lafréry's *Speculum*: reversed, but inscriptions of '*Opus Praxitelis*' left, and '*Opus Fidiae*' right (125c), led to confusion in later engravings which preserved this order while representing statues in correct sense (P. G. Hübner, 1911, *RM*, pp. 318–22; see Cavalieri, below).
- Beatrizet, engraving, 1550, for Lafréry's *Speculum*: back view (125d).
- Roman, mid 16th century, Oxford, Christ Church, 0816 (Byam Shaw, 1976, cat. 522, no. ill.): group on left from back.

- 'Maarten de Vos' *Skb.*, f.I (Netto-Bol, 1976, pp.14–15, illus.): left man, upper part, from front right.
- 'Peruzzi' Siena *Skb.*, f.6v: head and leg of right horse, from right; f.7: right horse from left with square pier in background.
- Guglielmo Fiammingo, Florence, Mus. Naz., inv. 444 (Venturi, 1936, X, 2, figs.453–4 as Elia Candido): bronze statuettes of both groups; men and horses on separate bases, figures interchanged.
- Cambridge *Skb.*, f.86 (Dhanens, 1963, fig.11, cat.69): group on right from left, *in situ*.
- Cavalieri, I–II, pl.89: '*Bucefalus, et Alexander Magnus, opus Phidiae*', right group; pl.90: left group with same title, '*Opus Praxiteles, ante aedes Cardinalis Ferrerii*'. Both groups unrestored.
- Perrier, 1638, pls.23–5: '*Signa sunt qui putent Alexandrum refere Bucephali domitorem. alij Castora Pollucemque. Opera Praxitelis et Phidiae in Area Quirinali*'.
- Piranesi, *Vedute di Roma*, 1748 (Haskell and Penny, 1981, *Exh. Cat.*, Ashmolean, cat.31, illus.): viewed on Piazza del Quirinale as Alexander the Great taming Bucephalus.

LITERATURE: Michaelis, 1898, pp.248–74, still the basic presentation of documentation, interpretations, topography and engravings; E. Petersen, 1900; Lorenz, 1979 (topographical reconstruction); Hoffmann, 1960; Winner, 1967, cat.57, bibl. of sources, and drawings listed in Bober, 1957, p.72 and Schmitt, 1970, cat.16, pp.127–8. For further representations and references, see Netto-Bol, 1976, pp.14–15, no.5. Haskell and Penny, 1981, cat.3: 'Alexander and Bucephalus'. Pogánay-Balás, 1980 (influences of the Dioscuri seen in works by Michelangelo and Raphael); Nesselrath, 1982 (with further literature).

THE RAPE OF THE DAUGHTERS OF LEUCIPPUS

The two lovely daughters of Leucippus, Hilaeira and Phoebe, were betrothed to the two sons of Aphareus. The Dioscuri (Castor and Pollux), however, fell in love with the girls and carried them off. This enraged the sons of Aphareus, who fought the Dioscuri and died at their hands. But the victory of the Dioscuri was Pyrrhic, for Castor, the mortal brother, also lost his life in the fray. Pollux, grief-stricken, implored Jupiter to let him share his own immortality with his beloved brother, and this wish was granted (Hyginus, *Fabularum liber* LXXX).

Scenes of divinities carrying off mortals, such as Jupiter abducting Ganymede, Pluto snatching Proserpina, or the Dioscuri capturing the daughters of Leucippus, were naturally popular as decorations for sarcophagi since they could easily be read as metaphors for the translation of the dead to a heavenly realm.

The shared immortality of the Dioscuri made these heroes welcome figures on sarcophagi, even apart from representations of the rape scene.

126. The Rape of the Leucippids
Hadrianic sarcophagus
Florence, Uffizi (Mansuelli, 1958, I, cat.252)

DESCRIPTION: The relief, a splendid example of Roman symmetry, is similar to another example, also known in the Renaissance, and now in the Vatican (Lippold, *Kat.*, III, 2, pp.439–43, no.35, pl.185; Robert, *ASR* III, 2, cat.181). The main differences are that the Uffizi relief omits the figures in the background; the knees of the confronted warriors on the left do not overlap; the hair of the Leucippid on the left is unbound (Fusco, 1979, p.261, pl.55e,f).

The front is flanked by windblown Victories holding garlands, frequent terminal motifs on Roman sarcophagi. In the centre, a girl raises the alarm while the Leucippids, presumably her sisters, are abducted by Castor and Pollux on either side. On the left, the Leucippids' intended bridegrooms seem locked in combat; it is thought the one on the right is trying to prevent the other from taking immediate action. On the right, the parents of the girls hurry away. Visconti, describing the Vatican replica (**126a**), observed that the mother snatches her veil away from her daughter's grasp, secretly content with this unexpected change of bridegrooms, and Leucippus, though agitated, makes no move to interfere (Visconti, 1820, IV, pp.288–9).

INTERPRETATIONS: Until Visconti's identification, it was thought to represent the Rape of the Sabines (Aldrovandi, 1556, p.219; Inventory of della Valle-Capranica Collection, 1583, in *Documenti Inediti* IV, p.379).

HISTORY: It is not known when the sarcophagus was acquired by Cardinal Andrea della Valle; it does not appear in views of his courtyard. An outlet in the right end of the sarcophagus suggests its previous use as a fountain basin. In 1584 it was sold to the Medici; in Rome, in the Villa Medici until 1788, when it entered the Uffizi.

REPRESENTATIONS:

- North Italian, (previously 'Raphael'), before 1550, Berlin-Dahlem, Kupferstichkabinett, KdZ 21 508 (Winner, 1967, pl. 39): detail from left, Victory, two bridegrooms confronting; one on left with ghost of arm; shield damaged (126b).
- Franco, Turin, Bibl. Reale, 'Contraffazione', 11c (Robert, *ASR*, III, 2, cat. 180): detail of front from bridegrooms up to mother.
- Girolamo da Carpi, Rosenbach *Album* (Canedy, 1976, R149): figures spaced out, details modified. Includes the central girl and mother.
- Cod. Coburgensis, f.91 (Matz, 1871, 212): unrestored. Missing are right arm of man on left, part of his shield; right wrist of Leucippid on right; left arm of mother; cf. Cod. Pighianus, f.272 (Jahn, 1868, 209).
- Naldini, Edinburgh, NG, Andrews, 1968, cat. 992A: left part of front up to second of the Dioscuri.
- Perino del Vaga, attrib., Lille, Mus. Wicar, 648 (Pluchart, 1889, cat. 70; Fusco, 1979, pl. 56a): detail of bridegrooms, unrestored.
- 'Maarten de Vos' *Skb.*, f. IIv(2) (Netto-Bol, 1976, p. 22 with ill.): central scene.
- Pierre Jacques, '*Album*', f. 15.
- Pozzo Windsor, VIII, f. 78, 8783 (Vermeule, 1966, p. 55): whole front.

LITERATURE: Robert, *ASR*, III, 2, cat. 180; Toynbee, 1934, pp. 194–5; Winner, 1967, cat. 74; Fusco, 1979, p. 261, n. 17.

THE TYRANNICIDES (HARMODIUS AND ARISTOGEITON)

In 514 B.C. a plot was hatched to assassinate the two sons of Peisistratus, the tyrants of Athens, and to liberate the city from their rule. Harmodius and Aristogeiton, who had a personal as well as a political grudge against one of them, were the leaders. The plan misfired; only the younger tyrant was killed and the would-be liberators were put to death; Harmodius immediately, and Aristogeiton shortly thereafter. It was not until four years later that the remaining tyrant was finally driven out of Athens (Thucydides VI, liv. 1–lix. 1).

Sometime after that Pliny (*Natural History* XXXIV, 17) says that it was the year that the kings were expelled from Rome, 509 B.C.,

the grateful Athenians erected a pair of statues representing Harmodius and Aristogeiton in the Agora. They were the first–and for a long time the only–mortals to be so honoured.

In 480 B.C. Athens was sacked by the Persians and the statues of the Tyrannicides were carried off. Despite the destruction of their city, the Athenians, along with the other Greeks, defeated the Persians in the memorable battles of Salamis (480 B.C.) and Plataea (479 B.C.) and drove them out of Greece. After their victory the Athenians returned to their devastated city. One of their first acts was to commission replacements for the statues of the Tyrannicides. By 477–6 B.C. these had been completed in bronze by Kritios and Nesiotes. The Romans made several copies in marble of the celebrated group. One such copy, now in Naples, was known to the artists of the Renaissance (127).

A complete discussion of the statuary group and the historical events that led to its erection is given in Brunnsåker (1971).

127. The Tyrannicides
Roman copies of Greek 5th century B.C. bronze statues by Kritios and Nesiotes
Naples, Museo Nazionale (Ruesch, 1911, cats. 6009 to 6010)

DESCRIPTION: In the Renaissance, both statues lacked heads; Harmodius, now with arm upraised, was a torso; Aristogeiton had legs, but no arms.

Another pair of Tyrannicides, also known in the Cinquecento, is now in the Boboli gardens.

INTERPRETATION: They were known as 'Gladiatori'. '*Un gladiatore* (Aristogeiton) *nudo in piedi senza testa et braccia*' ('A nude gladiator, standing without head and arms'); *Documenti inediti* II, p. 377: undated inventory of Palazzo Madama).

HISTORY: In the earlier part of the 16th century, the statues were in Rome in the Palazzo Medici-Madama where they were noted by Albertini (1510, pp. 87v–88). Heemskerck's drawings of the early 1530s provide the first specific pictorial documentation. The collection passed to the Farnese through

the marriage of Margarita of Austria, widow of Alessandro de' Medici, to Ottavio Farnese in 1538. In 1586 the statues were taken to the Palazzo Farnese and then to Naples c. 1790.

REPRESENTATIONS:
- Raphael Circle, Oxford, Ashmolean, Parker, 1956, II, cat.622: torso with legs to the knee of Aristogeiton, back view, tree trunk indicated (identified by Parker, as the Aristogeiton in the Boboli gardens, Florence, but the breakages are those of the statue of Harmodius in Naples).
- Heemskerck, *Skb.* I, f.5h and II, f.48h: Aristogeiton, unrestored in Pal. Medici Madama courtyard; f.48k: Harmodius torso, identified in distant corner by P.G.Hübner (1911, *RM*, pp.307–8); *Skb.* I, f.44ᵛ: Aristogeiton, hips and thigh; f.57ᵛ: back and right thigh of Aristogeiton.
- Aspertini, London, BM *Skb.* II, f.3 (Bober, 1957, fig.110): Aristogeiton 'restored', back view.
- Cambridge *Skb.*, views of Aristogeiton, f.4 **(127a)**: back; f.24: front; f.59: three views (Michaelis, 1892, cat.59; P.G.Hübner, 1911, cat.59; Dhanens, 1963, figs.35, 32 and 28; cats.4, 26 and 51 respectively).

LITERATURE: Brunnsåker, 1971, cats.A1 and H1; Bober, 1957, p.78.

ANTINOUS

The emperor Hadrian, who reigned from 117 to 138 A.D., travelled widely throughout the vast Roman empire. On a visit to Asia Minor he met the Bithynian youth, Antinous, who became his favourite and who thenceforth accompanied him on his travels.

In 130 Antinous was drowned in the Nile. Rumour had it that he gave his life to save the emperor's; an alternative version suggested that he wished to escape from his lust. Hadrian was inconsolable; according to the *Historia Augusta* (XV, 4) 'he wept for him like a woman'. The grieving emperor had his favourite deified, named a city after him, instituted festivals to celebrate him, and caused countless statues and paintings to be made of him, often in the guise of one or another of the gods (Dio Cassius, LXIX, xi, 2–3; Pausanias, VIII, ix, 4). The youth and beauty of the boy and the tragic manner of his death caught the imagi-

nation of artists who, by combining a revived classical style with a new psychological insight, produced images of Antinous which are among the most moving works of Roman art.

128. Antinous
Roman statue, derived from the bronze Doryphoros by Polyclitus
Naples, Museo Nazionale (Ruesch, 1911, cat.983)

DESCRIPTION: The nude youth stands with weight on right leg, his head turned slightly to his right. The arms and the legs from the knee are restored, and possibly the head and hair. It has been suggested that Lorenzetto made the restorations. The Greek pose, similar to the Camillus **(192)** was much used by Renaissance artists.

Another example of Antinous is an identical antique bronze head which, in the 16th century, had been in Cosimo I's collection in the Palazzo Vecchio (Florence, Mus. Archeologico, inv.1640; *Firenze e la Toscana dei Medici: Palazzo Vecchio*, Exh. Cat., 1980, cat.33, M.Cristofani; ill. on p.29). A Renaissance bronze copy of it is in the Museo Nazionale del Bargello, inv. no. Bronzi 97.

HISTORY: Early history obscure, but it was known in Rome at least by c.1520. Farnese Collection. To Naples in the 18th century.

REPRESENTATION:
- Lorenzetto, under Raphael's direction, marble statue of Jonah, c.1519, Rome, S.Maria del Popolo, Chigi Chapel (Kleiner, 1950, figs.9 and 11; Pope-Hennessy, 1970, fig.44): the head of Jonah has identical curls.

LITERATURE: Vasari–Milanesi, 1906, IV, pp.578–9, p.369, n.2; Kleiner, 1950, p.22, and n.37 with earlier literature noting analogy with Lorenzetto; Clairmont, 1966, p.50, cat.33 (with literature).

HERCULES

Hercules was the most popular and beloved of the Greek heroes and was frequently portrayed by ancient artists. As a hero, he was less

remote than the Olympian gods; as a mortal who won immortality through his unremitting labours, he stood as a symbol of hope for all humanity. Even after classical times his image remained popular, for his endurance and incessant toil suggested his figure as an embodiment of Fortitude and those who saw his labours as services performed for the sake of suffering mankind could even liken him to Christ.

Hercules' life was full of adventure. Tragically prey to fits of madness, he was driven to murder even those whom he tenderly loved; comically prey to enormous appetites, he could devour whole oxen at a sitting or father fifty sons within a single night. He fought giants, monsters, evil kings, and even Death himself. Although he was always triumphant, he nevertheless suffered greatly and so elicited compassion as well as admiration from his votaries.

After a life of toil, Hercules earned immortality and was reconciled with Juno, his jealous stepmother, who gave him her daughter Hebe (Youth) to wed.

Statues of Hercules showing him standing at the end of his labours could either emphasize the trials of his life and represent him aged and exhausted, wearily holding the apples of the Hesperides, or they could stress the happy outcome and portray Hercules youthful and triumphant, looking forward to his well-deserved reward.

Hercules was also frequently represented reclining, either resting from his labours or rejoicing in a banquet (perhaps an eternal one). He was depicted as a powerful athlete with short curly hair, either bearded or beardless. His usual attributes were the club–a primitive weapon that was associated with him–and the lion skin, a trophy that he either carries or wears, usually with the paws knotted over his chest and the open jaws crowning his head.

For interpretations and illustrations of Hercules and his Labours in the Renaissance, see Ettlinger (1972, pp. 119–42).

129. Hercules Standing
Colossal gilt bronze statue (2.40 m.)
Rome, Palazzo dei Conservatori (Stuart Jones, 1926, pp. 282–4, Galleria Superiore II, 5; Helbig, II, cat. 1804)

DESCRIPTION: The nude Hercules, the beardless small head comparable to Tyro-Phoenician coins of Hercules-Melqart, stands with attenuated Hellenistic elegance, weight well back on left leg, right leg flung out and forward. He holds an inverted club in his right hand; in the Renaissance it rested on a base (Heemskerck). On his left palm he holds three golden apples. He wears a wreath over his short curls, and 'appears made by the hand which created Adam', as 'Prospettivo Milanese' wrote, c. 1500 (stanza 60; Fienga, 1970, p. 47).

Pliny attributed the statue to an Italian sculptor, repeating the tradition that Evander established the cult of Hercules at the Ara Maxima. According to Pliny it was known as the triumphal Hercules, and was draped at every triumph in a triumphal robe (*Natural History* XXXIV, 33).

HISTORY: The statue was discovered in the Cattle Market (Foro Boario) in the time of Sixtus IV, in the Temple of Hercules Victor and brought to the Palazzo dei Conservatori to join the bronzes Sixtus IV had brought there from the Lateran in 1471 (inscription on base, *CIL*, VI, 312–19; Albertini, 1510, bk. III, p. Yii = 86). It was described in 1513 by Fulvio on the right side of the courtyard of the Palazzo dei Conservatori. By 1535 it was on a towering marble base (Heemskerck, *Skb*. I, f. 53v) near the colossal bronze head of 'Commodus' (**183**), as suggested by Albertini in 1510. By the mid 16th century it was given a lower base, the circular altar, as seen in the foreground of Heemskerck's drawing; the altar is now in the Museo Capitolino (Stuart Jones, 1912, p. 346, no. 6a, pl. 89). It stood on this round altar probably until 1707 when it was restored with a new base and with an inscription recorded by Forcella (1869, I, p. 73, no. 207).

REPRESENTATIONS:
– Gossaert, 'Mabuse', 1508–9, collection of Lord Wharton (Dacos, 1964, pl. II): left side, from back, 'restored'.
– Heemskerck, *Skb*. I, f. 53v: right profile on high Roman altar dedicated to Hercules; round marble altar to Hercules in foreground, fragments of colossal statues strewn about (**129a**).
– 'Maturino', Florence, Uffizi, 14569Fv: back view, restored.

- Engraving for Lafréry's *Speculum* (Hülsen, 1921, cat. 119a): front view on round altar; cf. Diana Scultori, 1581 (*ibid.*, cat. 118a): on round base in new room between two windows.
- Cavalieri, I–II, pl. 75: '*Erculis simulacrum aeneum excellentis artificis opus. Romae in capitolio*'. Club unsupported, three apples, round altar base reduced.
- Franzini, woodcut, 1599, E1: *Herculis simulacrum aeneum in Capit.*

LITERATURE: Lyngby, 1954, pp. 7–19; 155–8 (documentation in Renaissance); Haskell and Penny, 1981 cat. 45.

130. Hercules Resting
Roman copy of colossal bronze statue by Lysippus
Rome, Villa Borghese (Clarac, 1826–53, V, pl. 791, no. 1982)

DESCRIPTION: The statue represents Hercules standing, leaning on his club, at rest after his labours. It is one of the many replicas of the type of the celebrated Hercules Farnese discovered in 1546 and now in Naples (Goethe–Auden and Meyer, 1962, p. 150; Haskell and Penny, 1981, cat. 46, fig. 118). The original is described by the Greek antiquarian and rhetorician, Libanios, in the 4th century A.D.:
'… his head bends toward the earth and he seems to me to be looking to see if he can kill another opponent. Then his neck is bent downward along with his head. And his whole body is bare of covering, for Herakles was not one to care about modesty when his attention was directed toward excellence. Of his arms, the right one is taut and is bent behind his back, while the left is relaxed and stretches toward the earth. He is supported under the arm-pit by his club which rests on the earth, experiencing the same leisure (as he)… The lion skin is draped upon the club… Of Herakles' two legs the right one is beginning to make a movement, while the left is placed beneath and fitted firmly on the base, and this arrangement makes it possible for the onlookers to learn just what sort of man Herakles is, even though he has ceased from his labours' (*Ekphraseis* XV, in Pollitt, 1965, pp. 148–9).
Another replica, apparently a bronze? statuette, is drawn in the Fossombrone sketchbook (Raphael's Workshop, f. 80), but there the club rests not on a stump but on the ground, and the statue is mounted on a round base. Another replica, with the club resting on the remains of a boar, now in the Uffizi (Mansuelli, 1958, I, pl. 35a–b), is drawn on a sheet with the Apollo *Citharoedos* **(35b)**, both in the della Valle Collection.

HISTORY: At the end of the 15th century, or before 1503, the statue was in the palace of Cardinal Francesco Piccolomini of Siena (Pope Pius III in 1503), near Sant'Andrea della Valle in Rome. It is possible that it came, like the Three Graces **(60)**, from the collection of Cardinal Prospero Colonna, as it had been found on Monte Cavallo (*Cod. Escurialensis*, f. 37; Egger–Michaelis, 1906, pp. 106–7). Towards the mid 16th century it was in the Vigna of Cardinal Ridolfo Pio da Carpi on the Quirinal (Aldrovandi, 1556, p. 296; Hülsen, 1917, Römische Antikengärten, p. 56, Carpi 5). Later it went to the Villa Borghese.

REPRESENTATIONS:
- *Cod. Escurialensis*, f. 37: '*del chardinale di siena trovato imonte chavallo nela chapella derchole*', front view. Cf. Genoese sculptor, c. 1509, La Calahorra, Spain, courtyard, relief after the drawing in the *Codex* (phot. A. Nesselrath).
- Girolamo da Carpi, Rosenbach *Album* (Canedy, 1976, R138): front; Turin *Portfolio* (Canedy, 1976, T92 and T149): back, and right profile.
- Cambridge *Skb.*, f. 8 (Dhanens, 1963, fig. 43, cat. 9): '*Al Cardinale de carpe*'. Front view, figure turned towards right; f. 9 (*ibid.*, fig. 42, cat. 10): '*Carpe*'. Back view, figure turned towards right, little finger missing from hand resting palm out above buttocks. Tree trunk and club lightly sketched.

LITERATURE: Smetius, 1588, p. 24; Friend, 1943; Vermeule, 1975.

HERCULES AND TELEPHUS

When passing through Tegea in the Peloponnese, Hercules raped Auge, the daughter of King Aleos. The fruit of this unexpected union was Telephus, who was exposed and left to die in the wilderness. A doe (or a lion) suckled the baby, who was eventually discovered by Hercules. Hercules, carrying the infant Telephus, may well have appeared in Euripides' lost play *Auge* (Webster, 1967, p. 240). Such an image would have been particualrly treasured by the Pergamene kings who traced their descent from both Hercules and Telephus, for when Telephus grew up he became king of the Mysians in Asia Minor.

131. Hercules and Telephus ('Hercules Commodus')

Roman copy of Greek bronze statue of
4th century B.C.
Vatican, Museo Chiaramonti (Amelung, *Kat.*,
I, pp. 738–40, no. 636; Helbig, I, cat. 313)

DESCRIPTION: Hercules, bearded and crowned
with a coiled fillet studded with rosettes, stands
nude except for a lion skin across his chest with its
head on his left breast. He holds a club downward
in his right hand, and carries the nude child Tele-
phus in his left arm. The child rests a foot in Hercu-
les' hand, and turns to look up at him while reach-
ing up with his right arm. The lion skin partly
covers the supportive tree trunk beside them.

The statue was only partly restored at first,
probably by Montorsoli in 1532–3 (Vasari–Milanesi,
1906, VI, pp. 632–3; Brummer, 1970, p. 133) with
the completion of the right arm. Only the top part
of the club held against the thigh appears in later
16th century drawings. Subsequent restorations
are the fingers of Hercules' left hand, his toes, the
hands and feet of Telephus, and the remainder of
the club.

HISTORY: It was found May 15, 1507, and installed
in Julius II's new statue court in the Belvedere.

> 'Last Saturday a certain Roman … in the Campo
> di Fiore found a Hercules with the skin of the
> Lion over his shoulder … holding the club in his
> right hand, and on his left arm has a little boy of
> perhaps four years … Found one day, the Pope
> had it brought to the Palace the next…' (letter
> from Giorgio da Negroponte to Isabella d'Este,
> 19 May, 1507; Luzio, 1886, p. 94, n.; Lanciani,
> 1902–12, I, p. 144).

Set up near the entrance to the Belvedere courtyard
(Albertini); payments for a niche 1536 (Brummer,
1970, p. 133) in the east wall of the Belvedere court
between the Apollo Belvedere and the 'Cleopatra'
(*ibid.*, p. 22, pl. I, 4).

INTERPRETATIONS: The statue at the time of its
discovery was thought to be Hercules, but the Pre-
fect of the Vatican Library, Tommaso Inghirami,
known as 'il Phaedra' (or 'Phaedrus') for the part
he played in Seneca's play in his youth (Lumbroso,
1889, p. 238), pronounced it to be Commodus
(*'Fedra dice che non è Hercule ma Comodo'* wrote Gior-
gio da Negroponte in the same letter), as Commo-
dus was known to identify himself with Hercules
and appear in his guise. 'It is really a beautiful

thing' wrote Giorgio, 'but strange to see a statue
so ferocious, and then to see a little boy on his arm.'
Albertini (1510, p. QV = 61V; and in *CTR*, IV, p. 491,
lines 4–10) explained that it represented the Em-
peror Commodus imitating Hercules holding the
child Hylas with his lion skin. Fichard in 1536 called
the statue Hercules, but made short shrift of a sug-
gestion that it might represent Hercules Furens
(who destroyed his children in his madness, sub-
ject of plays by Euripides and Seneca). The pay-
ments for the niche in the same year refer to 'Com-
modus'. It seems not to have been identified as
Hercules and Telephus until 1819 (Visconti, 1818 to
1822, II, pp. 60–5, pl. 12; Brummer, 1970, p. 137).

REPRESENTATIONS:
– Heemskerck, *Skb.* I, f. 41V (Netto-Bol, 1976, fig. 14a):
 head of Hercules, front and right profile.
– 'Maarten de Vos' *Skb.*, f. IIIV (Netto-Bol, 1976, p. 27,
 notes 3–4, fig. on p. 26): after an earlier drawing be-
 fore Montorsoli's restoration.
– Frans Floris, lost skb., f. 7 (Netto-Bol, 1976, p. 27,
 n. 7; Brummer, 1970, p. 187, n. 6).
– Primaticcio, bronze cast for Francis I, Fontainebleau
 (Pressouyre, 1969, fig. 3): detail of Hercules' finger-
 less left hand 'restored'.
– Beatrizet's engraving, 1550, for Lafréry's *Speculum*
 (Hülsen, 1921, cat. 58d): in niche, unrestored.
– Cambridge *Skb.*, f. 5 (Dhanens, 1963, fig. 18, cat. 6;
 Brummer, 1970, fig. 113): Montorsoli's restoration.
– Pietro da Barga, bronze statuette, 1576, Florence,
 Mus. Naz. (de Nicola, *Burlington*, 1916, pl. I, fig. G).
– Goltzius, Haarlem, Teyler Mus. (Reznicek, 1961,
 figs. 163–5, cats. 206–7; Brummer, 1970, figs. 114–5):
 Montorsoli's restorations; indication of niche.

LITERATURE: Brummer, 1970, pp. 133–7; Netto-Bol,
1976, p. 27; Haskell and Penny, 1981, cat. 25: 'Com-
modus as Hercules'.

132. 'Hercules' – Torso Belvedere

(in the invariable Renaissance interpretation)
1st century B.C., signed by Apollonios, son of
Nestor, Athenian, probably after original of late 3rd
or early 2nd century B.C. (Robertson, 1975, II,
fig. 169a). Vatican, Atrio del Torso (Amelung, *Kat.*, II,
pp. 9–20, no. 3)

DESCRIPTION: Over life-size torso of a nude male
figure with exaggeratedly swollen musculature
typical of 'Pergamene baroque' style (which this
retrospective artist was imitating); broken at neck
and pectorals, armless, while the legs are preserved
from hip through knee. He is seated upon the skin

of a panther or other feline cast over a rocky support, its head drawn up over the figure's left thigh. Between his legs the signature of the artist is inscribed: 'Apollonius, son of Nestor, from Athens, has made it'.

INTERPRETATIONS: Because the animal-skin was mistaken for that of a lion, the Torso obviously represented Hercules to all observers before Winckelmann. From the Renaissance on, it has challenged reconstruction of its complicated pose, bending forward and at the same time twisting to his left so that the right shoulder is markedly lowered. Signs of attachment on the right thigh are still taken today as either the spot where the right elbow rested or where his double-flutes were poised (for those who recognize Marsyas bound in the pose of the Medici gem, 31). On the latter interpretation, see especially Carpenter and Säflund, below. Others have spoken of Marsyas teaching Olympus to play the *aulos*, for Skiron, for Polyphemus, or for Philoctetes on the island of Lemnos (Andrén). Loss of the buttocks makes it difficult to tell whether his arms were bound there, if a satyr-tail was attached, and so forth.

HISTORY: Until 1970, evidence from the early Quattrocento had placed it in the Colonna family house on the lower slope of the Quirinal ('Monte Cavallo') next to SS. Apostoli (the artist's signature with location recorded in two manuscripts, one attributed to Ciriaco d'Ancona, c.1432–4–Cod. Marucelliana A 79, 1, f.6, see Kaibel, 1890, XIV, cat.1234); an engraving c.1515 by Giovanantonio da Brescia inscribed '*in mo(n)te cavallo*' (see below) seemingly confirmed Colonna ownership in the early 16th century; and since the torso came to the Belvedere, where it was drawn by Heemskerck lying on the ground c.1532–5, it seemed reasonable to conclude that Clement VII had expropriated it from his Colonna enemies following the Sack of Rome. However, an Umbrian sketchbook of about 1500, now in an Italian private collection, published by Annegrit Schmitt (1970, pp.107ff.) contains a drawing of the torso which changes this hitherto simple sequence. It bears a notation that the sculpture was at that time owned by the sculptor, Andrea Bregno, confirmed by stanza 13 of the contemporary 'Prospettivo Milanese'. Since Bregno also lived on the lower slopes of the Quirinal (Monte Cavallo) the testimony of the engraving becomes equivocal and may, indeed, simply preserve memory of the spot where the torso was

found. The sculpture may well have been discovered on Colonna property in rebuilding of the family house that followed the return of Martin V to Rome, in 1420. For an engaging theory that it stood originally in the adjacent Baths of Constantine as counterpart to the bronze 'Boxer' by the same artist discovered in the 19th century, see von Salis (1947, p.167). Bregno died in 1503, so there still remains a question how and why the 'Hercules' came to the Vatican, complicated by older theories (Kristeller, 1891, pp.476ff. and Lanciani, 1899, pp.102ff.) that it was better preserved in the Quattrocento, or that there were two replicas of the figure. These were put forward because the Giovanantonio engraving 'restores' both legs and a Renaissance bronze statuette (examples in Ferrara and Florence, see below) reproduces it with one; on the contradictory evidence of the Wolfegg Codex, and now Dr. Schmitt's Umbrian sketchbook, where the torso is drawn in its present state c.1500–3, see Bober, 1957, pp.11 and 34. By the mid 16th century the torso was installed on its own base in the Statue Court of the Belvedere between a river god (Tigris) and the Cnidian Venus. In modern times it has been honoured with its own vestibule. Note that a false tradition of the torso's discovery at the Campo di Fiore in the period of Pope Julius II occasionally surfaces.

REPRESENTATIONS: The sculpture does not appear in antiquarian repertories like the Codex Pighianus or among Cavalieri's engravings; it was not iconographers or tourists but individual artists who appreciated it–once Michelangelo opened their eyes. The master's praise for the torso is a *leitmotiv* in Cinquecento literary sources and his admiration is embodied in the poses of some Sistine *ignudi* and, dramatically, in the back of his figure of *Day* in the Medici Chapel, among other adaptations.

– Umbrian *Skb.*, Calenzano, f.10ᵛ (Schmitt, 1970, fig.2): '*de m Andrea da Milano*'.
– Aspertini, Cod. Wolfegg, f.42 (Bober, 1957, fig.42).
– Giovanni Antonio da Brescia, engraving, c.1515, Bartsch, XIII, p.100, no.41 (Brummer, 1970, fig.124): reversed, restoring both legs, '*in mo(n)te cavallo*'.
– Raphael School, Oxford, Ashmolean, Parker, 1956, II, cat.625: in two views.
– Sebastiano del Piombo, London, BM, Sloane 5237–5251 (Pouncey and Gere, 1962, cat.281ᵛ): from the back.
– Bandinelli?, Milan, Bibl. Ambr. (Delacre, 1938, p.97, fig.50).

– Roman, 2nd quarter of 16th century, London, BM, 1901-6-19-2V (Schwinn, 1973, fig. 5; Gere and Pouncey, 1983, cat. 348): on sheet with Hercules and Lion (136).
– Beccafumi, Düsseldorf, Kunstmus., inv. FP 34V.
– Heemskerck, *Skb.* I, f. 63: tilted on the ground in a view; f. 73: seated, back view to right.
– South German, c. 1540, Erlangen, Univ. Lib. (Kuhrmann, 1974, cat. 97).
– Florentine, mid 16th century, Vienna, Albertina (Stix and Spitzmüller, 1941, VI, 63, pl. 717): in three views, formerly attrib. to Raphael.
– Roman, mid 16th century, Oxford, Christ Church, Byam Shaw, 1976, cat. 521, pl. 276 (132a): three views.
– Dosio, Marucelliana *Skb.* (Hülsen, 1933, cat. 157b, pl. CXLIII).
– Daniele da Volterra, Florence, Uffizi, 206S: back view with suggestion of a tail.
– Passarotti, Florence, Uffizi, 249F: front and back views.
– Melchior Lorch (Michaelis, 1892, p. 91, ff. II–III, f, g, h; no ills.).
– Cambridge *Skb.*, f. 22 (Dhanens, 1963, fig. 34, cat. 22; Brummer, 1970, fig. 128): inscribed. 'This pees doth michellangeli exstem above al the anttickes in belle fidere'.
– Goltzius, Haarlem, Teyler Mus., Mappe N, no. 31 (Brummer, 1970, fig. 129).

The above list is merely a selection. Many drawings or representations in other media are viewed as reconstructions; the most recent guide to the literature with her own additions, is Schwinn (1973).

RECONSTRUCTIONS: Bronze statuettes of the Renaissance restoring the figure in part or entirely (as Hercules):
– Statuettes discussed by Kristeller (1891) include an example in Ferrara, two versions attrib. to Antico by Bode (1907-12, III, pl. 237; reproduced by Brummer, 1970, figs. 132-3), and a torso with right leg restored, Florence, Mus. Naz. (*ibid.*, fig. 130), a replica of which is held by one of the members of the Licinio family in Bernardo's 1524 portrait group in the Galleria Borghese (detail, *ibid.*, fig. 131).
– A complete restoration (132b) is Camelio's *Hercules shooting at the Stymphalian Birds*, c. 1500-25, New York, MMA, 64.304.2 (Sheard, 1979, cat. 57, front view, same as Brummer, 1970, fig. 133 cited above).
– Numerous drawings from Michelangelo's circle are considered sketches for restoring the torso, for example, Oxford, Ashmolean (Parker, 1956, II, cat. 373) which Berenson gave to Raffaele da Montelupo, or Bayonne, Mus. Bonnat, 682 (Bean, 1960, no. 65), a *Raising of Lazarus* study attrib. to Michelangelo or Sebastiano del Piombo, or, again, Florence, Uffizi, 17391F, Daniele da Volterra.

– A sculptural reconstruction showing a flayed, kneeling figure has long been ascribed to Michelangelo; for a wax cast of it, see Tietze-Conrat (1936, pp. 163f., pls. C, D); the bronze statuette itself is lost.

LITERATURE: 'Prospettivo Milanese', c. 1500, stanza 13:

> Poscia in casa dun certo mastandrea
> ve un nudo corpo senza braze collo
> che mai visto non ho miglior diprea

('Then in the house of a certain Master Andrea there is a nude torso without arms or neck the equal of which I have never seen in stone... transl. Fienga, 1970, p. 41.)

Schmitt, 1970, has now proved the editor Govi's suggestion that this might refer to the Belvedere torso. Brummer, 1970, pp. 143ff., with bibl.; Helbig, I, cat. 265. For interpretation as Marsyas bound, see Carpenter, 1941, pp. 81ff. and Säflund, 1976; cf. Andrén, 1952, for arguments that the figure was Philoctetes. On the influence of the torso in the Renaissance and subsequently, note Schwinn, 1973, as well as von Salis, 1947, pp. 165ff., and Ladendorf, 1953, pp. 51ff., pls. 19–24 (including prints of Marcantonio and Cristoforo Robetta). Sheard, 1979, cat. 56 (Marcantonio). Haskell and Penny, 1981, cat. 80 with additional Renaissance copies on p. 313, and quotation, p. 314, from Stendhal's *Voyages en Italie* noting Raphael's use of the torso in his *Vision of Ezechiel*, but see 119.

133. Hercules Reclining ('Hercules Chiaramonti')

Roman copy of a Greek statue
Vatican, formerly Museo Chiaramonti, now in Giardino della Pigna (Amelung, *Kat.*, I, pp. 812–14, no. 733)

DESCRIPTION: Hercules, nude, reclines on the lion skin, a part of it draped over his right thigh. His position is closer to the Marforio's (64) than the Nile's (67), but the uncovered legs are crossed, the right over the left, and both knees are bent.

In 1568 the statue was restored with a head of Hercules, the left arm from the biceps, the right arm from the shoulder, and parts of the lion skin. The base, a block with inscription: 'O. OLIVARIVS. OPVS. SCOPAE. MINORIS' was found in 1895.

HISTORY: This statue or another replica was known in Rome in the early 16th century. The Vatican replica is recorded first as having been restored by '*maestro Nicolò scultore*' in 1568 in the Vigna of the Cardinal of Ferrara, Ippolito d'Este, on the Quiri-

nal (Petersen, 1896). It was then taken to the Villa d'Este in Tivoli (Gusman, 1904, pp. 283f.).

REPRESENTATION:
- Sebastiano del Piombo, Milan, Bibl. Ambr., F.290, no.22 (133a): after statue of the type with similar breakages; headless, right hand and leg below knee missing, sagging pose exaggerated and figure tilted downwards (Oberhuber, 1976, pl. and cat.9, entry by Michael Hirst, with reference to this statue; Hirst, 1981, fig.48).

LITERATURE: Scharmer, 1971, cat.1. Gais, 1978, for the type of reclining Hercules and its analogy with river gods.

THE TWELVE LABOURS OF HERCULES

Of the numerous deeds of Hercules, a certain group came to be known as the Twelve Labours performed in the service of Eurystheus, king of Mycenae. The Labours first appear together as a group on the twelve sculptured metopes adorning the temple of Zeus (Jupiter) at Olympia, and it may have been on account of the importance of the temple that this particular selection was accepted by tradition as canonic. Hercules' other undertakings (such as the wrestling match with Antaeus) were not considered part of the Labours.

The celebrated Twelve Labours fall into three groups. The first six took place near Mycenae in the area of the northern Peloponnese:

1. Slaying the Nemean Lion (it was invulnerable and had to be strangled);

2. Killing the many-headed lethal Hydra of Lerna (whenever one head was severed, two new ones would sprout);

3. Bringing the Erymanthian Boar alive to Eurystheus;

4. Capturing (or killing – accounts vary) the Ceryneian Hind;

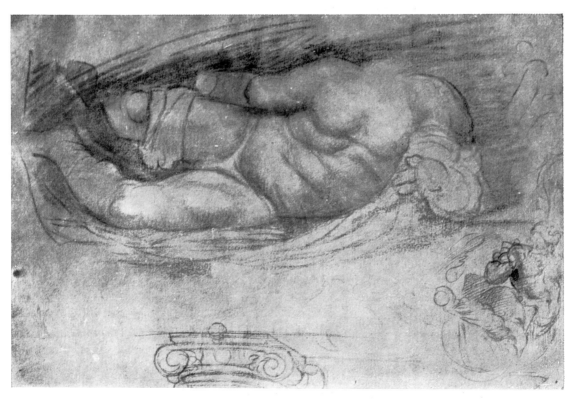

133a

5. Driving away (or killing) the Stympha-lian Birds (they shot their feathers out as arrows);

6. Cleansing the filthy Augean Stables in Elis in a single day.

The next four sent Hercules to the four points of the compass:

7. Fetching the Cretan Bull (South);

8. Fetching the man-eating Horses of Diomedes from Thrace (North);

9. Fetching the girdle of the queen of the war-like Amazon women (East);

10. Fetching the cattle of triple-bodied Geryon (West).

The last two sent him beyond the confines of mortality:

11. Bringing Cerberus, triple-headed watch-dog of Hades, up from the Underworld;

12. Bringing the golden apples, the fruit of immortality, from the garden of the Hesperides (the 'Daughters of the Evening' living beyond the western boundaries of the ocean).

Some of the Labours are mentioned in litera-ture or illustrated in art much earlier than others and some much more often than others. The organization into a cycle of Twelve La-bours probably did not take place before the 3rd century B.C. based on the Olympia meto-pes. In the Roman period, illustrations of the, by then, canonic cycle became popular, especially on sarcophagi, where the example of Hercules who, although born a mortal, through his arduous labours finally attained immortality, must have seemed particularly inspiring.

LITERATURE: Apollodorus, *Bibliotheke* II, v; Hyginus, *Fabularum liber* 30; Brommer, 1953.

134. The Labours of Hercules
Colossal Roman sarcophagus, 3rd century A.D.
Rome, Palazzo Torlonia (Visconti, 1885, cat. 420)

DESCRIPTION: In the best known of the sar-cophagi showing the twelve Labours as separate scenes, Hercules appears bursting forth from each of the five arcaded niches on the long sides of the sarcophagus; the remaining two Labours are re-presented on the right end.

Front (left to right, numbers refer to list of La-bours above)–(Labours 1–5); *right end*–Hercules with shovel (Labour 6), Fortuna, Hercules with apples (Labour 12); *back*–(Labours 7–11); *left end*–Vesta, closed funeral door, Mercury.

The cover was back to front in the Renaissance. It is composed of statues of reclining husband and wife with a putto standing cross-legged at the head, and another putto (headless) seated at the foot of the bed which has doubled-headed snake scrolls at either end. Below is a frieze of confronting winged sea-panthers with corkscrew tails.

HISTORY: In the 16th century, and possibly earlier, the sarcophagus was in the house of Cardinal Sa-velli (later Palazzo Orsini) built over the Theatre of Marcellus, and described by Albertini (1510). The sarcophagus was still in the Palazzo Orsini in the 19th century (Zoega, 1808, II, p. 78); it was then acquired by the Torlonia.

REPRESENTATIONS:
- Raphael Workshop, Fossombrone skb., f. 21V twice; f. 84V lid: from left, flat-ended with snake border, putto at foot of bed with head 'restored'.
- Antonio da Sangallo the Younger, Florence, Uffizi, 1660A (A. Bartoli, 1914–22, III, fig. 429): '*nel pilo grande in casa savelli*' ('in the big sarcophagus in the house of the Savelli'). Door on left end.
- Lambert Lombard, Album, D. 129 (Dacos, 1964, pl. X *Dessins de Lambert Lombard*, 1963, cat. 129): '*Roma 1538 Lambertus Lombardus fecit*'. Hercules and lion only; D. 128 (*ibid.*, cat. 128): Hercules with boar.
- Cod. Coburgensis, f. 95 (Matz, 1871, 196): front, back of lid, right end **(134a)**: cf. Cod. Pighianus, f. 312 (Jahn, 1868, 201, without statues on lid); Cod. Coburgensis, f. 96 (Matz, 1871, 196): back, all figures of Hercules headless, front of lid, left end **(134b)**; cf. Cod. Pighianus, f. 313 (Jahn, 1868, 201).
- Dosio, Marucelliana *Skb.*, f. 154 (Hülsen, 1912, *Ausonia*, ills. on pp. 29, 30, 32): '*Lato dinanzi d'una sepol-tura che è in Monte Savello*'. Present back with lid front; seen from below. Unrestored; f. 154V: '*Lato di dietro*'; front, back of lid outlined without figures; f. 156: '*Lato destro del pillo passato. Lato sinistro*'. The two sides. Hercules in third niche of present right end, missing arm and leg on right side, no apples.
- Dosio, Berlin *Skb.*, f. 48.
- Pierre Jacques, '*Album*', f. 20: left end. Mercury

holds baton and ram's head; f.21: back with front of lid. *'1577 nel teatro dy Marcello'*. 'Restored'.
- Pozzo London BM I, f.8, no.8 (Vermeule, 1960, figs.8–9): back, unrestored, with lid figures facing front; f.9, no.9: front unrestored without lid figures.
- Pozzo Windsor, V, f.60, 8544 (Vermeule, 1966, p.36, fig.10): lid; VIII, f.20, 8721 (*ibid.*, p.50, fig.11): un-restored front without lid; X, f.69, 8062 (*ibid.*, p.65): lid.
- Montano, skb. III, London, Soane Mus., f.63.

LITERATURE: Robert, *ASR*, III, 1, cat.126, with ills. of Cod. Coburgensis drawings. Loeffler, 1950–53, pp.8–24, for Greek motifs of Hercules' Labours in Roman columnar sarcophagi.

135. The Labours of Hercules

Roman altar, 1st century A.D.
Vatican, Museo Lateranense (Helbig, I, cat.1027)

DESCRIPTION: Square altar in extremely worn condition; evidently more legible in the Renaissance. Three Labours carved on each side. *Front*–dedication to Hercules by P. Decimus Lucrius (*CIL*, VI, 277), inscription top left and right; above, Hercules with sacrificial pig on left, and Minerva on right of an altar; below (Labours 1–3): Nemean Lion, Lernian Hydra, Erymanthian Boar. *Right side* (Labours 4–6)–Ceryneian Hind, Stymphalian Birds, Augean Stables. *Back* (Labours 7–9)–Amazon's girdle, Horses of Diomedes, Cretan Bull. *Left side* (Labours 10–12)–Geryon, Cerberus, Hesperides.

Such a Hesperides relief was known to Michelangelo who adapts the figure of Hercules, reaching over a Hesperid for an apple, to Adam in the *Fall of Man* (Ronen, 1974, pl.77a–b).

HISTORY: The altar was known in the late 15th and early 16th centuries in S. Rufina in Trastevere, Rome *(CIL)*; mid 16th century in Vigna di Cardinale Carpi, Quirinal (Hülsen, 1917, p.72, Carpi 168); by c.1575 in Villa Giustiniani near the Lateran (Dupérac, Louvre *Album*. Giustiniani, 1651, II, p.135; Zoega, 1808, II, p.52).

REPRESENTATIONS:
- Cod. Coburgensis, f.143, 1–2 (Matz, 1871, 68; Mandowsky and Mitchell, 1963, pl.22c, p.72; Maedebach, 1970, fig.38a): front without inscription, right side; ff.171, 2 and 191, 3: left side. Engraved in Beger, 1705, pl.5; **135a**.
- Dosio, Berlin *Skb.*, f.48: back and both sides. Left side.

– Pirro Ligorio, Naples, BN, MS XIII, B 7, p.95: front and right side. Mandowsky and Mitchell (1963, pl.21c, cat.34, p.72) point out Ligorio's reconstruction of flame on altar and olive branch, details left out in Cod. Coburgensis, f.143, 1, because of difficulty in interpreting the traces on the relief; copied in Cod. Ursinianus, Vat. Lat. 3439, f.130; and in Dupérac, Louvre *Album*, inv.26423 (Guiffrey and Marcel, 1910, V, pl.69, no.3884): *'In palatio Iustiniano'*.
– Pozzo Windsor, III, f.38, 8361 (Vermeule, 1966, p.23).

LITERATURE: Smetius, 1588, no.XXIII, I (description); Mandowsky and Mitchell, 1963, cat.34.

SOME OTHER EXAMPLES OF CYCLES OF THE LABOURS OF HERCULES KNOWN IN THE RENAISSANCE:
Sarcophagi
– Ferentillo, S. Pietro in Valle. Used as a medieval tomb (Ragusa, 1951, no.10).
– Florence, Boboli Gardens near Piazza Romana. Known late 15th century?. Used as a fountain basin at Pratolino, late 16th century (Robert, *ASR*, III, 1, cat.107, pl.XXX).
– Rome, Villa Borghese. Known later 16th century (Robert, *ASR*, III, 1, cat.127).
– Vatican Belvedere, Amelung, *Kat.*, II, pp.316–17, no.102µ, pl.24. Known early 16th century (Aspertini, Cod. Wolfegg; Robert, *ASR*, III, 1, cat.129).
– Lost sarcophagus or altar drawn in 'Ripanda' skb., Oxford, Ashmolean, f.51ᵛ, and Roman drawing, c.1550, Oxford, Christ Church (Byam-Shaw, 1976, cat.526): Birds, Amazon, Bull.
Altars
– Rome, Museo Capitolino. Badly damaged. In Albano early 16th century (Stuart-Jones, 1912, pp.62–4, SDT I, I).
Terracotta reliefs
– Campana plaques. Antique types known from 15th century cf. Reinach (*Rép. Rel.*, III, p.374, no.4; p.375, nos.1–2).

HERCULES AND THE LION

The Labours of Hercules were a popular subject in art either singly or as a cycle; the most popular of all was Hercules' combat with the Nemean Lion.

In mythology, Juno played the evil stepmother to Hercules, jealous that he was Jupiter's beloved son by a mortal woman. She was

supposed to have nurtured the Nemean Lion, like the Hydra of Lerna, so that it could be a specially exhausting trial for Hercules (Hesiod, *Theogony*, 309–32). No spear, sword or arrow could pierce this lion's hide and Hercules was therefore obliged to strangle it with his bare hands. After he had killed the lion, Hercules skinned it, ingeniously using the lion's own claws which were able to pierce anything. He then wore the lion skin himself, often using the lion's head as a helmet. It provided splendid protective armour.

Artists in Antiquity liked to portray the struggle of Hercules with the lion as a kind of wrestling match and they did so with many variations. The visual analogy to Samson, who also fought a lion, may have contributed to the appeal this theme had for Renaissance artists.

136. Hercules Wrestling with the Nemean Lion

Roman relief, 3rd century A.D., after late Hellenistic type

Rome, Villa Medici (Cagiano de Azevedo, 1951, cat. 49)

DESCRIPTION: The closed outline of the two combatants struggling in a death grip was a favourite motif in Raphael's Circle. The same motif is often found on Graeco-Roman gems also known in the Renaissance (see Cagiano de Azevedo, 1951, pp. 65f. for other representations of this type). What distinguishes the Medici relief from most of the gems is the almost continuous curve along the top of the lion's mane through Hercules' head and shoulders.

In the Renaissance, the relief was a fragment, nearly square and consisted only of the upper part of the figures except for the lion's right leg and Hercules' legs from below the knees, and part of the club (Pighius drawing). When the missing parts were restored in stucco, the flanking trees and rocky ground were added.

HISTORY: The relief was known in the early 16th century in Rome. It appears in the collection formed by Cardinal Andrea della Valle as a base for a colossal barbarian on the left of the courtyard, the *giardino pensile* (Cock engraving: Hülsen and Egger,

1913–16, II, pl. 128, no. 17). From the della Valle-Capranica Collection it passed to the Medici in 1584 and remained in the Villa Medici.

REPRESENTATIONS:
- G. N. Vicentino, chiaroscuro woodcut after Raphael, Bartsch, XII, p. 119, no. 17: 'restored', with landscape; cf. Niccolò Boldrini, *ibid.*, p. 120, no. 18.
- Agostino Veneziano, engraving, Bartsch, XIV, p. 219, no. 287: '1528'. Adaptation with both heads turned to plane; ruins.
- Roman, 2nd quarter of 16th century, London, BM, 1901–6–19–2ᵛ (Gere and Pouncey, 1983, cat. 348): unrestored with Torso Belvedere, **132** (Schwinn, 1973, fig. 5).
- Aspertini, London, BM *Skb.* I, f. 48ᵛ (Bober, 1957, fig. 103, p. 76): Hercules towers over lion; lower part hidden by figures in foreground.
- Cod. Coburgensis, f. 465 (Matz, 1871, 28): unrestored; cf. Cod. Pighianus, f. 33ᵛ, 2 **(136a)** (Jahn, 1868, 56; Beger, 1705, pl. 6): '*Card. de la Valle horto*'.
- Cambridge *Skb.*, f. 41 (Dhanens, 1963, fig. 10, cat. 37): '*la valle*'. Unrestored.
- Vaccaria, 1584, pl. 67?: statue group, restored, no club.
- Rubens, c. 1600, drawing in private collection, Dorset (Jaffé, 1977, fig. 285): unrestored; cf. adaptations, possibly from gems (*ibid.*, figs. 287–8).
- dei Rossi, 1654, I, pl. 34: '*in viridario magni ducis Etruriae*'. Reversed.

LITERATURE: Bober, 1957, p. 76 with bibl.

HERCULES AND ANTAEUS

In the course of performing his labours, Hercules travelled south to Libya. There he encountered Antaeus, who used to kill strangers by forcing them to wrestle with him. Antaeus had the great advantage of being a son of the goddess Earth, so that each time he was thrown and touched the ground, he grew stronger. When Hercules finally realised this, he lifted Antaeus up and while holding him aloft, crushed him. The elder Philostratos vividly describes an ancient painting of this conflict in his *Imagines* II, 21. A bronze statue corresponding to **137** is described in *The Greek Anthology* (1918, V, bk. XVI, no. 97): '... the giant doubled up seems even to be groaning'.

IN THE RENAISSANCE:

A neo-Platonic interpretation is given by a Florentine humanist in the circle of the Medici, Cristoforo Landino, about 1475. In his Myth of Hercules which forms part of *De vera nobilitate*, he explains the struggle. Antaeus, the son of the earth, cannot be destroyed as long as he maintains contact with earthly desires. Hercules, in lifting him from the ground, separates him from those material preoccupations which interfere with the attainment of divine things. For it is only when we are cut off from our physical possessions that we can attain spiritual rewards. In this manner, Landino interprets the other Labours and deeds of Hercules (Landino–Liaci, 1970, pp. 107ff.; see also M. A. Jacobsen, 1981, for the iconography in Quattrocento Florence).

137. Hercules and Antaeus
Roman group after a Hellenistic bronze
Florence, Palazzo Pitti, courtyard (Dütschke, II, cat. 37)

DESCRIPTION: Hercules, standing behind Antaeus, lifts him high off the ground, while Antaeus struggles in his grip. The group was greatly admired among the statues of the Vatican Belvedere, although it was a fragment: Antaeus lacked head and arms, and neither of the figures had legs. Even so, Antico called it 'the most beautiful *antichità* there could be'. Like the other great antique fragments, it offered artists opportunities for a variety of reconstructions before the group was restored in the 1560s in Florence. There, in Ammannati's courtyard of the Pitti, finished c. 1563, it has found a singularly appropriate setting. Both the columns strapped down by mighty stony rustication, and Antaeus crushed in Hercules' powerful arms contribute to the same grand design.

HISTORY: With the Venus Felix (16) and the Apollo Belvedere (28), it came in 1503 to the Belvedere when Julius II began to construct the Statue Court (P. G. Hübner, 1912, p. 112), and may have been part of his own collection as Cardinal of S. Pietro in Vincoli, as the group was already reconstructed in artists' representations of it in the late 15th century. The group was sent to Florence by Pius IV with other statues from the Belvedere as a gift to the Medici Duke Cosimo I in 1560 (Michaelis, 1890, p. 39), but the Hercules and Antaeus only arrived at the Palazzo Pitti in 1564 and seems to have been restored by Valerio Cioli (Davis, 1980, p. 52). Vasari did not include it among the statues of Cosimo's Antiquarium on the first floor of the palace, but described it '*sotto la loggia da basso*' (Bloch, 1892, p. 82). In a Medici inventory of 1597, however, it was in the '*salone grande delle nicchie*', the Antiquarium constructed by Ammannati in the early 1560s for Cosimo (Davis, 1980, p. 52, n. 91). When the group was placed in its present niche to the left of the Grotto in the main *cortile* of the Pitti is not clear. It had been paired with a restored replica of Menelaus and Patroclus there by 1677 (Bocchi, 1677, p. 116; cf. **154–5**) until that group was removed to another courtyard probably in 1830 (Mandowsky, 1946, pp. 117–18).

REPRESENTATIONS:
- Mantegna, Ceiling of Camera degli Sposi, Mantua, Pal. Ducale (Martindale, 1979, fig. 137): 'restored', adaptation. Hercules wears lion skin with tail curving down behind; cf. Florence, Uffizi, 1682F, reproduced by Mezzetti (1958, fig. 1 as Mantegna, and dated 1471).
- Mantegna School, Windsor, 12802 (Popham and Wilde, 1949, pl. 155, cat. 17): 'restored'. Figures nude. Antaeus puts up weak struggle, head back, one knee bent; he clutches his shin, the other leg outstretched. Outlines pricked for transfer.
- North Italian, late 15th century, bronze statuette, Baltimore, Walters Art Gall. (*Renaissance Bronzes in American Collections*, 1964, cat. 7, ill.): 'restored' with Hercules in similar stance to present restoration, but Antaeus' chest springs out like a bow, head back, knees akimbo; cf. Roman, c. 1500, bronze statuette, Florence, Mus. Naz. (Weihrauch, 1967, fig. 135).
- Antico, bronze statuette made for Isabella d'Este in 1519, Vienna, Kunsthist. Mus., Planiscig, 1924, cat. 98 (Weihrauch, 1967, fig. 136; Chambers and Martineau, 1981, fig. 48): better solution than present restoration. Antaeus' head back, outer knee bent less. Cf. bronze statuette, London, V&A, A37–1956 (Radcliffe in Chambers and Martineau, 1981, cat. 55): thought to be Antico's original cast of 1499, made for Bishop Ludovico Gonzaga.
- Michelangelo, Haarlem, Teyler Mus., A24 (facsimile in de Tolnay, 1976, pl. and cat. 238 recto and verso): adaptations with Antaeus as female; A24V: cancelled version, sex of Antaeus unrevealed; cf. lost painting of *Hercules and Antaeus* by Floris,

engraved by Cort (Hoff, 1964, fig.61); another sketch by Michelangelo, London, BM (Wilde, 1953, cat.33) as related to Hercules and Cacus project, c.1525.

- Adaptations in Raphael's circle with Antaeus at right angles to Hercules' chest, and one leg behind; Marcantonio Raimondi, engraving, Bartsch, XIV, p.258, no.346 (Brummer, 1970, fig.122); cf. Agostino Veneziano, XIV, no.347; and Ugo da Carpi, chiaroscuro woodcut after Raphael, reversed, in landscape, Bartsch, XII, p.117, no.14. A squared early drawing in the Cod. Pighianus (f.206, 2; Jahn, 1868, 27) exactly copies the figures in the above engravings.

- Lorenzo Lotto, *Portrait of Andrea Odoni*, 1527, Hampton Court (Zampetti, 1953, cat.67; detail, pl.106): small scale replica (unrestored) seen from back, on shelf behind the collector; cf. Venetian, second quarter of 16th century, Milan, Bibl. Ambr., F.284, inf.40 (Ruggeri, 1979, cat.30); cf. Heemskerck, *Skb.* I, f.59: unrestored in two views, back and back from left **(137a)**; cf. 'Maarten de Vos' *Skb.*, f.VI, 3–4: from slightly different view point; f.VIII, 5–6: right profile and left front.

- Aspertini, London, BM *Skb.* I, f.43V (Bober, 1957, fig.93): 'restored', back view, Antaeus' arms flung out and left leg back (*ibid.*, p.72 for Albertini and Aldrovandi's descriptions of unrestored group).

LITERATURE: Brummer, 1970, pp.138–41; Hoff, 1964; Netto-Bol, 1976, pp.37–8: the drawing by Pisanello cited in n.9, p.38 is another type (front to front) of Hercules and Antaeus; Haskell and Penny, 1981, cat.47.

HERCULES AND THE HESPERIDES

By the end of the 5th century B.C. the idea of a blessed after-life, the sort of immortality that was granted to Hercules, was conceived of as a blissful existence in an idyllic garden like that of the Hesperides. Thus Hercules, shown in the company of two Hesperides by the side of the apple tree, might not only illustrate the hero's labour, but also suggest his ultimate reward. It is probably this suggestion that gave the predominant meaning to the original 5th century B.C. relief of which **138** is a Roman copy, a point well argued by Harrison (1964). When only one Hesperid was shown with Hercules. and the tree with the snake, the image could be adapted for representations of Adam and Eve.

138. Hercules in the Garden of the Hesperides

Roman copy of Greek relief of 5th century B.C.
Rome, Villa Albani (Helbig, IV, cat.3247)

DESCRIPTION: The 16th century drawings of the whole fragment show only the figures of Hercules and the Hesperid in front of him. The restoration adds the Hesperid to the left, the top of the apple tree and the rocky ground below.

Hercules sits in profile on his lion skin on a rock, club under armpit and he dangles a quiver? on a strap in his left hand, while a snake winds up from the ground to the tree behind him. Pirro Ligorio describes but does not draw the relief which was over the doorway of his patron, Cardinal Ippolito d'Este on Monte Giordano in Rome. He interprets the Hesperid as

'… a beautiful and virtuous young woman, wearing lightest clothes, and with the left hand she holds the apples on a branch, and with the other shows herself to be bashful in the discussion that she seems to be having with Hercules…' (Naples, BN, MS XIII B.7, p.233; Italian passage quoted in Mandowsky and Mitchell, 1963, cat.142).

INTERPRETATIONS: Pighius draws the tree as an olive, and has the Hesperid holding pomegranates, shortly before Ligorio's correct interpretation. Girolamo da Carpi eliminates attributes and draws the pair as a loving couple.

HISTORY: The relief was known in the 15th century ('Pisanello'); in Monte Giordano, Rome (Aspertini), and was walled in over the doorway of Cardinal d'Este's house there from the mid 16th century (see above, Ligorio).

REPRESENTATIONS:
- Pisanello, formerly Rotterdam, Koenigs Collection, J.522 (Schmitt, 1960, fig.68): figure of Hesperid with apple branch.
- Aspertini, Cod. Wolfegg, f.18V: 'in monte giordano'. Hercules seated on lion skin, draped woman in helmet lopes towards him. (Bober, 1957, p.34, n.1: the relief as a model for 'restorations' of the Belvedere Torso.)
- Girolamo da Carpi, Amsterdam, Rijksprentenkabinet, A 2165 (Gernsheim, neg. no.4769a): free adaptation of the two figures without attributes, as lovers **(138a)**.
- Cod. Coburgensis, f.102, 3 (Matz, 1871, 23): whole broken relief, unrestored; cf. Cod. Pighianus, f.34 (Jahn, 1868, 39): '*In monte Jordano*'.

– Pozzo Windsor, II, f.45, 8300 (Vermeule, 1966, p.18): whole unrestored relief with left foot of missing Hesperid on left (noted by Schmitt, 1960, cat.22).

– Beger, 1705, pl.12 (after Pighius).
– Zoega, 1808, II, pl.LXIV (restored).
LITERATURE: Schmitt, 1960, cat.22 (drawings and bibl.): Mandowsky and Mitchell, 1963, cat.142.

BATTLES, MYTHOLOGICAL AND HISTORICAL

In the depiction of warfare ancient art created a rich, enduring legacy: both mythological battles intended as metaphors of current events in the Greek mode, or Roman 'documentaries' of combat against real barbarian foes. This inheritance poses questions of survival and revival in artistic representation which are too complex, too pervasive in Western culture for us to consider here. Yet, we have to recognize that a specific repertory of poses and combinations of figure types, established in Greek sculpture and painting of the 4th century B.C. and augmented by the Hellenistic art of Pergamon, affected all later portrayals of battle in Roman times and in the Middle Ages. Renaissance artists, heirs to this composite tradition, began to verify its recurrent motifs against what today might be called 'behavioural research', as well as fresh observation of Roman monuments dating from Trajan to include a Pergamene revival under the Antonines.

Rome still afforded impressive historical dedications which could be supplemented by scattered remains elsewhere (the Arch of Orange in France, drawn by Sangallo, for example). Artists could study the martial catalogue on Trajan's Column–or, at least, its lowermost third–even before Jacopo Ripanda devised a way of getting himself hauled to the top. The Column's variations on selected themes and, above all, calculated *disegno*, was more attractive than the exaggerated stereotypes of its Antonine imitation. Portrayals of the Parthian campaigns of Septimius Severus were also accessible physically, thanks to heightened ground levels about his Arch in the Forum, but not aesthetically; despite antiquarian interest and some drawings by artists, abstract rendering of strategic diagrams and the subordination of dwarfishly proportioned figures to the mass held as little appeal as the *sciocchissime* ('tasteless'–to quote Castiglione's famous letter on Raphael's behalf) sculptures of the 4th century friezes of the Arch of Constantine. What grabbed the eye were the great Trajanic battle friezes incorporated into Constantine's Arch along with allegorical reliefs celebrating Hadrian and Marcus Aurelius **(158, 161–3, 182, 189)**.

Even more valuable were sarcophagi from the second and early third centuries A.D. They could be studied close up at many different locations and their sculptors had learned from Trajan's master designer how to epitomize the vast confusion of a battlefield in a few figures; they had also worked out unifying compositional devices that instantly conveyed which combatants would be victorious, which the vanquished.

LITERATURE: Pinder, 1928 (fundamental); von Salis, 1947, 'Reiterschlacht'; Fuhrmann, 1931; Hamberg, 1945; Andreae, 1956.

AMAZONS AND AMAZONOMACHIES

Amazons ('breastless ones', allegedly from their custom of burning off the right breast for better use of javelin and bow) might be termed the Greeks' most beloved enemies, so romantic are the tales connected with these

legendary warrior women living on the borders of the civilized world (cf. **8**, 'Juno Cesi'). According to some authors, however, they had founded Ionian cities like Ephesus, Magnesia and Smyrna. The greatest heroes, from Hercules on, found them worthy opponents: Theseus succumbed to the beauty of Hippolyta and Achilles fell in love with Penthesilea, daughter of Mars and ally of Priam at Troy, at the very moment of slaying her (a story elaborated from the post-Homeric cycle by Quintus of Smyrna). In Hellenistic literature one learns of Dionysus' (Bacchus') encounter with the Amazons on the path to India (see the sarcophagus beloved of Donatello and Brunelleschi, **144**), as well as an Amazon queen who craved a child by the new Achilles, Alexander the Great.

The Greek bent for depicting mythological battles as metaphors of current events led to the creation of monumental Amazonomachies in 5th century B.C. Athens. Mikon's frescoes in the Sanctuary of Theseus and Phidias' designs for the shield of his Athena *Parthenos* or the west metopes of the Parthenon, were seen as parallels to the repulse of the Persians. Fourth century paintings and reliefs of the theme added to the repertory of Amazon combat motives which echo in battle representations of the Hellenistic period and hundreds of years later are taken up in the sarcophagi of Roman generals.

Replicas of the most famous Amazon statues of Antiquity, created for a competition at Ephesus with the participation of Phidias and Polyclitus, were readily restored as Lucretia in the Renaissance to make up for the lack of genuine representations of the heroine (Aldrovandi, 1556, *passim*).

LITERATURE: Redlich, 1942; Missonnier, 1932; Ridgway, 1974; 1976; Weber, 1976.

139. Amazonomachia, with Achilles and Penthesilea

Sarcophagus. Roman, first half of 3rd century A.D. Vatican, Belvedere (Amelung, *Kat.*, II, pp. 120–6, no. 49)

DESCRIPTION: As with third century battle sarcophagi, the mythological combats of Greeks and Amazons evolve into lofty slabs of relief filled to bursting with a tumult of figures; there is no longer the sense of background against which individual groups of adversaries are defined. The emotional content has been 'heated up' also: in this example poignancy is added to the anguish of war by making Achilles clasping the lifeless body of Penthesilea the hub of the action. Seen in heroic scale – like two of his companions at either side and the Amazons who rein in rearing horses to close the composition – this *imago* condenses the personal meaning of the sarcophagus. The heads of Achilles and the Amazon Queen are portraits (with late Severan fashionable hairdress for the Amazon), their poses are modelled on a famous Greek sculpture of the second century B.C., Menelaus with the body of Patroclus (**155–6**), then much admired among the cultured – even if a stock pattern of the atelier – and they must have likened their grief at death's parting to that which overwhelmed Achilles when he slew Penthesilea at the very moment they looked into each other's eyes and fell in love, all of this inextricably interwoven with the pessimism of the age and the hope of an enduring afterlife. Every available space around the main protagonists is filled in by smaller equestrians or crumpled bodies of dead and dying men, Amazons and horses. Numerous small restorations. The ends depict, on the right, an Amazon being girt for battle or having her knee inspected at an Amazon stronghold; and a single combat of Greek versus Amazon on a horse.

HISTORY: Although the provenance is unknown before the beginning of the 17th century when the sarcophagus was in the Villa Giulia, it seems to have been known in the Quattrocento. It was certainly studied in the Cinquecento and might possibly have been at the end of the century in the possession of Gironimo Manili (cf. Robert, *ASR*, II, cat. 92 and Pozzo Windsor, X, f. 79, 8072). The sarcophagus was still in the Villa Giulia in Winckelmann's day, coming to the Vatican in the period 1767–96, probably when the Belvedere was walled in during 1773 and the succeeding years.

REPRESENTATIONS:
– Central Italian, c. 1420–30, Paris, Louvre, R.F. 38 (Degenhart and Schmitt, 1968, cat. 137, pl. 179a): the warrior seen from the back at left, plunging into the fray, with figures from unrelated sarcophagi (**124a**).

– Giulio Romano, Vienna, Albertina, inv. 331 (Stix and Frohlich-Bum, 1932, III, cat. 89): the same figure with the entire right-hand corner (139a). Such a figure appears time and again in works of Raphael and his School, and of Michelangelo (Wilde, 1932–4) and is adapted by Giambologna for his bronze *Mercury* (Avery and Radcliffe, 1978, cats. 33–5).

NOTE: It is difficult to attribute single *reprises*, since a good many Achilles-Penthesilea sarcophagi of the type were accessible during the Renaissance, see Paris, Louvre (Robert, *ASR*, II, cat. 90) and Pal. Rospigliosi (*ibid.*, cat. 96) both drawn by Aspertini (Cod. Wolfegg) and in other sketchbooks.

LITERATURE: Robert, *ASR*, II, cat. 92; III, 3, p. 553, cat. 92.

140. Amazonomachia

Sarcophagus. Roman, 180–90 A.D.
Rome, Palazzo dei Conservatori (Stuart Jones, 1926, pp. 153–4, Sala degli Orti Lamaiani, 38)

DESCRIPTION: In keeping with its late second century date, the reliefs are developed as a frieze across the face of the sarcophagus and preserve individual fighting groups of Greeks and Amazons which trace their ancestry back to classical Athens and Hellenistic Pergamon. These are basically three, with two more reserved for the sarcophagus ends. In the centre, pyramidally composed, a naked Greek kneels on the back of a fallen adversary and raises his shield to defend himself against a mounted Amazon charging from the right. At either side of this central group, Amazons on horseback gallop outward, the one at right constricted in space and plunging on a diagonal from the background of the relief. The rider at left is coming to the aid of a valiant companion who wields a *bipennis* or axe with both hands over her head, battering a Greek crouched over the body of a friend; at the corner an Amazon is running off as if to go to the aid of the Amazon on the left end being pulled by her hair off her collapsing horse by a Greek who is ready to stab her. The right-hand group, correspondingly, shows an Amazon getting the worst of it; she is pressed to her knees by a Greek ready to deliver the final blow as another Amazon flees to the right over the corpse of a warrior. The right end displays a Phidian motif of a Greek grasping a crouching Amazon by the hair. The sarcophagus is in a very damaged and eroded condition.

HISTORY: In the first years of the 16th century, the sarcophagus was already in the possession of the della Valle (Cod. Wolfegg) and was apparently one of the sarcophagi reserved in the sale to the Medici in 1584. Like a number of other della Valle sculptures it passed ultimately to the Capitoline Museum and thence to the Conservatori.

REPRESENTATIONS:
– Aspertini, Cod. Wolfegg, ff. 1, 26ᵛ–27, above (Bober, 1957, fig. 50): '*in chasa de quilli dala valo*'.
– Girolamo da Carpi, Turin *Portfolio*, f. 11C.
– Aspertini, London, BM *Skb*. I, ff. 45ᵛ–46, below: centre and right half.
– Cod. Coburgensis, f. 207, 140a (Matz, 1871, 207).
– Pozzo Windsor, X, f. 77, 8070: '*alla valle da Mag. Lita*' on the verso; f. 82, 8075: the right end with comparable inscription on the verso; f. 118, 8111: left end.

NOTE: Also the source for stuccoes in the Vatican Loggie (Dacos, 1977, pl. LXVc, p. 224 and indices).

LITERATURE: Robert, *ASR*, II, cat. 111; Helbig, II, cat. 1478 (Andreae).

141. Amazon dismounting from a Fallen Horse

Statuary group. Roman copy after a Hellenistic adaptation of a classical Greek prototype
Rome, Palazzo Patrizi (Matz and Duhn, I, cat. 948)

DESCRIPTION: In a motif originally conceived for relief, an Amazon twists around in the plane to look back at some fresh assault, as she swings her right leg over a panther-skin saddle in order to dismount from her stricken horse; her left foot already touches the ground. Her head and left arm are the major restorations.

HISTORY: It is likely that this is one of the sculptures and inscriptions gathered towards the end of the Quattrocento in the court of the Palazzo Santacroce by Cardinal Prospero, although the first drawings date from the early 16th century. The group is mentioned by Aldrovandi at the Palazzo Santacroce (1556, p. 236); taken to the Palazzo Patrizi before 1624 when it appears in an inventory (*Documenti inediti* IV, 446).

REPRESENTATIONS:
All depict the group unrestored.
– Holkham album, f. 34ᵛb, 14b (Schmitt, 1970, fig. 20).

- Heemskerck, *Skb.* I, f.29ᵛb: in view of the Santa-croce court **(141a)**.
- F.Salviati, *Portrait of a Member of the Santacroce Family*, c.1530–8, Vienna, Kunsthist. Mus., inv.296, no.648 (*Verzeichnis der Gemälde*, 1973, pl.28).
- Cod. Coburgensis, f.150, 2 (Matz, 1871, 13).
- Cod. Pighianus, f.291 (Jahn, 1868, 22).
- Cavalieri, III–IV, pl.44: '*in aedibus Petri Santacruci*', reversed.

LITERATURE: Lanciani, 1902–12, I, p.110 (Santacroce Collection); identification by Michaelis, 1892, pp.97, no.100; 1893, p.127; Schweitzer, 1936, p.161, fig.2.

142. Captive Amazons

Sarcophagus lid. Roman, 2nd century A.D.
London, British Museum (A.H.Smith, 1904, cat.2299)

DESCRIPTION: The entire right portion is modern, possibly restored in excellent style *all'antica* by Guglielmo della Porta. Between corner masks of helmeted youths with long hair (Robert suggested they were Corybantes), eight seated captives were grouped in antithetical pairs, save for the two outer Amazons turned toward the corners; on the ends a pair of Amazons was disposed at a *tropaion*. While the central Amazons each rest one arm on the shields (*peltae*) that crown their heaped-up equipment, the two outer captives place inner hands to heads in a mournful gesture, but the restraint of expression is very classical and notable.

HISTORY: The cover belongs to a sarcophagus that was intact during the Renaissance, at SS.Cosma e Damiano in the Roman Forum. Sometime during the first half of the 16th century the cover was separated from the trough and came into the possession of Guglielmo della Porta (Dosio, Berlin *Skb.* drawing and inscription); Ligorio described the sarcophagus itself among reliefs at the Church, and notes that a similar one was in the Belvedere (Dessau, 1883, p.1085). It seems still to have been intact in Dal Pozzo's day, but was later sawn apart and exists today in fragments at the Vatican (the ends, one fragmentary; Amelung, *Kat.*, I, nos.301–2, pl.54), and part of the front in the Palazzo Salviati (still?). This cover portion came with the Townley Collection to the British Museum in 1805; it had been acquired in the mid 18th century from Cardinal Passionei at the Camaldolese monastery near Frascati.

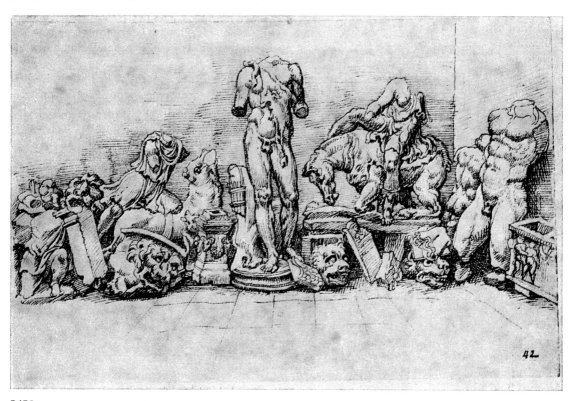

141a

REPRESENTATIONS:

Lid

- Pisanello, Rotterdam, Mus. Boymans van Beuningen, J.520ᵛ (Schmitt, 1960, fig.86, cat.5): two Amazons from lid drawn with warriors from end in Vatican (*ibid.*, fig.87).
- Cod. Escurialensis, f.25: '*Fregio del coperhio delamazone*', referring to the sarcophagus drawn at SS. Cosma e Damiano on f.36, according to Robert.
- Dosio, Berlin *Skb.*, f.50: '*Quest è un coperchio di marmo d'u(n) pilo, dove sono intagliate di basso rilievo le amazzone, oggi nella casa di fra guglielmo del pio(m)bo in strada julia*' ('This is the marble cover of a sarcophagus where the Amazons are carved in bas-relief, today in the house of Guglielmo del Piombo in the Strada Giulia'; Hülsen, 1933, no.125; on Guglielmo's collection–he died in 1577–see Aldrovandi, 1558, pp.231-2).

Front

- Studio of Filippino Lippi, before 1500, Oxford, Christ Church, 0062 (Byam Shaw, 1976, cat.40, pl.33): front with an end.
- Cod., Escurialensis, f.36 (**142ii**).
- Perino del Vaga, Florence, Uffizi, 1495E.
- Anon., 16th century, Florence, Uffizi, 5943 Horne (**110a**).
- Master L.D., engraving, Bartsch, XVI, p.325, no.51 (see now Zerner, 1969, cat.80, fig.80): right side of front, reversed, and loosely adapted.
- Cod. Ursinianus, Vat. Lat. 3439, unnumbered page between ff.62 and 63 (Robert, *ASR*, II, cat.79): front and ends.
- Pozzo London BM I, f.64, no number (Vermeule, 1960, p.13).

LITERATURE: Robert, *ASR*, II, pp.94f., cat.78 (and cat.79 for the body of the sarcophagus); also Matz and Duhn, II, cat.2221; and for drawings and adaptations of front, see Bober, 1957, pp.63-4.

143. Dead Amazon

Statue. Roman copy of a Pergamene original from small Attalid Dedication at Athens (see **148–152**). Naples, Museo Nazionale (Ruesch, 1911, cat.303)

DESCRIPTION: On a rocky base a lifeless Amazon lies supine, right leg bent in the crooked collapse of death, its sharp angle echoed by the right arm cast palm up beside her head–a pathetic motif which, at the same time, puts into full *rilievo* her bared right breast; the skirt of the short *chiton* has fallen away to reveal her entire right side. The Amazon's head is turned towards the closed left side of her body where both arm and leg are limply

extended alongside the corpse. Archaeologists have debated whether 16th-century texts and a drawing which record the torso of a small child at the Amazon's wounded breast preserve the original state or demonstrate a Renaissance addition to enhance the pitiful aspect of the sculpture. Klügmann (1876), who first identified this figure and its companions with 'small Gaul' dedications by Attalus I or II of Pergamon, could not accept the antiquity of such tear-jerking sentimentality, especially for an Amazon. Michaelis (1893), however, explained the subject within Near Eastern, Pergamene tradition and argued that the child had been chiselled away in restoring and polishing the sculpture; a passage in Pliny (*Natural History* XXXIV, 88) tells how the sculptor Epigonos outdid others with a statue of a trumpet player and a 'weeping infant pitifully caressing its murdered mother'. The 'small' attalid dedications–to distinguish them from the *large* group of which a *Gaul Slaying his Wife* and the *Capitoline Dying Gaul* (Haskell and Penny, 1981, cats.44 and 68, figs.116, 149) are copies–were dedicated on the Athenian Acropolis to commemorate Pergamene victories over the Gauls and, following good Attic precedent, included other metaphoric triumphs: gods over the giants, Greeks over Amazons and Persians.

HISTORY: A letter of 1514 by Filippo Strozzi (Gaye, 1839-40, II, p.139, no.84) tells of the good fortune of Alfonsina Orsini (widow of Piero de' Medici, dwelling in the Palazzo Medici, later Madama, in Rome), at having come into possession of 'about 5' (another source says seven) newly-discovered marbles showing dead and wounded 'Horatii and Curiatii'. In the winter of 1514-15, Claude Bellièvre of Lyons visited Rome and described six statues (four now in Naples, of which see **151–2**, as a result of Margarita of Austria's short-lived marriage to Alessandro de' Medici before her wedding to Ottavio Farnese) at the Palazzo Medici-Madama, as well as a seventh sent to the Pope at the Vatican (**148**), but makes no mention of three acquired by Domenico Grimani, apparently from the same find, and bequeathed to Venice (see **149**) at his death in 1523 (Bellièvre, *Noctes Romanae*, Paris, BN, MS lat.13, 123, f.187). Bellièvre is equally convinced that the warriors are to be identified according to Livy's tale of the Horatii and Curiatii 'plus a sister'. Heemskerck still knew one wounded Gaul which was separated from the group before Aldrovandi's day to reappear in the Villa Borghese and thence to the Louvre (**150**).

The dead Amazon was restored by Albacini, who received it in his Roman Studio in 1790 and sent it to Naples in 1796, together with the Dying Gaul, **151** (de Franciscis, 1946, p. 102, inv. 6012).

REPRESENTATIONS:
- In views of the Pal. Medici-Madama by Heemskerck, *Skb.* I, f. 5 and *Skb.* II, f. 48 (ill. on. p. 477), one can only make out some of the figures on a low wall projecting out from the loggia where the sculpture collection's larger pieces were gathered.
- Frans Floris Workshop, Basel *Skb.*, f. 19c: a rough sketch from above, showing the infant **(143a)**.
- Pozzo Windsor I, f. 68, 8227 (Vermeule, 1966, fig. 14, p. 12): a contemporary, fully-developed study, with no trace of infant.

LITERATURE: Klügmann, 1876, pp. 35–7; Michaelis, 1893, pp. 119ff., Lanciani, 1902–12, I, pp. 162f.; Petersen, 1893, pp. 251ff., Schober, 1933, pp. 107ff.; Bieber, 1961, p. 110; Michaelis, 1891, *JdI*, (I), pp. 135f., pp. 161f. and Hülsen and Egger, 1913–16, for comments on the Heemskerck views.

CENTAURS

Centaurs, wild woodland dwellers part human and part horse, are offspring born of, or descended from, Ixion. When Zeus saw that Ixion wanted to seduce Hera, he created a cloud-image of her; but Ixion, drunk, made love to it without recognizing the deception, and the result of this strange union were the centaurs. Ixion was punished by being strapped to a wheel for all eternity, but his children continued his debauched habits. For the Greeks they symbolized animal passions and untamed nature, being overly fond of hard drinking and the rape of maidens. The carnage that resulted when Perithous, king of the Lapiths, and friend to Theseus, invited centaurs to his wedding comes instantly to mind because of the west pediment at Olympia and Parthenon metopes. One is not so likely to think immediately of that wise old *guru*, Chiron the centaur, who had a cult in Thessaly and was the son of Saturn and Philyra and was not related to Ixion. It was he who taught the arts of medicine to Aesculapius and he was the tutor and mentor of Jason and that arch-hero, Achilles. The paradox of such very different capacities was irresistible to the Renaissance

and its emblem-makers; for neo-Platonists the centaur's bestial nature demonstrates that the soul could descend as well as ascend if its highest instincts were not cultivated. The imagery was well-served with examples carved on Roman sarcophagi, not only battles between centaurs and Lapiths, but centaurs alone, holding shields with funeral inscriptions, or participating in the triumphs of Bacchus (**78, 83**, also **84**).

LITERATURE: Baur, 1912; Gombrich, 1972, esp. pp. 69–72; Schiffler, 1976.

144. Battle of Bacchus and Retinue with Indians and an Amazon

Sarcophagus. Roman, c. 160 A.D.
Cortona, Museo Diocesano (Matz, *ASR*, IV, 3, cat. 237)

DESCRIPTION: A Battle of Bacchus' campaign in India rages across the face of the sarcophagus, composed in three groups of combatants. The first explodes to the right in contrast to the corner detail of a panther nibbling unconcernedly at a grapevine: the centaurs who draw Bacchus' chariot gallop forward over the body of a fallen Indian, charging at a naked Indian with *thyrsos* used as a spear (broken, as is the one Bacchus held) and bow. The god is caught in full action of the charge, while a Victory takes over the reins of the chariot. On the rocky *culisse* between centaurs and their enemy, another dead Indian's head is to be seen, but a fighting Indian is unaware of Pan emerging from the same rocky outcropping to attack him from the rear. The next group represents a satyr and old Silenus (seen from the back) attacking an Amazon, here an ally of the Indians, although joining with Bacchus after his conquest. The final scene pits two adversaries against one another, a bearded naked satyr and a mounted Indian who is about to tumble, wounded, onto the dead body of a companion who lies in the arched structure behind. The battle continues in low relief on the ends: to the left, a combat of a satyr and an Indian over a corpse; on the right, a satyr stabbing a fallen Indian with a lance as the latter struggles to pull it out of his chest and to rise. On the lid, at either side of a *clipeus* with a bust of Bacchus supported by flying Victories, appears a *tropaion* with fettered and mourning captives; Bacchic masks at the corners.

HISTORY: See Introduction, p.31 for the story of Donatello's admiration for the sarcophagus. Formerly in the Cathedral at Cortona.

REPRESENTATIONS: Although we probably cannot hope to find the drawing Brunelleschi is supposed to have made, it would be good to find *any* drawings after this piece. Apparently, it did not enter the sketchbooks which copied one from another and was too far from the beaten track for 16th century artists to attempt the pilgrimage that Donatello and Brunelleschi made. But the rider wounded and falling off his horse on the right–a wonderful motif compressed into the relief plane–appears on a fragment at Grottaferrata that attracted the attention of Pisanello (Milan, Bibl. Ambr., F.214, inf.14; see Schmitt, 1960, fig.84, pp.119–20, no.3). The following analogies have been noted:

- Pope-Hennessy points out analogies with fallen figures in stucco relief 'Discordia', attrib. to Francesco di Giorgio Martini, London, V&A (*Cat.*, 1964, I, cat.282; III, pl.281, cf.153).
- Krautheimer (1956, Appendix A, no.23a, pl.76) includes the sarcophagus among examples of flying Victories available to Ghiberti and other Renaissance artists.
- Mancini (1903) advanced the theory that the sarcophagus inspired certain grisailles on the Virgin's throne in Luca Signorelli's painting of the *Madonna with Saints*, Volterra, Gall. Pittorica.

LITERATURE: Minto, 1950.

145. Centaurs and Satyrs in Wrestling Matches and Centauromachy Motifs

Sarcophagus. Roman, 2nd century A.D.
Vatican, Sala delle Muse (Lippold, *Kat.*, III, 1, pp.49 to 55, nos.513, front, and 501, ends)

DESCRIPTION: The sarcophagus has been sawn apart and immured with the two ends, joined by a section in plaster, fashioned as pendant to the front. It is unusual in its design, having richly ornamented mouldings with a meander-decorated plinth and an upper small frieze of hunting amoretti. The subject matter of the main frieze **(i)** is also surprising: it represents a *palaestra* (wrestling ground) with three groups of wrestling centaurs and satyrs, separated by trees and flanked by athletic herms which raise their arms in supervision. The poses show wrestling holds: a centaur has thrown a satyr to the ground by pulling one leg out from

under him, a satyr has one arm of a centaur locked behind his back, and a centaur has a head-lock on a satyr trying to break out of it. The ends **(ii)** represent canonic groups of warriors battling centaurs, including some of the 5th century motifs found on the lost della Valle sarcophagus **(146)**; that figure who kneels on a crouched centaur's crupper to club the beast into submission is twice repeated here, although in these versions the centaur's torso is seen from the back.

HISTORY: Drawings and other reflections prove that the sculpture was known from the early 16th century, but its history is obscure. (See below, Florence, Uffizi, 5943 Horne.)

REPRESENTATIONS:
- Raphael, London, BM, 1895-9-15-631: free adaptation and conflation; the bearded Hercules figure kneeling on a centaur and beating at him with a club (Pouncey and Gere, 1962, cat.22, with reference to copy in Frankfurt, Städel. Kunstinst., 4469 as Viti).
- Filippino Lippi, Stockholm, Nationalmus., Print Room, inv.2 (Degenhart and Schmitt, 1968, I, Excurs. I, p.634, fig.974): the left-hand group of front, with herm and figure thrown to the ground.
- Raphael Workshop, stucco, Vatican Loggie, pilaster VIII (Dacos, 1977, pl.CXIIa as from **146**): two groups.
- Franco, Oxford, Christ Church, inv.1398 (Byam Shaw, 1976, cat.141, pl.86): all four groups of wrestlers in two registers, with Hercules and a centaur from one end.
- Bandinelli, Hamburg, Kunsthalle, 16834: one group from left end.
- Bandinelli, Paris, Louvre, n.131: two groups from right end; cf. anon, 16th century, Paris, Louvre, 10780ᵛ.
- Italian, 16th century, Madrid, Prado, Fernandez Duran Bequest: wrestlers and herm from right corner.
- Italian, 16th century, Florence, Uffizi, 5943 Horne: below, three wrestling groups from the herm at left corner, together with three other sarcophagi drawn at SS. Cosma e Damiano **(110a, 142)**.
- Pozzo Windsor, X, f.104, 8097 (Vermeule, 1966, p.68): inaccurate and compressed; and f.106, 8099: a detail.

LITERATURE: Robert, *ASR*, III, 1, cat.132; Helbig, I, cat.66; Amelung, on a Vatican Loggie stucco, pilaster VIII, in Hofmann, 1911, IV, p.103, disputed by Lippold, cf. Dacos, 1977, indices for this and della Valle centaur sarcophagus **(146)**.

146. Battle of Centaurs and Greeks

Sarcophagus front. Roman, 2nd century A.D.
Lost, formerly della Valle Collection (Robert, *ASR*, III, 1, cat. 133)

DESCRIPTION: Length is given as '*pal(mi) 9*' in the sale inventory of 1584. The sculptor used prototypes of the 'best period', as Robert expressed it: Greek 5th century B.C. models are the ultimate source for four groups of combatants set out between a winged amor holding a garland at each corner. At left a centaur wearing a panther-skin on one shoulder clasps to his chest a nude warrior (seen from the back with sword arm ready to defend himself, his helmet fallen to the ground) while a second rushes in from the corner, arms outspread, to strike at the centaur's undefended rump. In the next canonic group, a crouching centaur thrusts up one arm in anguish as a bearded (Robert asked whether this was Hercules) combatant kneels on his crupper with one leg, pulling back the creature's head with his left as he prepares to deliver a death-blow with the sword in his outflung right hand. A variant on this spectacular pose, in which the warrior is young and wears both helmet and a fluttering capelet, follows immediately as the Greek presses down the hind-quarters of a centaur who grimaces in agony and tries with both hands to pull away from his throat the steadying grasp of another nude warrior about to strike him over the head with a club. The final group on the right echoes a famous portion of the frieze at the Temple of Apollo in Bassae-Phigaleia in Greece (now in the British Museum); this centaur almost holds his own against two attacking heroes (another already dealt with lies huddled under a shield in the foreground) by using his equine force to lash out with his hind legs while trying to rescue his head from the grip of a bearded opponent who has pulled it down by the hair.

HISTORY: During the 16th century it was among the sarcophagi incastrated in the della Valle, later Capranica, *giardino pensile*, and was still recorded there by the artist of the Cambridge Sketchbook after the mid 16th century. It disappears after the 1584 sale to the Medici (*Documenti inediti* IV, p. 377), though it does not seem to have been among the reserved sarcophagi.

REPRESENTATIONS:
- Italian, 16th century, London, BM, 1946–7–13–1261: the warrior from the second group from the right.

- Aspertini, formerly in Stuttgart, Gutekunst Collection (Fabriczy, 1905, fig. on p. 409, p. 412, no. 31); now in Rome, Gab. Naz. delle Stampe.
- Falconetto, fresco, Mantua, Pal. d'Arco, Sala del Zodiaco.
- Perino del Vaga?, stucco, Vatican Loggie, Sottoarco IIB (Dacos, 1977, pl. LXVb): centaur attacked by kneeling warrior.
- Rosso Fiorentino, follower, Windsor, 0336 (Popham and Wilde, 1949, cat. 878).
- Anon., 16th century, Princeton, Univ. Mus., inv. 59.21 (Gibbons, 1977, cat. 799; Dacos, 1977, fig. 43): almost complete (**146**).
- Cod. Coburgensis, f. 145 (Matz, 1871, 198).
- Cod. Pighianus f. 253 (Jahn, 1868, 202).
- According to Dacos (1977, p. 223) it is this sarcophagus which inspired Mazzonis's centauromachia in the court of the Pal. Spada, Rome.
- Cambridge *Skb.*, f. 85 (Dhanens, 1963, cat. 68, fig. 27): '*A lavalle*'.
- Murillo, attrib., but seems 16th century, Paris, Louvre, RF14.1831: garland-bearer from left corner and first group.

LITERATURE: Dacos, 1977, p. 223.

147. Battle at the Ships

Sarcophagus fragment. Greek, neo-Attic, 2nd century A.D.
Venice, Museo Archeologico, inv. 154 (Anti, 1930, Saletta X, no. 11)

DESCRIPTION: A panel which has been sawn and trimmed from a large Greek sarcophagus (i.e. decorated on all four sides originally). Ships, richly ornamented with reliefs of nereids and marine creatures, are drawn up on a shore. Their crews, some clambering aboard naked, seem to have been surprised in the midst of rest and recreation. Three are already dead in the foreground, the rest seem to meet the unseen foe approaching from the right in various stages of preparedness. Traditionally interpreted as a scene from the *Iliad* (XV–XVI), or an episode in the life of Telephus; Phyllis Bober believes the entire sequence to be from the *Odyssey*–Odysseus' crew surprised by the Cyclops.

HISTORY: In Trastevere at an undesignated location during the late 15th century, the fragment was presumably acquired by Domenico Grimani before his death in 1523. At any rate it was part of the Grimani bequest of 1587 to the Republic of Venice; Giovanni Grimani, Patriarch of Aquileia, had the fragment cut down to be used decoratively in his Palace. The Signoria received it in 1596, at his death.

REPRESENTATIONS:

- *Cod. Escurialensis*, f.66: 'in tresteverj' (Robert, *ASR*, III, 2, Anhang II, fig.II[1]).
- Aspertini, London, BM *Skb.* I, ff.5[v]–6 (Bober, 1957, fig.23): main elements copied with elaborations.
- Cod. Ursinianus, Vat. Lat.3439, f.71 (a drawing of this late date, 1560s, could indicate that the relief stayed in Rome until two 'tavole historiate' were sent to Giovanni Grimani in 1575; Egger–Michaelis, 1906, p.157).
- Giulio Romano, *Battle of Constantine*, Vatican, Sala di Costantino: adaptation of two nude figures, cf. drawing in the Ashmolean, Oxford, Parker, 1956, II, cat.569, pl.CXLVI (as Raphael); pointed out by Gombrich (1963, p.35, pl.VIII, 13–15; 1966, fig.169).

NOTE: Numerous 16th century designs based on the relief might derive from copies of earlier drawings, however. For use by Perino del Vaga and Polidoro, the Master of the Die (Bartsch, XV, p.228. no.78)–indeed most 16th century representations of sea-battles *all'antica*, even fishing scenes, see Bober, 1957, p.53, to which add a drawing (attrib. to Salviati) in Bayonne, Mus. Bonnat, Bean, 1960, no.149.

LITERATURE: Robert, *ASR*, III, 2, p.366, no.II; Giuliano and Palma, 1978, VI, pp.23–4, pl.XVIII.

WOUNDED AND DEAD GAULS AND PERSIANS

Roman replicas, under life-size, thought to be copied from the bronze originals of the Pergamene 'Small Attalid Dedication' on the Acropolis of Athens (see also **143, 148–152**)

The art of Pergamon flourished in the Hellenistic period under the patronage of the kings.

Questions of date, patronage, attribution and reconstruction of the original group or groups of wounded and dead barbarians, indeed of the Roman replicas, are still to be resolved.

Attalos I commissioned a large monument to commemorate his victories over the Galatians (Gauls) at Pergamon, c.220 B.C. (see **143**).

Pausanias, writing hundreds of years later, referred to the subjects of another probably later dedication by the south wall of the Acropolis (I, 25, 2):

'...the legendary war of the giants..., the Athenian battle with the Amazons, the success against the Persians at Marathon, and the destruction of the Gauls in Mysia: each of these covers three or four feet.'

The under-life-sized marble replicas which were discovered in the Renaissance copy figures from the smaller dedication on the Acropolis; they may even be copies of other copies and have been usually dated to c.200 A.D., or to the reign of Attalos II, 159–38 B.C.

For the history of the group discovered in the Renaissance, see **143**.

The four Medici-Farnese statues in Naples are illustrated by Bieber (1961, fig.435) and discussed (*ibid.*, pp.109–10): *Dead Amazon* (**143**); *Dying Gaul* (**151**); *Dead Persian* (**152**); *Dead Giant*. The fifth, a *Wounded Gaul* (**150**) is in the Louvre (*ibid.*, fig.431), and the sixth, a *Fighting Persian*, which was also with the group described by Bellièvre in 1514 in the Palazzo Medici-Madama, was also taken to the Vatican (**148**) soon after its discovery, but its later history raises problems of identity. A dressed Persian in similar pose to **148** is in the Museum at Aix-en-Provence and belongs to such a group (Brendel, 1967, fig.1; Bieber, 1961, fig.437).

Of the three statues of wounded and dead Gauls in Venice, two, which were torsos before restoration, were not mentioned at the time of the discovery of the others in 1514, but may well also have been found then. One of them, the *Falling Gaul* (**149**), is often reflected in Roman works of art before Cardinal Grimani's death in 1523 when they were both sent to Venice. The other is the *Gaul Falling on a Knee*, and restored as a gladiator (Perry, 1978, pl.25). The third, a *Dead Gaul* is not traced before 1587 (Bieber, 1961, fig.436; Perry, 1978, p.233, n.94).

LITERATURE: Von Biénkowski, 1908, pp.37–54, figs.50–75, with detailed descriptions and accounts of restoration of the extant copies. Bieber, 1961, pp.108–110 and pls. Robertson, 1975, pp.529–32 and p.719, n.70 for bibl. on group. Stewart, 1979, pp.19–23 for recent original views on the date and occasion of the Athenian dedication; p.31, n.81 (bibl.); p.32, n.93 (dating of Roman copies).

148. Fighting Persian Kneeling

Roman copy of Pergamene statue from small Attalid Dedication at Athens (see also **143, 149 to 152**)

Vatican, Galleria dei Candelabri VI (Lippold, *Kat.*, III, 2, pp. 436–8, no. 32)

DESCRIPTION: The Persian is nude except for a battle helmet in Phrygian style. He kneels on his shield, on the back left knee, while the right leg, bent at the knee, advances, and he twists to one side with lowered head and raised right arm (restored) to deal or ward off a blow. The main restorations are both arms and the right leg from the knee.

It is similar in pose to a statue of a Persian in oriental dress in the Museum at Aix-en-Provence, also associated with the replicas of the group (Bieber, 1961, fig. 437).

This common motif has been traced through the history of art by Brendel (1967).

HISTORY: (See **143**). Discovered with the five other statues described by Bellièvre in 1514–15. In the margin of Bellièvre's MS description of the statue, he added: '*ad papam vecta erat*' (Paris, BN, lat. 13, 123, f. 188); thus it seems to have been taken at once to the Vatican where Aldrovandi saw it in the Swiss Guards' Room (1556, p. 122; Boissard, 1597, I, p. 14; Michaelis, 1893, p. 120, n. 6). In the literature it was thought to have later been in the Giustiniani Collection before it was sold by Cavaceppi in 1771 to the Vatican. Thus Pietrangeli in Lippold (*Kat.*, III, 2, p. 556, no. 32) thought Aldrovandi must have been wrong about seeing the statue in the Vatican. But Giustiniani (1631, pl. 118) shows a statue in a reversed pose restored and wearing a broad waist band, missing in the Vatican replica, and the statue was not engraved in Cavaceppi's volumes. (See also Visconti, 1818–22, III, p. 248; Klügmann, 1876, p. 36.)

REPRESENTATION:
– Italian, early 16th century, Dresden, Kupferstichkabinett, C34: drawn from a model in reconstructed pose (*Dialoge*, 1970, cat. and fig. 30).

LITERATURE: Helbig, I, cat. 574; Brendel, 1967, pp. 62–70, with many ills. of the type in Renaissance art. (Brendel's examples show the pose, but with the head turned up and back, in the manner of the Clothed Persian in Aix-en-Provence.)

149. Falling Gaul

Roman copy of Pergamene statue from small Attalid Dedication at Athens (see also **143, 148, 150–2**)

Venice, Museo Archeologico, inv. 55 (Anti, 1930, pp. 97–9)

DESCRIPTION: The statue was the one with a head from a pair of 'broken bodies' in a wooden chest in the Legacy of Cardinal Domenico Grimani of 1523 (Perry, 1978, p. 241, 6A).

Until 1587, when the missing parts were restored by Tiziano Aspetti, it lacked a nose, both arms, the whole right leg, and the left leg below the knee, as well as a base (Perry, 1978, pp. 238–9: 1587 inventory and record of Aspetti's restorations; *ibid.*, p. 233).

In Rome, where it could be seen in Cardinal Grimani's Palazzo S. Marco, and in Venice, after 1523, in the Palazzo Grimani near S. Maria Formosa, until it was offered to the Republic of Venice in 1587, it was greatly admired by artists, even in its fragmentary state. Like other fragments such as that of Hercules and Antaeus **(137)**, it presented a challenge. In the following selection of representations, the artists each completed the figure differently according to the requirements of their subjects. After the statue was restored, it lost its infinite possibilities for reconstruction.

For INTERPRETATION and HISTORY, see **143**.

REPRESENTATIONS:
– Albertinelli, *The Creation and Fall*, London, Courtauld Gall. (Blunt, 1967, fig. 6): Adam with right leg bent, and left extended, is pulled up by God the Father **(149a)**. The painting is full of references to other antique statues and reliefs, among them a horse of the Dioscuri **(125)**, and Adam, accepting the apple from Eve, is seated in the pose of Paris in the Villa Medici sarcophagus **(119)**.
– Perino del Vaga, after Raphael, *Joshua Stopping the Sun and Moon*, Vatican Loggie, Vault X, 3 (Dacos, 1977, pl. XL): warrior under shield, supported by right leg folded, seated on heel, left leg kicking out off the ground (first noted by P. G. Hübner, 1909, p. 277, fig. 4).
– B. Peruzzi, drawing for *Presentation of the Virgin*, Paris, Louvre, 1410 (Frommel, 1967–8, cat. 90, pl. LXIIIa): adaptation in beggar in left foreground holding out bowl, seen from back.
– B. Peruzzi, *God the Father Presenting Eve to Adam*, fresco, Rome, Pal. della Cancelleria, 'Volta Dorata' (Frommel, 1967–8, pl. XLIa, cat. 53a): Adam supported by both hands on the ground behind him, raises himself up with right leg bent and left extended.

- Marcantonio Raimondi, engraving after B.Bandinelli (c.1520?), *Martyrdom of St.Lawrence*, Bartsch, XIV, no.104 (Panofsky, 1969, fig.61): adaptation of figure seated on the pyre.
- Aspertini, London, BM *Skb.* II, f.17 (Bober, 1957, fig.117): 'restored' in foreground.
- Titian's adaptation of the 'restored' figure in various positions has been noted by Brendel, Rowland, Panofsky and others. Perry (1980, pp.189–90) objects to the word 'borrowings' as used by Brendel, as this statue was unrestored. She prefers to search for Titian's creative response to it. For references to some of Titian's and El Greco's uses of the *Falling Gaul*, see Dacos (1977, pp.192–3).
- Venetian, c.1580, bronze copy of head and shoulders, Vienna, Kunsthist. Mus. (Planiscig, 1924, fig. and cat.181; noted by Perry, 1978, p.239).

LITERATURE: Bober, 1957, p.82; Dacos, 1977, pp.192–193; Perry, 1978, for this (pp.238–9) and another Gaul fallen on knee (pl.25b); a Dead Gaul in Venice was the third from the same group, but not traced before 1587 (*ibid.*, p.233, n.94; Bieber, 1961, fig.436); Robertson, 1975, pp.529–32, pl.170b–c.

150. Wounded Gaul

Roman copy of Pergamene statue from small Attalid Dedication at Athens (see also **143, 148–9, 151–2**)
Paris, Louvre (MA 324)

DESCRIPTION: The nude Gaul crouches with one knee on his shield, and the forward leg extended at a wide angle, the heel on the ground, as he turns his head to look up, and thrusts out an arm with clenched fist (restored). Claude Bellièvre, who described the statues when they were discovered during the winter of 1514-15, noted the wounds on the upper left thigh and right side (Latin text in Dacos, 1977, p.157).

The polished greyish marble of the skin contrasts with the rough hair. For restorations, see von Biénkowski (1908, pp.52–3).

HISTORY: See **143**.

REPRESENTATIONS:
- Raphael, *The Death of Ananias*, tapestry cartoon, London, V&A (Shearman, 1972, pl.23, p.120, n.111): free adaptation; first noted by P.G.Hübner (1909, p.278).
- Raphael's design, *The Original Sin*, fresco, Vatican Loggie, Vault II, 2 (Dacos, 1977, pl.XIII): Adam

seated, with one leg bent under him, the other extended, reaches for the apple **(150a)**.
- Heemskerck, *Skb.* I, f.5 (Hülsen and Egger, 1913, p.49; see **143**): view of the portico of the Pal. Medici-Madama.

LITERATURE: P.G.Hübner, 1909, pp.277–8; Bieber, 1961, p.109. Dacos, 1977, p.157. See also **143** and **148** for literature on the group.

151. Dying Gaul

Roman copy of Pergamene statue from small Attalid Dedication at Athens (see also **143, 148 to 150, 152**)
Naples, Museo Nazionale (Ruesch, 1911, cat.302)

DESCRIPTION: The Gaul is nude, except for a helmet. He sits painfully, blood pouring from a wound in his side. He supports himself weakly with one arm while the other crosses his thigh, its weight pulling him downward. In the Renaissance the right foot, head and part of the left arm were missing (von Biénkowski, 1908, pp.47–9).

The pose is in reverse to that of the *Dying Gaul* thought to be copied from the large Attalid Dedication in the Museo Capitolino (Bieber, 1961, fig.427; Haskell and Penny, 1981, cat.44, fig.116: 'Dying Gladiator').

HISTORY: From Medici-Madama-Farnese Collection; see **143**.

REPRESENTATIONS:
- Raphael, *The Death of Ananias*, tapestry cartoon, London, V&A (Shearman, 1972, pl.21 and pp.120–121): freely transformed in figure of Ananias; first noted by P.G.Hübner (1909, p.277).
- Aspertini, London, BM *Skb.* II, f.17 (Bober, 1957, fig.117, p.82): adaptation.
- Heemskerck, *Skb.* I, f.5; *Skb.* II, f.48: on the garden wall of the Pal. Medici-Madama.
- Cambridge *Skb.*, f.46 (Dhanens, 1963, fig.29, cat.42): frontal view, unrestored.
- Pozzo Windsor, IX, f.31, 8814 (Vermeule, 1956, fig.25; 1966, p.57): unrestored, without head.

LITERATURE: P.G.Hübner, 1909, p.277; Bober, 1957, p.82 for further references; Bieber, 1961, p.109 and fig.435 for the four Medici-Farnese statues in Naples. Onians (1979, p.84) suggests an intentional contrast between the dead mythologial figures and the still living historical ones.
For bibl. of group, see **143** and **148**.

152. Dying Persian

Roman copy of Pergamene statue from small Attalid Dedication at Athens (see also **143, 148–151**)
Naples, Museo Nazionale (Ruesch, 1911, cat. 300)

DESCRIPTION: The Persian, wearing cap, tunic, and leggings, lies on his left side with left leg bent, and tucked under the extended right leg. His right arm is restored to reach the curved sword lying beside him.

HISTORY: From Medici-Madama-Farnese Collection, see **143** and **151**. The fourth of the group in Naples is a *Dead Giant* (Ruesch, 1911, cat. 301; illus. by Bieber, 1961, fig. 435; Onians, 1979, fig. 81).

REPRESENTATIONS:
- Related by von Holst (1935, pp. 35–46) both to Vincenzo Rossi's statue of the *Death of Adonis*, Florence, Mus. Naz., and to Stefano Maderna's statue of the dead S. Cecilia, Rome, S. Cecilia in Trastevere.

LITERATURE: Robertson, 1975, I, p. 529. See **143** and **148** for bibl. of group.

153. Battle of 'Romans against Barbarians'

Sarcophagus front. Roman, third quarter of 2nd century A.D.
Rome, Villa Doria Pamphili (Calza *et al.*, 1977, cat. 232)

DESCRIPTION: Befitting its late second century date, this cavalry combat between, ostensibly, Romans and Gauls depends very directly upon spectacular poses of individual figures as if, as Hamberg has put it, a group of statues and statuary groups had been pressed together and projected on the front of a sarcophagus. The *topoi* derive from Pergamene art of its golden age, as Andreae has demonstrated (1956): for example, note particularly the nude barbarian seen from the back falling off his horse, the barbarian striking into the relief with his raised sword in centre, the barbarian falling forward over the neck of his horse and the demonstration pieces which the artist has made of the fettered prisoners beneath a trophy which enclose each side. The types are idealized Hellenistic warriors and Gauls with no special representation of Roman armour or equipment, although the Gauls preserve ethnic characterizations created in Pergamene art.

HISTORY: There is no documentation for the location of this relief before it was built into the villa's ornamentation at the beginning of the 17th century.

REPRESENTATIONS:
- This, or a similar sarcophagus, inspired several figures in the *Discordia* relief sometimes attrib. to Francesco di Giorgio Martini, London, V&A (Bober, 1957, p. 65; cf. Pope-Hennessy, 1964, *Cat.* II, cat. 292; III, pls. 281–2, see also **144**).
- Domenico Campagnola, attrib., Chicago Art. Inst., 1922.16 (Joachim and McCullagh, 1979, pl. 14, cat. 8; Sheard, 1979, cat. 46): seems to utilize this sarcophagus, since the famous Amendola sarcophagus in the Capitoline was not discovered until after the Rennaissance.
- Pozzo Windsor, I, f. 3, 8147.

LITERATURE: Matz and Duhn, II, cat. 3320; Hamberg, 1945, p. 188; Vermeule, 1966, p. 8.

154. Battle of Romans against Gauls

Frieze fragment. Roman, early Imperial
Mantua, Palazzo Ducale (A. Levi, 1931, cat. 167)

DESCRIPTION: Roman horsemen and footsoldiers advance to the right over falling nude barbarians of Celtic type; in the centre a group modelled on the so-called Menelaus and Patroclus type (cf. **155**) portrays the nobility of a Gaul trying to carry off the lifeless body of a companion, while another seeks to open a path for them. Traditionally accepted as a representation of Book XVII of the *Iliad*, despite the explicit equipment of Romans and Gauls and the fact that no cavalry encounters appear in Homer.

HISTORY: At the end of the Quattrocento it was in the collection of the dealer, Giovanni Ciampolini at Rome. After his death in 1518, Giulio Romano acquired most of his sculpture; it was taken to Mantua in either 1524 or 1526 (see Bober, 1957, pp. 56–7, with references).

REPRESENTATIONS:
- *Cod. Escurialensis*, f. 59ᵛ **(154a)**.
- Aspertini, Cod. Wolfegg, ff. 32ᵛ–33, below (Egger, 1905–6, figs. 65–6; Bober, 1957, fig. 32): 'in chasa de misero Zoano canpolino', adding more figures at right.
- Fra Bartolommeo, in Pozzo London BM I, f. 118, no. 131 (Vermeule, 1960, p. 18, fig. 52): 'Janni Campo-

lino dellarcho dipiaza Judea', copied from the *Cod. Escurialensis* or its prototype.

- Fra Bartolommeo, Windsor, 12784[V] (Popham and Wilde, 1949, cat.115[V], fig.33): the equestrian warrior at right supplied with a woman fleeing before him in terror, bearing a child. Popham *(ibid.)* indicates other copies from *Cod. Escurialensis*, f.59[V].
- 'Bambaia' Berlin *Skb.*, f.14 (Dreyer and Winner, 1964, fig.41): a loose adaptation.
- Giovanni da Nola, Chatsworth, 1071 (Gernsheim, neg. no. 74767): detail of the central group, restoring the head of the noble Gaul as a bearded, elderly one.
- Aspertini, London, BM *Skb.* I, ff.10[V]–11 (Bober, 1957, fig.35): with a youthful 'Menelaus'.
- School of Fontainebleau, engraving (Zerner, 1969, LD47).
- Giulio Romano, Mantua, Pal. del Tè, Sala di Troia (Panofsky and Saxl, 1933, p.263, figs.54–5): use of the central group.
- Cod. Ursinianus, Vat. Lat. 3439, f.97.

LITERATURE: Reinach, *Rep.Rel.*, III, p.55, no.1; P.G.Hübner, 1912, p.89; Lanciani, 1899, pp.108ff; Dollmayr, 1901, p.182. D.Strong, 1962, pp.28–30, suggests that the *cyma reversa* of the architrave ornament attached to the relief is similar to that of the interior of the Augustan Temple of Castor, and that the relief represents the Battle of Lake Regillus (see Introduction to Dioscuri, p.158). We are grateful to M.Lyttelton for calling our attention to this article.

155. 'Pasquino'–Menelaus carrying the Body of Patroclus

Statue, or rather eroded torso. Hellenistic original of the 2nd century B.C.
Rome, Piazza Pasquino, at one corner
of the Palazzo Braschi (formerly Orsini)

DESCRIPTION: A mutilated and weathered torso, remnant of a group representing Menelaus carrying the body of Patroclus known in numerous copies, including two in Florence, Palazzo Pitti and Loggia dei Lanzi, discovered in Rome about 1570. 'Pasquino' came to light, apparently, at the end of the Quattrocento and rapidly entered the folk-lore of the city as one of the 'talking statues' that carried on an exchange of satiric verse and cynical commentary on events and people of the day. Although it was taken to represent Hercules after vanquishing Geryon, or Gladiators, the modern identification is due to the fact that the limp corpse is wounded in two places (visible in copies): under

the left breast and between the shoulders; Book XVII of the *Iliad* tells of Patroclus being struck once by Hector and again by Euphorbus. The Florentine copies show the full motif: a moment in which Menelaus, wearing a magnificently decorated parade helmet, short open tunic, and baldric, has caught up the body of Patroclus; still bent over under the weight, he looks about for attacking Trojans. Michelangelo and Bernini, among others, are said to have admired this fragment and the replicas give some idea of what has been destroyed in a remarkable contrast between the mature, heavily muscled active body and the youthful, now flaccid anatomy of the corpse. However, in its present condition Pasquino is of political and literary, rather than artistic, significance.

HISTORY: An inscribed dedication gives the date when Cardinal Oliviero Caraffa installed the fragment: '*Oliviero Caraffa Beneficio Hic Sum Anno Salutis MDI*', although it was set in its present location within the Piazza in 1791. Folk-lore has it that a tailor named Pasquino lived near the spot and invented the dialogue with other *statue pubbliche*, especially the Marforio (64) and 'Madama Lucrezia' (a colossal bust of a Priestess of Isis at the Palazzo Venezia) as a display for his mordant wit; his name then passed to the statue. Gnoli has shown, on the other hand, that the earliest verses pinned to Pasquino were literary productions bearing the stamp of learned humanists in the late 15th century in the Roman 'academy'; only later did they develop the biting sarcasm and satire of the 'pasquinade', which still plays a role in the street life of Rome today. Each year on St.Mark's Day, four days after the Parilia (the celebration on April 21 of the founding of Rome), Pasquino was painted and costumed in imitation of all sorts of mythological personages, even female ones like Flora and Minerva; the statue then held court and received epigrams cast before it. In 1509 Mazochius began the publication of the verses, over 3,000 of them for Pasquino as Janus in that year!: '*Carmina quae ad pasquillum fuerunt posita in A. MCCCCCIX*' (the first volume without the printer's name). An annual anthology was published subsequently, right into the 18th century (for 1513 cover, see Sheard, 1979, cat.54).

REPRESENTATIONS:
- Francisco de Hollanda, *Skb.*, f.18.
- Anon., engraving for Lafréry's *Speculum*, 1550 (Hülsen, 1921, cat.71, with variants): '*Io non son (Come Paio) un Babbuino*' (155a).

– Cavalieri, I–II, pl.92: *'Alexandri magni miles, vulgo Pasquinus...'* and derivatives.
– Franzini, woodcut, 1599 (Ashby, 1920, C3).

LITERATURE: 'Prospettivo Milanese', c.1500, stanza 111; Flaminio Vacca, 1594, *Memorie* 29 (Schreiber, 1881, p.65) records that *'dove è hoggi la torre de gl'Orsini dicono vi fu trovato il Pasquino'*; Cancellieri, 1854; Gnoli, 1890; Schweitzer, 1938, pp.43–72; Havelock, 1971, pp.116, 144–5, cat. and fig.139 (reconstructed cast from both Florentine examples); Haskell and Penny, 1981, cat.72, figs.153–5 with Florentine examples.

156. Battle of Romans against Barbarians

Sarcophagus. Roman, late Antonine c.200 A.D.
Rome, Villa Borghese (walled in the entrance)

DESCRIPTION: Like a closely related, but even more fragmentary example in Pisa (**157**), made famous by Bertoldo's bronze relief which reconstructs it, this battle sarcophagus illustrates the transformation that the age of Marcus Aurelius and his successors brought to a type created in the mid second century A.D. Earlier, frieze-like sarcophagi for military men who wished to commemorate their valour fighting barbarians also clearly reveal a heritage from Hellenistic prototypes and heroic single combat. Now, however, the late Antonine artist treats the face of the sarcophagus as a steeply rising vertical plane on which a tormented mass of bodies swirls about a central commander. Around the periphery terrified enemy horsemen flee above, or are crushed, expiring, to the lower frame. There is a new contemporaneity in depiction of Germanic tribes and Roman legionaries instead of idealized Gauls and Greeks. Ethnic as well as psychological differentiation is brought to extraordinary heights in a striking union of form (distortions, agitated carving and sharp contrasts of light and dark) and content (the anguish and horror of war); the military equipment is historically accurate–if sorted out in the chaotic welter filling every space. The motif of mourning captives at a *tropaion* must be expanded to contain so much activity. There are now standing as well as crouching prisoners (cf. **157**) or pathetic attenuated couples erect at the foot of lofty trophies; Shorr (1940) has shown how important the latter were for medieval Crucifixion

scenes in an intermingling of funerary and triumphal connotations.

Unrestored. In the similar sarcophagus at Pisa (**157**), where the ends are preserved, the commander is shown receiving the submission of the vanquished and granting clemency.

HISTORY: Visible at the end of the Quattrocento at St. Peter's, Rome; its later history is obscure.

REPRESENTATIONS:
– Ghiberti, bronze heads of prophets, Florence, Baptistry, North Door (Krautheimer, 1956, pp.341ff., nos.13–17, pls.61a, 64a–b, 57e; 59f): ref. also to **157**.
– Aspertini, Cod. Wolfegg, ff.30ᵛ–31, above (Bober, 1957, fig.96): *'da santo piero'*.
– Falconetto, c.1507–17, Verona, Casa Trevisani-Lonardi, façade decoration (Schweikhart, 1968, p.336, figs.1, 4, 6 and 11; 1973, cat.64, pls.110 and 112): free adaptation.
– Pupini, Edinburgh, NG, D3076 (Andrews, 1968, fig.701): free adaptation.
– Aspertini, London, BM *Skb.* I, ff.39ᵛ–40, b (Bober, 1957, fig.89, p.69): in a loose adaptation.
– Pozzo Windsor, I, f.2, 8146.

LITERATURE: Rodenwaldt, 1935, pp.24ff., pl.10; Hamberg, 1945, pp.179f., pl.41.

157. Battle of Romans against Barbarians

Roman sarcophagus, early 3rd century A.D.
Pisa, Campo Santo (Arias *et al.*, 1977, C21 est, pp.151–2)

DESCRIPTION: See **156** for a description of this and another sarcophagus of the type. Central part missing from front.

HISTORY: From medieval Abbey of S. Zeno, Pisa.

REPRESENTATIONS:
– Ghiberti, see **156**.
– Bertoldo, bronze relief, Florence, Mus. Naz. (Pope-Hennessy, 1971, fig.139; pls.92–3): reconstruction of whole front, adapting figures from other antique reliefs (**157a**).

LITERATURE: Vasari–Milanesi, 1906, II, p.423; Dütschke, I, cat.60; Gombrich, 1963, p.33; Pope-Hennessy, 1971, pp.83–4; 320. Seidel, 1975, figs.30–1 for use of Victory on left in work of Nicola Pisano's school.

PART TWO: 'ROMA TRIUMPHANS'

The Roman historical reliefs, monuments and statues illustrated in this second part of the book are arranged thematically, as before, with the emphasis on consecutive visual links. And the objects are chosen because of their popularity in the Renaissance.

The battles–mythological and legendary–raging at the close of the first part of the book surge on into the Roman part with historical battles. We begin here with Trajan's campaigns against the Dacians (158–159), and the victorious aftermath of warfare in general, celebrated in scenes and images which form some of the *leitmotifs* of Roman art (160–175): the subjugation of barbarians, the triumphs of emperors, the personification of Victory, and the spoils of war.

The following section consists of commemorative statues and triumphal arches intended to immortalize in stone and bronze the fame of successive emperors (176–183).

The next group includes the symbolic images, symbols and personifications of the power of Rome and of state religion (184–188). A section then follows concerned with the rites of state religion and images of sacrifice and apotheosis (189–195), which leads to the last section of Part Two illustrating two of the more important aspects of Roman life (196–199): the ceremony of marriage and the pastime of hunting. Representations of little boys (200–203) conclude the book, the final entry being the Spinario, a young boy pulling a thorn from his foot, a statue famous not only in the Renaissance, but throughout the centuries.

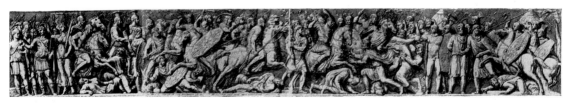

158d

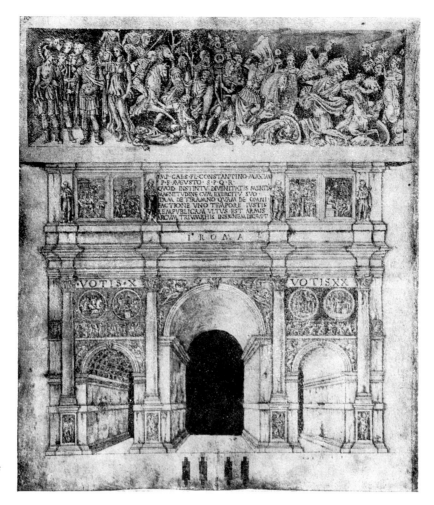

158e

Select List of Roman Emperors

JULIO-CLAUDIANS 27 B.C.-68 A.D.

Augustus	27 B.C.-14 A.D.
Tiberius	14-37
Gaius (Caligula)	37-41
Claudius	41-54
Nero	54-68

FLAVIANS 69-96 A.D.

Vespasian	69-79
Titus	79-81
Domitian	81-96
Nerva	96-98
Trajan	98-117
Hadrian	117-138

ANTONINES 138-192 A.D.

Antoninus Pius	138-161
Lucius Verus	161-169
Marcus Aurelius	161-180
Commodus	180-192

SEVERANS 193-235 A.D.

Septimius Severus	193-211
Caracalla	211-217
Elagabalus	218-222
Alexander Severus	222-235
Diocletian	284-305
Constantine	312-337

158. Trajan's Victorious Combat against the Dacians

Relief frieze, in four sections, probably from the Forum of Trajan. 2nd century A.D.
Rome, Arch of Constantine (see **182**)

DESCRIPTION: Trajan's Dacian wars are here represented in an allegorical mode very different from the documentary narrative of Trajan's Column (**159**). The same master sculptor (to follow the Italian archaeologist Bianchi Bandinelli) may be responsible for this great frieze–once part of an even longer composition–which was sawn into four sections and re-used in the central passage (**i** and **iii**) and on the ends of the *attica* (**ii** and **iv**) of the Arch of Constantine; but the result is a symbolic statement about the quality of imperial *virtus* and the value of Roman victory. A reconstruction of the four segments by Perrier (**158i–iv**) shows a generic and inevasible cavalry charge against Dacians contorted in death or fleeing in disarray; a bare-headed and weaponless emperor dominates the chaotic mass around him by sheer symbolic power (cf. Brilliant, 1963, cited below). On the left, Victory is crowning Trajan, who is received by the personification of Roma (a favourite excerpt among Renaissance draughtsmen).

HISTORY: Constantine's vision of himself as a new conqueror and pacifier in direct line of the noble tradition of the 'best' emperors such as Trajan, Hadrian and Marcus Aurelius, led him to incorporate reliefs from their monuments. These reliefs were always visible throughout the Middle Ages and in the Renaissance (see **182**).

REPRESENTATIONS:
i. *Central passage, east:* Adventus relief. *Left:* Victory crowning Trajan who is received by the personification of Roma. *Right:* a mounted Roman, riding towards the right, lances a kneeling barbarian; a wounded Dacian slumps on the ground near the horse.
- Giuliano da Sangallo, *Cod.*, Barberinianus, f.19ᵛ: **i** and **iii** (**158e**); the two passage reliefs joined and drawn above the whole arch (north side).
- Italian, by a late 15th century artist of the Holkham Album, Munich, SGS, 36909 (Degenhart, 1939, pp.135f., fig.48 as Federighi).
- Holkham Album, f.34 (**14b**): Victory crowning Trajan.
- 'Ripanda' skb., ff.38ᵛ–9, Oxford, Ashmolean: right.
- Aspertini, Cod. Wolfegg, ff.40ᵛ–41.
- Peruzzi, attrib., Paris, Louvre, 10644 (Wickhoff, 1899, pl.XXI; Frommel, 1967–8, cat.23, fig.XVIIIa): left (**158b**).

- Marcantonio Raimondi, engraving, Bartsch, XIV, p.275, no.361.
- Cesare da Sesto, c.1514, Berlin-Dahlem, Kupferstichkabinett, KdZ 5199 (Winner, 1967, cat.35, pl.17): adaptation of Trajan and Victory. Winner suggests that it is after a plaquette by Moderno (Bange, 1922, cat.498).
- North Italian, c.1520, Berlin-Dahlem, Kupferstichkabinett, KdZ 20716 (Winner, 1967, cat.34, pl.16): whole relief unrestored, Roma cut at left edge.
- 'Polidoro', Copenhagen (Gernsheim, neg. no.73.376): Roma and Trajan.
- Heemskerck, Berlin *Skb*. II, f.56ᵛ: relief *in situ* in the passage (**182f**).

ii. *East attic relief:* Battle to the sound of horn players wearing helmets made from the heads of wild animals.
- Ambrosiana Anon., Milan, Bibl. Ambrosiana, F.237 inf. no.1688 (Schmitt, 1966, cat. and fig.32ᵛ): unrestored.
- Domenico Ghirlandaio, *Judith*, c.1489, Berlin-Dahlem, Staatl. Mus. Gemäldegal., *Cat.*, 1975, no.1: detail quoted in a grisaille relief; cf.**83, 103**.
- Aspertini, Cod. Wolfegg, ff.33ᵛ–34.
- Aspertini, in Dosio, Berlin *Skb.*, f.36 (Dacos, *Hommages*, 1969).
- Raphael, Munich, SGS, 2460 (Harprath, 1977, cat.75, fig.20): central group.
- Beatrizet, engraving, 1543, for Lafréry's *Speculum*, Bartsch, XV, p.266, no.94.
- Ligorio, London, BM, 1946–7–13–640 (Gere, 1971, pl.19; Gere and Pouncey, 1983, cat.200): 'restored'.

iii. *Central passage, west:* Mounted emperor overpowering barbarian; soldiers on right hold out the severed heads of captives.
- North Italian *Skb.*, c.1450 ('Libro di Giusto'), f.1ᵛ: right.
- Giuliano da Sangallo, see **i**.
- Aspertini, Cod. Wolfegg, ff.39ᵛ–40.
- Aspertini, London, BM, 1923–21–20–2.
- 'Ripanda' skb., f.39ᵛ, Oxford, Ashmolean: left.
- Ripanda, attrib., Vienna, Albertina, 2583 (Stix and Spitzmüller, 1941, cat.17, pl.5; Oberhuber, 1966, fig.7 as Mantegna): **158c** (see **198** for verso of drawing).
- Fogolino, frieze from Ca' Impenta, Venice, Ca' d'Oro (Schweikhart, 1976, fig.12): Trajan and barbarian.
- Roman, 16th century, Windsor, 4376–77 (Popham and Wilde, 1949, cats.1145–6).
- Ligorio, London, BM, 1946–7–13–641 (Gere, 1971, pl.20; Gere and Pouncey, 1983, cat.201): 'restored'.

iv. *West attic relief, left:* Standing figures of soldiers and prisoner. *Right:* Mounted soldiers riding to left with oblong shields, pursuing barbarians.
- Aspertini, attrib., London, BM, 1905–11–10–3.

– Aspertini, Cod. Wolfegg, ff.35ᵛ–36 (Bober, 1957, fig.41).
– 'Ripanda' skb., Oxford, Ashmolean, f.47ᵛ: left.
– Marco Dente, engraving, Bartsch, XIV, p.167, no.206: reversed adaptation with an Amazon.

Other drawings:
– Polidoro, attrib., Rome, Gab. Naz. delle Stampe, FN 20099 and 20100 (Di Castro and Fox, 1983, cats. 6–7).

Series of engravings:
– Perrier, 1645, pls.23–6 **(158i–iv)**: 'restored'; reversed; and here printed again in the correct sense **(158a)**.

NOTE: Adaptations are common in Renaissance art; we may cite Ghiberti (Krautheimer, 1956, handlist no.28), Falconetto (Schweikhart, 1967–8, pp.324ff.) and Polidoro (Kultzen, 1961, p.209, fig.141).

LITERATURE: Pallottino, 1938, pp.17–56; Hamberg, 1945, pp.56ff., 168f.; Bianchi Bandinelli, 1943, pp.223ff.; Giuliano, 1955; Brilliant, 1963, pp.111f., fig.3.17 (the four segments rejoined).

159. Battles of Romans against Barbarians, Rites of Military Life

Reliefs of the Column of Trajan, completed 113 A.D.
Rome, Forum of Trajan (see **170A**)

DESCRIPTION: The epic narrative of the Emperor's Dacian campaigns unfolds on this Column, raised by Apollodorus of Damascus between twin libraries annexed to the Basilica Ulpia in Trajan's Forum. With something like 2,500 figures distributed in a spiral frieze rising 100 feet above its base, the Column's reliefs are a rich storehouse of narrative composition, of condensed formulae to represent Roman ritual, supply and transport of Trajan's army, as well as its battles against the enemy, and a veritable encyclopedia of antiquarian details of armour, weapons or implements. It is curious to note that these most Roman of Roman historical sculptures, which help to replace lost annals of the two wars between 101 and 106 A.D. written by Trajan himself, were carried out in part by Greek artisans. The chief designer and inventor of what has been termed (Hamberg) the epic-documentary mode in Roman art–created apparently from traditions of triumphal painting–has been dubbed 'Master of the Deeds of Trajan' by the Italian archaeologist, Bianchi Bandinelli (cf. Gauer,

1977; explication of Masters). Following Karl Lehmann's study of the Column (1926), scholars have concentrated upon this single monument of Roman historical art to mark a turning-point in artistic conception. Its visual conceits and abstractions devised to sustain and clarify the narrative, fed medieval didactic story-telling–one has only to think of specific conventions in the Utrecht Psalter–and continued to serve the Renaissance well. In concept, the *Colonna Traiana* not only inspired its successor in Rome, the Column of Marcus Aurelius, but a host of later copies and imitations in many different periods: the Paschal Candlestick of Abbot Bernward at Hildesheim, the Napoleonic column of the Place Vendôme in Paris and the Alexandrine Column of Leningrad, among others.

HISTORY: The bronze statue of Trajan which crowned the monument may have been a victim of the visit by Constans II in 663 that decimated the population of bronzes left in Rome after barbarian invasions; his name is carved by someone in his party at the top of the interior staircase. Depredations of late Antiquity and the early Middle Ages, which saw the painted colours fade and all the bronze accessories attached to the marble carried away, seem to have ended when the political significance of the Column was legislated in 1162; a decree of that year placed it under the protection of the Commune for the honour of the Church and the people of Rome, with death the penalty for any damage to it (see Scherer, 1955, p.105). Petrarch believed a tradition stemming from Dio Cassius that Trajan's ashes had been contained in a golden urn set into the chamber at the base of the Column. There is no other evidence for such funerary use, but the belief may have helped to foster esteem for the supposed tomb of a universally admired ancient emperor; note the legend of the Justice of Trajan and Gregory the Great's willingness to suffer if it would rescue the soul of so noble a Pagan (referred to in Canto X, 73 of Dante's *Purgatorio*). One must, however, acknowledge a false attribution to Hadrian which surfaces in some topographical literature: Dondi, Alberti, Rucellai (Valentini and Zucchetti, *CTR*, III, p.126; IV, pp.70, 73, 220 and 414 discuss possible explanations).

In the period of Paul III, the pedestal was cleared of debris and encroaching structures, including a little church of S.Nicolao de Columna. Lanciani (1902–12, II, p.63) suggests that Heemskerck's drawing of the base (*Skb.* I, f.17ᵛ) must have been made at this time, although there are drawings by

Giuliano da Sangallo, Fra Giocondo and Peruzzi before the mid 1530s. In 1544, Lafréry published a magnificent view of the entire Column, while engravings of its reliefs were first executed by Girolamo Muziano, with explanatory notes by Ciacconius (1576, Alfonso Chacon). In 1588 Sixtus V had Domenico Fontana organize a precinct wall around the base and had the present statue of St. Peter added to the summit.

REPRESENTATIONS: According to Raffaello Maffei, 'il Volaterrano' (1506), Jacopo Ripanda of Bologna was the first artist to draw the Column from top to bottom, 'circum machinis scandendo'. This adventure, comparable to Semper's 19th century descent in a basket lowered by pulley from the capital, must have taken place in the period when Ripanda was painting scenes from the Punic Wars for one of the *Sale* of the Palazzo dei Conservatori on the Capitoline, frescoes undertaken before 1503. Also Cardinal Fazio Santorio of Viterbo (1510) employed either Ripanda or Peruzzi to decorate his Roman palace with lost frescoes of Trajan's Dacian wars. However, drawings of the lower – but by no means lowermost – windings of the Column antedate Ripanda's perilous feat, indicating clarity of design and visibility from the ground owing to the graduated relief-height within each winding.

- Italian anon., dated 1467, six drawings, Chatsworth (E. Strong, 1913, pls. XXXVI–XXXVIII).
- Giuliano da Sangallo, *Cod. Barberinianus*, ff. 18–19: base.
- Giuliano da Sangallo, Siena *Skb.*, f. 19V.
- Ripanda, attrib., c. 1506: a series of 55 folios (see **159b**) in the Lib. of the Ist. di Archeologia e Storia dell'Arte, Pal. Venezia, Rome, MS. 254 is attrib. to Ripanda by Paribeni (1929; see now Pasqualitti, 1978). Mid 16th century copy of these folios is in same library, MS. 320.
- *Cod.* Escurialensis, ff. 60V–61V, 62V–63V, 64V (**159c** is f. 61V).
- Fra Giocondo, Florence, Uffizi, 484AV: part of reliefs of base, cf. J. Sansovino, Uffizi, 4337AV.
- Aspertini, Cod. Wolfegg, ff. 9V, 18V, 19 (base), 22V, 37V–8, 38V–9, 50 (Bober, 1957, pp. 30–1, 65ff.).
- Antonio da Sangallo, Florence, Uffizi, 1161E recto and verso; 1162E (Gernsheim, neg. no. 1808).
- A continuous scroll in Modena, Gall. Estense, attrib. to Giulio Romano by Macrea (1937) on the basis of literary tradition that the next to draw the Column in its entirety after Ripanda were Raphael, Giulio and Polidoro da Caravaggio.
- Aspertini, London, BM *Skb.* I, ff. 9V–10, 22V up to 35, 41V–2.
- Primaticcio, Frankfurt, Städel. Inst., inv. 584 (Malke, 1980, cat. and fig. 84): sacrifice of Trajan.

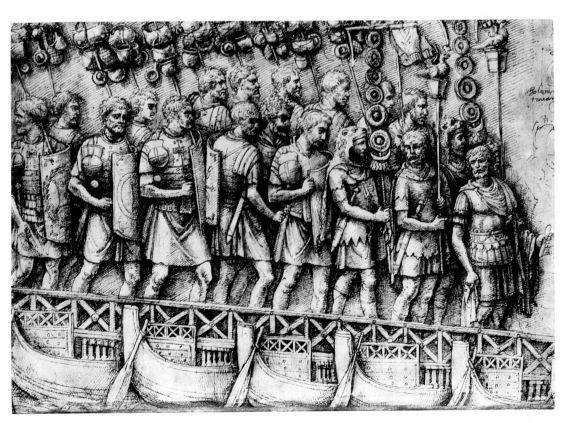

159c

– Francisco di Hollanda, *Skb.* f. 6ᵛ **(159a)**.
– Italian anon., first half of 16th century, Windsor, 0285 (Popham and Wilde, 1949, cat. 1147).
– Michelangelo School, sketch, Florence, Casa Buonarotti (Barocchi, 1964, pl. DIV, cat. 368ᵛg): head of a *signifer* (standard bearer) wearing a helmet made of the skin and muzzle of a wolf (cf. **159c**, worth mentioning because this has entered the literature as a study after an Etruscan painting of *Hades* similar to the Tomba dell'Orco at Corneto).
– Heemskerck, *Skb.* I, f. 17: base of the Column of Trajan.
– Girolamo da Carpi, Rosenbach *Album* (Canedy, 1976, R 11 and 63).
– Engravings and 17th century drawings may be pursued in Macrea, 1937.

AMONG THE MOST IMPORTANT ADAPTATIONS ARE:
– Roman, c. 1475–80, reliefs from Ciborium of Sixtus IV, Vatican, Grotte (Burger, 1907; Gombrich, 1963, pl. V,5; Pope-Hennessy, 1971, fig. 111).
– Ghirlandaio Workshop, *Resurrection of Christ*, c. 1495, Berlin (DDR), Staatl. Mus., Gemäldegalerie 75 (Warburg, 1966, fig. 118, with ref. to *Cod. Escurialensis*, f. 63; fig. 119).
– Stuccoes designed by Giulio Romano for the Pal. del Tè, Mantua, depicting the Triumph of Emperor Sigismund (Dollmayr, 1901, pp. 190ff.; Shearman, 1959).
– Franco, attrib. *grisaille* frieze, 1558?, Vicenza, Pal. Chiericati (Paribeni, 1929, p. 20, fig. 17; Sgarbi, 1980, fig. 51): three frontal soldiers corresponding to segment XIII in the Ripanda copy, *EAA, Atlante* (1973).

LITERATURE: Ross, 1938; Scherer, 1955, pp. 105–6; Ladendorf, 1953, p. 20, n. 44 (p. 86); Haftmann, 1939; Ciacconius, 1576; Lehmann-Hartleben, 1926; Bianchi Bandinelli, 1939, pp. 325ff. (in *Storicità dell'arte classica*, 1943, pp. 223ff.); Hamberg, 1945, ch. III, pp. 104ff., 162f.; Becatti, 1960; Gauer, 1977; Pasqualitti, 1978; Monti, 1980 (illus. booklet without bibl.). A new study by G. Agosti and V. Farinella on the representations of the Column of Trajan from Antiquity to Gauguin is in Settis, *Memoria*, 1984, pp. 390–421.

ROMANS AND BARBARIANS: CLEMENTIA

'But you, Roman, must remember that you have to guide the nations by your authority, for this is to be your skill, to graft tradition onto peace, to shew mercy to the conquered and to wage war until the haughty are brought low.' (*Aeneid* VI, lines 847–53, Jackson-Knight, transl.)

Such was the Roman ideal enunciated by Virgil in the time of Augustus. This ideal was embodied in visual form in the second century in reliefs which show the interaction between victorious Romans and conquered barbarians. Roman emperor and army are characterized as invincible, calm in their superiority or irresistible in their military might. The barbarians are shown as wild-haired and as pathetic; submission – voluntary or enforced – is all that is left for them.

160. General Crowned by Victory and receiving Barbarians

Roman sarcophagus, 2nd century A.D.
Vatican, Belvedere (Amelung, *Kat.*, II, pp. 98–103, no. 39; Helbig, I, cat. 239)

DESCRIPTION: The front is flanked by a pair of barbarians each sitting under a trophy, hands bound behind back and heads turned backward. They wear the leggings of the Sarmathians, defeated by Marcus Aurelius in 167 A.D. The general is seated on the right on a raised seat decorated by a sphinx on the visible corner. Behind him a semi-draped Victory holds a crown over his head with one hand, and a palm in the other. The barbarians crowd before the general, one advancing on one knee, while armed soldiers try to keep order. Apart from the restoration of the general's right hand, the front is much the same now as in the Renaissance; traces of colour, particularly on the left end, still remain. For ends, see below: Pozzo Windsor.

The motif of the seated general crowned by Victory with surrounding figures was often drawn and adapted in Raphael's circle.

INTERPRETATION: The general was thought to represent Trajan in the 16th century (Gio. Francesco Pico della Mirandola the Younger, 1512; Brummer, 1970, p. 273).

HISTORY: The date of acquisition is not known, but the statue of 'Cleopatra' **(79)** was installed in a niche of the Belvedere over the sarcophagus which was used as a fountain basin; its installation was described by Pico in 1512 (Brummer, 1970, p. 154). In the mid 16th century the statue was moved, but the sarcophagus remained in the Belvedere court.

REPRESENTATIONS:

- Francisco de Hollanda, *Skb.*, f.8^v (Brummer, 1970, fig.136): installation. Only flanking figures and trophies indicated on front (**79a**).
- Pozzo London BM I, f.137, no.154 (Vermeule, 1960, p.19): careful copy, unrestored (**160a**), of all but figures on the left; with plinth figures from Tiber (**66**) below. Italian, first half of 16th century.
- Biagio Pupini, Sotheby Sale Cat., London, 21 November, 1974, lot 14 (ill.): group around general; prisoner at right, adaptation of rest with other figures.
- Franco, Paris, Louvre, 4967: almost whole front freely drawn, cf. Franco, engraving after Giulio Romano, Bartsch, XVI, p.135, no.54: reversed, Victory flying over general, open landscape behind barbarians.
- Pozzo Windsor, I, f.6, 8150 (Vermeule, 1966, p.8; Brummer, 1970, fig.139): whole front; f.85, 8244: whole front; f.86, 8245: left end unrestored, two mules, two legionaries, shields; f.86, 8246 (Vermeule, 1966, p.14): right end, captives and weapons, late drawings, the ends with terminal barbarians from front.
- Pozzo Windsor, X, f.76, 8069 (Vermeule, 1960, p.66): whole front.
- P.S.Bartoli–Bellori, 1693, pl.29 (Brummer, 1970, fig.140): whole front reversed.

LITERATURE: E.Strong, 1926, II, pp.82, 292, pl.52; ends, figs.179 and 294. Brummer, 1970, pp.154ff. in connection with the 'Cleopatra'–Ariadne (**79**).

161. Emperor receiving Barbarian Prisoners

Antonine relief
Rome, Arch of Constantine (South façade)

DESCRIPTION: The emperor, Marcus Aurelius, with Pompeianus behind him, stands on a low dais to the left, waiting for his soldiers armed with shields and spears to bring two captives to him. A soldier in the foreground is seen in backview. In the background are *vexilla* (banners) fixed in the ground, and a tree.

REPRESENTATIONS:

- 'Pisanello', Chantilly,Mus. Condé, FR I–4^v (Schmitt, 1960, fig.82, cat.14; Fossi-Todorow, 1966, cat.171): the figures in simplified dress, no background.
- 'Ripanda' skb., Oxford, Ashmolean, f.42: whole relief 'restored' freely.
- Aspertini, copy after, in style of Cod. Wolfegg, Sotheby Sale Cat., London, 9 July, 1973, lot 1^v (ill.): man behind emperor on higher block; some of background omitted.

- *Cod.* Escurialensis, f.45: section of Arch of Constantine including this relief.
- Franco, engraving, Bartsch, XVI, p.136, no.51: reversed.
- Girolamo da Carpi, Turin *Portfolio* (Canedy, 1976, T53): 'restored', no background.
- Pozzo Windsor, I, f.31, 8188 (Vermeule, 1966, p.10 and fig.4): unrestored. Emperor headless.
- 'Pietro da Cortona' Toronto skb., unpaginated: 'restored'.
- Perrier, 1645, pl.28: reversed, 'restored'; and reversed again in **182d**).

LITERATURE: Ryberg, 1967, pp.56–61, no.5, fig.40.

162. Submission of Barbarian Chief before Enthroned Emperor

Antonine relief
Rome, Arch of Constantine (North façade)

DESCRIPTION: A barbarian chief, hardly able to stand, offers his submission to the emperor seated high above him reading a scroll. The soldiers, not without sympathy, surround the tragic figure and his son. In the Renaissance, the worn figure of Victory over the *vexillum* (banner) was drawn as an eagle or a helmet. The head of the emperor was missing (Pozzo) and a replacement was carved in the 18th century.

REPRESENTATIONS:

- Ghiberti, *St. John the Baptist before Herod*, bronze relief, Siena, Baptistry, Font: free adaptation (Krautheimer, 1956, II, pl.72, p.343, Handlist 22 as conflation with **161**).
- Zoan Andrea, engraving (Hind, 1948, VI, pl.578, 6; Bartsch, XIII, p.296, no.2): reversed adaptation as *Christ before Pilate* (**162a**).
- 'Ripanda' skb., Oxford, Ashmolean, f.41: 'restored'.
- Aspertini, copy after style of Cod. Wolfegg, c.1503, Sotheby Sale Cat., London, 9 July, 1973, lot 2 (ill.): free interpretation. Eagle above banner. Prisoner lifted off ground. Five instead of eight figures before emperor.
- 'Bambaia' Berlin *Skb.*, f.11^v (Dreyer and Winner, 1964, fig.40): five figures before emperor. No standards or headgear.
- Franco, engraving, Bartsch, XVI, p.135, no.48: reversed. Free play with standards. Helmet over banner.
- Pozzo Windsor, I, f.37, 8194 (Vermeule, 1966, p.10): unrestored. Emperor without head and right arm.
- Perrier, 1645, pl.29: reversed, 'restored'. Eagle over banner (**182d**).

LITERATURE: Ryberg, 1967, pp.61–6, no.6.

163. The Clemency of Marcus Aurelius to Barbarians

One of three reliefs from lost arch (others: **167, 191**)

Rome, Palazzo dei Conservatori (Stuart Jones, 1926, pp. 27–9, Scala II, no. 10)

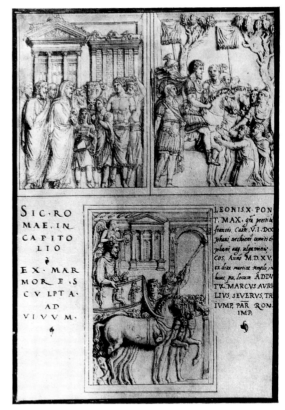

163b

DESCRIPTION: Two defeated barbarians throw themselves on their knees to submit to the emperor, who approaches them on his horse. Beside him rides his companion Pompeianus, and they are accompanied by foot soldiers, two of whom carry *vexilla*. In the Renaissance the emperor and his horse had no right legs; the emperor was armless and the horse headless, Projecting arms of the figures in the foreground were also missing.

HISTORY: The three reliefs have been thought to have originally decorated an arch, later destroyed, commemorating Marcus Aurelius and his friend and son-in-law, Pompeianus, who appears in every relief. In the 15th century the reliefs were visible in the church of S. Martina, previously the *secretarium senatus*, in the Roman Forum. The reliefs were brought to the Campidoglio in 1515, according to the wish of Leo X, and were placed in the courtyard of the Palazzo dei Conservatori (Fichard, 1536, p. 28), and in their present place on the staircase landing in 1572 (Stuart Jones, 1926, p. 371; Winner, 1969, cat. 12, pl. 7). Bescapè was contracted to restore the three reliefs in 1595.

In 1573, a fourth relief was installed with the three Antonine ones on the staircase landing. It came from another arch which had been destroyed before 1527 (Fulvio, 1527, III, f. L^v), and according to Castagnoli (1942, pp. 74–82), represented the Adventus of Hadrian in 134 A.D. in a commemorative arch erected by Antoninus Pius. The missing head was restored as Marcus Aurelius probably in 1595 when Bescapè restored all four reliefs. In the late 19th century it was again restored with a head of Hadrian (Stuart Jones, 1926, p. 29, Scala II, no. 12, pl. 12).

REPRESENTATIONS:
- Ambrosiana Anon., Milan, Bibl. Ambr., F. 237, inf. 1689 (Schmitt, 1960, fig. 106, cat. 17): six foreground figures only, no background, unrestored.
- Giuliano da Sangallo, *Cod.* Barberinianus, f. 60: 'ASANTA.MARTI.NELA.AROMA'. 'Restored', with emperor's hand opened towards himself **(163a)**.

- 'Ripanda' skb., Oxford, Ashmolean, f. 48: 'restored'. Emperor points at kneeling barbarians.
- Roman, early 16th century engraver (Hind, 1948, VII, pl. 895, cat. 20): adaptation, 'restored'.
- Polidoro da Caravaggio, attrib., New York, MMA, Lehmann Collection (Szabo, 1979, cat. 15B): figures only, 'restored'.
- Francisco de Hollanda, *Skb.*, f. 25^v: unrestored with the two other reliefs and inscriptions **(163b)**.
- Cod. Pighianus, f. 108, 2 (Jahn, 1868, 41): 'In Capitolio'. Complete relief, unrestored in frame.
- Cod. Ursinianus, Vat. Lat. 3439, f. 73 (Stuart Jones, 1926, fig. 2): unrestored.
- Pozzo Windsor, II, f. 1, 8256 (Vermeule, 1956, fig. 10; 1966, p. 14): restored.
- Perrier, 1645, pl. 43: reversed, restored; cf. P. Santi Bartoli-Bellori, 1693, pl. 7 in correct sense.

LITERATURE: Michaelis, 1891, *RM*, VI, pp. 24–5; Ryberg, 1967, pp. 9–15; Gordon, 1980; Bober, 1957, p. 73; Haskell and Penny, 1981, cat. 56. For Italian 17th century drawings of the three reliefs restored (Boston, MFA, Dept. of Classical Art, Rowland Bequest, 1974:

166–8), see also Sheard, 1979, cats. 27–9, with a discussion of the other drawings and bibl.

164. Victory with Trophies and Barbarians

Pedestal from lost Arch of Diocletian?
Florence, entrance of Boboli Gardens (Dütschke, II, cat. 68)

DESCRIPTION: The Victory stands on the left, her palm branch and wings flattened to the moulding of the relief. Next to her a small captive barbarian crouches on one knee, with the trophies standing behind him. The relief is on the front of the right-hand pedestal of a pair flanking the entrance to the Boboli drive beyond the Palazzo Pitti's north flank. Both pedestals are similarly decorated with a Victory on the front, one of the Dioscuri with horse, and barbarians on the sides, each with variations. Kähler (1936) considers them to have belonged to the lost Arch of Diocletian; Sieveking (1937, pp. 74–82) is of the opinion that the Victory on the left base is a copy executed between 1584 and 1788.

Victories with kneeling barbarians also appear on the pedestals of the Arch of Constantine (170B)

HISTORY: The Arch of Diocletian was destroyed in 1491 when the church of S. Maria in Via Lata was rebuilt (Infessura–Tomassini, 1890, p. 268). Fulvio, writing in 1527, reported that 'recently', near S. Maria in Via Lata 'we have seen excavated certain marbles with barbarian trophies' (1527, IV, p. Lv; 1588, p. 115). The Dioscuri and Victory reliefs on the bases of two statues of barbarians in the della Valle-Capranica courtyard were described by Aldrovandi (1556, p. 220): 'each barbarian has an antique base with sculpture on one side of one who holds a horse with his hand; on the other a winged victory with a trophy'. Sold to the Medici in 1584, they remained in the Villa Medici in Rome until they were brought to Florence in the 18th century. The bases still support the two porphyry barbarian prisoners.

REPRESENTATIONS:
– Although the reliefs were not visible in Heemskerck's lost drawing of the della Valle courtyard engraved by Cock, they are discussed by Hülsen (1913–16, II, pl. 126, pp. 58f., cats. 13–14; and Michaelis, 1891, *JdI*, (II), nos. 28–9).

LITERATURE: Kähler, 1936. Work in progress by Brilliant.

165 A–B. Two Barbarian Captives

A pair of Trajanic statues
Naples, Museo Nazionale, inv. 6122, 6116 (Ruesch, 1911, cats. 76–7)

DESCRIPTION: Many statues of captive Dacians decorated the Forum of Trajan; eight of them are on the Arch of Constantine (182). The pair in Naples are typical of the sympathetic Trajanic characterizations of noble Dacians. The barbarians have thick long hair and beards, and wear ample tunics, cloaks, and long trousers. Their caps with peaks folded forward were marks of distinction worn only by leaders.

In describing the Persian Porch, Vitruvius (I, 1, 6) writes that the effigies of the prisoners, dressed as barbarians, held up the roof, which started a tradition of statues of Persians supporting entablatures. Woodcuts of such statues illustrate this passage in some 16th century editions of Vitruvius (see below, REPRESENTATIONS: Giuseppe della Porta, and Haskell and Penny, 1981, p. 170).

Statue A stands on the left leg; the right forearm crosses the stomach to support the left elbow. Statue B's hands are crossed. Their left hands, missing in some of the 16th century representations, were restored in the 18th century.

HISTORY: In connection with Vitruvius' reference to the Spartan's Persian Porch, Fulvio (1527, IV, p. 69v) describes the pair of statues of barbarians holding up the roof of the *loggia* of the old house of the Colonna in Piazza SS. Apostoli at the foot of Monte Cavallo, just as seen in the drawing in Düsseldorf after Heemskerck (165a). The house dates from the late 15th century when it was rebuilt after the earlier house belonging to Prospero Colonna was burned in 1484 (see Albertini in Valentini and Zucchetti, *CTR*, IV, p. 518). The statues were still reported by Philander to be in the Colonna façade at the time of his visit to Rome in 1539–40 (Haskell and Penny, 1981, p. 169), but when Pope Paul III Farnese took over the possessions of Ascanio Colonna, the statues were probably moved to the still unfinished Palazzo Farnese in c. 1540–2 (Lanciani, 1902–12, II, p. 170). There Aldrovandi saw them in 1550 (1556, p. 152) and there they were drawn by Franco and by Dosio (see below; Dosio noted that they were in the 'Palace of the Cardinal of Sant'Angelo', Ranuccio Farnese, who had that title from 1546–65, Eubel 1910, III, p. 33). Flaminio Vacca (1594, no. 44) reported that they were at the top of the staircase in the Palazzo Farnese. They

were sent to Naples in 1790 after three years in the Roman studio of the restorer Albacini (Haskell and Penny, 1981, p.170; de Franciscis, 1946, p.98: '*nel 1787 ricevuto due figure di due Schiavi Frigi, doppo ristaorati spediti in Napoli nell 1790*').

REPRESENTATIONS:
- North Italian, before 1540, London, private collection (Baroni, 1981, cat.26, ill.) **A** and **B** 'restored', seen from below left on bases as in Colonna façade.
- Heemskerck, copy after, Düsseldorf, Kunstmus., F.P.5004 (Schaar and Graf. 1969, fig.100, cat.133): **A** and **B** *in situ* in the Colonna façade on Piazza SS. Apostoli with Monte Cavallo rising behind (**165a**; also illus. in Hülsen, 1927, pl.15; Egger, 1911–31, II, pl.86; Netto-Bol, 1976, fig.31. A later 16th century view, Egger, *ibid.*, pl.87, shows the façade with the statues removed and replaced by piers; this drawing is now in New York, MMA, Rogers Fund 1959, 59.73).
- Franco, Paris, Louvre, 4968: **A** and **B** on sheet with Hercules Farnese.
- Giuseppe della Porta Salviati, after Palladio, woodcut ill. for Vitruvius, *De Architectura*, ed. Daniele Barbaro, Venice, 1556, I: the pair stand in place of engaged column in an arch, **B** on left.
- Dosio, Berlin *Skb.*, f.50ᵛ: *Nel palazzo del cardinale S.Agniolo*' (Farnese); **B** 'restored'.

- Italian, 16th century, Florence, Bibl. Maruc., vol. CIV (Giuliano, 1979, figs.5 and 7): '*Romae in palatio S.Agneli…*'.
- 'Maarten de Vos' *Skb.*, f.Vᵛ (Netto-Bol, 1976, p.36, no.13 and ill.): **A** without left hand.
- 'Peruzzi' Siena *Skb.*, f.2ᵛ: **A** and **B**, hands sketchily 'restored'.
- Cavalieri, I–II, pl.30: **A**. '*Parthorum Rex captivus*'. Left hand missing; pl.31: **B**. '*Rex Armeniae captivus*'. Left hand missing and top of cap.
- Italian, 16th century, bronze statuette, Florence, Mus. Naz., inv.431: **B** 'restored'.

LITERATURE: Netto-Bol, 1976, p.36, no.13 with list of other representations; Haskell and Penny, 1981, cat.17: 'Farnese Captives', with reference to other statues of captives known in the Renaissance (among them, those referred to in **164** and **182**).

166. 'Thusnelda'
Trajanic female barbarian prisoner
Florence, Loggia dei Lanzi (Dütschke, III, cat.560)

DESCRIPTION: Thusnelda was the wife of Arminius, one of the most formidable German rebels against the power of Rome in the 1st century A.D. (Tacitus, *Annals* II, 88). When she was captured by

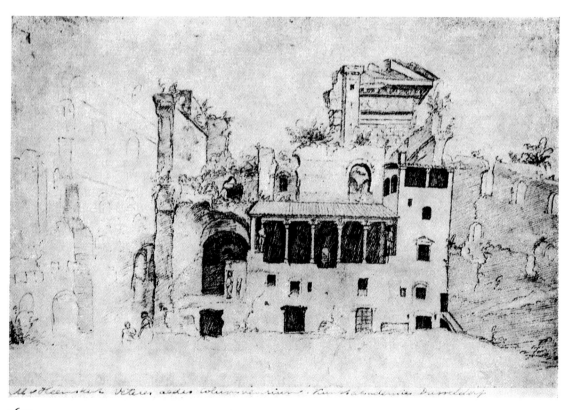

165a

the Romans, Thusnelda gave no hint of submission, but instead displayed an indomitable spirit (Tacitus, *Annals* I, 57).

Once the name Thusnelda was suggested, after the Renaissance, for the powerful figure of a barbarian prisoner, it seemed to fit so well that it became difficult to detach it, even when the statue was recognized to have been made in the reign of Trajan, about a century after the time of Thusnelda.

The expressive enclosed pose is based on 4th century B.C. Greek types of mourning women; the arrangement of the arms, one crossed over the waist to support the other elbow, is similar to that of Iphigenia (105), and a mourning sister of Meleager (116), but unlike these figures, 'Thusnelda' crosses the left leg in front of the right, and her arms and left breast are bare.

INTERPRETATIONS: Unlike the other 'Sabine Women' *(Sabine)*, as the five draped over life-size figures from the same provenance were called, 'Thusnelda' clearly belongs to another category than that of her companions who are thought to represent matrons, or vestal priestesses; but in the 16th century, she was also called a Sabine woman, and as such appears in the della Valle Capranica inventory of 1584. According to this inventory, all six 'Sabine' lacked arms (*Documenti inediti* IV, p. 377).

HISTORY: First recorded in the della Valle courtyard with the five other 'Sabine' (Cock engraving). As the sculpture court was installed in the 1520s, the statues may have been known earlier. The head was already restored when the statue was drawn in the niche (Cock's engraving after Heemskerck); Vico shows the head, with a break in the neck, but half covered in drapery, like some of the other 'Sabine', and right arm still unrestored. In 1584, Ferdinando de' Medici bought the six female figures for the Villa Medici, where they were fully restored and placed between the columns of the arcade. They were sent to Florence in 1787 and installed in the Loggia dei Lanzi in 1789.

REPRESENTATIONS:
- Cock, engraving after Heemskerck's lost drawing: head restored, in first niche on left, below (Hülsen and Egger, 1913–16, II, pl. 128; pp. 58f., no. 78; Michaelis, 1891, *JdI* (II), no. 77, fig. 10).
- E. Vico, engraving, 1541, Bartsch, XV, p. 302, no. 42: 'ROME. IN EDE. CAR. DE. VALLE.' With draped head, but otherwise unrestored; engraved with one of the 'Sabine' (Capecchi, 1975, cat. 6).

- Cavalieri, I–II, pl. 80: III–IV, pl. 83: '*Sabinae statua marmorea in aedibus Capranicae*'. Arm unrestored.
- Franzini, 1596, unnumbered: 'STA.PORFIRITEA. IN.HORT.CAR.MEDIC.' Reversed, both head and arm restored.
- Anon. Italian, 17th century, Florence, Uffizi, 14847F.
- Perrier, 1638, pl. 76: reversed. '*Veturia Martii Coriolani Mater in Hortis Mediceis.*'
- Pierre Legros, the Younger, life-size marble copy of statue, Paris, Jardin des Tuileries: adaptation.

LITERATURE: Capecchi, 1975, p. 172, cat. 3 and pp. 169–178, for types, history, documents, drawings, ills. and bibl. of the six 'Sabine'.

167. Triumph of Marcus Aurelius
One of three reliefs from lost Arch of
Marcus Aurelius (163, 191)
Rome, Palazzo dei Conservatori (Stuart Jones, 1926, pp. 25–6, Scala II, no. 7)

DESCRIPTION: On the tall, narrow panel representing the triumph of Marcus Aurelius, the number of participants in the procession is reduced to a bare minimum. The emperor in his triumphal chariot is shown about to pass through the Porta Triumphalis. A trumpeter precedes the horses and is followed by a lictor. A small Victory hovers above the emperor; she originally held a garland over his head. The awkward empty space to the right of Marcus Aurelius in the chariot testifies to the erasure of the figure of his son, Commodus, who had been shown accompanying his father. Commodus was condemned to a *damnatio memoriae* and so his image was chiselled off and the lower part of the temple in the background clumsily carved to fill the gap.

The side of the chariot is carved with two tiers of reliefs. Above are figures of Neptune with trident, the goddess Roma seated, and Minerva; below: a pair of Victories supporting a shield, the top part only is visible. The spokes of the wheels are the clubs of Hercules; the hub cap is a lion's head.

HISTORY: See 163.

REPRESENTATIONS:
- Aspertini, Cod. Wolfegg, f. 50V: 'restored' and freely interpreted.
- 'Ripanda' skb., Oxford, Ashmolean, f. 48V: 'restored'.
- Italian, 16th century, (Peruzzi, follower: B. Pupini?), Bayonne, Mus. Bonnat, inv. 708 (Bean, 1960,

cat. 249): 'restored' view of fortifications and acque-
duct on hillside seen through arch.
- Francisco de Hollanda, *Skb.*, f. 25V **(163b)**.
- Franco, Paris, Louvre, 4953: 'restored'.
- Dosio, Berlin *Skb.*, f. 43: unrestored.
- Beatrizet, engraving, 1560, for Lafréry's *Speculum*, Bartsch, XV, p. 264, no. 88: 'restored' with Victory's palm and crown; cf. Duchetti, engraving, 1583, for *Speculum* (Hülsen, 1921, cat. 49e).
- 'Pietro da Cortona' Toronto skb., unpaginated: restored, but without Victory's palm and crown.
- Perrier, 1645, pl. 44: restored, reversed.
- P. Santi Bartoli–Bellori, 1693, pl. 8: restored.

LITERATURE: Ryberg, 1967, pp. 15–20; Sheard, 1979, cat. 28; Haskell and Penny, 1981, cat. 56.

168. 'Gemma Augustea'.
Tiberius Triumphant with Roma and Augustus

Graeco-Roman sardonyx cameo (19 cm. high, 23 cm. wide, 2.5 cm. thick)
Vienna, Kunsthistorisches Museum, Antiken-sammlungen, IXa 79 (Eichler and Kris, 1927, cat. 7)

DESCRIPTION: Hellenistic art and Roman tri-umphal reliefs and paintings were rich in images of deified rulers, triumphing generals, trophies erected by victors, and barbarians crushed by de-feat.

A variety of triumphal imagery is combined within the small compass of a cameo exquisitely carved in two tiers, corresponding to the social order of the figures. Above a youth (Tiberius?), wreathed with laurel, descends from a triumphal chariot, while Victory herself holds the reins. A young man in a cuirass stands next to Roma enthroned with the emperor (Augustus?) who, like Jupiter, has an eagle under his throne; both seated figures hold spears and rest their feet on a shield. Capricorn, Augustus' birth sign, appears in a tondo. Three personifications are behind the throne to the right: a woman, thought to re-present the civilized world, is about to place a wreath on the emperor's head; the bearded man is thought to be the personification of the seas, and the seated woman, Tellus (Earth) with the cornu-copia and two children, to represent Fertility. Below, soldiers labour to raise a trophy on a pole while a defeated barbarian couple sit helplessly in the foreground on the left, and another pair of barbarians are humbled on the right.

Filarete, the Milanese sculptor and architect,

wrote in his *Treatise on Architecture*, finished in 1464, that he had had a cast made from the gem which was in the sacristy of the principal church in Tou-louse, and described it as somewhat broken and as large as one third of a *braccio* in each direction; he thought it, for its size and the mastery of the carving, the thing of the greatest worth he had ever seen.

> 'There are about twenty-four figures of every kind, of every quality: figures of men, of women, old and young, and children, arms, horses, figures sitting, standing, and in various acts and movements. There was a trophy where were certain prisoners and captive women which were certainly worth a treasure for the admirable mastery of those figures.' (*Filarete*–Finoli and Grassi, 1972, II, pp. 680–1.)

HISTORY: Filarete thought that the gem had be-longed to the Duke of Berry, but it had been in St. Sernin in Toulouse at least since 1246 when it was first recorded there. It was acquired by Fran-cis I in 1533, and remained in Fontainebleau (in-ventory of 1569). In 1591 it was stolen from the King of France, and several years later was bought in Venice for 12,000 ducats by Emperor Rudolf II, who died in 1612. It has been recorded in Vienna since 1619. It was known in Italy in the Renaissance through casts; one was in the collection of Paul II, who had unsuccessfully tried to buy the cameo from the monks of St. Sernin in exchange for building a bridge in Toulouse (Müntz II, 1878–82, p. 133).

REPRESENTATIONS:
- According to Peiresc, the French antiquarian who owned it, Niccolò dell'Abate painted a large scale grisaille copy which seems to be lost, and was com-pared most unfavourably with Rubens' copy (for texts and literature see Norris, 1948, pp. 179–88).
- For engraving after Rubens' copy, see van der Meulen-Schregardus (1975, cat. 82, pp. 157–61).

LITERATURE: Eichler and Kris, 1927, pp. 9, 52–6; A. Rubens–Kähler, 1968: a treatise on the gem was edited by Rubens' son and first published in 1665. For recent interpretations, dating and bibl., see Bastet, 1979.

PERSONIFICATION OF VICTORY (NIKE)

From the time of Hesiod (7th century B.C.) onwards, Greek thought and imagination was rich in abstractions and personifications. The

figure of Victory (Nike) was one of the earliest of these.

Before the end of the 6th century B.C., Victory had already been represented in sculpture: a winged female figure wearing a long robe. From then on she appeared in countless works of painting and sculpture, either winging her way swiftly towards a victor or standing quietly beside one. She was portrayed alone holding a palm, wreath or *patera* or was shown crowning a victor or pouring a libation for him, or sometimes acting as his charioteer.

Originally a single deity, Victory had proliferated by the end of the 5th century B.C. Many Victories are assembled together in the memorable images carved on the Nike parapet in Athens in the late 5th century B.C., decking trophies or bringing bulls to sacrifice (cf. **171, 179**).

Victory could also serve as an attribute not only of victors (athletic or military) but also of gods, as in Phidias' famous chryselephantine statues of Athena in Athens (Pausanias, I, xxiv, 7) and Zeus at Olympia (Pausanias, V, xi, 1).

The Romans eagerly adopted Greek types of Victory and sometimes created new ones. Occasionally an older image of another goddess would be turned into a Victory by means of the addition of wings and suitable drapery. Thus the famous type of Victory writing on a shield used on the Column of Trajan and the Arch of Constantine (**170**) is really just a transformation of the 4th century B.C. original of the Venus of Capua (cf. **13**).

The Romans associated Victory with triumphs and thus her image was usually carved on triumphal arches. She also came to be closely related to the emperor and so often appears with him either as an attendant or an attribute. She held a similar relationship to Roman generals (**160**).

Figures of Victory were frequently carved on sarcophagi; these may have been important for the ideological transformation of the pagan Victory into the Christian angel; formally, the types are identical.

LITERATURE: Hölscher, 1967.

169. Sacrifice with a Victory
Fragment of a Trajanic? relief
Paris, Louvre (MA 392)

DESCRIPTION: The much damaged relief is probably a fragment of a triumphal sacrifice (head of dead or stunned bull on right). The four figures are thought to represent Abundantia (Fortuna?, cf. **196**, Tyche, on left), Roma (headless), a faceless man in a toga, and a headless winged Victory in windblown long *chiton* who is sacrificing the bull.

HISTORY: In the Grifonetti Collection at the foot of the Quirinal, c. 1500 (*Cod.* Escurialensis). Its subsequent history before entering the Borghese Collection is unknown.

REPRESENTATIONS:
- *Cod.* Escurialensis, f. 48ᵛ: '*messer grifonetto*'. Figure of Abundance with cornucopia. Restored head, unrestored right arm (**169a**). The figure was thought to have been copied from a statue until McCann-Taggert recognized it as part of this relief (oral communication to Bober for the Census).
- Genoese sculptor, c. 1509, relief in courtyard, Spain, La Calahorra: copied after *Cod.* Escurialensis, f. 48ᵛ. Abundantia 'restored' (noted by A. Nesselrath).

LITERATURE: Ryberg, 1955, p. 156, fig. 85.

170. Victory writing on a Shield
(example of the type)
A. Relief on the Column of Trajan
B. Relief on a pedestal of the Arch of Constantine

DESCRIPTION: **A.** The personification of Victory stands with a foot on a helmet and writes on a shield supported on a pedestal. The winged figure is flanked by anthropomorphic trophies. Variants of this type were also known in the Renaissance from Roman coins.

B. The Victory writing on a shield supported by a crouching barbarian could be seen on two of the eight bases of the Arch of Constantine. The reliefs, on the front of the pedestals, were of cruder workmanship, but were more accessible than the relief on the Column of Trajan which was very high on the column.

Without the wings, the pose, figure type, and drapery of both examples depend on that of the

Venus of Capua (cf. **13**, with other examples known in the Renaissance). The similar winged bronze Victory of Brescia in the Louvre was discovered later.

HISTORY: **A**–see **159**; **B**–see **182**. The bases are visible c. 1500 in the *Cod. Escurialensis*, f. 28ᵛ, but were probably uncovered before.

REPRESENTATIONS:
A
– Paduan artist, c. 1470–80s, Paris, BN, MS, lat. 5814, f. 1, frontispiece to Suetonius' *Life of Caesar* (Alexander, 1977, colour pl. 13): adaptation. Two Victories facing each other in profile each with a foot on a helmet, write on shields supported by the letter A. The flanking trophies with other antiquities are in the borders.
– Mid 16th century copy of drawings, c. 1506, attrib. to Ripanda, of the Column of Trajan, Rome, Pal. Venezia, Bibl. del' Ist. di Archeologia e Storia dell'Arte, MS320 (*EAA*, *Atalante*, 1973, pl. 94, scene LXXVIII).
– *Cod. Escurialensis*, f. 31: Victory (**170a**) combined with a figure of the Venus of Capua type (**13**).
– P. Santi Bartoli in Ciacconius, [1673], pl. 58 (**170A**).
B
– Lambert Lombard, Album, D 220–21.
– Pozzo Windsor, I, f. 29, 8186 (Vermeule, 1966, p. 10): cf. second base on left of north side of arch; hands 'restored', late drawing.

LITERATURE: For literature on Column of Trajan, see **159**. For ills. of the Arch of Constantine bases, see L'Orange and von Gerkan, 1939, pls. 29b, 30b.

171. Victories sacrificing a Bull at a Thymiaterion

Relief from Trajan's Forum, Basilica Ulpia, 2nd century A.D.
Munich, Glyptothek (inv. 206)

DESCRIPTION: A much-restored section of a frieze, 0.78 m in height and 8.65 m in length; the outermost figure at right and both Victories at far left are modern, together with most of the next Victory with the bull, and most heads and the arms in the foreground plane. Two Victories, fully clothed, kneel at centre to crown a censer *(thymiaterion)* and sprinkle incense in its fire; at either side a semi-draped Victory crouches over a recumbent bull as she draws back its head to slit the throat. Each is then separated by a candelabrum from repetitions of the group. The motif of the sacrifice of the bull has a long ancestry in Greek art. These particular slender and half-nude types, however, were taken to represent 'winged Mithras' as late as the 18th century (Montfaucon, 1722, I, p. 384, pl. CCXIX). A favoured Roman theme – the Victories crouched over their victim – appeared on other monuments accessible to the Renaissance, including gems and both faces of the piers of the Arch of Trajan at Benevento (**179**), for example.

HISTORY: From the early 16th century at least, the relief was in the Palazzo della Valle, later in the Bufalo Collection, where it was still visible in the 18th century until Cardinal Fesch acquired it for his *Hôtel* in Paris; sold to Ludwig of Bavaria in 1816.

REPRESENTATIONS:
– Heemskerck, *Skb.*, I, f. 44 (Hülsen, emending Michaelis, 1891, *JdI*, (II), p. 237, n. 177 where it was attrib. to the oldest della Valle house owned by Lello).
– Aspertini, London, BM *Skb.* II, f. 2, above (Bober, 1957. p. 78, fig. 108).
– Girolamo da Carpi, Rosenbach *Album* (Canedy, 1976, R131).
– Franco, Budapest, Mus. of Fine Arts, inv. 3, 37 (noted by R. Palma; Schönbrunner and Meder, 1896–1908, VIII, pl. 956).
– Cambridge *Skb.*, MS R. 17. 3, f. 87ᵛ (Dhanens, 1963, cat. 70b, fig. 21): 'right aginst laval' (**171a**).

LITERATURE: Furtwängler, 1900, *Beschreibung*, cat. 348; cf. Louvre relief, Reinach, *Rép. Stat.*, I, p. 113. Goethert, 1936. On the type, see Kunisch, 1964.

172. Victory as Charioteer

Sardonyx cameo. Graeco-Roman, 1st century B.C.
Naples, Museo Nazionale (inv. 25844)
(example of the type)

DESCRIPTION: The cameo is signed by the Augustan master, Sostratos, Mark Antony's favourite gem-cutter. A winged Victory (Nike) drives a *biga* with reins close-checked in order to control a pair of spirited horses; the composition is thought to derive ultimately from Phidias. This is taken as an allegory of the soul, illustrating Plato's metaphor (in the *Phaedrus*) of the soul as winged horses, one docile and one difficult to control by the charioteer; in any case, the neo-Platonist implications for the Renaissance are made plain by a late 15th century bronze portrait bust attributed to Donatello (**172a**) in the Bargello which represents a young 'Phaedrus' wearing a vastly enlarged version of

such a cameo about his neck like an amulet, but with a nude Amor as charioteer (see LITERATURE, Wittkower).

HISTORY: In the collection of Lorenzo de' Medici and bearing his inscribed owner's mark; appears in the inventory of 1492. Apparently acquired in 1471 from the estate of Pope Paul II, who as Cardinal Barbo formed his impressive collection of bronze statuettes and gems; his inventory of 1457 lists: '*triumphus videlicet sunt duo equi cum curru et iuvenis allatus super curru et desuper sunt littere parvisime grece*'. But as this interprets the winged charioteer not as a Victory but as a winged youth, it may refer to another gem, now lost, which could have been the prototype of our representations.

REPRESENTATIONS:
– Florentine, 15th century, bronze plaquette after Donatello's adaptation? or cast from a lost Medici gem (Pope-Hennessy, 1965, cat.249, fig.39).
– A.Rossellino, Tomb of the Cardinal of Portugal, Florence, S.Miniato (Hartt *et al.*, 1964, pl.85): relief on the socle reproduces the motif; again with the charioteer as a nude Amor (see *Literature*, Chastel).

LITERATURE: Furtwängler, 1900, *Ant. Gemmen*, pl.LVII, 5; Pesce, 1935, p.85, no.16, pl.II; Dacos *et al.*, 1973, I, cat.7 (for Victory gem), p.143, p.162, *scheda* 16 (for lost Amor gem); Wittkower, 1937–8, pp.260f.; Chastel, 1950.

TROPHIES

In classical times, after the conclusion of a battle, the victors would erect a trophy of arms, a dedication of part of the spoils to a god. Trophies could take one of two forms: captured arms could either be assembled anthropomorphically or piled up in a glorious heap. In the anthropomorphic type a panoply would be hung up on a pole or a tree with the helmet at the top to create something rather like an armed scarecrow.

The Greeks were the first to give artistic form to trophies and to employ sculptured representations of them in either decorative or symbolic contexts starting in the 5th century B.C. The Romans, subsequently, made wide use of the theme. The motif of the Trophy was very flexible and could be

simplified or elaborated as required. Figures of Victory (**164, 170A**) were often associated with trophies, and barbarian prisoners could be brutally attached to them (as on the Gemma Augustea, **168**, and **170B, 174B**).

Among the most magnificent examples of sculptured trophies in the anthropomorphic tradition are the so-called 'Trophies of Marius', a pair erected for Domitian (**174**), while the tradition of rendering a pile of arms in relief is beautifully exemplified in a pair of carved pillars in Florence (**175**).

LITERATURE: G.C.Picard, 1957.

OTHER EXAMPLES OF TROPHY RELIEFS KNOWN IN THE RENAISSANCE (in addition to those catalogued):
– Pola, Porta Aurea (Reinach, *Rép. Rel.*,I, p.226).
– Outside Rome, Via Flaminia, flanking archway on 'Arco di Malborghetto', a destroyed *quadrifrons* (*Cod. Escurialensis*, f.18; Giuliano da Sangallo, *Cod. Barberinianus*, f.36ᵛ).
– The splendid trophy reliefs on the base of the Column of Trajan (**159**) were drawn by Giuliano da Sangallo, and Heemskerck, among other artists, q.v.
– Trophies in paintings in the Domus Aurea were copied in the *Cod. Escurialensis* (Netto-Bol, 1976, p.33).
– Trophies were also known from coin reverses, and from front pilaster reliefs of the Arch of the Argentarii (**180**), among other sources.

173. Trophies from the Temple of Jerusalem
Passage relief on the Arch of Titus, c.81 A.D. Rome (see **178**)

DESCRIPTION: After the conquest and destruction of Jerusalem in 70 A.D., Titus celebrated his victory over the Jews with a magnificent triumph in Rome. Josephus, the Jewish historian, wrote the *Jewish War* between 75 and 79 A.D., and was with Titus in Jerusalem and later in Rome. He witnessed the triumph and described it. (The arch had not yet been built.)

'The most interesting of all were the spoils seized from the temple of Jerusalem: a gold table weighing many talents, and a lampstand also made of gold, which was made in a form different from that which we usually employ. For there was a central shaft fastened to the base;

then spandrels extended from this in an arrangement which rather resembled the shape of a trident, and on the end of each of these spandrels a lamp was forged. There were seven of these, emphasizing the honour accorded to the number seven among the Jews.' (Josephus, *Jewish War* VII, v, 148–9, in Pollitt, 1966, p. 159.)

Flavio Biondo, writing in the late 1450s, compared the vividness of the first relief with Josephus' report: '... the gold candelabrum ... one sees carved in this arch much better than it was described by Josephus' (*Roma triumphans* X).

On the left of the passage, approaching the Forum, the relief shows the procession as if headed towards the Campidoglio along the Via Sacra, and about to pass under an arch on the right of the relief. On top of this arch a man stands between two *quadrigae*. Two victorious soldiers carry the seven-branched candlestick, the crossed silver trumpets, and the golden table of the shewbread all looted from the Temple of Jerusalem.

INTERPRETATION: In the Middle Ages and later, the table was thought to be associated with Moses (Biondo; Dosio).

HISTORY: See **178**. Jordan–Hülsen (1907, I, 3, p. 17) quote sources which indicate that the reliefs in the passage were obscured by constructions in the 15th century and were newly revealed by Pope Sixtus IV by 1489, while Biondo's remarks above show

that the candelabrum (trophy) relief, or at least the upper part of it, was in fact visible in the 1450s.

REPRESENTATIONS:
– Giuliano da Sangallo, *Cod*. Barberinianus, f.60: 'QUESTE.DUA. ISTORIE. SONO. NELA(R)CO. DITITO. A ROMA' (but only the trophy relief is drawn). Spirited procession, restored, and embellished with grottesque ornament (**173b**).
– Aspertini, *Cod*. Wolfegg, f.48[v], above: 'restored' with two frontal draped women replacing missing soldiers.
– 'Ripanda' skb., Oxford, Ashmolean, ff.53[v]–4: 'restored'.
– Bandinelli, manner of, Windsor, 8184 (Blunt, 1971, cat.26): both passage reliefs (see **178**).
– Dosio, Berlin *Skb.*, f.41: whole relief, unrestored. Drawing not by Dosio (**173a**).
– Naldini, c.1560, Oxford, Christ Church, 0839 (Byam Shaw, 1976, cat.202, pl.123): whole relief unrestored.
– Pozzo Windsor, I, f.27, 8184 (Vermeule, 1966, p.9): both reliefs unrestored; Italian, mid 16th century.
– Perrier, 1645, pl.1: 'restored', reversed.
– Carlo Maratta, attrib., 1645, London, H.Bier Collection (Christie's Sale Cat., July 6, 1977, lot 9 with ill.): unrestored with inscription by John Evelyn who commissioned the drawing to show the relief exactly as it was, and not 'restored' as by Perrier.

LITERATURE: Reeland, 1716, with engravings by B.Overbeck. Frontispiece: ruined arch, Forum side with trophy relief on right of passage; p.6: trophy relief *(Effigies Lychnuchi)*; p.70: the table.

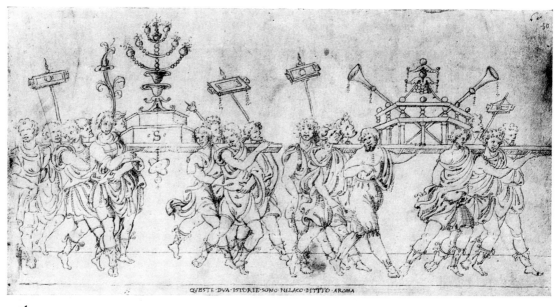

173b

174 A–B. 'Trophies of Marius'

Pair of free-standing Domitianic marble trophies
Rome, Campidoglio, balustrade

DESCRIPTION: Trophy **A**–In the present condition 'headless', but originally had a helmet on the end of the pole. The anthropomorphic trophy wears a heavy fur mantle, but instead of arms there are two decorated vertical shields, tapering at both ends. Below, the trophies include a helmet of Hellenistic type with plume supported by a winged sphinx on top, other shields, and traces of three winged *genii*.

Trophy **B**–The better preserved of the two. The figure is cuirassed, has two shields, decorated with the Medusa's head, in place of arms, and in front, a figure of a barbarian prisoner stands cross-legged flanked by fasces and traces of three winged *genii*. In the Renaissance the surmounting helmet was visible; it is now lost.

HISTORY: In Antiquity the trophies were later installed in the Nymphaeum Aquae Juliae on the Esquiline, built by Alexander Severus, and it was there that they were seen in the Renaissance, each in an archway in the upper part of the Nymphaeum **(174a)**. In 1590 they were installed by Giacomo della Porta on the balustrade above the Capitoline ramp, flanking the statues of the Dioscuri discovered in the time of Pope Pius IV.

INTERPRETATIONS: In the Middle Ages the Nymphaeum was thought to be the Temple of Marius who conquered the Cimbri (*Mirabilia* in *CTR*, III, p.60; see Tedeschi Grisanti, 1977, pp.52–5 for other Medieval and Renaissance references). In the mid 15th century, the trophies were identified with the Capitoline geese (Muffel, 1953, in *CTR*, IV, p.365) and Giovanni Rucellai in 1450 thought they decorated the Triumphal Arch of Marius, and called the images armed geese (*oche armate*, *CTR*, IV, p.414). The Nymphaeum is even drawn on plans of Rome with creatures looking like geese flanking it (Alessandro Strozzi, plan of Rome, 1474 in Florence, Bibl. Laur., Red.77, reproduced in Tedeschi Grisanti, 1977, pl.XXX).

After the mid 16th century, Pirro Ligorio seems to have been the first to take a critical view of the traditional identification. He pointed out that, according to Plutarch (*Life of Caesar* VI), the trophies of Marius were on the Campidoglio, and were carried by Victories (Tedeschi Grisanti, 1977, pp.53–4). In the late 16th century, when the tro-phies were moved, the fragment of an inscription was found by epigraphers under the one on the left, which together with the furry robe indicate that it may have been a trophy of a German war. In any case the trophies continue to be known as the 'The Trophies of Marius'.

REPRESENTATIONS:
– Aspertini, Cod. Wolfegg, f.18: '*Alo condure de la fonte de fora de lo arco de santo vito*'. Trophy **B** restored with prisoner and four *genii*.
– 'Ripanda' skb., Oxford, Ashmolean, f.37: Trophy **A** 'restored' with three *genii* **(174b)**; f.62: Trophy **B** 'restored' with four *genii* **(174c)**.
– Roman, 16th century, fresco, Vatican, Appartamento delle Guardie Nobili (Tedeschi Grisanti, 1977, ill. on p.x): view of the Esquiline with the Nymphaeum on top flanked by the Trophies *in situ*; the Laocoon unrestored at the bottom of the hill.
– Biagio Pupini, Turin, Bibl. Reale, 15818 (Bertini, 1958, cat.368): Trophy **B** 'restored' with putti and various *fantasie*.
– Heemskerck, *Skb.* II, f.49: view of whole Nymphaeum on the Esquiline with the trophies each framed by an arch.
– Francisco de Hollanda, *Skb.*, f.14ᵛ: Trophy **A** freely 'restored'; f.15ᵛ: Trophy **B** partly 'restored' with upper parts of *genii* and fragments of legs and feet on ground. The two drawing scarry a single Latin inscription explaining that they are the trophies of Marius sculpted in marble and erected thus in Rome from the triumph over the Cimbri.
– Master of the Prodigal Son, *Rebecca at the Well*, Dublin, NG, 845 (Adler, 1982, pl.48): in background the Nymphaeum with adaptations of the trophies on top of a hill which below contains a grotto with a river god reclining over a sarcophagus fountain.
– Lafréry, *Speculum* (Hülsen, 1921, cat.27a): Trophy **A** 'restored' with three *genii* and helmet; (*ibid.*, cat.28c): Trophy **B** 'restored'. Both reproduced in Siebenhüner (1954, figs.64–5).
– Dosio, Berlin *Skb.*, no folio number (Hülsen, 1933, pl.CXXIII): *in situ*.
– Dosio, Florence, Uffizi, 2526A (Borsi *et al.*, 1976, cat.66); cf. Dosio, 1569, pl.25 (Tedeschi Grisanti, 1977, pl.XIV, 2): view of whole Nymphaeum with trophies with inscription **(174a)**.
– Flemish?, 16th century, Rome, Gab. Naz. delle Stampe, 128533 (A.Bartoli, 1911, pl.lxxiii): Nymphaeum, view from left with trophies.
– Cavalieri, I–II, pl.100: Trophy **A**; pl.99: Trophy **B**, and evidently a later plate as the inscription adds: '*nunc in capitolio tra(n)slata*'.
– Goltzius, '*Skb.*', Haarlem, Teyler Mus., K216 and K217 (Reznicek, 1961, figs.150–1): Trophies **B** and **A** unrestored.

– Pozzo Windsor, I, f.89, 8249; f.90, 8250; f.91, 8251; f.92, 8252 (Vermeule, 1966, p.14): front and back of both trophies with details now no longer visible. (See also Vermeule, 1956, fig.6).

LITERATURE: Tedeschi Grisanti, 1977, esp. pp.49–60.

175. Two Trophy Pillars

Pillars carved with trophy reliefs on four sides
Florence, Uffizi (Mansuelli, 1958, I, cats.2–3)

DESCRIPTION: The pillars are carved in undercut relief and include some 800 trophies: pieces of armour, weapons, anchors, insignia of the legionaries, banners, helmets and shields all scrambled together and overlapping in continuous series, one to each of the four sides of both pillars. Crous (1933) has identified the images, catalogued them, divided them into 106 different types, and related them to the Pighius drawings of sections of the reliefs. The Pighius drawings record part of a finely carved base now lost (Crous, 1933, fig.7).

HISTORY: As early as the late 15th century, the pillars were in or near the Church of S.Sabina on the Aventine Hill in Rome, according to notations on the drawings ('S.Savina'). The pillars remained there until they were shipped to Florence in 1588 and set up in the Galleria degli Uffizi. At the end of the 18th century they were placed at the entrance to the Uffizi Gallery where they are today (Mansuelli, 1958, I, p.27; Crous, 1933, p.12).

REPRESENTATIONS:
– Sections of the reliefs were adapted in various architectural decorations in the 15th century, such as doorway friezes in the Pal. Ducale, Urbino (Rotondi, 1969, figs.110, 287, 289–90; for Renaissance borrowings in Florence, Arezzo and Verona, see Egger, 1905–6, pp.72f.; for Venice, see Martindale, 1979, pp.71–2).
– Baccio d'Agnolo?, Florence, Pal. della Signoria, Sala dei Dugento, frieze and column bases of doorway, c.1500: adaptation using Florentine symbols (lion, lily) on the shields, and introduction of modern bombards, etc., 'SPQF' on bases.
– Cod. Escurialensis, f.12, 2: 'in santa savina'.
– Aspertini, Cod. Wolfegg, ff.38v–9, below (Crous, 1933, fig.10): two sections freely drawn horizontally.
– Raphael, tapestry cartoon, Conversion of the Proconsul, London, V&A (Shearman, 1972, p.122 and pls.26, 28, 30): adaptation of trophy reliefs on side of throne.

– Jacopo Sansovino, attrib., Florence, Uffizi, 1558A (Crous, 1933, fig.5).
– Francesco da Sangallo?, Florence, Uffizi, 1693 Orn (Crous, 1933, fig.4): 'P Savina' with frieze of sacrificial instruments (193) above.
– Cod. Pighianus, ff.350v–54v; 362–63v (Jahn, 1868, 35; Crous, 1933, figs.6, 8, 9).
– Cod. Coburgensis, ff.17, 47, 133 (Matz, 1871, 20; Crous, 1933, fig.7 = f.17).
– Dosio, Berlin Skb., ff.19–20 (Crous, 1933, figs.2–3).
– Topham Albums, Eton College Lib., Bn.10, ff.1–36 (Crous, 1933, fig.1).

LITERATURE: Crous, 1933.

176. Equestrian Portrait of Marcus Aurelius

Bronze horse and rider, over life-size, c.176 A.D.
Rome, Piazza del Campidoglio

DESCRIPTION: Of the many bronze equestrian statues in Rome in Antiquity (Pliny, Natural History XXXIV, 19), that of Marcus Aurelius is the only one which survived destruction, thanks to its identification in the Middle Ages with Constantine the Great, the first Christian emperor. In the Renaissance the statue was so highly valued that, during the Pontificate of Paul III, Michelangelo gave it its present place of honour on the Campidoglio on a base which he designed. It inspired many equestrian statues to commemorate great men and rulers in the Renaissance and later, in Italian cities and abroad.

The emperor, bareheaded with short curls and trim beard, wears a short tunic, military cloak and sandals. His hand is extended in a gesture of adlocutio, addressing his troops. He sits on his horse firmly without the aid of stirrups, which were not yet invented, or saddle, instead there is a mat with a jagged triple border, and straps extending to the front; barely visible is a thinner strap around the horse's neck on which hangs a medallion. The horse, proud and graceful, with head close to the arched neck, and slightly turned to the right, the bit forcing the mouth open, steps forward vigorously with the right front hoof raised off the ground. The other three touch the ground, the left hind one only at the tip as the leg advances; the right hind leg extends behind with a verve missing in later adaptations. The mane, of medium length, falls to the left, the tail arches slightly and tapers to a point. The bridle has two circular bosses.

HISTORY: First recorded at the Lateran in the 10th century. Like the *Regisole*, the only other antique bronze group of horse and rider known in Italy in the Renaissance (at Pavia, destroyed 1797; Bovini, 1963, pp. 138–54), it appears to have had the figure of a crouching barbarian underneath the horse's raised hoof (see below, INTERPRETATIONS). No such figure appears in the Quattrocento representations which show supports under both feet of the emperor and an iron rod supporting the horse's raised hoof (*Cod. Escurialensis*). The statue was restored under Pope Paul II (in 1467–9) who paid the goldsmith and medallist, Cristoforo di Geremia, at least 300 gold florins for unspecified work (Müntz, 1878–82, II, pp. 92–3), and again by Sixtus IV in 1473–4 who removed it to a new rectangular base with inscription (Fehl, 1974). Alexander VI planned to bring the statue to the Campidoglio where other bronze statues from the Lateran had already been transported by Sixtus IV, but it was not until 1538 that Paul III transferred it there and it was later set up on Michelangelo's oval base in the centre of the Campidoglio (Bush, 1976, p. 84 for discussion of date; for history, inscriptions and bibl., see Knauer, 1968). In January, 1981, both emperor and horse were taken from that base to be restored (La Rocca, 1981, p. 60).

INTERPRETATIONS: Although generally thought in the Middle Ages to represent Constantine, it was also called Theodoric; and Quintius Curtius (Magister Gregorius, *CTR*, III, p. 145). The *Mirabilia* (*CTR*, III, pp. 32–3, 95) held that it was not Constantine, but a certain squire who, having defeated an Eastern king who had besieged Rome, was rewarded with an equestrian statue which showed him with hand outstretched to catch the king, a dwarf, crouching with hands tied behind his back, under the horse's hoof (Scherer, 1955, pp. 134–5; Ackermann, 1957, p. 75 for a 15th century version). Learned 15th century identifications of the statue include Poggio Bracciolini's as Septimus Severus because of the Severan barracks near the Lateran (*CTR*, IV, pp. 240–1); Filarete's as Commodus (see below); Platina's as Marcus Aurelius (*Vita Sixti IV* in Muratori, *RIS*, III, 2, p. 418). It is not known if this interpretation was in Platina's inscription on the Sistine base (Fehl, 1974, p. 367).

Albertini in 1510 refers to the statue as one which Marcus Aurelius had made of himself as a bringer of peace *(pacificator)*, although, he says, the people still call it the horse of Constantine (1510, II, p. Qii = p. 62). Fulvio follows Albertini *(pacificatore)*:

'and they say that it is of Marcus Aurelius Antoninus or Lucius Verus' (1527, IV, f. lxxix[v]; 1588, p. 148). According to Fulvio, the identification of the emperor was based on a comparison with portraits on imperial coins. Marcus Aurelius' name and family relationships are inscribed on the south side of Michelangelo's base (inscriptions in Knauer, 1968, p. 25; see also Bush, 1976, pp. 57–9 for interpretations).

REPRESENTATIONS:
The following selection is confined to actual copies; adaptations in works of art, which are legion, are not listed.

At the Lateran–

- Gozzoli Workshop, Rotterdam *Skb.*, f. 15, below (Degenhart and Schmitt, 1968, I, 2, cat. 437; I, 4, pl. 330): frontal view of horse only; noted by Nesselrath.
- Felice Feliciano, c. 1457–65, in Marcanova's 'Antiquitates', after Ciriaco d'Ancona?, Modena, Bibl. Estense, Cod. α L. 5, 15, f. 31[v] (Hülsen, 1907, pl. VII): rider in Renaissance armour, low platform supported by lions. The Lateran setting indicated by two colossal fragments: head and hand **(183)** on columns from bronze statue of Constantine or his son; copy (1465), Princeton Univ. Lib., Garrett MS 158, f. XIV (Fehl, 1974, pl. 80c; Sheard, 1979, cat. 4).
- Filarete, bronze statuette, Dresden, Albertinum, Sk. Samml. (Montagu, 1963, fig. 1): unrestored, with additional helmet on front right corner of base. Top surface of base with long Latin inscription: 'the artist gives this image of the bronze statue of Commodus Antoninus Augustus and his horse now at St. John Lateran to Piero de' Medici in 1465' (Latin text in Lazzaroni and Muñoz, 1908, p. 132 and fig. 84).
- Ambrosiana Anon., Milan, Bibl. Ambr., F. 265 inf. 92[v] (Schmitt, 1966, cat. and pl. 31[v]): unfinished? drawing of emperor mounted in profile to left. Lower right hind leg and left foreleg, details of bridle and saddle-pad not drawn. Top of thin column under rider's foot. Schmitt notes faint silver-point lines indicating stone blocks under the damaged legs, scarcely visible in reproductions. It is because of these blocks that she dates the drawings of the Anon. Ambrosiana to c. 1460 before the restorations by Paul II in 1467–9.
- Filippino Lippi, *Triumph of St. Thomas Aquinas*, fresco, 1489, Rome, S. Maria sopra Minerva, Cappella Carafa (Knauer, 1968, fig. 13; Fehl, 1974, pl. 80b): frontal view on Sixtus IV's base at Lateran. Raised plinth under horse decorated with flying amoretti holding the della Rovere coat of arms. Horse's leg restored; thin marble columns on either side supporting feet of rider.

– *Cod.* Escurialensis, f.31ᵛ (Siebenhüner, 1954, fig.26): profile to left with top of Sistine base, columns under rider's feet, thin rod under raised hoof, rising from top of base **(176a)**.
– Nicoletto Robetta da Modena, engraving, c.1507 (Hind, 1948, VI, pl.656, no.31): 'QUESTO EL CA-VALO QHESTA A SA(N)TO IANNI I(N) ROMA'. On Sistine base, indoors, profile to left.
– Fogolino, New York, MMA, Rogers Fund 65.1361: to left, adaptation with head turned outwards.
– Fogolino, engraving (Hind, 1948, VII, pl.802, no.3; Siebenhüner, 1954, fig.30; *Dialoge*, 1970, fig. and cat.32): 'ROMA MARCELLO FOGOLINO'. On Sistine base at Lateran, from front left, with view of aqueduct.
– Marcantonio Raimondi, engraving, Bartsch, XIV, p.375, no.514: 'ROMAE. AD. S. JO. LAT.' Profile to left. No supports; canted front of platform. Background consists of wall, otherwise cf.
– Marco Dente, engraving, Bartsch, XIV, p.375, no.515: with whole Sistine base inscribed: 'SIC ROME AERE SCULT ANTE PORTAM ECCL S IOH/NIS LATHER' (Monogram DR) and view of Temple of Minerva Medica.
– Raphael Workshop, Fossombrone skb., f.73ᵛ: profile to right.
– Heemskerck, *Skb.* I, f.71ᵛ: view of Lateran with statue in profile to right. Two lions *couchant* on columns in front of statue. Canted platform visible, and columns supporting feet of rider. Rod under raised hoof barely visible. The four partly buried columns in the foreground thought by Fehl to have supported low platform on which statue stood before Sixtus IV provided his grander base **(176c;** Fehl, 1974, pp.362–7; pl.80a).
– Heemskerck, details of horse, *Skb.* I, ff.56, 63ᵛ: raised foreleg; ff.75, 44ᵛ: hind legs; f.35ᵛ: right haunch and part of flank.

At Campidoglio after 1538–
– Francisco de Hollanda, *Skb.*, f.7ᵛ (Buddensieg, 1969, fig.10): profile to right, on Michelangelo's base with Paul III's inscription on north side. In background old Pal. dei Conservatori with the river gods *Tygris fl.* and *Nilus fl.*, **65A** and **B (176b)**.
– Beatrizet, engraving for Lafréry's *Speculum*, 1548 (Hülsen, 1921, cat.48A; Siebenhüner, 1954, fig.42): profile to left with inscription identifying Marcus Aurelius on south side of Michelangelo's base.
– Cavalieri, I–II, pl.68: statue from front right, showing Farnese coat of arms of Paul III on front of base. The top of the base has a surface canted on all sides to the cornice, to give the statue maximum visibility. Below inscribed: '*Marcus Aurelius Antoninus Augustus in Capitolio*'.
– Cherubino Alberti, Florence, Uffizi, vol.93695, f.37 (Buddensieg, 1969, fig.11): profile to left without base.

LITERATURE: Knauer, 1968. For other views of the statue at the Capitol before and after the Piazza was paved, see Siebenhüner, 1954; Scherer, 1955, pp.133–5 and notes pp.391–2, Fra Paolino da Venezia's view of Rome (1325) showing statue with colossal hand and head at Lateran (pl.212), Heemskerck's view at Lateran (pl.213); frontal view, engraving from Lafréry's *Speculum* showing Campidoglio in 1565 with Michelangelo's new steps in front of the Pal. dei Senatori (pl.214). Haskell and Penny, 1981, cat.55.

177. Four Horses

Copper-gilt monumental horses from a *quadriga*
Roman, 4th century A.D.?
Venice, until recently on façade of S.Marco;
now Museo Marciano

DESCRIPTION: Occasionally, even as early as the 5th century B.C., victories in the four-horse chariot races in Greece were commemorated by the erection of bronze *quadrigae*. Not surprisingly these elaborate and expensive dedications appealed to the Romans, who established a custom of their own of setting up bronze chariot groups with four horses in honour of those who had celebrated a triumph (Pliny, *Natural History* XXXIV, 19). Innumerable *quadrigae* must have existed, some surmounting the arches which abounded in Rome and throughout the empire, as shown on coin reverses.

Although many fine representations of the kind existed in Antiquity, these four magnificent gilt horses of S.Marco in Venice must have been outstanding even then, for they were among the treasures which Constantine chose to decorate his new capital at Constantinople, where they were acquired by the Venetians in the 13th century.

Scholarly attempts to date the horses have ranged from the 4th century B.C. to the 4th century A.D. Recent laboratory tests made at the British Museum show that the horses are made of almost pure copper in order to take a mercury gilding thought to have first been discovered by the Romans in the 3rd century A.D. (*New Scientist*, 6 September, 1979, p.713).

The four spirited gilt horses have, until recently, stood over the entrance arch on the roof of the porch of S.Marco overlooking the Piazza. Their manes are clipped, and they have upright topknots between their expressive ears. They wear 'gilded collars glittering in the sun' as Byron described them (*Childe Harold* IV, XIII), and traces of former bridles can be detected, otherwise they are com-

pletely unadorned. They each rested a fore hoof on top of a small capital, and two hind hooves on one larger capital behind. They were arranged in two pairs, tossing their heads towards their partners. The pair on the left raise the off-side foreleg and advance the off-side hind leg, while the pair on the right reflect this movement with their near-side legs, unlike Marcus Aurelius' horse (176) which advances on alternate legs, in a more natural rhythm.

HISTORY: The horses may have been brought by Constantine from Rome to Constantinople in the 4th century A.D. to decorate his Hippodrome. They were sent to Venice by the head of the Venetian colony in Constantinople, Marino Zeno, as part of the Venetian booty from the Sack of Constantinople (1204), and were set up on the façade of S. Marco in the mid 13th century. In 1797, they were taken to Paris by Napoleon for the Arch of the Carrousel and returned to Venice in 1815.

INTERPRETATIONS: For the history and legends attached to the horses, see Perry (1977).

Ciriaco d'Ancona visited Venice in 1436 and inspected 'those four bronze chariot horses which are so splendid a work of art and most elegant design, the noble work indeed of Phidias, and once the glory of the temple of warlike Janus in Rome' (Perry, 1977, p. 33; Ciriaco's attribution to Phidias was because he thought them to be of such high quality). With the help of Roman coins and medallions representing *quadrigae*, as well as with literary sources, the Venetian humanists invented a history for the horses which had many variations summed up by Pietro Giustinian in 1560:

> 'They say they are the work of Lysippus, and come from a long past age; they also say they were a gift to Nero from Tiridates, King of Armenia (cf. 125), and later taken by Emperor Constantine from Rome to Byzantium. Then Ziani brought them to Venice and set them in a permanent place on the firm upper part of that most famous temple.' (Perry, 1977, p. 35.)

REPRESENTATIONS:
- Uccello, *Sir John Hawkwood*, fresco, 1436, Florence, Duomo (Pope-Hennessy, 1969, pls. 12–15): horse, adaptation of one of left-hand pair in right profile (177b); cf. Uccello's squared preparatory drawing, Florence, Uffizi, 31F (*ibid.*, pl. 11).

- North Italian, 15th century, Bergamo, Accad. Carrara (Pope-Hennessy, 1969, fig. 6): heads, front and left profile.
- Donatello, *Gattamelata*, bronze equestrian statue, 1443–53, Padua, Piazza del Santo (Janson, 1963, pls. 70–1): adaptation; the pacing and turn of head is that of the second horse on right (177c).
- Castagno, *Niccolò da Tolentino*, fresco, 1456, Florence, Duomo (Horster, 1980, pls. 113–14): cf. outside horse on right seen in right profile.
- Piero della Francesca, *Portrait of Federigo da Montefeltro*, reverse of panel, Florence, Uffizi, 1615 (*Uffizi Cat.*, 1979, P1178): adaptation of pair on right.
- Verrocchio, *Colleoni*, bronze equestrian statue, Venice, Campo, SS. Giovanni e Paolo (Pope-Hennessy, 1971, fig. 89): adaptation; although the pacing is the same as one of the pair on the right, the longer mane, more detailed treatment of the muscles, and increased tension suggest a conflation with Marcus Aurelius' horse (176). A real horse may also have been used as a model.
- Gentile Bellini, *Procession in the Piazza S. Marco*, 1496, Venice, Accad., 567: view of Piazza with the four horses shown frontally on the façade (*The Horses of San Marco*, 1979, figs. 105, 118).
- North Italian, c. 1490, bronze statuette of horse on right, London, V&A (*NACF Annual Report*, LIV, 1957, no. 1889, p. 26, pl. XI).
- Paduan, c. 1500, bronze statuette, Munich, Bayerisches Nat. Mus. (Weihrauch, 1967, fig. 46): second horse on left; forward motion accentuated. Cf. Venetian?, 16th century, bronze statuette, Baltimore, Walters Art Gall. (Weihrauch, 1967, fig. 47; Bowron, 1978, p. 30 and ill. on p. 31): a copy of horse on left; more simplified and compact version. There are many other bronze statuettes apart from these examples.
- Giovanni Francesco Penni?, Vienna, Albertina, inv. 267–8 (Stix and Fröhlich-Bum, 1932, cats. 122–3): two drawings of pair on left with collars.
- Francisco de Hollanda, *Skb.*, f. 42 bis (177a).
- Anon., *The transport of the bronze horses to Venice*, cement? cast from lost silver plaque? on house, Venice, Castello N.A., 2778 (Perry, 1974–5, fig. 1; Perry, 1977, pl. 3a): both pairs in frontal perspective, arriving over the seas on a shell, Victory flying over their heads, and a doge presenting them to a personification of Venice.

LITERATURE: The exhibition catalogue, *The Horses of San Marco*, London, RA, 1979 (transl. from the Italian exhibition catalogue of 1977 by J. and V. Wilton Ely) has articles on various aspects of the history of the horses, their influence in Renaissance art, and detailed scientific analyses. Haskell and Penny, 1981, cat. 49: 'The Horses of St. Mark's'.

TRIUMPHAL ARCHES

IMPERIAL MONUMENTAL ARCHES IN ANTIQUITY

Pliny explains that the Romans constructed magnificent stone arches to elevate statues above ordinary men (*Natural History* XXX, 27), as they provided bases for the statues of the imperial *quadrigae*. The primary function of the arches, as we understand them, was to serve as conspicuous monuments of propaganda, commemorating in their reliefs, decorations, and inscriptions the battles and victories of the emperors whose specific deeds extended the power of Rome.

There were thirty-four honorific or triumphal arches in Rome alone in the time of Constantine.

The architecture of the arches develops from the simple form of the Arch of Titus (**178**) through the increasingly complex structures and decorative schemes culminating in the Arch of Constantine (**182**). What mainly concerns us here, however, are their remarkable figured reliefs which were eagerly studied by Renaissance humanists and artists.

LITERATURE: Panvinio (Panvinius), 1642; Weisbach, 1919; Noack, 1928; Brilliant, 1974, pp. 119–28.

TRIUMPHAL ARCHES IN THE RENAISSANCE

In the early Quattrocento, the Roman historical reliefs, particularly those on the triumphal arches, seemed to come alive for the humanists. The reliefs had certainly been noticed before (Krautheimer, 1956, pp. 294–99) and could be seen daily, but like most familiar things they tended to become invisible until someone came along to see them in a new way. This was Manuel Chrysoloras, the greatly loved and admired scholar from Greece whose work and teaching had a formative influence on the development of classical studies in the Renaissance. In a much circulated formal letter, written in Rome around 1411, he describes the way in which the ruins of Rome revealed 'the stamp of the Roman mind', particularly the

'triumphal arches erected in commemoration of their triumphs and solemn processions: on these are carved in relief their battles and captives and spoils, fortresses taken by storm; and also sacrifices and victims, altars and offerings. As well as these there are battles of ships, of horse and foot, and every shape of war-engine and arms; and conquered kings of the Medes, it may be, or Persians or Iberians or Celts or Assyrians, each in their own costume; and subject races with the generals triumphing over them, and the chariots and the *quadrigae* and the charioteers and bodyguards, and the captains following after and the booty carried before them – one can see all this in these figures as if really alive, and know what each is through the inscriptions there. So that it is possible to see clearly what arms and what costume people used in ancient times, what insignia magistrates had, how an army was arrayed, a battle fought, a city besieged, or a camp laid out; what ornaments and garments people used, whether on campaign or at home or in the temples or the council-chamber or the market-place, on land or sea, wayfaring or sailing in ships, labouring, exercising or watching the games, at festivals or in workshops – and all these with the differences between the various races. Herodotus and the other writers of history are thought to have done something of great value when they describe these things; but in these sculptures one can see all that existed in those days among the different races, so that it is a complete and accurate history – or rather not a history so much as an exhibition, so to speak, and manifestation of everything that existed anywhere at that time. Truly the

skill of these representations equals and rivals Nature herself, so that one seems to see a real man, horse, city, or army, breast-plate, sword, or armour, and real people captured or fleeing, laughing, weeping, excited or angry'.

Although the surviving 15th century drawings of the historical reliefs are almost all datable to the latter part of the century, Chrysoloras' enthusiasm must have ignited not only that of the humanists such as Poggio Braccriolini, Bartolomeo Aragazzi, Niccolò Niccoli, and Guarino Guarini, but also must have reached the artists with whom they were in close touch – such as Ghiberti, Donatello, Michelozzo, Gentile da Fabriano, and Pisanello.

LITERATURE: The passage from Chrysoloras' letter to John VIII Paleologus is quoted from the transl. by Baxandall, 1971, pp. 80–1; 149–50 (Greek text). A study on Chrysoloras which discusses this passage in relation to the arches, particularly to the Arch of Septimius Severus, is being prepared by David Thomason, who has found that 15th century MS copies of the letter indicate its wide dissemination. For sources concerning the relationships between the humanists and artists in the early Renaissance in Rome, see Spring, 1972. For engravings of the arches and details of their reliefs, see P. Santi Bartoli–Bellori, 1690. For bibl. on antique arches and Renaissance art, see Kruft and Malmanger 1975.

178. The Arch of Titus
Triumphal Arch, c. 81 A.D.
Rome, Forum (Nash, 1968, I, pp. 133–5)

DESCRIPTION: The Arch of Titus is the oldest of the great triumphal arches surviving in Rome. It was built to commemorate the Jewish wars and was erected shortly after 81 A.D. It is composed of two piers linked by a single arch supporting a high attic on which stood the statue of the emperor in his *quadriga*. The simple architectural structure is articulated by engaged columns bearing an entablature. The dedicatory inscription is carved on the attic.

The exterior is austere. Figured decoration is restricted to the flying Victories in the spandrels and the narrow band of frieze just below the attic on which a long triumphal procession was carved.

The rich sculptural decoration was reserved for the passageway. The most famous of the reliefs is on the south-west side of the passage, showing the Trophies from the Temple of Jerusalem being carried in procession (173); while opposite is the Triumph of Titus crowned by Victory in a chariot led by the personification of Rome. In the summit of the passageway is carved the Apotheosis of Titus, with the emperor on the eagle's back; the soles of the eagle's feet are splendidly displayed in an attempt at *di sotto in su* perspective.

In the Renaissance only part of the arch remained (178a). The side away from the Forum, facing the Colosseum and the Arch of Constantine, is the best preserved with the original inscription, frieze and Victories.

HISTORY: In the Middle Ages the arch was incorporated into the fortifications of the Frangipane family along the east end of the Forum. A chamber had been built in the upper part of the passage (see 173), but at least part of the the Trophy Relief seems to have been visible in the 15th century even before Pope Sixtus IV removed most of that construction. The single arch remained buttressed on both sides by buildings, and preserved the remains of a medieval tower on the attic until Valadier reconstructed the outer piers in travertine in 1821.

INTERPRETATIONS: In the 12th century, the *Mirabilia* called it 'The Arch of the Seven Lamps of Titus and Vespasian', taking its name from the Trophy Relief (173) and the inscription.

REPRESENTATIONS:
General views
– *Cod. Escurialensis*, f. 46ᵛ: 'al archo di vespasiano'. Victories from spandrels of the arch; f. 47: central façade of arch with entablature frieze and Victories drawn in.
– Heemskerck, *Skb.* II, f. 56 (178a): from east; Forum in background.
– Francisco de Hollanda, *Skb.*, f. 20ᵛ: conflation of Triumph of Titus relief and Trophy Relief seen on right of passage.
– Engraving for Lafréry's *Speculum*, 1548 (Hülsen, 1921, cat. 12a): 'restored' with three arches, seen from Forum.

The Triumph of Titus Relief (178b)
– Aspertini, c. 1500–3, New York, MMA, Rogers Fund 19.151.6 (Sheard, 1979, fig. 22): unfinished drawing.
– 'Ripanda' skb., Oxford, Ashmolean, ff. 55ᵛ–6: 'restored'.
– Bandinelli, manner of, Windsor, 8184 (see 173; Blunt, 1971, cat. 26).
– B. Peruzzi, manner of, Florence, Uffizi, 5682 Horne.

– Anon., 16th century, in Dosio, Berlin *Skb.*, f. 42: unrestored **(178c)**.

Victories in spandrels
– B. Peruzzi, Oxford, Ashmolean, Parker, 1956, II, cats. 462V, 465: unrestored Victories from east front.
– Raphael Workshop, Vatican Loggie, stucchi or spandrels in Vault X (Dacos, 1977, pl. LVIIIb): adaptations, the Victories also rest on foot on globe.

Apotheosis of Titus Relief
– Pozzo Windsor, I, f. 25, 8181 (Vermeule, 1966, p. 9, fig. 47): whole relief with garland frame; Blunt (1971, p. 121) as attrib. to Pietro Testa.

LITERATURE: See **173**. Kleiner, 1962; Scherer, 1955, pp. 75–6; pls. 119–23 and 124–5 seen with the Arch of Constantine; Pfanner, 1983, Chapter 2.

179. Arch of Trajan
Completed 114 A.D.
Benevento

DESCRIPTION: The Arch stood at the crossroads of the Via Appia and Trajan's new road to Brindisi, and was richly decorated with a system of figured friezes and panels commemorating, it is thought, Trajan's work in Italy (city façade) and the provinces (country façade).

Few artists apart from those working in Naples seem to have travelled south to Benevento to study the splendid reliefs, comparable in quality to those on the Column of Trajan **(159)**. The arrangement and use of such figured reliefs to convey propaganda was adapted in the mid 15th century by King Alfonso of Naples in his own triumphal arch at Naples.

REPRESENTATIONS:
Whole Arch
– Giuliano da Sangallo, Siena *Skb.*, ff. 24V–5 (Falb, 1902, pl. XXV): scheme of town side and left flank. Separate drawings of the various *ISTORIE* in two rows across the top **(179d)**.

Reliefs
– Nicola Pisano, Pisa, Baptistry, Pulpit, head of Simeon (Seidel, 1975, figs. 14–15): adaptation of the head of Silvanus.
– Paduan, c. 1500, London, BM, 1946.7.13.1263 (Pop-

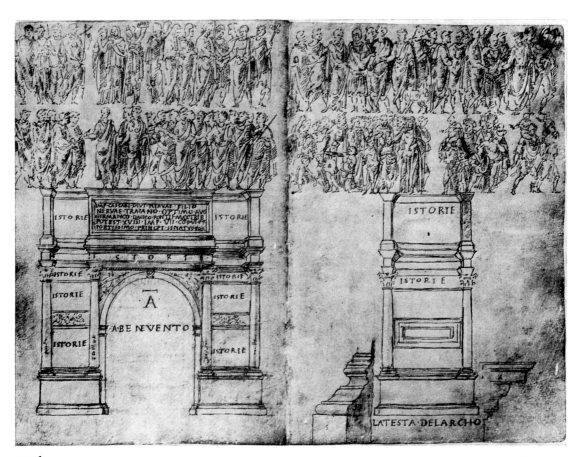

179d

ham and Pouncey, 1950, cat.349, not illus.): *Virtus* leading two soldiers to Trajan with Diana and Silvanus who hold the *vexillum*.

- Antonio da Sangallo, the Younger, Florence, Uffizi, 14793F (Degenhart, 1955, fig.321): sacrifice, unrestored, unfinished drawing; 14792F (*ibid.*, fig.323 etc.): relief of provinces and children, unfinished drawing.

LITERATURE: Rotili, 1972; Hassel, 1966; Fittschen,1972; Andreae, 1979. For the Renaissance, see pp.38–39; Kruft and Malmanger, 1975.

180. Arch of the Argentarii

Roman, 204 A.D.

Rome, Forum Boarium (Piazza della Bocca della Verità)

DESCRIPTION: The Arch of the Argentarii is neither a public monument nor, strictly speaking, an arch. Composed only of a pair of richly carved piers and a straight lintel, which may have supported statues, it was dedicated to the Imperial family by two groups of businessmen, the money changers and the cattle dealers (*Argentarii* and *Negotiantes Boarii*) in 204 A.D.

The best-preserved relief is in the passage on the east pier. Septimius Severus, his wife Julia Domna, and a third figure now effaced, are depicted frontally pouring a libation, preliminary to the sacrifice of a bull shown below (**180a**). The erasure of three figures in the two major pasageway reliefs was not due to the ravages of time, but to the malice of Caracalla who, when he came to power, had the inscription changed and the images of his brother, his wife and his father-in-law erased as he had condemned them to a *damnatio memoriae*.

To Renaissance artists, from illuminators of manuscripts and goldsmiths to architects, perhaps the most stimulating components of the arch were not only the figured reliefs, but also the proportions of the parts to the whole, and the details of the rich but roughly carved decoration: the trophies vertically strung in the front pilaster strips; the acanthus *rinceaux* in the pilasters on the side and passage piers; and in the passage, the horizontal reliefs on both sides above and below the main relief: the draped Victories or *genii* holding a garland, and particularly the friezes of sacrificial instruments (cf. **193**).

The ornamental articulation of the west pier and passage walls with main relief and subordinate 'predella' may have suggested the arrangements of panels in painted altarpieces.

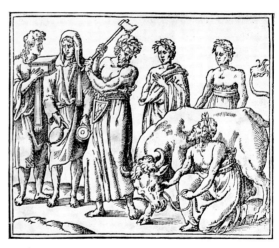

180b

HISTORY: The Arch was always visible, but the right pier (east) was concealed by the medieval church of S.Giorgio in Velabro.

REPRESENTATIONS:

- Giuliano da Sangallo, Siena *Skb.*, f.22: reconstruction of whole arch, with reliefs, south front and west side. Arch of Janus superimposed. Inscription in panel: 'QUESTO E SI DICIE CHE E LA/RCHO DIDECIO INROMA'.
- Giuliano da Sangallo, *Cod.* Barberinianus, f.32ᵛ: west side, mouldings, and top of figures in main relief through shoulders; f.33: view from south showing reliefs on right side of passage including frieze of sacrificial instruments. Free interpretations and reconstructions of missing figures; satyr added to front of 'restored' east pier.
- 'Ripanda' skb., Oxford, Ashmolean, f.10: whole front 'restored'.
- Heemskerck, *Skb.* II, f.45: back of arch with reliefs visible on east passage wall, and a view through arch to part of portico of S.Giorgio. Relief of bull led to sacrifice on west pier, below.
- Francisco de Hollanda, *Skb.*, f.18ᵛ: arch from south-west with both piers as if free-standing; inscription separate.
- Destailleur, skb., Berlin, Kunstbibl., OZ 109, f.31: west pier from centre.
- Du Choul, 1556, p.290: reversed, sacrifice relief, east passage below (**180b**).
- Dosio, Florence, Uffizi, 2530A (Acidini in Borsi *et al.*, 1976, cat. and fig.20): view from south, two main reliefs in passage, right, indicated; cf. Dosio, 1569, pl.29 with Latin explanation; Modena *Skb.*, f.119ᵛ (Luporini, 1958, fig.3, p.56): reconstruction of detail of east pier, which Dosio explains does not exist, '*ma si pensa per coniettura*'.
- Pierre Jacques, 'Album', f.27ᵛ: bull led to sacrifice;

213

f.43v: west pier; large relief of barbarian prisoners and fragment of 'predella' as one scene; f.44: '1576', east wall of passage with frieze of sacrificial instruments and sacrifice relief.

- Pozzo Windsor, I, f.78, 8237 (Vermeule, 1956, fig.1; 1966, p.13): left pier with Hercules relief; f.79, 8238 (Vermeule, 1956, fig.2; 1966, p.13): two reliefs of barbarians.
- P.Santi Bartoli–Bellori, 1690, pls.20–1 with commentary.

LITERATURE: Both Haynes (1939) and Pallottino (1946) list sketchbook drawings, and Pallottino gives descriptions from Renaissance guidebooks and antiquarian literature.

181. Arch of Septimius Severus
Roman triumphal arch, 203 A.D.
Rome, Forum

DESCRIPTION: The arch has been described as 'the biggest "billboard" yet erected for imperial propaganda' (D.Strong, 1976, p.219). The four main panels which flank the great central arch on both façades show episodes in the Emperor's Parthian campaigns in 195–9 A.D. Each panel contains a narrative with multiple incidents in a single landscape, a device found useful by Italian artists.

In the Renaissance the socles of the arch were buried and the higher ground level permitted a closer view of the large reliefs, the narrow friezes of triumphal processions, the figures of Victories and river gods in the spandrels, and the figures on the keystones, but the barbarians and soldiers carved on the socles were still underground, although they were briefly exposed in 1563; they were covered again after their measurements were taken, as the excavation impeded local traffic in the Forum (see Dosio, REPRESENTATIONS, 181a).

The eroded reliefs are now being restored, and are here illustrated in P.Santi Bartoli's 17th century reconstructions.

REPRESENTATIONS:
- Italian, 15th century, circle of Filarete?, bronze plaquette, Berlin-Dahlem, Staatl. Mus., Skulpturengal., inv.5967 (Bange, 1922, cat.187): panel on right towards Forum.
- Giuliano da Sangallo, Cod. Barberinianus, f.21v: whole arch; f.65: above: south-west bay, facing Campidoglio; below: north-west bay on same side.
- Aspertini, formerly attrib. to Giuliano da Sangallo, New York, Pierpont Morgan Lib., Fairfax Murray, 1910, I, pl.7: façade towards Campidoglio, above:

southwest bay, upper relief; below: lower relief on same bay (181c).
- 'Ripanda' skb., Oxford, Ashmolean, f.9v: whole arch 'restored' with high uncarved bases; separate groundplan below.
- Cod. Escurialensis, f.35v: 'fiume dell'archo di Luzio': river god in a spandrel of a lower side arch towards the Campidoglio; f.20: arch from Campidoglio, seen from above, right. Same viewpoint as Dosio, see below.
- Dosio, Florence, Uffizi, 2567A: with base of medieval tower and remains of battlements on top of attic (181a) (Borsi et al., 1976, cat. and fig.1). Other drawings by Dosio: Uffizi, 2145A (ibid., cat. and fig.94): detail of relief of battering ram from façade towards Campidoglio, with explanatory inscription; Uffizi, 2575A (ibid., cat. and fig.95): excavated pedestal of Forum side, left, with relief of two soldiers and two barbarian prisoners, with a later inscription by Dosio: Questo è il piedistallo sotto alle colonne de l'arco di Settimio Severo imp: Oggi tutto ricoperto fu scoperto al tempo di Papa pio iiii nel 1563 dal quale furono prese le misure e ricoperto nel medesimo anno che impediva la strada che viene del campidoglio e va al foro Romano; Uffizi, 2521A (ibid., cat. and fig.52): arch seen from Forum, excavated on left.
- Dosio, 1569, pl.22: arch from Forum side, reconstructed, with Latin inscription.
- B.Nerone, attrib., New York, MMA, Vanderbilt 80.3.632: free adaptation.
- Duchetti, engraving, 1583, for Speculum (Hülsen, 1921, cat.13B, b): arch from Campidoglio side, 'restored'.
- Pozzo Windsor, I, ff.73–6 (Vermeule, 1966, p.13): four panels 'restored'–8232: façade towards Capitoline, right; 8233: left; 8234: façade towards Forum, left; 8235: right; f.77, 8236: small frieze over side arch on left of façade towards Campidoglio.
- P.Santi Bartoli–Bellori, 1690, pls.9–14: reconstructions of the damaged reliefs (181b).

LITERATURE: Brilliant, 1967.

182. Arch of Constantine
Constantinian, 315 A.D., incorporating earlier reliefs: Trajanic (158); Hadrianic (189), and Antonine (161–2); Constantinian (170B)
Rome, between Colosseum and Roman Forum

DESCRIPTION: The Arch commemorates Constantine's victory over Maxentius in 312 A.D. The richness of its decoration surpasses that of the Arch of Septimius Severus (181), although architecturally it follows the same basic scheme of a high central arch flanked by two lower ones, and surmounted by an attic.

The sculpture of the Constantinian period on the arch consists of the river gods in the spandrels of the two lower arches, the Victories in those of the central arch, six narrow friezes distributed on the façades and sides, and reliefs of Victories (**170B**) and of barbarians on three sides of each of the eight column bases of the two façades. Constantinian also are the two tondi of the Sun and Moon driving their chariots on the east and west sides, and the pairs of busts lining the passageways of the two minor arches.

Into this decoration of both façades of the arch, the architect inserted reliefs of three different monuments of the second century. The earliest in date is the great Trajanic battle frieze in four sections: two in the central passageway (**158i** and **iii**), and two on the short sides of the attic (**158ii** and **iv**), as well as the Trajanic statues of Dacian prisoners over the eight free-standing columns, four on each façade. Next in date are the eight Hadrianic tondi (**189**), coupled over the minor arches; and the latest in date are the eight reliefs from an arch or monument dedicated to Marcus Aurelius. These Antonine panels are paired on either side of the Constantinian inscription in the attic on both façades (see **161–2**).

This marble collage was not assembled in any haphazard way, but was intended to show Constantine within the tradition of the great emperors. His own features were carved on the portrait-heads of his predecessors in the earlier reliefs. Like the Arch of Trajan at Benevento (**179**), the programme on the north façade is of domestic policy, and on the south, the theme is of war and the expanding Empire (Brilliant, 1979).

Raphael seems to have been the first to comment on the different styles of the reliefs. In an undated letter to Leo X, written on his behalf by Baldassare Castiglione, Raphael observed that Roman sculpture deteriorated towards the end of the Empire, but that architecture, even in late Antiquity, was the last of the arts to be lost. One could see this, he wrote, from many examples:

'... and among many others, the Arch of Constantine, the composition *(componimento)* of which is beautiful and well done in all which pertains to architecture, but the sculptures of the same arch are utterly inept *(sciocchissime)* with-

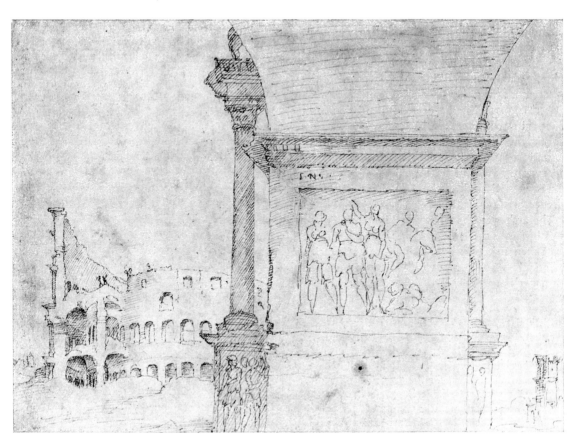

182f

out skill or any good design… Those which are from the spoils of Trajan and of Antoninus Pius are most excellent and of perfect style *(maniera)*'. (Golzio, 1936, p.85; Shearman, 1977, pp.137–9 for date of Raphael's first draft of the letter: 1513?. Cf. Vasari's more detailed critical assessment of the arch, Vasari–Milanesi, 1906, I, p.224.)

Not only were the earlier reliefs, so admired by Raphael, copied and used individually or for certain figures or motifs in the Renaissance, but the arch itself was frequently represented in the backgrounds of biblical and historical paintings as a symbol of pagan Antiquity. The Constantinian reliefs, on the other hand, were more admired in the Middle Ages when they were copied and adapted in a variety of media. Antelami's beautiful 12th century reliefs on the Baptistry of Parma (de Francovich, 1952, pls.151–2, cats.256–7) reflect the Constantinian tondi of the Sun and Moon in their chariots on the short sides of the arch.

HISTORY: Because of its association with Constantine, the first Christian emperor, the arch survived with less damage than the other Roman arches. Lorenzino de' Medici, the murderer of Alessandro de' Medici, was thought to have cut off the heads of the emperors, and for this atrocity to have been banished from Rome by Clement VII (Varchi, 1838–41, III, p.230). But it may have been the Constantinian heads in the passageways of the two minor arches that Lorenzino mutilated (Martini, 1882, p.15). The heads are still missing from their cuirassed busts. The barbarians' heads, missing in the Renaissance, were restored by Pietro Bracci in 1733 under Pope Clement XII (Gaddi, 1736, pp.113–19; von Damarus, 1915, pp.16–17). Some of the emperors' heads of the Antonine reliefs were also restored at this time.

The arch was known in the Middle Ages and Renaissance as the '*Arco de' Trasi*', perhaps because the Dacian prisoners were thought to be Thracian (Lanciani, 1897, p.192 with literature on the history of the arch).

REPRESENTATIONS:
- Bonfigli, *Miracle of St.Louis of Toulouse*, fresco, c.1461, Perugia, Pal. de' Priori (Magi, 1956–7, fig.5, detail): detailed adaptation with barbarians 'restored' as saints.
- Central Italian, *View of an Ideal City*, c.1500, Baltimore, Walters Art Gall. (Zeri, 1976, I, pl.72, cat.96): simplified adaptation of the arch in wide square.
- Giuliano da Sangallo, *Cod. Barberinianus*, f.19ᵛ: north façade with Trajanic battle frieze drawn separately on top (**158e** on p.190); Siena *Skb.*, ff.23ᵛ–24.

- Botticelli, *The Conturbation of the Laws of Moses*, fresco, Vatican, Sistine Chapel (Lightbown, 1978, pl.25; Magi, 1956–7, fig.1, detail): north façade.
- Perugino, *Christ consigning the Keys*, fresco, Vatican, Sistine Chapel (Magi, 1956–7, fig.2, detail): reliefs transposed, invented cornice; Sistine inscription.
- Pinturicchio, *St.Catherine of Alexandria disputing with the Emperor*, fresco, Vatican, Appartamenti Borgia (Magi, 1956–7, fig.3, detail): adaptation; inscription on arch: 'PACIS CULTOR'.
- *Cod.* Escurialensis, f.28ᵛ (Scherer, 1955, pl.133): north side from right; traces of superstructure; f.45: south side, upper left: barbarians drawn without heads.
- B.Brunelleschi, epigraphical skb., Florence, Bibl. Marucel., A 78 1, ff.3ᵛ–4ᵛ: figures of barbarians and *Rex Datus* panel.
- 'Ripanda' skb., Oxford, Ashmolean, f.9: north side; with groundplan below; f.16ᵛ: front and side; blank tondi, barbarians 'restored'.
- B.Peruzzi, *Triumph of David*, Milan, Castello Sforzesco, Gab. dei Disegni, Disegni Preziosi, B, 1801 (Frommel, 1967–8, pl.XXXI, cat.50): right-hand part of south side of arch with reliefs clearly drawn.
- School of Marcantonio Raimondi, engraving, Bartsch XIV, p.385, no.537: north side reversed; no inscriptions, or reliefs on bases.
- Heemskerck, *Skb.* I, f.69: central arch seen from left with profile of lower zone and columns shown freestanding; reliefs on bases; *Skb.* II, f.56ᵛ: from central passage with a Trajanic relief, looking towards Colosseum (**182f**).
- Francisco de Hollanda, *Skb.*, f.19ᵛ: from north-west with inscriptions, 'restored'.
- Dosio, Florence, Uffizi, 2531A: view of east and north sides, Meta Sudans and Arch of Titus in background (**182a**; Borsi *et al.*, 1976, cat. and fig.10).
- Dosio, 1569, pl.30: north façade (**182b**).
- B.Nerone, attrib., New York, MMA, Vanderbilt 80.3.585: 'restored', free interpretation.
- Perrier, 1645, pls.27–42 (**182d–i to viii**, and **182e–i to viii**): reversed, 'restored'. The Hadrianic and Antonine reliefs are here reversed again to show their relative positions in both façades.

LITERATURE: Magi, 1956–7, pp.83–110. Further bibl. in Nash, 1968, I, 104–12. Giuliano, 1955, for ills. For a brief iconographical account of the arch in terms of Constantinian propaganda, see Brilliant, 1979, cat.58, pp.67–9, and **158**, DESCRIPTION.

183. Constantine?
Colossal bronze head, 4th century A.D.
Rome, Palazzo dei Conservatori (Stuart Jones, 1926, pp.173–4, Sala dei Bronzi, 7)

DESCRIPTION: Two colossal Constantinian heads were brought to the Campidoglio in the late

Quattrocento. The bronze head had been at the Lateran, and the marble head from a colossal statue of Constantine was found in the time of Pope Innocent VIII in the Basilica of Constantine (known in the Renaissance as the 'Templum Pacis'). They were both drawn on the same sheet by Francisco de Hollanda (183a) with the colossal fragments that belonged to them; a bronze hand from the Lateran is also in the Palazzo dei Conservatori (Stuart Jones, 1926, p.174, no.9), and was drawn below the bronze head together with the fragments belonging to the marble colossus.

These colossal fragments, the river gods (64–7), and the Dioscuri (125) provided Renaissance artists with outstanding examples of monumental scale.

HISTORY: Documented by medieval sources as part of the antiquities at the Lateran Palace (Mirabilia in Valentini and Zucchetti, CTR, III, p.196; Magister Gregorius, CTR, III, pp.149–50; Graphia Aureae Urbis, CTR, III, p.90; Memoriale de Mirabilibus, CTR, IV, p.85). Brought to the Palazzo dei Conservatori from the Lateran by 1489; in the portico of the Palazzo until 1595.

INTERPRETATIONS: In the Renaissance the bronze head was thought to represent Nero or Commodus (Stuart Jones, 1926, pp.173–4); in the Middle Ages, it was described as the sun god (Scherer, 1955, pp.135–6, 392; Bush, 1976, pp.59–60).

REPRESENTATIONS:
- Felice Feliciano, c.1457–65, Modena, Bibl. Estense, Cod. α L.5, 15, f.31ᵛ (see above, 176): colossal hand holding a globe, and colossal head on columns with the bronze equestrian Marcus Aurelius.
- Heemskerck, Skb. I, f.45a (Scherer, 1955, pl.216): in situ with river gods in front of portico of Pal. dei Conservatori.
- Francisco de Hollanda, Skb., f.30 (183a): head and hand 'ex aere' on right (see DESCRIPTION).

LITERATURE: History and bibl. in Stuart Jones, 1926, who considers the portrait to be one of Constantine's sons, possibly Constans I. For more recent identifications, Winner, 1967, cat.2, pl.1 (discussed in connection with a view by Heemskerck of the Campidoglio: Skb. II, f.72); Helbig, II, cat.1578 (von Heintze, as Constantine; discusses other identifications). For a Renaissance interpretation as Commodus, see Biondo, Roma instaurata III, 46 in Valentini and Zucchetti, CTR, III, pp.149–50.

OTHER COMMEMORATIVE CONSTANTINIAN PORTRAITS KNOWN IN THE RENAISSANCE:
- Colossal marble head of Constantine the Great (seen on left in 183a) from Basilica of Constantine,

found in time of Innocent VIII; to Pal. dei Conservatori in 1489; known as Commodus, Domitian, Nero and Apollo (Buddensieg, 1962, pp.37f., esp. n.37; Stuart Jones, 1926, pp.5–6, no.2; pl.1).
- Four cuirass statues of Constantine the Great and his sons, from Baths of Constantine on Quirinal, were described in the mid 15th century by Biondo and Muffel (CTR, IV) near the Dioscuri (125). Only three are still traceable in the Cinquecento; they were moved to the Campidoglio in 1538. Two are now on the Campidoglio balustrade; the third is in the entrance to the Lateran basilica (von Heintze, 1979, for Renaissance sources and drawings).

SYMBOLIC FIGURES

The following miscellaneous statues and reliefs, like so many others in Antiquity, had the power to convey a meaning beyond their visible form. Thus the She-Wolf, the Eagle in an Oak Wreath, and the River Gods (64–7), carried patriotic and Imperial messages to the Roman people.

The Pine-cone, Peacocks, Griffins and Dolphins, all from separate antique monuments, were brought together in the early Middle Ages, and symbolized, in Early Christian as in Imperial Rome, aspects of immortality.

The statue of the Genius is a personification of the daimon, tutelary spirit, or guardian angel of an individual who protected him from birth. Not only did each Roman and emperor have his own genius, there was also a collective one, the genius populi romani, as well as the genius loci. Later artists took up the theme of the individual genius; a well-known example is an engraving by Salvator Rosa of his own genius.

Two figures among others elsewhere in this book, belong to this category: one is the female personification of an individual's Virtus, represented with the short hunting chiton and buskins of an Amazon or Diana (189), with the addition of a helmet (111, 167). The other is the symbolic figure of Roma, who appears either clad like Virtus, as in the Antonine Adventus relief on the Arch of Constantine (Ryberg, 1967, fig.19; 182d–i, Perrier), and in the relief of Victory Crowning Trajan

(158i), or in long robes, wearing a turreted helmet, as in the *Gemma Augustea* (168).

LITERATURE: Brilliant, 1974, pp.206–8 for Roman use of Greek emblematic types; Gombrich, 1971, on the value of personifications.

184. The 'Capitoline Wolf' (Lupa Capitolina)

Mid-Italic bronze statue, 5th century B.C. (Alföldi, 1977)

Rome, Palazzo dei Conservatori (Stuart Jones, 1926, pp.56–8, Sala dei Fasti Consolari, no.1)

DESCRIPTION: The date, sources and reconstruction of the bronze wolf have been much discussed (Helbig, II, cat.1454, Simon), but scholars tend to agree that the bronze wolf known in the Middle Ages at the Lateran was independent of the suckling twins in Antiquity, in spite of its heavy dugs. Renaissance antiquarians, however, knew the passage in Cicero's *In Catilinam* III, 8, 19, which referred to a bronze group of the wolf with the twins, Romulus and Remus, on the Capitoline Hill, which had been struck by lightning in 65 B.C. and torn from its base, leaving the feet attached. It may have been the traces of fire on the underbelly and hind legs of the Lateran Wolf which encouraged Pope Sixtus IV to identify it with the one described by Cicero, and probably then to have it restored with the twins when it was brought to the Campidoglio in 1471.

The archaic bronze wolf, powerful symbol of the origins of Rome as she was, did not appeal to Renaissance artists; the antiquarian Pirro Ligorio pronounced her *goffo*, awkward and clumsy (Buddensieg, 1969, p.218, n.17). The artists preferred the more naturalistic antique representation of the wolf turning her head towards the suckling twins. Such representations were to be found on funerary altars, and as the attribute, instantly recognized, of the river god Tiber, when the colossal statue was discovered in 1512 (66). The legendary origin of Romulus and Remus is represented in the sarcophagus relief of Mars and Rhea Silvia (25), and although that scene was not recognized in the Renaissance, the twins appear with the wolf on an end of the sarcophagus.

The motif of the she-wolf suckling the twins who were to be the founders of Rome was also a civic symbol of the Commune of Siena which boasted Roman origins. Siena was believed in the 15th century to have been founded by the two sons of Remus, Senio and Aschio.

HISTORY: Magister Gregorius reported that the bronze was under the portico of the papal winter palace at the Lateran (late 12th century), and that previously it had been in the square as a fountain; its feet were still attached to the base outside (Valentini and Zucchetti, *CTR*, III, pp.166–7; cf. Cicero, above). He recognized it as 'a bronze image of that wolf which is said to have fed Remus and Romulus'. In 1471 it was among the bronzes donated Pope by Sixtus IV to the city of Rome, and was probably then installed on the façade of the Palazzo dei Conservatori over the central bay of the portico (Müntz, 1878–82, III, p.171 for payment for building the place for the *luppa aenea apud eorum palatium*; seen *in situ* with twins in Heemskerck's view, *Skb.* II, f.72). So it may have been in 1471 that the bronze twins were added. Although Venturi (1919, pp.133–5) believed them to be the work of A. Pollaiuolo, the attribution remains unconfirmed. The twins were recorded by Albertini (1510, II, p.Qi^v = 61^v). The wolf was brought inside the Palazzo by 1544 and installed in the newly-built first floor in the Sala della Lupa (Stuart Jones, 1926, p.57, details of history).

REPRESENTATIONS:
- Giovanni Turino, bronze statue, c.1430, Siena, Pal. Pubblico (Del Bravo, 1970, figs.143–7): adaptation of wolf with head straight forward, and with twins.
- Italian, late 15th or early 16th century, bronze, Washington, D.C., NGA, Kress Collection, A.155 (Pope-Hennessy, 1965, fig.533, cat.531; Sheard, 1979, cat.17): copy with twins, ears shorter; cf. bronze statuette (Pope-Hennessy, 1965, fig.534, cat.532).
- Central Italian, early 16th century, bronze statuette, Amsterdam, Rijksms. (Weihrauch, 1967, fig.44): more naturalistic interpretation of wolf with twins.
- Heemskerck, *Skb.* II, f.72 (Winner, 1967, cat. and fig.2): view of Piazza del Campidoglio from north, showing wolf over central portico of façade of the Pal. dei Conservatori.
- Engraving for Lafréry's *Speculum*, 1552 (Hülsen, 1921, cat.47a).
- Franzini, woodcut, 1599, pl.DD8.

LITERATURE: Michaelis, 1891, *RM*, VI, pp.8, 12, 14, 30, 45 (history at Pal. dei Conservatori). Alföldi, 1977, pp.1–11 (origins and date of antique bronze). E.Strong, 1937, pp.475–501 (examples of the motif in Renaissance art, and expressing the wish, on p.501, that the twins be removed so that wolf could resume its historic and symbolic role as *Mater Romanorum*). Dulière, 1979, II, cat.1 with bibl.; Haskell and Penny, 1981, cat.93: 'The Wolf'.

185. Lion Attacking a Horse

Fragment of colossal Hellenistic group
Rome, Palazzo dei Conservatori (Stuart Jones, 1926,
pp. 249–50, Giardino, no. 100)

DESCRIPTION: The lion, pouncing upon the back
of the fallen horse, tears furiously at his victim's
flank with claws and fangs. In the Renaissance, the
group was a compact fragment, the horse a torso,
the lion without projecting parts. Artists had ac-
cess to it on the Campidoglio, and the fragment
offered them the freedom of their reconstructions.

The group was vigorously described by 'Prospet-
tivo Milanese' (stanza 64 in Fienga, 1970, p. 47), and
Aldrovandi wrote that it was 'of such excellence
that Michelangelo judged it to be most marvellous'
(1556, p. 270).

In 1594, Ruggiero Bescapè restored the head,
neck, legs and tail of the horse, and the hind legs
and tail of the lion (Lanciani, 1902–12, II, p. 93).

The motif of animals fighting goes back to the
origins of art. The group is thought to be a Roman
copy from a work of the late Pergamene school.
Motifs of various animals attacked by lions were
also carved in late Roman sarcophagus reliefs, and
were later adapted in Romanesque portals, and
drawn by Jacopo Bellini, and Uccello. Later still the
theme was taken up by Wilson and Stubbs. (For
ills. of late representations, see Sutton and Cle-
ments, 1968, cat. 16.)

HISTORY: The fragment was on the Campidoglio,
perhaps as early as the mid 13th century; first
documented in 1347 as on the steps in front of the
Palazzo dei Senatori, or Palace of Justice, known as
the *scale al leone*, or *scale della giustizia*, where death
sentences were read out. The group remained
there, as seen in Heemskerck's views (*Skb.* I, f. 61,
see below; *Skb.* II, f. 72, see Winner, 1967, cat. and
fig. 2). It was removed during the rebuilding of the
staircase in the late 1540s and transferred to the
northeast side of the Piazza (Egger, 1931, II, pl. 3,
see below). Restored by Bescapè in 1594, it was
removed to the Palazzo dei Conservatori and is
now part of a fountain in the garden behind the
new museum. For details of history, see Michaelis
(1891, *RM*, VI, pp. 6–10, 28, 49; Winner, 1967, cat. 6).

REPRESENTATIONS:
– Jacopo Bellini, London, BM *Skb.*, f. VII^V (Goloubew,
 1912, I, pl. IX): 'restored', lion reversed.
– Milanese or Bolognese, end of 15th century, Berlin-
 Dahlem, Kupferstichkabinett, KdZ 25020 (Winner,
 1967, cat. and fig. 6): group unrestored, ventral view
 of horse, no base (185a).

– Aspertini, c. 1500–3, New York, MMA, Rogers Fund
 19.151.6^V: 'restored'; (for recto see 27).
– Aspertini, London, BM *Skb.* I, f. 48^Vb (Bober, 1957,
 fig. 103 and p. 76): 'restored'.
– Heemskerck, *Skb.* I, f. 61: *in situ* on base within left-
 hand corner of old staircase leading to portico of
 old Pal. dei Senatori.
– Michelangelo, follower of, c. 1530–40, Oxford,
 Christ Church, 0790 (Byam Shaw, 1976, cat. 107):
 free adaptation with animals facing in opposite
 directions, the lion on top.
– A. Scultori ('Ghisi'), engraving, Bartsch, XV, p. 429,
 no. 107, pl. 74 (Bober, 1957, fig. 101): 'restored'.
– Italian?, after 1522, Brunswick, Kupferstichkabinett
 (Egger, 1931, II, fig. 3): view from Pal. dei Conserva-
 tori across Piazza showing the fragment on low base
 before the niche in the wall under the flank of
 S. Maria in Aracoeli.
– Central Italian, 16th century, Princeton Univ. Print
 Room, 53–88 (Gibbons, 1977, cat. and pl. 746):
 'restored'.
– Dosio, Florence, Uffizi, 91A^V (Borsi *et al.*, 1976, cat.
 and fig. 138): sketch with hind quarters of horse
 'restored'.
– Engraving for Lafréry's *Speculum* (Quaritch, cat. 277).
– G. Susini, bronze statuettes, after models by Giam-
 bologna, in Detroit, Inst. of Arts; Rome, Pal.
 Venezia; Vienna, Kunsthist. Mus., etc. (Avery and
 Radcliffe, 1978, cats. and figs. 170, 172, and 174 with
 other examples and bibl.): variations reconstructing
 the unrestored group.
– Cavalieri, I–II, pl. 79.
– Goltzius, '*Skb*'., Haarlem, Teyler Mus., K III 19
 (Reznicek, 1961, pl. 149): unrestored with corner of
 base; see *ibid*. (cat. 220) for other Dutch and Flemish
 representations.

LITERATURE: Winner, 1967, cat. 6 (with earlier lit-
erature); Helbig, II, cat. 1793; Haskell and Penny, 1981,
cat. 54.

186. Eagle within an Oak Wreath

Trajanic relief
Rome, SS. Apostoli, Portico

DESCRIPTION: In Rome, the eagle, symbol of Ju-
piter's domination of the skies, was adopted as a
symbol of supreme imperial power and apotheosis.
During the Republic, an eagle with wings out-
spread, made of precious metal, and surmounting
a tall pole, was carried by each legion as its own
divine protector *(proprium legionis numen)*. The oak
wreath was used by the Romans as a military
honour awarded to a soldier who had saved the
life of a citizen *(corona civica)*.

The eagle in the portico of SS. Apostoli has been described by Eugenie Strong as 'the supreme message of Trajanic art' (1907, p. 230). The relief shows the eagle standing frontally on the lower part of the wreath, with head in profile to the left, and outspread wings projecting on either side from behind the wreath, which is tied at the bottom with a ruched ribbon which flutters out on either side, contrasting, in its undulating movement, with the rigid wings above. The top of the wreath projects above the frame of the relief.

HISTORY: Giovanni Rucellai in 1450 admired an eagle under the pulpit of SS. Apostoli (Rucellai–Perosa, 1960, p. 74: 'et con una bella aquila sotto il pergamo di marmo') which is not certain to have been the one which Cardinal Giuliano della Rovere installed in the portico of the church which he began to restore c. 1474. The cardinal was the nephew of Sixtus IV, and in 1503 became Pope Julius II whose collections of antique sculpture formed the nucleus of the Belvedere Sculpture Court which he installed in the Vatican. His coat of arms was the oak tree (rovere), and his interest in the eagle linked an early enthusiasm for antique sculpture with his own emblem. He 'saved' the eagle in the oak wreath 'from so many ruins' and installed it where it is now, according to the inscription which runs below the relief: 'TOT. RUINIS. SERVATAM. IUL. CAR. SIXTI.IIII.PONT.NEPOS.HIC.STATUIT' (Weiss, 1961, p. 36).

The credible tradition that the relief came from the nearby Forum of Trajan is without evidence (Hülsen and Egger, 1913–16, I, p. 10).

REPRESENTATIONS:
– Benozzo Gozzoli, Stockholm, Nationalmus., inv. 88 (Degenhart and Schmitt, 1968, cat. 411 as original drawing by Gozzoli directly of relief, pl. 319b): unframed, ends of eagle's wings cut by edge of sheet; tail feathers seen behind and below wreath at bottom right (**186a**). Cf. Fra Angelico, *St. Lawrence before Decius*, fresco, Vatican, Chapel of Nicholas V (Greco, 1980, colour pl. VI, p. 37): eagle in wreath in frieze above throne.
– Luciano Laurana, Urbino, Pal. Ducale, marble friezes of eagle, wreath and ribbons throughout the palace (Rotondi, 1961, fig. 94 and *passim*).
– Heemskerck, *Skb.* I, f. 16: quick sketch of eagle, wreath barely indicated.

LITERATURE: E. Strong, 1907, p. 230; 1915, pp. 181–7, on symbolism of the eagle.

187. Pine Cone ('Pigna'), Peacocks and Griffins

Bronze colossal pine cone from Roman fountain, 1st century A.D.
Pair of gilt bronze peacocks, 2nd century A.D.
Vatican, Giardino della Pigna (Amelung, *Kat.*, I, pp. 896–904, no. 227, pine cone; pp. 894–6, nos. 225–6, peacocks)

DESCRIPTION: The giant pine cone, over three and one half metres high, is of a Hellenistic type, perhaps associated with the worship of Bacchus, the Bacchic *thyrsos* (wand) having a pine cone at the top. The pine tree itself was a symbol of Attis, signifying regeneration. For the Romans the pine cone may have symbolized generation and resurrection (E. Strong, 1915, p. 195), and for the Christians who brought it to the forecourt of St. Peter's in the early Middle Ages, the pine was the Tree of Life (*arbor vitae*; discussed by Hülsen, 1904).

The elements of the fountain set up in the forecourt, as described from the 12th century to the Renaissance, consisted of a tabernacle of Early Christian type with a Greek-cross vault, covered with gilt bronze tiles, resting on eight porphyry columns, one under each of the four corners, and one in the middle of each side. The columns supported a straight entablature on which perched a pair of gilt bronze peacocks, their heads crossing in opposite directions; a second pair is thought to have existed on the opposite side. There were two late antique portrait busts on the columns with laurel crowns and cuirasses which are now in the Louvre (MA 1068–9), known as 'Les Deux Philippes'.

In Greek mythology the peacock became the attribute of Juno, and was used by the later Roman emperors as a symbol of eternity and apotheosis, a concept adopted by Early Christians.

From the four corners of the entablature, bronze dolphins seemed to spring from the cornice into space. As conveyors of the soul to the Other World, they too were symbols of rebirth and eternity.

The giant pine cone filled the space within the tabernacle, and was fenced in on four sides by low marble panels, now lost, each carved with a pair of symmetrically-confronting griffins, seated, with a fore-paw lifted towards the candelabrum between them, 'symbolic of the sun-like omnipresent majesty of the Emperor' (Vermeule, 1957, p. 235). The griffin, with head and wings of the eagle, and body of the lion, combined the most powerful creatures of sky and land. It was a creation of the most ancient

Orient, and in Greece the mascot of Apollo and guardian of treasure. In Rome it was, from the time of Augustus, associated with the emperor. It was widely used as a decorative motif in Antiquity and in periods of classical revival.

HISTORY: The pipes inside the pine cone and holes in its surface, which produced musical sounds in the wind ('Prospettivo Milanese', stanzas 55–6; Fienga, 1970, p.46), also indicate its use as a fountain. It gave its name Pigna to one of the regions of Rome (Rione Pigna) where it was discovered in the early Middle Ages near the Temple of Isis and Serapis, not far from where the river gods Nile and Tiber (66, 67) were found much later.

The pine cone was brought to the forecourt of Old St.Peter's even before the time of Pope Symmachus (late 5th century), and was first described as a fountain in the *Mirabilia* (c.1140). The 'Cantharus', as the tabernacle was called, remained intact with all its components from the early Middle Ages until 1574, when the griffin reliefs were removed. In 1605, the remaining elements were dismantled when Pope Paul V destroyed the forecourt for the rebuilding of the nave of St.Peter's. The pine cone and peacocks were taken to the Vatican Belvedere. The pine cone is now on a figured capital discovered in the 17th century, flanked by the peacocks.

INTERPRETATIONS: Opinions varied in the Middle Ages and Renaissance, and even now, as to the original location of the pine cone in Antiquity. According to one early version, it was set up as the pinnacle of the dome of the Pantheon (cf. Benozzo Gozzoli's lost fresco in Pisa, Campo Santo, as Hülsen, 1904, pointed out), and struck by lightning or a high wind, landed in the square still called the Piazza della Pigna near S.Stefano del Cacco (see below, Lafréry). The peacocks are still thought to have decorated the railing enclosing the Mausoleum of Hadrian (Castel Sant'Angelo). In the Middle Ages and Renaissance, the forecourt, or atrium, of Old St.Peter's was known as the *Paradiso*, in which the Cantharus was a fitting centre piece.

REPRESENTATIONS:
- Matteo Civitale, marble relief, Lucca, Duomo, monument of Pietro da Noceto, c.1467–72 (Pope-Hennessy, 1971, fig.63): griffin reliefs copied on centre of base, adapted to decorative frieze with addition of garlands.
- Cronaca, attrib., Florence, Uffizi, 1578ᵛ (187a; Hülsen, 1904, pl.V, 1): Cantharus with elaborated

ornament. Bust attached to inner surface of a column.
- Cod. 'Coner', f.160 (Ashby, 1904, pl.160; 1913, p.210): a griffin in profile to right.
- *Cod.* Escurialensis, f.59, 1: griffins flanking candelabrum.
- Francisco de Hollanda, *Skb.* f.26ᵛ: whole Cantharus with scale figure.
- Dosio, lost drawing, c.1565, Florence, Uffizi, 2555A (Hülsen, 1904, fig.1): view of forecourt with Michelangelo's cupola in construction. Cantharus without the griffin reliefs (see also Acidini in Borsi *et al.*) 1976, cat. and fig.139 with list of dependent ills. in 16th century and later guide books).
- Engraving in Lafréry's *Speculum* (Quaritch, cat.313; copied by Andrea della Vaccaria, 1600) both with text: *molti credono che questa Pina fosse tolta de la mole di Adriano Imp.* (Castel Sant'Angelo) *la quale Simmaco Papa ne fece fare una fontana, dentro il Cortile di S.Pietro, dove hoggi risiede, detto il Paradiso facendola ornare con q(u)esti pauoni et delfini, opera antica, et questo fece per comodità de'forestieri, et peregrini che in quel tempo uenivano a visitare quella sacrosanta Basilica.*
(Hülsen, 1904, p.92, no.7, and fig.3.)

LITERATURE: *Pine Cone*–Hülsen, 1904, lists and illustrates other later 16th century representations, interpretations and history; Alfarano–Cerrati, 1914, pp.108–9, n.4 (for plan, no.116, and description made prior to destruction of the forecourt in 1605); E. Strong, 1915, p.195 (for symbolism); Helbig, I, cat.478. *Peacocks*–Helbig, I, cat.479. Debbie Glovin, Univ. of Calif., Santa Cruz, is preparing a book on the history of the symbolism of the peacock in art. *Griffins*–Simon, 1962, pp.749–80.

188. Genius
Colossal Roman statue, over four metres high
Naples, Museo Nazionale (Ruesch, 1911, cat.37)

DESCRIPTION: The colossal figure has its own head, the curling hair framing a face of remarkable serenity. The *genius* wears the short tunic of the *camillus*, draped by a short mantle tucked into a roll of material above the waist. What fascinated the Renaissance artists particularly was his very elaborate footgear consisting of laced sandals and buskins decorated with the mask of a lion at the front, and an acanthus leaf curving around the heel.

The statue had lost the forearms below the sleeves and with them the attributes. It was restored after the Renaissance with the customary *patera*, and a bunch of laurel?, but may have originally carried a cornucopia, the attribute of the *genius*, which distinguished him from his human counterpart.

The *genius* was the divine protector of each individual, like a guardian angel, but was worshipped in cults when he protected groups, such as a family or corporation, or a place. The *genius* of the emperor was also worshipped in a cult, much as the *genius* of the paterfamilias was worshipped by his household.

The identity of this colossal *genius* (or *Lar?*) is not known.

HISTORY: The statue was in Rome even before it came to the Villa Madama (built c.1515–27), as it was first drawn in 1508–9. It was installed in a niche in the garden of the Villa Madama where it was drawn by Heemskerck (see below). It went with Farnese sculpture to Naples in the 18th century (Ruesch wrongly assumed that it was found during the Farnese excavations of the Baths of Caracalla in the 1540s).

REPRESENTATIONS:
- Gossaert (Mabuse), Leyden, Rijksuniv., Welcker Collection (**188b**; van Gelder, 1942, fig.1, pp.1–11; Pauwels *et al.*, 1965, cat.45 with bibl.): right foot on sketchbook sheet with Spinario (see **203**) etc.
- Italian, 16th century, (formerly attrib. to Andrea Mantegna), Besançon, Mus. B–A, D.1931 (Gernsheim, neg. no.14435): inner side of whole right foot and same foot in frontal view, faintly drawn above hatching.
- Raphael, attrib. male saint, c.1508–1511. Lille, Mus.B–A, inv. Pl.485 (*Raphaël dans les collections françaises*, 1983, cat.and fig.82): 'restored' with attributes of a standard and model of a town, possibly as St.Valerian, martyr of Forlì (**188a**).
- Marco Dente, engraving, Bartsch, XIV (undescribed): reversed view of whole statue from left, unrestored. Cf. engraving, copy by follower of Marco Dente, Bartsch, XIV, p.360, no.486.
- Heemskerck, *Skb.* I, f.58a: frontal view of whole statue, unrestored, with a shield; f.24d: view of terrace of Villa Madama on Monte Mario. The unrestored statue seen obliquely from left in an arched niche in garden wall; ff.31b, 65ᵛ: views of footgear of right foot and details.
- Francisco de Hollanda, *Skb.*, f.29: both feet in frontal view.
- Cambridge *Skb.*, f.54 (Dhanens, 1963, fig.20, cat.47): left foot seen from right.

LITERATURE: Rink, 1933, for various antique types; Callu, 1960, pp.9–16 (references to sources, definition, bibl.).

SACRIFICE

The sacrifice was a most important element in state and private religion and often appears in Roman historical reliefs, on arches and columns, on sarcophagi depicting the biography of a Roman general (**197**), or on funerary reliefs. Sacrifices in Roman religion were usually made to propitiate the gods before an undertaking such as a battle, expedition, hunt, or marriage ceremony; or to show gratitude for a successful outcome (**159**). The closely observed ritual of sacrifice, described in detail by Varro, Festus, and other authors cited by Biondo, was the most conspicuous rite through which men acknowledged the gods.

Animals sacrificed to the gods by Romans included the pig, the sheep and the bull; the combination of the three was the *suovetaurilia* (*sus-ovis-tauris*) (**190**). The formula used in many Roman reliefs and by Raphael and other artists in the Renaissance, of conveying the full size of the bull by showing it not in profile but foreshortened and head-on, had its source in a painting by Pausias, according to Pliny (*Natural History* XXXV, 126–7; McGrath, 1978, pp.259 to 261).

LITERATURE: Biondo, [1473–5], I; 1544, pp.21ᵛff. Brendel, 1930, pp.196–226 with list of representations of Pausias' formula in Roman reliefs known in the Renaissance. Ryberg, 1955, pp.1–5 for Greek background; *passim* for Roman representations.

189. Sacrifice to Diana after a Boar Hunt

Hadrianic tondo
Rome, Arch of Constantine

DESCRIPTION: Hadrian, larger than his three companions, stands to the right of a rustic altar placed before an image of Diana. The goddess of the hunt is shown wearing boots, and a short *chiton*. The head of the boar can be seen in the tree to the right as a trophy of the hunt.

HISTORY: Always visible.

REPRESENTATIONS:
- Jacopo Bellini, Pattern-book sheet, Munich, SGS, 1970:20 (Degenhart and Schmitt, 1972, fig.1): adaptation in different poses and shorter dress of

the four men; the one nearest the altar on the left pours a libation while on the opposite side, the 'emperor' holds out a *patera* over the altar. No background. Volutes and vases drawn below.

- Giuliano da Sangallo, Sienese *Skb.*, f. 24.
- 'Ripanda' skb., Oxford, Ashmolean, f. 47: 'restored'.
- Lambert Lombard, Album, D.263: with relief of *Wolf with Romulus and Remus* on the front of the altar.
- Dosio, Berlin *Skb.*, f. 24V: unrestored, in quick sketch of section of the arch.
- Pietro Testa, Pozzo skb., Florence, Uffizi, no. 227, in 6975–7135A (Conti, 1974–5, fig. 4): unrestored. Cf. Pozzo Windsor, I, f. 50, 8207 (*ibid.*, fig. 14; Vermeule, 1966, p. 11): unrestored, outer arms of figures missing, Diana without right forearm.

LITERATURE: Winner, 1967, cat. 36.

190. Sacrifice, Suovetaurilia Procession

Relief. Roman, Julio-Claudian
Paris, Louvre (MA 1096)

DESCRIPTION: A tall priest (whose face and right arm are restored, making it difficult to identify the emperor involved) stands, *velatus*, at a garlanded and fruit-topped altar assisted by incense bearer and *camillus* (see **192**). A second altar is slightly foreshortened, and laurel trees appear at the right edge of the relief–indicating that a second procession and sacrificer approached from that direction, marking the closure of the census (*lustrum*) by two censors, possibly Claudius and Vitellius in 47/48 A.D. (Ryberg). The main figure was often taken as female and so drawn during the Renaissance. Behind him in easy conversation, as in the Ara Pacis and the Claudian Ara Pietatis, follow other officials and the *victimarii* who will sacrifice the animals which are lined up in the foreground in ascending, ritual order: pig, ram, and bull.

HISTORY: Known in Rome at least by the end of the 15th century, the relief was probably in the collection of Cardinal Domenico Grimani at the Palazzo S. Marco (Venezia). As part of the Grimani gift of 1587, it was sent to the Library of S. Marco in Venice, where it was displayed over the door of the Statuario Pubblico below the inscription of donation (Perry, 1972, pl. 223, fig. 6, and p. 136 for Zanetti's inventory of 1736, no. 13). Under Napoleon it was appropriated in 1797 for the Louvre.

REPRESENTATIONS:

- Venetian, (Mocetto?), late 15th century, Paris, Louvre, inv. 56121: '*m..mar...fra...*', restored by Michon (see below, LITERATURE) as '*Messer Mario Fraiapane*', but this probably copies a replica in the Pal. Frangipane, rather than the relief itself (Bober, 1957, p. 46).
- Aspertini, Cod. Wolfegg, ff. 30V–1V: '*in lo gardino di santo marco*'.
- Aspertini, London, BM, 1905–11–10–2 (Bober, 1957, fig. 4; **190a**).
- Florentine, late 15th–early 16th century, Bayonne, Mus. Bonnat (Bean, 1960, cat. 252).
- 'Ripanda' skb., Oxford, Ashmolean, f. 51: the *togatus* at the altar drawn as a priestess (**190b**).
- 'Bambaia' Berlin *Skb.*, f. 7 (**190c**; Dreyer and Winner, 1964, fig. 28).
- Aspertini, London, BM *Skb.* I, ff. 1V, 9 (Bober, 1957, figs. 6 and 30).
- Giulio Romano or Polidoro (Denon, 1829, II, pl. CIII).
- Heemskerck, *Skb.* II, f. 4V: sow.
- Cod. Coburgensis, f. 62 (Matz, 1871, 29).
- Dupérac, Louvre *Album*, inv. 26470.
- Engraving for Lafréry's *Speculum*, 1553 (Hülsen, 1921, cat. 52A, citing the relief at S. Marco).

LITERATURE: Aldrovandi, 1558, p. 261 (Pal. S. Marco): '*si vede questo sacrificio depinto a punto come quivi è, in una camera terrena di M. Curtio Fraiapane*'; Michon, 1910, pp. 192ff. Ryberg, 1955, pp. 106–9. See p. 36.

191. Marcus Aurelius sacrificing before the Capitoline Temple

One of three reliefs from the lost Arch of Marcus Aurelius (**163, 167**)
Rome, Palazzo dei Conservatori (Stuart Jones, 1926, pp. 22–5, Scala II, no. 4)

DESCRIPTION: The climax of a triumph came when the *triumphator* reached the Capitoline Hill. He then dedicated the laurels from his *fasces* in the temple and sacrificed to Jupiter Optimus Maximus, thereby fulfilling the vows he had made before setting out on the military campaign.

On the relief, Marcus Aurelius is shown slightly to left of centre pouring a libation over the flames of a small tripod altar, a preliminary to the sacrifice of white oxen to Jupiter. The head of an ox appears behind the young *camillus* holding a box of incense and the flute player who stands to the left of the altar. The Capitoline temple with its characteristic triple doors is visible behind the emperor. The dignified bearded man who stands to the left of Marcus Aurelius is a personification of the Senate.

In the Renaissance the outside arms of the figures in the foreground of the relief were missing, and the legs of the tripod. The reliefs were restored in 1595 by Bescapè.

For HISTORY of the three reliefs, see **163**.

REPRESENTATIONS:
- 'Bambaia' Berlin *Skb.*, f.8 (Dreyer and Winner, 1964, fig.31): freely 'restored'.
- Aspertini, London, BM *Skb.* I, f.44 (Bober, 1957, fig.93): 'restored', flute player's hands raised in astonishment; other free interpretations.
- Francisco de Hollanda, *Skb.*, f.25ᵛ **(163b)**: unrestored; all three reliefs with Latin inscription recording Leo X's transference of the reliefs from S.Martina to the Conservatori in 1515.
- Girolamo da Carpi, follower of, London, BM, 1950–8-16-9 (Gere and Pouncey, 1983, cat.181): 'restored'.
- Polidoro da Caravaggio, attrib., Chatsworth, 130 (CI neg. no.307/11/7): priest and *camillus*, priest's missing arm 'restored' **(191a)**.
- Cod. Coburgensis, f.68 (Matz, 1871, 26): unrestored; cf. Cod. Pighianus, f.89 (Jahn, 1868, 40): 'in Capitolio'.
- Cod. Ursinianus, Vat. Lat.3439, f.87 (Stuart Jones, 1926, fig.1): unrestored; background and feet incomplete.
- Dupérac, Louvre *Album*, inv.26469 (Guiffrey and Marcel, 1910, V, cat.3930): unrestored.
- Pozzo Windsor, II, f.2, 8257 (Vermeule, 1966, p.14, fig.20): whole relief restored.
- Pozzo London BM I, f.107b, no.118 (Vermeule, 1960, p.16): without background; f.166, no.194 (*ibid.*, p.22): lower right detail.
- Perrier, 1645, pl.46: reversed, restored.
- Jan de Bisscop, London, Christie's Sale Cat., May 1, 1959, lot 3: figures in foreground only, restored (Phot. Cooper, neg. no.246084).
- P.Santi Bartoli–Bellori, 1693, pl.9.

LITERATURE: Ryberg, 1955, pp.157–8; 1967, pp.21–7. Bober, 1957, p.73 for list of drawings, history and discussion of date of transfer to Campidoglio. Haskell and Penny, 1981, cat.56. (See LITERATURE for **163**.)

192. Camillus ('Zingara')

Roman bronze statue, 1st century B.C. or A.D., based on 5th century pose (Robertson, 1975, pl.180b)
Rome, Palazzo dei Conservatori (Stuart Jones, 1926, pp.47–9, Sala de'Trionfi, no.3)

DESCRIPTION: A *camillus* was a youth who assisted in the performance of religious rites and ceremonies. To serve as a *camillus*, he had to be free born, perfect in form, and sound in health, with both parents living. He would wear a short belted tunic with long sleeves and have his hair carefully dressed, as here. Officiating priests would often choose their own sons under the age of puberty to serve as *camilli*.

The marvellously preserved bronze figure, with silver eyes, unrestored, except for the replacement of the left foot, may have once held the bowl and jug used for sacrificial rites. The boy is dressed in an ample but clinging short tunic with wide sleeves on which the stitching of the seams is represented. It is tied around his hips with a thin scarf. He wears simple heel-covering sandals secured by a 'T'-strap attached between the toes and around the ankle.

Representations of *camilli* are frequent in Roman reliefs depicting sacrifices **(191)**, but in the Renaissance, this bronze was thought to represent not a youth, but a gipsy girl. Another statue, almost identical, was described by Aldrovandi (1556, pp.274, and 192–3) in the Archinto Collection in Rome.

The calm stance and gesture are similar to those of the nude statues of Antinous **(128)**, and the bronze 'Idolino' discovered in 1530 (Haskell and Penny, 1981, cat.50).

HISTORY: Although not documented among the bronzes which came from the Lateran with Sixtus IV's donation to the Capitol in 1471, the statue was placed in an upstairs room of the Palazzo dei Conservatori with the Lateran Spinario **(203)**, and was there described by 'Prospettivo Milanese', shortly before 1500.

INTERPRETATIONS: 'Prospettivo's' stanza leaves room for speculation:

> … e una *zingara di magior varizia*
> *che non son quelle che fecel verochio…*
> (stanza 63).

Fienga (1970, p.47) translates:

> Nearby within eye range (of the thorn-puller)
> there is a gypsy showing greater greediness
> than those modelled by Verrocchio.

This interpretation is borne out by the gesture of the outstretched hand, but Buddensieg (1969, p.181) interprets '*varizia*' not as avarice, but as '*varietas*'.

Fulvio (1527, p.XXI) identifies the statue as a young person 'who stands in the dress of a servant' ('*giovani*', is the word he uses for the Spinario and

the Camillus in the room where the Conservatori give audience).

Aldrovandi (1556, p.274) thought the statue to be a female figure and says that the statue is popularly called 'La Zingara' because of the dress she wears.

REPRESENTATIONS:
– Heemskerck, attrib., Oxford, Ashmolean (Ashmolean Museum, *Report of Visitors*, 1957, p.61): back view from right (192a).
– Girolamo da Carpi, Rosenbach *Album* (Canedy, 1976, R37, above): as female figure without right hand (although right hand described by Aldrovandi).

LITERATURE: For the *camillus* figure in Antiquity, see Ryberg, 1955, p.21, n.10 and *passim*. Stuart Jones, 1926, cited above, summarizes the history of the statue in the Renaissance. Haskell and Penny, 1981, cat.16, note (p.169) that Benvenuto Cellini, in his autobiography, ranked it, and some of the great statues in the Belvedere, as 'the most beautiful things in Rome'.

193. Sacrificial Instruments and Naval Symbols

From the frieze of a Roman temple (dedicated to Neptune?)
Rome, Museo Capitolino (Stuart Jones, 1912, pp.258–63, nos.99, 100, 102, 104, Stanza dei Filosofi)

DESCRIPTION: Like the trophy pillars (175), the four fragments of friezes from S.Lorenzo fuori le mura offered a wide variety of representations of antique objects carved in careful detail, in this case showing the ritual instruments used in antique sacrifices, and certain naval symbols, ships' prows, and anchors. These were eagerly studied by the artists not only to learn about the details of objects employed in antique rites, and to use them as decorative motifs, but because, in certain cases, they could be considered as hieroglyphs to be studied for their messages from the world of Antiquity waiting to be decoded (Wittkower, 1977, pp.113–128, for further references).

These reliefs were not the only sources of sacrifi-

193

cial instruments for Renaissance artists. Some of the others were the small friezes of the passage of the Arch of the Argentarii (180) and a relief *'di stucco sotto terra'* (stucco, underground), copied by Aspertini (Cod. Wolfegg, f.22V, below; Bober, 1957, fig.31). (See Martindale, 1979, fig.174, and pp.173 to 174, for discussion and table showing incidence of the symbols in the various sources among which he includes a frieze from the Temple of Vespasian.)

HISTORY: According to the artist in Dosio's circle (see below), the friezes were built into the inside wall of the basilica of S.Lorenzo fuori le mura, and may have therefore been on view from the Middle Ages, although the earlier drawings date from the late 15th century. Later they were taken to the Palazzo dei Conservatori and are now in the Museo Capitolino (for history, drawings and literature, see Stuart Jones, 1912).

REPRESENTATIONS: *(Instruments identified by letter on Ill.* 193b)

– Mantegna, *Triumph of Caesar*, Hampton Court, Canvas IX, Caesar in Triumphal Chariot: adaptations, exact source unknown. Independent arrangement of sacrificial instruments on frieze of triumphal arch in background (Martindale, 1979, fig.43 and p.171 with diagram of Mantegna's emblems).

– Francesco Colonna, *Hypnerotomachia Polifili*, Venice, 1499, p.C (Wittkower, 1977, p.118 and fig.167): adaptation as Egyptian hieroglyphs or picture script.

– *Cod. Escurialensis*, f.43V(2) (Hülsen in Egger, 1906, pp.116f.): *'asanto lorenzo fuor delle mur'*, details from frieze.

– Aspertini, Cod. Wolfegg, ff.27V–8, below (Bober, 1957, fig.66; Robert, 1901, p.228): some of the implements wittily combined (cf. 193b: H on top of P) with additional vases, spindles, baskets of fruit, etc.; Stuart Jones (1926) was not convinced that Aspertini's drawings refer to the S.Lorenzo reliefs.

– Sebastiano del Piombo, *Portrait of Andrea Doria*, 1526, Rome, Pal. Doria Pamphili (Hirst, 1981, pl.124, p.106): on fictive marble frieze under portrait, the following naval trophies (cf. 193b): N, O, P, Q, R and S variant.

– Heemskerck, *Skb.* I, f.21 (193a; cf. 193b): view of S.Lorenzo with sacrificial instruments above Q, R, N, S, I, S; f.53: N, O, P, A, B, H, B etc.; f.58: details.

– Beatrizet, engraving, 1572, for Lafréry's *Speculum*, Bartsch, XV, p.265, nos.91 (193b) and 93; cf. Dupérac, Louvre *Album*, inv.26458 (Guiffrey and Marcel, 1910, V, no.3922).

– Dosio's circle, skb., f.60V (cf. Stuart Jones, 1926, pl.62, cats.107 and 105): *'questo è una fregiatura che sta dentro a S.Lorenzo fuor delle mura di Roma et è murata...'*; f.61V (cf. 193b, rows 3–4): *'questa fre-*

giatura è in san Lorenzo fuori delle mura in roma murato in detta chiesa'.

– 'Peruzzi' Siena *Skb.*, f.53V (Toca, 1971, pl.XXXVI): single figure 'P', cf. 193b, row 3.

– 'Pietro da Cortona' Toronto skb., 3 unpaginated folios.

LITERATURE: Biondo, *Roma triumphans* (c.1473–5), bk.I; Italian transl., 1544, pp.25–25V, description and function of the various instruments based on Cicero, Nonius Marcellus, Festus Pompeius and other ancient Roman sources. Crous, 1940, pp.65–77.

194A. Sacrifice to the Lares by Augustus
194B. Apotheosis of Julius Caesar

Augustan reliefs on an Altar of the Lares, erected at a crossroads in the late 1st century B.C. Vatican, Gabinetto dell'Apoxyomenos (Amelung, *Kat.*, II, pp.242–7, no.87b)

DESCRIPTION: The altar, rich in Augustan and Virgilian imagery, was of historical importance in Antiquity, as explained below. Its inscription to the Emperor Augustus as Pontifex Maximus and the son of the deified Caesar, was often copied in the Renaissance (see below, HISTORY).

The altar was carved on four sides, the two short sides representing Augustus' Sacrifice to the *Lares* (194A); and the portent of the Laurentine Sow (Virgil, *Aeneid* VIII, lines 42ff.) with the river god Tiberinus as a prophet seated on the left, while Aeneas leans on a staff before him, the Sow and piglets between them. The long sides show a Victory hovering over a round shield carved with the inscription supported on a pilaster between two laurel trees; and the Apotheosis of Julius Caesar (194B).

To judge from the drawings, the relief was damaged and badly worn in the Renaissance.

A–*Sacrifice and Commemoration of the Establishment of the Cult of the 'Lares Augusti':*

The Lares were believed to be spirits that guarded crossroads and homes. Augustus re-established the old cult of the *Lares compitales* at shrines at the crossroads in the city of Rome and combined it with the worship of his own *Genius* (cf. 188). The cult of the *Lares Geniusque Augusti*, in which plebs and freedmen participated, spread throughout Italy and the provinces.

The establishment of the cult is commemorated in this relief. Augustus is shown to the right accompanied by two of the four *vicomagistri* who

administer the cult. He is handing the statue of a Lar to one of the two *camilli* (see **192**) on the left, while the other has received the second Lar. The image of the *Genius Augusti* which should be in the emperor's left hand is now invisible.

B – *Apotheosis of Julius Caesar*:

Apotheosis, ascent to the gods, was not believed to be the usual fate of mortals in classical Antiquity, but divine status had been accorded to many Hellenistic monarchs from Alexander the Great on. The charismatic personality of Julius Caesar suggested that he was more than an ordinary human being, and the appearance of a new star in the sky after his death was taken by many to be proof of his apotheosis. Augustus, adopted son of Julius Caesar, encouraged this idea which made him into a *Divi filius* (son of a god) as he is called in the inscription on the altar.

In this relief, Caesar is shown as a semi-nude figure riding up into the heavens in a chariot drawn by four winged horses. Astonished onlookers stand on either side, probably Augustus to the left, and his wife, Livia, with two of their grandsons, to the right. Above, the Sun in his chariot and a personification of the heavens enveloped in clouds (to left and right respectively) converge to welcome the new god. The eagle of apotheosis was shown hovering in the centre of the relief, but now only traces of it can be detected. This earliest extant carved representation of an Imperial Apotheosis is discussed by E. Strong (1915, pp. 65–7).

HISTORY: The altar was in several private collections in the late 15th and early 16th centuries. It was first recorded by the epigraphers Fra Giocondo and Pietrus Sabinus, who copied its inscription, and later also by artists. Around 1500, it was recorded in the house of Maestro Andrea, the stone – cutter or sculptor (identified as Andrea Bregno who died in 1503). By 1517 it was in the house of Giulio Tamarozzi (as referred to by Mazochius in 1521) near the Pantheon. From the late 16th to the 18th century, it was in the Villa Madama on Monte Mario (*CIL*, VI, 876).

REPRESENTATIONS:
– Aspertini, Cod. Wolfegg, f. 46ᵛ, below, left (see Bober, 1957, p. 11): 'in casa de mestro andrea scarpelino'. Faint drawing of Relief **A**. Augustus gestures across altar towards two statuettes held one on each hand of a *camillus*; f. 47, below, right: inscribed as above, faint drawing of Relief **B**; f. 48ᵛ, below: inscribed as above, Laurentian Sow.
– Italian, before 1503, Chantilly, Mus. Condé, F.R. 24

(**194a**): sketchbook page with three herms, and the altar showing two sides with damages. Relief **B** with eagle, scarcely visible, seen frontally, head to left, and wings outspread in sky over *quadriga*; Relief **A** with three figures on left as priestesses. The one nearest to altar holds out a figure of a Lar. A second figure seems to float over altar; otherwise shown unrestored. Inscribed above (lines cut by edge of page): '*un pilastro che a da ogni canto op(ere) sta in casa di mastro andrea scarp(ellino) e chusa griffo*'(?). The herms are inscribed as being in the garden (*orto*) of '*maistro andrea scultor*' (see Appendix I and II: Bregno).
– Dupérac, Louvre *Album*, inv. 26458 (Guiffrey and Marcel, 1910, pl. 77, no. 3919): three sides – **A**, **B**, and the portent of the Laurentine Sow 'restored'.

LITERATURE: Ryberg, 1955, pp. 55–8; Helbig, I, cat. 255.

195A. Apotheosis of Sabina
195B. Adlocutio of Hadrian
Reliefs from a Hadrianic monument re-used in the late or post-antique 'Arco di Portogallo'
Rome, Palazzo dei Conservatori (Stuart Jones, 1926, p. 266, Scala VI, no. 11: Sabina; p. 37, Scala III, no. 1: Hadrian)

DESCRIPTION: **A.** After the Empress Sabina, wife of Hadrian, died in 136 A.D., her body was burned with due ceremony on the Campus Martius, but her spirit was supposed to have ascended to the gods. Apotheosis, by this time, had become practically routine for members of the Imperial family (see above, p. **194 B**).

The empress is shown borne up from the flames by a winged female figure carrying a torch, representing *Aeternitas*. A personification of the Campus Martius reclines to the left; Hadrian, with an attendant behind him, is shown seated to the right.

All the heads have been restored, but enough of the original relief remained to identify the head of Sabina, according to coin portraits.
B. On the other side of the archway, to the left, was a relief of the *Adlocutio* of Hadrian on a rostrum addressing an attentive crowd to the right. Wace (1907, pp. 258–63) believed that both reliefs originally decorated the base of a monument erected to commemorate the cremation of Sabina on the Campus Martius, and that Hadrian's speech was the funeral oration (*laudatio memoriae*) delivered at the cremation of his wife. (For the relief of Hadrian, see Helbig, II, cat. 1800.)

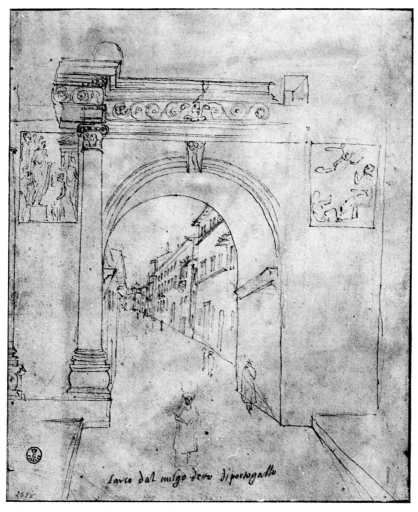

195a

HISTORY: The two reliefs were visible in the Middle Ages and Renaissance on either side of the late or post-antique pastiche known in the Renaissance as the 'Arco di Portogallo'. The arch was destroyed in 1662, and both reliefs were brought to the Capitol and probably then restored. For history, present location of components, early interpretations of the arch, and other drawings, see Lanciani (1897, pp. 503–5).

REPRESENTATIONS:
- Cristoforo di Geremia, *Allegorical Female Figure*, bronze plaquette, Washington, D.C., NGA, Kress Collection (Pope-Hennessy, 1965, fig. 20): adaptation in pose of Sabina.
- Giuliano da Sangallo, *Cod. Barberinianus*, f. 3: arch.
- Aspertini, *Cod. Wolfegg*, f. 47, below, right: **A**–'*in el archo acanto casa del cardinale de porpogrilo*'. Incomplete in places and very faint, Emphasis on

figures of Campus Martius, Hadrian and attendant behind him, all with heads 'restored', and the personification of *Aeternitas*. Sabina's head appears in profile above Aeternitas' wings; f. 46ᵛ: **B**–'*in nel arco icontro la chasa del cardinale de Portogallo*'.
- Dosio, Florence, Uffizi, 2528A (Acidini in Borsi et al., 1976, cat. and fig. 36): '*L'arco del vulgo detto di porto-gallo*' **(195a)**, cf. Dosio, 1569, pl. 28 **(Frontispiece)**: both reliefs on unrestored arch with 'Via Flaminia' in background.
- Pirro Ligorio, Turin, Archivio di Stato, vol. XIV (Lanciani, 1897, fig. 198): reconstruction of the arch with reliefs.
- Pozzo Windsor, I, f. 71, 8230 (Vermeule, 1966, fig. 15 and p. 12): **A** restored. Campus Martius with beard; f. 72, 8231: **B**.

LITERATURE: Toynbee, 1934, p. 245. Vermeule, 1953, p. 474.

MARRIAGE

Various types of Roman sarcophagi with scenes of marriage rites were known in the Renaissance. The culminating feature of the marriage ceremony was the *dextrarum iunctio* in which the bride and groom clasped each other's right hand, symbolizing concord. In representations of the *dextrarum iunctio*, a woman with head covered by a veil usually stands between the couple. A comparison with inscribed coin reverses shows that she is not Juno Pronuba as previously thought, but, in fact, a personification of Concordia.

The scene of *dextrarum iunctio* can be shown alone, as in the centre of certain strigilated sarcophagi, or combined with other scenes and figures. The famous sarcophagus in S. Lorenzo **(196)** has marriage as its dominant theme, combining the marriage rites with the sacrifice and attendant personifications of virtues, but this is not the case with another type of sarcophagus exemplified by one in the Uffizi **(197)**. Although the sacrifice and the *dextrarum iunctio* are represented, Rodenwaldt (1935) has shown that this type commemorates the life of a Roman General in scenes in which his virtues are represented, and that the marriage rite stands as a symbol of Concord.

LITERATURE: Flavio Biondo's detailed description in *Roma triumphans*, bk. VIII, of the Roman marriage ceremony, and the rites which precede and follow the *dextrarum iunctio*, is culled from a number of classical sources, and provided a basis for Renaissance and later knowledge of the subject (Biondo, 1544, pp. 279–85). Kötting, 1956, for bibl., and on individual works of art representing marriage; Reekmans, 1958, pp. 23–95; pls. I–XVI.

196. Marriage Ceremony

Roman sarcophagus, 164–82 A.D. (Fittschen, 1971)
Rome, S. Lorenzo fuori le mura (Matz and Duhn, II, cat. 3090)

DESCRIPTION: This sarcophagus was much drawn and engraved in the Renaissance and later. It had been incorporated, in the 13th century, into the splendid early Cosmatesque wall tomb for Cardinal Fieschi, the nephew of Pope Innocent IV, where it is still visible in the basilica (Hutton, 1950, pl. 48).

The lid, flanked by Oceanus masks, represents the Sun *(Sol)* in his rising *quadriga*, the river god Oceanus reclining under the horses' hooves while, on the right, the Moon *(Luna)* declines with her two plunging horses. In the centre is Pluto flanked by Ceres and Proserpina, and the Dioscuri, here possibly representing the morning and evening stars between the realms of light and darkness.

The front is carved with four draped allegorical figures on the left, the marriage ceremony of *dextrarum iunctio* on the right with attendants, and in the centre the priest and his assistants with the sacrificial ram, and a *tabula ansata*, left blank for an inscription, raised on four columns. The figure on the left wearing a turreted head - dress and carrying a cornucopia is characteristic of the Tyche *(Fortuna)* of a city or province; various interpretations have been offered for the other figures who may represent *Honos* (a male figure of *Virtus*), and the Horae of Spring and Summer, or *Pietas*. The figure with the upward floating garland was most elegantly engraved separately by Marcantonio Raimondi, as were five other figures from the front and right ends. Between the bride and groom stands the personification of Concordia (thought by the 17th century antiquarian Bellori to be Juno Pronuba who presides over weddings). A little *genius* of marriage stands with the lighted torch below the couple's clasped hands.

The left end is carved with three figures with the pig to be sacrificed to the Lares; on the right end are three graceful female figures, the one on the left holding an open incense box, the central one with incense burner, and a banjo-shaped mirror held by the maiden on the right (Reinach, *Rép. Rel.*, III, p. 320, 3 and 4; right end reproduced by Becatti, 1969, fig. 63).

HISTORY: See above.

REPRESENTATIONS:
- Marcantonio Raimondi, engravings of six female figures, each as a statue in a niche. *Front*: Tyche (Bartsch, XIV, p. 214, no. 275); figure with floating garland **(196a**; Bartsch, XIV, p. 213, no. 272; Becatti, 1969, fig. 61); figure with doves (Bartsch, XIV, p. 213, no. 274). *Right end*: figure with incense casket **(196b**; Bartsch, XIV, p. 213, no. 273; Becatti, 1969, fig. 62); figure with incense burner **(196c**; Bartsch, XIV, p. 214, no. 276); figure with mirror **(196d**; Bartsch, XIV, p. 212, no. 268; Becatti, 1969, fig. 66).
- Girolamo da Carpi Workshop, Bonn, private collection (Horster, 1975, fig. 1): lid reversed, unrestored.

- Cod. Coburgensis, f.35 (Matz, 1871, 234): front un-
restored; f.105 (*ibid.*, 235): lid, left through part of
Luna, unrestored; f.177 (*ibid.*; Horster, 1975, figs.6
and 3a–b): Luna; cf. Cod. Pighianus, f.330 (Jahn,
1868, 221): front, with legs of little *genius* 'restored';
f.298 (Jahn, 1868, 221; Horster, 1975, figs.7 and 4):
lid; Luna in *quadriga* drawn separately below;
above, Greek inscription 'TŌN THEŌN'.
- Dosio, Berlin *Skb.*, f.46 (Horster, 1975, fig.5): '*questo
Pillo è in s. lorenzo fuor de le mura, et è una sepoltura
d'un vescovo*'. Whole lid and most of front, un-
restored, cutting through bride on right; f.39:
ends, no damages recorded; left end: **(196e)**.
- Cod. Ursinianus, Vat. Lat.3439, f.90: centre and
right of front unrestored.
- Dupérac, Louvre *Album*, inv.26473 (Guiffrey and
Marcel, 1910, V, pl.78, no.3936): whole sarcophagus
with lid unrestored.
- Pozzo Windsor, V, ff.27–8, 8510 (Vermeule, 1966,
fig.110): front unrestored; f.28a–b, 8511 (*ibid.*, p.33):
both ends intact; VIII, f.27, 8728 (*ibid.*, p.50 with
reference to 18th century Tresham Album): lid un-
restored.
- Pozzo London BM I, f.71, no.79 (Vermeule, 1960,
p.14): front 'restored'; f.85, no.95 (*ibid.*, p.15): lid.
- Perrier, 1645, pl.18: reversed, front 'restored'.
- P. Santi Bartoli–Bellori, 1693, pl.58: front restored.
Various copies of Bartoli's engravings exist: cf.
Edinburgh, NG, D.3203 (Andrews, 1968, fig.118);
Felice Giani, Skb., Faenza, Mus. Civico (Sotheby Sale
Cat., London, April 17, 1980, lot 91, illus.); the most
outstanding copy of Bartoli's engraving is a forgery
of the marble sarcophagus from Sarreguemines in
the Mus. Historique Lorrain (Massing, 1979, pp.15–
18, fig. on p.17).

LITERATURE: Fittschen, 1971, pp.117–19 with an
Antonine interpretation.

197. Biography of a Roman General with Marriage Ceremony

Roman sarcophagus, 2nd century A.D.
Florence, Uffizi (Mansuelli, 1958, I, cat.253)

DESCRIPTION: Like other sarcophagi of the type
(see below), the reliefs on the front and ends re-
present events in the life of a Roman general who
is portrayed with the features of the deceased. Ac-
cording to Rodenwaldt (1935), the scenes exemplify
the general's Clemency (to a barbarian family),
Piety (sacrifice), and Concord (marriage), the com-
ponents of his *Virtus*. These scenes are represented
on the front of this sarcophagus, with a bear hunt
on the left. The left end shows an orderly putting
on the general's greaves (Mansuelli, 1958, I,
pl.253b); and the right end has been called 'The

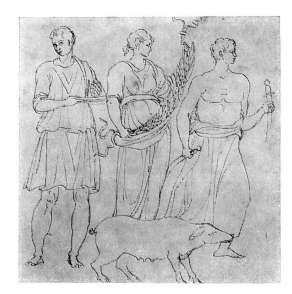

196e

Education of a Child in the Presence of the Muses'
(*ibid.*, pl.243c).

The sarcophagus was restored in the 18th cen-
tury. In the Renaissance the dogs' heads from the
hunt scene were missing, and also the head, hand
and attribute of *Virtus* (the female figure behind
the general in the scene of Clemency, restored as a
Victory), and the right hand of the sacrificing gen-
eral and other less important parts. The Renaissance
artists 'restored' what was missing in their draw-
ings, but a 17th century drawing in Windsor shows
the sarcophagus unrestored.

HISTORY: Known at the end of the 15th century in
Rome; probably in the della Valle Collection, as in
the 17th century it was in the garden of the Villa
Medici (P.Santi Bartoli, 1693). It was brought to
Florence in 1784 and was probably restored by
F.Carradori shortly before.

REPRESENTATIONS:
- Florentine, end of 15th century, Paris, Louvre, 2694
(Horster, 1975, fig.11a): 'restored', *Virtus* restored
with a lamp or trophy on a staff. General wears
fringed mantle as in relief, but also fringed boots
which is the only detail in any of the drawings which
could refer specifically to the similar relief in Man-
tua (see below; 'OTHER EXAMPLES'), but the left hand
of the general sacrificing holds up his drapery, un-
like the corresponding hand in Mantua which holds
a staff. Other figures could refer to either relief.
- Florentine?, end of 15th century, Oxford, Christ
Church, 0023 (Byam Shaw, 1976, pl.32, cat.42):

same selection of figures as above, but by different hand.

- Milanese or Bolognese, end of 15th century, Berlin-Dahlem, Kupferstichkabinett, KdZ 11 843 (Winner, 1967, pl. 39, cat. 70): 'restored'. Left end with hunt from front as single scene.
- *Cod.* Escurialensis, f. 28 (Horster, 1975, fig. 10a): 'restored'. The general holds his hand over the fire on the altar as if to warm it, and gathers drapery in left hand as on the relief.
- Bambaia, c. 1515, Berlin-Dahlem, Kupferstichkabinett, KdZ 1536: 'restored'. Clemency and Sacrifice scenes from front (Dreyer and Winner, 1964, fig. 27, cat. 32; see also Winner, 1967, cat. 71 for further discussion: the drawing is not part of 'Bambaia' sketchbook, and seems to have been drawn not from the relief itself, but copied from another drawing).
- Cirro Ferri, Oxford, Christ Church, 0829 (Byam Shaw, 1976, pl. 360, cat. 649): 'restored' front.
- Pozzo London, BM I, f. 71, no. 78 (Vermeule, 1960, p. 14; mid 16th century hand?): omits hunt, 'restored' front, general holds *patera* over altar; f. 42, no. 51 (*ibid.*, p. 12): right end 'restored'; f. 108, no. 119 (*ibid.*, p. 16 as 16th century): left end 'restored' with mounted huntsman from front; cf. Pozzo Windsor, V, f. 30, 8513 (Vermeule, 1966, p. 34).
- Pozzo Windsor, V, f. 29, 8512 (Vermeule, 1966, p. 34): whole front unrestored. See above, DESCRIPTION.
- Poussin studio, Windsor, 11881 (Blunt, 1945, cat. 271).
- P. Santi Bartoli–Bellori, 1693, pl. 82: 'restored', reversed.

LITERATURE: Rodenwaldt, 1935, pp. 1–27. Kampen, 1981.

TWO OTHER EXAMPLES of this type of sarcophagus, also drawn in the Renaissance, are compared by Ryberg (1955, figs. 90–2; pp. 163–5) with **197** (Uffizi).
Scenes, left to right:
- Uffizi: Hunt, Clemency, Sacrifice, Marriage.
- Mantua, Pal. Ducale (A. Levi, 1931, cat. 186): Clemency, Sacrifice, Marriage.
- Los Angeles, County Mus. (Loeffler, 1957): Battle, Clemency, Sacrifice, Marriage.

198. 'Nova Nupta' ('the New Bride')

Graeco-Roman relief based on a Hellenistic type of mourning woman

Rome, Palazzo Albani del Drago? (Matz and Duhn, III, cat. 3479 as in Villa Albani)

DESCRIPTION: On the left, a woman sits in right profile, holding drapery to her eyes, and leaning her right hand on the stone seat. She extends her left foot held by a crouching girl facing her who bathes it with a sponge. Behind them is draped a large sheet, and between them a water jar lies with its mouth to the plane.

Since the 17th century the relief has been interpreted as the preparation of a young bride, but the figure has its source in Greek mourning women such as Penelope.

An antique variant of the relief is in the reserve collection of the Louvre; it has an upright shallow bowl between the two women instead of the overturned water jar (Vermeule, 1966, p. 20, Pozzo Windsor, II, 8321; Reinach, *Rép. Stat.*, I, pp. 187 ff., p. 91, 2). Vermeule considers the reliefs to represent a scene of ritual initiation.

HISTORY: In Rome in late 15th century (Mantegna?); della Valle Collection (Perrier and P. Santi Bartoli); Mattei Collection (*Monumenta Matteiana*, 1778, III, pl. XLIII, 2, and bibl. p. 81); Villa Albani (Zoega, 1808, pl. 12; Matz and Duhn, III, cat. 3479); Palazzo Albani del Drago (Reinach, *Rép. Stat.*, I, p. XLV, n. 91, 2); still there in the 1940s; Vermeule (1966, p. 20) gives location as Villa Albani Torlonia.

REPRESENTATIONS:
- Ripanda, attrib., Vienna, Albertina, inv. 2583V (Stix and Spitzmüller, 1941, cat. 17V, pl. 5): 'a Roma', copies seated woman only **(198a)**; Oberhuber returns to an earlier attrib. to Mantegna (1966, pp. 227 f., fig. 5, supported by fig. 7, the recto, a splendid drawing after a horseman in the Trajanic frieze of the Arch of Constantine, **158c**; recto and verso are also illus. by Martindale, 1979, figs. 139–40).
- Raphael?, sleeping woman in window embrasure, study for ceiling of Stanza di Eliodoro, Florence, Uffizi, 1973F (Oberhuber, 1966, fig. 1; Forlani Tempesti, 1969, fig. 132): 'Danae' (later inscription); adaptation **(198b)**: one hand held to head, the other in lap. Raphael's design had a wide circulation through prints (Bartsch, XIV, no. 460; XII, p. 190, no. 3) which inspired Parmigianino, Veronese (*Vision of St. Helena*, NG, London, 1041) and others, including Stradano. Raphael himself used the pose for a sleeping guard in *The Liberation of St. Peter*, in the Stanza di Eliodoro (Oberhuber, 1966, fig. 6) and for a Muse in a tapestry border reversed from his design (Shearman, 1972, fig. 28b).
- Pozzo Windsor, V, f. 21, 8594; X, f. 66, 8059 (Vermeule, 1966, pp. 33, 65).
- Perrier, 1645, pl. 50 **(198)**: reversed, 'in aedid. D. D. de Valle' with commentary by Bellori on the anointing of the bride's feet for the marriage rites with reference to Pliny (*Natural History* XXVIII, 9).
- Italian, 17th century, Perugia, Accad., inv. 13 (Cresti et al., 1977, cat. 36, ill. on p. 49): relief without water jar.

- Stefano della Bella, engraving, c.1660, Florence, Uffizi (Forlani Tempesti, 1973, fig. and cat.89): with shimmering effect; cf. Stefano della Bella's drawing in reverse, Paris, Louvre (Viatte, 1974, cat.314).
- P.Santi Bartoli, 1693, pl.59: 'NOVA NUPTA', Bellori's comment and location: 'In aedibus D.D. de Valle'.

LITERATURE: Montfaucon–Humphreys, 1722, II, p.142 and pl.41 (Bartoli). Oberhuber, 1966, esp. pp.225–30; 243–4.

THE HUNT

Hunting, the royal sport of the ancient Near Eastern kings, was made fashionable by Hadrian in the mid second century A.D. The Hadrianic tondi set into the Arch of Constantine (**182** and **189**) represent bear, boar, and lion hunts, as well as sacrifices to the presiding deities of the respective hunts. Hunts of the various animals also appear on Roman sarcophagus reliefs, of which some were available to Renaissance artists, but none captured their interest as much as the lion hunt on the sarcophagus that was in the Atrium of Old St. Peter's **(199)**.

In Antiquity, lion hunts on a sarcophagus had a special significance. The devouring lion was thought to be a symbol of the ravening power of death which must be overcome. Motifs from the mythological hunts of Adonis **(21)**, Hippolytus **(111)**, and Meleager **(113)**, were borrowed for the lion hunt.

LITERATURE: Andreae, 1978, pp.301 and 450 with many ills. showing the development of hunt motifs on sarcophagus reliefs; Andreae, 1980.

199. Lion Hunt

Roman sarcophagus, mid 3rd century A.D.
Rome, Palazzo Rospigliosi (Andreae, *ASR*, I, 2, cat.131)

DESCRIPTION: The relief was admired in the forecourt of Old St.Peter's from the early 16th century, and was much copied from engravings made in Raphael's circle.

The deceased, wearing a cuirass and short man-

tle, is represented twice, once about to mount the horse which his groom leads through an archway on the left, and again with flying mantle, mounted and riding down the lion, in much the same pose as a rider in the Trajanic battle relief from the Arch of Constantine **(158iii)**. The female figure dressed as the personification of Roma, is *Virtus* who often accompanies the hero of the hunt in Roman sarcophagi (cf. **111**; **197**; see also pp.217–218.

The restorations are minor, but the head of a dog leaping over the felled gazelle was missing in the Renaissance and was 'restored' by Marcantonio as another lion. The wounded figure seated under the horse's hooves was sometimes interpreted as female by the artists.

HISTORY: At least by very early 16th century the sarcophagus was in the forecourt of St.Peter's, and was still there in the 17th century until it was walled into the façade of the Casino of the Palazzo Rospigliosi when it had been restored.

REPRESENTATIONS:
- Aspertini, Cod. Wolfegg, ff.35v–36, below (Bober, 1957, fig.41): '*in tel cortile de santo piro do(v)è la pina*'. On left, instead of the pilaster, is a draped tree trunk with two pine cones on top (reference to the *Pigna*, **187**). An old groom without a cap leads on the horse without the lion's-head collar. The hair of the deceased is curly and not cropped. The wounded reclining figure is young and beautiful, lightly draped and lies in foreground out of the action which accelerates from the left towards the lion.
- Giovanni Antonio da Brescia, engraving after Aspertini (Hind, 1948, V, no.27; VI, pl.545; Bober, 1957, fig.141; p.38, n.1): compressed composition omitting all but central group. Draped stump on left with sheeps' heads and pine cones, *Virtus* with lance, reclining figure asleep or dead on shield, deceased thrusts lance into mouth of lion. Scene closes on right with leafless tree; cf. Agostino Veneziano, engraving, Bartsch, XIV, p.313, no.416 with blank tablet on tree, right.
- Marcantonio Raimondi, engraving, Bartsch, XIV, p.317, no.422 **(199a)**: 'QUE STABANT VIX HOSPITIBUS SPECTANDA SEPULCRA, QUILIBET ARBITRIO JAM VIDET ILLA SUO. MAF. ROMAE IN IMPLUVIO S. PETRI ('The tombs which stood almost out of sight of strangers are now seen and judged by anyone who wishes. Made by Marcantonio. In Rome in the Atrium of St.Peter's'). Freer poses of the deceased, a lion leaps through legs of *Virtus*, the fallen figure is a girl, trees in full foliage added to background, Cf. B.Peruzzi, c.1524–7, Chatsworth, 43 (Frommel, 1967–8, cat.98, pl.LXXIa and b): trees in background left unfinished; horse's

head nearly fills arch on left; cf. Giulio Romano, attrib., Florence, Uffizi, 13338F.
- 'Xanto', attrib., Faenza dish (c.1530) signed 'F.L.R.', London, BM, Dept. of Medieval and Later Antiquities (Tait, 1976): adapted from Marcantonio's engraving with its inscription on back. (Also illus. by Humphris, 1967, cat.27 with further bibl.)
- Cod. Coburgensis, f.203, 1 (Matz, 1871, 231): whole relief unrestored showing missing arms, legs, heads of dogs etc., later supplied by present restorations. Reclining figure bearded; deceased with cropped hair.
- Pozzo Windsor, X, f.45, 8038 (Vermeule, 1966, p.64): after Marcantonio. On verso: 'S.Pietro'; IV, f.55, 8458 (ibid., p.29): whole relief, restored, but without pilaster on left.
- Carlo Maratta, former attrib., Windsor, 4375 (Popham and Wilde, 1949, cat.1144, as by 16th century draughtsman): with present restorations.

LITERATURE: Matz and Duhn, II, cat.2953. Vaccaro Melucco, 1966, cat.8 (description).

BOYS–PUTTI

Putti (little boys) played a vital part in Quattrocento art. Closely akin to the Hellenistic type of Amor, the naturalistic children, developed from late 4th century Greek types, were enthusiastically copied by the Romans, and came to life again in the Quattrocento as the Christ Child and the little St. John the Baptist, or simply as chubby figures introduced into narrative reliefs, manuscript borders, fresco and architectural decoration, to say nothing of Quattrocento tomb reliefs and the Cantorie.

Several popular types of statue, derived from Hellenistic originals, were known in the Renaissance. One was of a standing boy hugging a goose (200), another of a younger seated child holding down a duck-like 'Fox Goose' (201); several replicas of the two types exist today. A third type of a seated boy cuddling the bird was described by Pirro Ligorio who found in Plutarch and Pliny a story of a goose which fell in love with a boy (Mandowsky and Mitchell, 1963, cat.62, and pl.34a–b). A fourth

type of boy with goose is the putto astride the goose as described by 'Prospettivo Milanese' c.1500 in the garden of Cardinal Savelli (stanza 31; Fienga, 1970, p.43; P.G.Hübner, 1911, pp.20–3.

The first three types were used as fountain figures in Antiquity, the water issuing from the beak of the squeezed bird. Another popular fountain derived from a Hellenistic type is the Boy with an Urn (202), also used as a fountain in Renaissance sculpture gardens.

Apart from these Hellenistic nude boys, the Renaissance artists could also use as sources the draped children in Roman historical reliefs (179, 182) and in sacrifice reliefs (camilli), as well as on funerary altars, while other examples of nude children could be found on Bacchic sarcophagi, riding the shoulders of satyrs (83), or playing on the ground (78, 110). No other antique models were more influential for the putto in Renaissance art, than the amoretti of the type carrying garlands (54), or playing with the attributes of the gods (52).

LITERATURE: Herzog, 1903, pp.215–36, with ills. of the types of boy with goose known in the Renaissance; Robertson, 1975, p.561 with bibl. A general study covering many contexts is by Stuveras, 1969. For MSS by the 'Master of the Putti' and their classical sources, see Armstrong, 1981; Ragusa, 1984.

200. Boy standing with a Goose
Roman copy of a Hellenistic type by Boethos, early 2nd century B.C. (example of the type)

Replicas in Vatican, Galleria dei Candelabri (Lippold, Kat., III, p.2, no.66, pl.145); Munich, Glyptothek, 268 (200); Paris, Louvre, MA40; Rome, Museo Nazionale delle Terme (Paribeni, 1932, no.161) and others

DESCRIPTION: The little boy stands with legs wide apart and leans back as he pulls the neck of the goose, which stands behind him, against his side. This is thought to be a copy of the bronze by Boethos described by Pliny (Natural History XXXIV, 84): 'Boethos, though greater as a worker in silver, made a child hugging a goose till he throttles it'.

Of the replicas listed above, only the one in the Terme was known in the Renaissance, according to Nesselrath who will discuss it in his edition of the Fossombrone Sketchbook. None had heads, and all have been restored after another example found in Rome in 1741, now in the Museo Capitolino (Stuart Jones, 1912, pl. 80, pp. 321–2, Stanza del Fauno 16; Helbig, II, cat. 1410. Lippold, *Kat.*, III, p. 2, no. 66, pp. 325–7 gives variants. Andreae, 1976, pls. 104–5 illustrates the replicas in Munich, the Vatican, the Louvre and Geneva.)

HISTORY: The late 15th century drawing in Oxford of a statue in the house of Cardinal Savelli in Rome is the earliest record of this type.

REPRESENTATIONS:

– Cronaca?, attrib., or Sienese, late 15th century, Oxford, Christ Church, 0814 (Byam Shaw, 1976, pl. 50, cat. 41ᵛ): 'in chasa del chardinale savello'. Two views, one from front-left, group on high pedestal, boy without head, goose complete, supported underneath body by tapered round strut; the other incomplete in right profile on base **(200a)**. Since Byam Shaw's catalogue went to press, Buddensieg, who first gave the attribution to Cronaca, is now considering this and other drawings in the same hand, to be by a late 15th century Sienese artist.
– Riccio, bronze statuette, Vienna, Kunsthist. Mus., 5518 (Planiscig, 1924, cat. 32; Weihrauch, 1967, fig. 110): copy with 'restored' head: curls, no topknot.
– Antonio da Sangallo the Younger, Florence, Uffizi, 1660A (A. Bartoli, 1914–22, III, fig. 429): lower part of boy and goose in profile to left with part of **134** inscribed 'casa savelli'.
– Raphael Workshop, Fossombrone skb., f. 82: unrestored example of type, boy lacks head, goose without body below neck.
– Sebastiano del Piombo, study for the *Holy Family* in Burgos Cathedral, Paris, École B-A (Hirst, 1981, pl. 132; Berenson, 1938, cat. 2499, fig. 770): adaptation of a headless, armless, Christ Child in the pose. Cf. Anon. follower of Michelangelo, Oxford, Ashmolean, Parker, 1956, II, cat. 372: adaptation of boy, with billowing cape (Berenson, 1938, cat. 1709 as related to Sebastiano del Piombo).
– Jacopo Sansovino, *Madonna and Child* marble group, 1516–21, Rome, S. Agostino (Garrard, 1975, pl. 50a): reversed adaptation of boy as Christ Child **(36b)**. (*Ibid.*, p. 337 and n. 34 refer to Vasari–Milanesi, 1906, VII, p. 492, praising Sansovino's marble statue of a boy with a swan, now lost.)

LITERATURE: Robertson, 1975, p. 561, fig. 175b (Munich replica). Andreae, 1976.

201. Seated Boy with Fox-Goose or Bird

Roman statue after Hellenistic type of 3rd century B.C.
Florence, Uffizi (Mansuelli, 1958, I, cat. 60)

DESCRIPTION: The chubby seated boy presses down on his pet while reaching forward with the other hand, his legs bent naturalistically in front of him. The Hellenistic prototype may have originated as the infant Aesculapius with his sacred goose and later developed into the genre fountain figure popular with the Romans. Herodas' fragment in *Mimes (Mimiambi)*, IV, lines 30–4 (third century B.C.) is thought to describe this type because of the reference to the fox-goose (*chenalopex*). See Bieber, 1961, pp. 136–7 and Robertson, 1975, p. 176 for identification of the passage with this type.

Other replicas existed in the Renaissance (see Mansuelli, 1958, I, cat. 59).

HISTORY: Vasari in his description of the antiques in the Pitti, often omitted from editions of the *Lives*, notes the two replicas (Mansuelli, 1958, I, cats. 59–60) over the third door of the Salone in the Pitti: '*due putti posti a sedere in terra, che tengono sotto una mano un'uccello assomigliante a un'anitra, e l'altro braccio alzono*' (Bloch, 1892, p. 82: 'Two little boys, sitting on the ground, who hold a duck-like bird under one hand and raise the other arm'). Their previous history is still untraced, but these or others of the type were known to artists in the Quattrocento.

REPRESENTATIONS:

– Masaccio–Masolino, *Madonna and Child with St. Anne*, panel, c. 1420, Florence, Uffizi, inv. 8386: the Christ child in similar pose and with similar proportions to the statue. This relationship has often been noted in the literature; see Fremantle (1969, fig. 3, detail, pp. 40–1).
– Donatello School, bronze statuette, Berlin-Dahlem, Staatl. Mus. (Bode, 1930, cat. 37, pl. 17): almost exact replica.
– Domenico Ghirlandaio or School, *St. John Preaching*, (detail), fresco, Florence, S. Maria Novella (Parronchi, 1971, *Annali Pisa*, pl. XLIV; Dacos, 1962, fig. 33, pp. 446–7): nude putto seated in same pose, frontal view.
– Leonardo da Vinci, *Virgin of the Rocks*, London, NG, 1093: adaptation of the pose in profile to left (noted by Cocke, 1980, p. 31).

LITERATURE: Herzog, 1903; Bieber, 1961, pp. 136–7, fig. 534 (Vienna); Robertson, 1975, p. 561.

202. Boy with an Urn
Roman fountain statue based on Hellenistic type
Untraced. Formerly in Rome, Cesi garden

DESCRIPTION: The boy stands with legs apart, the
urn on his left shoulder and he raises both hands
to pour. His mantle is gathered under the urn and
falls behind him.

The type is very common. As many as eight putti
with urns on their shoulders were listed in the 1633
inventory of the Ludovisi Collection; two of them
were brought from the Villa Altemps in Frascati.
Some of them may have been Renaissance copies,
as they made very popular fountain figures.

Many identical and similar examples exist. One
was in the Cook Collection (E. Strong, 1908, fig. 4,
cat. 30); another in Rome, Palazzo dei Conservatori
(Stuart Jones, 1926, p. 148, no. 33, pl. 53).

A similar pose, without the urn, was used in Ro-
man sarcophagus reliefs of amoretti holding garl-
ands (54) and playing with the attributes of the
gods (52).

HISTORY: First drawn by Heemskerck in the 1530s
in a niche near the corner in the south wall of the
Cesi garden as a fountain figure, where it was last
recorded by Gnoli (1905, p. 271). It may have been
among the antiques collected by Cardinal Paolo
Emilio Cesi in the early 16th century. For this statue
in the Cesi gaden, see van der Meulen (1974, p. 21)
with references to earlier literature.

REPRESENTATIONS:
– Heemskerck, *Skb.* I, f. 25k: in Cesi garden, seen in
 background along wall, water falling from the urn
 into a carved sarcophagus (ill. on p. 472).
– Heemskerck, *Skb.* II, f. 62ᵛ: detail of figure in niche,
 water from urn falling into a plain basin. Drapery
 shown at shoulder, but not falling behind the boy
 (cf. Aldrovandi's description, 1556, p. 125); cf.
 engraving for Lafréry's *Speculum*, Bartsch, XV,
 p. 40, no. 10: reversed in a wall niche in background
 of *Diana and Actaeon*.
– A. Cesati, reverse of medal of Paul III, 1545 (Hill and
 Pollard, 1967, cat. and fig. 366): Ganymede watering
 the Farnese lilies, with an eagle. Adaptation of the
 pose, reversed, arms lower, mantle flying.
– Girolamo da Carpi, Oxford, Ashmolean, 141A
 (Macandrew, 1980, pl. XIII): two views from right;
 Turin *Portfolio* (Canedy, 1976, T160): front without
 drapery.
 Vasari or Ammannati, 1552–3, London, RIBA, VIII,
 6ᵛ (MacDougall, 1978, pl. VII, 13): as fountain figure
– in niche in Ammannati's Nymphaeum of the
 Vigna of Julius III, Rome.

– Cambridge *Skb.*, MS R. 17. 3, f. 6, (Dhanens, 1963,
 cat. 7, fig. 25): '*pallas de cardenal Cesars*' (202); cf.
 Heemskerck, *Skb.* II, f. 22ᵛ, above: with drapery at
 back, no niche; Dhanens suggests as the source a rep-
 lica in Pal. dei Conservatori (Stuart Jones, 1926, p. 148,
 no. 33).
– Spanish, 16th century, Cordova, Mus. (Angulo and
 Pérez-Sánchez, 1975, I, pl. CX, cat. 489): free adapta-
 tion of type.

LITERATURE: For type, see E. Strong. 1908, cat. 30.

203. The 'Spinario' (Thorn-Puller)
Bronze, life-size. Probably 1st century B.C.
Rome, Palazzo dei Conservatori (Stuart Jones, 1926,
pp. 43–7, Sala dei Trionfi, no. 2)

DESCRIPTION: The famous Spinario represents
a boy of about twelve, seated on a rock, who is
bending to extract a thorn from his left foot, placing
the sole up on his right knee. The natural pose has all
the suppleness of Hellenistic art, but the head is of
an Early Classical style meant for an upright statue.
Thus the bronze, admired throughout the ages in
Rome, is an eclectic and classicizing work.

Of all the antiques visible in Rome, none was
more copied than the Spinario. Its influence on
medieval and later works of art has been the sub-
ject of many art-historical studies. Such illustrious
collectors as the Medici and Isabella d'Este treas-
ured their splendid bronze statuettes, now lost, of
it, by Filarete? and Antico (Weihrauch, 1967,
pp. 81, 117); less exigent later travellers to Rome
returned home with souvenir copies.

HISTORY: The Spinario was recorded by Magister
Gregorius in the 12th century among the antique
bronzes at the Lateran (*CTR*, III, pp. 150–1). The
statue formed part of Sixtus IV's donation of the
Lateran bronzes to the Palazzo dei Conservatori in
1471 (Heckscher, 1955, pp. 20–3). It was described
c. 1500 by 'Prospettivo Milanese' in a room on the
upper floor of the palace with the bronze Camillus
(192). It was taken to Paris in 1797–8 but was
returned to Rome in 1816 (Haskell and Penny, 1981,
p. 308).

INTERPRETATIONS: Magister Gregorius was the
only writer to describe the statue as Priapus. In the
Middle Ages it became known as Marzo as it
represented the month of March in cycles of the
months (for example, see Glass, 1970, esp. p. 130
and fig. 22). A Renaissance interpretation of the
figure as a shepherd *(pastor)* begins with Fulvio

(1513, p.28; 1527, p.21). He is likened by Marliani (1544, II, p.27) to the shepherd Battus in Theocritus' *Idyll* IV, 50–5, who has a thorn in his foot, extracted by his friend, Corydon.

The statue was also called Corydon by the 17th century German art historian and artist, Joachim von Sandrart (Schweikhart, 1977, pl.13). The two parallel traditions of 'Marzo' and shepherd seem to converge in the 17th and 18th centuries with the apocryphal story, noted by Haskell and Penny (1981, p.308), that the statue commemorated a conscientious shepherd boy named Martius ('Marzio Pastore'), who delivered a message to the Roman Senate before removing a thorn from his foot. The statue is still called *Marzio Pastore* on postcards. For a history of the earlier interpretations, see Schweikhart (1977).

REPRESENTATIONS:
The following representations are chosen because their intention is mainly to show the original bronze statue, or its precise pose. Our selection suggests that the Spinario was used by artists as differently oriented as 'Granacci' and Rubens who both drew their models in the pose. If in the Middle Ages the statue was considered to be a pagan idol exemplifying Vice (Heckscher, 1958, pp.291–4), in the Renaissance it appeared to be an exemplar for artists of how to portray a complex movement with ease and grace. The back, sinuously bent in concentration, provided a favourite view. The artists, copying the statue from all sides, rang the changes by varying not the pose but the surroundings, sometimes indoors, sometimes among trees or ruins. At times the statue was painted as if a real boy, while remaining on the base. Some later examples of interiors with the figure as an ornament or as an important model in artists' studios are included to show its wide dissemination.

- Granacci?, Florence, Uffizi, 325E (Berenson, 1938, fig.397, cat.949): boy in studio posed as the *Spinario*. (For other drawings in the Uffizi, 394E and 200FV, see Ragghianti and dalli Regoli, 1975, figs.80 and 109; Jacobsen, 1904, p.251).
- Gossaert, ('Mabuse'), skb. sheet, 1508/9, Leiden, Rijksuniv., Print Room, Welcker Collection (Pauwels *et al.*, 1965, cat.45): seen from below right (188a).
- Marco Dente, engraving, Bartsch, XIV, p.356, no.480: '*ROME IN CAPITOLIO*'. Profile to right, on base, indoors.
- Marcantonio Raimondi, engraving, Bartsch, XIV, p.346, no.465: in profile to right in outdoor setting.
- Parmigianino, Chatsworth, 783A (Popham, 1971, pl.211, cat.710): back from above.
- Holkham Album, f.34V (14b): two back views, from left and right.

- Heemskerck, Oxford, Ashmolean (*Report of the Visitors*, Ashmolean, 1957, p.61): back view from below (203a).
- Francisco de Hollanda, *Skb.*, f.29V: from left front below, on column. '*IN CAPITOLIO EX AERE.*'
- Bronzino, attrib., *Portrait of an Unknown Man*, oil painting, Florence, Gall. Corsini: next to the sitter on a table covered by an Oriental rug, with books and inkwell, is a small bronze statuette of the Spinario on a base dated '*KAL. DECEMB. M.D.XL.*'.

Italian Bronze statuettes of the Spinario, 15th and 16th centuries
- New York, Pierpont Morgan Lib. (Bode, 1910, I, pl.LVI, 87); Florence, Mus. Naz., see Alinari neg. no.17173 with Nymph *alla spina* (61), with which the Spinario was often paired.
- For others, see catalogues of bronzes in Berlin (Bode, 1930), Vienna (Planiscig, 1924), Washington, NGA, Kress Collection (Pope-Hennessy, 1965) and New York, Frick Collection (Pope-Hennessy, 1970).

Frontal view from below, from mid 16th century
- Engravings for Lafréry's *Speculum*: C. Cort (Hülsen, 1921, cat.122a); Diana [Scultori], 1581, Bartsch, XV, p.451, no.42 (Hülsen, 1921, cat.122c); cf. Carlo Saraceni, oil painting from B. Nicolson Collection: as living boy on base but out of doors with ruins (Waterhouse, 1960, fig.3; Pouncey, 1960, p.167; *Italian Art in Britian*, RA exh., London, 1961, cat.47; cf. Heckscher, 1963, *Imago*, pl.14).

Later views from right:
- Cavalieri, I–II, pl.74: profile to right.
- Rubens, London, BM, F.5213–1 (Rowlands, 1977, fig. and cat.14): two views from right; the most distant boy looks towards artist, the other looks down at his foot; drawn from a live model?.

Late Dutch paintings with plaster casts of Spinario in artists' studios
- P. Claez, 1628, Amsterdam, Rijksmus.; J. Terborch, Manchester, Whitworth Art Gall.

NOTE: For influences of Spinario in the Middle Ages, see Heckscher (1958, pp.289–99). In the Trecento and Quattrocento the pose was adapted not in figures of nude boys, but in those of clothed men by Giotto, Brunelleschi, Masaccio, Piero della Francesca, Cossa and others in their works of art, while Signorelli adapted the nude figure. The pose was transferred to nude nymphs (von Salis, 1947, pp.124ff.); for further adaptations, Dacos (1977, pp.283–4).

LITERATURE: For the Spinario in Antiquity, see Helbig, II, cat.1448 (W.Fuchs); Zanker, 1974, pp.71–4, with bibl; Robertson, 1975, pp.559–60. Haskell and Penny, 1981, cat.78.

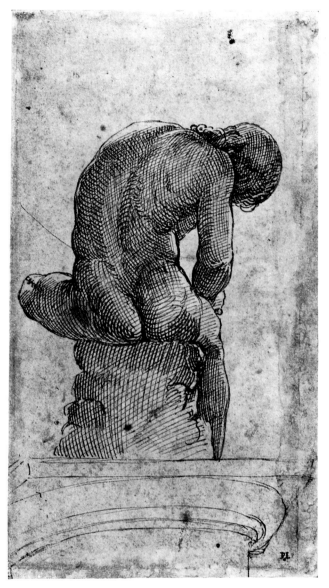

203a

THE ILLUSTRATIONS

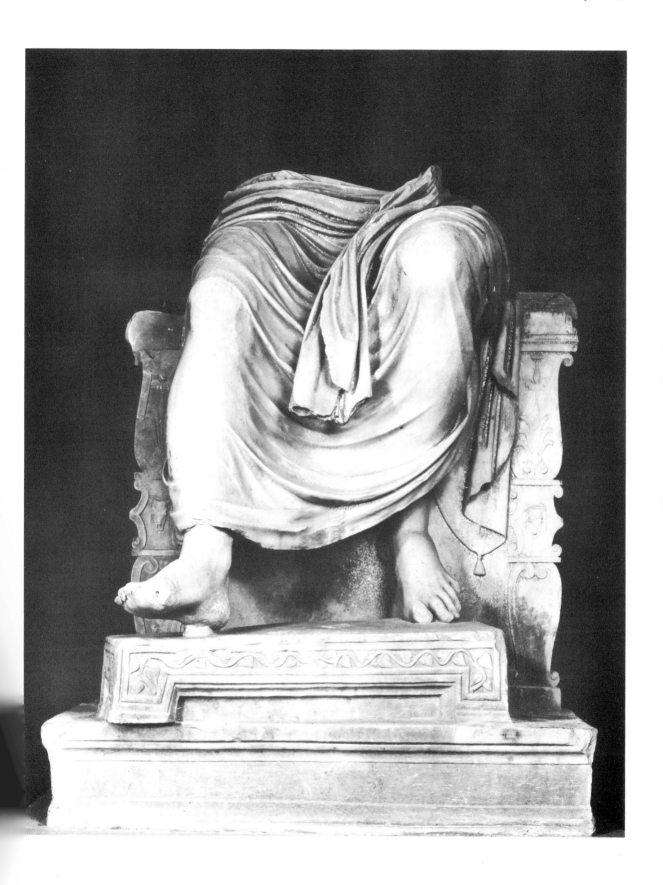

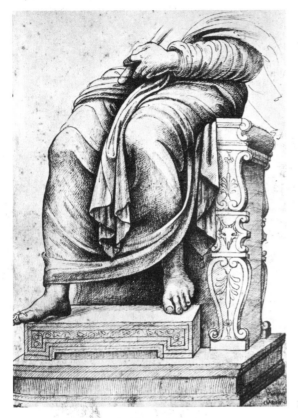

1a

1b

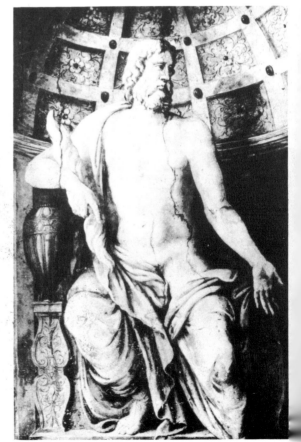

1c

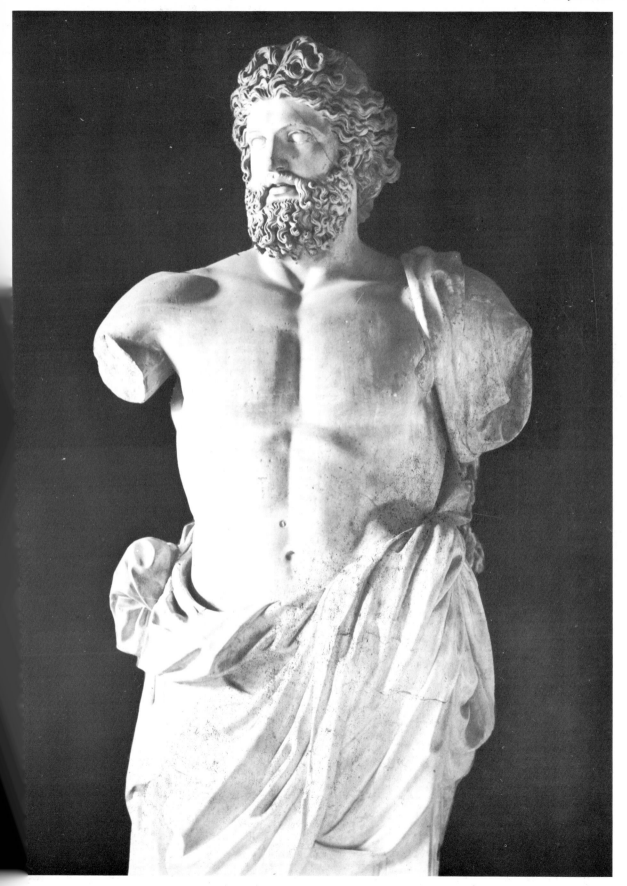

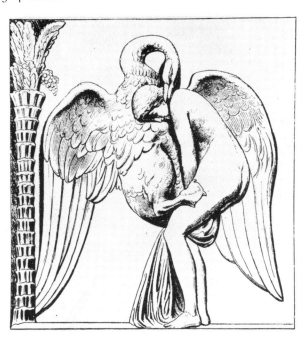

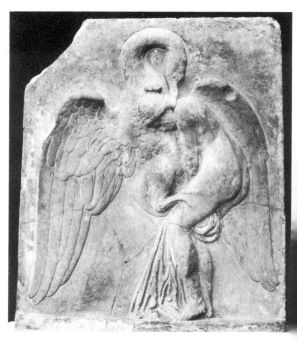

3

3a

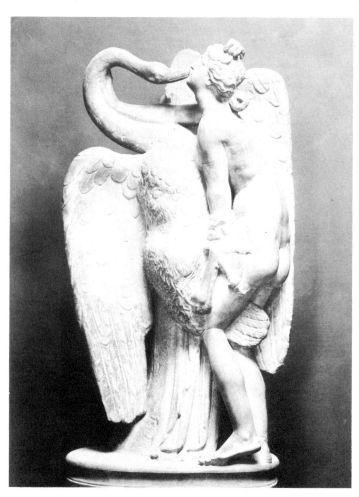

4

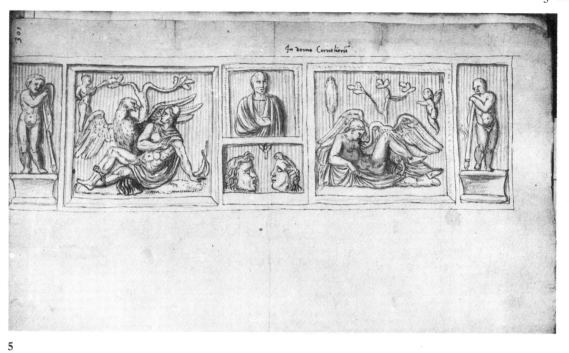

5

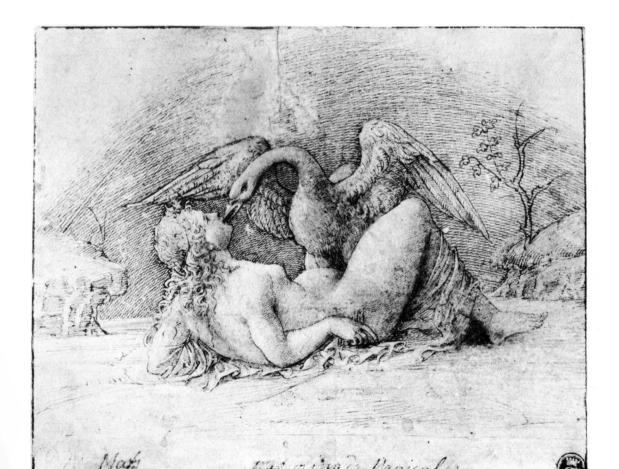

5a

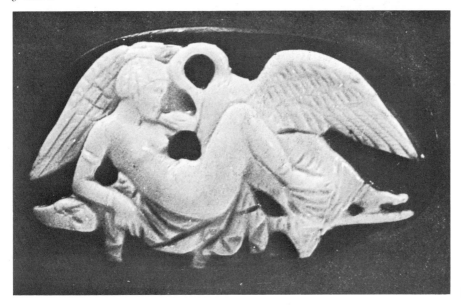

5b

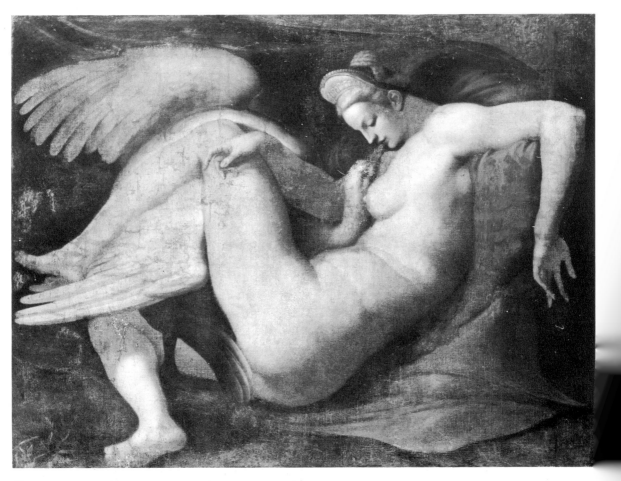

5c

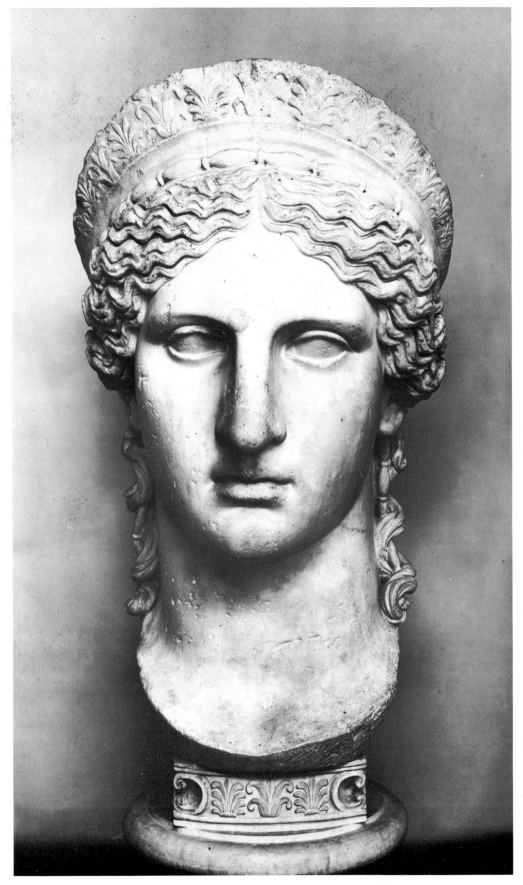

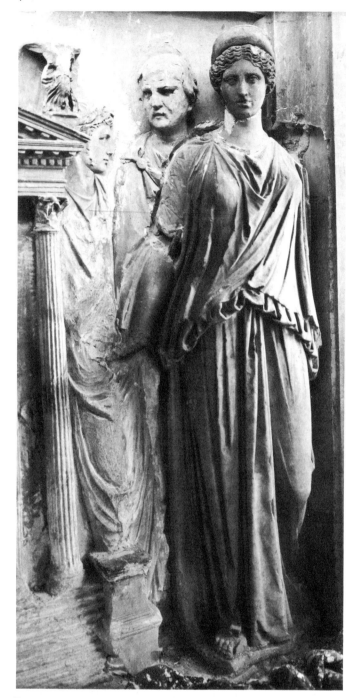

7

7a

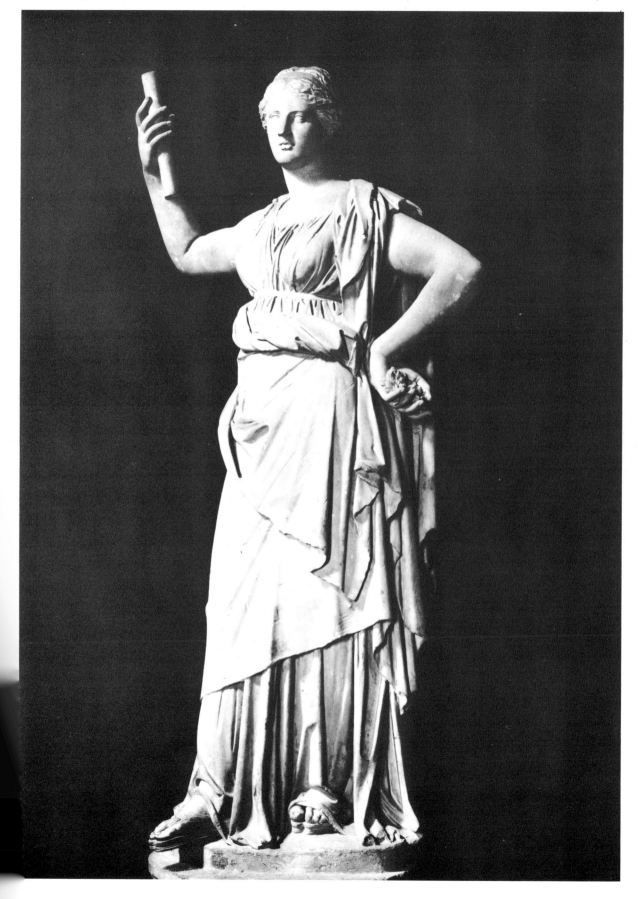

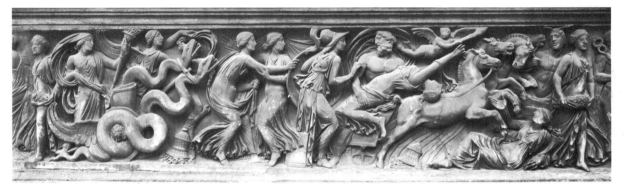

9i

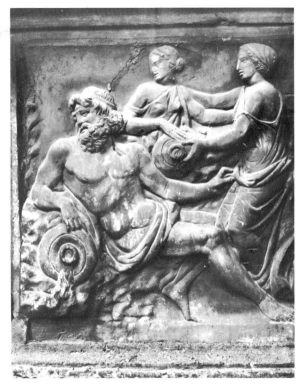

9ii

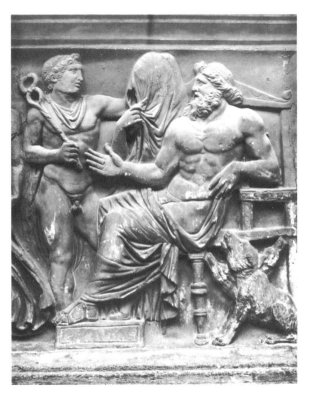

9iii

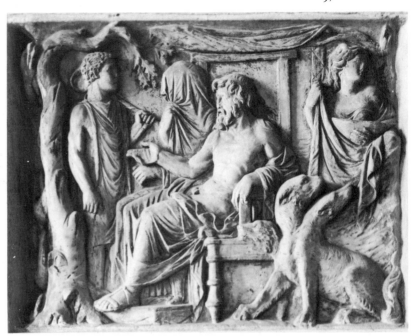

9a

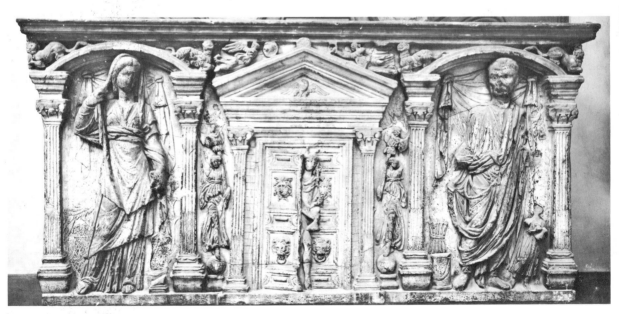

11

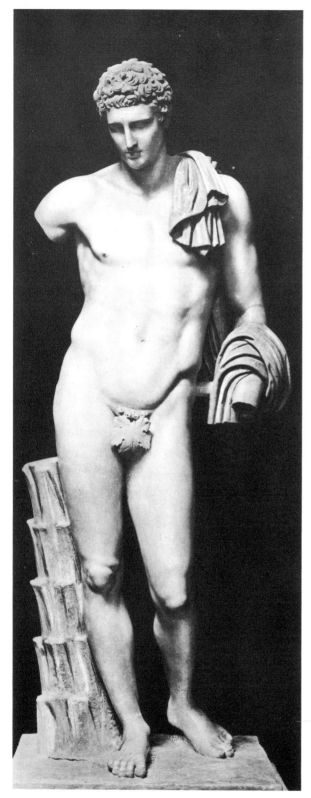

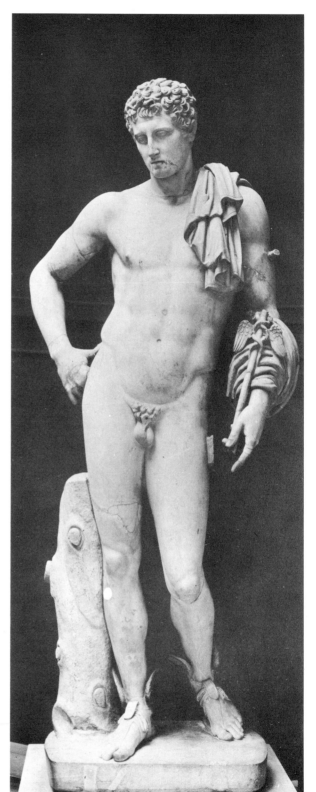

10

10a

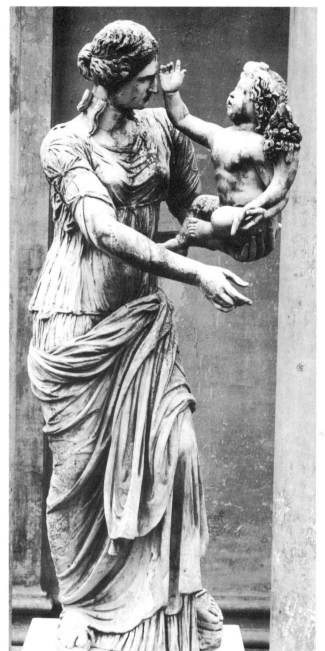

13

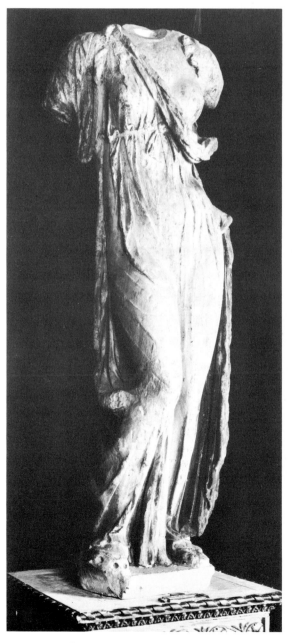

12

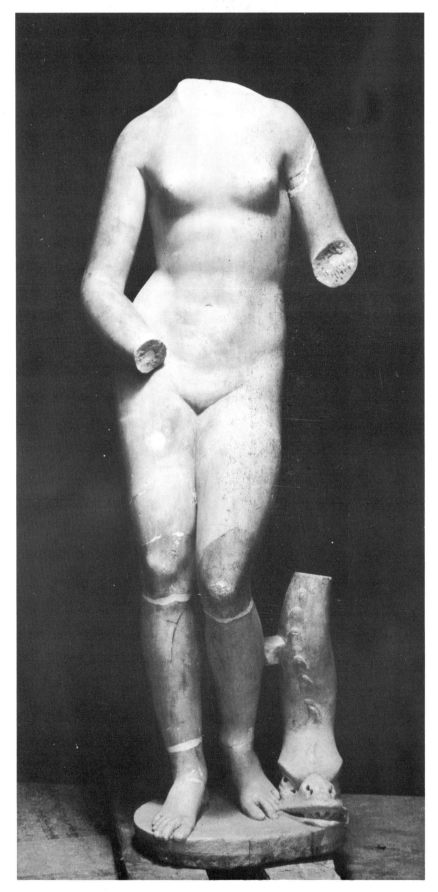

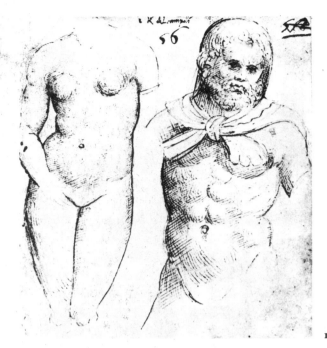

14a

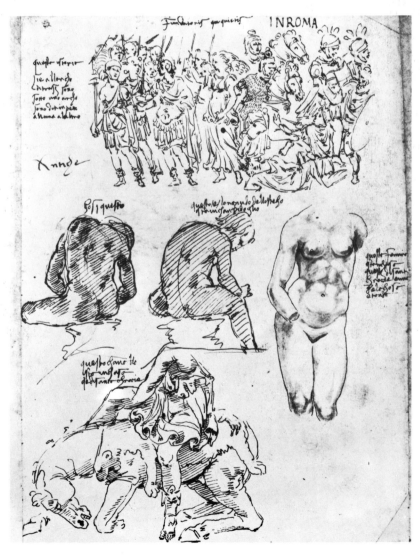

14b

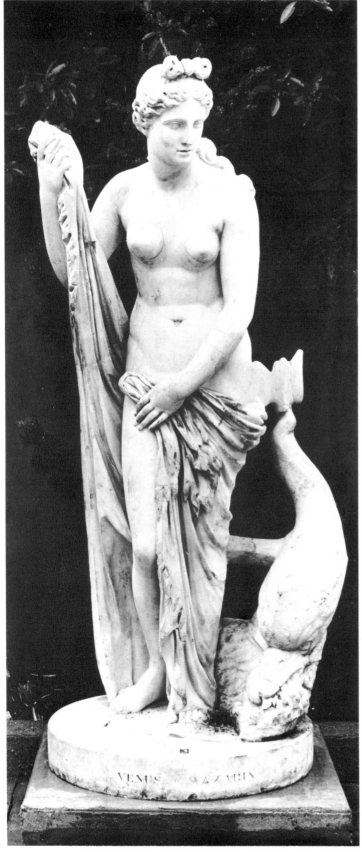

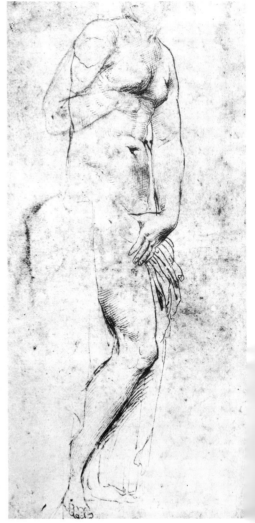

15

15a

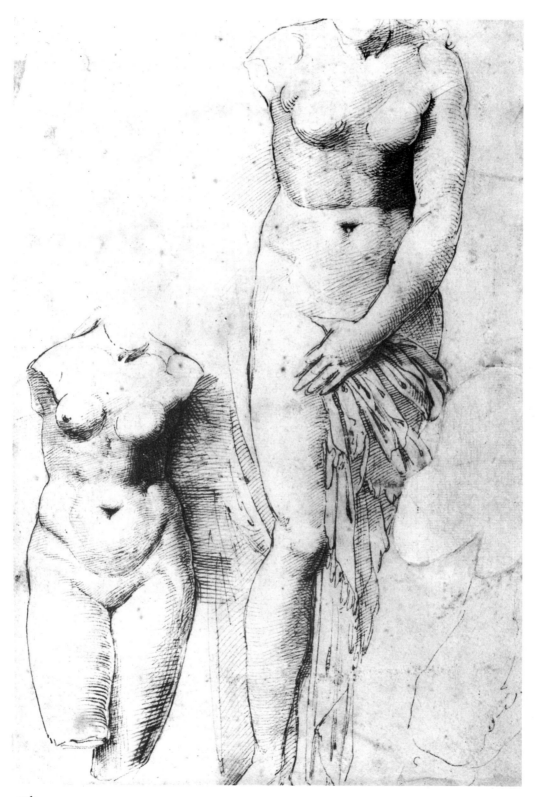

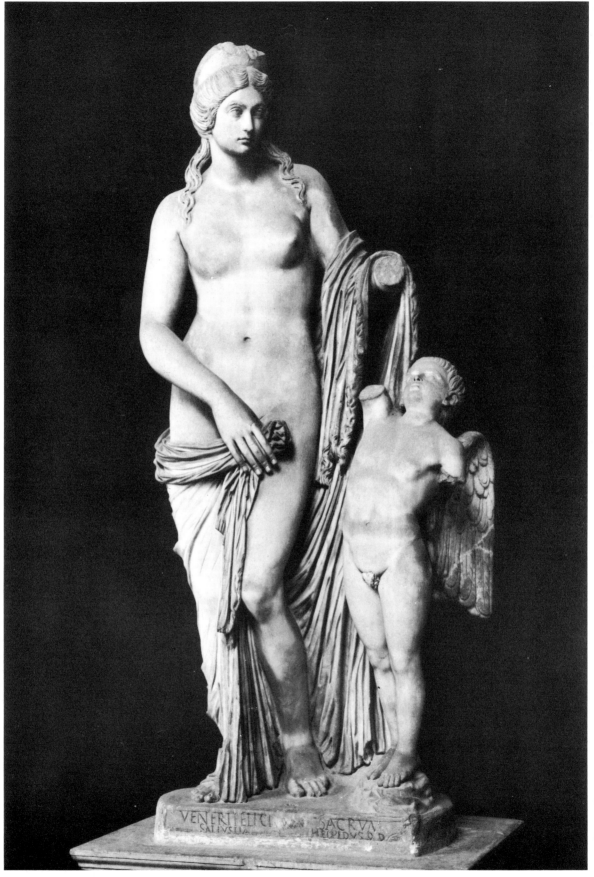

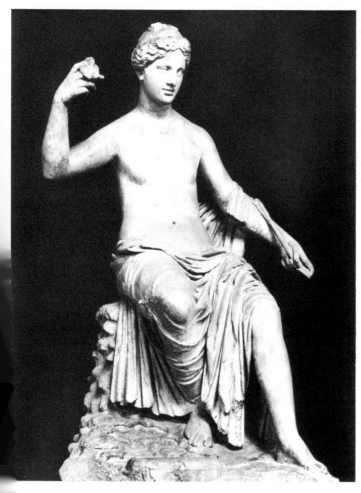

17a

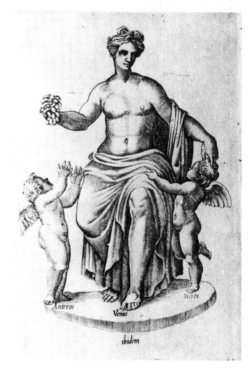

17c

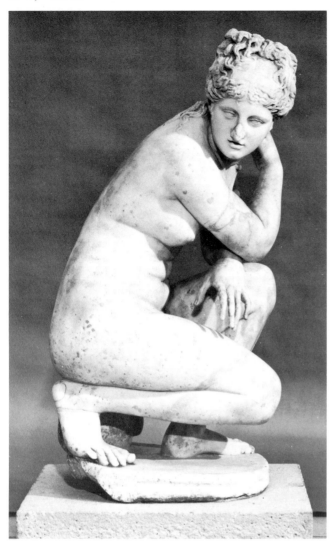

18

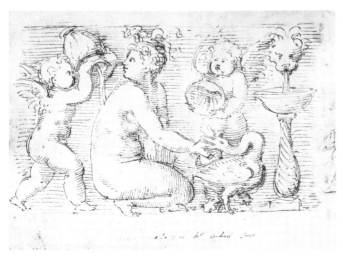

19a

19

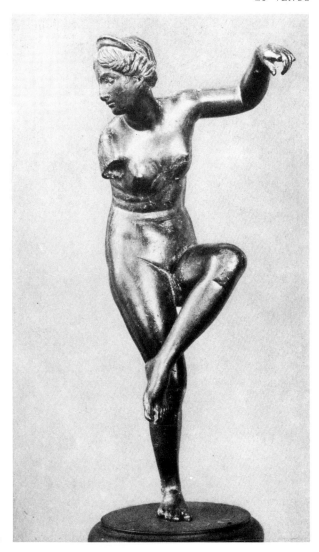

20

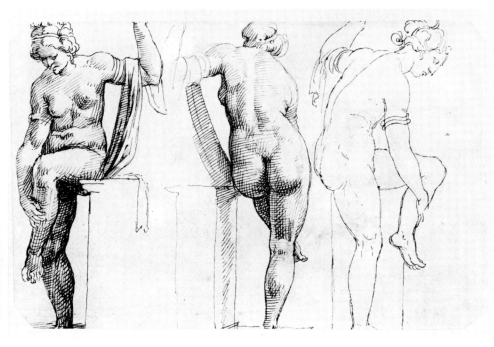

20a

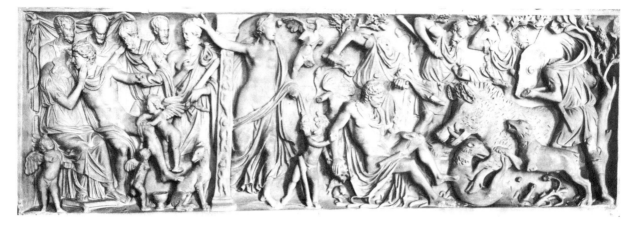

21

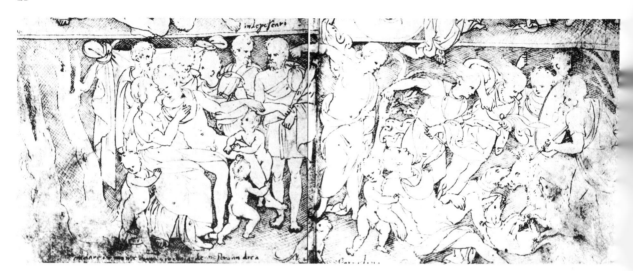

21a–i

21a–ii

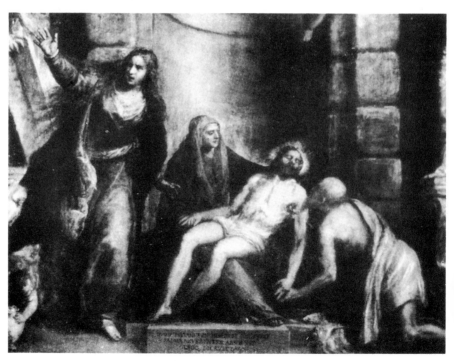

21b

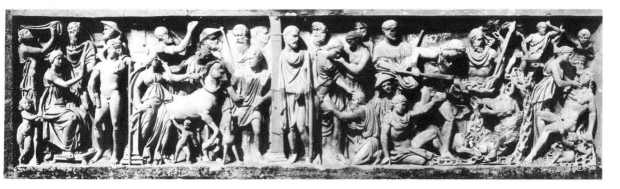

22

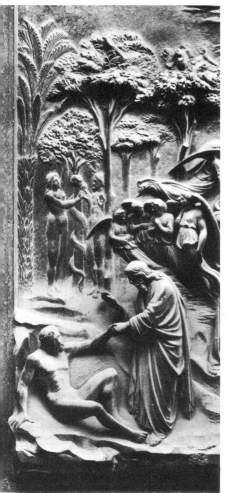

22a

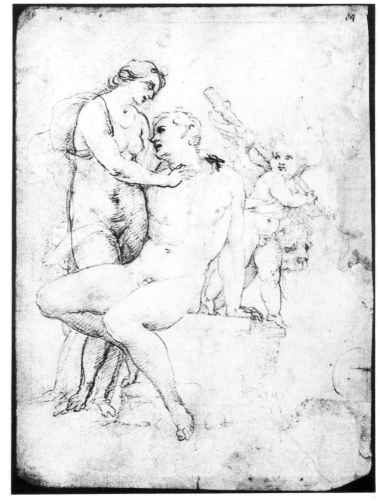

22b

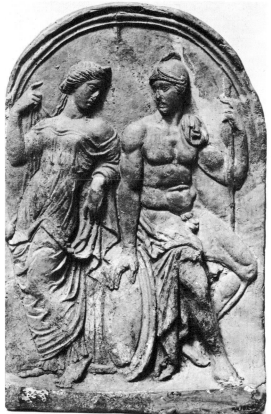

23

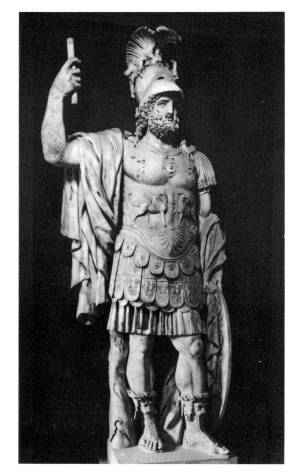

24

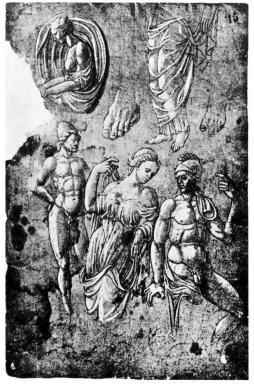

23a

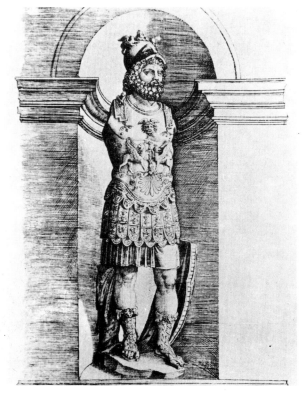

24a

25

25a

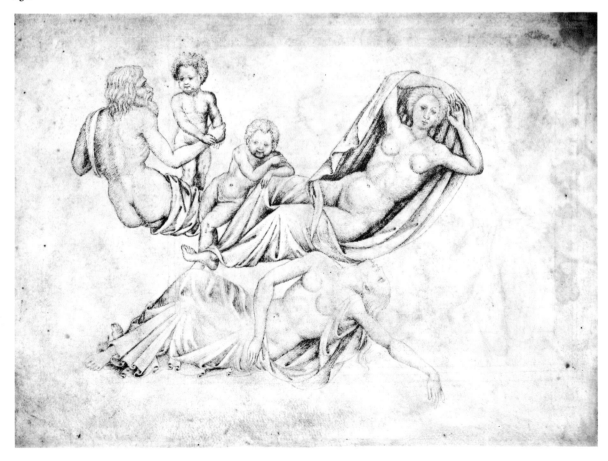

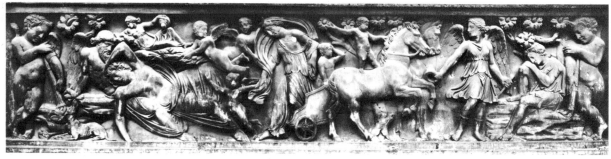

26

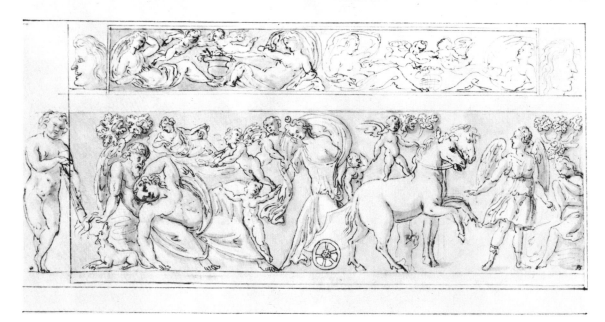

26a

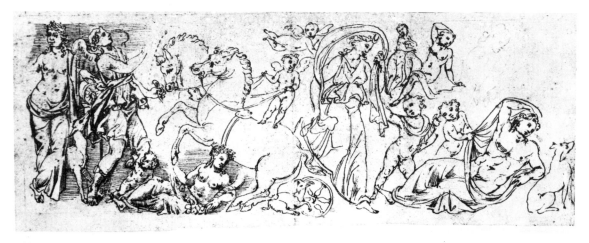

26b

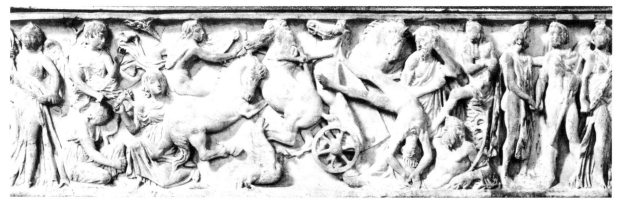

27

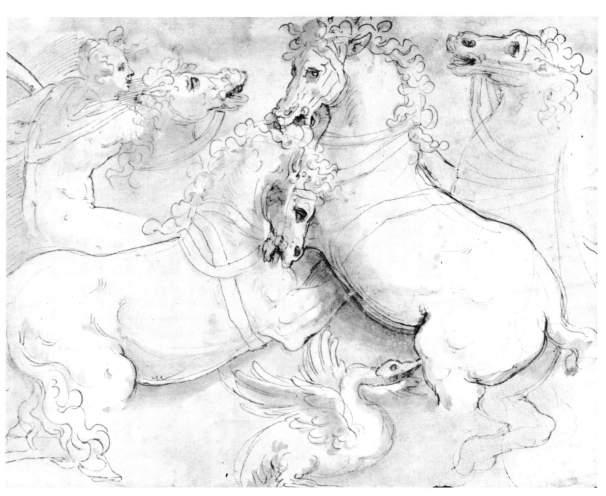

27a

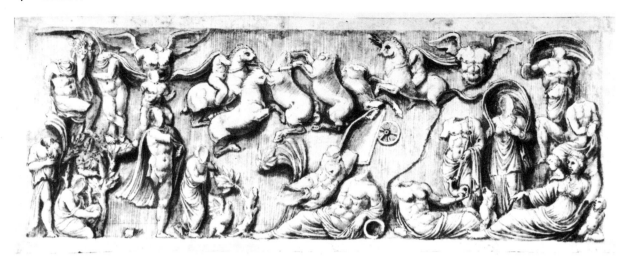

27b

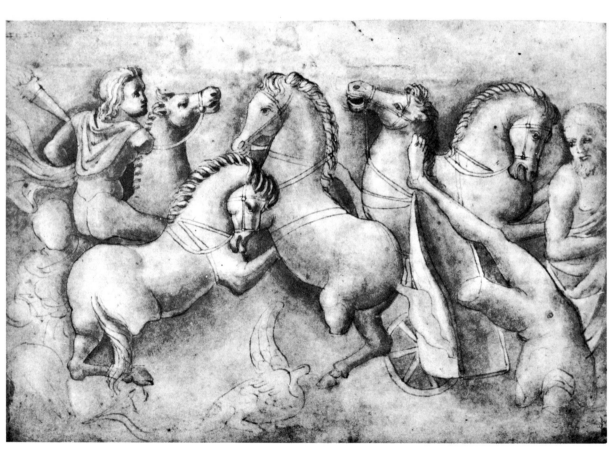

27c

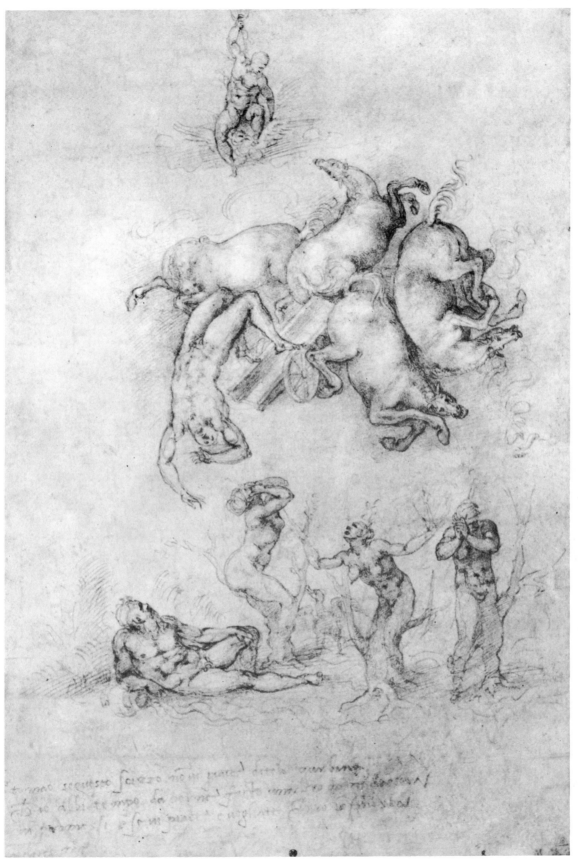

27d

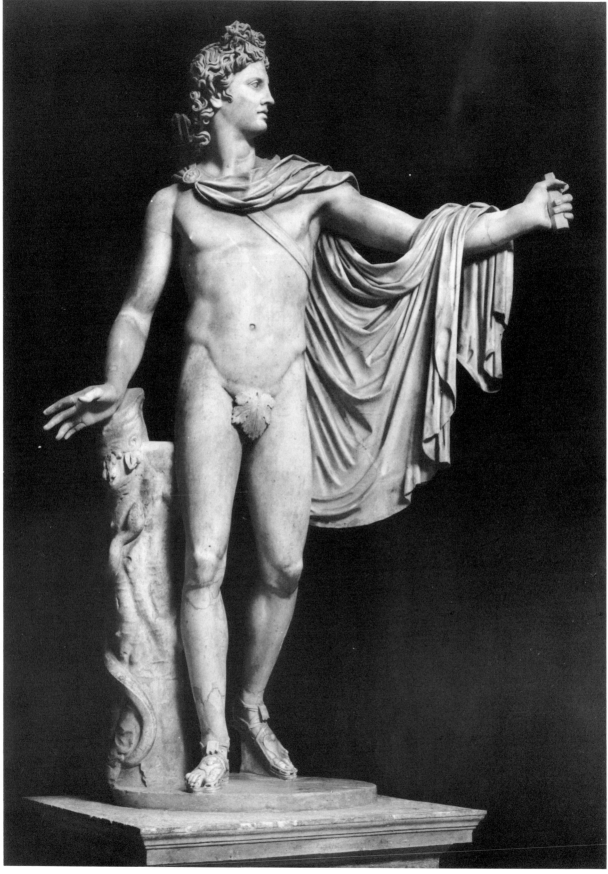

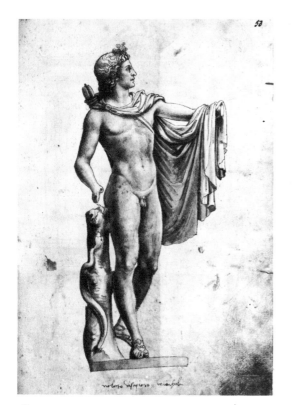

28a

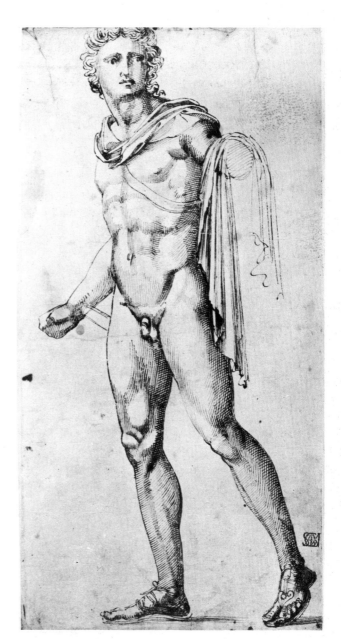

28b

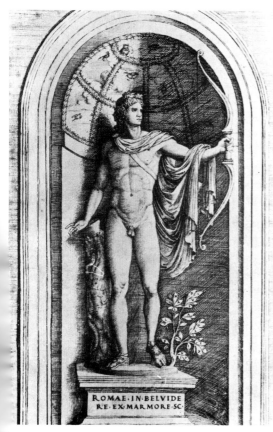

28c

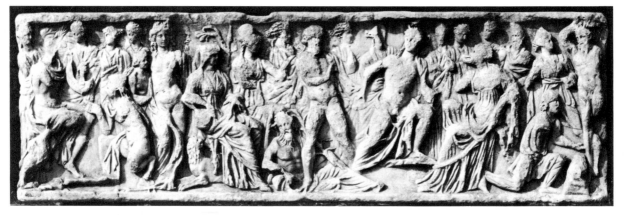

29

31

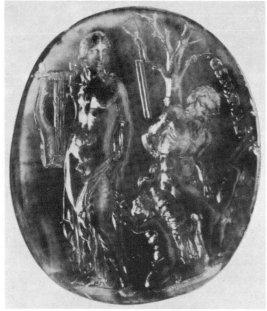

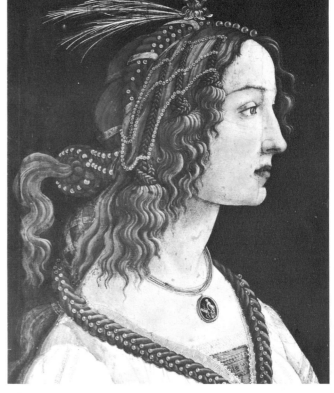

31b

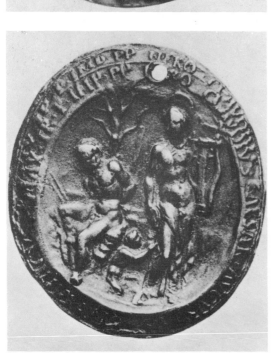

31a

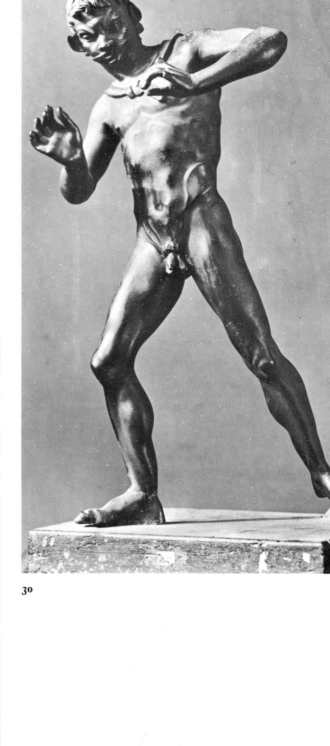

30

30a

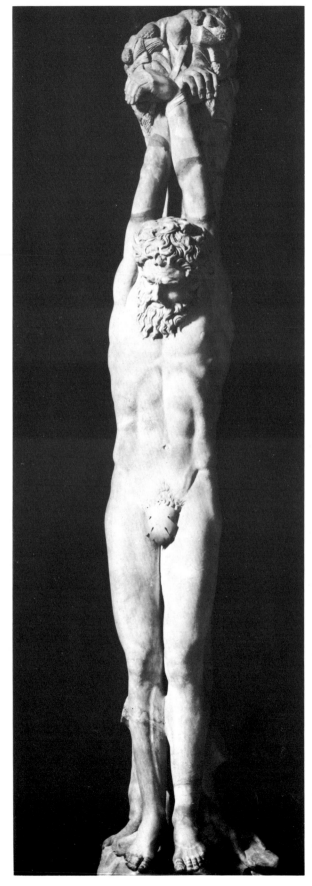

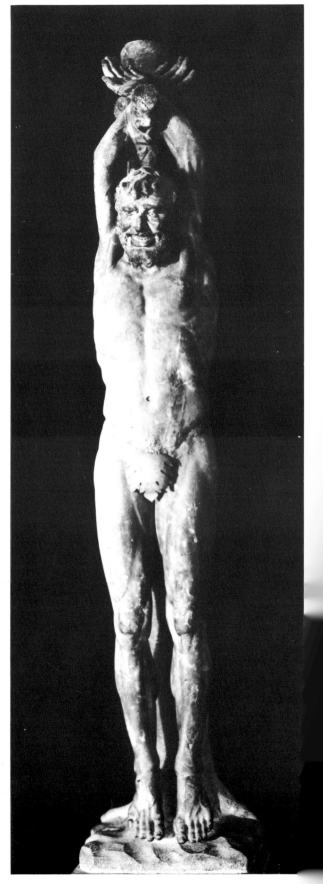

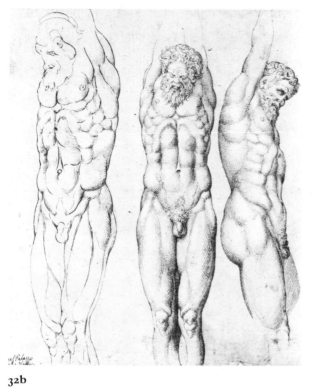

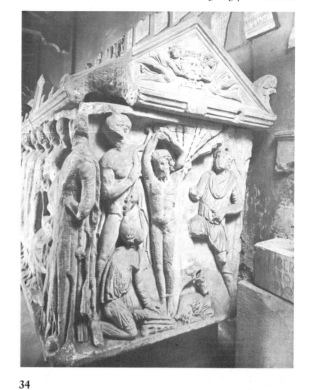

32b

34

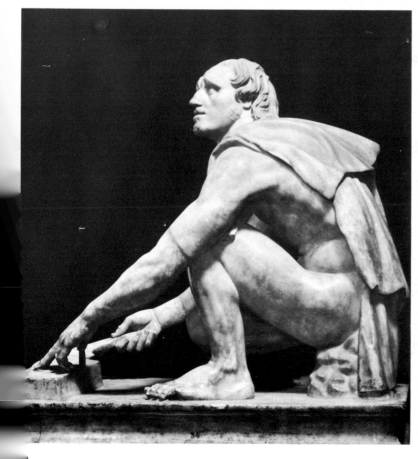

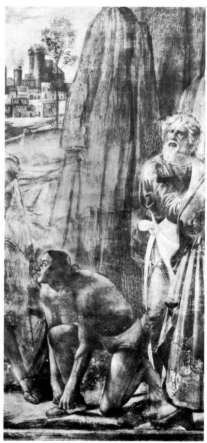

33a

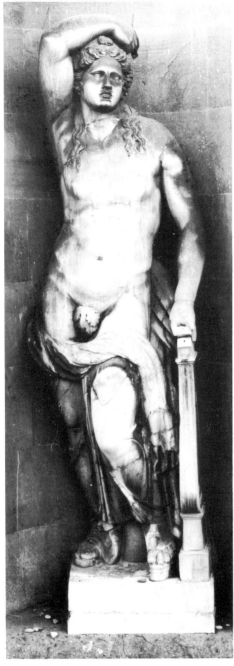

35

35a

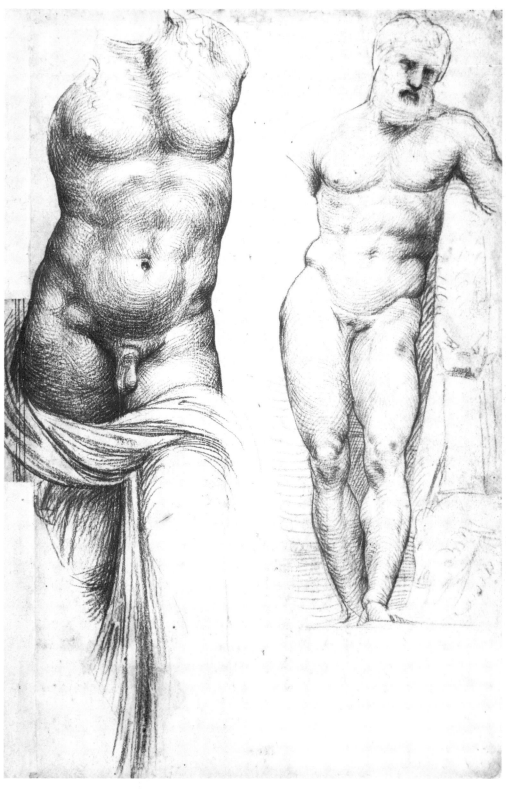

35b

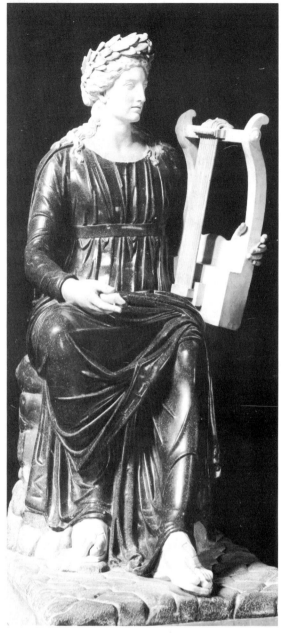

36

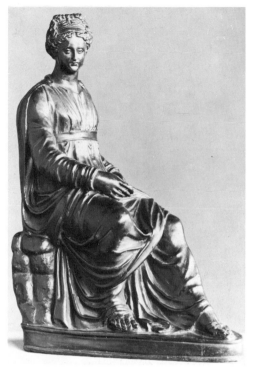

36a

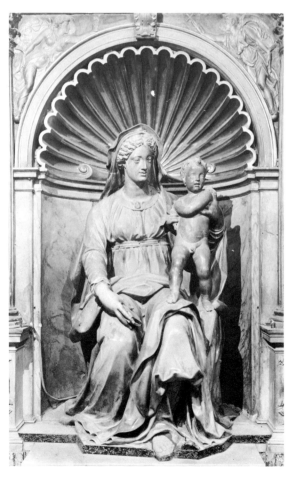

36b

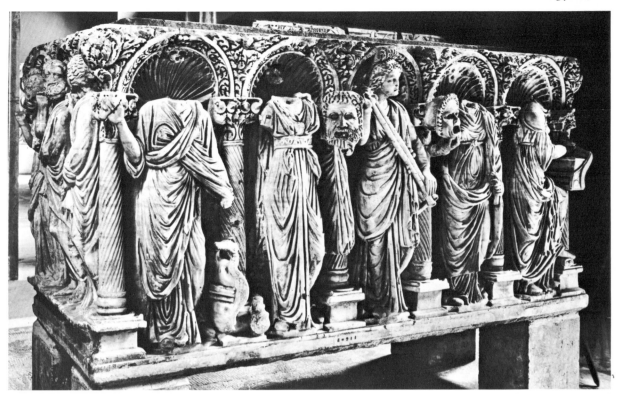

37i

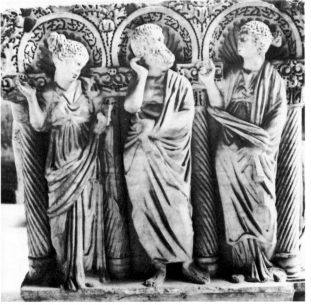

37ii

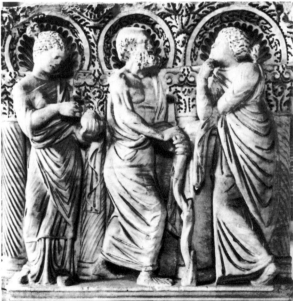

37iii

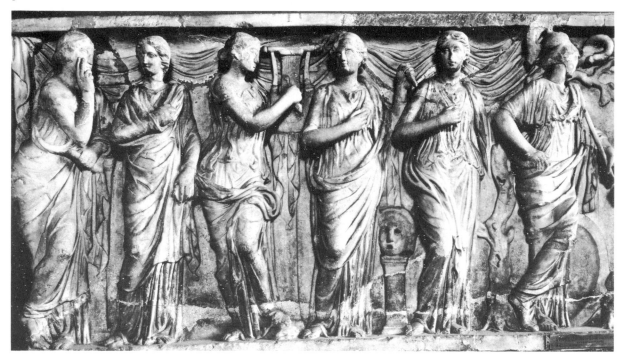

38i

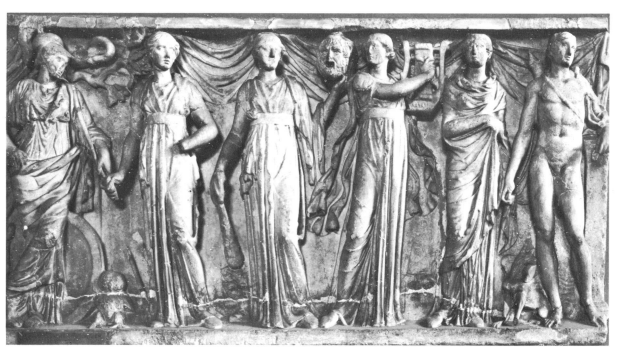

38ii

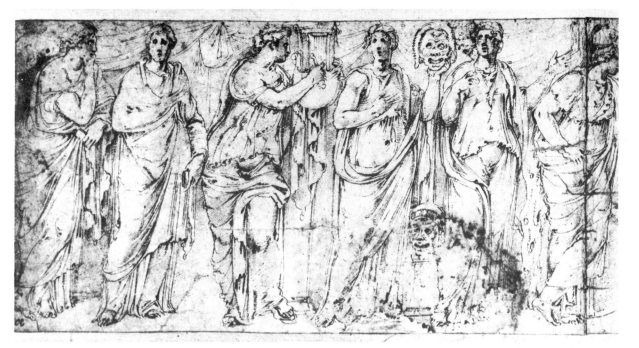

38a–i

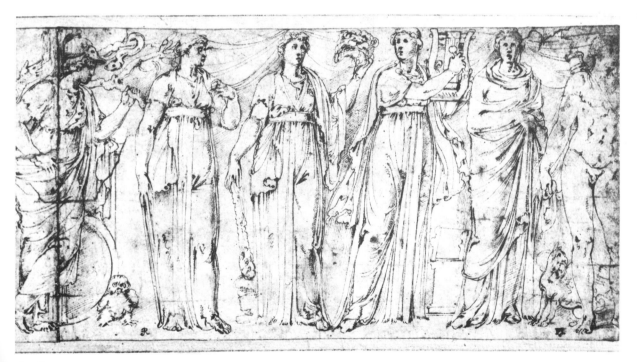

38a–ii

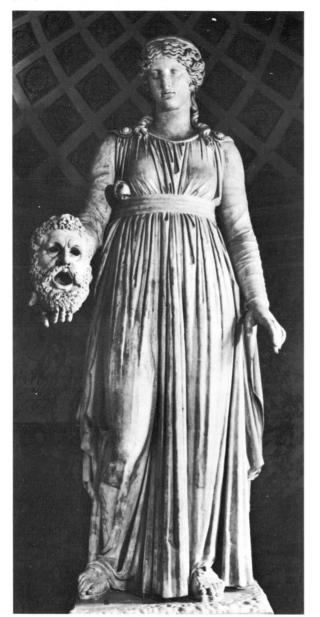

39

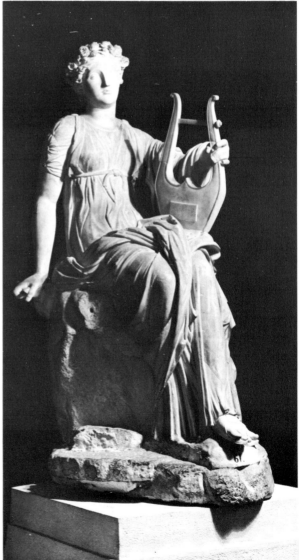

40

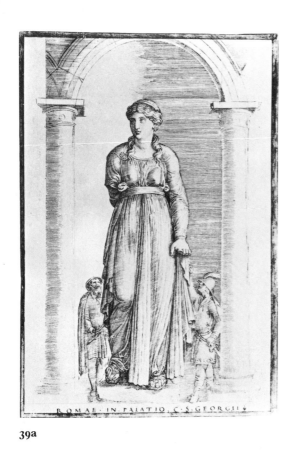

39a

39b

40a

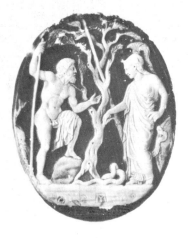

41

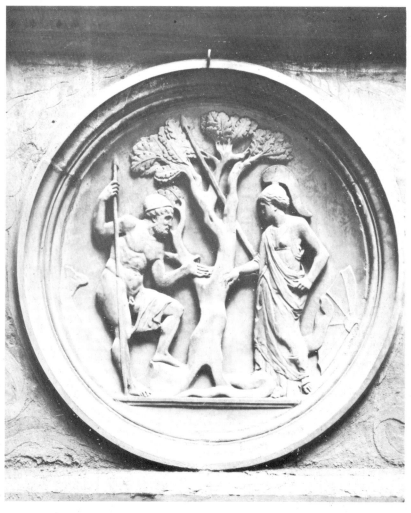

41a

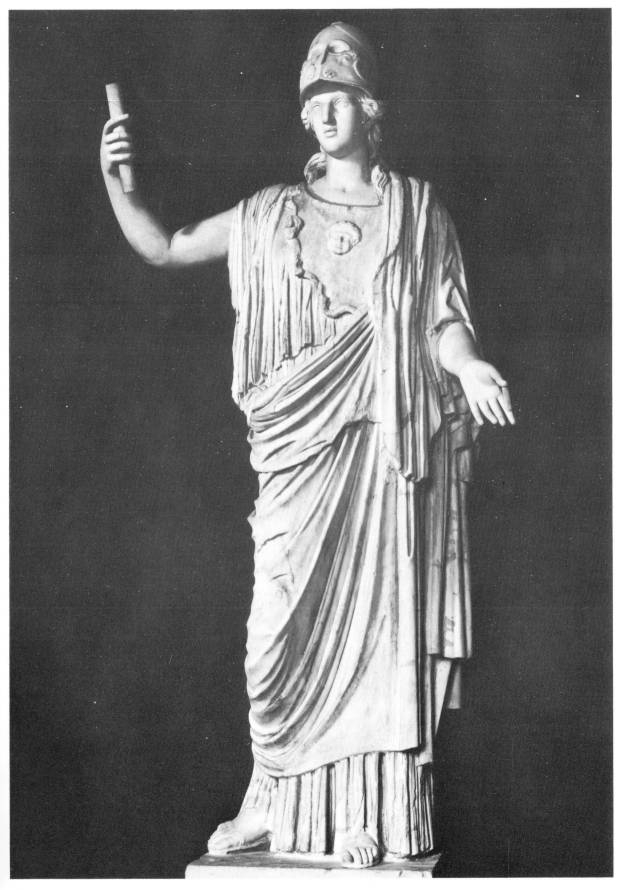

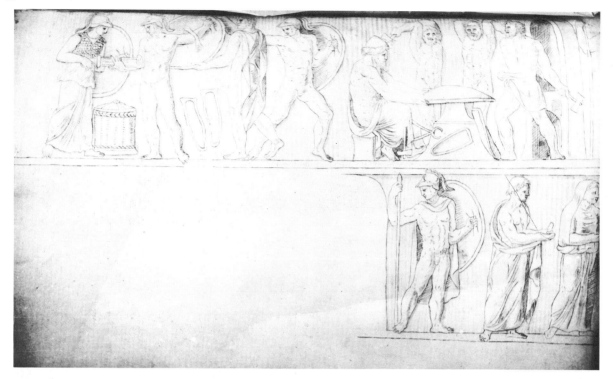

43

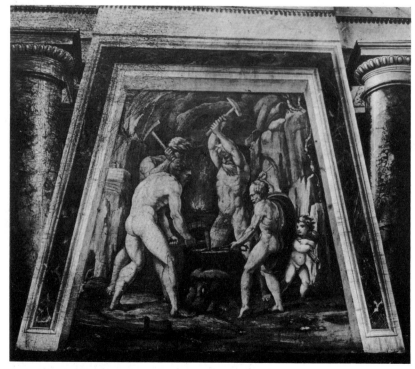

43a

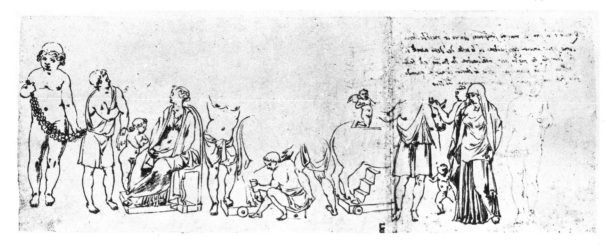

44a

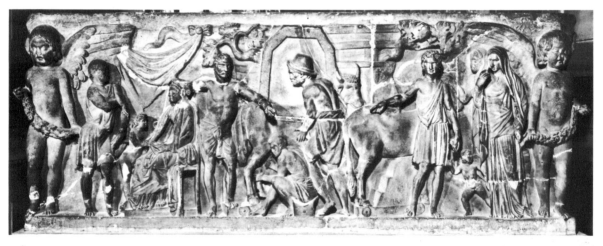

44i

44ii

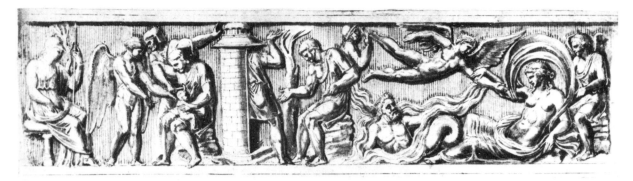

45

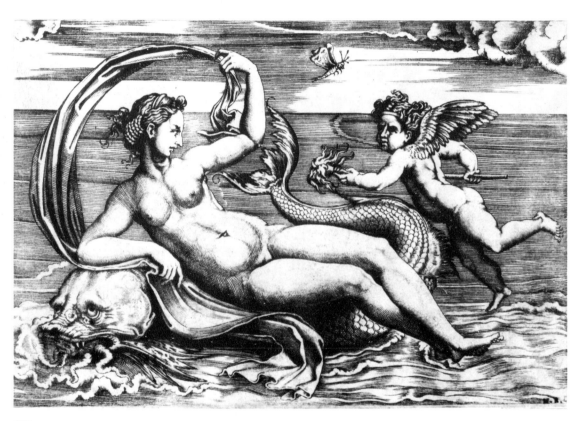

45a

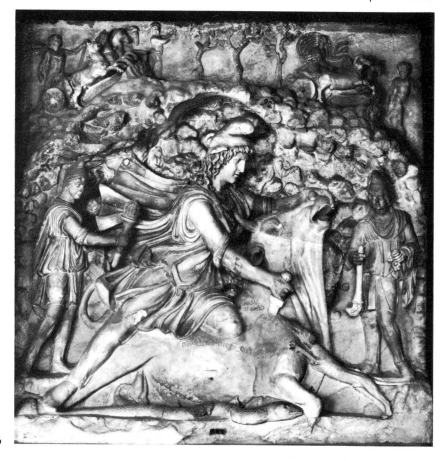

46

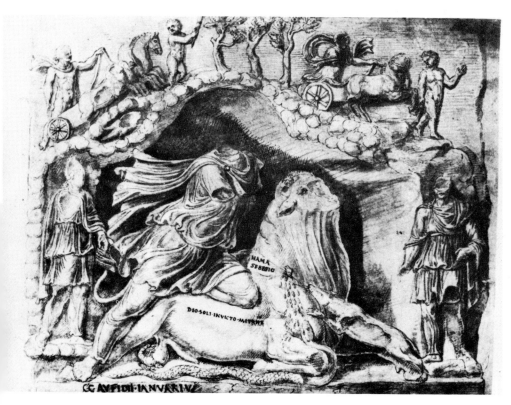

46a

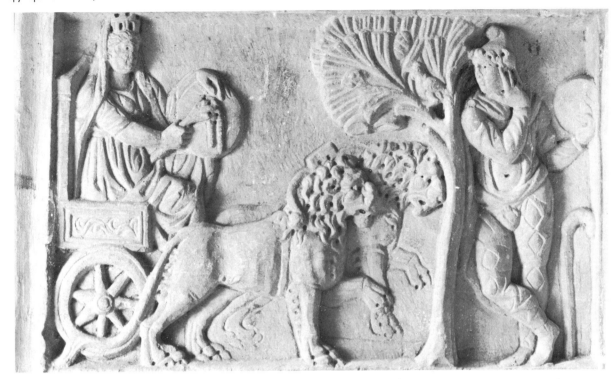

47

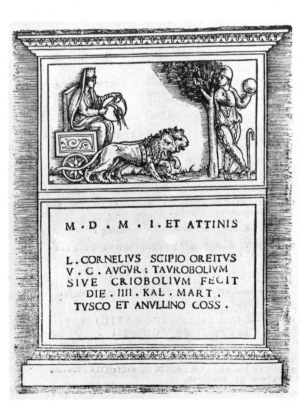

M.D.M.I.ET ATTINIS

L.CORNELIVS SCIPIO OREITVS
V.C.AVGVR: TAVROBOLIVM
SIVE CRIOBOLIVM FECIT
DIE.IIII.KAL.MART.
TVSCO ET ANVLLINO COSS.

47a

48

49i

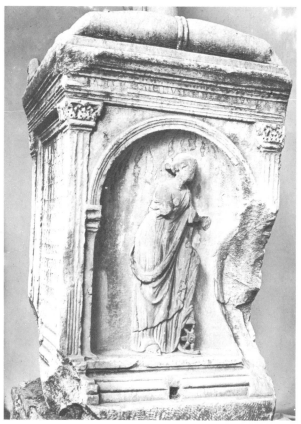

49ii

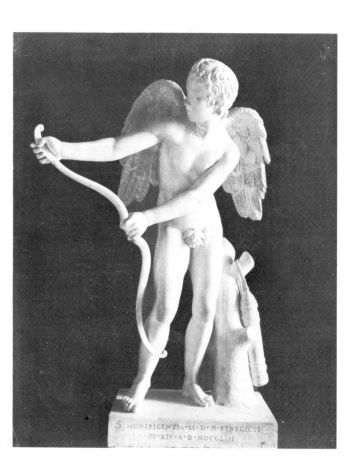

50

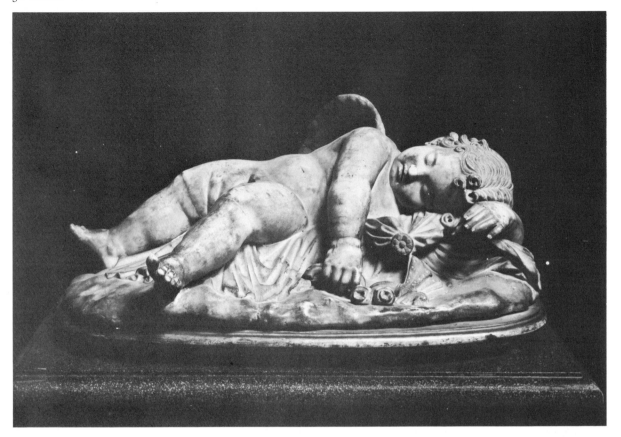

51

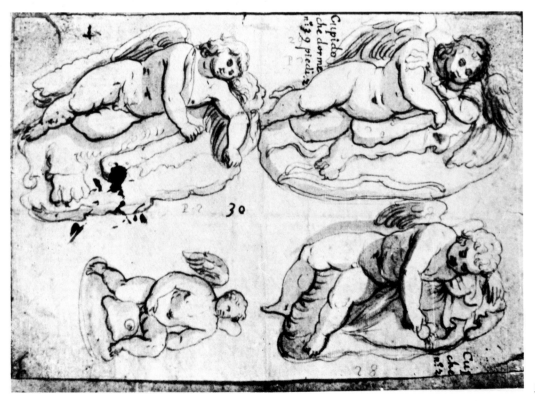

51a

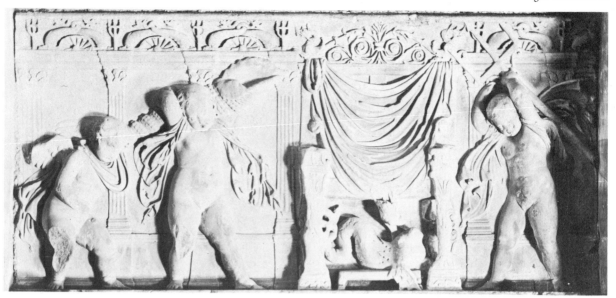

52A

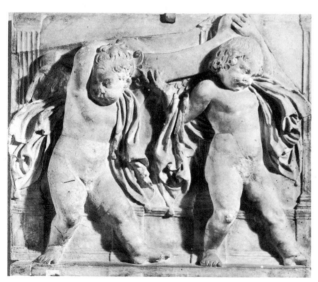

52B–i

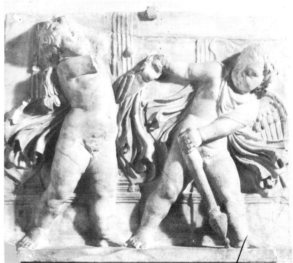

52B–ii

52A–a

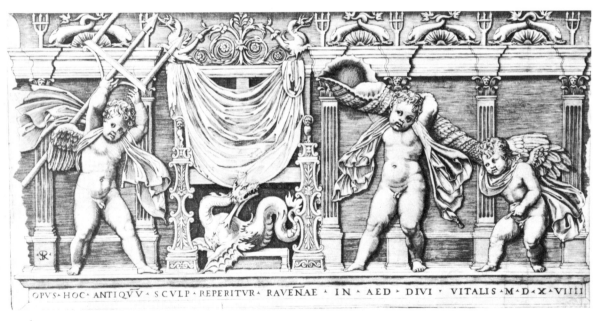

OPVS·HOC·ANTIQVV·SCVLP·REPERITVR·RAVEÑAE·IN·AED·DIVI·VITALIS·M·D·X·VIIII

52A–b

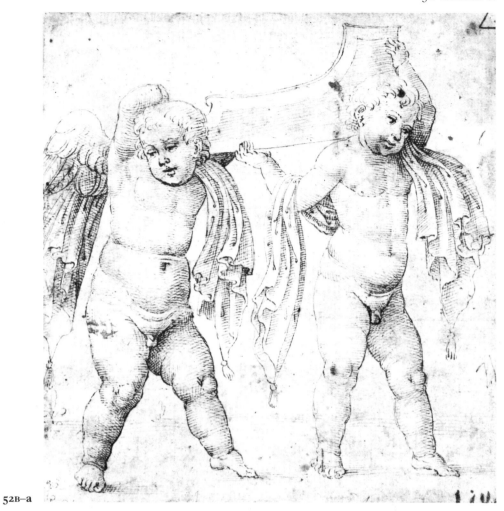

52B–a

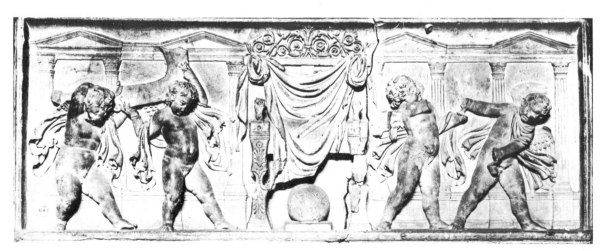

52B–b

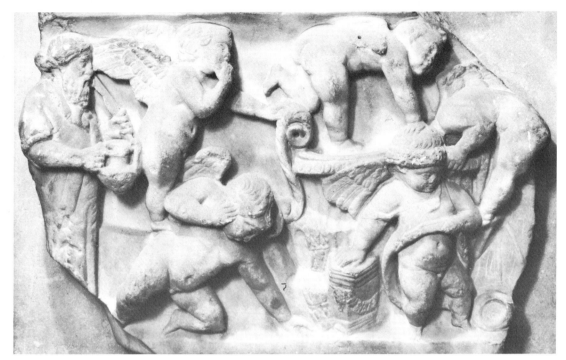

53

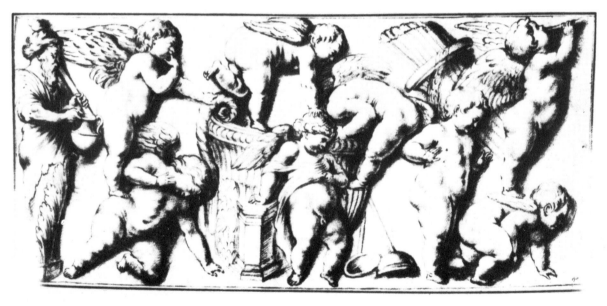

53a

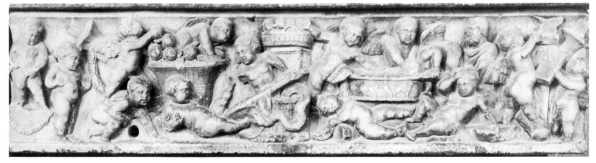

53b

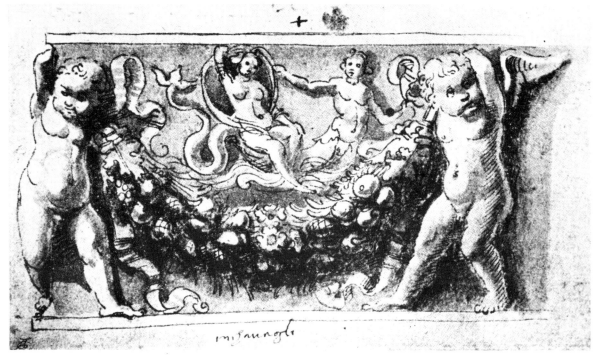

54

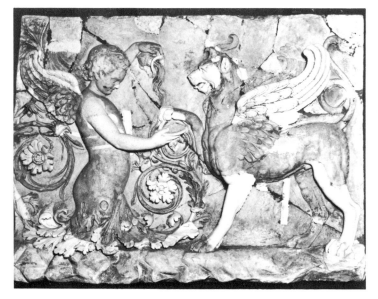

55

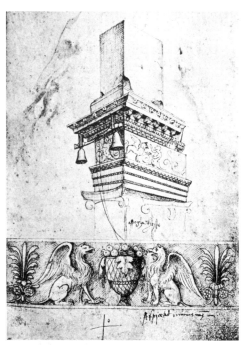

55a

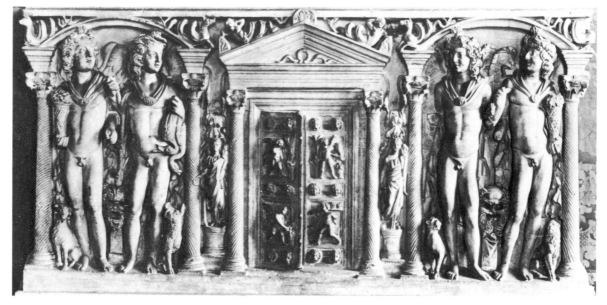

56

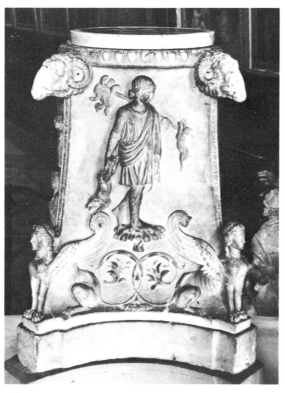

57i

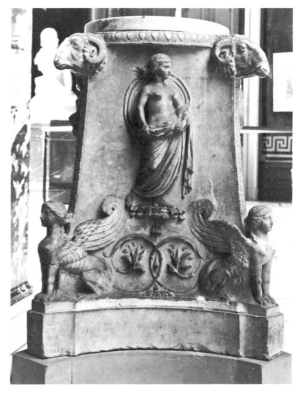

57ii

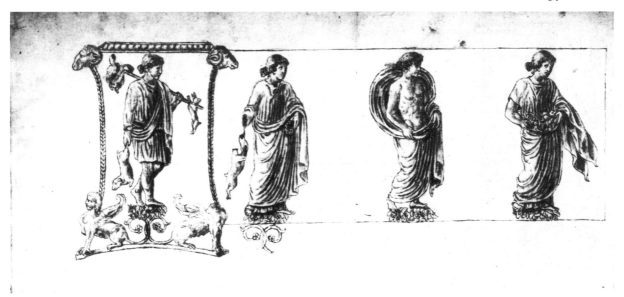

57a

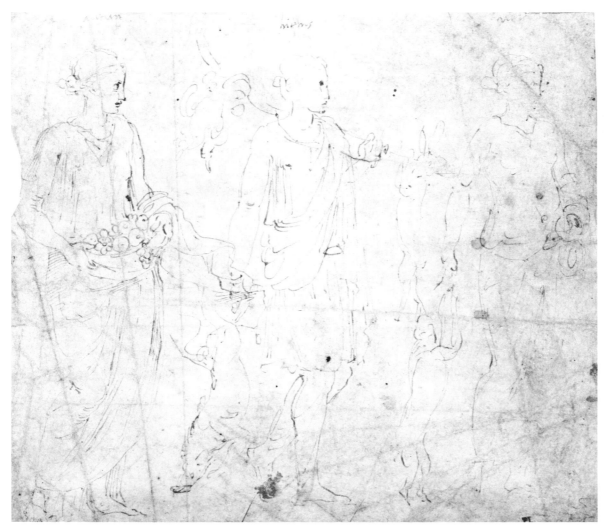

57b

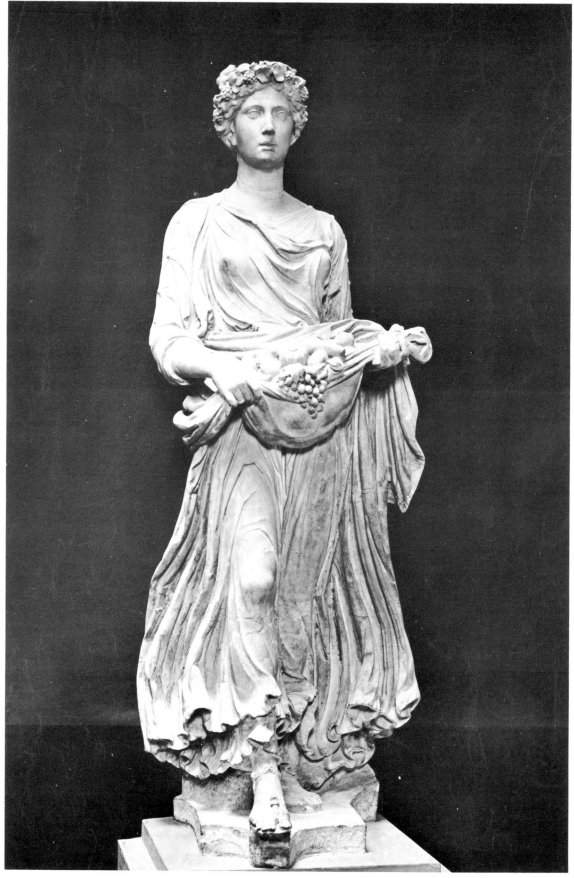

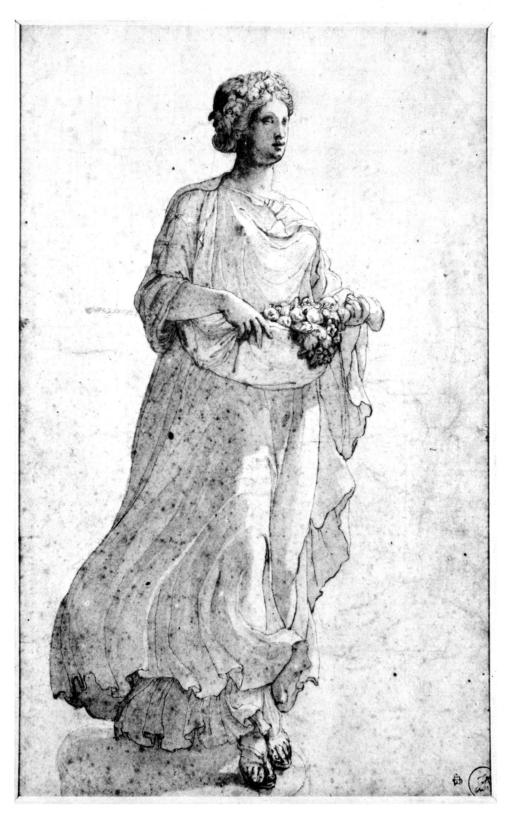

58a

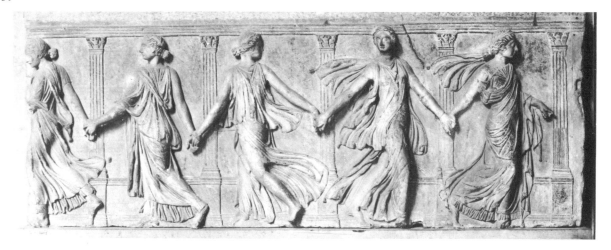

59A

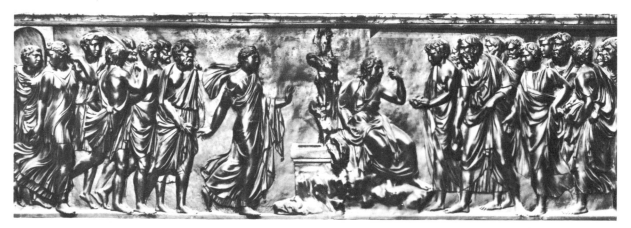

59A–a

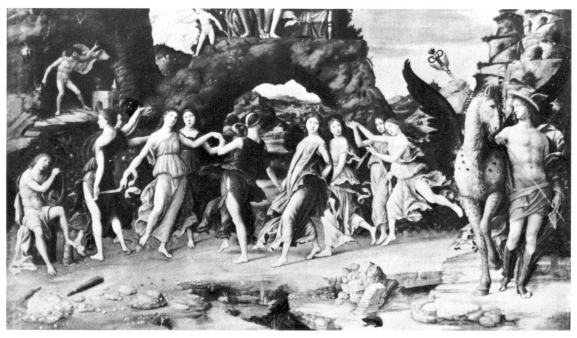

59A–b

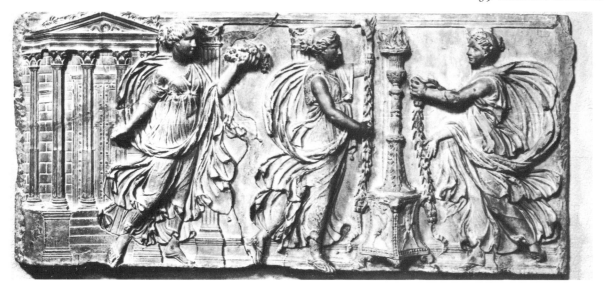

59B

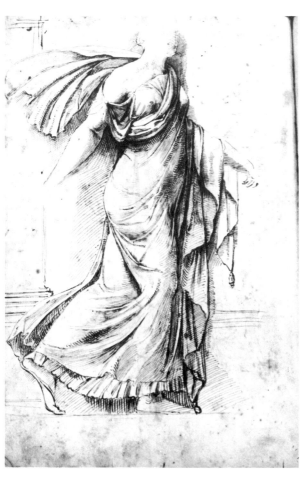

59A–c

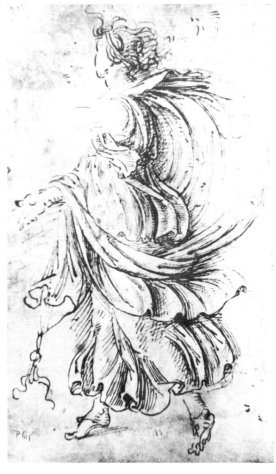

59B–a

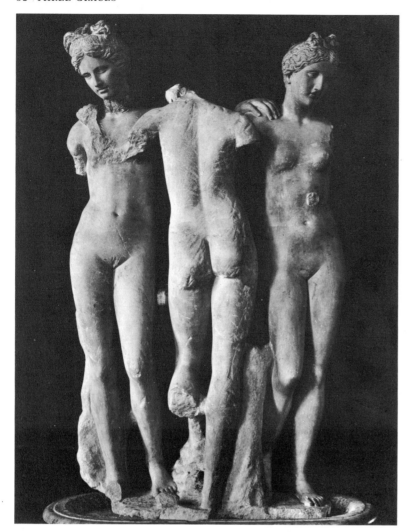

60

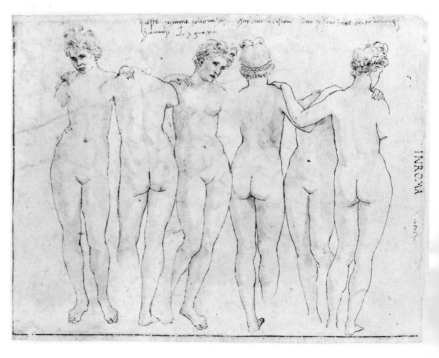

60a

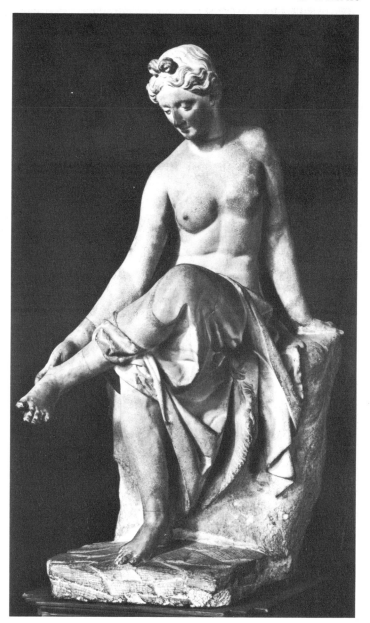

61

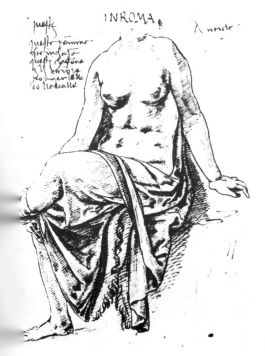

61a

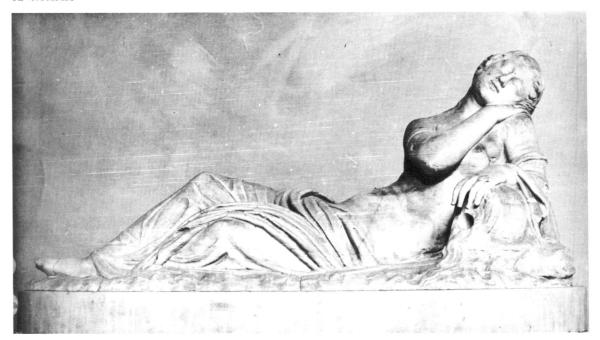

62

62a

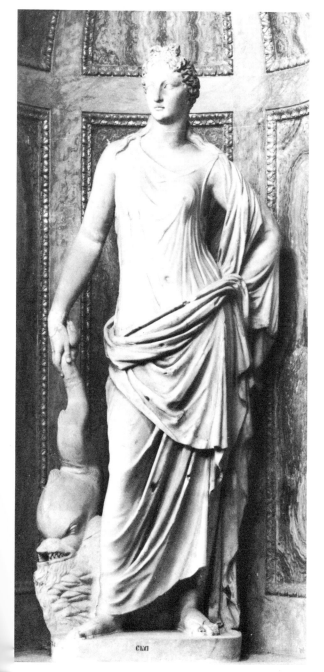

63

63a

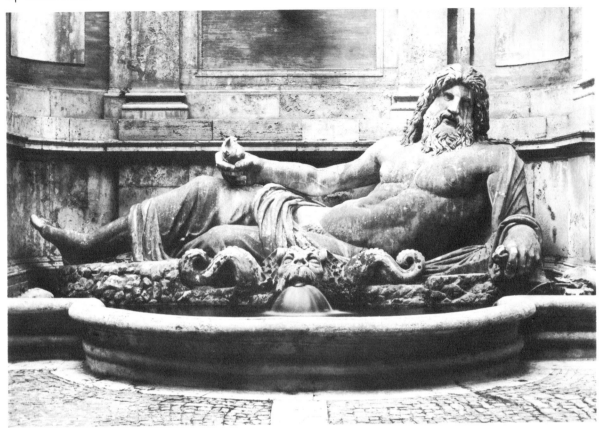

64

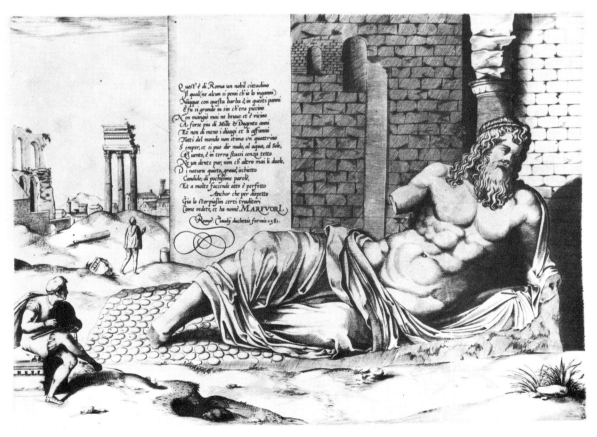

64a

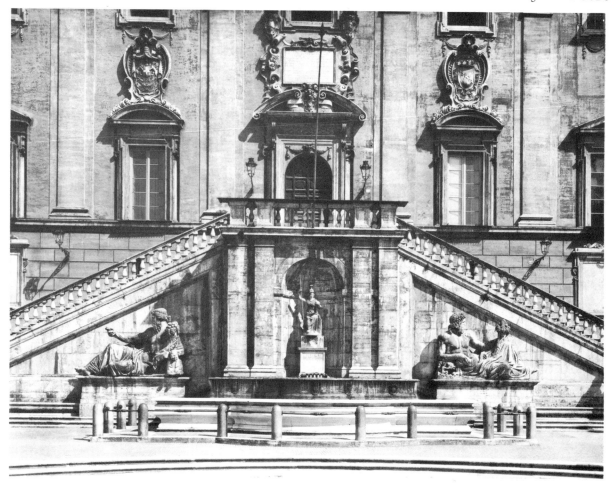

65

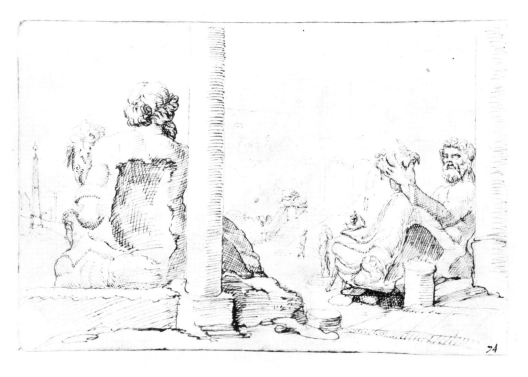

65a

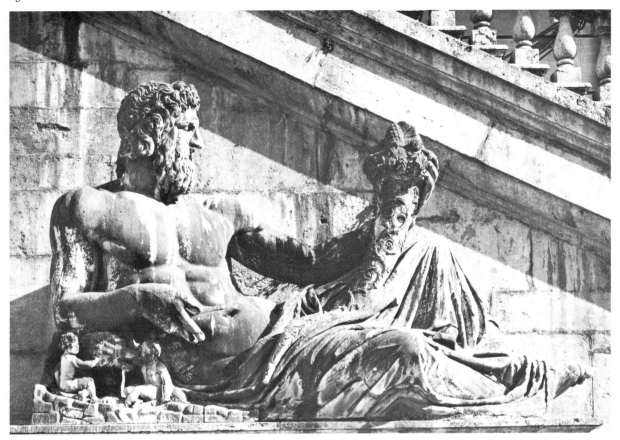

65A

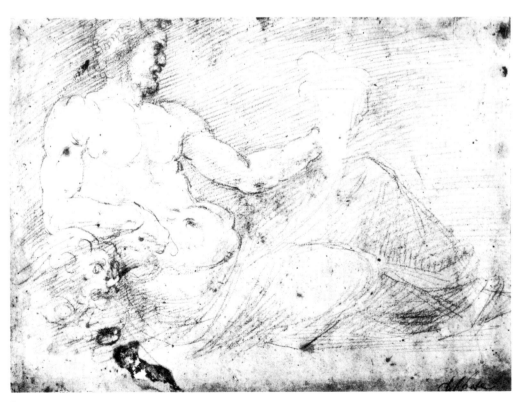

65A–a

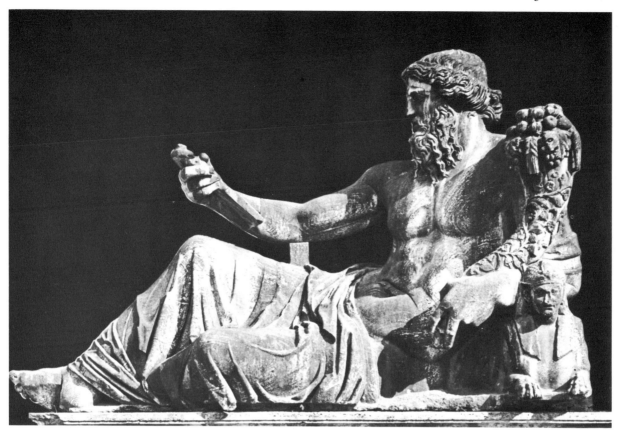

65B

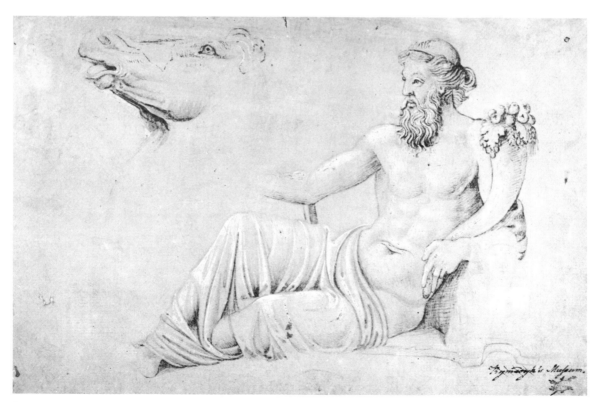

65B–a

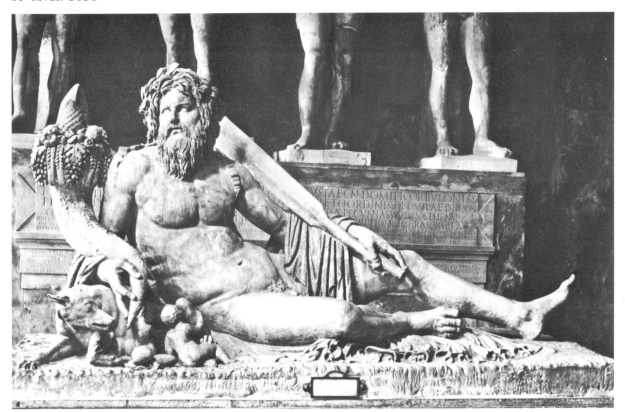

66

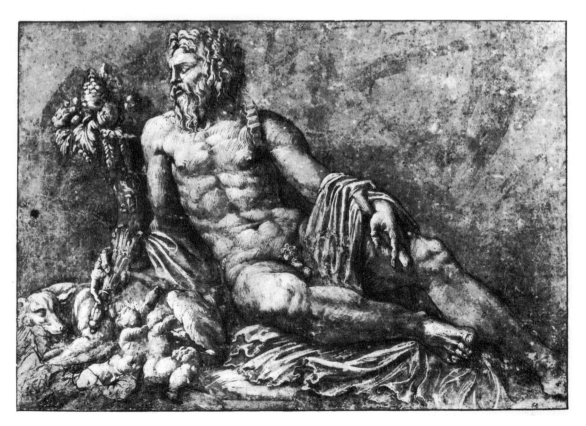

66a

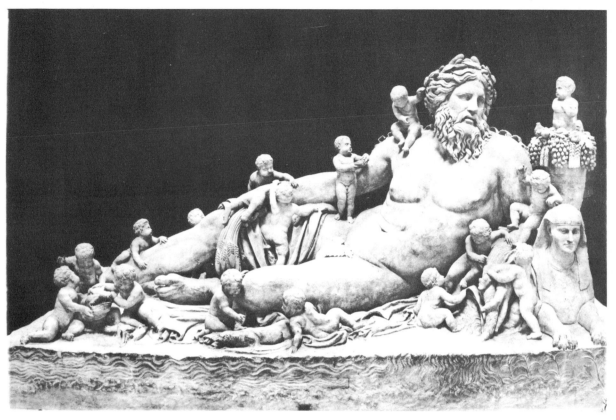

67

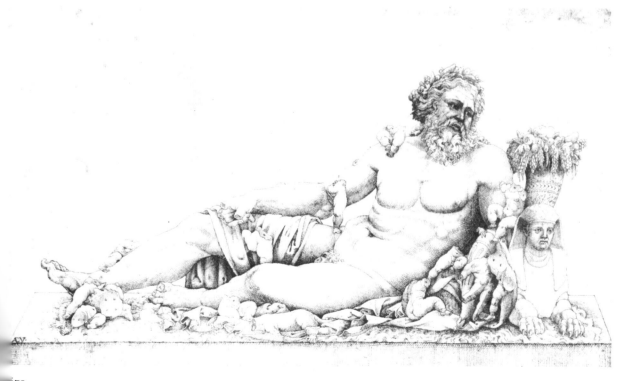

67a

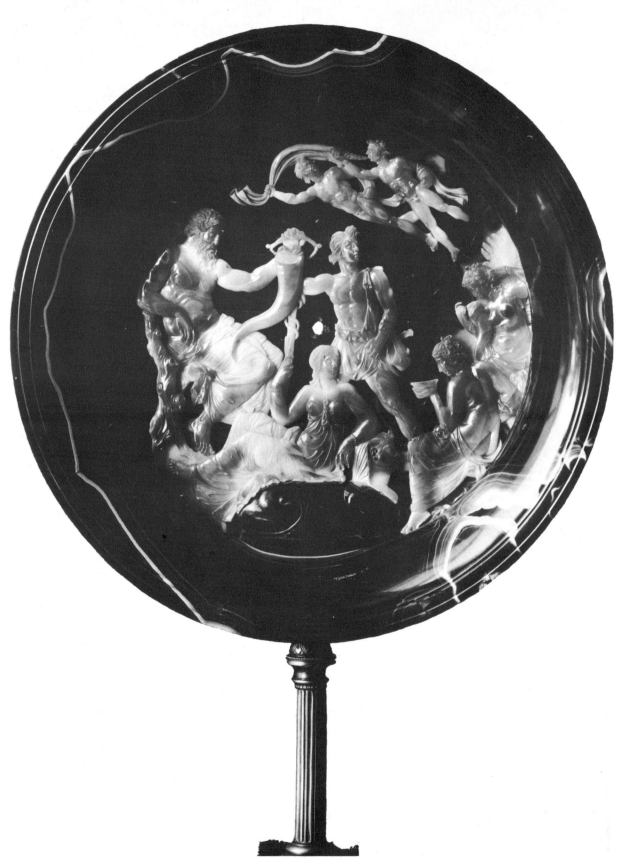

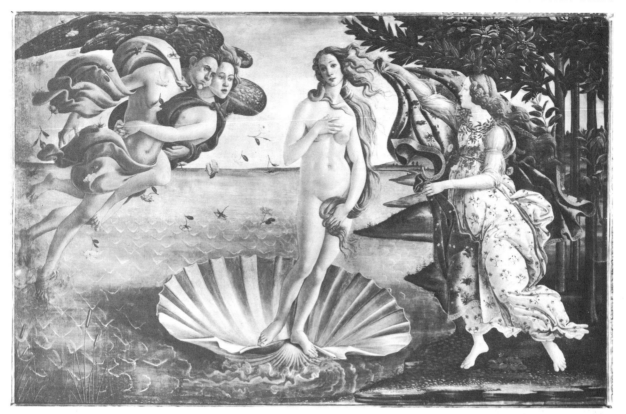

68a

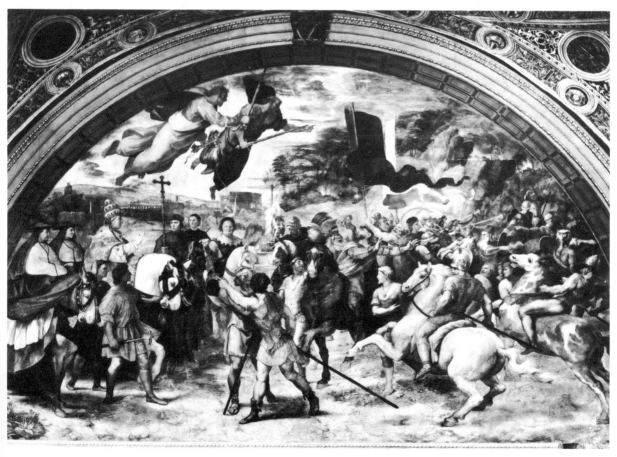

68b

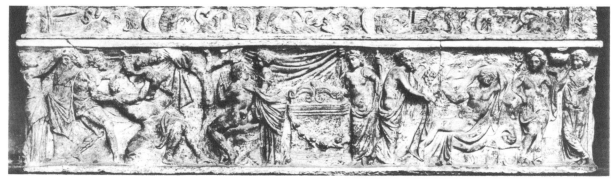

69

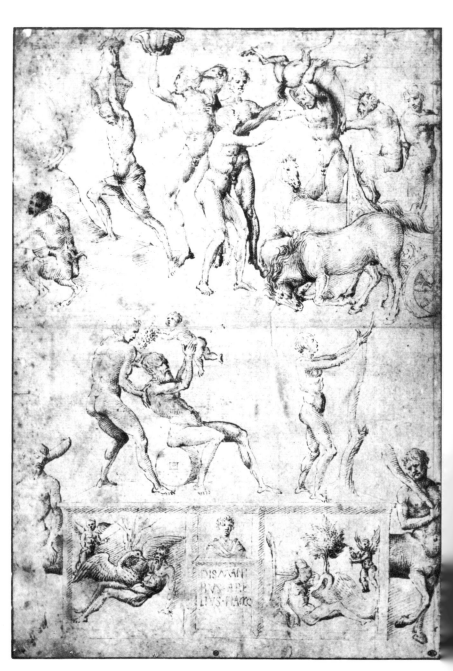

69a

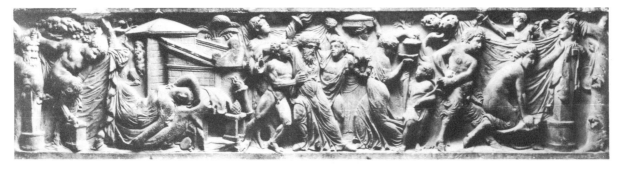

70

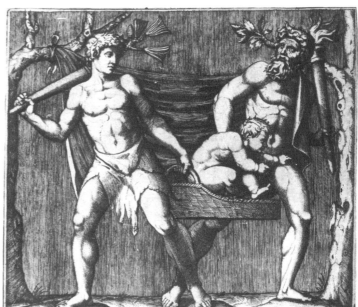

70a

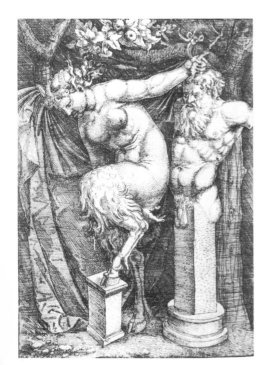

70b

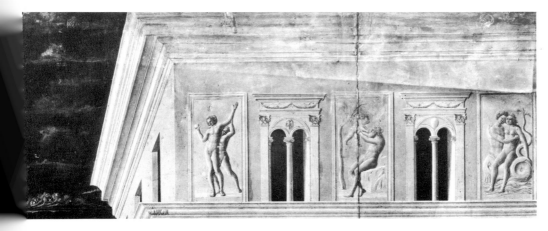

69b

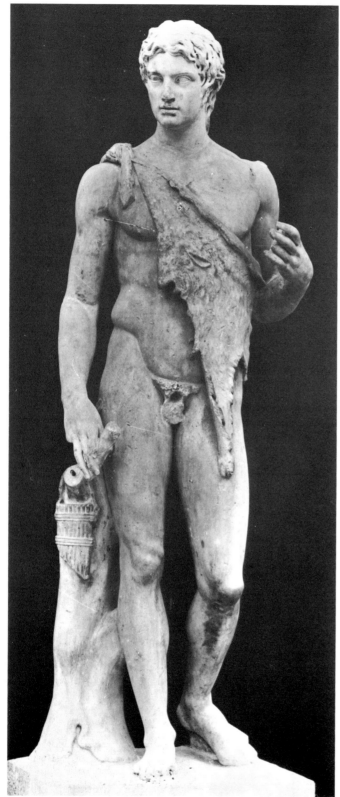

71

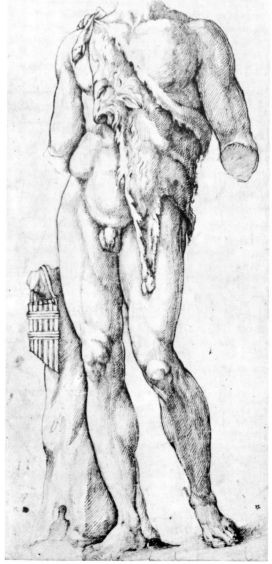

71a

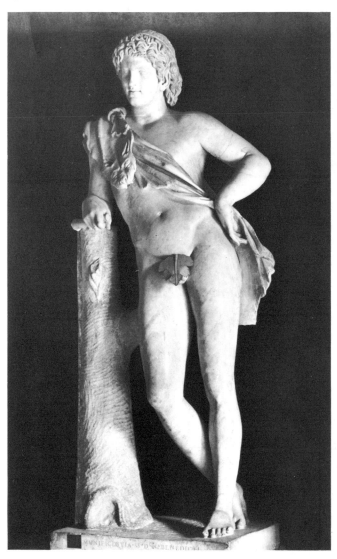

72

72a

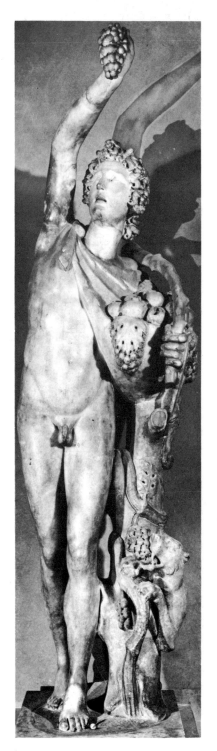

73

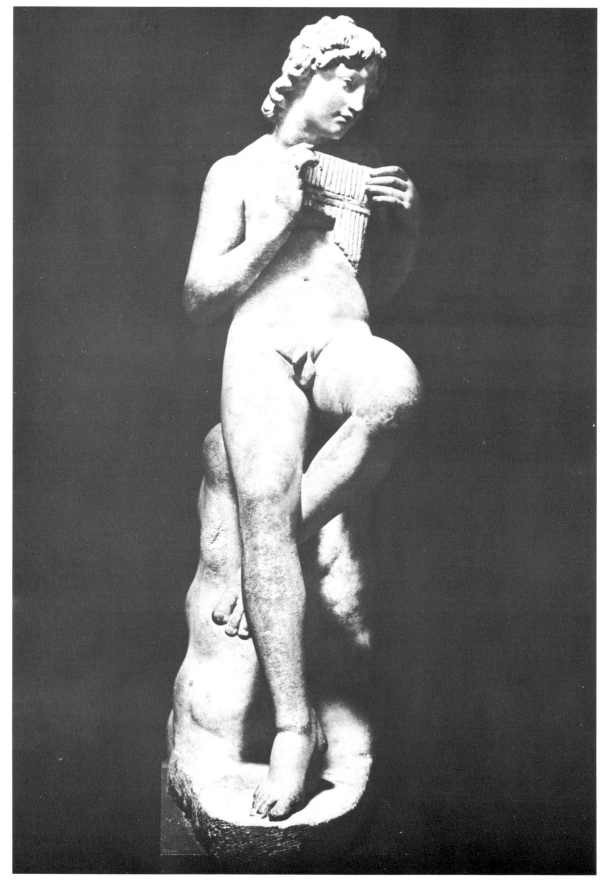

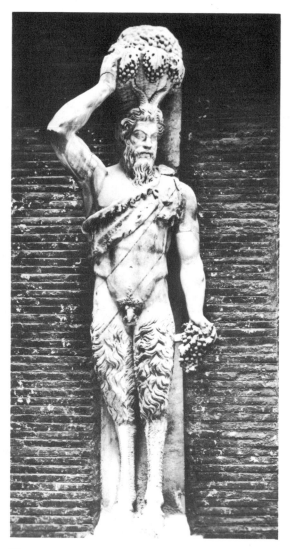

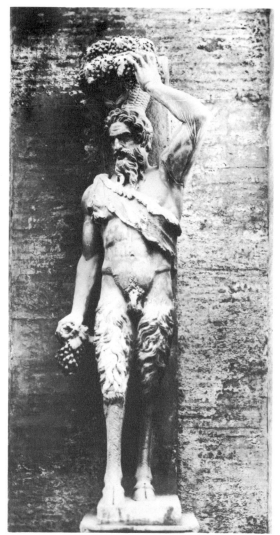

75

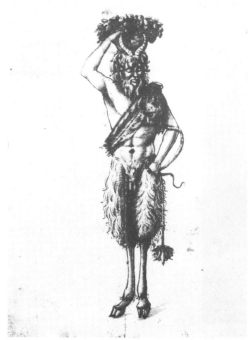

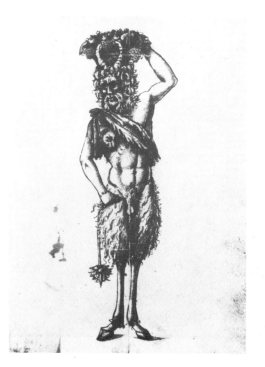

75a

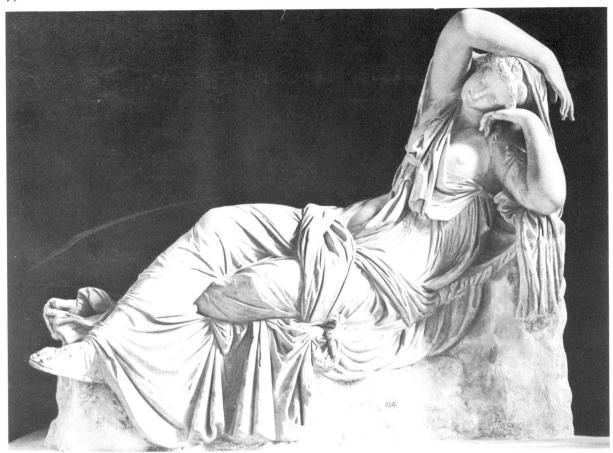

79

79a

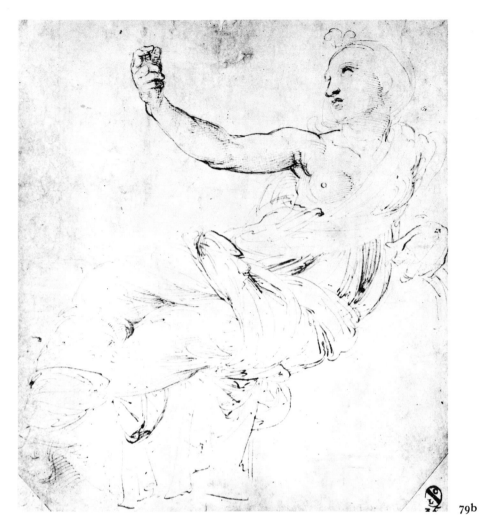

79b

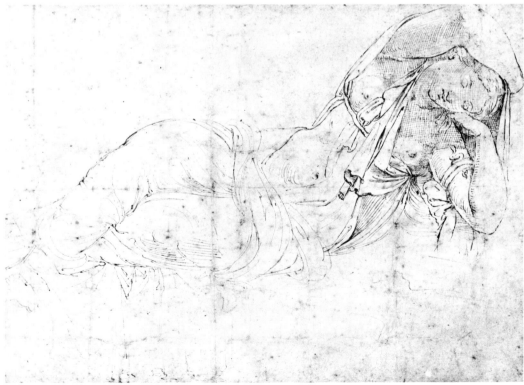

79c

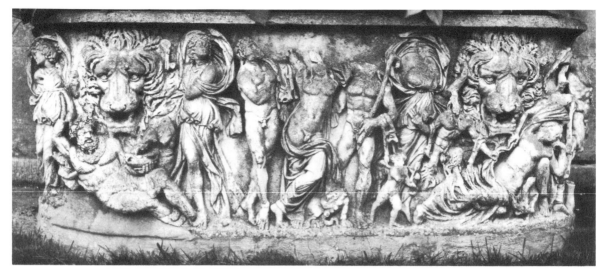

80

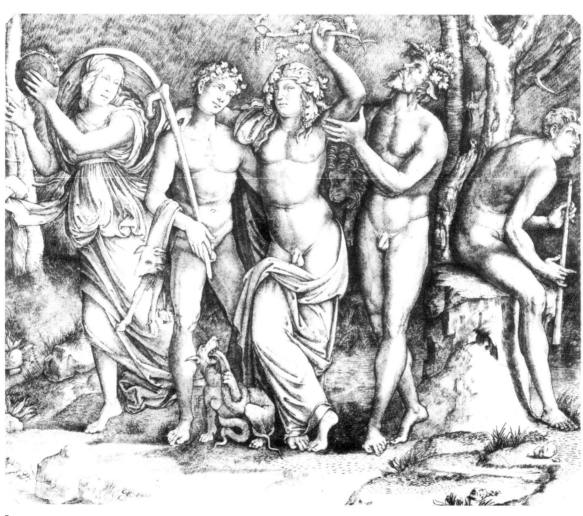

80a

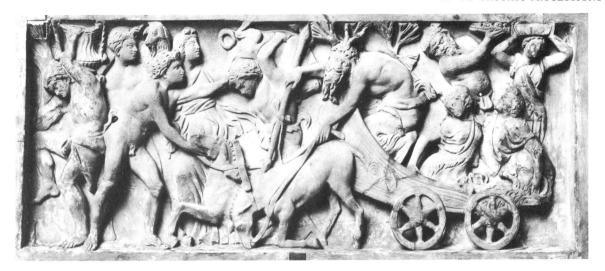

81

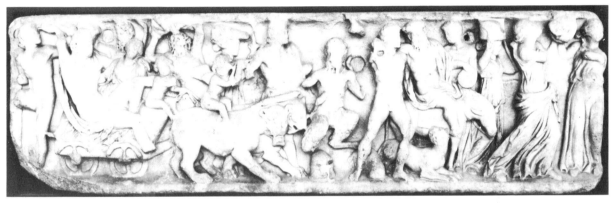

82

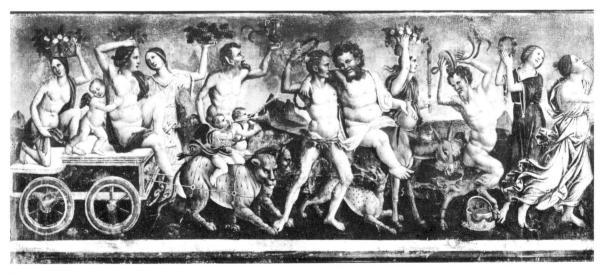

82a

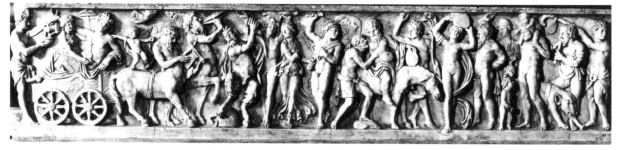

83i

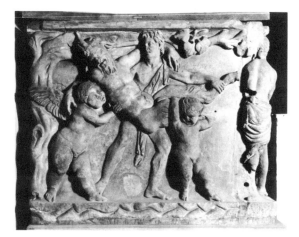

83ii

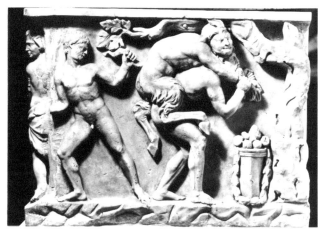

83iii

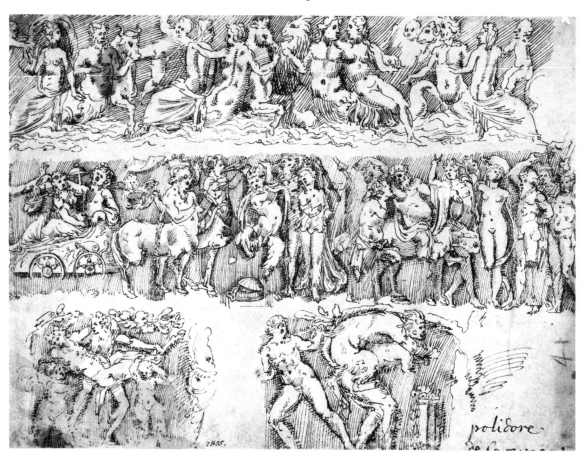

83a

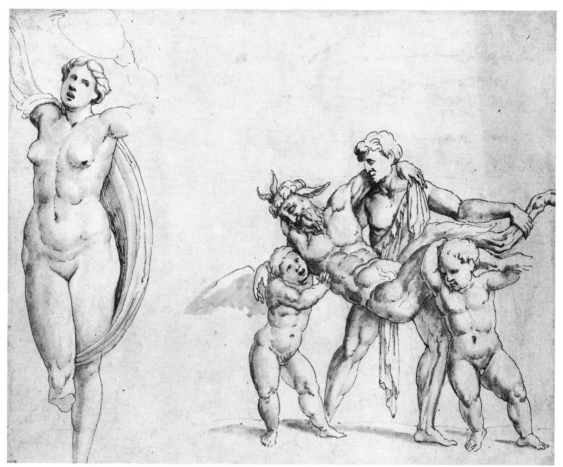

83b

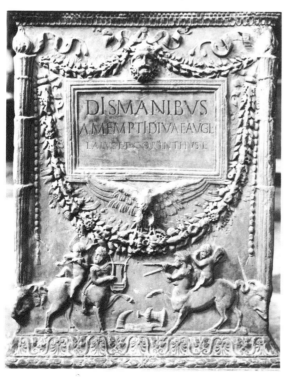

84

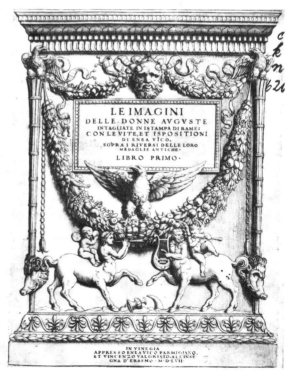

84a

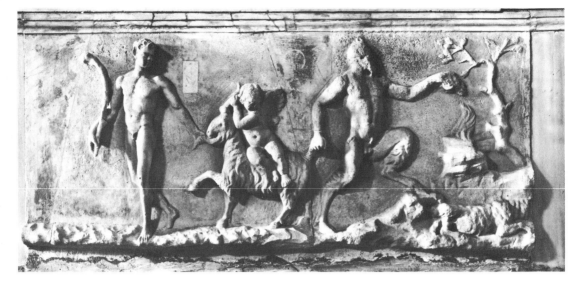

85i

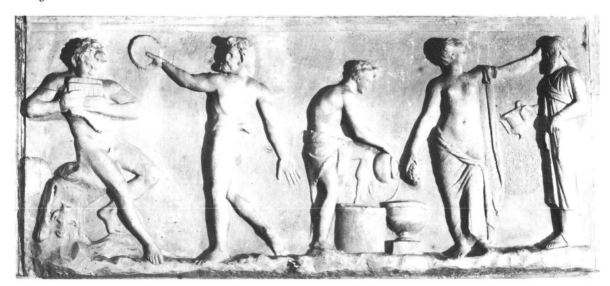

85ii

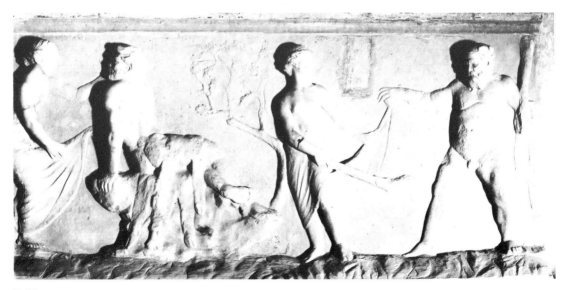

85iii

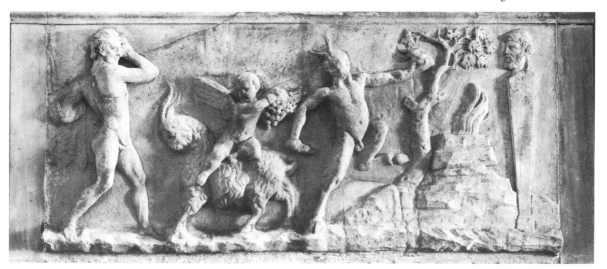

85iv

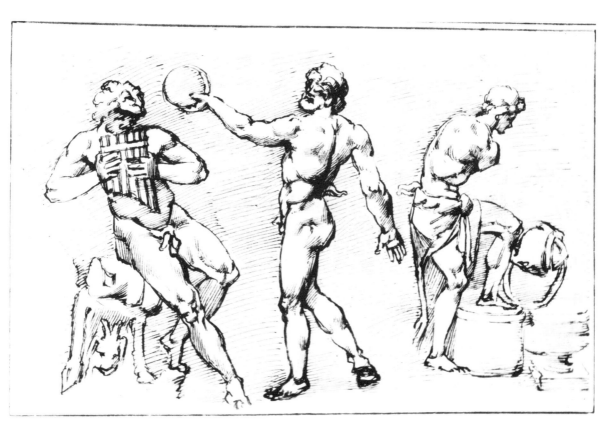

85a

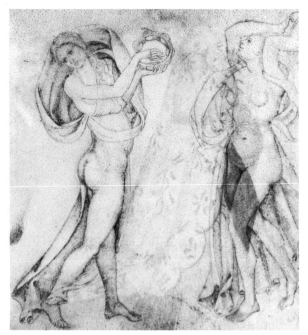

86a

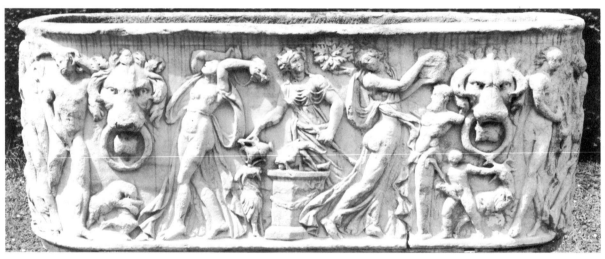

86

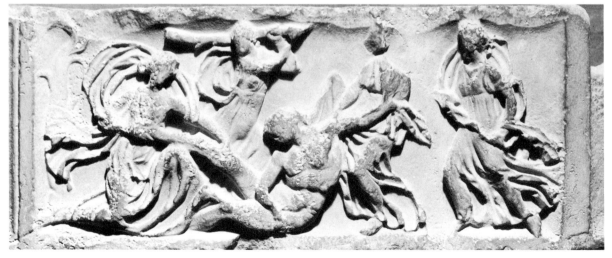

87

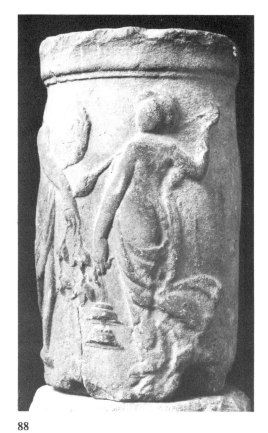

88

88a

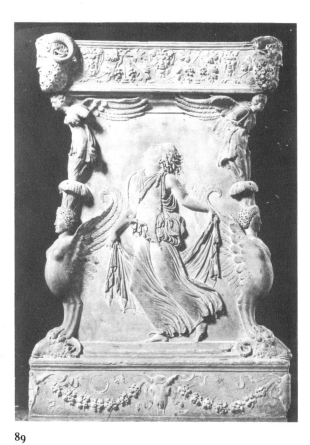

89

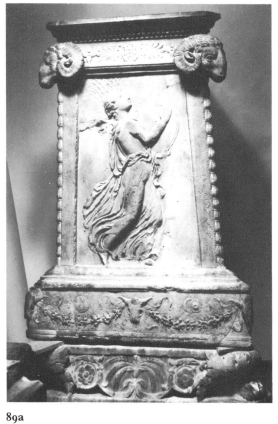

89a

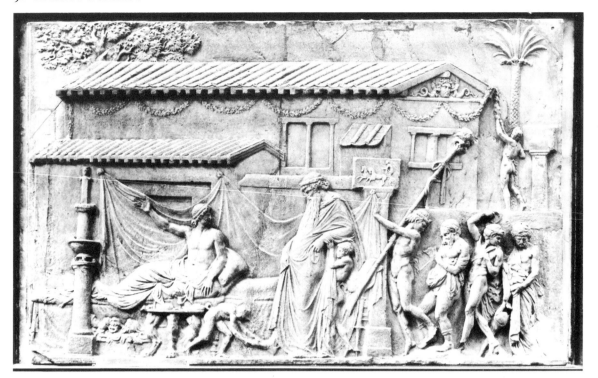

90

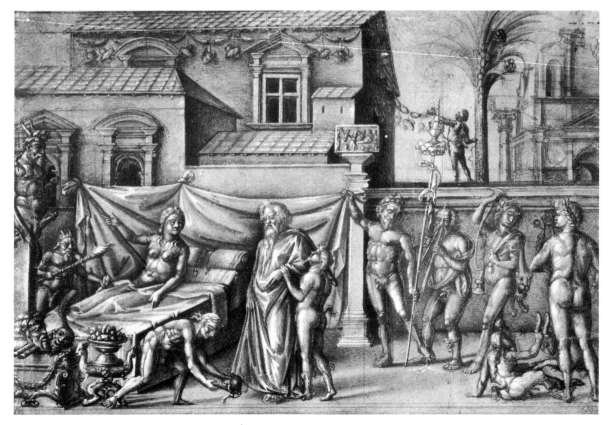

90a

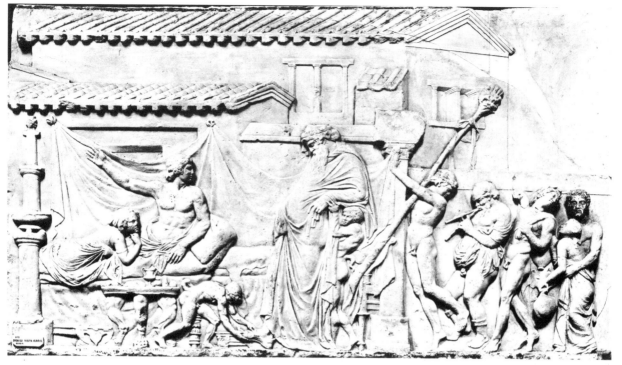

90c

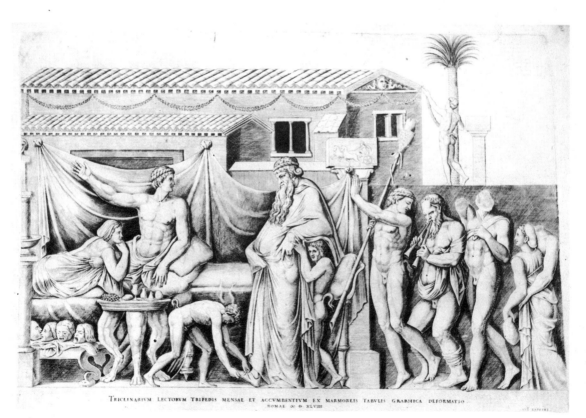

TRICLINARIVM LECTORVM TRIPEDIS MENSAE ET ACCVMBENTIVM EX MARMOREIS TABVLIS GRAPHICA DEFORMATIO·
ROMAE ✠ ⵙ XLVIII

90d

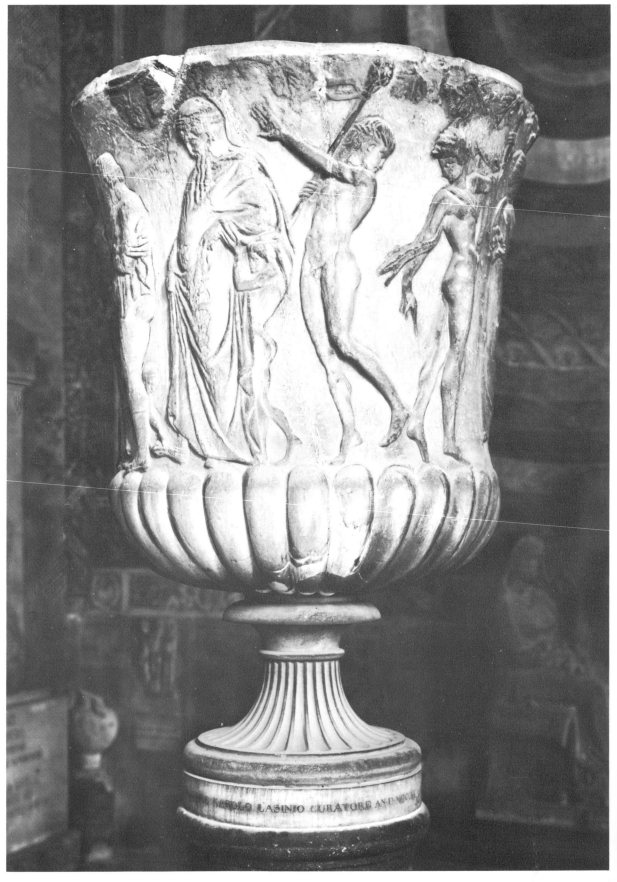

91a

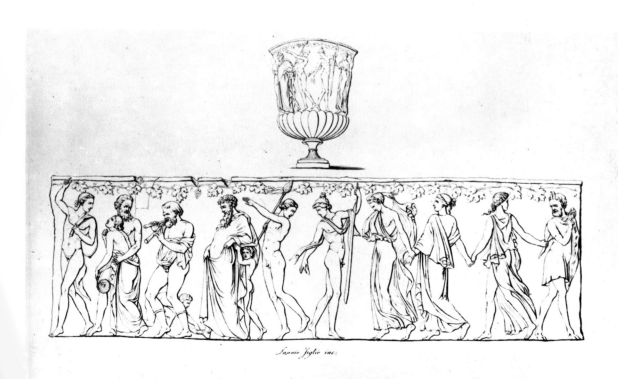

91b

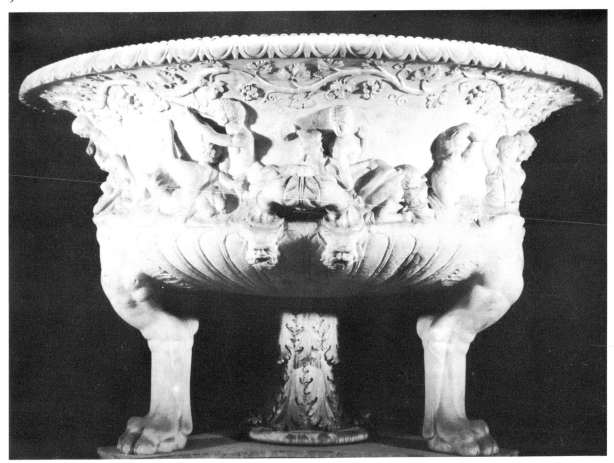

92

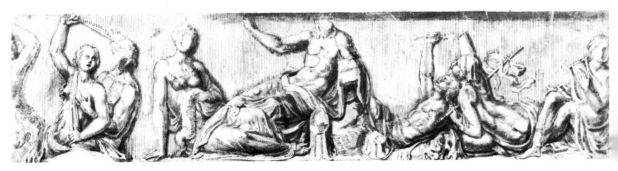

92a

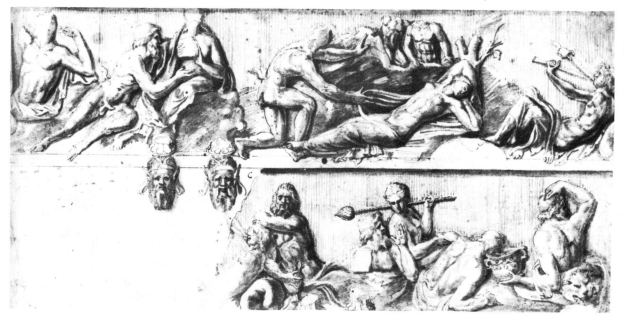

92b

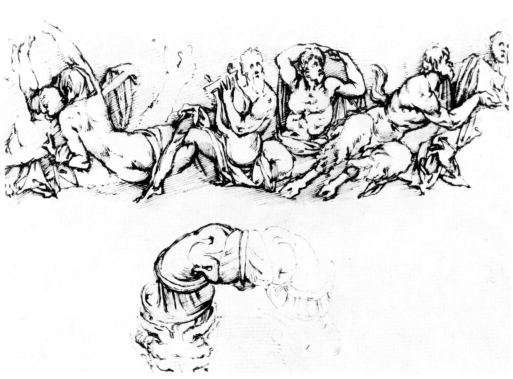

92c

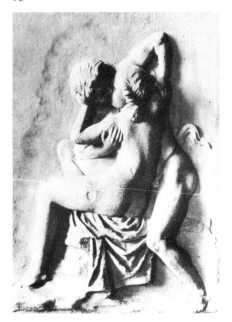

93i

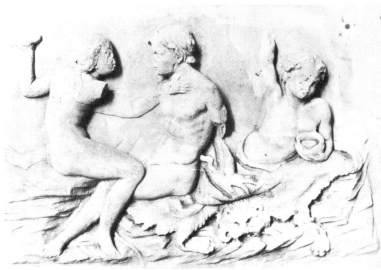

93ii

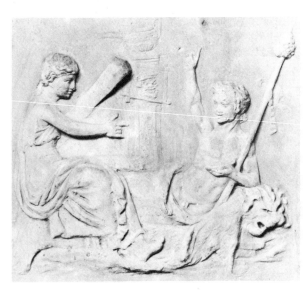

93iii

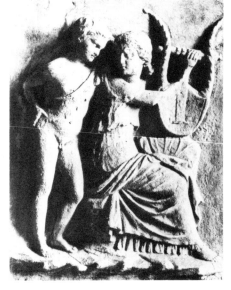

93iv

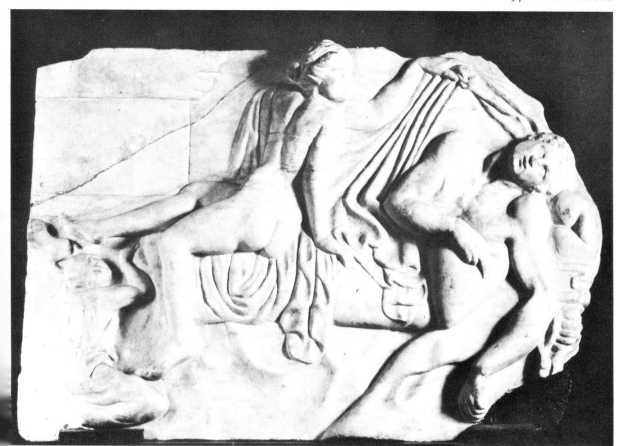

94

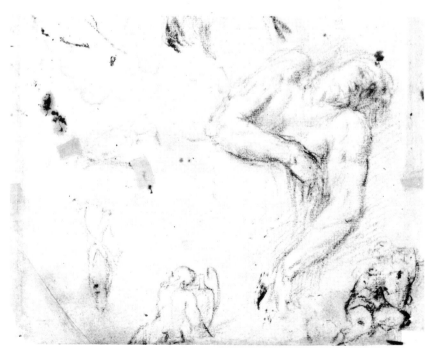

94a

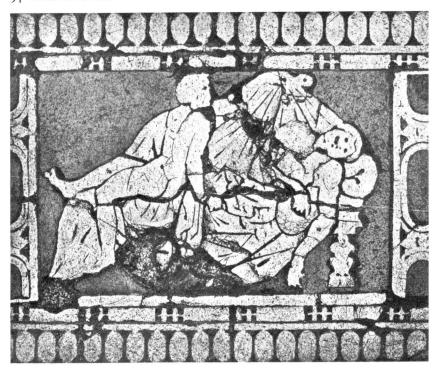

94b

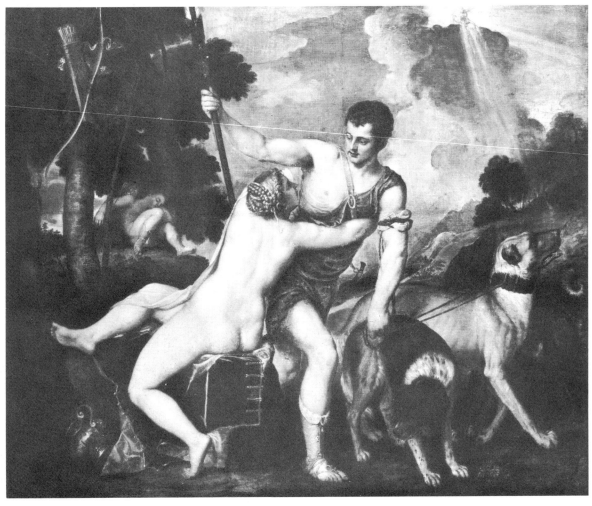

94c

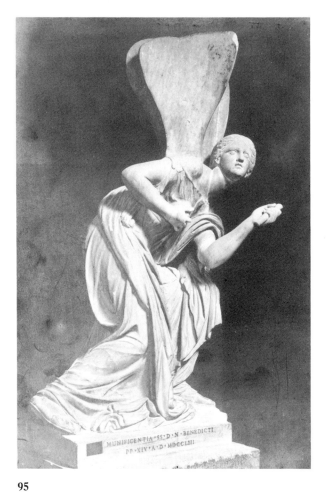

95

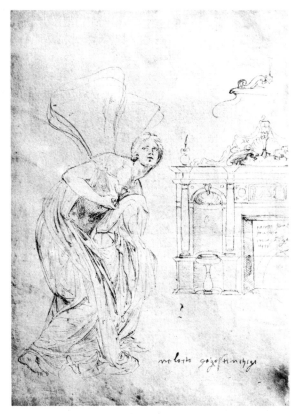

95a

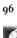
96

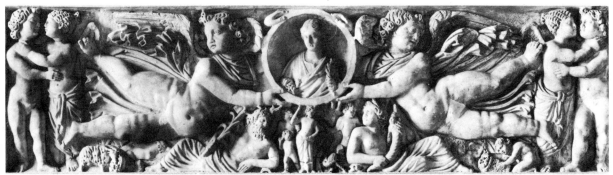

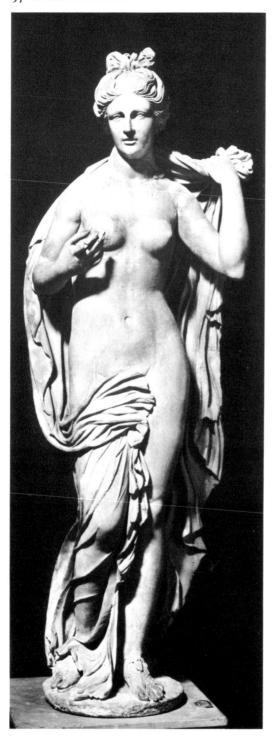

97

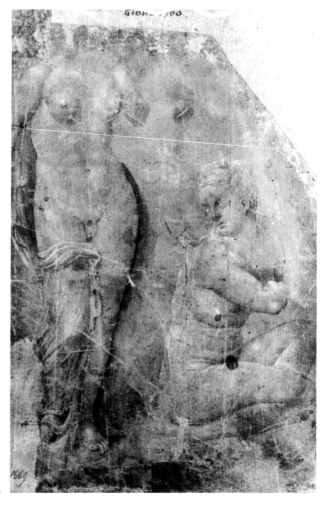

97a

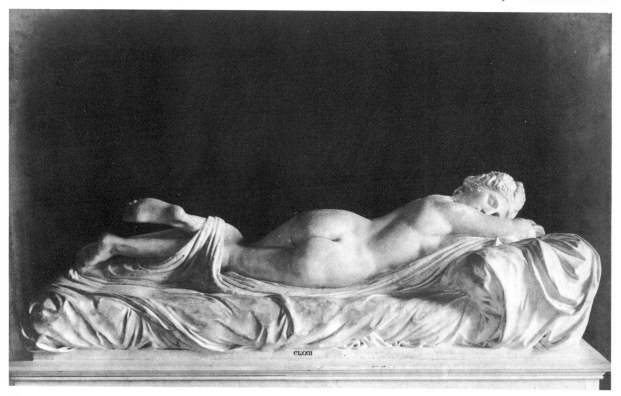

98

98a

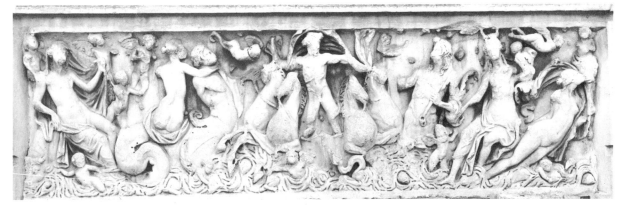

99

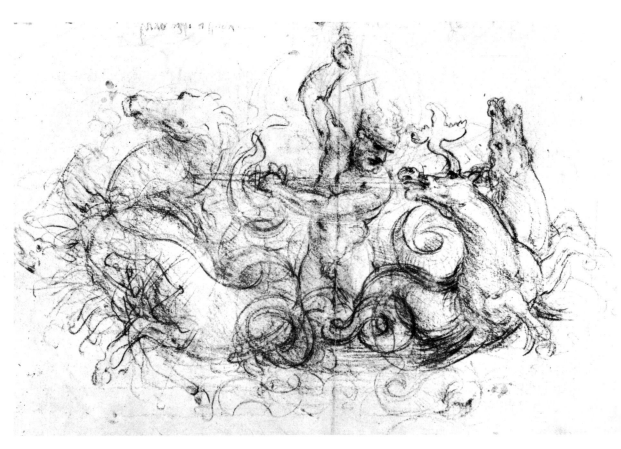

99a

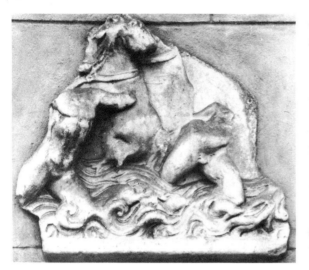

100i

100ii

100a

100b

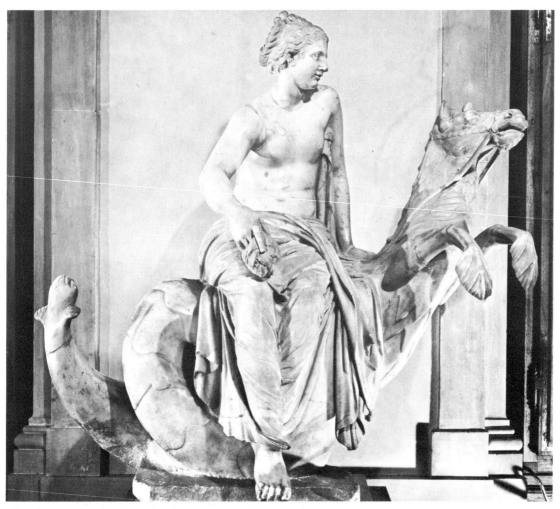

101

101a

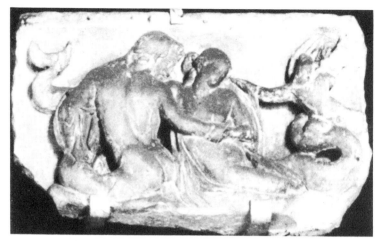

102

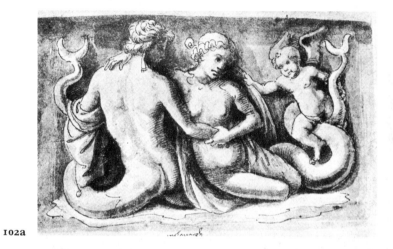

102a

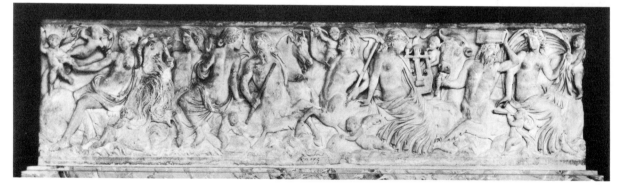

103

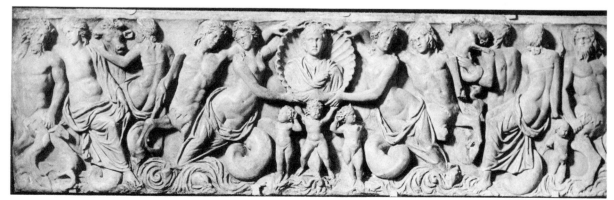

104

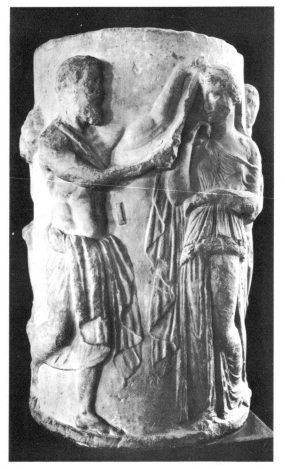

105i

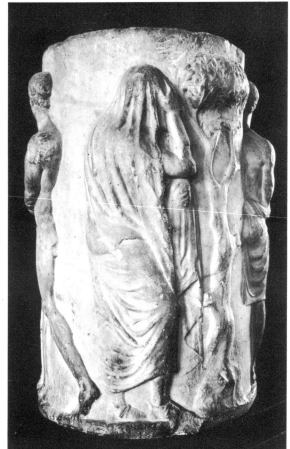

105ii

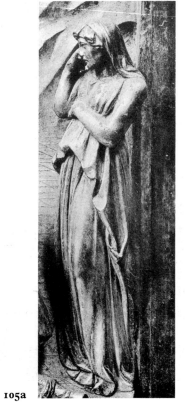

105a

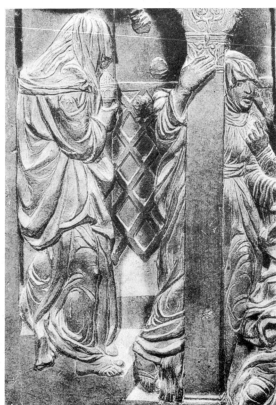

105b

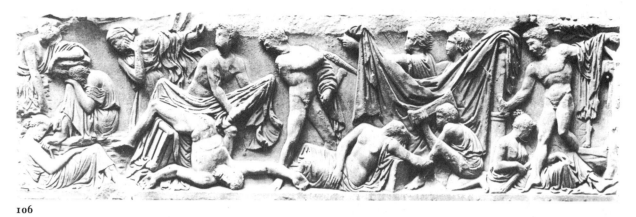

106

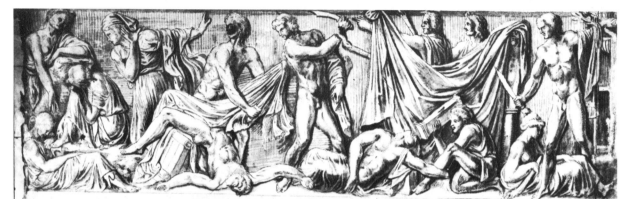

106a

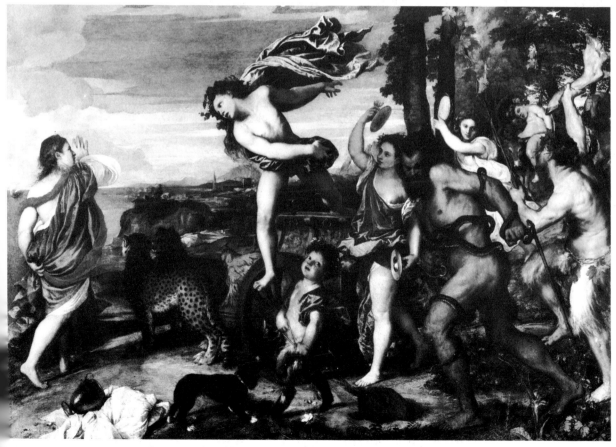

106b

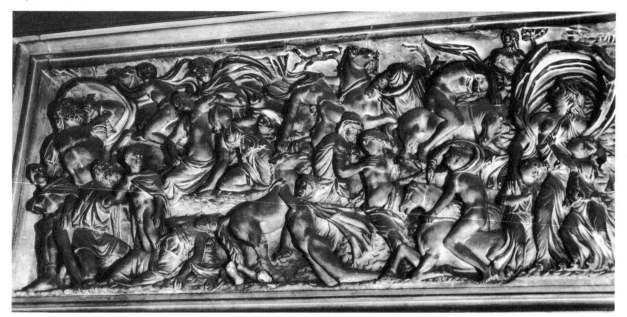

107

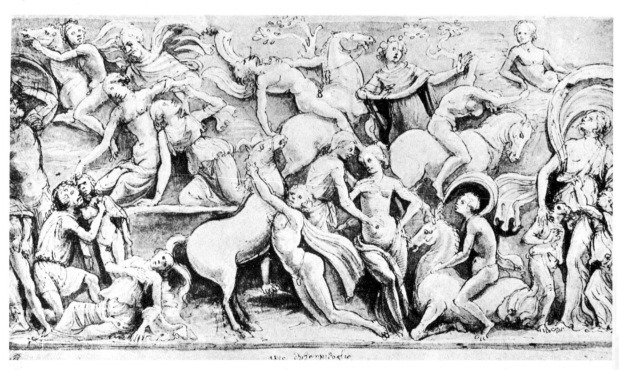

107a

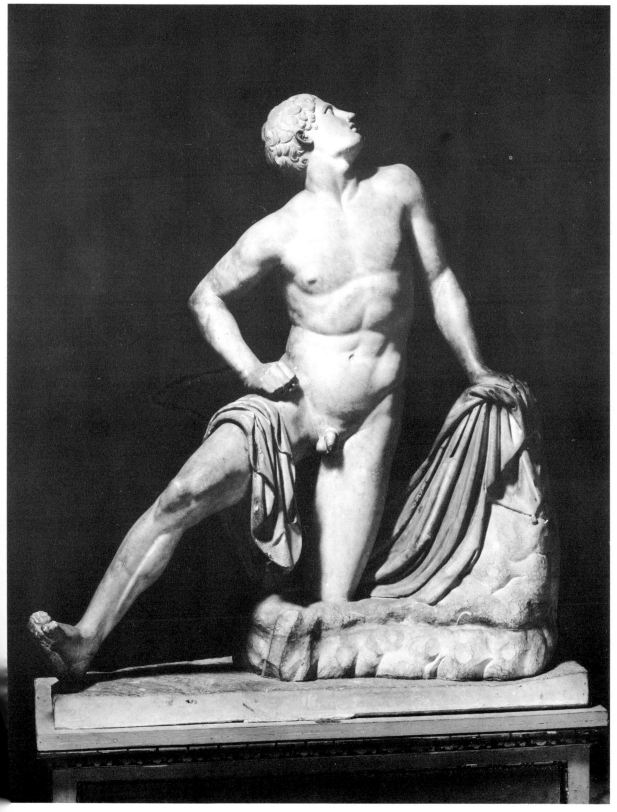

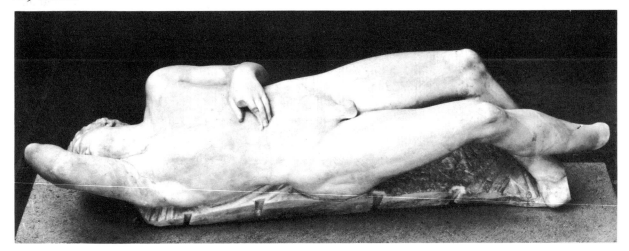

109

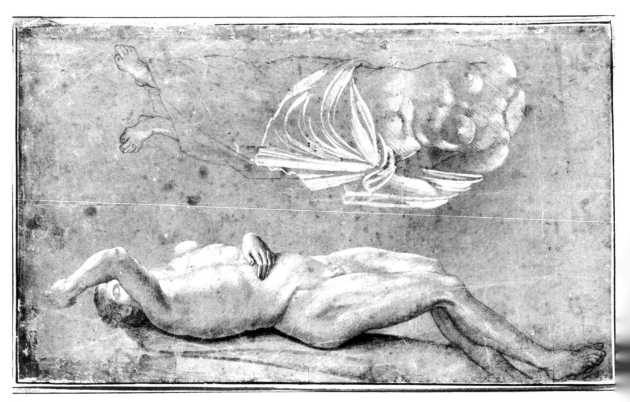

109a

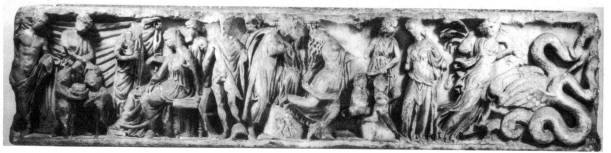

110

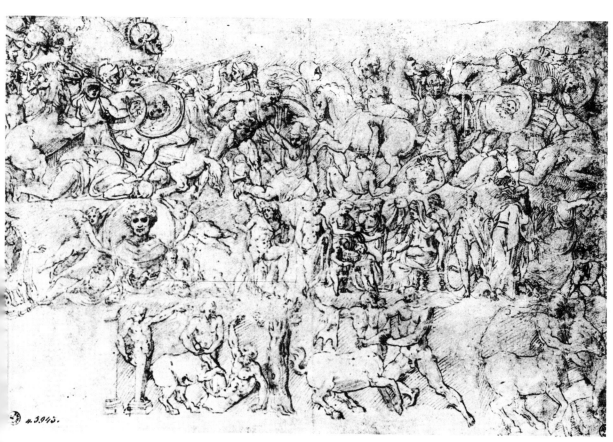

10a

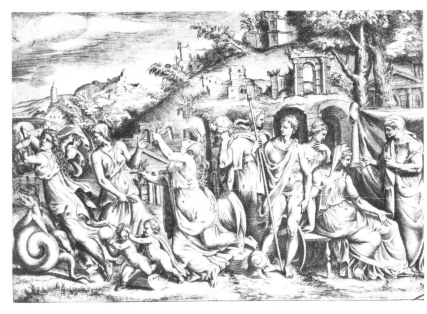

110b

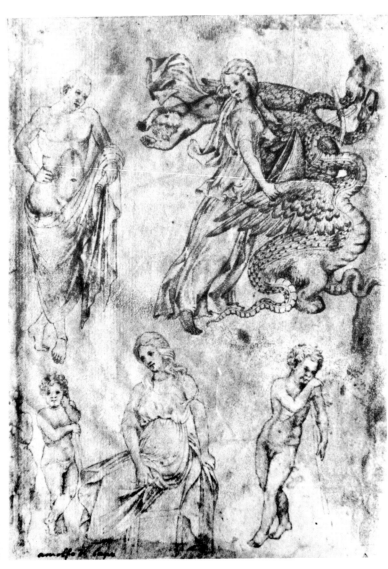

110c

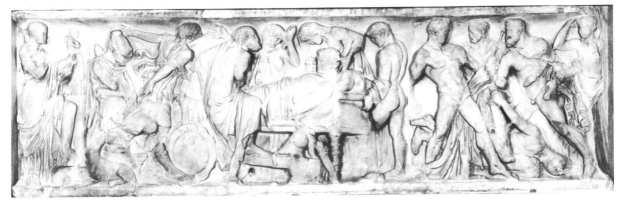

114

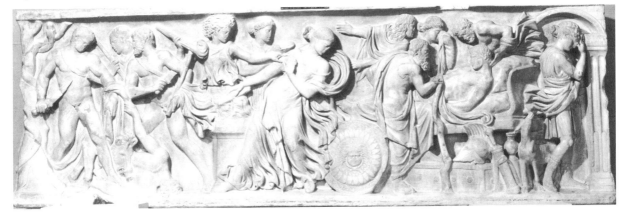

115

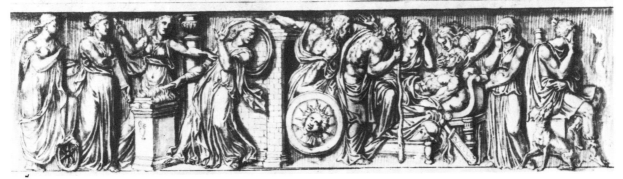

116

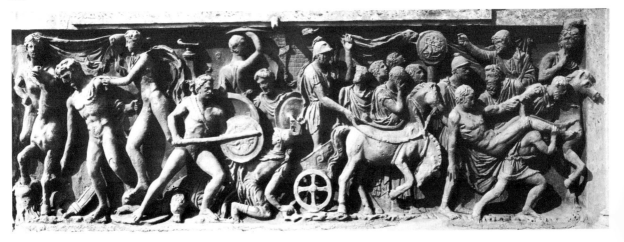

117

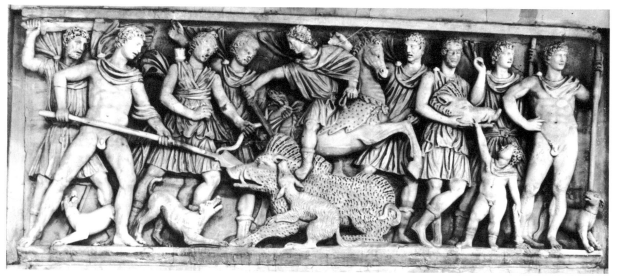

113

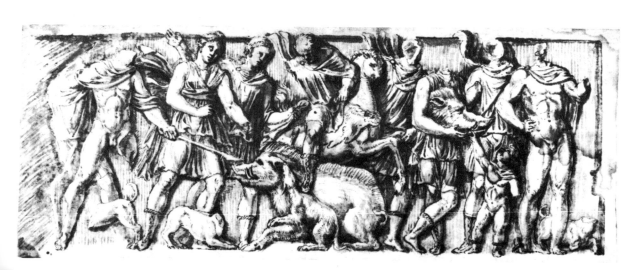

113a

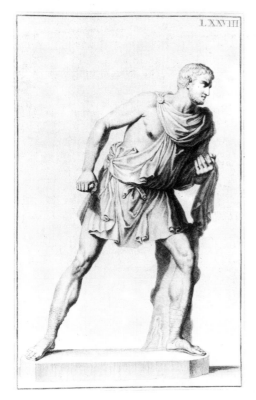

112

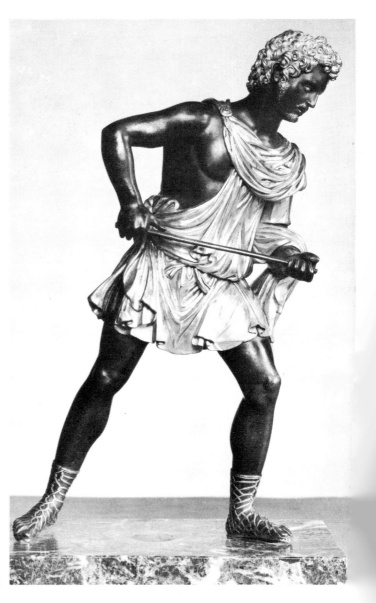

112a

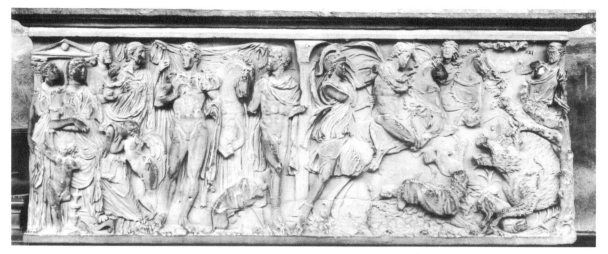

III

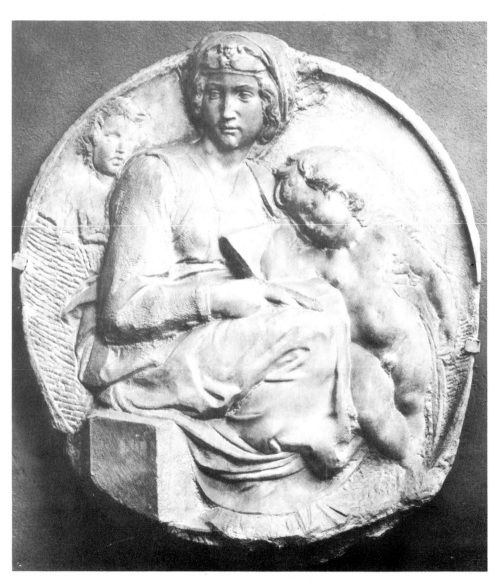

IIIa

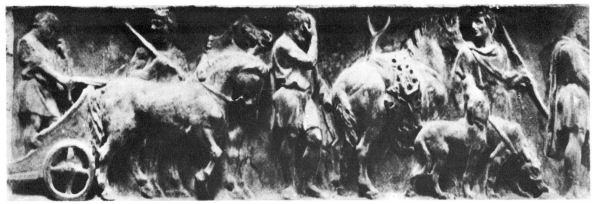

118i

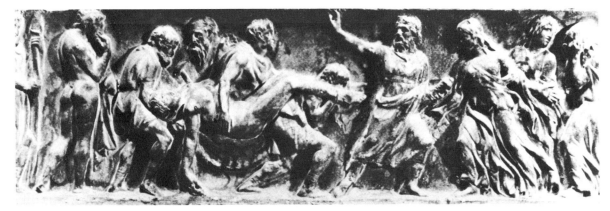

118ii

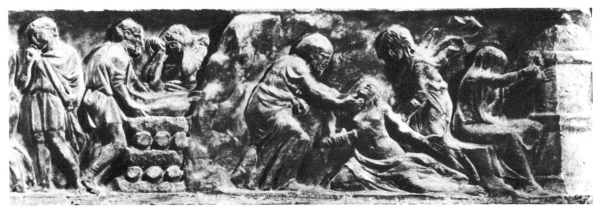

118iii-iv

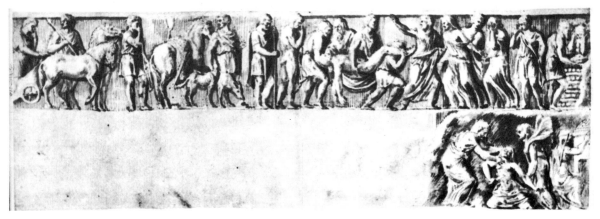

118a

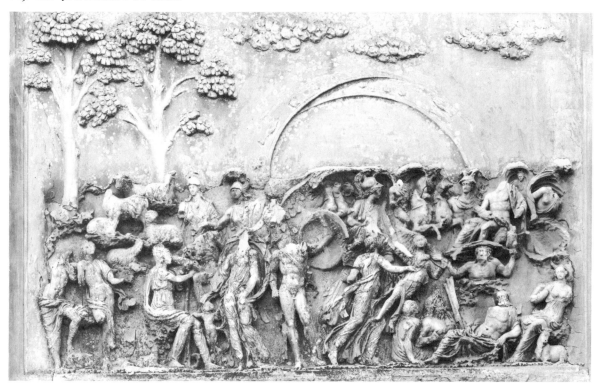

119

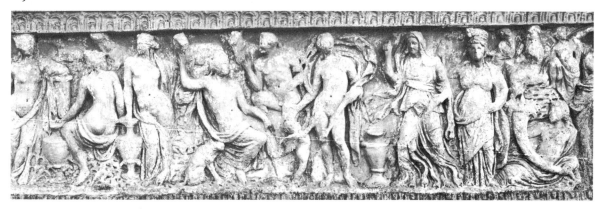

120

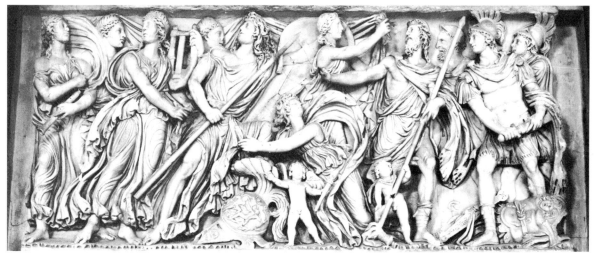

121

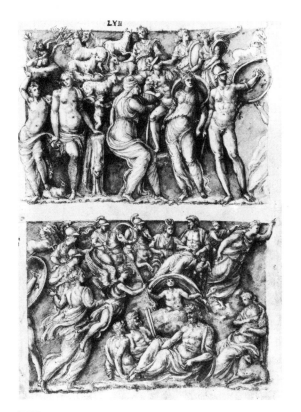

119a

121a

121b

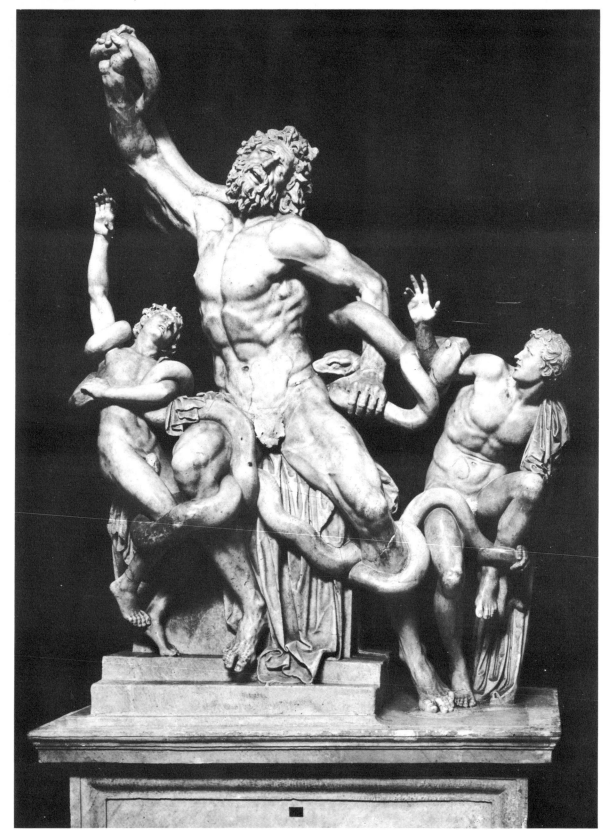

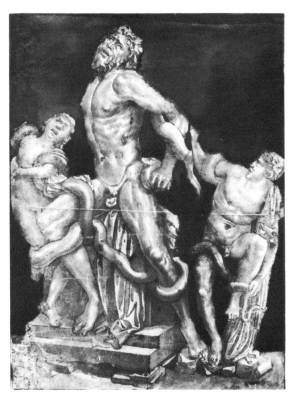

122a

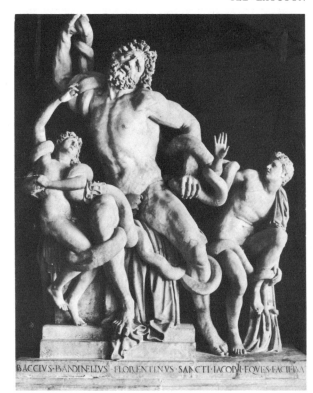

122b

BACCIVS·BANDINELIVS·FLORENTINVS·SANCTI·IACOBI·EQVES·FACIE·RA

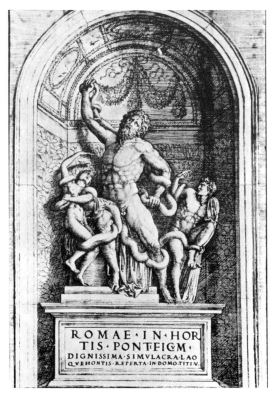

122c

ROMAE·IN·HOR
TIS·PONTIFICM·
DIGNISSIMA·SIMVLACRA·LAO
QVEHONTIS·REPERTA·IN·DOMO·TITI·V·

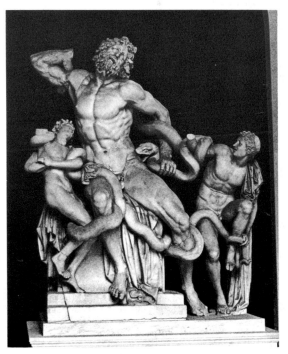

122d

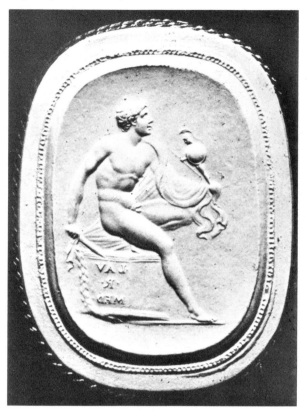

123

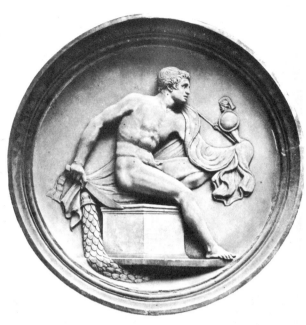

123a

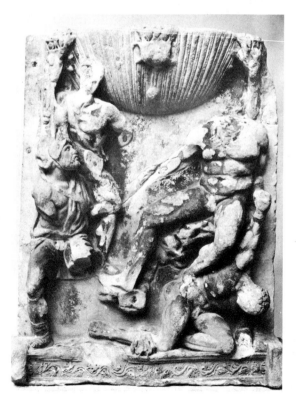

124

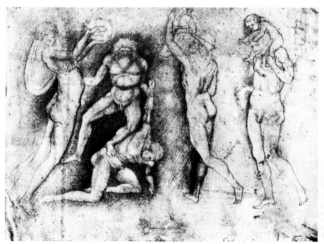

124a

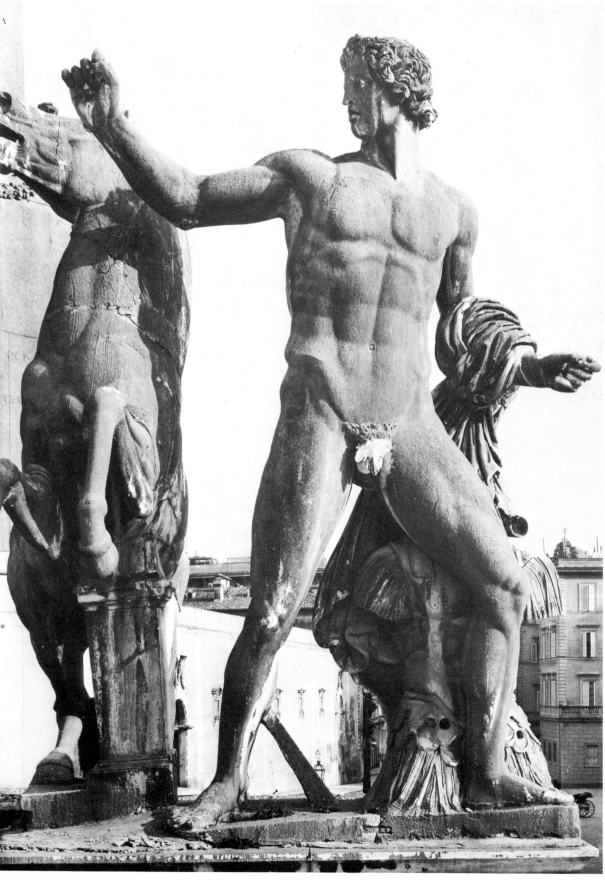

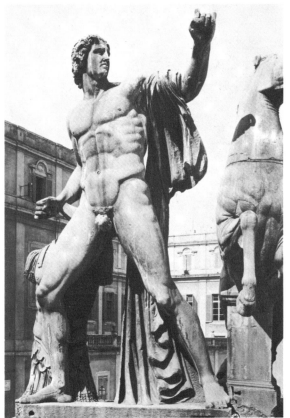

125i

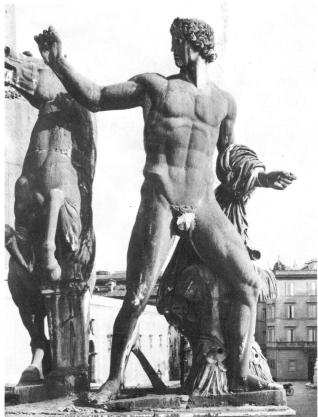

125ii

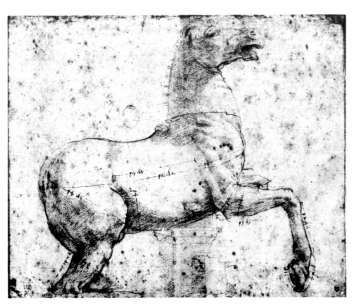

125a

125b

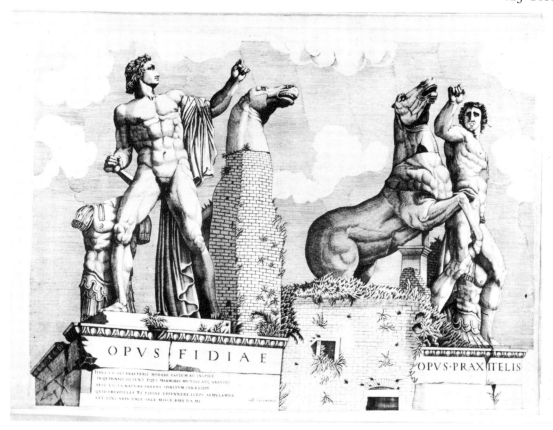

125c

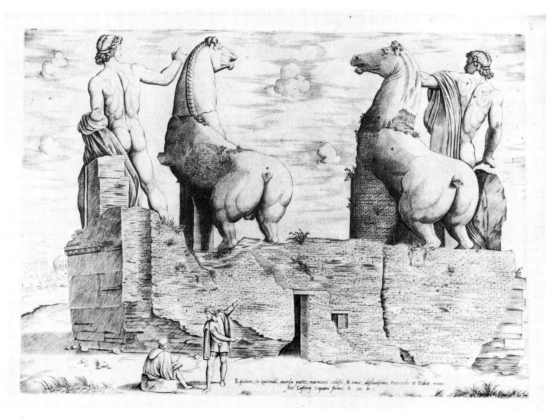

125d

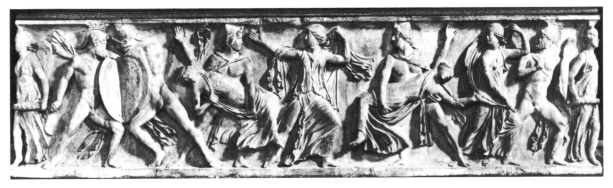

126

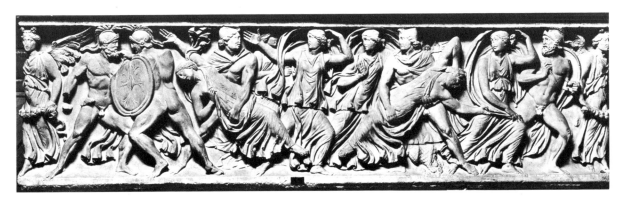

126a

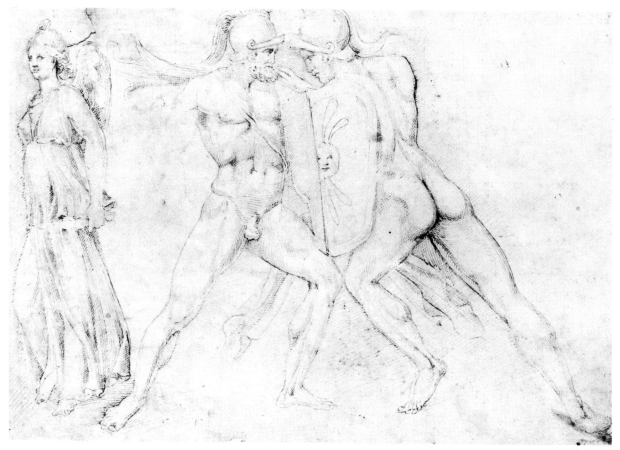

126b

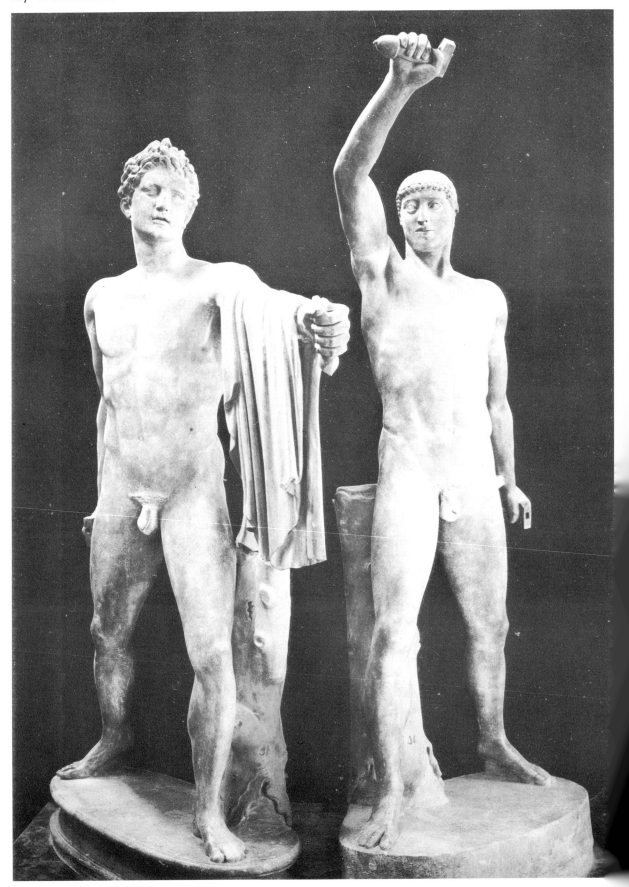

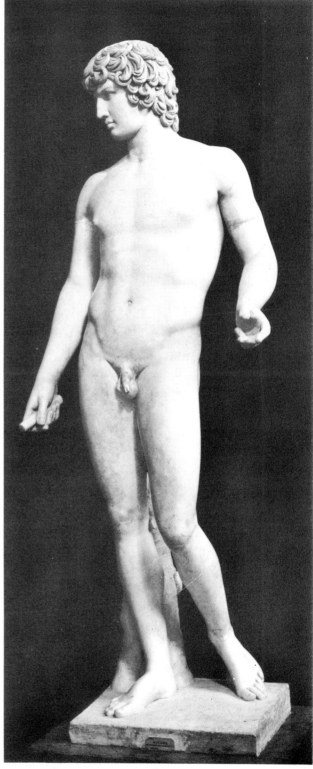

127a

128

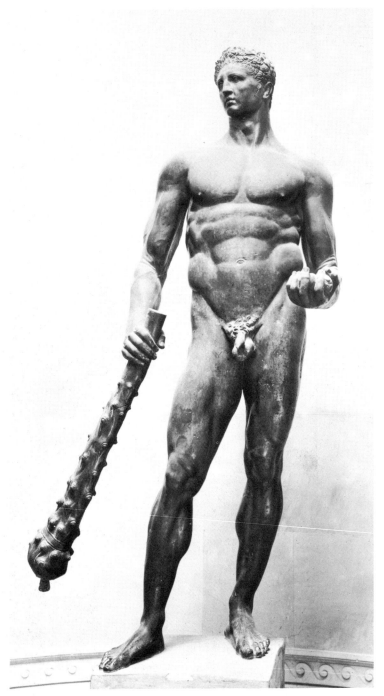

129

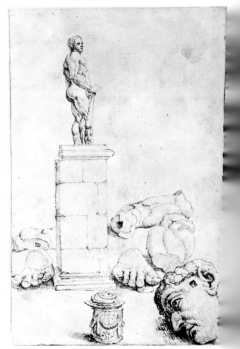

129a

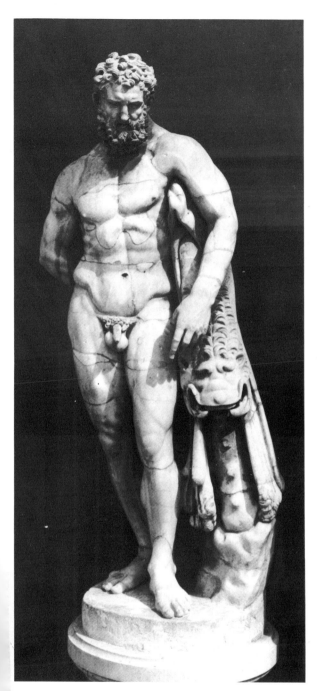

130

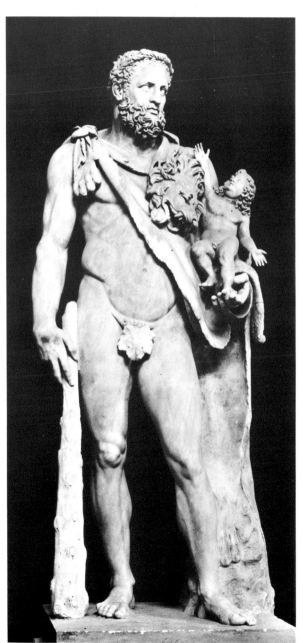

131

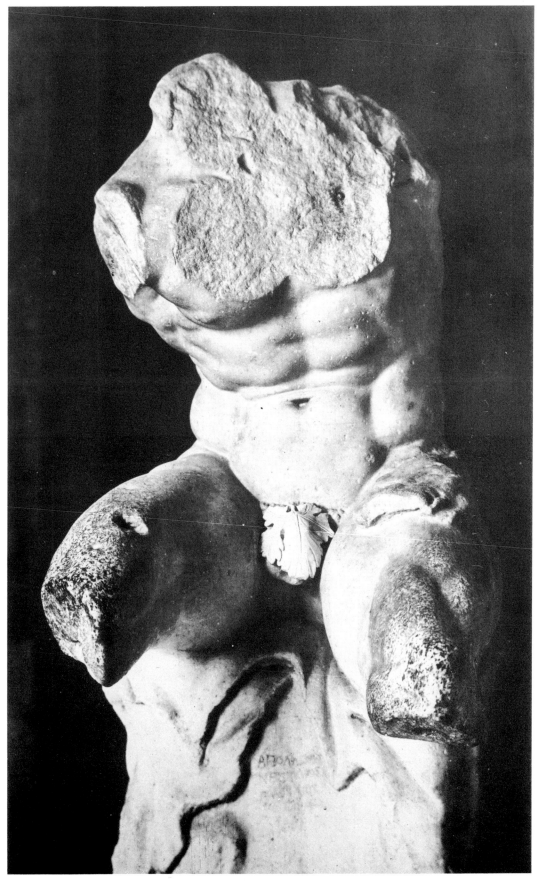

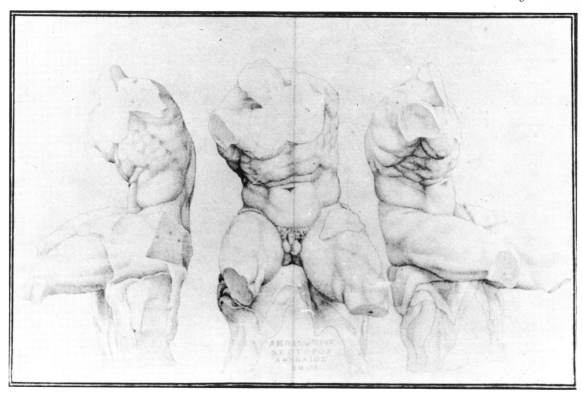

132a

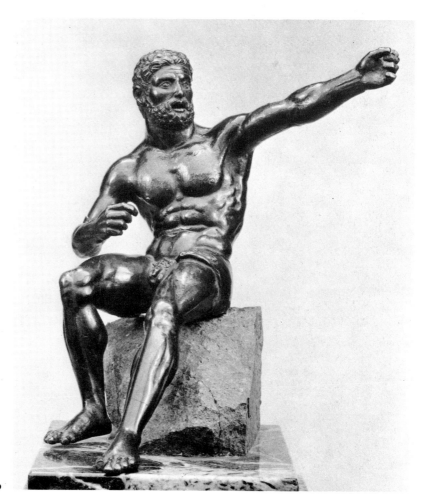

132b

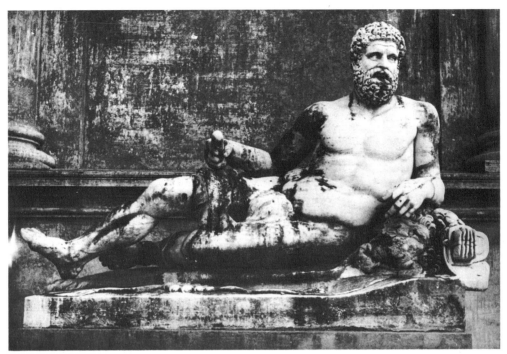

133

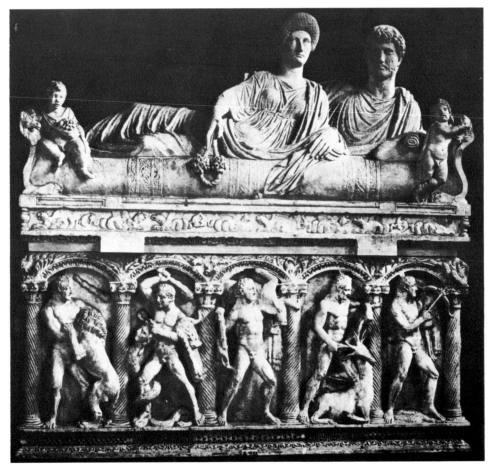

134

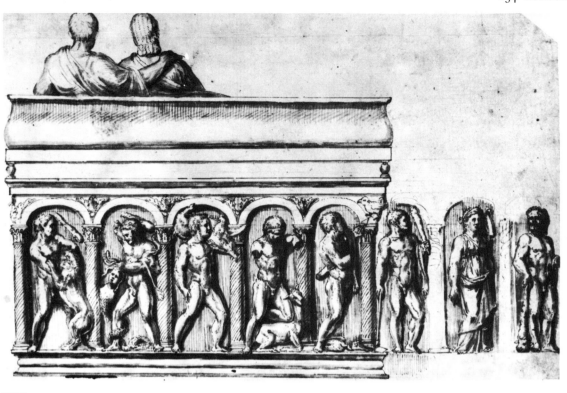

134a

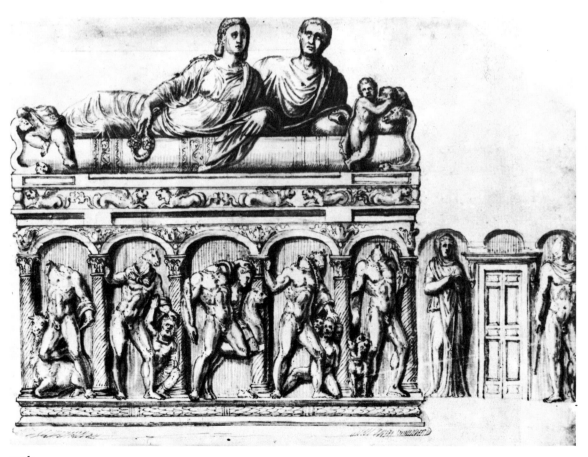

134b

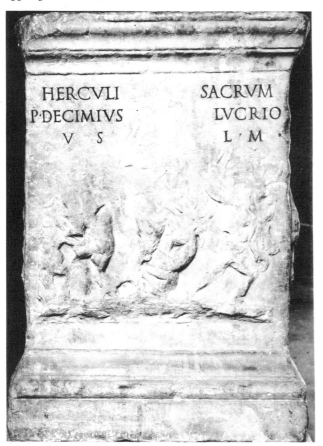

135i

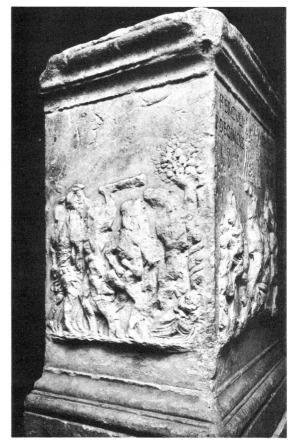

135ii

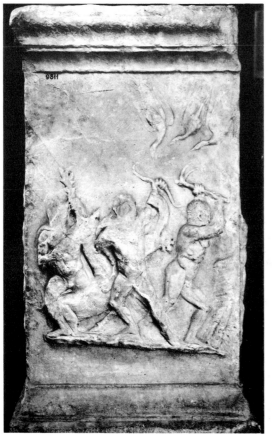

135iii

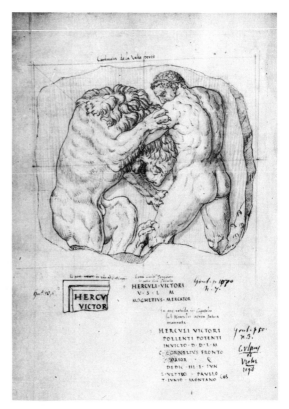

136a

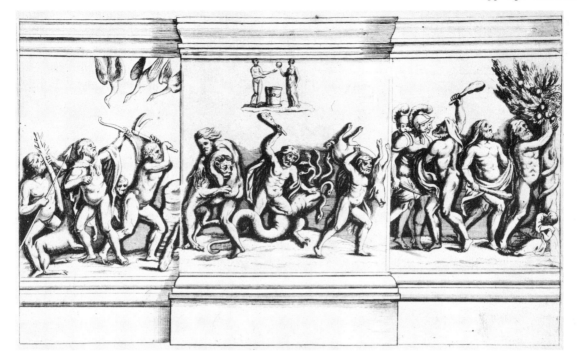

135a

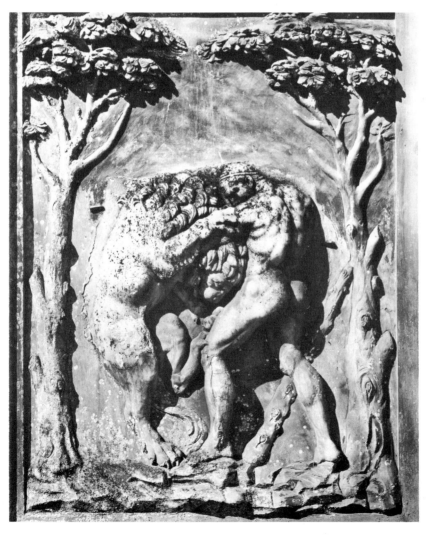

136

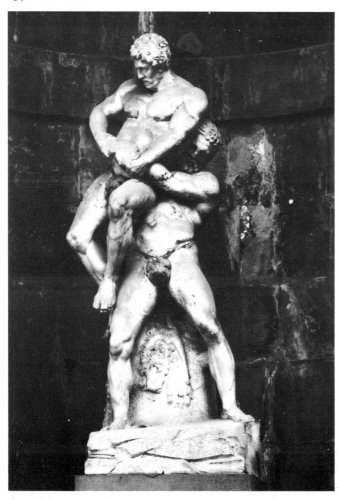

137

137a

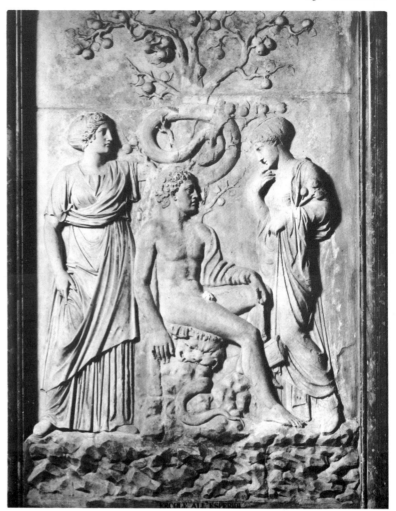

138

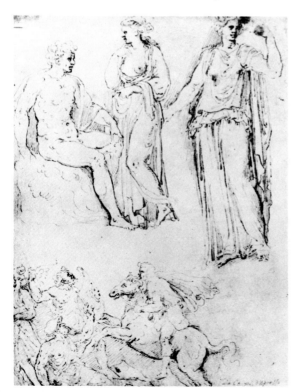

138a

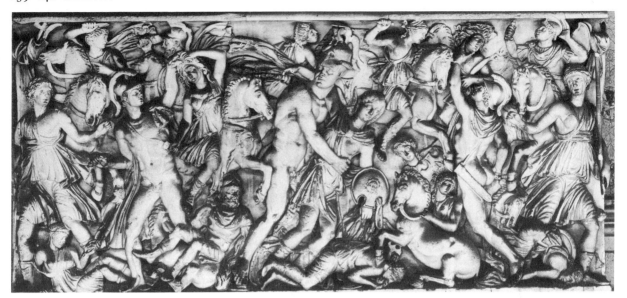

139

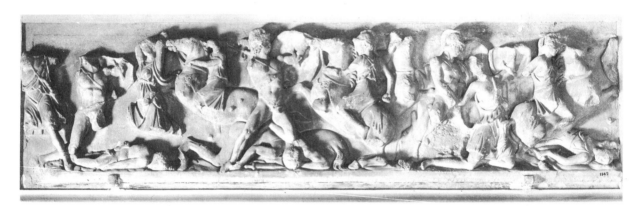

140

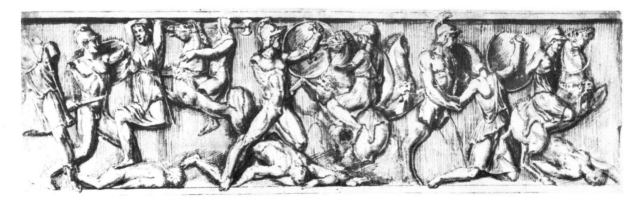

140a

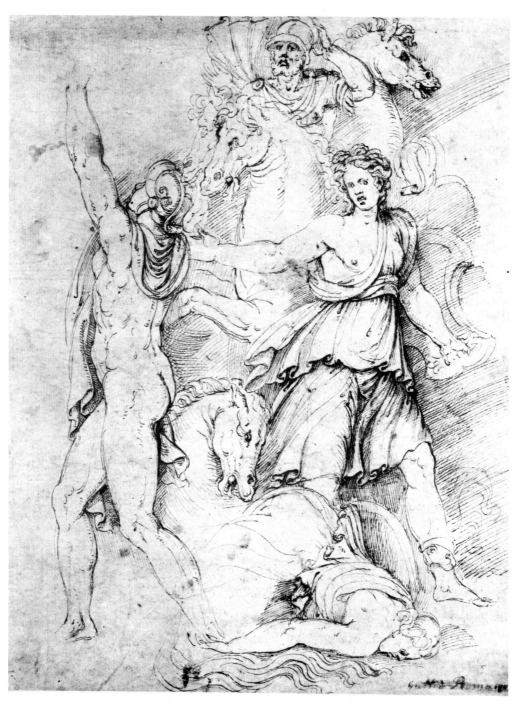

139a

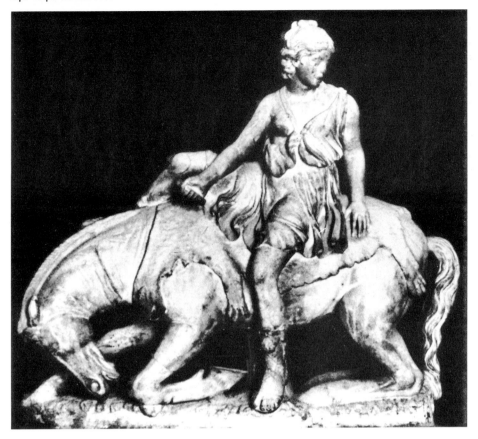

141

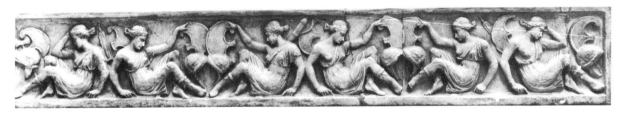

142i

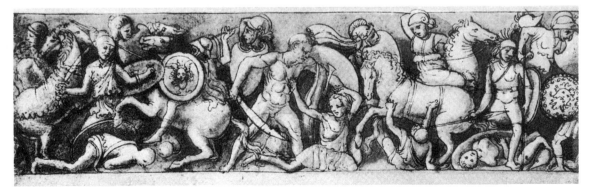

142ii

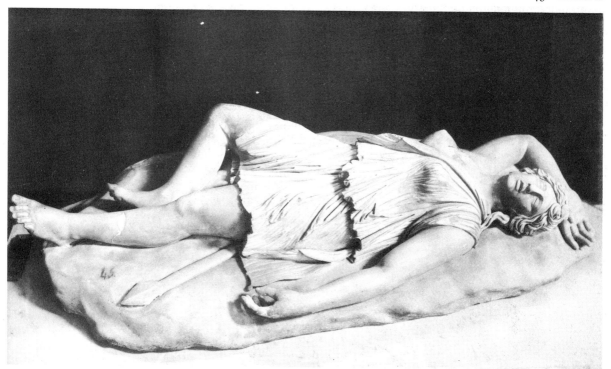

143

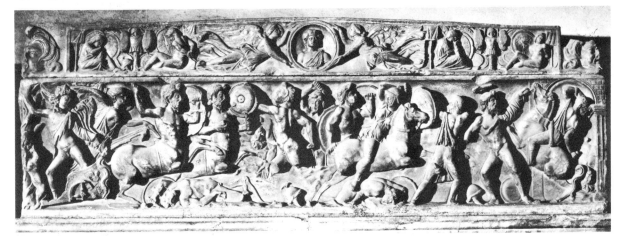

144

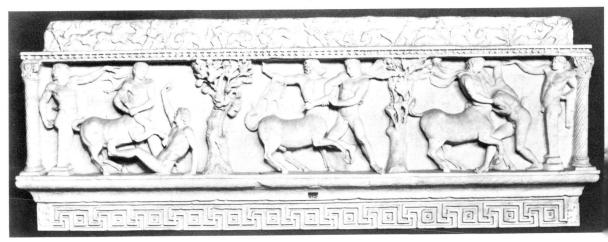

145i

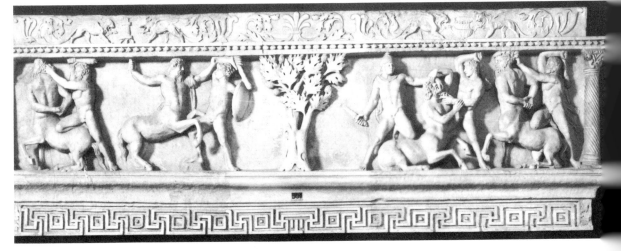

145ii

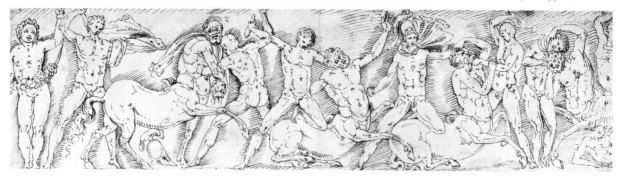

146

147

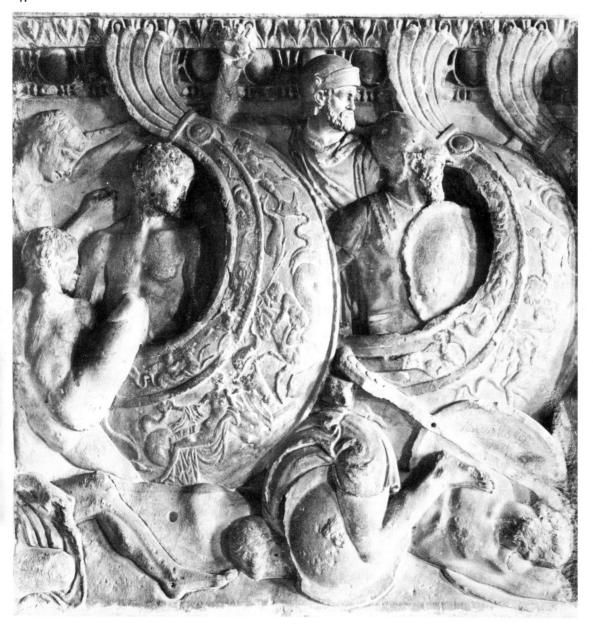

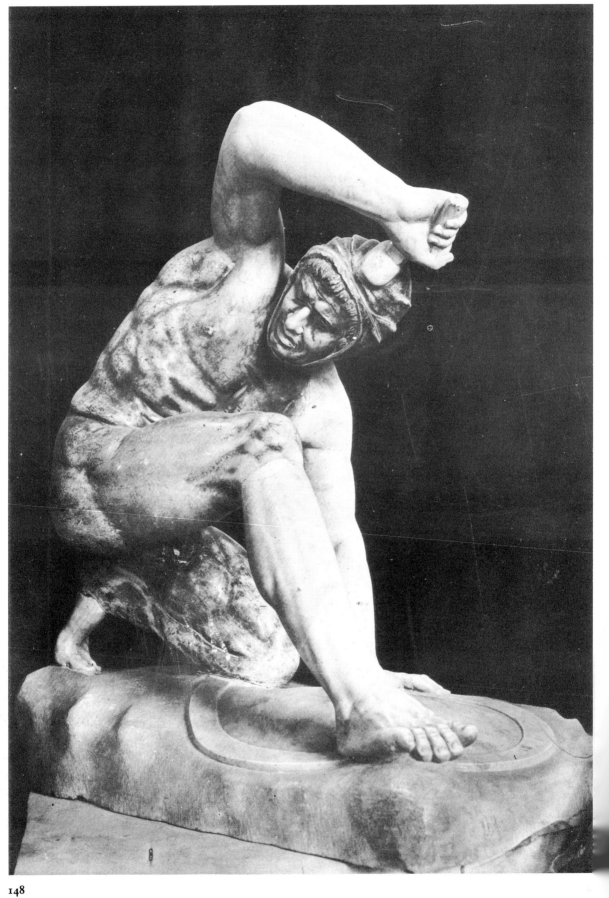

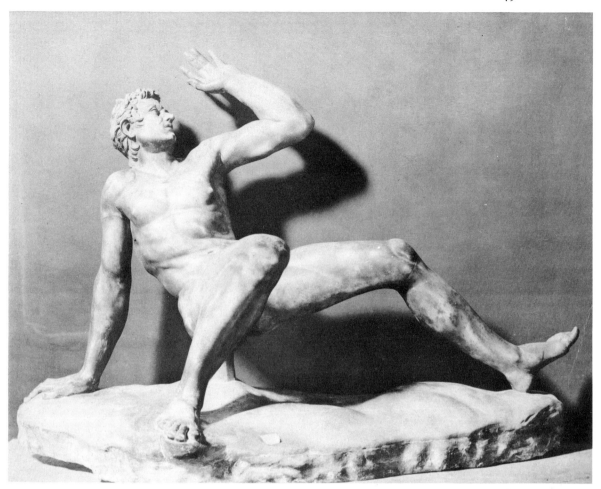

149

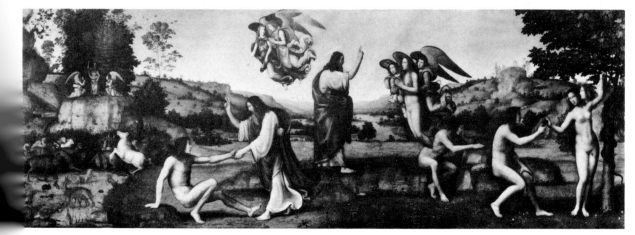

49a

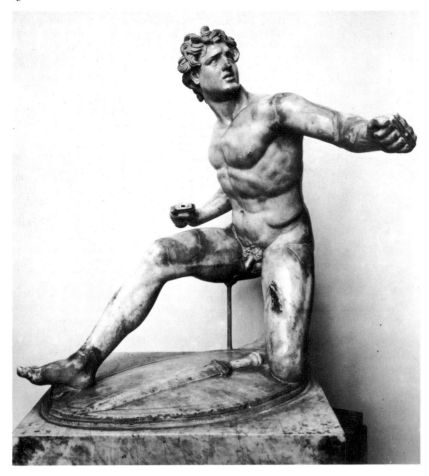

150

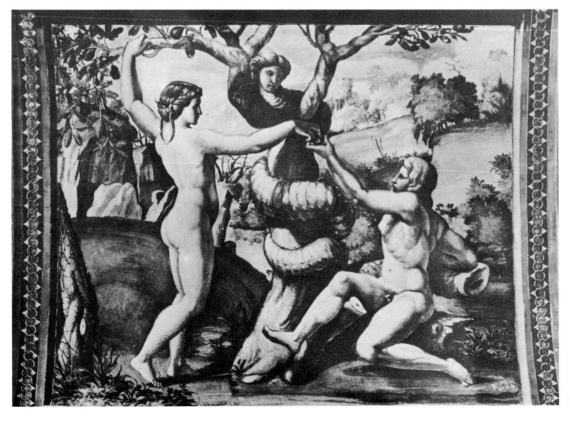

150a

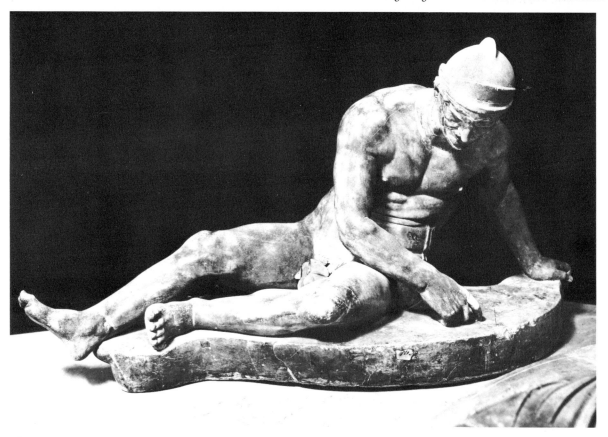

151

152

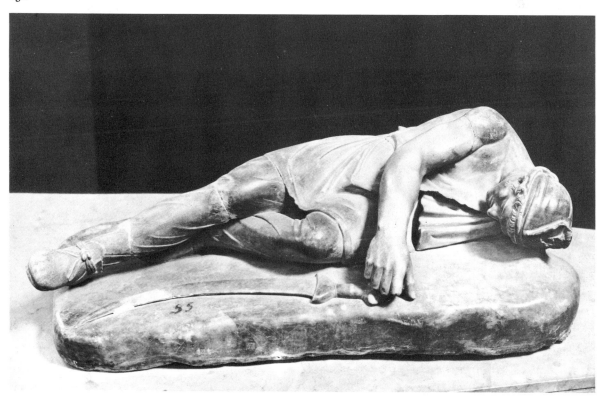

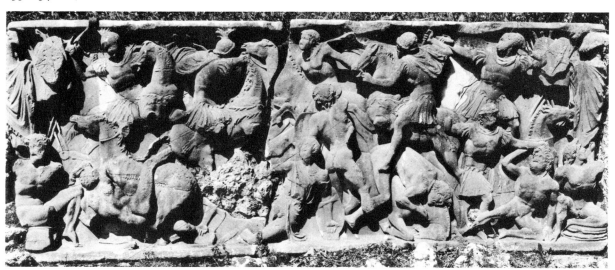

153

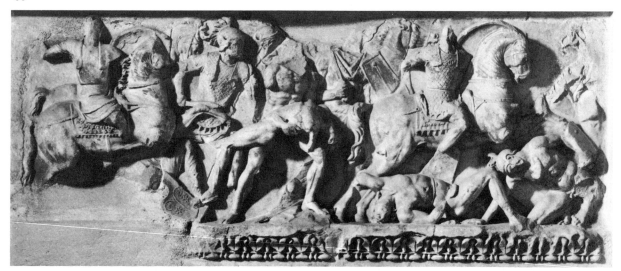

154

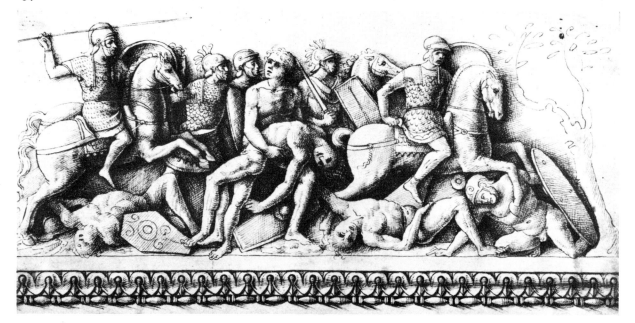

154a

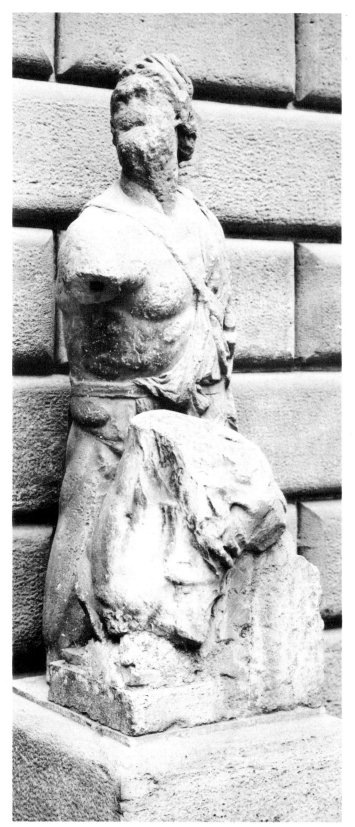

155

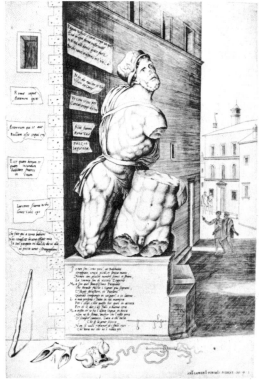

155a

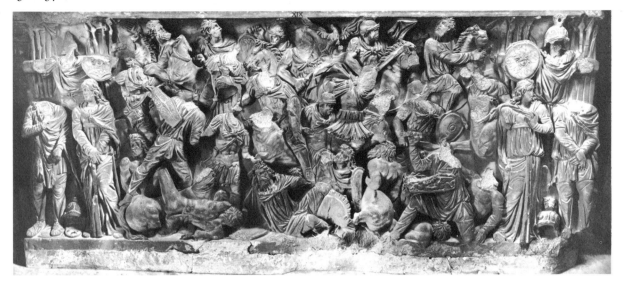

156

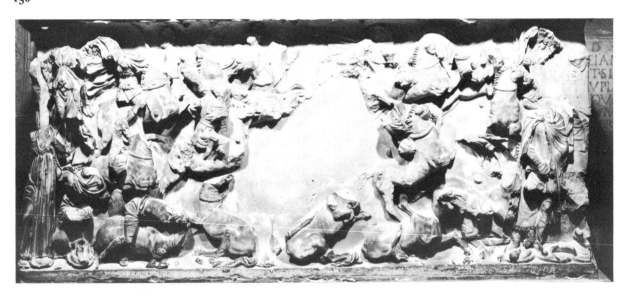

157

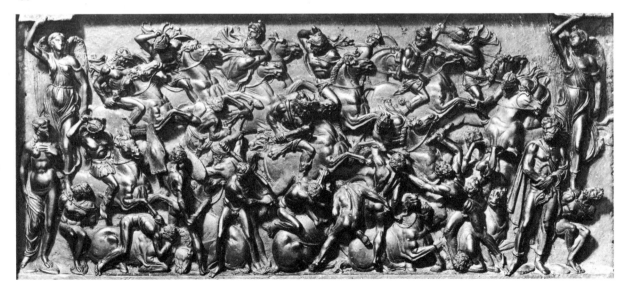

157a

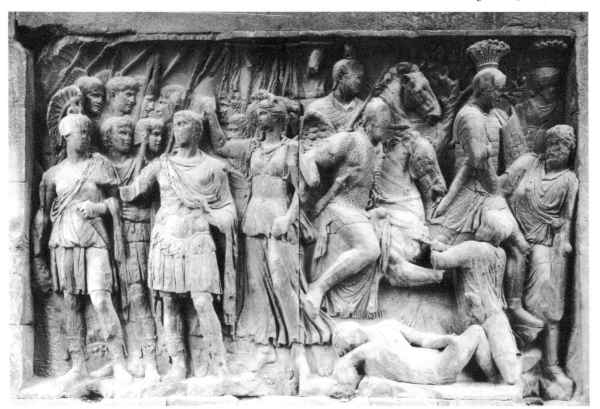

158i

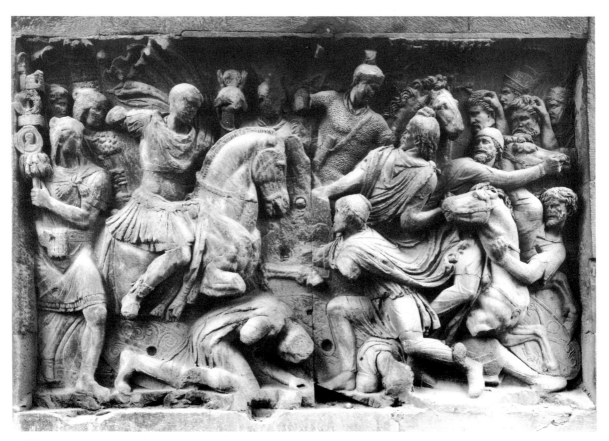

158iii

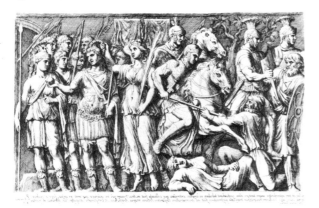

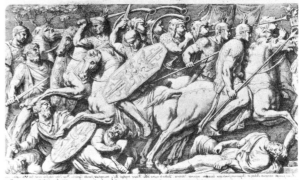

158a–i

158a–ii

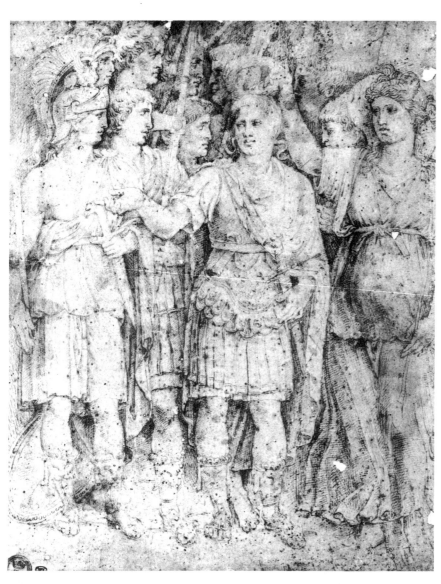

158b

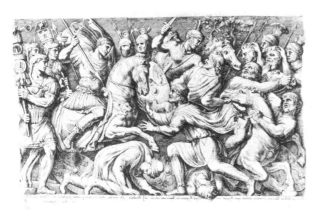

158a–iii

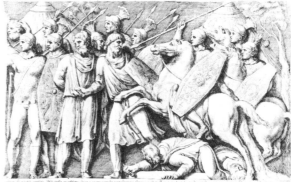

158a–iv

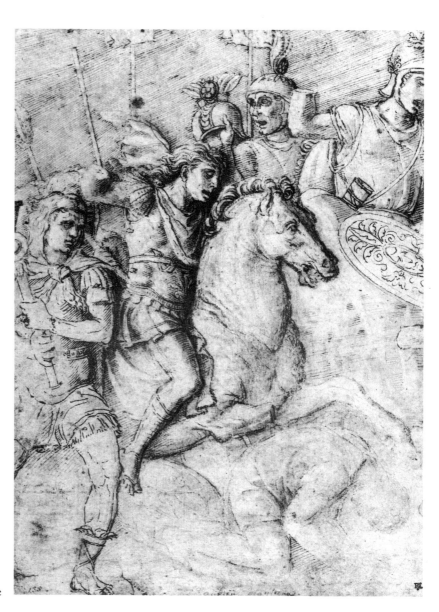

158c

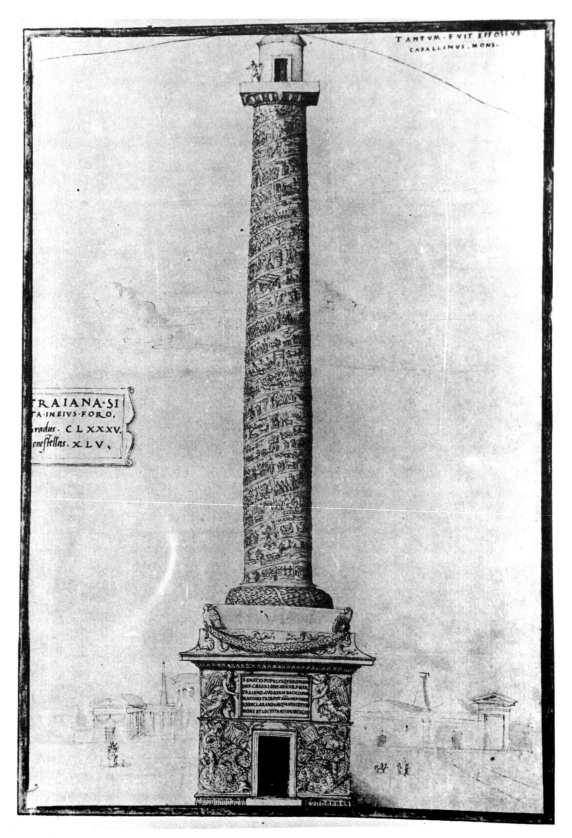

159a

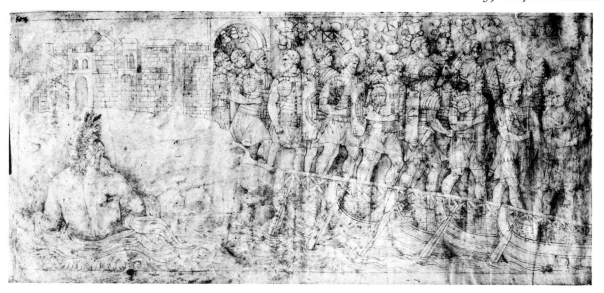

159b

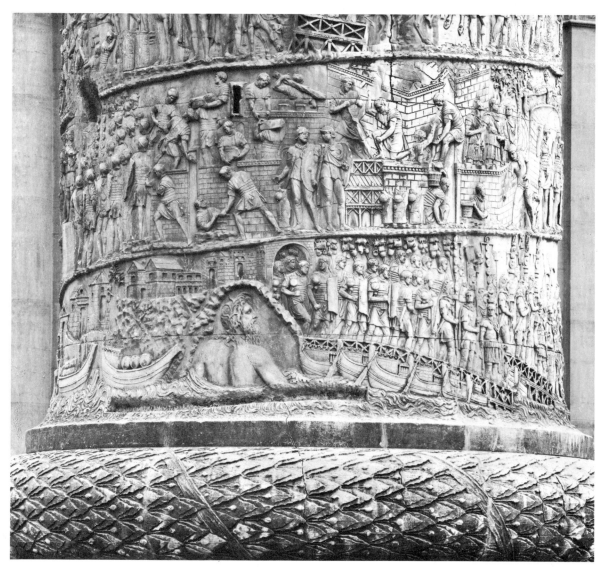

159

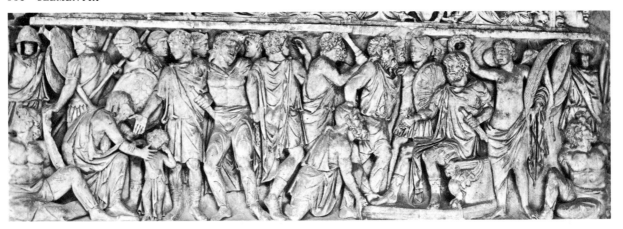

160

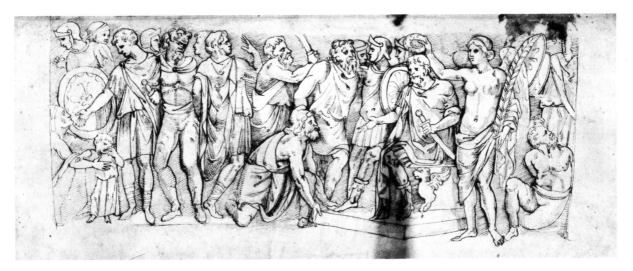

160a

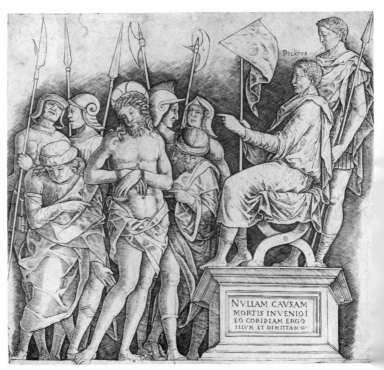

162a

161

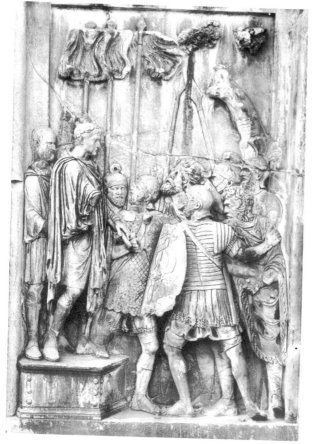

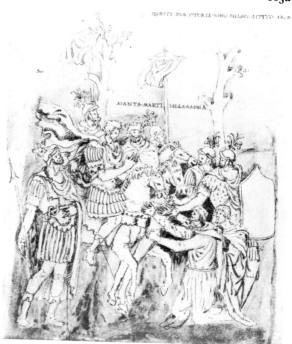

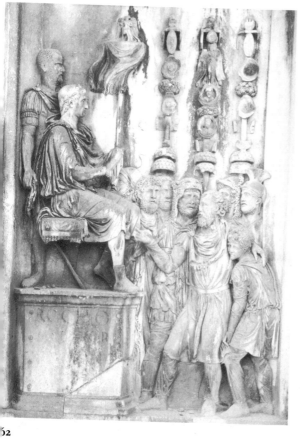

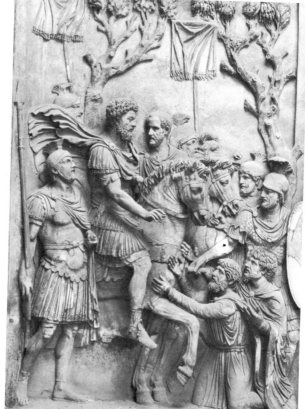

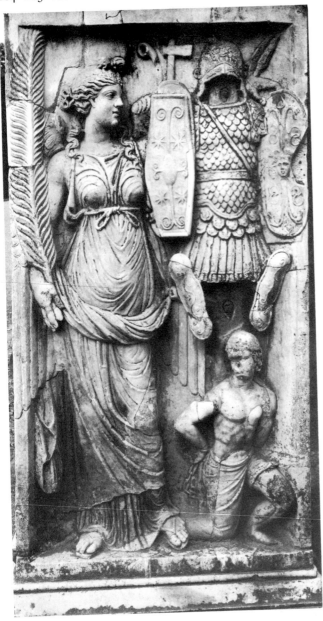

164

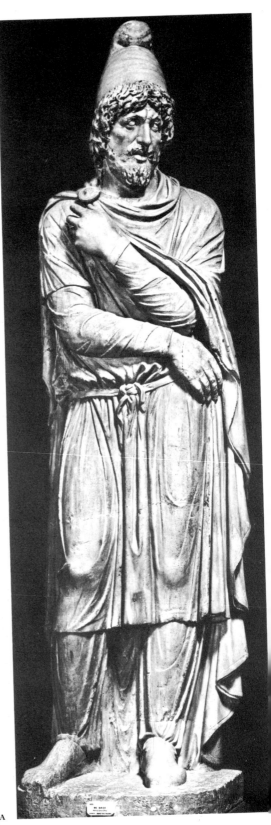

165A

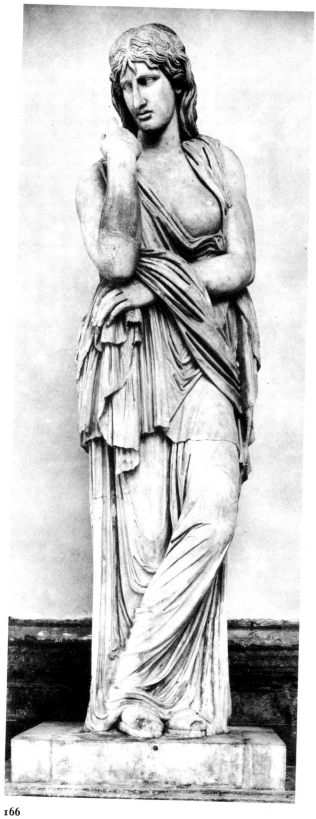

166

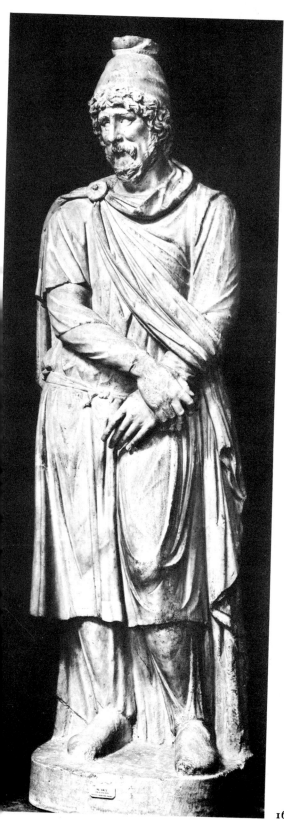

165B

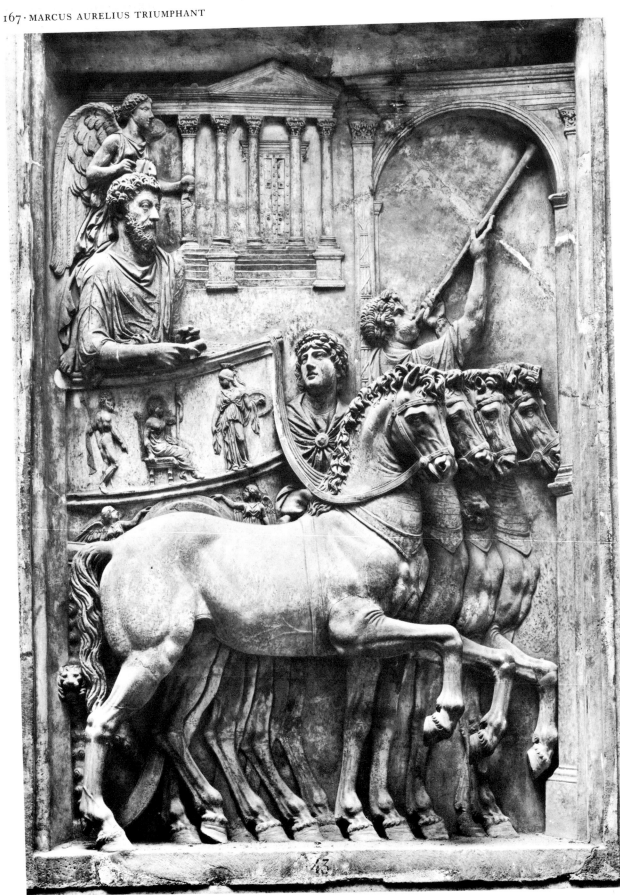

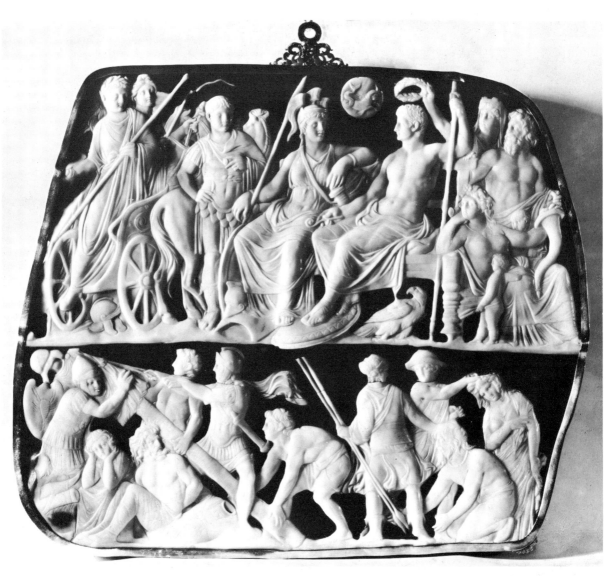

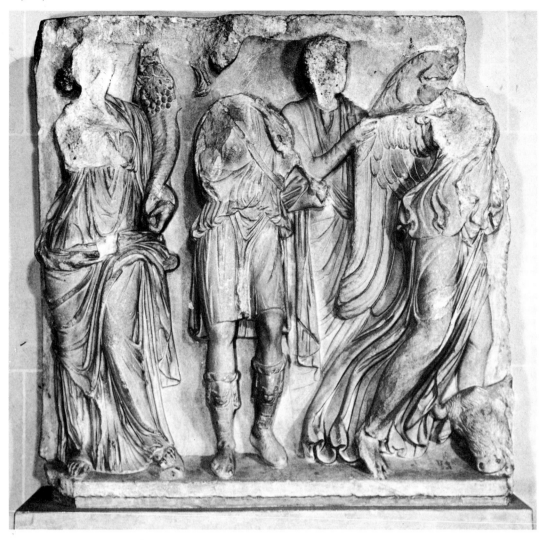

169

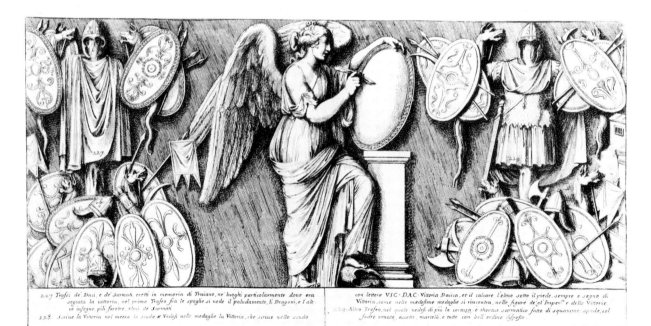

227 Trofei de' Daci, e de' Sarmati eretti in memoria di Traiano, ne' luoghi particolarmente doue era seguita la vittoria, nel primo Trofeo frà le spoghe si uede il paludamento, li Dragoni, e l'alt re insegne, più faretre, elmi de Sarmati

228 Scriue la Vittoria nel mezzo lo scudo e Vedesi nelle medaglie la Vittoria, che scriue nello scudo

con lettere VIC·DAC: Vittoria Dacia, et il calcare l'elmo sotto il piede sempre e segno di Vittoria, come nelle medesime medaglie si rincontra, nelle figure de' gl'Imper" e delle Vittorie

229 Altro Trofeo, nel quale uedesi di più la coraza, e thorace sarmatico fatto di squamme, spade, col fodre ornate, accette, martelli, e tutto con bell'ordine disposto

170A

169a

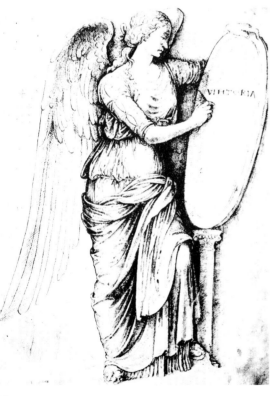

170A–a

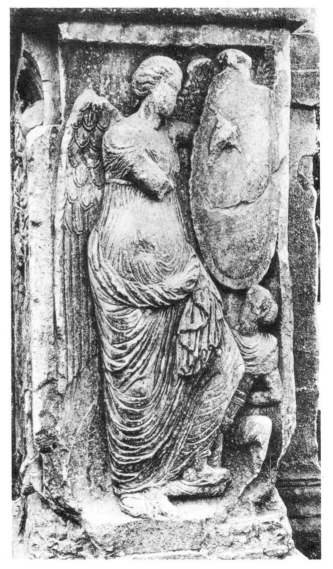

170B

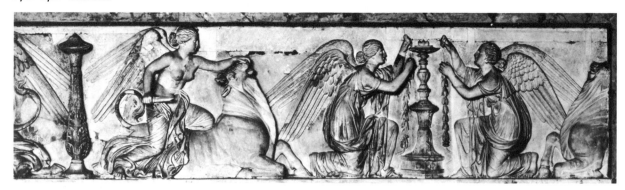

171

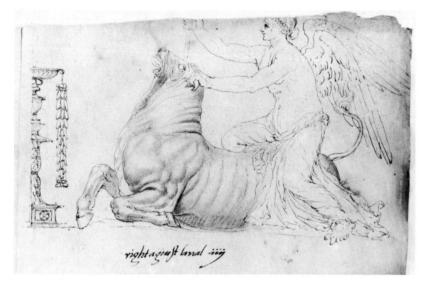

171a

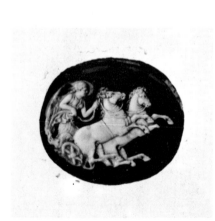

172

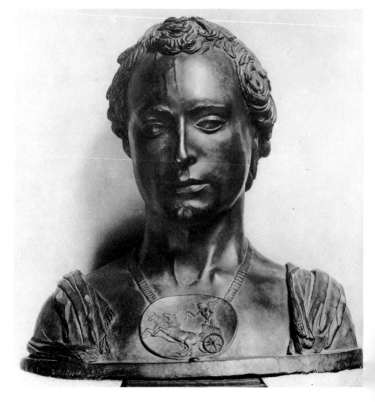

172a

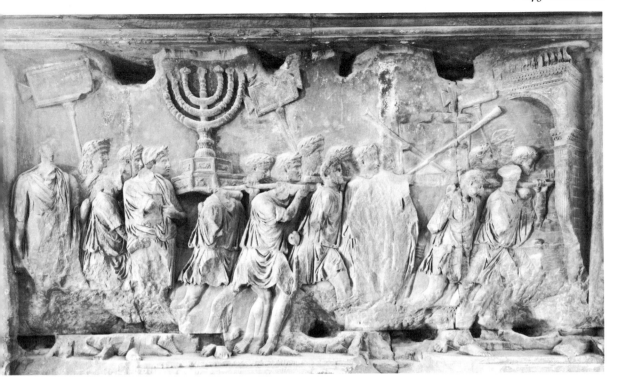

173

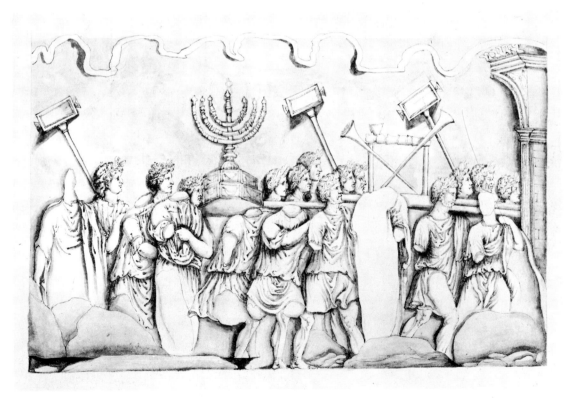

173a

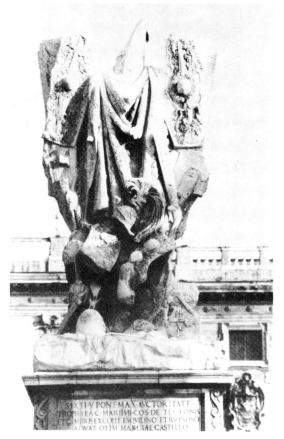

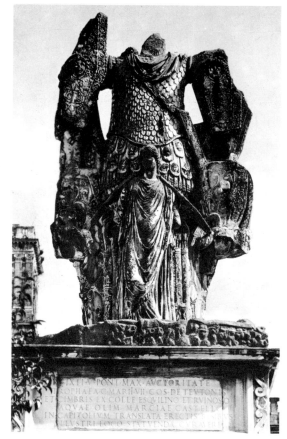

174A

174B

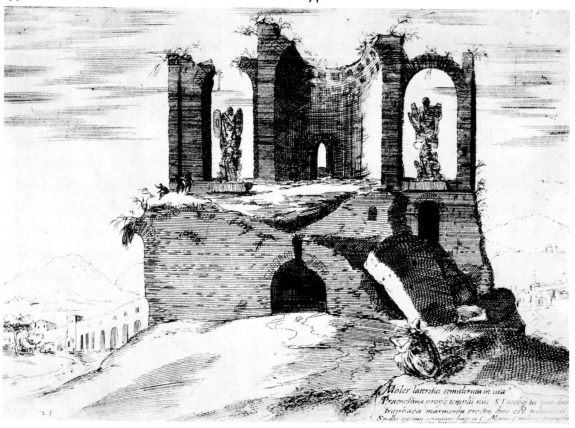

174a

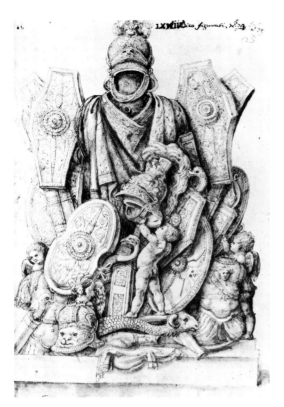

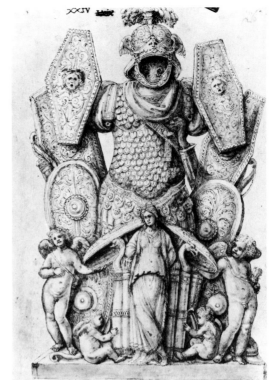

174b

174c

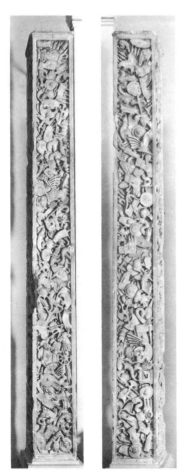

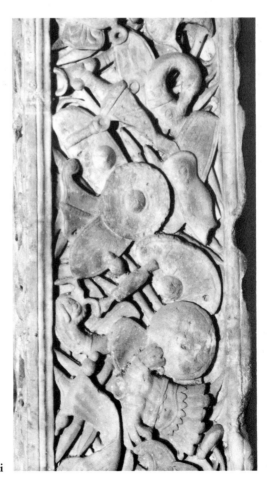

175i

175ii

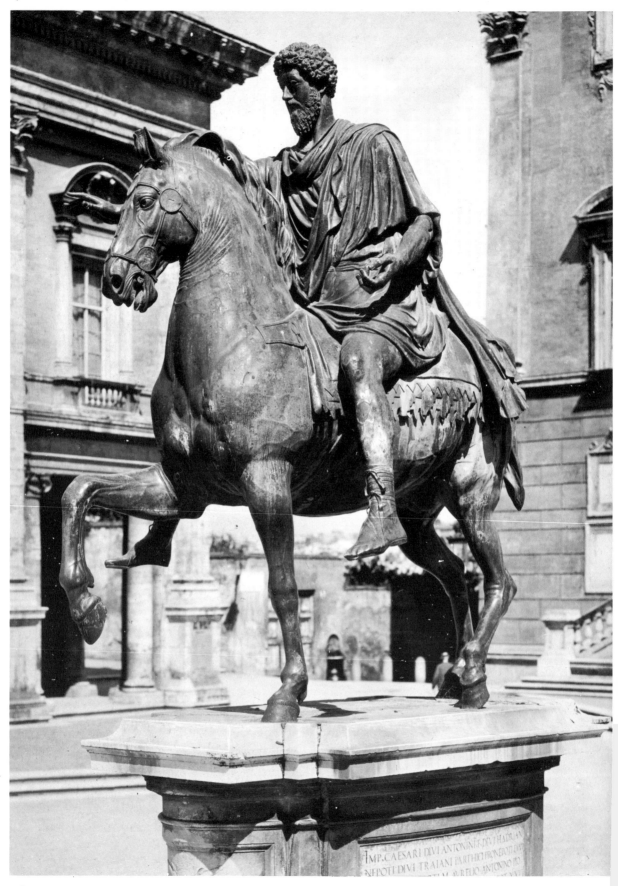

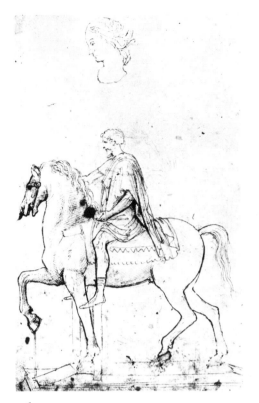

176a

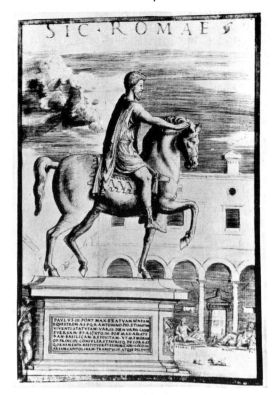

176b

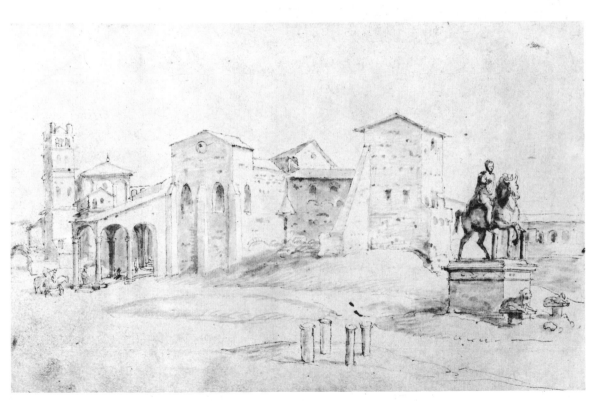

176c

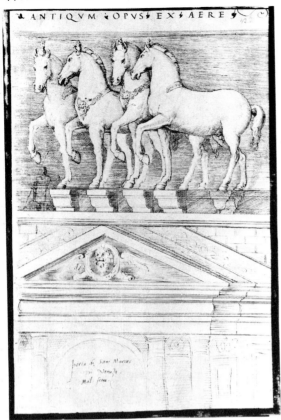

ANTIQVM · OPVS · EX · AERE

177a

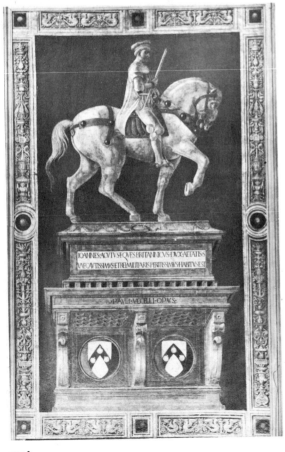

177b

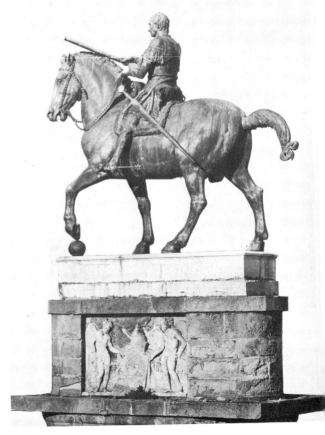

177c

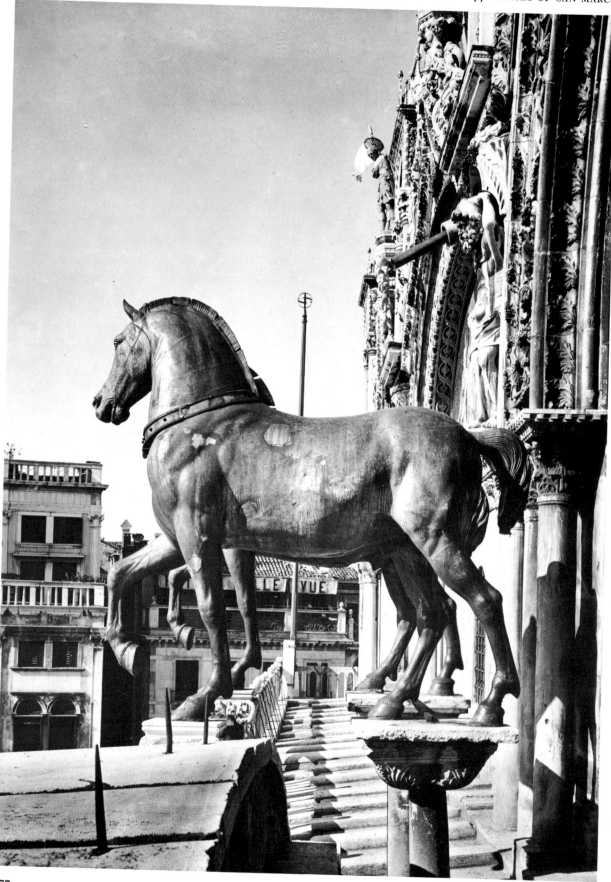

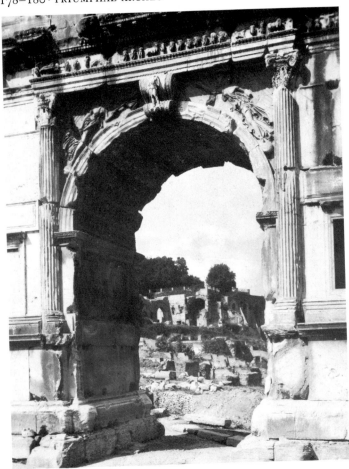

178

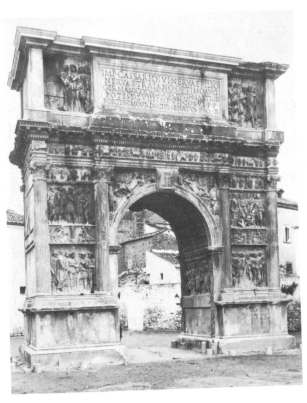

179

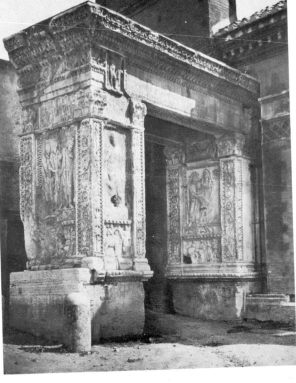

180

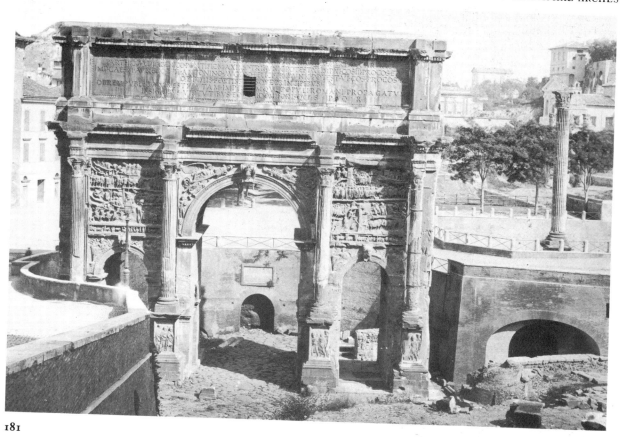

181

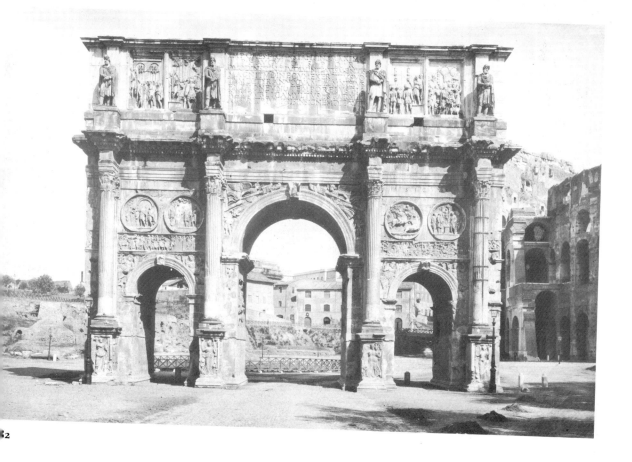

182

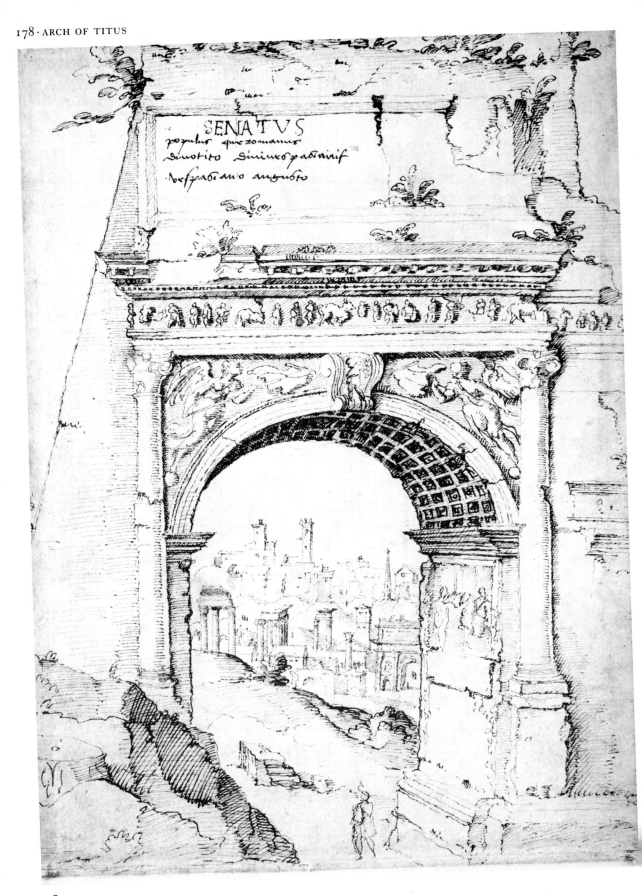

SENATVS
populus que romanus
diuo tito diui uespatinif
uespatiano augusto

178a

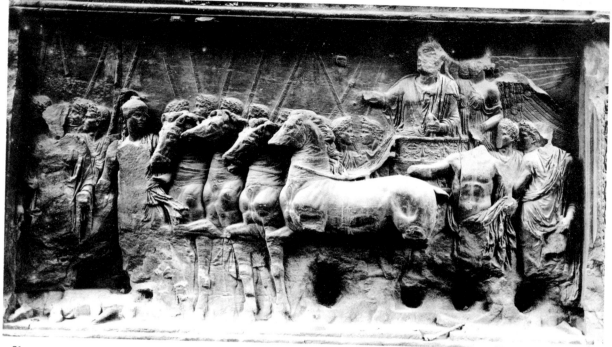

178b

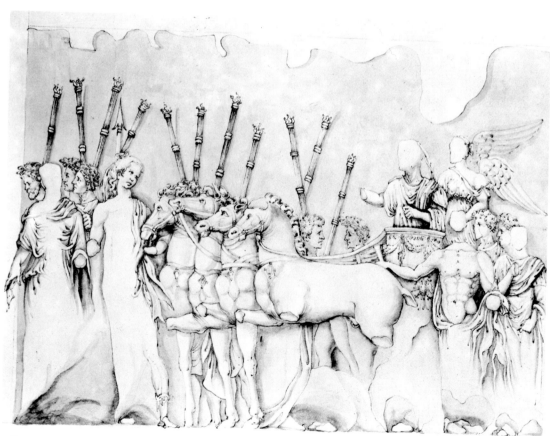

178c

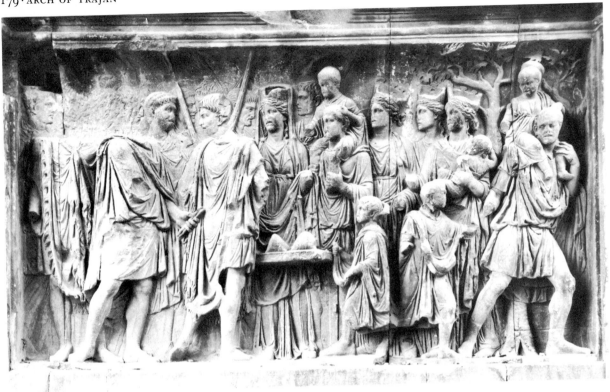

179a

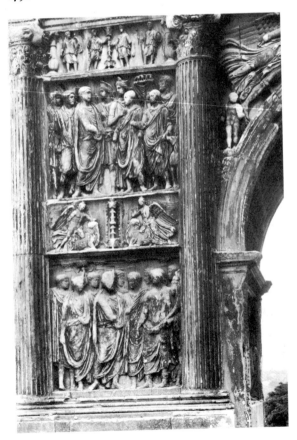

179b

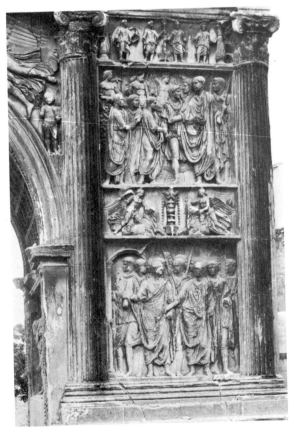

179c

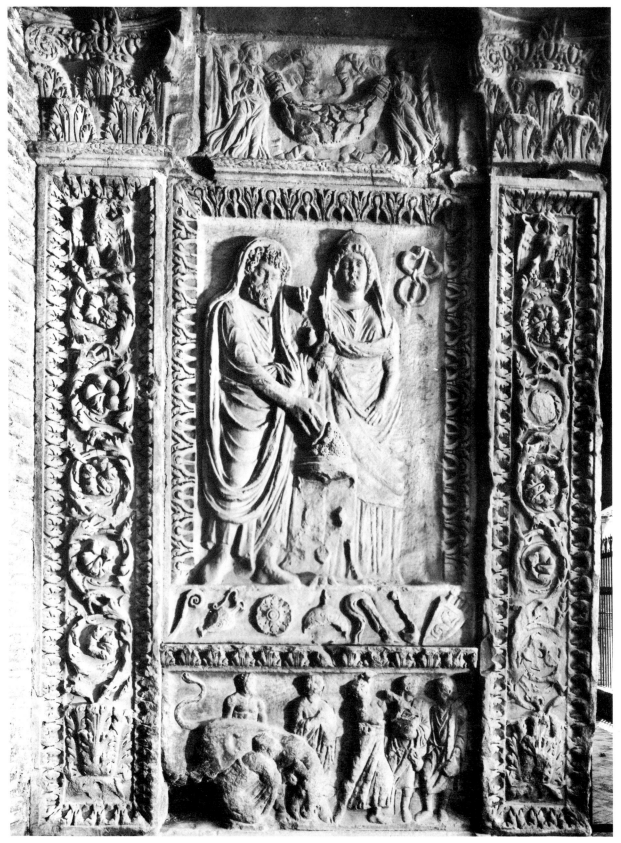

180a

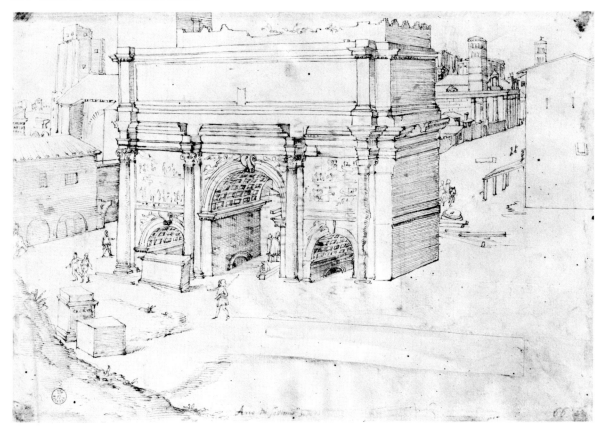

181a

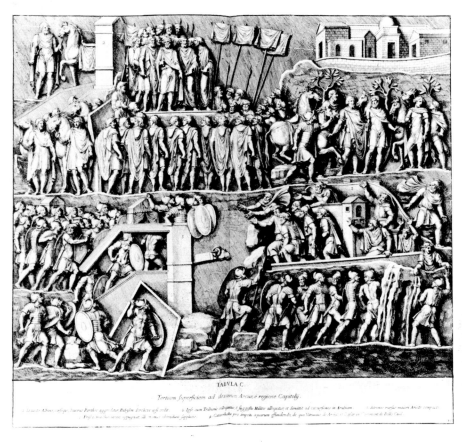

181b

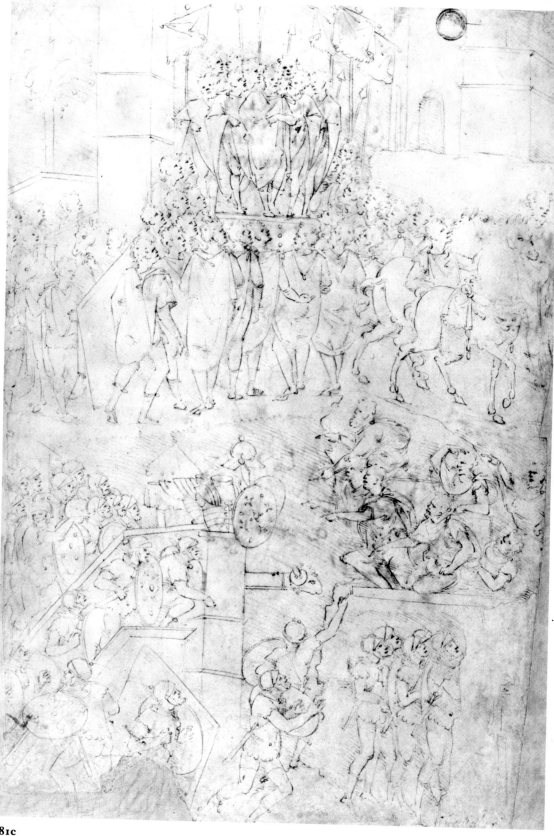

181c

182a

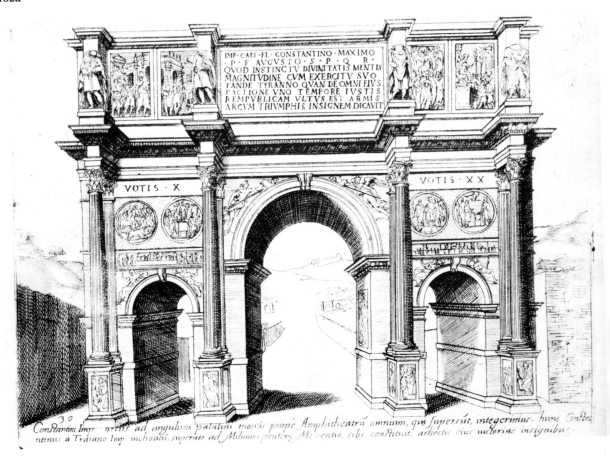

IMP·CAES·FL·CONSTANTINO·MAXIMO
P·F·AVGVSTO·S·P·Q·R
QVOD·INSTINCTV·DIVINITATIS·MENTIS
MAGNITVDINE·CVM·EXERCITV·SVO
TANDE·TYRANNO·QVAM·DE·OMNI·EIVS
FACTIONE·VNO·TEMPORE·IVSTIS
REMPVBLICAM·VLTVS·EST·ARMIS
ARCVM·TRIVMPHIS·INSIGNEM·DICAVIT

VOTIS · X VOTIS · XX

Constantini Imp· arcus ad angulum palatini montis propè Amphitheatrú omnium, quæ supersút, integerimus. hunc Constá-
ntinus a Traiano Imp· inchoati, superato ad Miluium pontem Maxentio, sibi constituit, adiectis eius uictoriæ insignibus.

182b

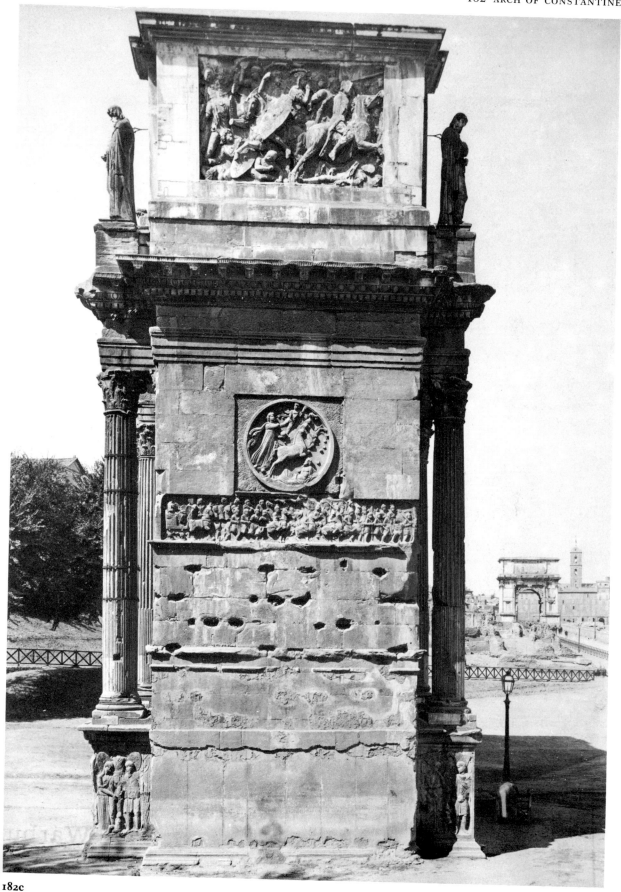

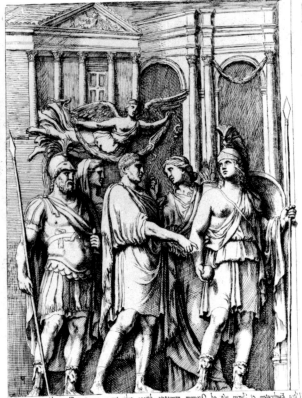

182d–i

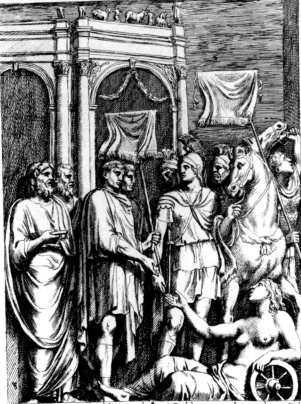

182d–ii

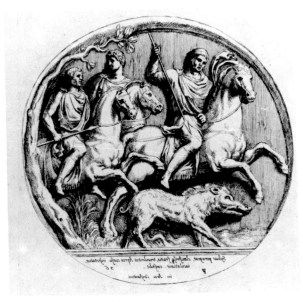

182d–v

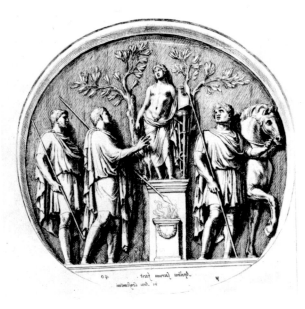

182d–vi

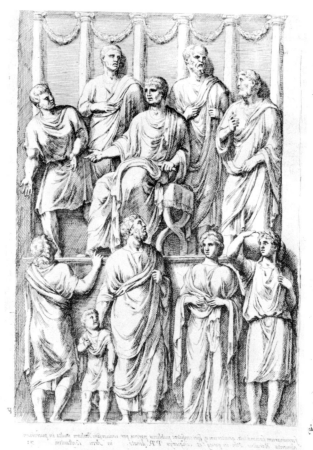

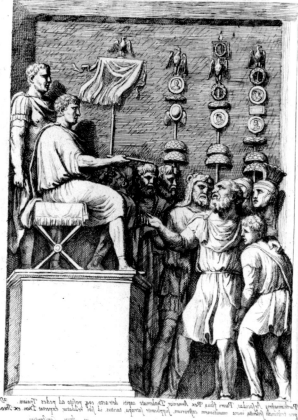

182d–iii

182d–iv

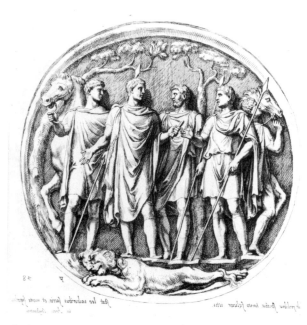

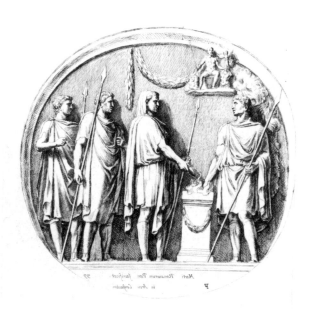

182d–vii

182d–viii

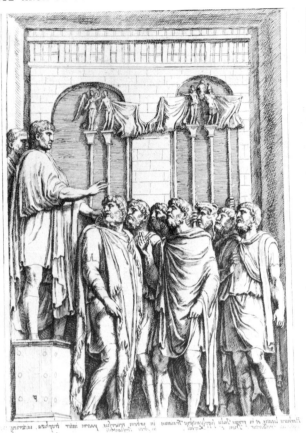

182e–i

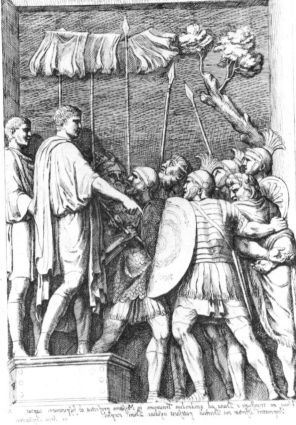

182e–ii

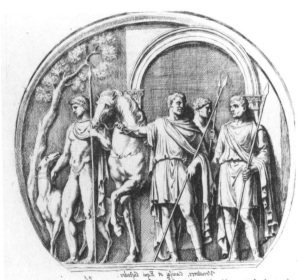

182e–v

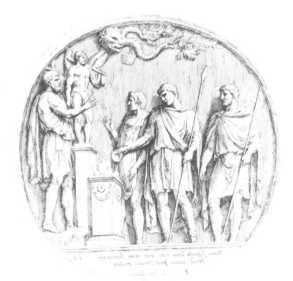

182e–vi

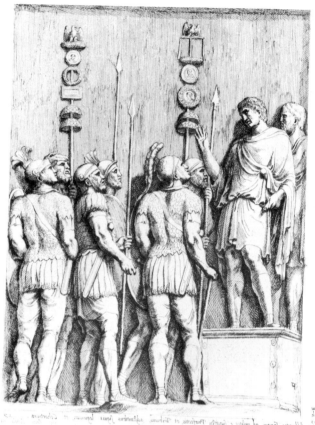

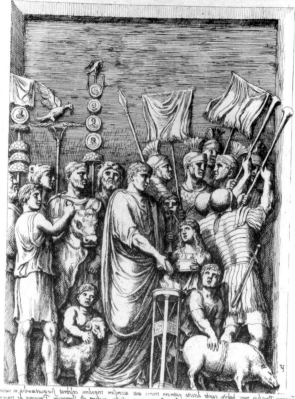

182e–iii

182e–iv

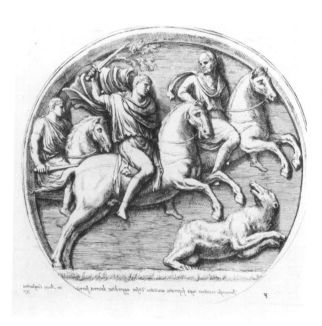

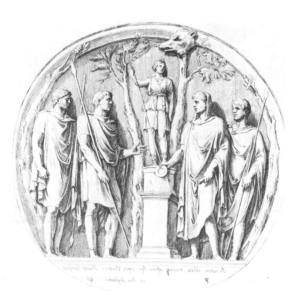

182e–vii

182e–viii

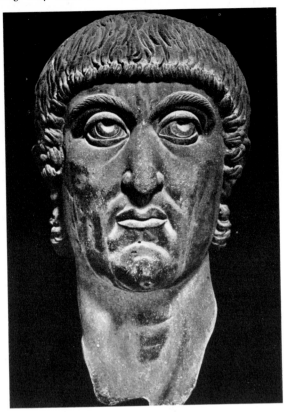

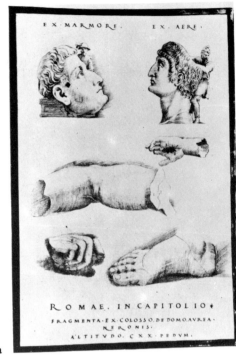

183 183a

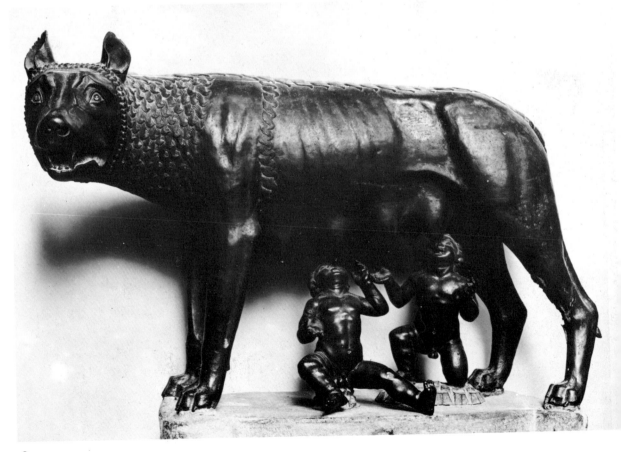

184

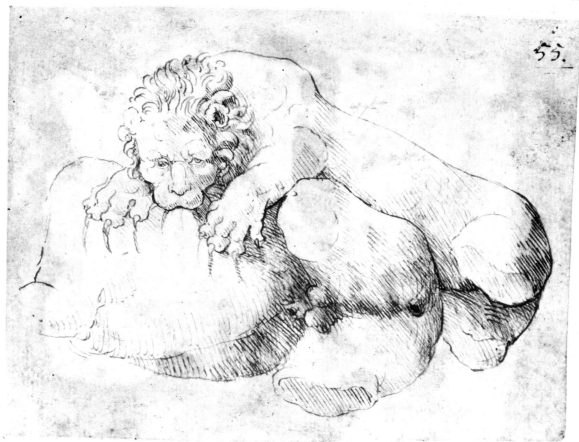

185a

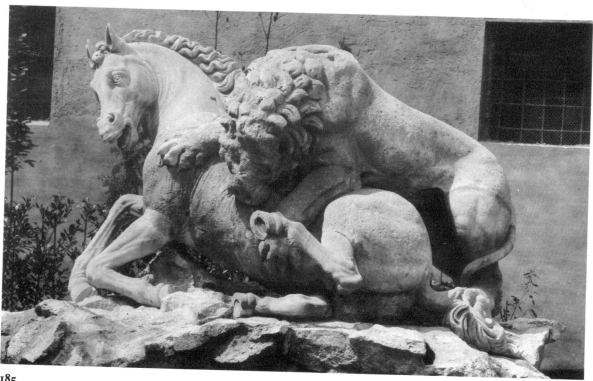

185

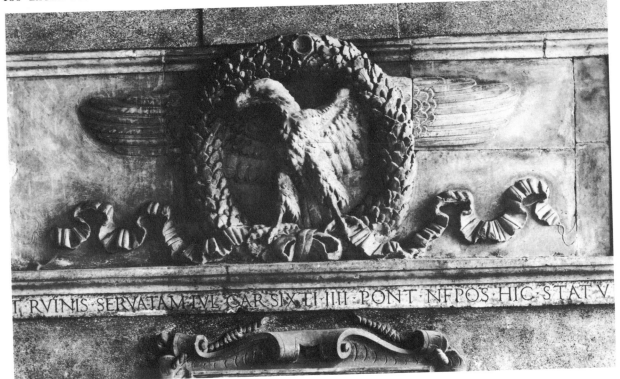

T RVINIS SERVATAM IVL CAR SIX TI IIII PONT NEPOS HIC STAT V

186

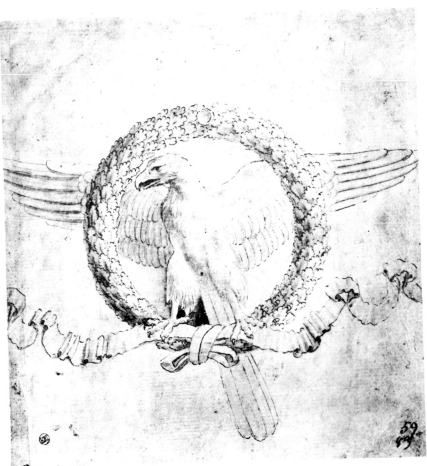

186a

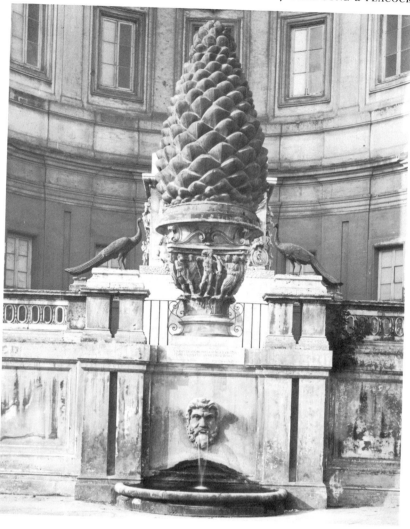

187

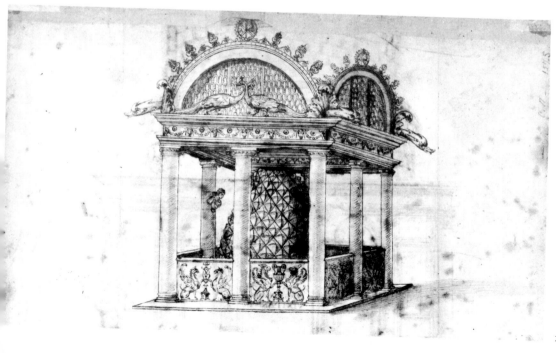

187a

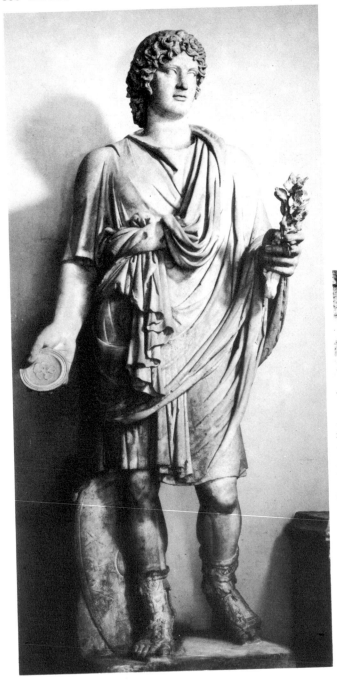

188

188a

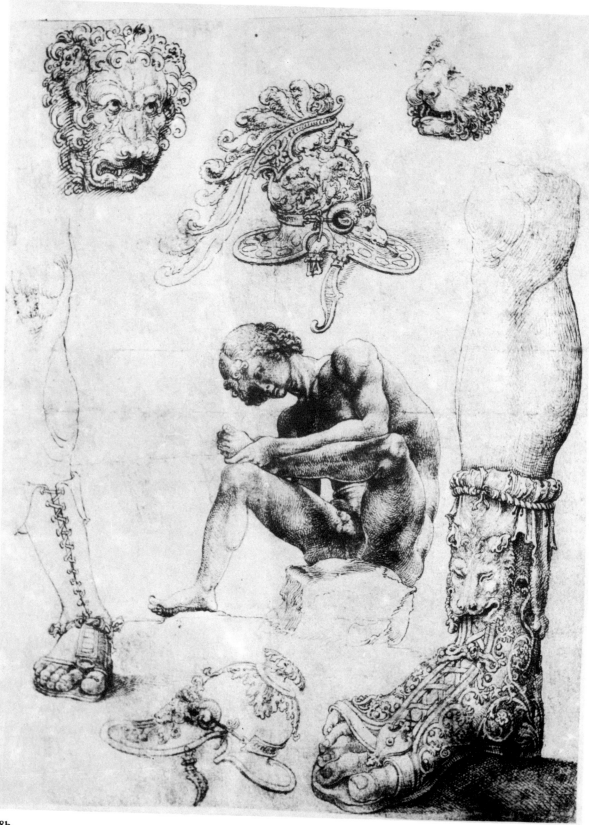

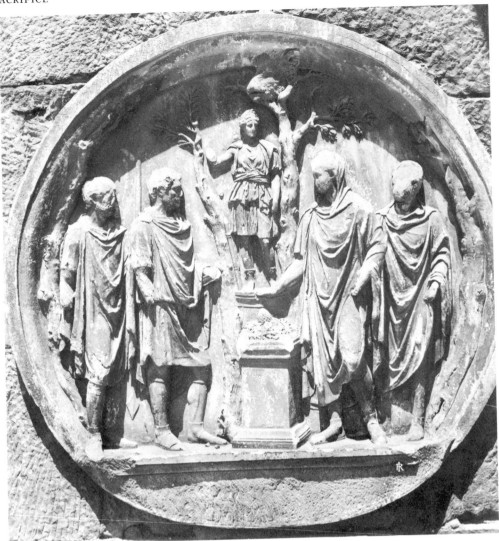

189

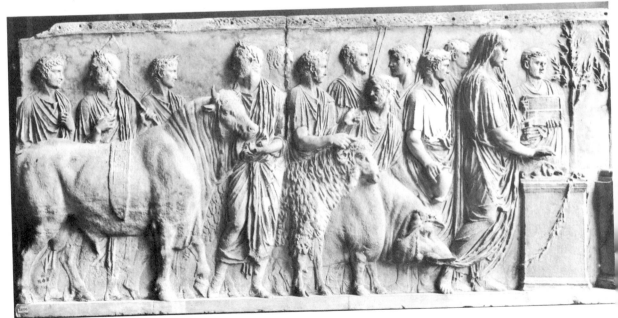

190

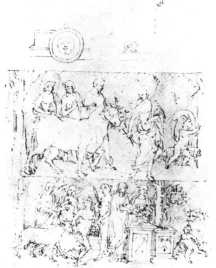

190c

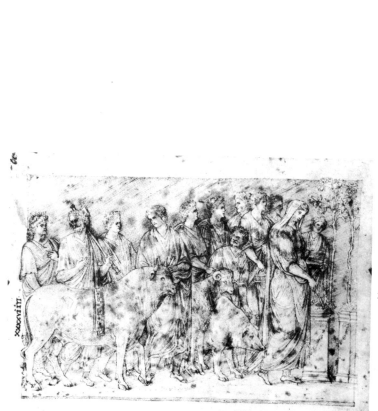

190b

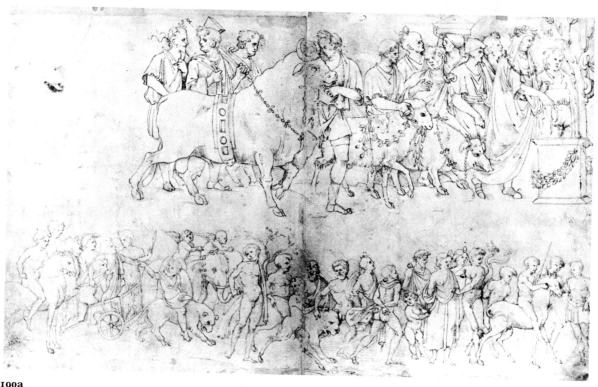

190a

191

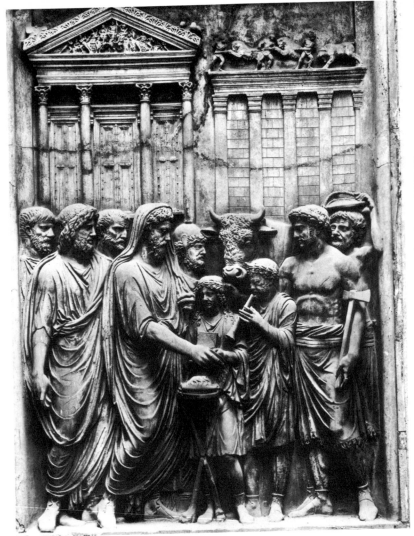

191a

193i–ii

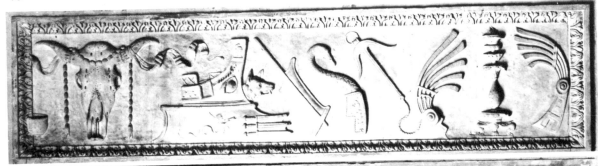

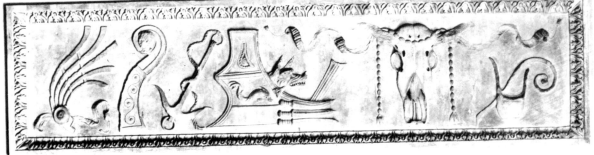

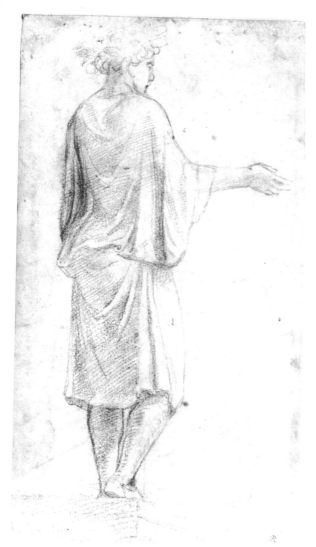

192a

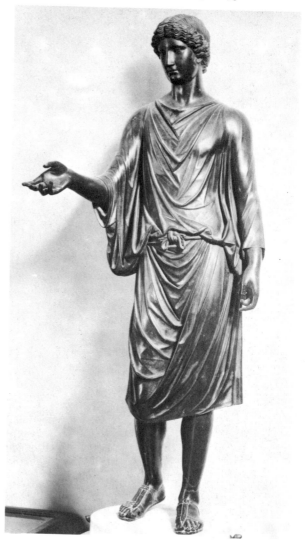

192

193a

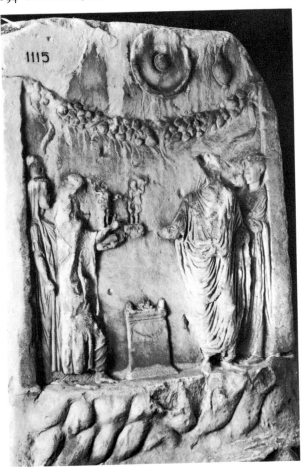

194A

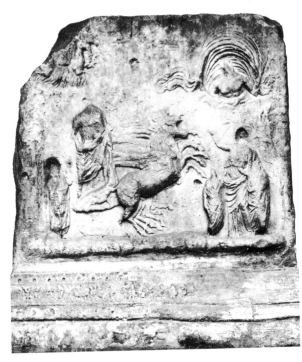

194B

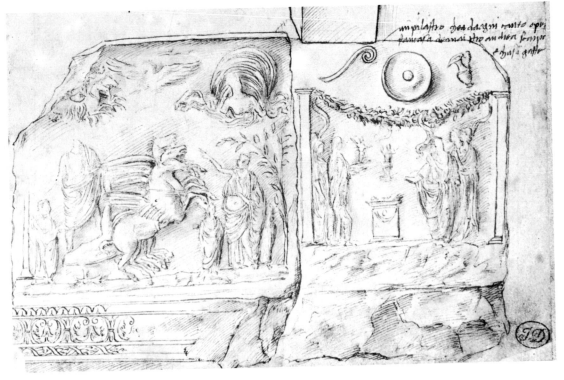

194a

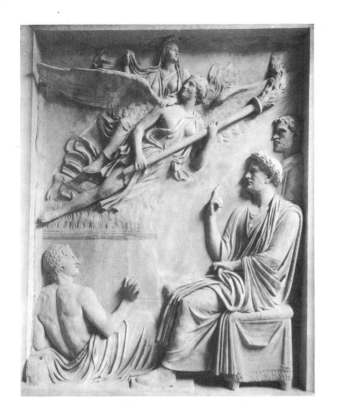

195 A

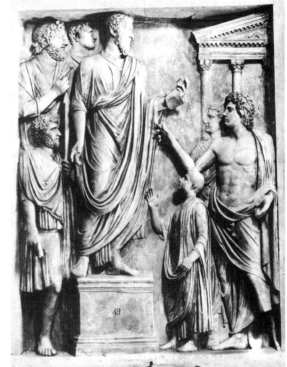

195 B

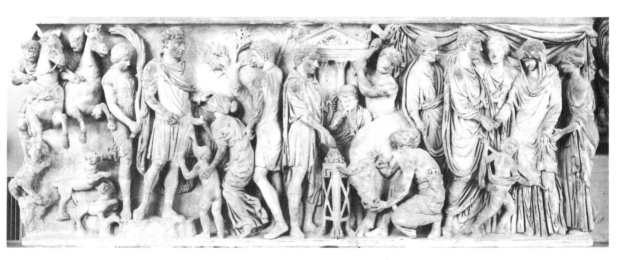

197

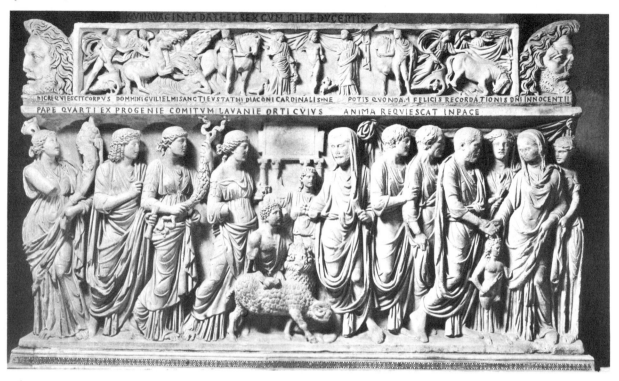

196

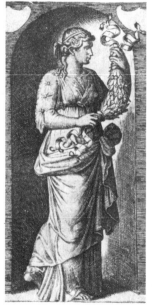

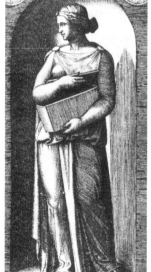

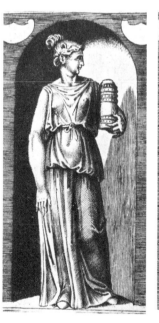

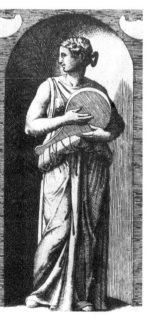

196a b c d

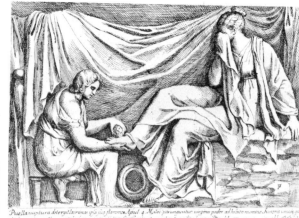

198

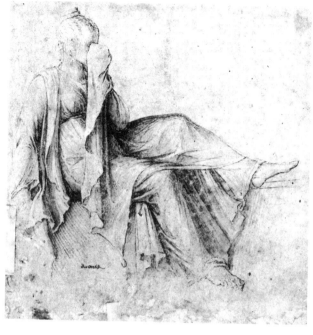

198a

198b

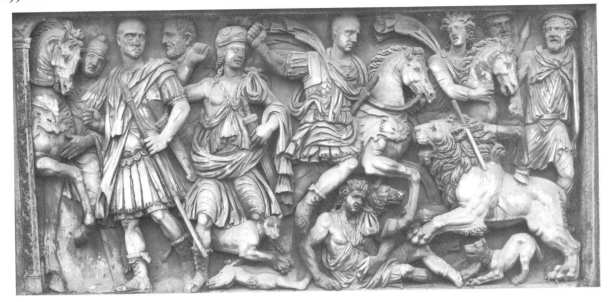

199

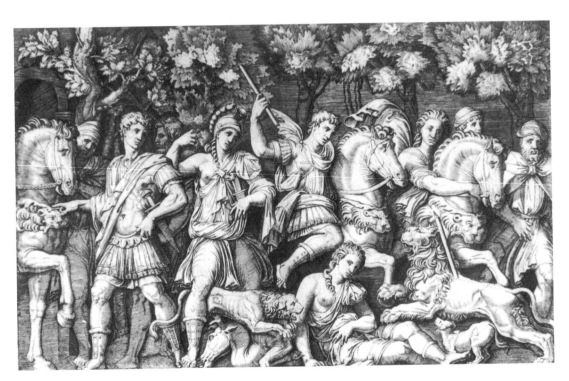

199a

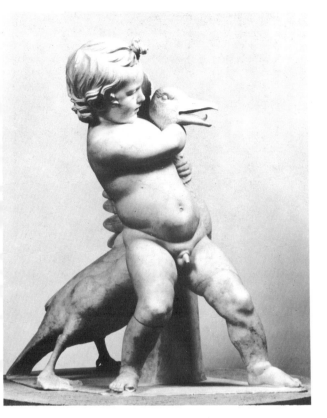

200

200a

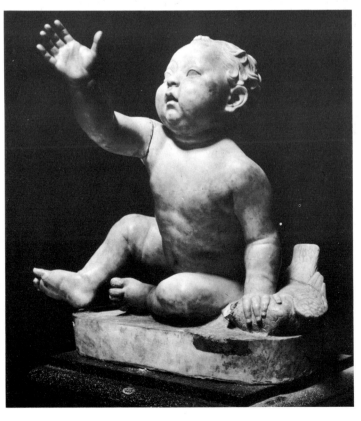

201

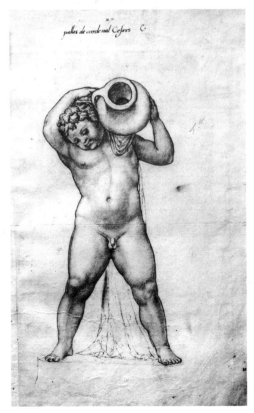

202

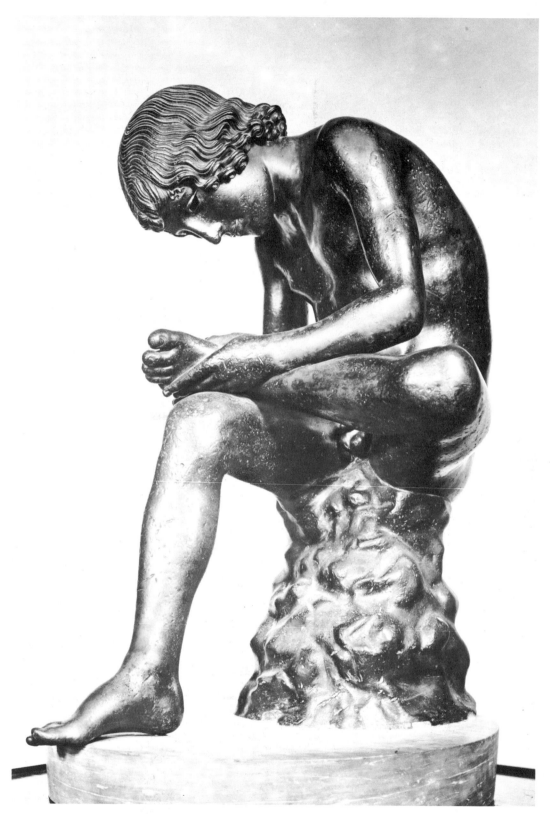

APPENDICES ·
BIBLIOGRAPHY ·
GENERAL INDEX

Index of Renaissance Artists and Sketchbooks

Dates of the artists' birth and death, and of their visits to Rome are noted, when known. (Some important earlier and later artists are also included.) Numbers refer to the catalogue entries listing copy or copies of antique work made by the artist; the numbers in brackets indicate either that the artist has adapted rather than copied the original or has been referred to in some other connection with it. Wrong attributions are also noted. Numbers in italics refer to the illustrations. Biographies of the artists can be found in Vasari–Milanesi, 1906; Thieme-Becker, *Allgemeines Lexicon der bildenden Künstler*, I–XXXI, 1907–50; *Dizionario Biografico degli Italiani (DBI)*, 1960ff. We have also used recent monographs and catalogues of drawings, such as Byam Shaw, 1976, and Gere and Pouncey, 1983, for artists' dates. For published sketchbooks (*Skb.* in catalogue entries), the date and attribution, if known, are given with a short bibliographical reference (full reference in Bibliography). Asterisk indicates that the publication illustrates all the folios. A bibliography of sketchbooks including some not noted here is in Horster, 1975. A useful orientation containing a bibliography for the early sketchbooks is by J.G.Rushton, *Italian Renaissance Figurative Sketchbooks, 1450–1520*, University of Minnesota, PhD, 1976, Ann Arbor, 1979. A Study by A. Nesselrath of Renaissance Sketchbooks after the Antique is in preparation.

APPENDIX I: INDEX OF RENAISSANCE ARTISTS AND SKETCHBOOKS

Aspertini (continued)

3. London, BM, 1862–7–12–394 to 435. 'Sketchbook II'. *Lit.* *Bober, 1957.

127, (149), (151), 171

Other drawings:

Berlin: 158; London, BM: 76, 79 (wrong attrib.), 146, 158, 190; London Art Market: 161, 162; New York, MMA: 27, 178, 185; New York, Pierpont Morgan Lib.: 181 (attrib.); Rome, Gab. Naz. delle Stampe: 146; *181c*, *190a*

Fresco:

Bologna, Oratorio of S. Cecilia: (109)

Aspetti, Tiziano (1565–1607)

Sculptor and restorer working in Venice in later 16th century.

(35), 149 as restorer

Attavante degli Attavanti (1452–1520/25)

Tuscan miniaturist.

100, *Fig. 15*

Averlino *see* **Filarete**

Baccio d'Agnolo [Bartolommeo Baglioni] (1462 to 1543)

Florentine architect.

175 (attrib.)

Balducci, Matteo (active first half 16th century)

Umbrian painter.

82 (attrib.); *82a*

Bambaia, Agostino Busti (1483–1548)

Milanese sculptor and engraver *see* **'Bambaia' Sketchbook**, below.

'Bambaia' Sketchbook c. 1515

Berlin-Dahlem, Staatl. Mus., Preussischer Kulturbesitz, Kupferstichkabinett. *Lit.* *Dreyer and Winner, 1964 (as by Master of 1515); Winner, 1967, cats. 14, 37, 71 (as by Bambaia, probably identical to the Master of 1515).

p. 36; 103, 115, (120), (154), (162), 190, 191, *190c*

Other engravings:

79

Other drawings:

(197)

Bandinelli, Baccio (1493–1560)

Florentine sculptor. First in Rome 1514; lived in Vatican 1517–21/22; and often returned to Rome thereafter, *Lit.* Ward, 1982.

10 (attrib.), 28, (28), 33 (attrib.), (64), (80), 94, (110), 122, 123, 132 (attrib.), 145, (149); *28b*, *122b*

Bandinelli, manner of: 173, 178

Barbari, Jacopo de' (c. 1460/70–c. 1516)

Venetian engraver, influenced by Dürer and Mantegna.

102 (attrib.)

Barili, Antonio (1453–1516)

Sienese intarsia worker, collaborated with Francesco di Giorgio Martini.

55 (attrib.)

Barga *see* **Pietro da Barga**

Barocci, Federigo (1535–1612)

Painter from Urbino, in Rome c. 1555; 1561–c. 1563.

(94)

Bartoli, Pietro Sante or **Santi** (1635–1700)

Engraver. *See also* Bibliography.

Colonna Traiana (1673)

170A; *170A*

Veteres Arcus (1690)

180, 181; *181b*

Admiranda (1693) *see also* **Giani**

9, 25, p. 81, 83, (106), (110), 116, 118, 160, 163, 167, 191, 196, 197, 198

Bartolommeo, Fra (1475–1517)

Florentine painter.

63, (after 63 attrib.), 65A, 90, 154; *65A–a*

Basel Sketchbook *see* **Frans Floris Workshop**

Beatrizet, Nicolas (c. 1515–65)

French engraver, in Rome 1540–65. Engravings for Lafréry's *Speculum* (q.v.); Bartsch, XV.

66, 67, 122, 125, 131, 158, 167, 176, 193; *125c*, *125d*, *193b*

Beccafumi, Domenico (1486–1551)

In Rome c. 1517 and 1542. Sienese painter; sculptor of bronzes.

132

Bella, Stefano della (1610–64)

Florentine engraver, in Paris 1639–49; to Rome in 1650.

198

Bellano, Bartolommeo (c. 1434–1496/7)

Paduan. Bronze sculptor in Donatello's workshop. In Rome 1466–7.

p. 39, p. 42 n. 22

Bellini, Gentile (1429–1507)

Venetian painter, son of Jacopo Bellini.

177

Bellini, Giovanni (1430?–1516)

Venetian painter, son of Jacopo Bellini.

94 (attrib.), 100 (attrib.?)

Bellini, Jacopo (c. 1400–71)

Venetian painter.

London, BM Sketchbook. *Lit.* *Goloubew, 1912.

(185)

Paris, Louvre Sketchbook. *Lit.* *Goloubew, 1908.

p. 35, p. 41 nn. 4 and 6; 81, 88; *88a*

Other drawings:

(189)

Bellini, Jacopo, Circle of
Paris, Louvre, R.F.524. *Lit.* Degenhart and Schmitt, 1972.
5, 69, 81; *69a*

Bernabei, Tomaso ['Il Papacello'] (d.1559)
Painter from Cortona, influenced by Giulio Romano. *Lit.* Vasari–Milanesi, 1906, III, p.694.
122; *122e*

Bernardino della Volpaia *see* **'Coner, Codex'**

Bernini, Gian Lorenzo (1598–1680)
Foremost Roman Baroque sculptor.
(10), (28), (122), (125), (155)

Bertoldo di Giovanni (1420–91)
Florentine sculptor and medallist, pupil of Donatello, employed by Lorenzo de' Medici.
157; *157a*

Bescapè, Ruggiero (?–1600)
Lombard sculptor and restorer; in Rome 1594–1600.
64, 163, cf.167, 185, 191

Binck, Jacob (1500–69)
German engraver and medallist.
70 (after Marcantonio)

Bisschop, Jan de ['Episcopius'] (1628–71)
Dutch draughtsman and engraver. *Lit.* van Gelder, 1971.
Album, London, V&A, Dept. of Prints and Drawings 93. E.29 (with motifs from Perrier, 1645):
83
Drawing:
191
Signorum veterum icones, 1668, 1669. 100 plates of antique statues most of them engraved from 17th century Dutch drawings:
3 (after Poelenburgh), 7 (after Salviati)
Paradigmata Graphices, 1671. 47 plates after drawings mostly by 16th century Italian artists, of which only a few are antique statues. An additional 10 plates are of antique portrait busts:
(72 after Boscoli)

Boissard, Jean-Jacques (1528–1602)
French antiquarian and draughtsman.
Sketchbook in Stockholm, Royal Lib., Cod. Holmiensis, S.68 (1559). *Lit.* Boissard, 1597–1602. Boissard's six books on Roman antiquities draw on material from his sketchbook as well as on other sources; plates engr. by Theodor de Bry. Callmer, 1962; Mandowsky and Mitchell, 1963, pp.27–8.
19, 47, 49, 84, (122)

Boldrini, Niccolò (c.1500–c.1570?)
Venetian engraver.
122 (after Titian?), 136 (after Raphael)

Bolognese School, 16th century
Berlin, Kupferstichkabinett
28

Oxford, Ashmolean
31 (attrib.; *see* Marcantonio attrib.)
see also Aspertini, Francia, Marcantonio Raimondi, Ripanda

Bonasone, Giulio (active 1531–74)
Bolognese engraver, active in Rome; influenced by Marcantonio. Bartsch, XV.
64, (110), (119); *110b*

Bonfigli, Benedetto (c.1420?–1496)
Perugian painter.
(182)

Bos, Cornelius or **Corneille** (c.1506 or 1510–70?)
Flemish painter specialising in grotesque decorations. Journey to Rome c.1540?; Rome from c.1546–c.1570. *Lit.* Dacos, 1964.
(5 after Michelangelo)

Bos, Jacop *see* **Lafréry**
24

Boscoli, Andrea (c.1560–1607)
Florentine painter, in Rome c.1580–90.
(72)

Botticelli, Sandro (1444/5–1510)
Florentine painter. In Rome 1481–2.
p.36, p.41 n.13; 31 Workshop, (58), (60), (68), (121), 182; *31b, 68a*

Bracci, Pietro
18th century Roman sculptor and restorer.
182

Bregno, Andrea (1421–1503). Last will, 1503; date on tomb, 1506 Lombard sculptor in Rome. *Lit.* Egger 1927, p.128.
(59B)
see also Appendix II; BREGNO, ANDREA

Bronzino [Agnolo di Cosimo Tori] (1503?–1572)
Florentine painter.
203 (attrib.)

Brunelleschi, Battista
Florentine epigrapher. In Rome 1509, 1511, 1512–13.
Sketchbook, 1509–1513. Florence, Bibl. Marucel., A 78 1. *Lit.* Giuliano, 1971.
47, 89, 182

Brunelleschi, Filippo (1377–1446)
Florentine architect.
p.31, p.32; (144), (203)

Bry, Theodor de, *see* **Boissard**

Busti, Agostino, *see* **Bambaia**

Cambiaso, Luca (1527–85)
Genoese painter.
5 (attrib.)

Cambridge Sketchbook (second half of 16th century. 1550–3 according to P.G.Hübner, 1912, and Dhanens; 1583 according to Michaelis.) Trinity College Lib., MS R.17.3
Anon. Netherlandish artist (sculptor?). *Lit.* Michaelis, 1892 (inventory); *Dhanens, 1963 with new numbering and attribution to Giambologna.

> 10, 28, 32, 66, 67, 80, 92, 119, 122, 125, 127, 130, 131, 132, 136, 146, 151, 171, 188, (202); *127a, 171a, 202*

Camelio [Gambello], Vittor (c.1460–1537)
Venetian sculptor in bronze.

> (132); *132b*

Campagnola, Domenico (1500–64)
Venetian painter and engraver recorded in Venice and Padua. *See also* **Corona.**

> (153 attrib.)

Campi, Barnardino (1522–91)
Cremonese painter.

> (100)

Canova, Antonio (1757–1822)
From the Veneto. Sculptor active in Rome.

> (52B), 98, (122), (125)

Capitelli, Bernardino (1589–1639)
Sienese engraver, drew antique reliefs for Cassiano dal Pozzo c.1626. Bartsch, XX.

> 9

Carnevale, Fra, *see* **Master of the Barberini Triptych**

Carpi *see* **Girolamo da; Ugo da**

Carpio Album

> London, Society of Antiquaries. 17th century drawings collected by Spanish Ambassador to Rome 1676–82. *Lit.* Harris, 1957, 1958; Vermeule and von Bothmer, 1956, p.332.

> > 80

Carracci, Annibale (1560–1609)
Bolognese painter.

> 77 (studio)

Castagno, Andrea del (1419–57)
Florentine painter. Visited Rome in 1454 (Horster, 1980, pp.41–4).

> p.35, p.37, p.41 n.12, p.42 n.17, p.139, (177); *Figs. 6, 8*

Cavalieri, Giovanni Battista (c.1525–1601)
Engraver from Trento, working in Rome; engraved plates in *Antiquarum Statuarum Urbis Romae liber …* *Lit.* Ashby, 1920 pp.146–53 (inventories of various editions); B.Passamani in *DBI*, Vol.22, 1979 (revised dates of the various editions of which first ed. of bk.I is undated, but second ed. is 1561–2).
Books I–II (1st ed., n.d., probably c.1569 or early 1570s; 1585 ed. most frequent):

> (7), 8, 10, 13, 17, 24, 32, 36, 64, 65A, 65B, 66, 67, 71,

Cavalieri (continued)

> 75, 79, 122, 125, 129, 155, 165, 166, 174, 176, 185, 203; *17c*

Books III–IV (1594):

> 33, (58), p.109, 92, 95, 101, 108, 141, 166

Central Italian artist (1420–30)
Lit. Degenhart, 1950, as Michele di Giovanni di Bartolo; Degenhart and Schmitt, 1968, I, cats.136^{r-v}–137 with present attribution.

> Paris, Louvre
> > 83, 86, 124, 139; *124a*

Central Italian 16th century artists

> Baltimore, Walters Art Gall.
> > (182) (painting c.1500)
> Port Sunlight, Lady Lever Art Gall. (mid 16th century)
> > 58; *58a*
> Princeton, N.J., Univ. Mus.
> > 185

Cesare da Sesto (1477–1523)
Milanese painter, in Rome first c.1507–10; 1514 to Messina.

> 'Lombard Sketchbook', New York, Pierpont Morgan Lib., Fairfax Murray, 1910, II (early 16th century):
> > 3, (22?); *22b*
> Other drawing:
> > (158 attrib.)

Cesati Alessandro (active 1538–64)
Italo-Cypriot medallist. Worked in Rome 1538–c.1560.

> (202)

Cioli, Cosimo (d.1615)
Florentine sculptor from Settignano. Restored antiques in Pisa, 1602–5.

> 91

Cioli, Valerio (1529–59)
Florentine sculptor from Settignano. Restored antiques for Cosimo dei Medici's 'Antiquarium'.

> (137)

Ciriaco d'Ancona (1391–c.1455)
Antiquarian traveller and epigrapher, singular in his time for recording antiquities in Greece and the Levant, as well as in Italy. The following include copies in various hands in lost MSS by or attributed to Ciriaco. *See also* **Felice Feliciano.**

> (p.57), (46), (59A), 75 (after C.), (87), (132), (176, after C.), (177), (183, after C.)

Civitale, Matteo (1436–1501)
Lucchese sculptor.

> (187)

Claez, P. (1597/8–1640)
Dutch painter.

> (203)

Claude Lorrain (1600–82)
French painter in Rome.
 49 (attrib.)

Clovio, Giulio (1498–1578)
Croatian miniaturist in Rome 1516–19 (?); 1526–7 (?);
then almost continually from 1535–78.
 48 (attrib.)

Coburgensis, Codex, c. 1550
 Veste [= Schloss or Castle] Coburg, Cod. HZ II. *See
 also* **Pighius** and cf. Codex Pighianus. *Lit.* Matz, 1871
 (inventory, not illus.); Mandowsky and Mitchell,
 1963; Maedebach, 1970. Robert, *ASR*, 1890ff. often
 uses Pighius drawings as illustrations. H. Wrede
 and R. Harprath are preparing an edition of the
 Codex Coburgensis.
 5, 7, 19, 25, 27, 29, 37, 38, 43, 45, 46, 47, 49, 56, 57, 76,
 78, 80, 84, 85, 86, (89), 89, 92, 99, 100, 103, 110, 113,
 115, 116, 118, 119, 120, 121, 126, 134, 135, 136, 138,
 140, 141, 146, 175, 190, 191, 196, 199; *25, 27b, 45, 46a,
 92a, 92b, 100b, 113a, 118a, 134a and b, 135a, 140a*

Cock, Hieronymus (1510–70)
Flemish engraver, published 26 plates of views of an-
cient Rome in 1551 and another 21 plates in 1562.
Engraving after lost drawing by Heemskerck of della
Valle Courtyard. *Lit.* Michaelis, 1891, *JdI* (II); Hülsen
and Egger, 1913–16, II, pl. 128, pp. 55–6.
 7, 32, 35, 42, (164), 166; *ill. p. 480*
 Other engravings:
 65A and B

Codex = Manuscript; bound sketchbook
 see Aspertini (for Codex Wolfegg); Coburgensis;
 Colonna; Coner; Escurialensis; Pighianus, Ursinia-
 nus, Zichy

Colonna, Giovanni da Tivoli
(active mid 16th century)
In Rome 1554.
 Cod. Vat. Lat. 7721, containing drawings of antique
 and modern architecture and funerary reliefs.
 Lit. *Micheli, 1982.
 47

'Coner, Codex', attrib. Bernardino della Volpaia,
early 16th century
 London, Sir John Soane's Mus. *Lit.* *Ashby, 1904;
 1913; Buddensieg, 1975 (as Bernardino).
 187

Cornacchini, Agostino (1685–after 1754)
Florentine sculptor in Rome.
 122

Corona, Gian Antonio (active 1501–c. 1527)
 30 (fresco in Padua formerly attributed to
 D. Campagnola)

Correggio, Antonio Allegri (1489?–1534)
Emilian painter; visit to Rome (?) undocumented
 between 1513–19?
 (60), 93

Cort, Cornelis (1533 or 1536–78)
Flemish engraver, pupil of Cock, influenced by Titian,
with school of engraving in Rome from 1571.
 (137 after Floris), 203

Cortona, Pietro da (1596–1669)
Tuscan painter active mainly in Rome.
 'Pietro da Cortona' Sketchbook, 17th century;
 Toronto, Royal Ontario Mus. Includes drawings of
 famous Roman historical reliefs. *Lit.* Brett, 1957,
 with inventory of contents and attribution to P. d. C;
 no pagination; dated after 1616 to before 1623–44.
 (p. 92), 161, 167, 193, (also 158, 159, 196, not listed)

Cossa, Francesco del (1435/6–1477/8)
Ferrarese painter.
 (203)

Cristoforo di Geremia (active 1456–76)
Mantuan goldsmith and medallist working in Rome
after 1456; *see* Appendix II: GONZAGA FAMILY.
 (176)

Cronaca, [Simone Pollaiuolo] (1457–1508)
Florentine architect in Rome 1475–85.
 55 (attrib.), (125), 187, 200 (attrib.); *187a, 200a*

Daniele (Ricciarelli) da Volterra (c. 1509–66)
Tuscan painter in Rome from 1536.
 132, (132)

David, Gerard (active c. 1484–1523)
Flemish painter.
 31

Dente, Marco [Marco da Ravenna] (c. 1493–1527)
Engraver in Raimondi's Workshop, Circle of Raphael.
Bartsch, XIV.
 52A, 74, 122, 158, 176, 188, 203; *52A–b*

Destailleur Sketchbook
 Berlin, Staatl. Mus., Preussischer Kulturbesitz,
 Kunstbibl., OZ 109. (Album composed of drawings,
 mostly architectural, by various hands, Italian and
 French. Unpublished.):
 180

Donatello (c. 1386–1466)
Florentine sculptor.
 p. 31, p. 32, p. 36; pp. 41–42 nn. 1, 16, 17; 7 (wrong
 attrib.), (11), p. 72, (32), p. 000, (53), (87), (105), (114),
 (115), (116), (118), (144), (172 attrib.), (177), p. 211;
 105b, 172a, 177c

Donatello, School of
 41, p. 90, 123, 201; *41a, 123a*

Dosio, Giovannantonio (1533–c. 1610)
Florentine architect and architectural sculptor work-
ing mainly in Rome from c. 1548–74.

Dosio (continued)

1. Sketchbook (Cod. Berolinensis) c.1561–5
Berlin, Staatl. Mus. Preussischer Kulturbesitz, Kupferstichkabinett, 79 D 1. (The volume is actually an album often with more than one drawing pasted on to a page, and it includes the work of other hands.) *Lit.* *Hülsen, 1933.

16, p.69, 44, 85, 87, 90, 91, p.139, 118 (not by Dosio), 120, 134, 135, 142, 158 (by Aspertini), 165, 167, 173 (not by Dosio), 174, 175, 178 (not by Dosio), 189, 196; *26b, 44a, 90b, 91a, 173a, 178c, 196e; Fig. 5*

2. Sketchbook
Florence, Bibl. Marucel. *Lit.* Hülsen, 1912, *Ausonia;* *Hülsen, 1933.

(7), 132, 134

3. Sketchbook
Modena, Bibl. Estense (attrib.). *Lit.* Luporini, 1957.

180

4. Loose drawings in Florence, Uffizi (c.1560–5). *Lit.* *Acidini in Borsi *et al.*, 1976.

p.92 174, 180, 181, 182, 185, 187 (lost), 195; *181a, 182a, 195a*

5. Dosio, *Urbis Romae aedificiorum … reliquiae,* Rome, 1569.

174, 180, 181, 182, 195; *Frontispiece, 174a, 182b*

6. Sketchbook, originally part of 1 and 2, Florence, BN, Nuovi Acquisti 618. *Lit.* Tedeschi Grisanti, 1983.

Dosio, Circle of (c.1560), Florentine draughtsman
Sketchbook
Florence, BN, Nuovi Acquisti 1159. *Lit.* To be published by E.Casamassima and R.O.Rubinstein.

47, 49, 84, (129), 193

Duchetti, Claudio *see* **Lafréry,** *Speculum*

Dupérac, Étienne (1525–1604)
Antiquarian and draughtsman, to Rome, c.1559. Paris, Louvre, *Album* (inv.3833–3938) c.1575. *Lit.* *Guiffrey and Marcel, 1910.

47, 67, 135, 190, 191, 193, 194, 196

Duquesnoy, François (1597–1643)
Belgian sculptor in Rome from 1618.

10

Dürer, Albrecht (1471–1528)
German painter in Northern Italy 1494–95; 1505–7.

(28), 50

'Episcopius' *see* **Bisschop, Jan de**

Escurialensis, Codex

Spain, El Escorial, Bibl., Cod. 28-II-12 (late 15th century–c.1505–8). Thought by Egger (1906) to have been compiled in Ghirlandaio's Florentine workshop from copies of drawings made when Domenico Ghirlandaio was in Rome, 1481–2. Seen by Shearman (1977) to comprise three sketchbooks, the cen-

Escurialensis (continued)

tral one (ff. 12–68) having been completed c.1505–8 and including copies of earlier 16th century drawings by Raphael. If this is so, most of the drawings cited below would date from the early 16th century. Ghirlandaio Workshop. *Lit.* *Egger *et al.*, 1905–6; re-examination by Shearman, 1977.

1, (13), 27, 28, 54, 55, 59B, 63, (64), 65B, 76, 84, (89), 92, 102, 103, 107, 120, 130, 142, 147, 154, 159, 161, 169, (170), p.203, 175, 176, 178, 181, 182, 187, 193, 197; *1a, 28a, 54, 55a, 63a, 76a, 102a, 107a, 142ii, 154a, 159c, 169a, 170A–a, 176a*

Falconetto, Giovanni Maria (1468–1535)
Veronese painter and architect. In Rome c.1500. *Lit.* Buddensieg and Schweikhart, 1970; Schweikhart 1967–8; 1968; 1975.

9, 44, 70 (after Marcantonio), (80), (83), (90), (99), (100), (110), (116), 146, (156); *90a*

Federighi, Antonio (c.1420–90)
Sienese architect and sculptor.

60 (wrong attrib.), 158 (wrong attrib.); *60a*

Feliciano, Felice (1433–80?)
Veronese antiquarian, epigrapher and scribe. Codex Marcanova (1465), Modena, Bibl. Estense, MS α. L.5.15 (lat.992). Thought to be a copy of a lost codex by Ciriaco d'Ancona. It is mostly in the hand of Felice Feliciano and edited by Giovanni Marcanova (1410–67) humanist, physician, epigrapher and book collector. *Lit.* Hülsen, 1907; Mitchell, 1961.

(176), (183)

Ferri, Cirro (1634–89)
Roman painter, pupil of Pietro da Cortona.

(197)

Figino, Ambrogio (1548–1608)
Milanese painter.

Album, Windsor. *Lit.* Popham and Wilde, 1949, cat.326.

122

Filarete [Antonio Averlino] (c.1400–69)
In Rome 1433–45. Milanese sculptor in bronze, and architect; author of a treatise on architecture *see also* Bibliography.

(168), 176, 181 (follower?), (203?)

Flemish *see* **Netherlandish**

Florentine bronzes *see* **Italian bronzes: plaquettes; statuettes**

Florentine, late 15th century drawings
Bayonne, Mus. Bonnat

190

Chantilly, Mus. Condé

121; *121a*

Garofolo [Benvenuto Tisi] (1481?–1559)

Ferrarese painter who visited Rome twice; teacher of Girolamo da Carpi.

(77)

Genoese sculptor (c. 1509)
Connections with Giuliano da Sangallo, Cod. Escurialensis and La Calahorra, Spain. *Lit.* de Bosque, 1968, pp. 436–49 with plates; Shearman, 1977, pp. 107–8.

59B, 130, 169

Gentile da Fabriano (c. 1385–1427)
Marchigian painter working in International Gothic style. In Rome 1426–7. *Lit.* *Schmitt, 1960; *Fossi Todorow, 1966, pp. 47–8, and cats. 166–208 including these drawings grouped with those attributed by Degenhart and Schmitt to a Central Italian artist c. 1420–30 (q.v.) and considered in connection with a travel sketchbook ('taccuino di viaggio') copied in Pisanello's Circle. *See also* Pisanello Workshop, but *see* Christiansen, 1982, cat. LXVII, who does not believe that Gentile was involved in this group of drawings.

p. 35; 21, 25, 29, 52A, 86 (attrib.), (100), 106, 110, (p. 211); *25a, 52A–a, 110c*

German 16th century drawing, (c. 1540)
Erlangen, Univ. Lib.

132

Ghiberti, Lorenzo (1378?–1455)
Florentine sculptor. *Lit.* Krautheimer, 1956, Appendix A: 'Handlist of Antiques' (illustrated).

p. 33; p. 59, (22), (31), (60), (77), (89, 'Circle'), (94, Workshop), (98), (99), (105), (108), (110), (111), (116), (117), (123), (144), (156), (157), (158), (162), p. 211; *22a, 105a*

Ghiberti, Vittorio (1418–96)
Florentine bronze sculptor, son of Lorenzo.

83 (Workshop)

Ghirlandaio, Domenico (1449–94), or Workshop, (late 15th to early 16th century)
Florentine painter, in Rome 1481–2. *Lit.* Dacos, 1962. *See also* Codex Escurialensis.

(33), (59B), 83, 103, 125 (attrib.), 158, 159, 201; *33a*

Giambologna [Giovanni da Bologna] (1529–1608)
Flemish sculptor, in Rome c. 1555, thereafter in Florence. *See also* Cambridge Sketchbook attributed to him by Dhanens, 1963; Avery and Radcliffe, 1978, for workshop bronzes after the antique.

20, (139), (185 see Susini)

Gian Cristoforo Romano (c. 1470–1512)
Sculptor, medallist, gem engraver. Active from 1491. Worked for Mantuan court.

(122)

Giani, Felice (c. 1750–1823)
Painter and illustrator, in Rome and Faenza, etc.

Giani (continued)
Sketchbook, Faenza, Mus. Civico. *Lit.* Sotheby's Sale Cat. April 17, 1980, lot 91 (mostly drawings after engravings by P. Santi Bartoli, *Admiranda,* 1693).

196

Giocondo, Fra Giovanni (1433–1515)
Veronese architect, engineer, epigrapher, and an editor of Vitruvius. Worked principally in Rome, Naples, Verona and Venice.

60 (epigraphy), 84 (epigraphy), 159, 194 (epigraphy)

Giotto (c. 1266?–1337)
p. 32, (203)

Giovanni Antonio ['Giovanantonio'] da Brescia
(active c. 1490–after 1525)
Engraver in Rome between 1509 and 1525. Bartsch, XIII; *Illustrated Bartsch,* 1980, Vol. 25.

15, 85, 122, 132, 199

Giovanni da Bologna *see* **Giambologna**

'Giovanni da Cremona' *see* **Fonduli**

Giovanni da Nola [Marigliano] (c. 1488–1558)
Neapolitan sculptor, and maker of woodcuts.

(154)

Giovanni da Udine (1487–1564)
Member of Raphael Workshop; worked on stucco and grottesque decorations of Vatican Loggie (q.v.).

(33), (75), 83, 92, 106, (106), 110, 119

Girolamo da Carpi (1501–56)
Ferrarese painter in Rome 1549–53.
1. Rosenbach Album, Philadelphia, Rosenbach Foundation. *Lit.* *Canedy, 1976.
 7, 8, 16, 32, 36, 38, 39, (42), 49, (51), (63), 71, 83, (89), 95, 100, 103, 125, 126, 130, 159, 171, 192
2. Turin Portfolio. Turin, Royal Lib. *Lit.* *Canedy, 1976.
 38, 64, 67, 79, 86, (89), 110, 120, 125, 130, 140, 161, (202)
Other drawings:
 Amsterdam: 7, 138; Bonn: 196 (attrib.); Budapest: 32; Düsseldorf: 83; Edinburgh: (5); Florence, Uffizi: 64, 76, 80, 108, 117 (attrib.); London, Christie's Sale (attrib.): 106; London, Pozzo BM: 8 (attrib.), 44 (attrib.), 107, 119 (studio); London, BM: 44, 65B; London, Sotheby's (Ellesmere Sale): 80; Munich: 77; New York, MMA: 66; New York, Cooper-Hewitt Mus.: 42; New York, Scholz Collection: 36; Oxford, Ashmolean: 202; Providence, R.I.: 83; Turin: 80 (attrib.); Windsor, Pozzo Albums: 82; Windsor: 82 (attrib.); *138a*

Girolamo da Carpi, followers of,
London, BM. *Lit.* Gere and Pouncey, 1983.

27, 76, (89), 100, (119), 121, 191; *121b*

Girolamo da Cremona (active 1467–83)
Miniaturist.
> (75 attrib.).

Giuliano da Sangallo *see* **Sangallo**

Giulio Romano (c. 1499–1546)
Principal artist in Raphael's Workshop (q.v.); to Mantua in 1524. *See* Appendix II: Ciampolini
> p. 37, p. 41,; (1), 4, (12), 17, 28, p. 73, 32 (attrib.), (43), (52A), 57 (attrib.?), (66), 77 (after GR), 78 (Pozzo, Windsor attrib. to studio of GR), (79 cf. 98), p. 126, (94), 100 (attrib.), 107 (attrib.), (109), 125, 139, (147), 154, 159 (attrib.), (159), (160), 190 (attrib.); *1c, 17b, 139a*

Giulio Romano, follower
> 83 (in Heemskerck, *Skb.* II)

Giusto dei Menabuoi da Padova
> 'Libro di Giusto' *see* **North Italian Sketchbook,** c. 1450?

Goltzius, Hendrik (1558–1616)
Dutch engraver and painter. Visited Rome 1590–1. His drawings of antique statues are in the Teyler Mus., Haarlem. *Lit.* ★Reznicek, 1961.
> 10, 16, 28, 64, 66, 67, 79, 131, 132, 174, 185

Gossaert, Jan ['Mabuse'] (c. 1478–c. 1536)
Flemish painter. Visited Rome 1508–9.
Lit. ★van Gelder, 1942; ★Pauwels, 1965.
> 129, 188, 203; *188b*

Goujon, Jean (active in France c. 1540–c. 1562)
French sculptor influenced by Cellini.
> 102

Gozzoli, Benozzo (1420–97)
Florentine painter. Visits to Rome in 1440s and 1458.
> 76, 186, (187); *76b, 186a*

Gozzoli Workshop, mid 15th century
Sketchbook in Rotterdam, Mus. Boymans–van Beuningen, with leaves in other collections. *Lit.* ★Degenhart and Schmitt, 1968, I, 2, pp. 478–90; cats. 434–69; I, 4, pls. 327–38.
> 176

Gozzoli follower
> 125 (attrib.)

Granacci, Francesco (1469/77?–1543)
Florentine painter.
> (203 attrib.)

Greco, El [Domeniko Theotokopoulos] (1541–1614)
Cretan painter, in Venice (and Rome?), to Spain c. 1577.
> (122), (149)

'Guglielmo Fiammingo' [Willem van Tetrode]
Flemish sculptor. From 1548 in Cellini's Workshop, restoring antique sculpture; c. 1560–2 visited Rome. *Lit.* Weihrauch, 1967, pp. 344–5.
> 125

Heemskerck, Marten van (1498–1574)
Dutch painter, in Rome 1532–6. (*See also* H. Cock after Heemskerck.) Sketchbooks (2 vols.) in Berlin, Staatl. Mus. Preussischer Kulturbesitz, Kupferstichkabinett, 79D2 = Vol. I; 79D2ᵃ = Vol. II. Although called Skizzenbücher, the volumes are really albums, in which drawings from Heemskerck's and others' sketchbooks are laid down. *Lit.* ★Hülsen and Egger, 1913–16; Veldman, 1977 (review of reprint).
> Berlin Sketchbook, Vol. I:
> > 1, 2, 20, 24, 28, 33, 40, p. 85, p. 86, (55), 57, 62, (63), 64, 65AB, 67, 71, 74, 90, 92, 109, 121 (not by H.), 122, 125, 127, 129, 131, 132, 137, 141, 150, 151, 159, 171, p. 203, 176, 182, 183, 185, 186, 188, 193, 202; *1b, 2a, 20a, 40a, 62a, 64b, 65a, 129a, 137a, 141a, 176c, 193a, ills. on pp. 472, 475, 476*
> Berlin Sketchbook, Vol. II (contains also drawings by other hands):
> > 28, 49, 64, 65AB, 75, 83 (Giulio Romano follower), 127, 151, 158, 174, 178, 180, 182, 190, 202; *75b, 83b, 178a, 182f, ill. on p. 477*
> Other drawings:
> > Berlin, Kupferstichkabinett: 36; Cambridge, Mass.: 125 (attrib.); Dresden: 125 (Circle); Düsseldorf: (7), 165 (copy); Paris, Louvre: 63 (attrib.); Oxford, Ashmolean: 192, 203; *165a, 192a, 203a*; *ill. on p. 479*
> Paintings:
> > (2), 36, (43), (75)

Holkham Album, Holkham Hall, Norfolk, MS 701 (partly c. 1490s)
By many different hands, among them North Italian and Florentine. *Lit.* Inventory in Passavant, 1839, II, pp. 586–93.
> 14, 57, 61, (75 description), 141, 158, 203; *14b, 61a*

Italian bronze plaquettes (anonymous)
> Berlin-Dahlem, Skulpturgal.
> > 31, 181 (15th century, Circle of Filarete); *31a*
> Florence, Museo Naz.
> > 172 (15th century, after Donatello)
> Vienna, formerly Lederer Collection
> > 68 (16th century)
> Washington, D.C.
> > (99; North Italian c. 1480), (100; Venetian late 15th or early 16th century), (122, early 16th century), 123 (15th century), (172, Florentine 15th century)
> *see also* Cesati, Cristoforo di Geremia, Donatello, Dusquesnoy, Filarete, Leopardi

Italian bronze statuettes (anonymous)
> Amsterdam, Rijksmus.
> > (184, Central Italian)
> Baltimore, Walters Art Gall.
> > 137 (North Italian), 177 (Venetian?)

Italian bronze statuettes (continued)

Berlin-Dahlem, Skulpturengalerie
18 (Paduan), 20 (Paduan), 30, 201 (Donatello School), 203

Ferrara, Mus. Civico di Schifanoia
132 (Antico?)

Florence, Mus. Naz. (Bargello)
30 (formerly attrib. Pollaiuolo), (128), (132), (137), 165B, 203

London, V & A
(36), 177 (North Italian); 36a

London, Wallace Collection
(e.g. 18 and 33)

Modena, Mus. Estense
30

Munich
177 (Paduan, c. 1500)

New York, Frick Collection
30

New York, Pierpont Morgan Lib.
203

Venice, Ca' d'Oro
30

Vienna, Kunstmus.
33 (Florentine, second half 16th century), 149 (Venetian), (203)

Washington D.C., NGA, Kress Collection
184, (203)

Private Collection. U.S.
18 (Venetian or Paduan)

see also Antico, Aspetti, Camelio, Duquesnoy, Filarete, Fonduli, Giambologna, Guglielmo Fiammingo, Pietro da Barga, Riccio; *and* schools: Paduan, Venetian, etc.

Italian drawings (anonymous)

Bayonne, Mus. Bonnat. *Lit.* Bean, 1960 (illus. cat.).
167, 190

Bergamo, Accad.
177

Berlin, Staatl. Mus. Preussischer Kulturbesitz, Kunstbibl.
see Destailleur Sketchbook, 'Mantegna' Sketchbook

Berlin-Dahlem, Staatl. Mus. Preussischer Kulturbesitz, Kupferstichkabinett. *Lit.* *Winner, 1967 (after antique).
158 (North Italian c. 1520), 185 and 197 (Milanese or Bolognese), *see also* Bolognese anonymous

Besançon, Mus. B–A
7 (first quarter of 16th century, old attrib. to Donatello), 188 (16th century Italian, attrib. 'Mantegna')

Boston, Mass., MFA, Dept. of Classical Sculpture
163 cf. 167 and 191

Bowdoin College of Fine Arts, Bowdoin, Maine
119

Brunswick, Kupferstichkabinett
65A and B, 185

Italian drawings (continued)

Carpi, Castello dei Pio
30 (fresco)

Chantilly, Mus. Condé
121, 194AB; *121a, 194a*

Chatsworth, Duke of Devonshire's Collection
15th century: 159
16th century: 82

Copenhagen, Print Room
30 (Florentine, 15th century), before 43 (Venetian, early 16th century)

Dresden, Kupferstichkabinett
83, 148 (16th century)

Düsseldorf
122 (early 16th century); *122a*

Edinburgh, NG of Scotland
196 (18th century)

Eton College Lib. *see* Topham Albums

Florence, Bibl. Laur.
75 (15th century)

Florence, Bibl. Marucel.
165 (16th or 17th century)

Florence, Uffizi
16th century: 85, 166
Uffizi, Horne 5943 (16th century drawing of sarcophagi at SS. Cosma and Damiano): 110, 142, 145; *110a*
17th century: 10, 166

Florence, Sotheby, Parke Bernet
late 16th century: 9

Haarlem, Teyler Mus.
32; *32b*

Holkham *see* Holkham Album

London, BM, Dept. of Greek and Roman Antiquities (*see* Pozzo Albums)
Early 16th century: 27, 160

London, BM, Dept. of Prints and Drawings
15th century: 89, 99
16th century: 28, 90, 97, 132, 146, 179 (Paduan c. 1500)

London, Society of Antiquaries *see* Carpio Album

London, V & A, Dept. of Prints and Drawings
Lit. Cat. Ward-Jackson, 1979.
82

London, Private Collection
72; *72a*

Lyons, Mus. B–A
83

Madrid, BN
late 16th century: 8, (17)

Madrid, Prado
late 15th century *see* Florentine anon. drawings (cf. 63), 109; *109a*
16th century: 145

Milan, Bibl. Ambr.
52B (Tuscan 15th century), 137 (Venetian 16th century); *52B–a*

Italian drawings (continued)

Munich, SGS
15th century: 60 (formerly attrib. to Federighi); *60a*
mid 16th century: 83; *83a*

New York, MMA
77 (Lehmann Collection), 165

New York, Pierpont Morgan Lib.
15th century: 65, 125 *see also* Umbrian School

Oxford, Ashmolean *see* 'Raphael School'

Oxford, Christ Church
Lit. Cat. Byam Shaw, 1976 *see* Florentine and Roman anon.

Paris, BN
170A (Paduan MS, c.1470–80)

Paris, École B–A
100

Paris, de Hévesy Collection (in 1931)
3

Paris, Louvre
65AB, 70, 122, 145, 146 (as 'Murillo), 190, 197 *see also* Central Italian, 1420–30; Florentine, and Venetian

Perugia, Accad.
198 (17th Century)

Princeton, Univ. Mus.
76 (Perino?), 146, 185 (Central Italian); *146*

Rhode Island, Private Collection in 1957
76

Swarthmore PA., Swarthmore College
56 (unpublished, no reference)

Vienna, Albertina
1 (18th century), 17 (after Giulio Romano), 95; *95a*

Windsor
16th century: 82, 159, 199
17th century *see* Pozzo Windsor Albums

Jacques, Pierre (d. 1596)
Sculptor from Reims; visited Rome 1572–7.
'Album', 1572–7. Paris, BN, Codex Remensis. The so-called Album is in fact a sketchbook. *Lit.* *Reinach, 1902.
5, 8, 19, 43, 44, 47, 49, (63), (100), 126, 134, 180; *19a*

Juvarra, Filippo (1678–1736)
Sicilian Baroque architect in Piedmont.
(125)

Kock, H. *see* **Cock**

Lafréry, Antoine [Lafreri, Antonio], (1512–77)
Born in the Jura, and worked in Rome as a publisher of engravings of the monuments and sculpture of ancient and modern Rome by various artists among them Beatrizet, Bonasone, the Scultori ('Ghisi') and Vico. From about the mid 16th century, collectors selected

Lafréry (continued)
prints to be bound, so each volume was unique. From the 1570s the volumes were entitled *Speculum Romanae Magnificentiae* with the title page made by Dupérac (c.1573–77). After Lafréry's death, volumes of the *Speculum* continued to be compiled with prints published by his successors, Stefano and Claudio Duchetti, Nicolaus van Aelst and others who added many more plates to those of the 107 monuments of Rome catalogued by Lafréry in 1573. Prints in various states were also included from the books of engravings by Cavalieri and his followers so that later *Speculum* compilations could include many hundreds of examples from a variety of sources. *Lit.* Hülsen, 1921; Quaritch, 1926; Lowry, 1952; McGinniss, 1976. *See also* Salamanca (another publisher).
24, 28, 64, 65AB, 66, 67, 74, (90), 92, 122, 125, 129, 131, 155, 158, 159, 167, 174, 176, 178, 181, 184, 185, 187, 190, 193, (202), 203; *64a, 90d, 155a*

Lasinio figlio, Giovanni Paolo (1780–1885)
see Bibliography: Lasinio, 1814
91; *91b*

Laurana, Luciano (1420/5–1479)
Dalmatian architect, trained in Venice, worked in Urbino 1464–72.
(52A), 186

Legros, Pierre, The Younger (1666–1719)
French sculptor who spent most of his working life in Rome.
(166)

Leonardo da Vinci (1452–1519)
1513–c.1519 in Rome.
p.38, (27), (28), 79, (99), 123, (201); *99a*

Leoni, Leone (1509–90)
Lombard sculptor and medallist *see* **Primaticcio**

Leopardi, Alessandro (active after 1482–1522/6)
Venetian sculptor.
(100)

Licinio, Bernardino (c.1489–c.1560)
Painter from Bergamo, active in Venice.
(132)

Ligorio, Pirro (1513–83)
Neapolitan architect, archaeologist, painter, antiquarian author of vast quantities of unpublished, illustrated studies of Roman antiquities and classical mythology. In Rome c.1534–69, 1570 and 1573. *See* Codex Ursinianus.
Codex, Naples, BN, MS XIII.B.7. *Lit.* *Mandowsky and Mitchell, 1963 (with list of his other MSS, pp.35–40).
p.85, 46, p.86, 47 135, (138)
Other drawings:
19 (Naples), p.92, Oxford, 83 (attrib., Florence), 158 (London), 195 (Turin)

Ligorio (continued)
Other works:
(75)
See also General Index, Ligorio, Pirro: Writings

Lippi, Fra Filippo (c. 1406–69)
Florentine painter.
125 (studio)

Lippi, Filippino (1457/8–1504)
To Rome in 1488 where according to Cellini (1949, p.20) he made several books of drawings 'from the best antiquities of Rome'.
p.36; (28 attrib.), 38, (50), (65B), 142 (studio), 145, 176

Lombard, Lambert (1506–66)
Flemish painter. In Rome 1535–8.
Album, Liège, Mus. de l'Art Wallon. Forthcoming edition by G.Denhaene. The drawings, over 500, which had been pasted in an album, have now been renumbered separately. Our references are to the new numbers and not to the old folio numbers of the disbanded album.
27, 36, 39, (73), 80, 83, 85, (120), 122, 134, 170B, 189

'Lombard Sketchbook' *see* **Cesare da Sesto**

Lorch (Lorichs, Lorck), Melchior (c. 1527–after 1583)
In Rome, 1551. *Lit.* Michaelis, 1892, *JdI*, pp.82–92.
63, 132

Lorenzetti, Ambrogio (active 1319–48)
Sienese painter.
p.59

'Lorenzetto' [Lorenzo Lotti] (1490–1541)
Florentine sculptor. In Rome with Raphael, 1519–20; again in Rome from 1523 onwards. Restored antique statues for Cardinal Andrea della Valle.
Lit. Vasari–Milanesi, 1906, IV, pp.579–80.
(13), 59A, 128; *59A–a*

Loschi, Bernardino (c. 1460–1540)
Painter from Parma.
(30)

Lotto, Lorenzo (c. 1480–1556)
Venetian painter, active in the Marches and Bergamo.
137

Luzio Romano [Luzio Luzzi da Todi]
Painter and stucco worker, pupil of Perino del Vaga. Active in Rome c. 1548–66.
83 (attrib.)

Maderno, Stefano (1576–1636)
Sculptor working in Rome. Restored antiques and made terracotta and bronze statuettes.
(152?)

Manet, Eduard (1832–83)
French painter, contemporary of Impressionists.
(119 after Marcantonio Raimondi)

Mantegna, Andrea (1430/1–1506)
Paduan painter, working in Mantua from 1459, in Rome 1489–90.
p.32, p.34, p.41 n.9; (23), p.86, (50), (59A), (76), (100), 125, (137), 158 (attrib.), 188 (wrong attrib.), (193), 198 (attrib.); *59A–b, 125b, 158c(?)*

Mantegna School
70, 83 (former attrib.), 100 (former attrib.), 137
see also Zichy, Codex

Mantegna School (attrib.), second half of
15th century
'Mantegna Sketchbook', Berlin, Staatl. Mus. Preussischer Kulturbesitz, Kunstbibl., OZ 111. Mostly architectural drawings, unpublished, see Martindale, 1979, p.149. Some of the drawings seem to be of the first third of the 16th century:
3, 75

Mantuan, 15th century
80 (Berlin)

Maratta, Carlo (1625–1713)
Classicizing Marchigian Baroque painter in Rome.
173 (wrong attrib.), 199 (wrong attrib.)

Marcanova Codex, Modena *see* **Feliciano, Felice**

Marcantonio *see* **Raimondi**

Marco da Ravenna *see* **Dente, Marco**

Martini *see* **Francesco di Giorgio**

Masaccio (1401–28)
Florentine painter of the early Renaissance. In Rome during the 1420s.
(203)

Masaccio–Masolino
(Masolino, c. 1400–1440(?) or 1447(?). Tuscan artist, worked in Rome and Florence with Masaccio c. 1420–8).
201

Master L. D.
Previously identified with Leon Davent or L. Thiry, see *Illustrated Bartsch*, 1979, vol. 33 as 'Davent'. See also Zerner, 1969, as 'L. D.'
142

Master of the Barberini Panels (mid 15th century)
Lit. Christiansen, 1979, for attribution to Giovanni Corradini of Urbino, called Fra Carnevale (active 1445 to 84).
69; *69b*

Master of 1515 *see* **Bambaia**

Master of the Die [Dè, Wurfel, Dado] (active c. 1530s)
Engraver. Bartsch, XV.
(33), p.126, (95), (110), (147)

Master of the Prodigal Son (Flemish painter, active c. 1535–c. 1560)
174

Master of the Putti (active 1469–73)
Venetian miniaturist. *Lit.* ★Armstrong, 1981.
 100

'Maturino'
An unidentified artist to whom mid 16th century
Italian drawings are sometimes wrongly attributed,
according to J. A. Gere.
 58 (former attrib.), 125, 129

Mazzolino, Ludovico (c. 1480–c. 1528)
Ferrarese painter
 81

Mazzoni, Giulio (1525?–1618)
Lombard sculptor. Decorated Pal. Spada, Rome,
c. 1556–60.
 (146)

Michelangelo Buonarroti (1475–1564)
First in Rome in 1496. Established in Rome 1534–64.
 p. 37; (5), (27), (28), p. 72, 32 (wrong attrib.), 33
(attrib.), (35), (51), (53), (56), (65), 94, (110), (111),
(116), (122), (123), (125, *Lit.*), (132), (135), (137), (139),
(155), (176), (185); 5c (copy?), 27d, 111a

Michelangelo Circle or School
 31, (132), (159), (185), (200)

'Michele di Giovanni di Bartolo'
Florentine sculptor. *Lit.* Degenhart, 1950. *See also*
'Central Italian c. 1420–30'.
 83 (attrib.)

Michelozzo, Michelozzi (1396–1472)
Florentine architect.
 p. 24

Milanese or Bolognese, end of 15th century
 Berlin, Kupferstichkabinett: 185, 197; 185a

Mocetto, Girolamo (1454/58–c. 1531)
Brescian painter and engraver, pupil of Giovanni
Bellini.
 101 (attrib.), 190 (attrib.); 101a

'Moderno'
North Italian plaquette artist active in the late 15th
and early 16th centuries.
 (158)

Mohammed al-Khayyam
Persian artist, active early 15th century. *Lit.* Blanck,
1964.
 68 (attrib.)

Montano, G. B. (1534–1621)
Milanese architect working in Rome.
 Architectural Sketchbook, London, Soane Mus.
 G. B. Soria in 1624–36 published four books of
engravings after architectural drawings by Mon-
tano. These are the drawings which were in the col-
lection of Cassiano dal Pozzo, now in the Soane
Mus. (Ashby, 1920, p. 133, n. 1). *Lit.* Zander, 1958,
1962.
 134

Montorsoli, Giovanni Angelo (1507?–1563)
Florentine sculptor. Restored antique sculpture in
Vatican Belvedere 1532–3.
 (28), 122 (attrib.), (131)

Murillo, Bartolome Esteban (1617–82)
Spanish painter.
 146 (attrib.)

Muziano, Girolamo (1532–92)
Trained in Veneto, painted in Rome from 1549.
 159

Naldini, Giovambattista (c. 1537–91)
Florentine painter, pupil of Pontormo, and later of
Vasari.
To Rome c. 1560 where he made a sketchbook now
dispersed. *Lit.* Barocchi, 1965.
 83, 85, 92, 126, 173; 85a, 92c

Neroccio de' Landi (1447–1500)
Sienese painter.
 p. 41 n. 6; 78

Nerone, Bartolommeo (Sienese, 1500?–1571/3)
The two drawings in New York, MMA, have old in-
scription *'Cherubino Alberti Scuola'* but are thought by
P. Pouncey to be possibly by Nerone (as inscribed on
mount, 5 Feb. 1958).
 (181), (182)

Netherlandish or Flemish anonymous drawings
 Basel, Kunstmus. *see* Frans Floris Workshop
 Cambridge, England *see* Cambridge Sketchbook
 Munich, SGS:
 (13, 16th century)
 Oxford, Christ Church
 92
 Rome, Gab. Naz. delle Stampe
 174

Nicoletto Robetto da Modena (active 1500–12)
Engraver. In Rome 1507. *Lit.* Hind, 1948, V, pp. 107–13;
Bartsch, XIII, 2; *Illustrated Bartsch*, 1980, Vol. 25.
 176

Niccolò Fiorentino *see* **Spinelli**

Nocchieri, Francesco Maria
Pupil of Bernini, active in Rome in 17th century.
 40

North Italian bronzes *see* **Italian Bronzes:**
plaquettes; statuettes; Paduan; Venetian

North Italian drawings
 Bayonne, Mus. Bonnat
 1 (detail)
 Bergamo, Accad.
 177
 Berlin, Kupferstichkabinett
 126, 158; 126b

North Italian drawings (continued)
Cambridge, Fitzwilliam Mus.
83 (late 15th century)
Cambridge, Mass., Fogg Mus.
101 (early 16th century, Mocetto?)
Dresden, Kupferstichkabinett
83
London, BM
28, 97; *97a*
London, Private Collection
165
Milan, Ambrosiana
Fig. 14
New York, Pierpont Morgan Lib.
65B, 125 (former attrib. *see also* Umbrian)

North Italian Sketchbook, c. 1450
(formerly 'Libro di Giusto')
Wrongly attributed to a 14th century painter, Giusto
dei Menabuoi. Rome, Gab. Naz. delle Stampe (mid
15th century drawings including *uomini famosi all'anti-
ca*, liberal arts, virtues and vices. Among them are two
drawings after the antique: a satyr from a neo-Attic
Bacchic relief and a section of the Trajanic battle frieze
from the Arch of Constantine). *Lit.* ★Venturi, 1902, as
by Giusto; Scheller, 1963, pp.202–6 (description and
discussion of date c. 1450); Micheletti, 1954, (as anon.,
c. 1440–50)
158

Paduan School (anonymous)
London, BM
179 (c. 1500)
Paris, BN, Anon. MS. Late 15th century
170A

Paduan bronzes (anonymous)
Berlin-Dahlem, Skulpturgal.
18, 20
London, V&A
177
Munich
177
Private Collection
18

Paduan drawings
London, BM, c. 1500
179
Ottawa, NG
70
Rome, Gab. Naz. delle Stampe, mid 15th century
158 *see also* North Italian Sketchbook, c. 1440 (for-
merly 'Libro di Giusto')

Paolino da Venezia, Fra (c. 1270/74–1344)
Cartographer.
176

Parmigianino [Francesco Mazzola] (1503–40)
In Rome, 1524–27. *Lit.* ★Popham, 1971 (Drawings).
10, (31), 36 (attrib.), 122 (attrib.), (125), (198), 203

Passarotti, Bartolomeo (1529–92)
Bolognese painter and engraver, in Rome c. 1551–
c. 1565.
36 (attrib.), 71 (attrib.), 132 (attrib.); *71a*

Penni, Giovanni Francesco ['Il Fattore'] (1496?–1536?)
Collaborated with Raphael and 1520–24 with Giulio
Romano. Suggested as a possible draughtsman of the
Fossombrone Sketchbook (*see* Raphael Workshop).
(100), 177 (attrib.)

Perino del Vaga (c. 1501–47)
Florentine painter, early to Rome in Raphael's Work-
shop and Circle c. 1517–27, with interruption in
Florence. 1527 to Genoa. Rome 1536/7–1547.
76 (attrib.), 77, p.126, 109 (attrib.), 119, 126 (attrib.),
142, 146 (attrib.), (147), (149)

Perrier, François (1590–1650)
French painter, in Rome (second visit) 1635–45.
Segmenta ... Statuarum. 1638 (*see* Bibliography):
16, 32, 33, 73, 74, 75, 125, 166
Icones ... Tabularum, 1645 (reversed engravings; *see*
Bibliography):
9, 83, 103, 116, 118, 158, 161, 162, 163, 167, 173, 182,
191, 196, 198; *158a, 158d, 182d, 182e*

Perugino [Pietro Vannucci] (1445–1523)
Umbrian painter.
(182)

Peruzzi, Baldassare (1481–1536)
Sienese architect and painter. Worked with Raphael
in Rome.
7 (attrib.), (35), (38), (39), (43), (46), (59B), 66, 86, (125),
(149), 158 (attrib.), (159), 167 (by a follower), 178,
182, 199; *43a, 66a, 158b*

Peruzzi, Giovanni Sallustio (active 1555–73)
Sienese architect *see also* 'Peruzzi' Sketchbook, Siena.
(24)

'Peruzzi' Sketchbook
Siena, Bibl. Comunale, Cod. S.IV.7
Copies by several hands, among them Sallustio
Peruzzi's (q.v.). *Lit.* Toca, 1971 (analysis of hands,
some folios illustrated); ★facsimile, Peruzzi, 1981.
5, 47, 110, 125, 165, 193

Piero della Francesca (1416?–1492)
Painter from Borgo San Sepolcro, in Rome 1459.
(177), (203)

Piero di Cosimo (1462–1521)
Florentine painter.
p. 82, (68)

Pietro da Barga (second half of 16th century)
Florentine sculptor of small bronzes. In 1576 in Rome
he copied famous antique statues for Cardinal Ferdi-
nando de Medici. These statuettes are now in Florence,
Mus. Naz. (Bargello). *Lit.* ★de Nicola, 1916. *Burlington.*
10, 73, 74, 75, 131

'Pietro da Cortona' Sketchbook *see* **Cortona**

Pighianus, Codex, c. 1550
Berlin, Staatsbibl. Preussischer Kulturbesitz, Lib. Pict. A.61. Since going to press, we have learned that the folios have been renumbered after f. 77. Our references are to the old folio and cat. numbers as given by Jahn, 1868.
See Pighius and cf. Coburgensis, Codex.
5, 21, 25, 27, p. 73, 29, 37, 38, 43, 45, 47, 49, p. 91, 56, 57, (60), 84, 89, (90), 106, 107, 110, 113, 116, 119, 126, (129), 134, 136, (137), 138, 141, 146, 163, 175, 191, 196; *5, 43, 57a, 106a, 136a*

Pighius, Stephanus Vinandus (1520–1604)
Netherlandish antiquary, in Rome c. 1549–57.
Lit. Mandowsky and Mitchell, 1963, ch. III; Maedebach, 1970, pp. 20–2.
See Coburgensis, Codex and Pighianus, Codex.
The drawings in these codices were made by various anonymous hands, but the prevailing one is accurate in recording the exact state of the antique reliefs without attempting to supply the missing parts. Neither Codex is completely preserved. The Cod. Pighianus may or may not depend on the Cod. Coburgensis. There is an overlap of 136 pieces by the same hand in both codices. The subjects drawn are mostly sarcophagus reliefs, funerary cippi and altars.

Pinturicchio [Bernardino Betti] (c. 1454–1513)
Umbrian painter, probably first in Rome 1481–2; 1492–5?
p. 38; 65B, (85), 102, (182)

Piranesi, Giovanni Battista (1720–78)
Venetian engraver, in Rome from 1740.
57, 125

Pisanello [Antonio Pisano] (1395?–1455/6)
Veronese painter and medallist working in International Gothic Style. In Rome 1431–2. *Lit.* *Fossi-Todorow, 1966, *see also* Gentile da Fabriano; Pisanello Workshop.
p. 39; 21, 65A, 86 (attrib.), p. 155, 125, (137), 138, 142, (144), (161 attrib.), p. 211; *Fig. 3.*

Pisanello Workshop (c. 1440s)
Mantua. *See also* Central Italian c. 1420–30 (formerly attributed to Michele di Giovanni di Bartolo), Gentile da Fabriano, and Pisanello.
Lit. Degenhart, intro. to Schmitt, 1966; *Fossi Todorow, 1966, pp. 47–8 and included in cats. 166–208 where drawings attributed to the above artists are grouped as Pisanello Workshop, based on a travel sketchbook ('taccuino di viaggio') begun by Gentile da Fabriano and inherited and continued by Pisanello. But *see* Christiansen, 1982, cat. LXVII.
p. 35; 86, 106, 110; *86a*

Pisano, Giovanni (c. 1245/50–c. 1314)
Pisan sculptor, son of Nicola.
(87), (125)

Pisano, Nicola (c. 1210?–1284?)
Lit. Seidel, 1975.
p. 31; (87), (91), (104), (111), (157, school), (179)

Plaquettes *see* **Italian Bronzes**

Polidoro da Caravaggio (1490/1500–43?) *see also* **Galestruzzi**
Began his career in Raphael's Workshop in the Loggie.
p. 42 n. 18; 9 (after Polidoro), 59A, 81 (attrib.), 83 (former attrib.), (107), (147), (158), (159), 163, 190 (attrib.), 191 (attrib.); *191a; Fig. 12*

Pollaiuolo, Antonio (c. 1432–98)
Florentine painter and sculptor of small bronzes.
p. 35, p. 41 n. 6; 30 (four bronzes in Florence, Mus. Naz.; old attrib.), 87 (after P.), (184); *30; Fig. 4*

Pollaiuolo, Simone *see* **Cronaca**

Pontormo, [Jacopo Carrucci] (1494–1557)
Florentine painter.
(60)

'Pontormo' Sketchbook *see* **Zucchi**

Porta, Giacomo della (1533?–1602)
Architect in Rome.
(64)

Porta, Giuseppe della [Salviati] (c. 1520–c. 1577)
Florentine painter active mostly in Venice and Rome.
165

Porta, Guglielmo della (active in Rome 1537–77)
Lombard sculptor, worked for Farnese in Rome.
see Appendix II, p. 478

Poussin, Nicolas (1594–1665)
French painter, working mainly in Rome from 1624.
(10), (106?), (110), (116 *see* 106), 117, 197 (Studio)

Pozzo, Cassiano dal (1588–1657)
Born in Turin, educated in Pisa. In Rome from 1611. Antiquarian scholar with interests in sciences and art. In his '*Museum Chartaceum*' (paper museum), compiled during the second quarter of the 17th century, he assembled drawings and engravings by earlier artists and by a team of young draughtsman, which recorded antique funerary and historical reliefs and artefacts throughout Rome which 'were the fragmentary clues to a vanished world whose values were of the greatest intrinsic interest' (Haskell, 1963, p. 101). Originally bound in 23 volumes, the drawings were arranged according to subject, and were available to contemporary artists for their own work and to scholars.
Among the artists, mostly anonymous, who drew antique reliefs for Cassiano were Pietro Testa; and possibly Pietro da Cortona. Most of the surviving drawings came to England in 1762 when George III acquired them from the Albani. *Lit.* Vermeule, 1956.
See Pozzo Florence, Uffizi; Pozzo London BM; Pozzo Windsor

Pozzo Florence, Uffizi, Architettura 6975–7135A
Anonymous Sketchbook of antiquities probably compiled for Cassiano dal Pozzo in the second quarter of the 17th century. *Lit.* Conti, 1974–5; 1983.
189 (Testa q.v.)

Pozzo London BM
Two Franks Albums in Dept. of Greek and Roman Antiquities. *Lit.* Vermeule, 1960 partly illustrated complete inventory of both BM Albums: Vol. I.
Sarcophagus reliefs:
8, 25, 27, 43, 44, 53, 80, 86, 107, 111, 115, 116, 117, 119, 120, 134, 142, 160, 191, 196, 197; *27c, 53a, 160a*
Vol. II. Funerary reliefs, misc. antiquities:
46, 49, 84

Pozzo Windsor
Cassiano dal Pozzo–Albani Albums in the Royal Lib., Windsor Castle. *Lit.* Vermeule, 1966 (inventory, partly illustrated; Pozzo Windsor, Vol. X, formerly XVIII, includes 16th century drawings).
1, 9, 22, 25, 26, 33, 34, 37, 43, 44, (59A), 67, 70, 75, 77, 78, 80, 82, 85, 86, (90), 96, 99, (100), 103, 106, 113, 116, 117, 118, 119, 120, 121, 126, 134, 135, 138, 139, 140, 143, 145, 151, 153, 156, 160, 161, 162, 163, 170B, 173, 174, 178, 180, 181, 189, 191, 195, 196, 197, 198, 199; *26a*

Primaticcio, Francesco (1504–70)
Bolognese painter and stucco sculptor at Fontainbleau from 1532. Directed Vignola to make moulds in Rome of famous antique statues which were cast in bronze with the help of Vignola 1541–3 at Fontainebleau for Francis I. In 1545 Primaticcio had more moulds made in Rome which were cast at Fontainebleau by 1549. *Lit.* Pressouyre, 1969; Boucher, 1981, for subsequent casting by Leone Leoni from the same moulds; Vasari–Milanesi, 1906, VII, p. 407.
10, 28, 66, 67, 75, 79, 122, 131

Puligo, Domenico (1475–1527)
Florentine pupil of Ridolfo Ghirlandaio.
122 (attrib.)

Pupini, Biagio [dalle Lame] (active 1511–c. 1575)
Bolognese painter. Worked in Rome in Circle of Raphael and Polidoro.
25 (attrib.), (29), (63), 99, (156), (160), 167 (attrib.?), (174)

Raffaello da Montelupo (1504/5–1566/7)
Florentine sculptor, assistant to Michelangelo.
(132 attrib.)

Raimondi, Marcantonio (c. 1480–1527/34)
Bolognese engraver first influenced by Francia. To Venice in 1506; to Rome in 1510 where he engraved designs by Raphael and his Workshop (q.v.). Among his many pupils were Marco Dente, and Agostino

Raimondi (continued)
Veneziano. *Lit.* Thode, 1881; Bartsch, XIV, 1; *Illustrated Bartsch,* 1978, Vol. 26.
15 (attrib.), 17 (attrib.), (18), (23), (25, School), 28, 31 (attrib.), 38, (43), (60), 70, (79), (83), (85), 100 (School), (119–120 'after Raphael'), 176, 182 (School), 196, 199, 203; *15a, 17a, 70a, 70b, 196a–d, 199a*

Raphael [Raffaello Sanzio] (1483–1520)
Documented in Rome from 1507, probably visited it earlier.
p. 32, p. 35, p. 38 p. 42 n. 19; (1), 7 (attrib.), (17, after Raphael), (28), (31), (35), (37), (45 after Raphael), (54), (60), (64), (68), (79), p. 126, (94), (95), (106), (109), (119), (120), (120 after Raphael), p. 151, (122), 125, (125), (126 wrong attrib.), (128), (132), 136 (after Raphael), (137 after Raphael), p. 175, (139), (145), (147, attrib.), (149, after Raphael), (150), (151), 158, (159), (175), (182), 188 (attrib.), p. 222, (198); *7a, 68b, 79b, 125a, 188a, 198b*

Raphael and Workshop, Vatican Loggie (1518–19)
see also **Giovanni da Udine.** *Lit.* *Dacos, 1977.
31, (46), 48, 59A, (60), 70, (77), (77–78), 83, (85), (90), (94), (99), (140), 145, 146, (149), (150), (178); *150a; Fig. 10*

Raphael Workshop
'Fossombrone Sketchbook' (c. 1520s? after earlier drawings) Fossombrone, Bibl. Passionei as Giulio Romano. *Lit.* Forthcoming edition by A. Nesselrath.
3, 7, 39, 59A, 83, (89), 92, (130), 134, 176, 200; *39b, 59A–c*
see also Giovanni da Udine, Giulio Romano, Marcantonio Raimondi, B. Peruzzi, G. F. Penni, Polidoro, Perino

Raphael 'Circle' or 'School' (anon. 16th century drawings traditionally but wrongly associated with Raphael)
p. 32, p. 38; (14), 15, 25, 32, 35, (43), 57, (59A), (63), 79, (89), 127, 132, (137), (139); *15b, 35a, 35b, 57b, 79c*
Engraving:
(120)

Riccio [Andrea Briosco] (c. 1470/75–c. 1532)
Paduan sculptor in bronze
(70 after Marcantonio?), 200

Rinaldo Mantovano
An assistant to Giulio Romano in Mantua. *Lit.* Hartt, 1958.
(79)

Ripanda, Jacopo (active 1490–1530)
Bolognese painter, working in Rome late 15th century to early 16th century.
1. Sketchbook attributed to Ripanda, Oxford, Ashmolean. Drawings 'restore' damaged reliefs. *Lit.* Parker, 1956, II, no. 668 (inventory); Rushton, 1976, pp. 54–7 (description as c. 1520?).
(26), 29, (38), 52B, 56, 82, 83, (90), (106), 110,

APPENDIX II: INDEX OF RENAISSANCE COLLECTIONS

This is a selective, annotated index, arranged alphabetically, of the major Renaissance collections mentioned in this book. References are to catalogue entries; italic numbers refer to the illustrations. For further information on Cinquecento collections and on 17th and 18th century private collections into which many monuments subsequently passed, see 'Collezioni archeologiche', by L.Salerno in *Enciclopedia dell'arte antica– Supplemento*, 1970, pp.242–59.

ARCHINTO, FILIPPO

The owner of a replica of the Capitoline Camillus and other antiquities, was of a Milanese family. He was persuaded into Papal service by Paul III, becoming Governor of the city of Rome in 1537. He was ultimately Archbishop of Milan from 1556 until his death in 1558. The Philadelphia Museum of Art owns a portrait of him by Titian during the period when he was Papal Nuncio in Venice, 1554–6.

192 (cf.)

ASTALLI

In a house and garden adjacent to the Piazza San Marco in Rome (recalled today in the 'Via degli Astalli'), destroyed when the Via del Plebescito was opened up from 1539, the Astalli gathered sculptures and, above all, inscriptions which figure in epigraphic compendia from the end of the Quattrocento on into the 16th century. A different branch of the family, STAGLIA, lived in Parione and are sometimes confused in the literature.

97

BARBO, PIETRO

The Cardinal of San Marco, who reigned as Pope Paul II from 1464–71, assembled an impressive collection of precious gems, coins and small bronzes at the palazzo and 'palazzetto' he built next to his titular church (the present Palazzo Venezia, so-called because of its use from the Renaissance until 1797 for the ambassadors of Venice and the Venetian cardinals of the Church of the Serenissima's patron saint). An inventory of 1457, annotated in 1460, was first published by Müntz, 1878–82, II, pp.223–65; and reprinted in part by Dacos *et al.*, 1973, pp.87–118.

Pope Sixtus IV inherited much of the collection and dispersed it; many of the gems and intaglios were acquired by Lorenzo de' MEDICI, and in the 16th century a part of them passed by way of the Medici-Madama collection to the FARNESE. Twenty-three of Barbo's gems are now in the Museo Archeologico in Naples.

On Paul II's Palazzo Venezia and collections, see Casanova Uccella, 1980 (Exh. Cat.)

68(?), 123, 168 (cf.), 172 (cf.)

BREGNO, ANDREA

This Lombard sculptor, responsible for many Roman tombs from the 1460s, lived in Rione Trevi on the ascent to Monte Cavallo (the Quirinal). Epigraphic collections of the end of the Quattrocento give evidence of a substantial collection of Roman monuments owned by 'Andrea scarpellino', and dispersed after his death in 1503. See Egger, 1927.

21, 132, 194

del BUFALO

Already collectors of inscriptions and *anticaglie* at the end of the 15th century, the family had its most active member in this respect in Stefano del Bufalo. His palace and garden above the Trevi fountain, incorporating portions of the earlier COLOCCI *vigna*, boasted Parnassian frescoes by Polidoro which were keyed to several statues of Muses and other classical sculpture, as well as a Nymphaeum of *grottesche all'antica*. On the programmatic aspects, see Kultzen, 1960. Antiquities passed to the FARNESE, to the MEDICI, to the Borghese.

60 (cf.), 171

CAFFARELLI

Several members of the Caffarelli family were notable collectors of inscriptions and antiquities in the Quattrocento. Two important examples are the households of Cardinal Prospero (d.1500) at Campo di Fiore in Rome and the palazzo opposite the della Valle houses on the site of the present S.Andrea della Valle. The destroyed palazzo on the Campidoglio belongs to a much later period.

61

CAPODIFERRO, CARDINAL GIROLAMO: see GUISA

CARPI

The most extensive and antiquarian among Roman collections of the 16th century belonged to Rodolfo Pio da Carpi (1500–64), who was created a Cardinal in 1537 by Pope Paul III. Small sculptures, portraits, every variety of *objet* from precious gems, gold, silver and crystal to implements of bronze, antique as well as

modern, were housed in his studio and library at the palazzo he rented from the Pallavicini in Campo Marzio in 1547 (for a decade earlier he had lived in the Palazzo Cardelli which is today the Palazzo di Firenze). Inscriptions, more portraits, funerary or votive monuments, and large-scale sculpture were displayed at a villa on Monte Cavallo that Aldrovandi deemed 'an earthly paradise'. This *vigna* was set out and ornamented according to a programme of specific *concetti*. Following the Cardinal's death, the villa passed briefly to the Cardinal Giulio della ROVERE from Urbino, then to the Sforza; Cardinal Ippolito d'ESTE acquired some sculptures (now in Modena). Many works ended up in the Barberini collections, although major pieces are scattered throughout European museums. Hülsen in his *Antikengärten*, 1917, used prints and drawings from the mid and second half of the Cinquecento to illustrate his reconstruction of the *vigna*.

19, 94(?), 130, 135

CESI

The Cesi were a Roman family, who provided two cardinals in the Cinquecento; they possessed a carefully planned and thematically coordinated sculpture garden at their villa in the Borgo on the northern edge of the Janiculum near St. Peter's (the palace, on the Via S. Uffizio, 25, was destroyed in 1938). Cardinal Paolo Emilio Cesi (became cardinal in 1517 and died

in 1537) was responsible for its foundation, amassing hundreds of funerary monuments–particularly of the *gens* Caesia–portraits and statues; the collection continued to be developed by his brother, Federico, who became a cardinal in 1544 and died in 1565, and by Pierdonato in the next generation. Dispersal from the 17th century permitted works to find their way into the Ludovisi gallery, into the Capitoline collections, and to the Villa Albani, among others. A view of the villa complex in the late 16th century, by Hendrick van Cleef (van der Meulen, 1974), together with Hülsen's *Antikengärten*, 1917, permit reconstruction of the installation.

6, 8, 47, 49, 51 (cf.), 74 (cf.), 92, 202; *ill. below*

CEVOLI (CEULI, CEOLI), TIBERIO

This wealthy banker of a Pisan family founded a collection in the third quarter of the 16th century at his residence on the Via Giulia in Rome, the present Palazzo Sacchetti. Engravers of the end of the century reproduced statues from it, many of which passed to the Borghese in the 17th century. See de Lachenal, 1982.

22, 72 (cf.)

CHIGI

Agostino Chigi 'the Magnificent', came from a noble Sienese family. He was an international financier, and banker to Julius II, who made him a member of his

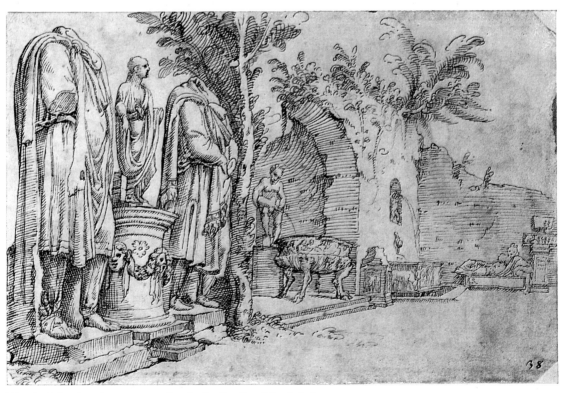

The Cesi Garden, Rome. Heemskerck, Berlin Sketchbook I, f. 25

family. In his Transtiberine villa by Peruzzi, antique sculpture was integrated with comprehensive fresco schemes worked out by leading artists of the decades from 1505–20. Chigi died in 1520, like his intimate, Raphael, who had led the decoration of what came to be called the Farnesina, as the villa was gradually annexed (first through rental, then by outright purchase) to the adjacent Farnese *vigna*. In the course of the 16th century, as profligate heirs sold off whatever was movable, many sculptures passed to the FARNESE, but also to Cardinal Ippolito II d'ESTE and to the trade with France.

74 (cf.), 95

CIAMPOLINI, GIOVANNI

One of the principal *antiquarii* of Quattrocento Rome, this friend of Poliziano owned an impressive collection of ancient inscriptions and sculpture in his house in the Ghetto area, near the Porticus Octaviae. Following his death in 1518, Ciampolini's executors sold many of the sculptures to Giulio Romano and they have entered the ducal collections in Mantua. (See GONZAGA.)

1, 12?, 15 (cf.), 76, 154

COLOCCI, ANGELO

This neo-Latin poet and learned antiquarian who headed the Roman Academy after the death of Pomponius Laetus, held many positions in the Curia before being designated Bishop of Nocera in 1537. Angelo's house and study in Parione contained a working collection of antiquites, while his famous *vigne*, which retreats above the Fontana Trevi and S. Maria in Via, incorporated many of his larger sculptures. See Fanelli, 1962, and, on the context of a fountain-nymph installation, Bober, 1977.

101

COLONNA

Descended from the Counts of Tuscolo, this Roman family–famous for having brought the eponymous Column of Christ's Flagellation from the Holy Land to S. Prassede in the early 13th century–was among the first to be concerned with antiquarian matters. After the return of the Colonna Pope Martin V to Rome in 1420, their old Roman house on the slopes of the Quirinal beneath the ruins of Aurelian's Temple of Serapis ('Frontispitio Neronis'), as well as a new palazzo flanking SS. Apostoli, were enriched by a series of collectors. An early archaeological enthusiast was Cardinal Prospero (d. 1463), friend and patron of Flavio Biondo, sponsor of Alberti's scheme to raise ancient Roman ships sunk in the depths of Lake Nemi and of excavations in the 'Temple of the Sun' looming above the family gardens.

26 (cf.), 27, 60, 63(?), 102(?), 130(?), 132, 165; *165a*

d'ESTE:

CARDINAL IPPOLITO II d'ESTE (1509–72),

became, like his aunt Isabella in Mantua, an ardent collector of ancient sculpture, although with more grandiose, less private intellectual concerns. After his hopes to succeed Pope Paul III were dashed in 1549, he devoted himself to developing a *vigna* on the Quirinal and his villa at Tivoli–with the advice of the French humanist, Marc-Antoine de Muret, as well as Pirro Ligorio. It was Ligorio in particular who absorbed restored antique statues into vast iconographical programmes of landscape architecture.

13, 17, 50, (72?), 94(?), 95, 133, 138

ISABELLA D'ESTE (1474–1539) married Francesco Gonzaga in 1490. Soon after her marriage, she began to collect antiquities destined mainly for her Grotta in the Palazzo Ducale, Mantua, which was finished in 1508. She continued throughout her life to add to this collection which was inherited by her son Federigo (see GONZAGA) and remained intact throughout the 16th century. Indeed, some of it can still be traced. It included cameos and intaglios, medallions, marble reliefs and statues, and of the forty-eight antique and modern bronze statuettes, some were copies of famous statues, cast for her after 1519 by Antico (see Appendix I: Antico). Isabella came to Rome in 1514–15 and again 1525–7, visiting the papal and private collections. Her agents throughout Italy and even in Greece kept her informed of available antique works of art and made acquisitions for her.

See Brown, 1976, with documents; Chambers and Martineau, 1981, pp. 51–63 (Fletcher), cats. 116–24 and *passim*.

9 (cf.), 18(?), 51 (cf.), 203 (cf.)

FARNESE

One of the most spectacular among Cinquecento museums of antiquity resulted not from a long history of family accumulation, but from outright purchase of earlier collections (from Agostino CHIGI, the ROSSI, the COLONNA, the SASSI, the BUFALI, *inter alia*), as well as from excavations at the Baths of Caracalla during the 1540s. The Farnese came to prominence in Rome with the creation of twenty-five-year-old Alessandro as a Cardinal in 1493. A disciple of Pomponius Laetus, he began to transform and to acquire antiquities for a house purchased in Arenula on the via Recta (Via della Regola) in 1495. By 1517 Antonio Sangallo was employed to rebuild this into the present palazzo, thoroughly modified in a new programme under Michelangelo's direction after Alessandro's election as Pope Paul III in 1534. Following the death of the Pope in 1549, his grandsons carried on the embellishment of the palace with works of art and antiquities; meanwhile Margarita of Austria's marriage to Ottavio Farnese in 1538 had brought into nominal Farnese

possession the sculptures of the Palazzo MEDICI-MADAMA as well as the rich antiquarian adornment of the Villa Madama, Pope Clement VII's villa on Monte Mario.

10 (cf.), 18 (cf.), 31, 35 (cf.), 36, 57, 68, 70, 74 (cf.), 90 (cf.), 95, 127, 128, 130 (cf.), 165, 188

FRANGIPANE

A pre-eminent family of medieval Rome, which traced its noble lineage back to the late Roman Empire, had diversified by the Quattrocento into several branches ensconced in *palazzi* and *vigne* in many regions of the city (Campitelli, Monti, Pigna, Trevi). The most important collections of inscriptions and sculptures were features of the ancestral home near S. Marco owned in the Cinquecento by Curzio and his brother, Mario (a Commissioner of Antiquities); another toward the Aqua Vergine, behind S. Maria in Via (the residence of Girolamo in Aldrovandi's day); and a *vigna* and *domus* at the 'Palazzo Maggiore' on the far slope of the Palatine. Excavations at the latter site, documented for the second decade of the 16th century, augmented inscriptions and statuary cited by early epigraphers, Albertini, and the 'Prospettivo Milanese'.

120(?), 190 (cf.)

GADDI, GIOVANNI

This prelate (d. 1542), dean of the Apostolic Camera, enters the history of antiquarian collecting because Vasari tells us he purchased the ancient sculptures once owned by Ghiberti (Vasari–Milanesi, 1906, II, p. 245). Gaddi's Roman palace was in the Rione Arenula on the Via Giulia, not far from the Palazzo Farnese (from which Costanza Farnese moved in 1542 to rent space from the Gaddi). See also GARIMBERTI.

94

GALLI

The family Galli of Parione included Giovanni Gallo, who owned many inscriptions copied by Fra Giocondo and presumably founded the sculpture collection in the Quattrocento; there was Giuliano and his son, and the banker Jacopo whose patronage added young Michelangelo's *all'antica* renderings of Apollo, Cupid and Bacchus to the statuary. Their residence lay on the Via dei Leutari in Rome just to the north of the Cancelleria (Cardinal Riario's Palazzo San Giorgio, q.v.). Drawings by Heemskerck document the installation of their garden from which works were already being dispersed.

9 (cf.), 24, 62; *62a, ill. on p. 475*

GARIMBERTI, GIROLAMO

Bishop of Gallese, living in apartments in the Roman palazzo of Giovanni Gaddi in the Via Giulia, was visited by Aldrovandi. His collections were subsequently enlarged by acquisitions from earlier Cinquecento collectors, including those of Cardinal CARPI. Clifford Brown is preparing a study of Garimberti's antiquities as well as his antiquarian service in the interests of Cesare GONZAGA.

58 (cf.)

GHIBERTI, LORENZO

Like many Renaissance artists, Ghiberti acquired a small collection of ancient marble and bronze sculpture, including torsi and fragments, valued at 1500 florins at the time of his death in 1455. A number of its most valuable pieces were acquired by Giovanni GADDI from Ghiberti's heirs, including the 'Letto' attributed to the hand of Polyclitus that was ultimately purchased by Emperor Rudolph II. A reconstruction of Ghiberti's collection with putative identification of its chief ornaments appeared in J. von Schlosser (1903); see also Krautheimer, 1956, I, p. 305; II, p. 339.

94, 98 (cf.)

GONZAGA

Ludovico Gonzaga (1412–72) is better known for his patronage of artists devoted to Antiquity than for his collection of antique sculpture, which he seems to have acquired through an intermediary, the goldsmith Cristoforo di Geremia. Ludovico's son, Francesco (1444–83) created a Cardinal by Pius II in 1461, was known to have a collection of gems, bronzes and vases in his Roman palace; his brother Federigo inherited the bronzes, while Lorenzo de' MEDICI acquired his cameos and intaglios (Weiss, 1969, pp. 189–96).

The Gonzaga collection, of which a part still remains in the Palazzo Ducale in Mantua, owes much to the efforts of Isabella d'ESTE, who married Ludovico's grandson, Francesco (1466–1519) in 1490. Her son, Federigo, the first Duke (1500–40), was also an avid collector; in 1524 Giulio Romano brought to him from Rome the antique sculpture he had acquired from Giovanni CIAMPOLINI.

Some of the antique statues and reliefs were displayed in the Loggia de' Marmi, which Giulio Romano installed in the palace for Federigo in c. 1538–9; it was extended in 1572. The long Galleria della Mostra was also built c. 1592–1608 for antique sculpture, although it is not known which pieces were displayed in it. Other antique sculpture was acquired for the Galleria delle Antichità in Sabbioneta, the 'Little Athens' of Vespasiano Gonzaga (1531–91) and for Duke Fernando's Villa Favorita built in the early 17th century.

In 1627–8 a large number of paintings and antique statues and busts from the Gonzaga collections were purchased by King Charles I (18; cf. 51; Appendix I: Whitehall Gardens, Album of Busts and Statues). See Scott-Elliott, 1959; Chambers and Martineau, 1981,

p.193 (Burckhardt on Loggia de'Marmi); *ibid.*, pp.229 and 241 (Chambers on La Galleria della Mostra and the Villa La Favorita); A. Levi, 1931.

12, 18, 21, 51 (cf.), 110 (cf.), 122 (cf.), 154, 197 (cf.)

GRANVELLE: see PERRENOT DE GRANVELLE

GRIFONETTI (GRIFFONI)

This collection was assembled by a notary of Florentine origin at the end of the Quattrocento. Except for inscriptions cited by Fra Giocondo and the female 'statue' drawn in the Codex Escurialensis, not much is known of it. The family residence was in Trevi at the foot of the Quirinal.

169

GRIMANI, DOMENICO

At his Palazzo San Marco (Venezia) in Rome, as well as in a *vigna* on the Quirinal, the Cardinal collected statues, inscriptions and other antiquities. Although he donated the major sculptures to Venice at his death in 1523, his nephew Cardinal Marino Grimani inherited bronze statuettes, medals and gems, while some marbles seen by Aldrovandi at the Palazzo in mid century were presumably remnants of a collection which had astounded the Venetian ambassadors visiting in 1505 (Sanuto, 1881, cols.171–5).

35 (cf.), 89, 106 (cf.), 122 (cf.), 143 (cf.), 147(?), 149, 190(?)

GUISA

The Nicolò Guisa whose residence was cited by Aldrovandi as the location of the Scythian Knife-grinder (**33**) in 1549 is not otherwise identified. The palazzo in Rome was close by the Palazzo Farnese, and there is reason to believe that it was owned by Cardinal Capodiferro (then absent as the Pope's emissary to France), but occupied by a member of the great French house of Guise, and an adherent of Francis I, the Duke of Melfi (explaining a French coat-of-arms among the stuccoes of the Palazzo Spada-Capodiferro that has puzzled architectural historians). The Mignanelli lived in this palace in the late 16th century, and it was they who sold the 'Arrotino' to the MEDICI. Corroborating evidence is found in Renaissance sources which refer to a statue, owned by CAPODIFERRO, representing the augur, Attius Navius, with his knife on the miraculous whetstone.

33

Jacopo Gallo's Garden (lower part), Rome, with Michelangelo's Bacchus.
Heemskerck, Berlin Sketchbook I, f.72

LISCA, FRANCESCO

This wealthy Milanese merchant, in the 1530s, developed a collection of statues and epigraphic material in his house in the Via del Governo Vecchio, Rome. By the second half of the 16th century, many of the antiquities described by Aldrovandi had passed into the hands of Bishop GARIMBERTI. On the collection, see Bober, 1967.

58 (cf.)

MAFFEI

Members of this distinguished family, with branches in Verona and Volterra, enter the history of Roman collecting in the period of Sixtus IV when the Pope's intimate, Benedetto Maffei (d. 1494) purchased a house in the Rione Pigna at the Arco della Ciambella among ruins of the Baths of Agrippa behind the Pantheon. This became the nucleus of a family compound corresponding to the site of the present Vicarage of Rome (Via della Pigna and Via dei Cestari). Benedetto's son, Achille (d. 1510) seems to have been the first of a number of antiquarian enthusiasts who brought together an important collection of inscriptions and sculptures. The archaeological ardour of Achille II (d. 1568), the son of Girolamo Maffei, *maestro delle strade* with Latino Giovenale dei Manetti, and Canon of St. Peter's, is well known through reports of his friends Pighius and Ligorio. A drawing by Heemskerck records in the mid 1530s the appearance of antiquities in the court of their oldest house.

63 (cf.), 73, 79, 90, 109; *ill. below*

MANILI

A collection formed in the first quarter of the 16th century in a house near S. Maria di Monserrato was owned in Aldrovandi's day by Paolo Manili, in dal Pozzo's by Gironimo. This is not to be confused with the house of Lorenzo Manilio completed in 1497 in the old Ghetto area, a major tourist attraction because of its façade displaying an entire series of ancient reliefs and inscriptions.

139

MASSIMI

This very ancient clan, claiming descent from Quintus Fabius Maximus *(gens Fabia)*, had many branches in Rome. The complex of interest in this work involves the three sons of Domenico Massimi, who was already an ardent collector of inscriptions and antique sculpture in the waning Quattrocento. Angelo, Piero and Luca divided the property after the original house was ruined in the Sack of Rome. Peruzzi's Palazzo Massimi alle Colonne on the Corso Vittorio Emmanuele, Piero's heritage, had many antiquities from the older collection as well as newly-acquired items, but the 'Pyrrhus' (24) stood in the neighbouring palace to the north owned by Angelo. This still preserves façade frescoes by Daniele da Volterra with scenes from Roman history (and that of Fabius Maximus, who was meant to be represented by the statue later dubbed 'Pyrrhus'); it is famous in the annals of printing because of the site of the first *incunabulum* produced in Rome (1467, Schweynheim and Pannartz from Mainz).

24, 47, 49, 80(?)

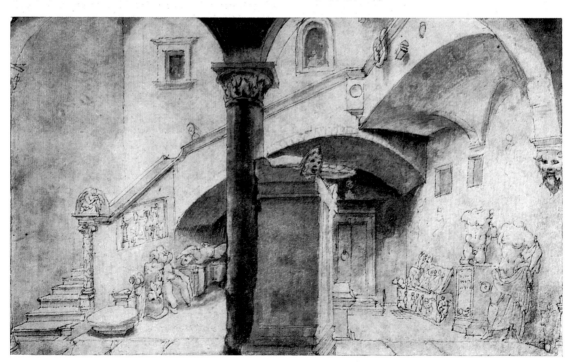

The Maffei Court, Rome. Heemskerck, Berlin Sketchbook I, f. 3ᵛ

MATTEI

A family of several branches, noted in the story of Roman collecting of antiquities from the late Quattrocento (with special attention to inscriptions on the part of the Mattei of Trastevere) up to the 18th century. The Villa Mattei on the Caelian, with its obelisk from Aracoeli as of 1581–2, owes its rich inventory of 1614 to the acquisitiveness of Ciriaco Mattei from earlier collections.

25, 37, 94 (cf.)

MEDICI

The long history of Medici collecting initiated by Cosimo the Elder in Florence has received new precision in recent years with the Exhibition, *Il Tesoro di Lorenzo il Magnifico*, held at the Palazzo Medici-Riccardi in 1972, and the extensive Council of Europe series of exhibitions *Firenze … dei Medici nell'Europa*, 1980 (see especially the Palazzo Vecchio exhibition: *Committenza e collezionismo medicei*). Sculptures brought to Florence from their Roman Villa on the Pincio in the 18th century are indexed in their Renaissance collections (see *della Valle*, p. 480).

27, 30 (cf.), 31, 32, 33, 41, 51(?), 58, 68, 73, 74, 76, 79 (cf.), 80, 100, 101, 105, 112, 119, 123, 126, 136, 137, 166, 172, 203 (cf.)

MEDICI-'MADAMA'

On the site of the ancient Baths of Nero and Severus Alexander, Cardinal Giovanni de' Medici, the future Pope Leo X, began construction c. 1505 of the palazzo that was to become the home first of Alfonsina Orsini, widow of Piero de' Medici, then of Margarita of Austria, daughter of Charles V and widow of Alessandro. 'Madama' of Austria gave the palace its subsequent name and her marriage to Ottavio Farnese in 1538 brought it, its antiquities, and the Medici villa on Monte Mario built for Giulio de' Medici (Clement VII) by Raphael and his pupils into FARNESE hands and ultimately to Naples.

Palazzo Medici-Madama: 18 (cf.), 127, 143, 148, 150, 151, 152; *ill. below*.

Villa Madama on Monte Mario, Rome: 1, 2, 40, 57, 188, 194

Medici-Madama gems: 31, 68, 123

del MONTE, GIULIO (JULIUS III)

From his election to the papacy in 1550, Cardinal del Monte enlarged his uncle's villa outside the Porta Flaminia. Giulio's casino and nymphaeum were assembled too late to be included in Aldrovandi's itinerary of 1549–50.

71

PERRENOT DE GRANVELLE, NICOLAS and CARDINAL ANTOINE

Nicolas Perrenot (1486–1550), a minister of Charles V, built a palace in Besançon where he gathered a diverse collection, the centre-piece of which was the Jupiter (2) discovered in 1525 and sent to him in 1541 by Margarita of Austria. His son Antoine (1517–86)

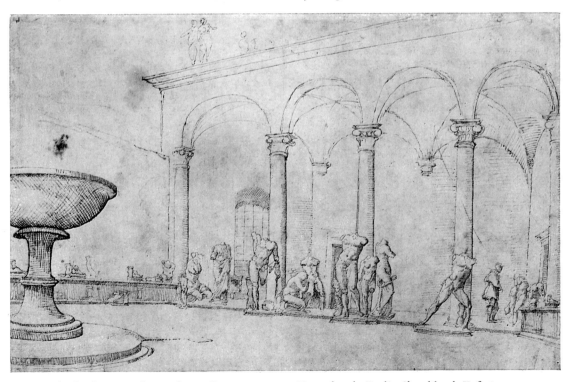

Courtyard of Palazzo Medici-Madama, Rome, *c.* 1532–5. Heemskerck, Berlin Sketchbook II, f. 48

was also a minister of the Emperor, became Cardinal in 1561, and lived in Rome and Brussels. His collection included both modern and ancient *objets de luxe*.

2, 94 (cf.)

PICCOLOMINI, FRANCESCO

In the 1480s, the Cardinal of Siena (nephew of the humanist Pope Pius II, Enea Silvio Piccolomini), who was to reign a few brief weeks as Pius III before his death in 1503, built a palace on the site of part of the present S. Andrea della Valle. Here he gathered a select group of ancient sculptures that included two famous works acquired from the COLONNA family: the Three Graces, given to his native Siena as the central ornament of the Duomo's Piccolomini Library, and a Hercules statue of the type later renowned in a Farnese replica.

60, 130

PODOCATTARO

Cardinal Lodovico, secretary to Alexander VI (d. 1504), and his nephew, Livio, Archbishop of Cyprus, were both learned men and patrons of artists; they lived in Arenula, at the Chiavica di S. Lucia. Lodovico's collection was highly regarded in Raphael's circle. The palazzo was sold in 1565 to the DELLA PORTA family and the antiquities dispersed.

60 (cf.)

PORCARI

Tracing its purported lineage to the Roman Republican censor, M. Porcius Cato, this family already in the Quattrocento produced important collectors of antiquities (above all, inscriptions and representations of pigs as genealogical puns), such as the learned Stefano, executed on the orders of Pope Nicholas V, and Francesco, who is often cited by the earliest epigraphers. Part of their garden court still exists on the Vicolo delle Ceste, close to S. Maria sopra Minerva in Rome where the *Risen Christ* commissioned by Metello Varo from Michelangelo continues to attract tourists. Many works from the collection ended in the hands of the Pamphili or at the Vatican by bequest of an early 19th century Prince Doria, who became the ultimate heir of the Porcari.

113, 121 (cf.)

della PORTA, GUGLIELMO (GUGLIELMO del PIOMBO)

This sculptor from Como (1500–77) came to Rome in 1537, as Vasari tells us, to be taken in hand by Michelangelo, who first set him to restoring antique statues for the Palazzo Farnese. Ultimately he received numerous sculpture commissions and, following the death of Sebastiano del Piombo in 1547, the lucrative office of Piombatore Apostolico of the Cancelleria.

Aldrovandi tells us how many antiquities he had amassed by 1549 in his studio at the Botteghe Oscure; in the course of the next decade he had acquired two palazzi in the Via Giulia. Guglielmo is not to be confused with Giovanni Battista della Porta (c. 1542–97) whose collection of ancient sculptures was also impressive (inventory published by Graeven, 1893).

142

RIARIO

Created a cardinal by his great-uncle, Sixtus IV, in 1477, Raffaele Sansoni Riario began about 1484 a slow rebuilding of the Palazzo San Giorgio at the Campo di Fiore, adjacent to the property of the family GALLI. His scheme was grandiose – swallowing up its *raison d'être*, the church of S. Lorenzo in Damaso – and so were two colossal statues of 'Muses' which came to be one of the spectacular sights of Cinquecento Rome in the courtyard attributed to Bramante. Riario's avidity in collecting ancient sculpture is recorded in the story of his purchase in 1496 of young Michelangelo's *Sleeping Cupid*, taken for an antique. It is not clear whether the wealth of Roman portraits described by Aldrovandi in the mid 16th century were remnants of the Cardinal's collection (he died in 1521) or whether they belonged to the period when the palazzo was turned into the new Apostolio Chancery by Clement VII.

39, 51 (cf.)

ROSSI (ROSCIA or de RUBEIS)

This family's collection figures in Quattrocento antiquarian studies and was admired in Raphael's circle; by the time of Aldrovandi's visit to Rome in the mid 16th century it had been dispersed. Works passed to the Capitoline collections, to (ultimately) the Villa Albani, or cannot be identified from the brief mention in Albertini and in Claude Bellièvre.

48

della ROVERE

Francesco della Rovere of Savona, elected to the Papacy in 1471 as Sixtus IV, was indirectly responsible for the formation of many a Cardinal's collection of antiquities, both through an edict requiring members of his Curia to renovate and ornament their Roman residences, and through setting an example in improving the appearance of Rome. Already in December of 1471 he presented the Conservatori of the Roman Commune with a collection of bronze statuary and the Lex Vespasiana which had formerly stood at the Papal Palace of the Lateran, 'restoring and solemnly donating them to the Roman people'. (See below: CAPITOLINE COLLECTIONS.)

Giuliano della Rovere, Sixtus's nephew and subsequently Pope Julius II, started a collection of antique statues in his palazzo at SS. Apostoli and in his garden

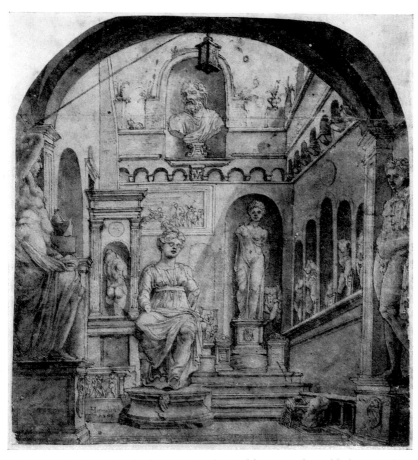

Sassi Courtyard. Heemskerck, drawing. Berlin–Dahlem, Kupferstichkabinett KdZ 2783

at S.Pietro in Vincoli when he was still a Cardinal (the Belvedere Apollo, for example). (See VATICAN, BELVEDERE.)

28, 137, 186

SANTACROCE

The alleged origins of this noble family of collectors can be traced back to Valerius Publicola and the expulsion of the Tarquins from Rome. Cardinal Prospero Santacroce (d. 1511) is mentioned in Quattrocento records of epigraphic monuments and sculptures at his house next to S.Maria in Publicolis (still visible at no. 43 Via in Publicolis, in contradistinction to the present Palazzo Santacroce). Heemskerck drew a view of the sculptures stored in its court.

14, 46 (cf.), 71, 141; *141a*★

SASSI

This ancient Roman family possessed a notable collection of ancient statues and reliefs, tastefully installed in the court of their palace on the present Via del Governo Vecchio in Parione. Although it has vanished in subsequent rebuilding, views by Heemskerck and

others preserve the appearance of this court in the early 16th century. In June, 1546, the collection was sold to the FARNESE and, in the course of the 18th century, its showpieces ended up in Naples with their family holdings.

10 (cf.), 35 (cf.), 36, 90 (cf.); *ill. above*

SAVELLI

The chief residence of this noble and ancient family was in the Theatre of Marcellus during the 14th century; there Peruzzi later designed the new palazzo, today the Palazzo Orsini-Sermoneta. The collection of antiquities was already important in the Quattrocento and continued to be outstanding throughout the Renaissance. The line became extinct in the 18th century, when many pieces of sculpture remaining in the palazzo were sold by the Orsini to the Prince Torlonia.

134, 200 (cf.)

della VALLE

One of the most important collections of the entire 16th century was already well-established during the Quattrocento in a complex of houses in Rione S.

479

Eustachio by this family of learned jurists, physicians and classical scholars, linked by marriage to the Savelli. But its real development came at the hands of Cardinal Andrea della Valle (1463–1534). While still a bishop he consolidated and enlarged the family households into a new palace on the Via Papale (present Corso Vittorio Emmanuele) with a court designed as a showplace for ancient statuary. This first palace (subsequently Rustici-del Bufalo) was joined, after Andrea's election as Cardinal in 1517, by a more ambitious Palazzo (inherited by his niece, Faustina, and her husband, Camillo Capranica). Although the latter has been swallowed up in the Teatro della Valle, its statue-garden is documented in Cinquecento prints and drawings, as well as in a sales inventory drawn up at the time Ferdinando de' Medici bought most of the sculptures in 1584. Other pieces of the della Valle patrimony found their way into the Capitoline collections and elsewhere, while major reliefs are still incastrated in the Villa Medici on the Pincio. In the 18th century, many of the statues and reliefs were taken to Florence and installed in various MEDICI collections.

7, 32, 35, 42, 43, 53 (cf.), 61(?), 73, 74, 75, 76, 80, 84, 100, 108, 116, 118 (?), 119, 126, 130 (cf.), 136, 140, 146, 164, 166, 171, 197(?), 198; *ill. below.*

Also seen in Renaissance Rome:

CAPITOLINE COLLECTIONS

(*Lit.* Siebenhüner, 1957; Buddensieg, 1969; 1983)
65, 65A & B, 129, 163, 167, 176, 183, 184, 185, 191, 192, 203

THE LATERAN

(*Lit.* Buddensieg, 1983)
176, 183, 184, 203

'MONTE CAVALLO' (QUIRINAL)

(*Lit.* Michaelis, 1898)
5, 54, 65A–B, 125, 130, 132

VATICAN PALACE, CORTILE DEL BELVEDERE
(Sculpture acquired by Julius II)

(*Lit.* Michaelis, 1890; Ackerman, 1954; Brummer, 1970)
16, 28, 66, 67 (?), 79, 122, 131, 137, 160

VATICAN, S. PIETRO (forecourt)

59B, 156, 187, 199
(*For other churches see General Index*)

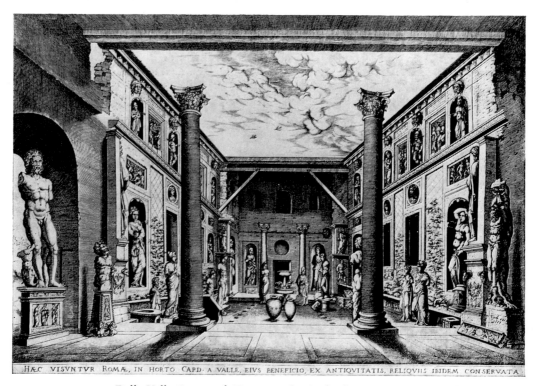

Della Valle Courtyard. Engraving by Cock after Heemskerk

BIBLIOGRAPHY

Accursius [Accorso], Mariangelo, *Diatribae*, Rome, 1524.

Acidini, C. *see* Borsi et al., 1976.

Ackerman, J. S., *The Cortile del Belvedere*, Vatican City, 1954.

Ackerman, J., 'Marcus Aurelius on the Capitoline Hill', *Renaissance News*, X, 1957, pp. 69–75.

Adhémar, J., *Influences antiques dans l'art du moyen âge français; recherches sur les sources et les thèmes d'inspiration*, London, 1939.

Adler, W., *Corpus Rubenianum*, XVIII (1), *Landscapes*, London, 1982.

Alberti, Leon Battista, *On Painting and On Sculpture*. The Latin texts of *De Pictura* and *De Statua* edited with translations, introduction and notes by Cecil Grayson, London–New York, 1972.

Albertini, Francesco degli, *Opusculum de mirabilibus novae et veteris Urbis Romae*, Rome, 1510, 1515, 1522, ed. A. von Schmarsow, Heilbronn, 1886 (the third book dealing with the 'modern' city). 1510 ed. in *CTR*, IV, 1953, pp. 462–546; facsimile reprint. ed. P. Murray, *Five Early Guides to Rome and Florence*, Gregg International, 1972.

Aldrovandi [Aldroandi], Ulisse, *Delle statue antiche che per tutta Roma, in diversi luoghi, et case si veggono*, in L. Mauro, *Le Antichità della Città di Roma*, Venice, 1558 (first ed. 1556).

Alexander J. J. G., *Italian Renaissance Illuminations*, London, 1977.

Alfarano, T., *Tiberii Alpharani de Basilicae Vaticanae antiquissima et nova structura*, ed. D. M. Cerrati, Rome, 1914.

Alföldi, A., 'Lupa Capitolina', in *Hommage à la mémoire de Jérôme Carcopino*, Paris, 1977.

Allison, A. H., 'Antique Sources of Leonardo's Leda', *ArtBull*, LVI, 3, 1974, pp. 375–84.

Altmann, W., *Die römischen Grabaltäre der Kaiserzeit*, Berlin, 1905.

Amaduti, J. C. [Amaduzzi, G. C.] *see* Venuti and Amaduzzi, 1776–9.

Amelung, W., *Die Skulpturen des Vatikanischen Museums (Kat.)*, Vols. I and II, Berlin 1903–8. For Vol. III *see* Lippold.

Amelung, W., 'Saggio sull' arte del IV secolo', *Ausonia*, III, 1909, pp. 91–135.

Amelung, W., 'Zerstreute Fragmente römischer Reliefs', *RM*, XXIV, 1909, pp. 177–92, esp. 181–8.

Amelung, W., 'Die Stuckreliefs in den Loggien Raffaels und ihre Vorbilder', in Hofmann, T., *Raffael in seiner Bedeutung als Architekt*, IV, Zittau–Leipzig, 1911, pp. 57–137.

Andreae, B., *Motivgeschichtliche Untersuchungen zu den römischen Schlachtsarkophagen*, Berlin, 1956.

Andreae, B., 'Schmuck eines Wasserbeckens in Sperlonga. Zum Typus des sitzenden Knäbleins aus dem Schiffsfund von Mahdia', *RM*, LXXXIII, 1976, pp. 287–309.

Andreae, B., and Jung, H., 'Vorläufige tabellarische Übersicht über die Zeitstellung und Werkstattzugehörigkeit von 250 römischen Prunksarkophagen des 3. Jhs. n. Chr.', *AA*, XCII, 1977, pp. 432–6.

Andreae, B., 'Zur Weiterführung des Gesamtplans des Corpus der antiken Sarkophagreliefs', *AA*, XCII, 1977, pp. 475–8 with list of all the vols. of the *ASR* on pp. 477–8.

Andreae, B., *The Art of Rome*, London, 1978.

Andreae, B., 'Zum Triumphfries des Trajansbogens von Benevent', *RM*, LXXXVI, 1979, pp. 325–9.

Andreae, B., *Die Sarkophage mit Darstellungen aus dem Menschenleben* II, *Die römischen Jagdsarkophage* (*ASR*, I, 2), Berlin, 1980.

Andreae, B., 'Bibliographie zur Sarkophagforschung nach Rodenwaldt 1945–1980', in *Aufstieg und Niedergang der römischen Welt*, ed. H. Temporini and W. Haase, II, xii, 2, Berlin–New York, 1981.

Andreae, B., and Settis, S., eds., *Colloquio sul reimpiego dei sarcofagi romani nel medioevo, Pisa 5.-12. September 1982*, (Marburger Winckelmann-Programm 1983), Marburg-Lahn, 1984.

Andreae, B., ed., *Symposium über die antiken Sarkophage, Pisa 5.-12. September 1982*, (Marburger Winkkelmann-Programm 1984), Marburg-Lahn, 1984.

Andreae, B. *see also* Canticello and Andreae, 1974.

Andrén, A., 'Il Torso del Belvedere', *Opuscula Archaeologica*, VII, 1952, pp. 1–45.

Andrews, K., *National Gallery of Scotland, Catalogue of Italian Drawings*, 2 vols., Cambridge, 1968.

Angeliocussis, E., *see* Gordon, E.

Angulo, D., and Pérez Sánchez, A. E., *A Corpus of Spanish Drawings*. Vol. I: *Spanish Drawings 1400–1600*, London, 1975.

Antal, F., 'Some Examples of the Role of the Maenad in Florentine Art of the Later Fifteenth and Early Sixteenth Centuries', *JWI*, I, 1937, pp. 71–3.

Antal, F., 'Observations on Girolamo da Carpi', *ArtBull*, XXX, 1948, pp. 81–103.

Anti, C., *Il R. Museo archeologico nel Palazzo Reale di Venezia*, Rome, 1930.

Apollodorus, *The Library (Bibliotheke)*, with an English transl. by Sir James Frazer, 2 vols., Cambridge, Mass.–London, 1921.

Bocci, M., and Bencini, R., *Palazzi di Firenze*, 4 vols., Florence, 1971.

Bode, W. von, *Die italienischen Bronzestatuetten der Renaissance*, 3 vols., Berlin, 1907–12. Smaller revised ed. 1922.

Bode, W. von, *The Italian Bronze Statuettes of the Renaissance*, English transl. of first German ed., 3 vols., London, 1907–12. New ed., edited and revised by J.D.Draper, assisted by M.Marks, New York, 1980.

Bode, W. von, *Collection of J.Pierpont Morgan. Bronzes of the Renaissance*, 2 vols., Paris, 1910.

Bode, W. von, *Die italienischen Bildwerke der Renaissance und des Barock*, 2: *Bronzestatuetten* (Staatl. Mus. zu Berlin. Bildwerke d. Kaiser-Friedrich Museums), 4th ed., Berlin, 1930.

Bodmer, H., 'Die Kunst des Bartolomeo Passarotti', *Belvedere*, XIII, 1938–9, pp.66–73.

Boissard, J.J., *I(–VI) pars Romanae urbis topographiae et antiquitatum…*, 6 parts in 4 vols., Frankfurt, 1597–1602.

Bonnano, M. *see* Calza *et al.*, 1977.

Borbein, A.H., 'Die Statue des hängenden Marsyas', *MarbWpr*, 1973, pp.37–52.

Borda, M., *La Scuola di Pasiteles*, Bari, 1953.

Borghini, G., 'Baldassare Peruzzi, Cesare di Sesto e altre presenze nell'episcopio di Raffaelle Riario ad Ostia', *Quaderni di Palazzo Venezia*, I, 1981, pp.11–50.

Borsi, F.; Acidini, C.; Mannu Pisani, F.; Morolli, G., *Giovanni Antonio Dosio, Roma Antica, e i disegni di architettura agli Uffizi*, Rome, 1976. The chapter by Acidini: 'Roma Antica' pp.27–131 illustrates some drawings in the Uffizi for Dosio's engravings printed by Gamucci (1565) and Cavalieri (1569).

Borsook, E., and Offerhaus, J., *Francesco Sassetti and Ghirlandaio at Santa Trinita, Florence. History and Legend in a Renaissance Chapel*, Doornspijk, 1981.

Bosque, A. de, *Artisti italiani in Spagna dal XIV Secolo ai re Cattolici*, Milan, 1968.

Bothmer, D. von, *see* Vermeule, *AJA*, 1956.

Boucher, B., 'Leone Leoni and Primaticcio's moulds of antique sculpture', *Burlington*, CXXIII, 1981, pp.23–5.

Bovini, G., 'Le vicende del Regisole', *Felix Ravenna*, XXVI, 1963, pp.138–54.

Bowron, E.P., *Renaissance Bronzes in the Walters Art Gallery*, Baltimore, 1978.

Braham, A., 'A reappraisal of The Introduction of the Cult of Cybele at Rome by Mantegna', *Burlington*, CV, 1973, pp.457–63.

Brendel, O.J., 'Immolatio Boum', *RM*, XLV, 1930, pp.196–226.

Brendel, O.J., 'Prolegomena to a Book on Roman Art', *MAAR*, XXI, 1953, pp.7–73.

Brendel, O.J., 'Borrowings from Ancient Art by Titian', *ArtBull*, XXXVII, 1955, pp.113–25.

Brendel, O.J., 'A Kneeling Persian: Migrations of a Motif', *Essays in the History of Art presented to Rudolf Wittkower*, London, 1967, pp.62–70.

Brett, G., 'A Seventeenth Century Sketchbook', *Royal Ontario Museum. Bulletin of the Division of Art and Archeology*, December, 1957, no.26, pp.4–10, pls.2–5. ('Pietro da Cortona' skb.).

Brilliant, R., *Gesture and Rank in Roman Art* (Memoirs of the Connecticut Academy of Arts and Sciences, XIV), 1963.

Brilliant, R., 'The Arch of Septimius Severus in the Roman Forum', *MAAR*, XXIX, 1967.

Brilliant, R., *Roman Art from the Republic to Constantine*, London, 1974.

Brilliant, R., 'North façade of the Arch of Constantine', in *Age of Spirituality. Late Antique and Early Christian Art, Third to Seventh Century*, ed. K.Weitzmann (Exh. Cat., MMA, 1978), New York, 1979, cat.58, pp.67–9.

Brilliant, R., *Visual Narratives. Storytelling in Etruscan and Roman Art*, Ithaca and London, 1984.

Brinkerhoff, D., 'Hypothesis on the History of the Crouching Aphrodite Type in Antiquity', *GettyMusJ*, VI–VII, 1978–9, pp.83–96.

Brommer, F., *Herakles: Die Zwölf Taten des Helden in antiker Kunst und Literatur*, Münster–Cologne, 1953.

Brommer, F., *Hephaistos, der Schmiedegott in der antiken Kunst*, Mainz, 1978.

Brown, C.M., '"Lo insaciabile desiderio nostro de cose antique": New Documents on Isabella d'Este's Collection of Antiquities', in *Cultural Aspects of the Italian Renaissance. Essays in Honour of Paul Oskar Kristeller*, ed. C.H.Clough, Manchester–New York, 1976, pp.324–53.

Brown, C.M., 'Marten van Heemskerck, The Villa Madama Jupiter and the Gonzaga Correspondence Files', *GazBA*, XCIV, September 1979, pp.49–60.

Brummer, H.H., *The Statue Court in the Vatican Belvedere*, Stockholm, 1970.

Brunnsåker, S., *The Tyrant-Slayers of Kritios and Nesiotes. A Critical Study of the Sources and Restorations*, Stockholm, 1971.

Budde, L., and Nichols, R., *A Catalogue of the Greek and Roman Sculpture in the Fitzwilliam Museum, Cambridge*, Cambridge, 1964.

Buddensieg, T., 'Die Konstantinsbasilika in einer Zeichnung Francescos di Giorgio und der Marmorkoloss Konstantins des Grossen', *MJb*, XIII, 1962, pp.37–48

Buddensieg, T., 'Raffaels Grab', in *Munuscula Discipulorum* (Kunsthistorische Studien Hans Kauffmann zum 70.Geburtstag), ed. T.Buddensieg and M.Winner, Berlin, 1968, pp.45–70.

Buddensieg, T., 'Zum Statuenprogramm im Kapitolsplan Pauls III.', *ZfKg*, XXXII, 1969, pp.177–228.

Buddensieg, T., and Schweikhart, G., 'Falconetto als Zeichner', *ZfKg*, XXXIII, 1970, pp.21–40.

Buddensieg, T., 'Bernardino della Volpaia und Giovanni Francesco da Sangallo. Der Autor des Codex Coner und seine Stellung im Sangallo-Kreis', *RömJbKg*, XV, 1975, pp.89–108.

Buddensieg, T., 'Die Statuenstiftung Sixtus IV. im Jahre 1471', *RömJbKg*, XX, 1983, pp.33–73.

Burger, F., 'Das Konfessionstabernakel Sixtus' IV. und sein Meister', *JpK*, XXVIII, 1907, pp.95–116; 150–67.

Busch, R. von, *Studien zu deutschen Antikensammlungen des 16. Jahrhunderts*. Diss., Tübingen, 1973.

Bush, V., *The Colossal Sculpture of the Cinquecento*, New York–London, 1976. PhD thesis, Columbia Univ., 1967, Historical and topographical context of the antique colossi in Rome (cf. our cat. nos. *24, 39, 64, 65, 66, 67, 125, 176, 183*); ills. of the statues and some of the drawings.

Byam Shaw, J., *Old Master Drawings from Chatsworth* (International Exhibitions Foundation), Washington D.C., 1969–70.

Byam Shaw, J., *Drawings by Old Masters at Christ Church*, 2 vols., Oxford, 1976.

Cagiano de Azevedo, M., *Le Antichità di Villa Medici*, Rome, 1951.

Callmer, C., 'Un Manuscrit de Jean-Jacques Boissard à la Bibliothèque Royale de Stockholm', *Opuscula Romana*, IV, 1962, pp. 47–59.

Callu, J.P., *Genio Populi Romani (295–316). Contribution à une histoire numismatique de la Tétrarchie*, Paris, 1960.

Calza, R.; Bonanno, M.; Messineo, G.; Palma, B.; Pensabene, P., *Antichità di Villa Doria Pamphilij*, Rome, 1977.

Camesasca, E., *All the Paintings of Raphael*, 2 vols.; *All the Frescoes of Raphael*, 2 vols., London, 1963.

Campana, G.P., *Museo Campana. Antiche opere in plastica*, 2 vols., Rome, 1851–2. (First ed., 1842.)

Cancellieri, F., *Notizie delle due famose statue ... di Marforio e di Pasquino*, Rome, 1789. (Second ed. 1854.)

Candida, B., *I calchi rinascimentali della collezione Mantova Benavides nel Museo del Liviano a Padova*, Padua, 1967.

Candida, B., *Bronzetti terrecotte plachette rinascimentali di ispirazione classica alla Ca' d'Oro e al Museo Correr di Venezia*, Rome, 1981.

Canedy, N.W., 'The Decoration of the Stanza della Cleopatra', in *Essays in the History of Art presented to Rudolf Wittkower*, London, 1967, pp. 110–18.

Canedy, N.W., *The Roman Sketchbook of Girolamo da Carpi* (Studies of the Warburg Institute, 35), London–Leiden, 1976.

Capecchi, G., 'Le statue antiche della Loggia dei Lanzi', *Boll d'Arte*, LX, 3–4, 1975, pp. 169–78.

Capecchi, G.; Lepore, L.; Saladino, V., *La Villa del Poggio Imperiale* (Collezioni fiorentine di antichità I), Rome, 1979.

Carli, E., *Le storie di San Benedetto a Monte Oliveto Maggiore*, Siena, 1980.

Carpenter, R., 'Observations on Familiar Statuary in Rome', *MAAR*, XVIII, 1941, pp. 84–93 ('The Belvedere Torso').

Cartari, Vincenzo, *Le vere e nuove imagini de gli dei delli antichi*, ed. Lorenzo Pignoria, Padua, 1615. The first ed., *Le Imagini con la spositione dei Dei degli Antichi*, Venice 1556, is unillustrated. Later 16th century eds. are illus. by fanciful engravings based on classical texts. Pignoria's and later editions use woodcuts of some antique statues and reliefs to illustrate the gods and their myths.

Casanova Uccella, M.L., *Palazzo Venezia. Paolo II e le fabbriche di S. Marco* (Exh. Cat., Mus. del Pal. Venezia), Rome, 1980.

Castagnoli, F., 'Due archi trionfali della Via Flaminia presso Piazza Sciarra', *BullComm*, LXX, 1942, pp. 74–82.

Castagnoli, F., 'Raphael and Ancient Rome', in *The Complete Work of Raphael*, Novara–New York, 1969, pp. 585–602.

Cavalieri, G.B. [Cavalleriis, J.B. de], *Antiquarum statuarum Urbis Romae*, Books I and II, Rome, n.d. [c. 1574], 1585; Books III and IV, 1594. *See* Appendix I: Cavalieri.

Cellini, Benvenuto, *The Life of Benvenuto Cellini written by Himself*, transl. J.A. Symonds; introduced and illus. by J. Pope-Hennessy, London, 1949.

Chambers, D., and Martineau, J., *Splendours of the Gonzaga* (Exh. Cat., London, V & A), Milan, 1981.

Chastel, A., 'Le jeune homme au camée platonicien du Bargello', *Proporzioni*, III, 1950, pp. 73–4.

Chastel, A., 'L'"Etruscan revival" du XVᵉ siècle', *RA*, I, 1959, pp. 165–80; repr. in *Art et humanisme à Florence au temps de Laurent le Magnifique*, Paris, 1961.

Christiansen, K., 'For Fra Carnevale', *Apollo*, CIX, March 1979, pp. 198–201.

Christiansen, K., *Gentile da Fabriano*, London, 1982.

Christina Queen of Sweden, Exh. Cat., Stockholm, 1966.

Chrysoloras, Manuel, Letter to John VIII Paleologue from Rome, 1411, in J.-P. Migne, *Patrologiae Cursus Completus*, Ser. Graeca, XLVI, Paris, 1866, cols. 28–9. Extracts in Baxandall, 1971 (q.v.), pp. 80–1: transl. of passage on Roman historical reliefs; pp. 149–50: Greek text, including passage on mythological reliefs. We use D. Thomason's unpublished transl. of this passage.

Ciacconius, A., *Historia belli Dacici*, Rome, 1576.

Ciacconius, A., *Colonna Trajana ... Engravings* by P. Santi Bartoli, transl. from Latin of A. Ciacconius by G.P. Bellori, Rome, [1673].

Ciardi-Dupré, M.G., 'Presentazione di alcuni problemi relativi al Tribolo scultore', *Arte Antica e Moderna*, XIII/XVI, 1961, pp. 244–7.

Ciardi-Dupré, M.G., *I Bronzetti del Rinascimento*, Milan, 1966.

CIL = *Corpus Inscriptionum Latinarum*, Berlin, 1863–1936.

Clairmont, C., *Das Parisurteil in der antiken Kunst*, Zurich, 1951.

Clairmont, C., *Die Bildnisse des Antinous* (Bibliotheca Helvetica Romana, VI), Rome, 1966.

Clarac, Comte C.O.F. de, *Musée de sculpture*, 6 vols., text and plates, Paris, 1826–53 (Reinach, *Rép. Stat.*, I, 1897 = 'Clarac de Poche').

Clark, K., *Piero della Francesca*, London, 1951.

Clark, K., 'Transformations of Nereids in the Renaissance', *Burlington*, XCVII, 1955, pp. 214–17.

Fabriczy, C. von, 'Un taccuino di Amico Aspertini', *L'Arte*, VIII, 1905, pp.401–13.

Fahy, E., 'The Beginnings of Fra Bartolommeo', *Burlington*, CVIII, 1966, pp.456–63.

Fairfax Murray, C., *Drawings by the Old Masters. Collection of J.Pierpont Morgan*, 4 vols., London, 1905–12.

Falb, R., *Il taccuino senese di Giuliano da Sangallo*, Siena, 1902.

Fanelli, V., 'Le case e le raccolte archeologiche del Colocci', *Studi Romani*, X, 1962, pp.391–402.

Farnell, L.R., *Greek Hero-Cults and Ideas of Immortality*, Oxford, 1921.

Fehl, P., 'The Placement of the Equestrian Statue of Marcus Aurelius in the Middle Ages', *JWCI*, XXXVII, 1974, pp.362–7.

Fenyö, I., *North Italian Drawings from the Collection of the Budapest Museum of Fine Arts*, Budapest, 1965.

Ferino Pagden, S., *Disegni umbri del Rinascimento da Perugino a Raffaello* (Exh. Cat., Gab. dei Disegni e Stampe, Uffizi, LVIII), Florence, 1982.

Ferrucci, G., appendix to Fulvio, 1588, q.v.

Fichard, Johannes, 'Italia' [1536], *Frankfurtisches Archiv für ältere deutsche Litteratur und Geschichte* (ed. J.C.V.Fichard), III, 1815, pp.3–130 ('Rome': pp.14–74).

Ficoroni, F. de', *Le vestigie e rarità di Roma antica*, Rome, 1744.

Fienga, D., 'The *Antiquarie Prospettiche romane composte per Prospectivo Melanese Depictore*: A Document for the Study of the relationship between Bramante and Leonardo da Vinci.' PhD thesis., Univ. of California, 1970, Ann Arbor, 1980.

Filarete = Averlino, A., *Trattato di architettura*, ed. A.M.Finoli and L.Grassi, Milan, 1972.
Treatise on Architecture, facsimile transl. and annotated by J.R.Spencer, 2 vols., (Yale Publications in the History of Art, 16), New Haven, 1965.
See also von Oettingen, 1888.

Fiocco, G., 'Giammaria Falconetto e le sue derivazioni dall' antichità', *Atti del I° Congresso Nazionale di Studi Romani*, Rome, 1929, I, pp.565–9.

Firenze e la Toscana dei Medici nell' Europa del Cinquecento. Palazzo Vecchio: Commitenza e Collezionismo medicei (Council of Europe Exh. Cat.), Florence, 1980.

Fischel, O., 'Die Zeichnungen der Umbrer II, No.96: Das venezianische Skizzenbuch', *JpK* (Beiheft), XXXVIII, 1917, pp.1–188.

Fischel, O., *Raphael*, 2 vols., London, 1948.

Fischel – Oberhuber *see* Oberhuber, 1972.

Fittschen, K., 'Hochzeitssarkophag San Lorenzo', *AA*, LXXXVI, 1971, pp.117–19.

Fittschen, K., 'Das Bildprogramm des Trajansbogens zu Benevent', *AA*, LXXXVII, 1972, pp.742–88.

Fontana, V. and Morachiello, P., eds., *Vitruvio e Raffaello. Il 'De Architectura' di Vitruvio nella traduzione inedita di Fabio Calvo Ravennate*, Rome, 1975.

Forcella, V., *Iscrizioni delle chiese e d'altri edificii di Roma dal secolo XI fino ai giorni nostri*, 14 vols., Rome, 1869–1884.

Forlani Tempesti, A., 'The Drawings', in *The Complete Work of Raphael*, Novara, 1969, pp.303–428.

Forlani Tempesti, A., *Mostra di Stefano della Bella* (GDSU), Florence, 1973.

Forlati Tamaro, B., *Il Museo Archeologico del Palazzo Reale di Venezia*, 2nd ed., (Itinerari dei musei, gallerie e monumenti d'Italia, 88), Rome [1969].

Forster, R., 'Laokoon-Denkmäler und -Inschriften', *JdI*, VI, 1891, pp.177–96.

Forster, R., 'Laokoon', *JdI*, XXI, 1906, pp.1–32.

Fossi Todorow, M., 'Un taccuino di viaggi del Pisanello e della sua bottega', in *Scritti in onore di M.Salmi*, II, Rome, 1962, pp.133–161.

Fossi Todorow, M., *I Disegni del Pisanello e della sua cerchia*, Florence, 1966.

Franciscis, A. de, 'Restauri di Carlo Albacini a statue del Museo Nazionale di Napoli', *Samnium*, XIX, 1946, pp.96–110.

Francovich, Geza de, *Benedetto Antelami architetto e scultore e l'arte del suo tempo*, 2 vols., Milan–Florence, 1952.

Frankfort, Enriqueta, *see* Harris.

Frankfort, H., 'The Dying God' (Inaugural lecture as Director of the Warburg Institute, 1949), *JWCI*, XXI, 1958, pp.141–51.

Franzini, G., *Icones statuarum antiquarum Urbis Romae*, Rome, eds. of 1587, 1596, 1599.

Franzoni, L., *Per una storia del collezionismo. Verona: la Galleria Bevilacqua*, Milan, 1970.

Freedberg, S.J., *Painting of the High Renaissance in Rome and Florence*, 2 vols., Cambridge, Mass., 1961.

Fremantle, R., 'Masaccio and the Antique', *Critica d'Arte*, XVI, 103, 1969, pp.39–56.

Friedlaender, W., and Blunt, A., *The Drawings of Nicolas Poussin. Catalogue Raisonné*, 5 vols., London, 1939–1974.

Friend, A.M., 'Dürer and the Hercules Borghese-Piccolomini', *ArtBull*, XXV, March 1943, pp.40–9. Includes a study on 'Dürer and the Apollo Belvedere', pp.40–3.

Froehner, W., *Notice de la sculpture antique du Musée Impérial du Louvre*, Paris, 1869.

Fröhlich-Bum, L. *see* Stix and Fröhlich-Bum, 1926; 1932.

Frommel, C.L., *Baldassare Peruzzi als Maler und Zeichner*, Vienna–Munich, 1967–8.

Froning, H., 'Die ikonographische Tradition der kaiserzeitlichen mythologischen Sarkophagreliefs', *JdI*, XCV, 1980, pp.322–41.

Frutaz, A.P., *Le Piante di Roma*, 3 vols., Vatican City, 1962.

Fuhrmann, H., *Philoxenos von Eretria. Archäologische Untersuchungen über zwei Alexandermosaiken*. Diss., Göttingen, 1931.

Fulgentius, Fabius Planciades, *Fulgentii Episcopi Carthaginensis Mythologiarum ad Catum Presbyterum Carthaginensem..*, in Hyginus, C.J., *Fabularum liber*, Basle, 1535.

Fulgentius the Mythographer, transl. with intro. by L.G.Whitbread, Columbus, 1971.

Fulvio, Andrea, *Antiquitates Urbis* ..., Rome, 1527 (revised ed. of *Antiquaria Urbis ...*, Rome, 1513). Transl. by Girolamo Ferrucci, *L'antichità di Roma ... con le aggiuntioni e annotationi di Girolamo Ferrucci*, Venice, 1588.

Furtwängler, A., *Beschreibung der Glyptothek König Ludwigs I. zu München*, Munich, 1900.

Furtwängler, A., *Die antiken Gemmen* 3 vols., Leipzig–Berlin, 1900.

Fusco, L., 'Antonio Pollaiuolo's Use of the Antique', *JWCI*, LII, 1979, pp. 257–63.

Gabba, E. see Arias *et al.*, 1977.

Gaddi, G., *Roma nobilitata nelle sue fabbriche dalla Santità di Nostro Signore Clemente XII*, Rome, 1736.

Gadol, J., *Leon Battista Alberti, Universal Man of the Early Renaissance*, Chicago–London, 1969.

Gais, R.M., 'Some Problems of River-God Iconography', *AJA*, LXXXII, 3, 1978, pp. 355–70.

Galestruzzi, G.B., *Polidoro da Caravaggio, Opere ... disegnate et intagliate da Gio. Battista Galestruzzi...*, Rome, 1658.

Gargan, L., *Cultura e arte nel Veneto al tempo di Petrarca*, Padua, 1978.

Garrard, M.D., 'Jacopo Sansovino's *Madonna* in Sant' Agostino: An Antique Source Rediscovered', *JWCI*, XXXVIII, 1975, pp. 333–8.

Gaudioso, E., 'I Lavori Farnesiani a Castel Sant'Angelo, precisazioni ed ipotesi', *Boll d'Arte*, LXI, 1976, I, pp. 21–42.

Gaudioso, F.M.A., *et al.*, *Gli Affreschi di Paolo III a Castel Sant'Angelo. Progetto ed esecuzione 1543–1548* (Exh. Cat., Mus. Naz. di Castel Sant'Angelo, Rome, 16 Nov. 1981–31. Jan. 1982), 2 vols., Rome, 1981.

Gauer, W., *Untersuchungen zur Trajanssäule, I: Darstellungsprogramm und künstlerischer Entwurf* (Monumenta Artis Romanae, Universität Köln, XIII), Berlin, 1977.

Gaye, G., *Carteggio inedito d'artisti dei secoli XIV, XV, XVI*, 3 vols., Florence, 1839–40.

Gelder, J.G. van, 'Jan Gossaert in Rome 1508–1509', *Oud Holland*, LIX, 1942, pp. 1–11.

Gelder, J.G. van, 'Jan de Bisschop's Drawings after Antique Sculpture', *Studies in Western Art* (Acts of the 20th International Congress of the History of Art), III, Princeton, 1963, pp. 51–8.

Gelder, J.G. van, 'Jan de Bisschop', *Oud Holland*, 1971, pp. 201–88.

Gere, J.A., *Taddeo Zuccaro. His development studied in his drawings*, London, 1969.

Gere, J.A., 'Some Early Drawings by Pirro Ligorio', *Master Drawings*, IX, 3, 1971, pp. 239–50.

Gere, J.A., and Pouncey, P., *Italian Drawings in the Department of Prints and Drawings in the British Museum: Artists Working in Rome c. 1550 to c. 1640*, London, 1983. See also Pouncey and Gere, 1962.

Gere, J.A., and Turner, N., *Drawings by Raphael* (Exh. Cat., London, BM), London, 1983.

Gerkan, A. von see L'Orange and Gerkan, 1939.

Gernsheim, W., 'Corpus Photographicum of Drawings'. Unpublished corpus of old master drawings in major European collections; in progress. The Corpus includes drawings after the Antique and can be consulted in London in the Library of the Victoria and Albert Museum, and in the Print Room of the British Museum with new attributions by John Gere and Philip Pouncey. The Corpus can also be found at the Institute of Fine Arts, New York University, and elsewhere in the United States.

Ghedini, F., *Sculture greche e romane del Museo Civico di Padova* (Collezioni e musei archeologici del Veneto, ed. G. Traversari), Rome, 1980.

Ghiberti, Lorenzo, *I Commentari*, ed. O. Morisani, Naples, 1947. See also Schlosser, 1910

Gibbons, F., *Catalogue of Italian Drawings in the Art Museum Princeton University*, 2 vols., Princeton, 1977.

Gilbert, F., 'Bernardo Rucellai and the Orti Oricellari: A Study on the Origin of Modern Political Thought', *JWCI*, XII, 1949, pp. 101–31.

Giraldi [Gyraldus], Lilio Gregorio, *De deis gentium*, Basle, 1548.

Giuliano, A., *L'Arco di Costantino*, Milan, 1955.

Giuliano, A., 'La Roma di Battista Brunelleschi', *Rendiconti dell'Accademia di Archeologia Lettere e Belle Arti di Napoli*, XLVI, 1971, pp. 43–50.

Giuliano, A., and Palma, B., *La maniera ateniese di età romana: i maestri dei sarcofagi attici* (Studi miscellanei – Seminario di archeologia e storia dell'arte greca e romana dell' Università di Roma, XXIV), 1978.

Giuliano, A., 'Documenti per servire alla storia del Museo di Napoli', *Rendiconti dell' Accademia di Archeologia Lettere e Belle Arti di Napoli*, LIV, 1979, pp. 93–113.

Giuliano, A. see also Dacos *et al.*, 1973.

Giustiniani, G., *Galleria Giustiniani del Marchese Vincenzo Giustiniani*, Rome [1631].

Glass, D., 'The Archivolt Sculpture at Sessa Aurunca', *ArtBull*, LII, 2, 1970, pp. 119–31.

Gnoli, D., 'Storia di Pasquino dalle origini al Sacco del Borbone', *Nuova Antologia*, XXV, 1890, pp. 51–75, 275–96.

Gnoli, D., 'Il giardino e l'antiquario del Cardinale Cesi', *RM*, XX, 1905, pp. 267–76.

Goethe, W.J. von, *Italienische Reise,* ed. and commentary by H. von Einem, Munich, 1978; *Italian Journey*, English transl. W.H. Auden and E. Meyer, London, 1962.

Goethert, F.W., 'Trajanische Friese', *JdI*, LI, 1936, pp. 72–81.

Goethert, F.W., *Katalog der Antikensammlung des Prinzen Carl von Preussen im Schloss zu Klein-Glienicke bei Potsdam*, Mainz, 1972.

Goldscheider, L., *Michelangelo Drawings*, [London], 1951.

Goloubew, V., *Les dessins de Jacopo Bellini au Louvre et au British Museum. I: Le Livre d'Esquisses de Londres*, Brussels, 1912; II: *Le Livre d'Esquisses de Paris*, Brussels, 1908.

Golzio, V., *Raffaello nei documenti*, Vatican City, 1936. Gregg rpt. with additions and corrections by the author, 1971.

Gombrich, E.H., 'Zum Werke Giulio Romanos', *JbKSWien*, N.F. VIII, 1934, pp.79–104; N.F. IX, 1935, pp.121–50.

Gombrich, E.H., 'A Classical Quotation in Michael Angelo's "Sacrifice of Noah"', *JWI*, I, 1937, p.69.

Gombrich, E.H., 'The Renaissance Concept of Artistic Progress and its Consequences', *Actes du XVII Congrès International d'Histoire de l'Art* (Amsterdam, 1952), The Hague, 1955, pp.291–307. Reprinted in E.H.Gombrich, *Norm and Form, Studies in the Art of the Renaissance*, London, 1966, pp.1–10.

Gombrich, E.H., 'Renaissance Theory and the Development of Landscape Painting', *GazBA*, XLI, 1953, pp.335–60. Reprinted in E.H.Gombrich, *Norm and Form. Studies in the Art of the Renaissance*, London, 1966, pp.107–121.

Gombrich, E.H., 'The Early Medici as Patrons of Art', in *Italian Renaissance Studies. A Tribute to the late Cecilia M. Ady*, ed. E.F.Jacob, London 1960, pp.279–311. Reprinted in E.H.Gombrich, *Norm and Form. Studies in the Art of the Renaissance*, London, 1966, pp.35–57.

Gombrich, E.H., 'The Style *all' antica*: Imitation and Assimilation', *Studies in Western Art*, II: *The Renaissance and Mannerism* (Acts of the XXth International Congress of the History of Art), Princeton, 1963, pp.31–41. Reprinted in E.H.Gombrich, *Norm and Form. Studies in the Art of the Renaissance*, London, 1966, pp.122–8.

Gombrich, E.H., 'From the Revival of Letters to the Reform of the Arts: Niccolò Niccoli and Filippo Brunelleschi' in *Essays in the History of Art presented to Rudolf Wittkower*, London, 1967, pp.71–82. Reprinted in E.H.Gombrich, *The Heritage of Apelles. Studies in the Art of the Renaissance*, London, 1976, pp.93–110.

Gombrich, E.H., *Aby Warburg. An Intellectual Biography. With a Memoir on the History of the Library by F.Saxl*, London, 1970.

Gombrich, E.H., 'Personification', in *Classical Influences on European Culture A.D. 500–1500*, ed. R.R.Bolgar, Cambridge, 1971, pp.247–57.

Gombrich, E.H., 'Botticelli's Mythologies: A Study in the Neoplatonic Symbolism of his Circle', *JWCI*, VIII, 1945, pp.7–60; revised in E.H.Gombrich, *Symbolic Images*, London, 1972, pp.31–81.

Gonzaga: *see* Chambers and Martineau, 1981.

Goodgal, D., 'The Camerino of Alfonso I d'Este', *Art History*, I, 2, 1978, pp.162–90.

Gordon, E., The Panel Reliefs of Marcus Aurelius. PhD thesis, New York Univ., Inst. of Fine Arts, 1980, now published E. [Gordon] Angelicoussis, *RM*, *XCI*, 1984, pp.141–205.

Gori, A.F., *Museum Florentinum* II, Florence, 1732; III, Florence, 1740.

[Gotti, A.], *Le Gallerie di Firenze*, Florence, 1872.

Govi, G., ed., 'Intorno a un opuscolo rarissimo della fine del secolo XV intitolato *Antiquarie Prospettiche Romane* composte per Prospettivo Milanese Dipintore', *Atti della R. Accademia dei Lincei*, ser.II, Vol.III, Rome, 1876, pp.39–66.

Graeven, H., 'La raccolta di antichità di G.B. della Porta', *RM*, VIII, 1893, pp.236–45.

Graevius [Graeve], J.G., *Thesaurus antiquitatum Romanorum*, 12 vols., Utrecht, 1694–9.

Graf, D., *see* Schaar and Graf, 1969.

Grant, M., *Roman Mythology*, London, 1971.

Graves, R., *Greek Myths*, 2 vols., Harmondsworth, 1955; revised ed., 1960.

Greco, A., *La Cappella di Niccolò V del Beato Angelico*, Rome, 1980.

The Greek Anthology, English transl. W.R.Paton (Loeb Classical Library), Cambridge, Mass.–London, 1918, 5 vols.

Greenhalgh, M., *The Classical Tradition in Art*, London, 1978.

Greenhalgh, M., *Donatello and his sources*, London, 1982.

Grimm, H., 'Zu Raffael III: Die Rossebändiger auf Monte Cavallo', *JpK*, III, 1882, pp.267–74.

Guiffrey, J., and Marcel, P., *Inventaire général des Dessins du Musée du Louvre et du Musée de Versailles, École française* V, Paris, 1910, pls.61–78, nos.3833–3938, pp.60–79 (*see* Appendix I: Dupérac *Album*).

Gusman, P., *La Villa Imperiale de Tibur*, Paris, 1904.

Guthmüller, B., *Ovidio Metamorphoseos vulgare. Formen und Funktionen der volkssprachlichen Wiedergabe klassischer Dichtung in der italienischen Renaissance*, Boppard-am-Rhein, 1981.

Gutman, E., 'An unknown small bronze by Frans Duquesnoy', *AQ*, III, 1940, pp.267–71.

Haftmann, W., *Das italienische Säulenmonument. Versuch zur Geschichte der antiken Form des Denkmals und Kulturmonumentes und ihrer Wirksamkeit für die Antikenvorstellung des Mittelalters und für die Ausbildung des öffentlichen Denkmals in der Frührenaissance* (Beiträge zur Kulturgeschichte des Mittelalters und der Renaissance, 55), Leipzig, 1939.

Haight, E.H., *Aspects of Symbolism in the Latin Anthology and Renaissance Art*, New York–Toronto, 1952.

Halm, P., 'Das unvollendete Fresko des Filippino Lippi in Poggio a Caiano', *MittFlor*, III, 8, 1931, pp.393–427.

Hamberg, P.G., *Studies in Roman Imperial Art*, Uppsala–Stockholm, 1945.

Handley, E.W., 'The poet inspired?', *JHS*, XCIII, 1973, pp.104–8.

Hanfmann, G.M.A., *The Seasons Sarcophagus in Dumbarton Oaks*, 2 vols., Cambridge, Mass., 1951.

Hare, Augustus J.C., *Walks in Rome*, 16th ed. revised, 2 vols., London, 1903.

Harprath, R., *Italienische Zeichnungen des 16.Jahrhunderts aus eigenem Besitz* (Exh. Cat., SGS München), Munich, 1977.

Harprath, R., *Papst Paul III. als Alexander der Grosse. Das*

Freskenprogramm der Sala Paolina in der Engelsburg, Berlin–New York, 1978.

Harris, E., 'Varia: El Marqués del Carpio y sus cuadros de Velázquez', *Archivo Español de Arte*, XXX, 1957, pp. 136–9.

Harris, E., 'Velázquez en Roma', *Archivo Español de Arte*, XXXI, 1958, pp. 185–92, esp. 185, n. 1.

Harris, E., 'Velázquez and the Villa Medici', *Burlington*, CXXIII, 1981, pp. 537–42.

Harris, E., *Velázquez*, Oxford, 1982.

Harrison, E. B., 'Hesperides and Heroes: A Note on the Three-figure Reliefs', *Hesperia* (Journal of the American School of Classical Studies at Athens), XXXIII, 1964, pp. 76–82.

Hartmann, J. B., 'Die Genien des Lebens und des Todes. Zur Sepulkralikonographie des Klassizismus', *RömJbKg*, XII, 1969, pp. 11–38.

Hartt, F., *Giulio Romano*, New Haven, 2 vols., 1958. Rpt. in one vol., New York: Hacker Art Books, 1981.

Hartt, F.; Corti, G.; Kennedy, C., *The Chapel of the Cardinal of Portugal*, Philadelphia, 1964.

Hartt, F., *The Drawings of Michelangelo*, London, 1971.

Haskell, F., *Patrons and Painters. A Study in the Relations between Italian Art and Society in the Age of the Baroque*, London, 1963.

Haskell, F., and Penny, N., *Taste and the Antique. The Lure of Classical Sculpture 1500–1900*, New Haven–London, 1981. Revised ed., Paperback, 1982.

Haskell, F., and Penny, N., *The Most Beautiful Statues. The Taste for Antique Sculpture 1500–1900* (Exh. Cat., Ashmolean), Oxford, 1981.

Hassel, F. J., *Der Trajansbogen in Benevent*, Mainz, 1966.

Hauser, F., *Die neu-attischen Reliefs*, Stuttgart, 1889.

Haussherr, R. *et al.* eds., *Die Zeit der Staufer* (Exh. Cat., Württembergisches Landesmus. Stuttgart), 4 vols., Stuttgart, 1977. Plates in Vol. II, ed. by C. Väterlein *et al.*

Havelock, C. M., *Hellenistic Art*, Greenwich, Conn. [1969] and London, 1971.

Haynes, D. E. L., and Hirst, P. E., *Porta Argentariorum* (Supplementary Papers, British School at Rome), London, 1939.

Haynes, S., 'A fifteenth-century drawing and its Classical Prototypes', *Burlington*, CXXI, November 1979, pp. 653–4.

Heckscher, W. S., *SIXTUS IIII AENEAS INSIGNES STATVAS ROMANO POPOLO RESTITVENDAS CENSVIT*, The Hague, 1955.

Heckscher, W. S., 'Dornauszieher', in *Reallexikon zur deutschen Kunstgeschichte*, IV, Stuttgart, 1958, pp. 289–99.

Heckscher, W. S., *Imago. Ancient Art and its Echoes in Post-Classical Times. A Pictorial Calendar for 1963*, text and plates, n. l., 1962.

Heikamp, D., and Grote, A., *Il Tesoro di Lorenzo il Magnifico* II: *I Vasi* (Exh. Cat., Pal. Medici-Riccardi), Florence, 1974.

Heintze, H. von, 'Statuae quattuor marmoreae pedestres, quarum basibus Constantini nomen inscriptum est', *RM*, LXXXVI, 1979, pp. 399–437.

Heissmeyer, A., *Apoll und der Apollonkult seit der Renaissance*. Diss. Tübingen, 1967.

Helbig, W., *Führer durch die öffentlichen Sammlungen klassischer Altertümer in Rom*, 4th revised ed., ed. H. Speier, 4 vols., Rome (DAI), 1963–72.

Held, J., *Rubens Handzeichnungen*, Cologne, 1960.

Hermann, H. J., 'Zur Geschichte der Miniaturmalerei am Hofe der Este in Ferrara', *JAK*, XXI, 1900, pp. 117–271.

Hermann, H. J., 'Pier Jacopo Alari-Bonacolsi, genannt Antico', *JAK*, XXVIII, 1910, pp. 201–88.

Héron de Villefosse, A., *Musée du Louvre: Catalogue sommaire des marbres antiques*, Paris, 1896; revised with same catalogue numbers by E. Michon, Paris, 1922, q. v. These numbers are in current use in the department of Greek and Roman Antiquities in the Louvre, with the prefix 'MA'.

Herrmann, P., 'Zu den antiken Sarkophagreliefs', *JdI*, XVI, 1901, p. 38.

Hersey, G. L., *The Aragonese Arch at Naples, 1443–1475* (Yale Publications in the History of Art, 24), New Haven, 1973.

Herzog, R., 'Das Kind mit der Fuchsgans', *JÖAI*, VI, 1903, pp. 215–36.

Herzog, S., *see* Pauwels *et al.*, 1965.

Hesiod, *The Homeric Hymns and Homerica*, transl. H. G. Evelyn-White (Loeb Classical Library), London–Cambridge, Mass., 1914.

Hévesy, A. de, 'L'évolution du thème de Léda', *L'Amour de l'art*, XII, 1931, pp. 469–80.

Hill, D. K., 'Nymphs and Fountains', *Antike Kunst*, XVII, 1974, pp. 107–8.

Hill, G. F., 'Sodoma's Collection of Antiques', *JHS*, XXVI, 1906, pp. 288–91.

Hill, G. F., *A Corpus of Italian Medals of the Renaissance before Cellini*, 2 vols., London, 1930.

Hill, G. F., and Pollard, G., *Renaissance Medals from the Samuel H. Kress Collection at the National Gallery of Art*, London–New York, 1967.

Hind, A. M., *Early Italian Engraving. Part II: Known Masters other than Florentine monogramists and anonymous*, Vol. V (Cat.), Vol. VI (pls. 486–698); Vol. VII (pls. 699–916), London, 1948.

Hirst, M., *Sebastiano del Piombo*, Oxford, 1981.

Hoetink, H. R. *see* Pauwels *et al.*, 1965.

Hoff, U., 'The Sources of "Hercules and Antaeus" by Rubens', in *In Honour of Daryl Lindsay. Essays and Studies*, ed. F. Phillip and J. Stewart, Melbourne, 1964, pp. 67–79.

Hoffmann, P., 'I Colossi del Quirinale', *Capitolium*, XXXV, 11, 1960, pp. 7–17.

Hofmann, T., *see* Amelung, 1911.

Holo, S., 'A Note on the Afterlife of the Crouching Aphrodite in the Renaissance', *GettyMusJ*, VI–VII, 1978–9, pp. 23–36.

Hölscher, T., *Vittoria Romana*, Diss., Mainz, 1967.

Holst, N. von, 'Die Cäcilienstatue des Maderna. Ihre Entstehung und ihre antiken Vorbilder, *ZfKg*, IV, 1935, pp. 35–46.

Holt, E.G., *A Documentary History of Art*, 2 vols., Garden City, N.Y., 1958. First printed 1947.

The Horses of San Marco (Exh. Cat., RA), London, 1979.

Horster, M., 'Eine unbekannte Renaissance-Zeichnung nach römischen Sarkophagen', *AA*, XC, 1975, pp. 403–26, pp. 427–32: A list of some Renaissance sketchbooks after the Antique.

Horster, M., *Andrea del Castagno*, Oxford, 1980.

Houser, C., *Dionysos and his Circle. Ancient through Modern* (Exh. Cat., Fogg Mus.), Cambridge, Mass., 1979.

Howell, W.S., 'Rhetoric and Poetics: a Plea for the Recognition of the two Literatures', in *The Classical Tradition, Literary and Historical Studies in Honor of Harry Caplan*, ed. L. Wallach, Ithaca, N.Y., 1966, pp. 374–90.

Hübner, E., *Antike Bildwerke in Madrid*, Berlin, 1862.

Hübner, P.G., 'Studien über die Benutzung der Antike in der Renaissance', *Monatshefte für Kunstwissenschaft*, II, 1909, pp. 267–80, esp. 273–80: II. Raffael und die Sammlung Grimani.

Hübner, P.G., 'Studien über das Verhältnis der Renaissance zur Antike: III. Der Knabe mit der Gans auf vlämischen Bildern', *Monatshefte für Kunstwissenschaft*, IV, 1911, pp. 20–3.

Hübner, P.G., 'Detailstudien zur Geschichte des antiken Roms in der Renaissance', *RM*, XXVI, 1911, pp. 288–328: I. 'Der Jupiter von Versailles und andere Statuen der Villa Madama' (pp. 288–301); II. 'Bemerkungen zu den Statuenzeichnungen Marten van Heemskercks' (pp. 302–17); III. 'Die Aufstellung der Dioskuren von Monte Cavallo' (pp. 318–22); IV. 'Der Niobidenpaedagoge' (pp. 322–8).

Hübner, P.G., *Le Statue di Roma. I: Quellen und Sammlungen* (Römische Forschungen der Bibliotheca Hertziana, II), Leipzig, 1912. Review by Hülsen, 1914, q.v.

Hülsen, C., 'Der Cantharus von Alt-St. Peter und die antiken Pignen-Brunnen', *RM*, XIX, 1904, pp. 87–116.

Hülsen, C., 'La Pianta di Roma dell' Anonimo Einsiedlense', *Atti della Pontificia Accademia Romana di Archeologia*, ser. II, IX, 1907.

Hülsen, C., *La Roma antica di Ciriaco d'Ancona*, Rome, 1907.

Hülsen, C., 'Escurialensis und Sangallo', *JÖAI*, XIII, 1910, pp. 210–30 (Anhang. 'Der Nereiden Sarkophag von Monte Cavallo', pp. 225–230).

Hülsen, C., *Il libro di Giuliano da Sangallo. Codice Vaticano Barberiniano Latino 4424.* (Facsimile and intro. by C. Hülsen, text and pls.) Leipzig, 1910.

Hülsen, C., 'Dei lavori archeologici di Giovannantonio Dosio', *Ausonia* (Rivista della Società Italiana di Archeologia e Storia dell'Arte), VII, 1912, I, pp. 1–100.

Hülsen, C., 'Vier bacchische Reliefs im Kasino Borghese', *JÖAI*, XV, 1912, pp. 109–23; 'Zu den bacchischen Reliefs aus Kasino Borghese', *JÖAI*, XVI, 1913, pp. 208–211.

Hülsen, C., 'Le Statue di Roma von Paul Gustav Hübner', *Göttingische gelehrte Anzeigen*, CLXXVI, 5, 1914, pp. 257–311.

Hülsen, C., and Egger, H., *Die römischen Skizzenbücher von Marten van Heemskerck* I, Berlin, 1913; II, 1916. Facsimile ed., Soest, 1975, reviewed by I.M. Veldman, *Simiolus*, 1977, q.v.

Hülsen, C., *Römische Antikengärten des XVI. Jahrhunderts*, (Abhandlungen der Heidelberger Akademie der Wissenschaften, philos.-hist. Klasse, IV), 1917.

Hülsen, C., 'Das Speculum Romanae Magnificentiae des Antonio Lafreri', *Collectanea variae doctrinae L.S. Olschki …*, Munich, 1921.

Hülsen, C., 'Unbekannte römische Zeichnungen von Marten van Heemskerck', *MededRom*, VII, 1927, pp. 83–96.

Hülsen, C., *Das Skizzenbuch des Giovannantonio Dosio im Staatlichen Kupferstichkabinett zu Berlin*, Berlin, 1933.

Humphris, C., *69 Pieces of Islamic Pottery and Italian Maiolica from the Adda Collection* (Exh. Cat., 23 Old Bond St.), London, 1967.

Hutton, E., *The Cosmati*, London, 1950.

Hyginus, *Fabularum liber*, Basle, 1535. Ed. and transl. by M. Grant, *The Myths of Hyginus*, Lawrence, Kansas, 1960.

Infessura, S., *Diario della città di Roma*, ed. O. Tomassini, Rome, 1890.

Italian Art in Britain (Exh. Cat., RA), London, 1961.

Jacobsen, E., 'Die Handzeichnungen der Uffizien in ihren Beziehungen zu Gemälden, Skulpturen und Gebäuden in Florenz', *RfKw*, XXVII, 1904, pp. 251–260; 322–31; 401–429. (Time-consuming as it uses old attribs. and inv. nos.; no ills.)

Jacobsen, M.A., 'A Note on the Iconography of Hercules and Antaeus in Quattrocento Florence', *Source. Notes in the History of Art*, I, 1, 1981, pp. 16–20.

Jaffé, M., *Rubens and Italy*, Oxford, 1977.

Jahn, O., 'Über die Zeichnungen antiker Monumente im Codex Pighianus', *Jahresberichte der k. Sächsischen Gesellschaft der Wissenschaften zu Leipzig*, XX, 1868, pp. 161–235.

Janson, H.W., *The Sculpture of Donatello*, Princeton, 1963 (first published 1957; paperback 1980).

Janson, H.W., review of B. Rowland, Jr., *The Classical Tradition in Western Art*, *ArtBull*, XLVI, 1964, pp. 405–407.

Janson, H.W., 'Donatello and the Antique', in *Donatello e il suo tempo: Atti del Congresso internazionale del Vᵒ Centenario della morte di Donatello (1966)*, Florence, 1968, pp. 77–96.

Jestaz, B., *Jules Romain, L'Histoire de Scipion* (Exh. Cat., Grand Palais), Paris, 1978.

Jestaz, B., 'Requiem pour Alessandro Leopardi', *Revue de l'Art*, LV, 1982, pp. 23–34.

Joachim, H., and McCullagh, S.F., *Italian Drawings in the Art Institute of Chicago*, Chicago–London, 1979.

Jordan, H., ed. C. Hülsen, *Topographie der Stadt Rom im Altertum*, I, 3, Berlin, 1907.

Jung, H., *see* Andreae and Jung, 1977.

Kähler, H., *Zwei Sockeln eines Triumphbogen im Boboli Garten zu Florenz* (96 BWpr), 1936.

Kaibel, G., (ed.), *Inscriptiones Graecae Siciliae et Italiae*, Berlin, 1873 ff. (Vol. XIV, 1890.)

Kampen, N. B., 'Biographical Narration and Roman Funerary Art', *AJA*, LXXXV, 1, 1981, pp. 47–58.

Kantorowicz, E., *Frederick the Second*, New York, 1957. Translating first German edition, 1927–31.

Kapossy, B., *Brunnenfiguren der hellenistischen und römischen Zeit*. Diss., Zürich, 1969.

Kekule von Stradonitz, R., *Die Bildnisse des Sokrates*, Berlin, 1908.

Kemp, M., and Smart, A., 'Leonardo's *Leda* and the Belvedere *River-Gods*: Roman sources and a new chronology', *Art History*, III, 2, 1980.

Kennedy, G., *see* Hartt *et al.*, 1964.

Keutner, H., 'Italienische Kleinbronzen', *Kunstchronik*, XV, 7, 1962, pp. 169–77.

Klein, W., 'Die Aufforderung zum Tanz. Eine wiedergewonnene Gruppe des antiken Rokoko', *ZfbK*, XX, 1909, pp. 101–8.

Klein, W., *Vom antiken Rokoko*, Vienna, 1921.

Kleiner, D. E. E., and F. S., Appendix [to 'A Heroic Funerary Relief on the Via Appia']: 'Ancient Cuirass Struts', *AA*, XC, 1975, pp. 261–5, esp. 264–5, Dioscuri *(125)*.

Kleiner, G., *Begegnungen Michelangelos mit der Antike*, Berlin, 1950.

Kleiner, G., 'Der Triumph des Titus', in *Festschrift Max Wegner zum sechzigsten Geburtstag*, ed. D. Ahvens, Münster, 1962, pp. 42 ff.

Klügmann, A., 'Zu den attalischen Statuen', *Archäologische Zeitung*, XXXIV, 1876, pp. 35–7.

Knauer, E., *Das Reiterstandbild des Kaisers Marc Aurel* (Reclams Universal-Bibliothek, no. 128), Stuttgart, 1968.

Knauer, E., 'Leda', *JBerlMus*, XI, 1969, pp. 5–35.

Knauer, E., 'Zu Correggios Io und Ganymed', *ZfKg*, XXXIII, 1970, pp. 61–7.

Koch, G., *Die mythologischen Sarkophage: Meleager*, ASR, XII, 6, Berlin, 1975.

Koch, G., and Sichtermann, H., *Römische Sarkophage* (Handbuch der Archäologie, ed. U. Hausmann), Munich, 1982.

Koch, G., *see also* Sichtermann and Koch, 1975.

Koschatzky, W., and Strobl, A., *Die Dürer-Zeichnungen der Albertina*, Salzburg, 1971.

Kötting, B., '*Dextrarum iunctio*', in *Reallexicon für Antike und Christentum*, ed. Th. Klauser, III, 1956.

Kranz, P., *Jahreszeiten-Sarkophage*, ASR, V, 4, Berlin, 1984.

Kraus, T., *Die Aphrodite von Cnidos*, Bremen, 1957.

Krautheimer, R., and Krautheimer-Hess, T., *Lorenzo Ghiberti*, Princeton, 1956. 2nd printing with corrections, new preface and bibl., 2 vols., 1970.

Kris, E., *Meister und Meisterwerke der Steinschneiderkunst in der italienischen Renaissance*, 2 vols., Vienna, 1929.

Kris, E., *see also* Eichler and Kris, 1927.

Kristeller, P., 'Un' antica riproduzione del Torso Belvedere', *Archivio storico dell'arte*, IV, 1891, pp. 476–8.

Kruft, H.-W., and Malmanger, M., 'Der Triumphbogen Alfonsos in Neapel. Das Monument und seine politische Bedeutung', *Acta ad Archaeologiam et Artium Historiam Pertinentia*, VI, 1975, pp. 213–305, with 137 figs.

Kuhrmann, D., *Altdeutsche Zeichnungen aus der Universitätsbibliothek Erlangen* (Exh. Cat.), Munich, 1974.

Kultzen, R., 'Die Malereien Polidoros da Caravaggio im Giardino del Bufalo in Rome', *MittFlor*, IX, 1960, pp. 99–120.

Kultzen, R., 'Bemerkungen zu einer Fassadenmalerei Polidoros da Caravaggio an der Piazza Madama in Rom', *Miscellanea Bibliothecae Hertzianae zu Ehren Leo Bruhns, Graf Franz Wolff Metternich, Ludwig Schmidt*, Munich, 1961, pp. 206–12.

Kunisch, N., *Die Stiertötende Nike. Typengeschichte und mythologische Untersuchungen*. Diss., Munich, 1964.

Kurz, O., 'Huius Nympha Loci', *JWCI*, XVI, 1953, pp. 171–7. Reprinted in *The Decorative Arts of Europe and the Islamic East: Selected Studies*, I, London, 1977, pp. 171–7.

Kurz, O., 'An engraved gem by Thamyras', in *Album Amicorum J. G. van Gelder*, The Hague, 1973, pp. 211–214. Reprinted in Kurz, O., *Selected Studies*, II, London, 1982, pp. 211–18.

Kurz, O., 'Early Art Forgeries from the Renaissance to the Eighteenth Century', *Selected Studies*, II, London, 1982, pp. 179–200.

Lachenal, L. de, 'La collezione di sculture antiche della famiglia Borghese e il palazzo in Campo Marzio', *Xenia*, IV, 1982, pp. 49–117.

Ladendorf, H., *Antikenstudium und Antikenkopie* (Abhandlungen der sächsischen Akademie der Wissenschaften zu Leipzig XLVI, 2), Berlin, 1953 (2nd ed. 1958, revised).

Lafréry, A., *Speculum*. See Hülsen, 1921, and Appendix I.

Lamb, C., *Die Villa d'Este in Tivoli*, Munich, 1966.

[Lambert Lombard], *see* Lombard.

Lanciani, R., *The Ruins and Excavations of Ancient Rome*, Boston–New York, 1897.

Lanciani, R., 'La raccolta antiquaria di Giovanni Ciampolini', *BullComm*, XXVII, 1899, pp. 101–15.

Lanciani, R., *New Tales of Old Rome*, London, 1901.

Lanciani, R., *Storia degli Scavi di Roma*, 4 vols., Rome, 1902–12.

Landino, Cristoforo, *De vera nobilitate*, ed. M. T. Liaci (Nuova collezione di testi umanistici inediti o rari, XV), Florence, 1970.

Lang, S., *see* Pevsner, 1968.

Langedijk, K., 'Baccio Bandinelli's Orpheus: A Political Message', *MittFlor*, XX, 1, 1976, pp. 33–52.

La Rocca, E., 'Sulle vicende del Marco Aurelio dal 1912 al 1980', *Studi Romani*, XXIX, 1981, pp. 56–60.

La Rocca, E., *L'eta d'oro di Cleopatra: indagine sulla Tazza Farnese*, Rome, 1984.

Lasinio, P., figlio, *Raccolta di sarcofagi, urne e altri monumenti di scultura del Campo Santo di Pisa*, Pisa, 1814; *see* Appendix I: Lasinio.

Lavin, I., 'The Sources of Donatello's Pulpit in S. Lorenzo', *ArtBull*, XLI, 1959, pp. 19–38.

Lavin, I., 'On the Sources and Meaning of the Renaissance Portrait Bust', *AQ*, XXXIII, 1970, pp. 207–26.

Laviosa, C., 'L'Arianna addormentata del Museo archeologico di Firenze', *Archeologia Classica*, X, 1958, pp. 165–71.

Lazzaroni, M., and Muñoz, A., *Filarete, scultore e architetto del secolo XV*, Rome, 1908.

Lederer, S., 'Sodoma Lukrécia-Képeiröl', *Az Országos Magyar Szepmúvésti Muzeum Evkönyvei*, II, 1919–20, pp. 41–56.

Lee, R.W., '*Ut Pictura Poesis*: a Humanistic Theory of Painting', *ArtBull*, XXII, 1940, pp. 197–269.

Lehmann, P.W., *Samothracian Reflections*, Princeton, 1973.

Lehmann-Hartleben, K., *Die Trajanssäule*, text and plates, Berlin, 1926.

Lehmann-Hartleben, K., and Olsen, E.C., *Dionysiac Sarcophagi in Baltimore*, Baltimore, 1942.

Leon, C.F., *Die Bauornamentik des Trajansforums und ihre Stellung in der früh- und mittelkaiserzeitlichen Architekturdekoration Roms*, Vienna–Cologne–Graz, 1971.

Lepore, L., *see* Capecchi *et al.*, 1979.

Leto, P. [Pomponius Laetus], *Excerpta ...*, in *CTR*, IV, 1953, pp. 423–36.

Levenson, J.A.; Oberhuber, K.; Sheenan, J.L., *Early Italian Engravings from the National Gallery of Art*, Washington, D.C., 1973.

Levi, A., *Sculture greche e romane del Palazzo Ducale di Mantova*, Rome, 1931.

Levi, C.A., *Le collezioni veneziane d'arte e d'antichità dal secolo XIV ai nostri giorni*, 2 vols., Venice 1900.

Lexicon Iconographicum Mythologiae Classicae (LIMC), I, (Aara-Aptilad), text and plates, Zurich–Munich, 1981. In progress.

Lightbown, R.W., *Sandro Botticelli*, 2 vols., London, 1978.

Lightbown, R.W., *Donatello and Michelozzo*, London, 1980.

Ligorio, Pirro (from Naples, BN, MS XIII.B.10, book 49), *see* Dessau, H., 'Römische Reliefs beschrieben von Pirro Ligorio', *SbBerl*, XL, 1883, pp. 1077–1105.

Lilius, H., 'Gli Stucchi della loggia di Villa Lante. Aspetti dell' iconografia e dei suoi prototipi antichi', *Colloqui del Sodalizio*, II, 4 (1973–4), 1975, pp. 165–76. See now Lilius, H., *Villa Lante al Gianicolo*, 2 vols., Rome, 1981.

Linfert, A., 'Der Meister der kauernden Aphrodite', *Mitteilungen des deutschen Archäologischen Instituts, Athenische Abteilung*, LXXXIV, 1969, pp. 158–64.

Lippold, G., *Die Skulpturen des Vatikanischen Museums* (*Kat.*), Berlin, 1936–56 (Vol. III[1] 1936; III[2] 1956). Each with plate and text vol. *See* Amelung 1903–8 for Vols. I and II.

Loeffler, E., 'Lysippos' Labors of Herakles', *Marsyas*, VI, 1950–3, pp. 8–24.

Loeffler, E., 'A famous Antique: A Roman Sarcophagus at the Los Angeles Museum', *ArtBull*, XXXIX, 1, 1957, pp. 1–7.

Loewy, E., 'Di alcune composizioni di Raffaello inspirate a monumenti antichi', *ASA*, II, 1896, pp. 241–51.

Loewy, E., 'Der Schluss der Iphigenie in Aulis', *JÖAI*, XXIV, 1929, pp. 1–41.

[Lombard, Lambert]. *Dessins de Lambert Lombard Ex-Collection d'Arenberg* (Exh. Cat., Mus. de L'Art Wallon, Liège), Liège, 1963.

L'Orange, H.P., and Gerkan, A. von, *Der spätantike Bildschmuck des Konstantinsbogens*, Berlin, 1939.

Lorenz, T., 'Monte Cavallo. Ein Nymphäum auf dem Quirinal', *MededRom*. XLI, N.S.6, 1979, pp. 43–57.

Lowry, B., 'Notes on the *Speculum Romanae Magnificentiae* and related publications', *ArtBull*, XXXIV, 1952, pp. 46–50.

Luce, J.V., *see* Stanford and Luce, 1974.

Lullies, R., *Die kauernde Aphrodite*, Munich, 1954.

Lumbroso, G., 'Gli Accademici nelle catacombe', *Archivio della Reale Società Romana di Storia Patria*, XII, 1889, pp. 215–39.

Luporini, E., 'Un libro di disegni di Giovanni Antonio Dosio', *Critica d'Arte*, IV, 1957, pp. 442–67; V, 1958, pp. 43–72.

Luzio, A., 'Federico Gonzaga ostaggio alla Corte di Giulio II', *Archivio della Reale Società Romana di Storia Patria*, IX, 1886, pp. 509–82.

Luzio, A., 'Isabella d'Este e il sacco di Roma', *ArchStorLombardo*, X, 1908, pp. 5–107.

Lyngby, H., *Beiträge zur Topographie des Forum-Boarium-Gebietes in Rom*, Lund, 1954.

Macandrew, H., 'A Group of Batoni Drawings at Eton College, and some Eighteenth-century ·Italian Copyists of Classical Sculpture', *Master Drawings*, XVI, 2, 1978, pp. 131–50.

Macandrew, H., *Catalogue of the Collection of Drawings in the Ashmolean Museum*, Vol. III: *The Italian Schools, Supplement*, Oxford, 1980. For Vol. II *see* Parker, K.T., 1956.

MacDougall, E.B., 'The Sleeping Nymph: Origins of a Humanist Fountain Type', *ArtBull*, LVII, 1975, pp. 357–65.

MacDougall, E.B., '*L'Ingegnoso Artifizio*. Sixteenth Century Garden Fountains in Rome', in *Fons Sapientiae. Renaissance Garden Fountains*, ed. E.B. MacDougall, Washington, D.C., 1978, pp. 85–113.

Macrea, M., 'Un disegno inedito del Rinascimento della Colonna Traiana', *Ephemeris Dacoromana*, VII, 1937, pp. 77–116.

Maedebach, H., ed., *Ausgewählte Handzeichnungen von 100 Künstlern aus fünf Jahrhunderten, 15.–19.Jhr.* (Exh.

Cat., Kupferstichkabinett der Kunstsammlungen der Veste Coburg), Coburg, 1970.

Maffei, R., *see* Volaterranus.

Magi, F., 'Il coronamento dell' arco di Costantino', *RendPontAcc*, ser. III, XXIX, 1956–7, pp. 83–110.

Magi, F., 'Il ripristino del Laocoonte', *Atti della Pontificia Accademia Romana di Archeologia, Memorie*, ser. III, IX, 1, 1960, pp. 5–117.

Magi, F., 'Laocoonte a Cortona', *RendPontAcc*, ser. III, XL, 1967–8, pp. 275–94.

Malke, L. S., *Italienische Zeichnungen des 15. und 16. Jahrhunderts* (Exh. Cat., Städel. Kunstinst. und Städt. Gal.), Frankfurt-am-Main, 1980.

Malmanger, M. *see* Kruft and Malmanger, 1975.

Mancini, G., *Luca Signorelli*, Florence, 1903.

Mandowsky, E., 'Two *Menelaus and Patroclus* Replicas in Florence and Joshua Reynolds' Contribution', *ArtBull*, XXVIII, 2, 1946, pp. 115–18.

Mandowsky, E., 'Some Notes on the Early History of the Medicean Niobides', *GazBA*, XLI, 1953, pp. 251–264.

Mandowsky, E., and Mitchell, C., *Pirro Ligorio's Roman Antiquities. The Drawings in MS.XIII.B.7 in the National Library in Naples* (Studies of the Warburg Institute, 28), London, 1963.

Mann, J. G., *Wallace Collection Catalogues: Sculpture*, London, 1931.

Mannu Pisani, F. *see* Borsi et al., 1976.

Mansuelli, G. A., *Galleria degli Uffizi: Le Sculture*, I, Rome, 1958.

Marabottini, A., *Polidoro da Caravaggio*, Rome, 1969.

Marcel, P. *see* Guiffrey and Marcel, 1910.

Marlianus, J. B., *Urbis Romae topographia*, Rome, 1544. (New and completely revised edition of *Topographia antiquae Romae*, Rome, 1534).

Martianus Capella, *De nuptiis Philologiae et Mercurii librii II*, Basle, 1532.

Martin, J. R., *The Farnese Gallery*, Princeton, 1965.

Martindale, A., *The Triumphs of Caesar by Andrea Mantegna in the Collection of Her Majesty the Queen at Hampton Court*, London, 1979.

Martineau, J. *see* Chambers and Martineau, 1981.

Martini, F., *Lorenzino de' Medici e il tirannicidio nel Rinascimento*, Florence, 1882. Reprinted, Rome, 1972.

Massing, J.-M., 'Le devant de sarcophage romain de l'ancienne collection Huber, à Sarreguemines: une copie d'après P. S. Bartoli', *Le Pays Lorrain* (Journal de la Société d'archéologie Lorraine et du Musée Historique Lorrain), LX, 1979, pp. 15–18.

Matz, F., 'Über eine dem Herzog von Coburg-Gotha gehörige Sammlung alter Handzeichnungen nach Antiken', *Monatsberichte der Königlich Preussischen Akademie der Wissenschaften zu Berlin. Philos.-hist. Kl.*, October, 1871, pp. 445–99.

Matz, F., and Duhn, F. von, *Antike Bildwerke in Rom*, 3 vols., Leipzig, 1881–2.

Vol. I, 1881 (Statues, herms, etc. Nos. 1–2206),

Vol. II, 1881 (Sarcophagi. Nos. 2207–3438),

Vol. III, 1882 (Reliefs and misc. Nos. 3439–4117).

Matz, F., *Die dionysischen Sarkophage* (*ASR*, IV, 1–4), Berlin, 1968–75.

Mazochius, Jacobus, *Epigrammata antiquae Urbis*, Rome, 1521.

McGinniss, L. R., with the assistance of H. Mitchell, *Catalogue of the Earl of Crawford's 'Speculum Romanae Magnificentiae' now in the Avery Architectural Lib.*, Columbia Univ., New York, 1976.

McGrath, E., 'The Painted Decoration of Rubens' House', *JWCI*, XLI, 1978, pp. 245–77.

McKillop, S. R., *Franciabigio*, Berkeley–Los Angeles–London, 1970.

Meder, J., *Die Handzeichnung: Ihre Technik und Entwicklung*, 2nd ed. Vienna, 1923.

Meder, J., *Handzeichnungen aus der Albertina*, 12 vols., *see* Schönbrunner and Meder, 1896–1908.

Meiss, M., 'Sleep in Venice. Ancient Myths and Renaissance Proclivities', *Papers of the American Philosophical Society*, CX, 5, 1966, pp. 348–82.

Meller, P., 'Riccio's Satyress Triumphant: Its Source, Its Meaning', *The Bulletin of the Cleveland Museum of Art*, LXIII, 10, 1976, pp. 324–34.

Mély, F. de, 'La Tête de Laocoön de la collection d'Arenberg à Bruxelles', *Monuments Piot*, XVI, Paris, 1909, pp. 209–22.

Merot, K., *Musen, Sirenen und Charites*, 1958.

Messineo, G. *see* Calza et al., 1977.

Meulen, M. van der, 'Cardinal Cesi's Antique Sculpture Garden: Notes on a Painting by Hendrick van Cleef III', *Burlington*, CXVI, January, 1974, pp. 14–24.

Meulen-Schregardus, H. M. van der, *Petrus Paulus Rubens Antiquarius, Collector and Copyist of Antique Gems.*, Alphen-on-the-Rhine, 1975.

Mezzetti, A., 'Un "Ercole e Anteo" del Mantegna', *Boll d'Arte*, XLIII, 1958, pp. 232–44.

Mezzetti, A., *Girolamo da Ferrara detto da Carpi*, Milan, 1977.

Michaelis, A., *Ancient Marbles in Great Britain*, Cambridge, 1882. For addenda *see* Vermeule, *AJA*, 1955, 1956, 1959.

Michaelis, A., 'Geschichte des Statuenhofes im vatikanischen Belvedere', *JdI*, V, 1890, pp. 5–72.

Michaelis, A., 'Storia della collezione Capitolina di antichità fino all'inaugurazione del Museo (1734)', *RM*, VI, 1891, pp. 3–66.

Michaelis, A., 'Römische Skizzenbücher Marten van Heemskercks und anderer nordischer Künstler des XVI. Jahrhunderts', *JdI*, VI, 1891, pp. 125–72 (I: 'Die Überreste der Römischen Skizzenbücher Marten van Heemskercks'); pp. 218–38 (II: 'Ein Stich von Hieronymus Kock [Die Sammlungen della Valle]').

Michaelis, A., 'Römische Skizzenbücher nordischer Künstler des XVI. Jahrhunderts', *JdI*, VII, 1892, pp. 83–105 (includes Basel skb., Melchior Lorch, and Cambridge skb.).

Michaelis, A., 'Der Schöpfer der attalischen Kampfgruppen', *JdI*, VIII, 1893, pp. 119–34.

Michaelis, A., 'Monte Cavallo', *RM*, XIII, 1898, pp. 248–274.

Micheletti, E., in *Mostra di quattro maestri* (Exh. Cat., Pal. Strozzi), Florence, 1954, pp. 72–3, cat. 32.

Micheli, M. E., 'Giovanni Colonna da Tivoli: 1554', *Xenia, Quaderni* 2, 1982.

Michon, E., 'Les bas-reliefs historiques romains du Musée du Louvre', *Monuments Piot*, XVII, 1910, pp. 145–253; pp. 190 ff.

Michon, E., *Musée du Louvre: Catalogue sommaire des marbres antiques*, Paris, 1922. Revision of catalogue by A. Héron de Villefosse, 1896, q.v. (Their catalogue numbers correspond to the 'MA' numbers in current use in the Dept. of Greek and Roman Antiquities in the Louvre.)

Middeldorf, U., 'Su alcuni bronzetti all'antica del Quattrocento', in *Il Mondo Antico nel Rinascimento*, Atti del V Convegno Internazionale di Studi del Rinascimento (Ist. Naz. di Studi sul Rinascimento, Firenze, Pal. Strozzi, 1956), 1958, pp. 167–77.

Middledorf, U., *Sculptures from the Samuel H. Kress Collection: European Schods, XIV–XIX Century*. London, 1976.

Minto, A., 'Il sarcofago del Duomo di Cortona', *Rivista d'arte*, XXVI, 1950, pp. 1–22.

Mirabilia. The oldest twelfth century version is in Valentini and Zucchetti, *CTR*, III, 1946, pp. 17–65.

Missonier, F., 'Sur la signification funéraire du mythe d'Achille et Penthesilée', *Mélanges d'archéologie et d'histoire de l'École française de Rome*, XLIX, 1932, pp. 111–31.

Mitchell, C., 'Archaeology and Romance in Renaissance Italy', in *Italian Renaissance Studies: a Tribute to the late Cecilia M. Ady*, ed. E. F. Jacob, London, 1960, pp. 455–83.

Mitchell, C., 'Felice Feliciano *Antiquarius*', *Proceedings of the British Academy*, XLVII, 1961.

Mitchell, C. *see also* Mandowsky and Mitchell, 1963.

Mommsen, T. *et al.*, eds., *CIL*, Berlin, 1863–1936.

Monbeig-Goguel, C., *Vasari et son Temps (Inventoire général des dessins italiens I: Maîtres toscans nés après 1500, morts avant 1600)*, Paris, 1972.

Mongan, A., and Sachs, P. J., *Drawings in the Fogg Museum of Art*, 3 vols., Cambridge, Mass., 1940.

Montagu, J., *Bronzes*, London, 1963; London (Octopus Books), 1972.

Montagu, J., *Alessandro Algardi*, New Haren and London, 1985.

Montfaucon, B. de, *L'Antiquité expliquée et representée en figures*, 1st ed. 1719; 2nd ed. revised, 15 vols., Paris, 1722–4; transl. D. Humphreys, *Antiquity Explained and Represented in Sculpture by the Learned Father Montfaucon*, 2 vols., London, 1721, 1722 (and *Supplement* Vol. III, 1725). Reprint of Humphreys, 3 vols., London–New York: Garland Press, 1976.

Monti, P. M., *La Colonna Traiana*, Rome, 1980.

Monumenta Matteiana, see Venuti and Amaduti, 1778.

Morrone, A., *Pisa Illustrata*, II, 1812.

Muffel, N., *Beschreibung der Stadt Rom*, CTR, IV, 1953, pp. 354–73.

Müller, W., 'Zur schlafenden Ariadne des Vatikan', *RM*, LIII, 1938, pp. 164–74.

Muñoz, A., *Filarete, see* Lazzaroni and Muñoz, 1908.

Müntz, E., *Les arts à la cour des Papes pendant le XV*e *et le XVI*e *siècle: recueil de documents inédits*, 3 vols., Paris, 1878–82.

Müntz, E., *Les précurseurs de la Renaissance*, Paris–London, 1882.

NACF (National Art Collections Fund), *Annual Report*, LIV, London, 1957.

Nash, E., *Pictorial Dictionary of Ancient Rome*, 2 vols., London, 1961, 1962; 2nd revised ed., London–New York, 1968.

National Gallery, The Illustrated General Catalogue, London, 1973.

Nesselrath, A., 'Antico and Monte Cavallo', *Burlington*, CXXIV, 1982, pp. 353–7.

Nesselrath, A., 'Das Fossombrone Skizzenbuch', Diss. Bonn, 1981. To be published, Warburg Inst.

Netto-Bol, M. M. L., *The So-called Maarten de Vos Sketchbook of Drawings after the Antique* (Kunsthistorische Studiën van het Nederlands Instituut te Rome, IV), The Hague, 1976.

Neuerburg, N. *see* Vermeule and Neuerburg, 1973.

Nicco Fasola, G., *Nicola Pisano*, Rome, 1941.

Nichols, R. *see* Budde and Nichols, 1964.

Nicola, G. de, 'Due marmi ravennati in Firenze', *Rivista d'Arte*, IX, 1916, pp. 218–23.

Nicola, G. de, 'Notes on the Museo Nazionale of Florence – II. A Series of Small Bronzes by Pietro da Barga', *Burlington*, XXIX, 1916, pp. 363–73.

Nilsson, M. P., *Primitive Time-Reckoning* (Acta Societatis Humaniorum Ludensis), Lund, 1920.

Nilsson, M. P., *The Dionysiac Mysteries of the Hellenistic and Roman Age* (Acta Instituti Atheniensis Regiae Sueciae, 5), Lund, 1957.

Noack, F., 'Triumph und Triumphbogen', *Vorträge 1925–1926 der Bibliothek Warburg*, Leipzig–Berlin, 1928, pp. 147–200.

Norris, C., 'Rubens and the Great Cameo', *Phoenix. Maandschrift voor beeldende Kunst*, V, 1948, pp. 179–188.

Norton, P. F., 'The Lost *Sleeping Cupid* of Michelangelo', *ArtBull*, XXXIX, 1957, 4, pp. 251–7.

Oberhuber, K., 'Eine unbekannte Zeichnung Raffaels in den Uffizien', *MittFlor*, XII, 1966, pp. 225–44.

Oberhuber, K., 'Marcantonio Raimondi', *Albertina Informationen*, I, 3, 1970, pp. 1–4.

Oberhuber, K., *Raphaels Zeichnungen IX: Entwürfe zu Werken Raphaels und seiner Schule im Vatican 1511/12 bis 1520*, Berlin, 1972. (In series begun by O. Fischel in 1913.)

Oberhuber, K., and Walker, D., *Sixteenth-century Italian Drawings from the Collection of Janus Scholz* (Exh. Cat., 1973 at NGA, Washington, D.C., and Pierpont

Morgan Lib., New York City), Washington, D.C., 1973.

Oberhuber, K., *Disegni di Tiziano e della sua cerchia* (Venice, Fondazione Cini, Exh. Cat. 38), Vicenza, 1976.

Oberhuber, K. *see also* Levenson *et al.,* 1973.

Oettingen, W. von, *Über das Leben und die Werke des Antonio Averlino genannt Filarete,* Leipzig, 1888.

Offerhaus, J., *see* Borsook and Offerhaus, 1981.

Olsen, E.C. *see* Lehmann-Hartleben and Olsen, 1942.

Onians, J., *Art and Thought in the Hellenistic Age,* London, 1979.

Onofrio, C. d', *Le Fontane di Roma,* Rome, 1957.

Orlandini, P., 'Cariti', *EAA,* II, Rome, 1959, pp. 349–52.

Ost, H., *Leonardo Studien,* Berlin–New York, 1975.

Otto, W.F., *The Homeric Gods: the Spiritual Significance of Greek Religion,* transl. Moses Hadas, New York, 1954 (paperback rpt. London, 1979).

Ovid, *Fasti,* transl. Sir James G. Frazer (Loeb Classical Library), Cambridge, Mass.–London, 1931. *See* Guthmüller, B., 1981, for early editions and translations.

Ovid, *Metamorphoses,* transl. F.J. Miller, 2 vols., (Loeb Classical Library), Cambridge, Mass.–London, 1916. *See* Guthmüller, B., 1981, for early editions and translations.

Oxford Classical Dictionary, The, 2nd ed., Oxford, 1970.

Pallottino, M., 'Il grande fregio di Traiano', *BullComm* LXVI, 1938, pp. 17–56.

Pallottino, M., *L'Arco degli Argentarii,* Rome, 1946.

Palma, B. *see* Calza *et al.,* 1977, and *see also* Giuliano and Palma, 1978.

Pannuti, U. *see* Dacos *et al.,* 1973.

Panofsky, E., and Saxl, F., 'Classical Mythology in Mediaeval Art', *Metropolitan Museum Studies,* IV, 2, 1933, pp. 228–79.

Panofsky, E., 'The First Two Projects of Michelangelo's Tomb of Julius II', *ArtBull,* XIX, 1937, pp. 561–79.

Panofsky, E., *Studies in Iconology: Humanistic Themes in the Art of the Renaissance,* Oxford, 1939; New York: Harper Torchbook, 1962, with added comments in preface.

Panofsky, E., *Renaissance and Renascences in Western Art,* Stockholm, 1960; 2nd revised ed., 1964; paperback, London, 1970.

Panofsky, E., *Tomb Sculpture,* ed. H.W. Janson, London–New York, 1964.

Panofsky, E., *Problems in Titian, Mostly Iconographic,* New York, 1969.

Panvinius, O., *De ludis circensibus libri II. De triumphis liber unus. Quibus universa fere Romanorum veterum sacra ritusque declarantur ac figuris aeneis illustrantur cum notis Ioannis Argoli…,* Padua, 1642. Reprinted in Graevius, *Thesaurus,* IX, pp. 1136–98, q.v.

Paoletti, J. *see* Sheard and Paoletti, 1978.

Paribene, E., *Meleagros e storia della sua fortuna nell' arte italiana da fra' Guglielmo a Michelangelo,* Milan, 1975.

Paribeni, R., 'La Colonna Traiana in un codice del Rinascimento', *RIA,* I, 1929, pp. 9–28.

Paribeni, R., *Le Terme di Diocleziano e il Museo Nazionale Romano* (Guide dei Musei italiani), 2nd ed., Rome, 1932.

Parker, K.T., *Catalogue of the Collection of Drawings in the Ashmolean Museum,* Vol. II: *The Italian Schools,* Oxford, 1956; paperback, Oxford University Press, 1972. For Vol. III, *Supplement, see* Macandrew, H., 1980.

Parronchi, A., *Opere giovanili di Michelangelo* (Accademia Toscana di Scienze e Lettere 'La Colombaria', *Studi,* X), Florence, 1968.

Parronchi, A., 'L'Arrotino, opera moderna', *Annali Pisa,* ser. III, Vol. I, 2, 1971, pp. 345–74.

Parronchi, A., *Il Cupido dormente di Michelangelo,* Florence, 1971.

Parronchi, A., 'Le tre "anticaglie" portate da Napoli da Giuliano Sangallo', in *Opere Giovanili di Michelangelo,* III: *Miscellanea Michelangiolesca* (Accademia Toscana di Scienza e Lettere 'La Colombaria', *Studi,* LVII), Florence, 1981, pp. 27–37.

Pasqualitti, M.G., 'La Colonna Trajana e i disegni rinascimentali della Biblioteca dell'Istituto d'Archeologia e Storia dell' Arte', *Accademie e biblioteche d'Italia,* XLVI, 1978, pp. 157–201.

Pauli, G., *Inkunabeln der deutschen und niederländischen Radierung,* Berlin, 1908.

Pauli, G., 'Jakob Binck und seine Kupferstiche', *RfKw,* XXXII, 1909, pp. 31–48.

[Pauly], *Der Kleine Pauly. Lexicon der Antike,* eds. K. Ziegler and W. Sontheimer, 4 vols., Stuttgart, 1964–1975.

Pauwels, H.; Hoetink, H.R.; Herzog, S. eds., *Jan Gossaert genaamd Mabuse* (Exh. Cat., Mus. Boymans-van Beuningen), Rotterdam, 1965.

Peel, David, and Co. Ltd., *From Passerotti to Boizot* (Exh. Cat.), London, 1972.

Penny, N. *see* Haskell and Penny, 1981.

Pensabene, P. *see* Calza *et al.,* 1977.

Pérez Sánchez, A.E., *I grandi disegni italiani nelle collezioni di Madrid,* Milan, 1978.

Pérez Sánchez, A.E., *see also* Angulo and Pérez Sánchez, 1975.

Perrier, F., *Segmenta nobilium signorum et statuarum quae Romae adhuc exstant,* Rome, 1638. 100 plates. *See* Appendix I: Perrier.

Perrier, F., *Icones et segmenta illustrium e marmore tabularum quae Romae adhuc exstant,* Rome, 1645. Over 50 plates, with commentary by G.P. Bellori on each plate.

Perry, M., 'The Statuario Pubblico of the Venetian Republic', *Saggi e memorie di storia dell'arte,* VIII, 1972, pp. 76–150; 148 figs.

Perry, M., 'The Pride of Venice', *Aquileia Nostra,* XLV–XLVI, 1974–5, cols. 785–802.

Perry, M., 'Saint Mark's Trophies: Legend, Superstition and Archaeology in Renaissance Venice', *JWCI,* XL, 1977, pp. 27–49; reprinted in *The Horses of San Marco,* London, 1979 (Exh. Cat.) q.v.

Perry, M., 'Cardinal Domenico Grimani's Legacy of Ancient Art to Venice', *JWCI*, XLI, 1978, pp. 215–44.

Perry, M., 'On Titian's "Borrowings" from Ancient Art: A Cautionary Case', in *Tiziano e Venezia 1976* (Convegno di Studi, Univ. degli Studi di Venezia), Vicenza, 1980, pp. 187–91.

[Peruzzi, B.], *Taccuino S IV 7 detto di Baldassare Peruzzi della Biblioteca Comunale di Siena*, (V Centenario della Nascita di Baldassare Peruzzi), Sovicille (Siena), 1981.

Pesce, G., 'Gemme Medicee del Museo Nazionale di Napoli', *RIA*, V, 1935, pp. 50–97.

Petersen, E., 'Amazzone madre?', *RM*, VIII, 1893, pp. 251–8.

Petersen, E., Sitzungsprotokolle, Jan. 24, 1895, *RM*, XI, 1896, pp. 100–2.

Petersen, E., 'Die Dioskuren auf Monte Cavallo und Juturna', *RM*, XV, 1900, pp. 309–51.

Pevsner, N., *Studies in Art, Architecture and Design*, I, London, 1968, ch. XII with S. Lang: 'The Egyptian Revival', pp. 212–35 and notes pp. 245–8.

Pfanner, M., *Der Titusbogen*, Mainz am Rhein, 1983.

Philostratus the Elder, and the Younger, *Imagines*, and Callistratus, *Descriptions*, with an English transl. by Arthur Fairbanks, London–Cambridge, Mass., 1931.

Picard, C., 'Nouvelles archéologiques et correspondance: Dionysos chez le poète: suites diverses d'un thème antique', *RA*, 1960–1, pp. 114–17.

Picard, G. C., *Les trophées romains*, Paris, 1957.

Pietrograde, A. L., 'Sarcofago policromo con rappresentazione Bacchica', *BullComm*, LX, 1932, pp. 177–215.

Piganiol de la Force, J.-A., *Les Délices de Versailles*, II, 2nd ed., Leiden, 1728.

Pignoria, Lorenzo, see Cartari, 1615.

Pinder, W., 'Antike Kampfmotive in neuerer Kunst', *MJb*, N.F.V, 1928, pp. 353–75; and in *Gesammelte Schriften*, Leipzig, 1938, pp. 121–41.

Piranesi, G. B., *Vasi, Candelabri, Cippi, Sarcofagi…*, Rome, 1778.

Pittaluga, M., *L'Incisione italiana nel Cinquecento*, Milan, 1928.

Planiscig, L., *Die Bronzeplastiken* (Vienna, Kunsthist. Mus.), Vienna, 1924.

Platina, Bartolomeo [Sacchi], *Liber de Vita Christi ac omnium pontificum*, ed. G. Gaida in L. A. Muratori, *Rerum Italicarum Scriptores*, III, 1, Città di Castello-Bologna, 1913–32.

Pliny the Elder, *Natural History*, Bks. XXXIV–XXXVI in Loeb Classical Library, Cambridge–London, Vol. IX (1952): Bks. XXXIII–V; Vol. X (1962): Bks. XXXVI–XXXVII. Also in *The Elder Pliny's Chapters on the History of Art*, transl. K. Jex-Blake; commentary E. Sellers, revised rpt., Chicago, 1976.

Pluchart, H., *Musée Wicar, Notice des Dessins*, Lille, 1889.

Pogány-Balás, E., 'Antique Sources of Draped Figures in Leonardo's Works', *Acta Historiae Artium* [Budapest], XXIV, 1978, pp. 189–94.

Pogány-Balás, E., *The Influence of Rome's Antique Monumental Sculptures on the Great Masters of the Renaissance*, Budapest, 1980.

Poggetto, P. dal, *I disegni murali di Michelangiolo e della sua scuola nella Sagrestia Nuova di San Lorenzo*, Florence, 1979.

Polidoro da Caravaggio, see Galestruzzi, Rome, 1658.

Pollak, B. H., 'A Leonardo Drawing and the Medici Diomedes Gem', *JWCI*, XIV, 1951, pp. 303–4.

Pollard, G., 'The Felix Gem at Oxford and its provenance', *Burlington* CXIX, August 1977, p. 574.

Pollard, G. see also Hill and Pollard, 1967.

Pollitt, J. J., *The Art of Greece 1400–31 B.C.* (Sources and Documents in the History of Art, ed. H. W. Janson), Englewood Cliffs, N.J., 1965.

Pollitt, J. J., *The Art of Rome, c. 753 B.C.–337 A.D.* (Sources and Documents), Englewood Cliffs, N.J., 1966.

Pollitt, J. J., *The Ancient View of Greek Art*, London–New Haven, 1974.

Polzer, J., 'Masaccio and the Late Antique', *ArtBull*, LIII, 1971, pp. 36–40.

Pope-Hennessy, J., assisted by R. W. Lightbown, *Catalogue of Italian Sculpture in the Victoria and Albert Museum*, 3 vols., London, 1964.

Pope-Hennessy, J. W., 'The Italian Plaquette', *Proceedings of the British Academy*, L, London, 1964, pp. 63–85. Reprinted in John Pope-Hennessy, *The Study and Criticism of Italian Sculpture*, New York and Princeton, 1980, pp. 192–222.

Pope-Hennessy, J., *Renaissance Bronzes from the Samuel H. Kress Collection: Reliefs, Plaquettes, Statuettes…*, London–New York, 1965.

Pope-Hennessy, J., *The Portrait in The Renaissance* (A. W. Mellon Lectures in Fine Arts, 12), London–New York, 1966.

Pope-Hennessy, J., *Paolo Uccello. Complete Edition*, London–New York, 1969. (First ed., London, 1950.)

Pope-Hennessy, J., assisted by A. F. Radcliffe, *Italian Sculpture. The Frick Collection, Illustrated Catalogue*, III, New York, 1970.

Pope-Hennessy, J., *Italian High Renaissance and Baroque Sculpture*, revised ed., London, 1970. (First ed., London, 1963).

Pope-Hennessy, J., *Raphael*, (The Wrightsman Lectures, 4), London, n.d. [1971].

Pope-Hennessy, J., *Italian Renaissance Sculpture*, revised ed., London, 1971. (First ed., London, 1958.)

Pope-Hennessy, J., *Fra Angelico*, revised ed., London, 1974. (First ed., London, 1952.)

Pope-Hennessy, J., *Luca della Robbia*, Oxford, 1980.

Popham, A. E., *The Drawings of Leonardo da Vinci*, New York, 1945; London, 1946; 2nd ed., London, 1947.

Popham, A. E., *Catalogue of the Drawings of Parmigianino*, 3 vols., New Haven–London, 1971.

Popham, A. E., and Pouncey, P., *Italian Drawings in the Department of Prints and Drawings in the British Museum: The Fourteenth and Fifteenth Centuries*, 2 vols., London, 1950.

Popham, A. E., and Wilde, J., *The Italian Drawings of the XV and XVI Centuries in the collection of His Majesty the King at Windsor Castle*, London, 1949.

Port Sunlight, *Lady Lever Art Gallery, Port Sunlight. Catalogue of Foreign Paintings, Drawings, Miniatures, Tapestries, Post-Classical Sculpture and Prints*, Liverpool, 1983.

Potts, A.D., 'Greek Sculpture and Roman Copies I: Anton Raphael Mengs and the Eighteenth Century', *JWCI*, XLIII, 1980, pp.150–73.

Poulsen, F., *Catalogue of Ancient Sculpture in the Ny Carlsberg Glyptothek*, Copenhagen, 1951.

Poulsen, H., 'Eine archäologische Zeichnung von Melchior Lorck', *Acta Archaeologica* [Copenhagen], IV, 1933, pp.104–9.

Pouncey, P., 'The Spinario' (Letter), *Burlington*, CII, 1960, p.167.

Pouncey, P. and Gere, J.A., *Italian Drawings in the Department of Prints and Drawings in the British Museum: Raphael and his Circle*, 2 vols., London, 1962. *See also* Gere and Pouncey, 1983.

Pouncey, P. *see also* Popham and Pouncey, 1950.

Prandi, A., 'La fortuna del Laocoonte dalla sua scoperta nelle Terme di Tito', *RIA*, n.s.,III, 1954, pp.78–107.

Praz, M., *Mnemosyne: The Parallel between Literature and the Visual Arts* (Mellon Lectures, 16), 1970.

Preibisz, L., *Martin van Heemskerck*, Leipzig, 1911.

Pressouyre, S., 'Les fontes de Primatice à Fontainebleau', *Bulletin Monumental*, CXXVII, 1, 1969, pp.223–239.

Procacci, U., *All the Paintings of Masaccio* (The Complete Library of World Art), London, n.d.

'Prospettivo Milanese', *Antiquarie Prospettiche Romane*, c.1500. *See* Fienga, 1970 (with English transl., annotated and illus.), and Govi, 1876 (annotated ed. of Italian text).

Pulszky, C. von, *Beiträge zu Raffaels Studium der Antike*. Diss., Leipzig, 1877.

Puppi, L., *Il trittico di Andrea Mantegna per la Basilica di San Zeno Maggiore in Verona*, Verona, 1972.

[Quaritch], *The 'Speculum Romanae Magnificentiae' of Antonio Lafreri...'* offered for sale by Bernard Quaritch Ltd., [London, 1926]. Brief descriptions of an edition of 377 plates, some of them undescribed by Hülsen, 1921, q.v.

Radcliffe, A., *European Bronze Statuettes*, London, 1966.

Radcliffe, A., *see also* Avery and Radcliffe, 1978.

Radice, B., *Who's Who in the Ancient World. A Handbook to the Survivors of the Greek and Roman Classics*, Harmondsworth, 1973.

Ragghianti, C.L., and Regoli, G. dalli, *Firenze 1470–1480. Disegni dal Modello. Pollaiuolo/Leonardo/Botticelli/Filippino*, Pisa, 1975.

Ragusa, I., The Re-use of Roman Sarcophagi during the Middle Ages and the Renaissance. Unpublished MA thesis, New York Univ., Inst. of Fine Arts, 1951.

Ragusa, I., review of Armstrong, 1981, in *Speculum*, LIX, 1984, pp.110–112.

Raphaël dans les collections françaises (Exh. Cat. Paris, Grand Palais, 1983–4), Paris, 1983.

Redig de Campos, D., 'Il "soffitto dei semidei" del Pinturicchio e altri dipinti suoi restaurati nel Palazzo di Domenico della Rovere', in *Scritti di storia dell'arte in onore di Mario Salmi*, II, Rome, 1962, pp.363–75.

Redlich, R., *Die Amazonensarkophage des 2. und 3. Jahrhunderts nach Christus* Diss., Berlin, 1942.

Reekmans, L., 'La "dextrarum iunctio" dans l'iconographie romaine et paléochrétienne', *BullBelge*, XXXI, 1958, pp.23–95.

Reeland, A., *De Spoliis templi Ierosolymitani in Arcu Titiano*, Utrecht, 1716.

Regoli, G. dalli *see* Ragghianti and Regoli, 1975.

Regteren Altena, I.Q. van, *Cent dessins du Musée Teyler Haarlem* (Exh Cat., Mus. du Louvre, Cabinet de Dessins), 1972.

Regteren Altena, I.Q. van, and Ward-Jackson, P.W., *Drawings from the Teyler Museum, Haarlem* (Exh. Cat., V&A), London, 1970.

Reinach, S., *Répertoire de la statuaire grecque et romaine (Rép.Stat.)*, 6 vols., Paris, 1897–1910.
Vol.I = *Clarac de poche*, reductions of engravings in Clarac's volumes, q.v.

Reinach, S., *L'Album de Pierre Jacques Sculpteur de Reims dessiné à Rome de 1572 à 1577*, Paris, 1902; *see* Appendix I: Jacques.

Reinach, S., *Répertoire des reliefs grecs et romains (Rép. Rel.)*, 3 vols., Paris, 1909–12.

Renaissance Bronzes in American Collections (Exh. Cat., Smith College Mus. of Art), Northampton, Mass., 1964.

Reznicek, E., *Die Zeichnungen von Hendrik Goltzius*, Utrecht, 1961.

Ricci, C., 'Marmi ravennati erratici', *Ausonia*, IV, 1909, pp.247–89.

Ridgway, B.S., 'A Story of Five Amazons', *AJA*, LXXVIII, 1974, pp.1–17; LXXX, 1976, p.82.

Riggs, T.A., *Hieronymus Cock. Printmaker and Publisher*, Ph.D. thesis, Yale University, 1971, New York and London, 1972.

Rink, E., *Die bildliche Darstellung des römischen Genius*. Diss., Giessen, 1933.

Rizzo, G.E., 'Sculture antiche del Palazzo Giustiniani', *BullComm*, XXXIII, 1905, pp.3–125, esp.18–36.

Robert, C., *Die antiken Sarkophagreliefs* (Deutsches Archäologisches Inst., Berlin):
Vol.II. *Mythologische Cyklen*, 1890.
Vol.III. *Einzelmythen* (3 vols.):
 1. *Actaeon-Hercules*, 1897;
 2. *Hippolytos-Meleagros*, 1904;
 3. *Niobiden, Triptolemos, Ungedeutet*, 1919.
In progress. For list of existing vols., new editions and work in progress, *see* Andreae, 1977. *See also* Koch, Kranz, Matz (1968–1975), Rumpf, Wegner.

Robert, C., 'Über ein dem Michelangelo zugeschriebenes Skizzenbuch auf Schloß Wolfegg', *RM*, XVI, 1901, pp.209–43.

Robertson, M., *A History of Greek Art*, Cambridge, 1975.

Rodenwaldt, G., 'Über den Stilwandel in der antoninischen Kunst', *Abhandlungen der preußischen Akademie der Wissenschaften, Philosophisch-Historische Klasse*, X, 3, Berlin, 1935, pp. 1–27.

Rogers, C., *A Collection of Prints in Imitation of Drawings to which are Annexed Lives of their Authors with Explanations and Critical Notes*, London, 1778, 2 vols.

Rohden, H. von, *Die antiken Terrakotten*, Berlin–Stuttgart, 1911.

Rohden, H. von, *see also* Winnefeld and Rohden, 1911.

Ronen, A., 'An Antique Prototype for Michelangelo's *Fall of Man*', *JWCI*, XXXVII, 1974, pp. 356–8.

Rosand, D., 'The Crisis of the Venetian Renaissance Tradition', *L'Arte*, 11–12, 1970, pp. 5–53.

Rosand, D., '*Ut Pictor Poeta*: Meaning in Titian's *Poesie*', *New Literary History*, III, 1972, pp. 527–46.

Rosand, D., 'Titian and the "Bed of Polyclitus"', *Burlington*, CXVII, 1975, pp. 242–5.

Roscher, W., *Ausführliches Lexikon der griechischen und römischen Mythologie*, 10 vols., Leipzig, 1884–1937.

Rose, H. J., *A Handbook of Greek Mythology*, New York, 1959.

Ross, J. B., 'A Study of Twelfth-Century Interest in the Antiquities of Rome', in *Medieval and Historiographical Essays in Honor of James Westfall Thompson*, Chicago, 1938, pp. 302–21.

Rossi, E., 'Marforio in Campidoglio', *Roma*, VI, 1928, pp. 337–46.

Rossi, G. G. dei [I. I. de Rubeis], *Villa Pamphilia*, Roma, 1649.

Rossi, G. G. dei [I. I. de Rubeis], *Insigniores Statuarum Urbis Romae Icones*, 2 vols., Rome, n.d. [1654?]. (First ed., 1619, with 60 plates from Cavalieri and others.)

Röthlisberger, M., 'Studi su Jacopo Bellini', *Saggi e memorie di storia dell'arte*, II, 1958–9, pp. 41–89.

Rotili, M., *Fortuna di Michelangelo nell' Incisione* (Exh. Cat., Benevento, Mus. del Sannio; Rome, Gab. Naz. delle Stampe), ed. M. Rotili *et al.*, Benevento, 1964.

Rotili, M., *L'Arco di Traiano a Benevento*, Rome, 1972.

Rotondi, P., *The Ducal Palace of Urbino. Its Architecture and Decoration*, London, 1969. (Transl. from first ed., Urbino, 1950.)

Rowland, B., Jr., 'Monte Cavallo Revisited', *AQ*, XXX, 1967, pp. 143–52.

Rowlands, J., *Rubens: Drawings and Sketches* (Exh. Cat., BM), London, 1977.

[Rubens, A.,] *Alberti Rubeni Dissertatio de Gemma Augustea*, ed. H. Kähler (Monumenta Artis Romanae, IX), Berlin, 1968.

Rubinstein, R. O., 'A Bacchic Sarcophagus in the Renaissance', *The British Museum Yearbook I: The Classical Tradition*, 1976, pp. 103–57.

Rubinstein, R. O., 'The Renaissance discovery of antique river-god personifications', in *Scritti di storia dell' arte in onore di Roberto Salvini*, Florence, 1984, pp. 257–263.

Rucellai, G., ed. Perosa, A., *Giovanni Rucellai ed il suo Zibaldone*, London, 1960.

Ruesch, A., *Guida illustrata del Museo Nazionale di Napoli*, Naples, 1908; 1911.

Ruggeri, U., *Disegni veneti dell' Ambrosiana* (Exh. Cat., Venice, Fondazione Cini), Vicenza, 1979.

Rumpf, A., *Die Meerwesen auf den antiken Sarkophagreliefs* (ASR, V, 1), Berlin, 1939.

Rushton, J. G., Jr., *Italian Renaissance Figurative Sketchbooks, 1450–1520*. PhD thesis, Univ. of Minnesota, Fine Arts, 1976, Ann Arbor, 1979.

Ryberg, I. S., *Rites of the State Religion in Roman Art* (MAAR, XXII), 1955.

Ryberg, I. S., *Panel Reliefs of Marcus Aurelius* (Monographs on Archeology and Fine Arts, XIV. The Archeological Institute of America. The College Art Association), New York, 1967.

Sachs, P. J., *see* Mongan and Sachs, 1940.

Säflund, G., 'The Belvedere Torso. An Interpretation', *Opuscula Romana*, XI, 1976, pp. 63–84.

Saladino, V. *see* Capecchi *et al.*, 1979.

Salis, A. von, *Antike und Renaissance: über Nachleben und Weiterwirken der alten in der neueren Kunst*, Erlenbach–Zurich, 1947.

Salutati, Coluccio, *Invectiva in Antonium Luschum Vicentinum*, ed. D. Moreni, Florence, 1826.

Salutati, Coluccio, *De laboribus Herculis*, cd. B. L. Ullman, 2 vols., Zurich, 1951.

Sandström, S., *Levels of Unreality: Studies in Structure and Construction in Italian Mural Painting during the Renaissance* (Acta Universitatis Upsaliensis, Uppsala Studies in the History of Art, n. s. IV), Uppsala, 1963.

Sansovino, F., *Venetia città nobilissima*, Venice, 1581.

Santi Bartoli, P. *see* Bartoli, P. Santi.

Sanuto, M., *I Diarii di Marino Sanuto*, VI, ed. G. Berchet, Venice, 1881.

Saxl, F., 'Rinascimento di Antichità: Studien zu den Arbeiten A. Warburgs', *RfKw*, XLIII, 1922, pp. 220–72.

Saxl, F., *Mithras. Typengeschichtliche Untersuchungen*, Berlin, 1931.

Saxl, F., 'Pagan Sacrifice in the Italian Renaissance', *JWI*, II, 1938–9, pp. 346–67.

Saxl, F., 'The Classical Inscription in Renaissance Art and Politics', *JWI*, IV, 1940–1, pp. 19–46.

Saxl, F., *Lectures*, 2 vols., London, 1957.

Saxl, F., *A Heritage of Images. A Selection of Lectures*, ed. H. Honour and J. Fleming, Harmondsworth–Baltimore 1970.

Saxl, F., 'Jacopo Bellini and Mantegna as Antiquarians', in Saxl, 1957, I, pp. 150–60; in Saxl, 1970, pp. 57–70.

Saxl, F. *see also* Panofsky and Saxl, 1933; Gombrich, 1970.

Schaar, E., and Graf, D., *Meisterzeichnungen der Sammlung Lambert Krave* (Exh. Cat., Düsseldorf, Kunst Mus.), Düsseldorf, 1969.

Scharmer, H., 'Der gelagerte Herakles', *124 BWpr*, 1971.

Schauenburg, K., 'Marsyas', *RM*, LXV, 1958, pp. 42–66.

Schauenburg, K., 'Der besorgte Marsyas', *RM*, LXXIX, 1972, pp. 317–22.

Scheller, R.W., *A Survey of Medieval Model Books*, Haarlem, 1963.

Scherer, M.R., *Marvels of Ancient Rome*, London–New York, 1955.

Scherer, M.R., *The Legends of Troy in Art and Literature*, London–New York, 1963.

Schiavo, A., *Il Palazzo della Cancelleria*, Rome, 1964.

Schiffler, B., *Die Typologie des Kentauren in der antiken Kunst vom 10. bis zum Ende des 4. Jhr. v. Chr.*, Frankfurt, 1976.

Schilling, E., *see* Blunt [1971].

Schlosser, J. von, 'Über einige Antiken Ghibertis', *JAK*, XXIV, 4, 1903, pp. 125–59.

Schlosser, J. von, 'Lorenzo Ghibertis Denkwürdigkeiten, Prolegomena zu einer künftigen Ausgabe', *Kunstgeschichtliches Jahrbuch der K.K. Zentralkommission*, IV, 1910, pp. 105–211.

Schlosser, J. von, ed., *Lorenzo Ghibertis Denkwürdigkeiten (I Commentarii)*, Vols. I (Text) and II (Commentary), Berlin, 1912.

Schlosser, J. von, *Leben und Meinungen des florentinischen Bildners Lorenzo Ghiberti*, Basle, 1941.

Schmidt, E.E., 'Wiedergefundene Sarkophagfragmente', *AA*, LXXXIII, 1968, pp. 663–73.

Schmitt, A., 'Gentile da Fabriano und der Beginn der Antikennachzeichnung' (Part II of the article, 'Gentile da Fabriano in Rom und die Anfänge des Antikenstudiums', of which B. Degenhart contributes Part I: 'Ein Musterblattkomplex Gentiles und seiner Schüler), *MJb*, XI, 1960, pp. 91–151. *See* Degenhart and Schmitt, 1960.

Schmitt, A., *Disegni del Pisanello e di maestri del suo tempo* (Venice, Fondazione Cini, Exh. Cat. 24) Vicenza, 1966.

Schmitt, A., 'Römische Antikensammlungen im Spiegel eines Musterbuchs der Renaissance', *MJb*, XXI, 1970, pp. 99–128. *See* Appendix I: Umbrian Sketchbook, c. 1500.

Schmitt, A., *see also*, Degenhart and Schmitt, 1960, 1968, 1972.

Schober, A., 'Zur Amazonengruppe des attalischen Weihgeschenkes', *JÖAI*, XXVIII, 1933, pp. 102–11.

Schofield, R., 'Giovanni da Tolentino goes to Rome: A Description of the Antiquities of Rome in 1490', *JWCI*, XLIII, 1980, pp. 246–56.

Schönbrunner, J., and Meder, J., *Handzeichnungen alter Meister aus der Albertina und anderen Sammlungen*, 12 vols., Vienna, 1896–1908.

Schreiber, T., *Die Antiken Bildwerke der Villa Ludovisi*, Leipzig, 1880.

Schreiber, T., 'Flaminio Vaccas Fundberichte', *Berichte über die Verhandlungen der k. sächsischen Gesellschaft der Wissenschaften zu Leipzig*, XXXIII, 1881, pp. 43–91.

Schreiber, T., *Die hellenistischen Reliefbilder...*, Leipzig, 1894.

Schröter, E., *Die Ikonographie des Themas Parnass vor Raffael. Die Schrift- und Bildtraditionen von der Spätantike bis zum 15. Jahrhundert*, Hildesheim–New York, 1977.

Schubring, P., *Cassoni, Truhen und Truhenbilder der italienischen Frührenaissance*, 2 vols., 2nd ed. with additions, Leipzig, 1923. (First ed.: *Cassoni*, 1915.)

Schwarzenberg, E., 'Raphael und die Psyche-Statue Agostino Chigis', *JbKSwien* N.F. 37, LXXIII, 1977, pp. 107–36.

Schweikhart, G., 'Eine Fassadendekoration des G.M. Falconetto in Verona', *MittFlor*, XIII, 1967–8, pp. 324–342.

Schweikhart, G., 'Studien zum Werk des Giovanni Maria Falconetto', *Bollettino del Museo Civico di Padova*, LVII, 1968, pp. 17–67.

Schweikhart, G., and Buddensieg, T., 'Falconetto als Zeichner', *ZfKg*, XXXIII, 1970, pp. 21–40.

Schweikhart, G., *Fassadenmalerei in Verona vom 14. bis zum 20. Jahrhundert*, Munich, 1973.

Schweikhart, G., 'Antike Meerwesen in einem Fries der Casa Vignola in Verona. Ein unbekanntes Werk des Giovanni Maria Falconetto', *Arte Veneta*, XXIX, 1975, pp. 127–33.

Schweikhart, G., 'Un rilievo all'antica sconosciuto nell' Odeo Cornaro a Padova', *Padova e la sua Provincia*, XXI, 7–8, 1975, pp. 8–11.

Schweikhart, G., 'Antikenkopie und -verwandlung im Fries des Marcello Fogolino aus der Villa Trissino-Muttoni (Ca' Impenta) bei Vicenza', *MittFlor*, XX, 3, 1976, pp. 351–78.

Schweikhart, G., 'Von Priapus zu Coridon, Benennungen des Dornausziehers in Mittelalter und Neuzeit', *Würzburger Jb. f. Altertumswissenschaft*, N.F. III, 1977, pp. 243–52.

Schweikhart, G., *see also* Buddensieg and Schweikhart, 1970.

Schweitzer, B., 'Dea Nemesis Regina', *JdI*, LVI, 1931, pp. 175–246.

Schweitzer, B., 'Späthellenistische Reitergruppen, *JdI*, LI, 1936, pp. 158–74.

Schweitzer, B., 'Die Menelaos-Patroklos Gruppe', *Die Antike*, XIV, 1938, pp. 43–72.

Schwinn, C., *Die Bedeutung des Torso von Belvedere für Theorie und Praxis der bildenden Kunst vom 16. Jahrhundert bis Winckelmann* (Europäische Hochschulschriften, Reihe XXVIII, Kunstgeschichte, I), Bern–Frankfurt, 1973.

Scott-Elliot, A.H., 'The Statues from Mantua in the Collection of King Charles I', *Burlington*, CI, June 1959, pp. 218–27.

Seidel, M., 'Die Rankensäulen der Sieneser Domfassade', *JBerlMus*, XI, 1969, pp. 81–160.

Seidel, M., 'Studien zur Antikenrezeption Nicola Pisanos', *MittFlor*, XIX, 3, 1975, pp. 307–92.

Serafini, A., *Girolamo da Carpi. Pittore e architetto ferrarese 1501–1556*, Rome, 1915.

Settis, S., ed., *Memoria dell'antico nell' arte italiana I: L'uso dei classici* (Biblioteca di storia dell'arte. Nuova serie I), Turin, 1984.

Seznec, J., *La Survivance des dieux antiques: Essai sur le rôle de la tradition mythologique dans l'humanisme et dans l'art de la Renaissance* (Studies of the Warburg Institute, XI), London, 1940; English transl.: *The Survival of the Pagan Gods. The Mythological Tradition and Its Place in Renaissance Humanism and Art*, by B.F. Sessions (Pantheon Books, Bollingen Foundation Library Vol. 38), New York, 1953; Harper Torchbook (paperback), New York, 1961 (with corrections and bibl. brought up-to-date).

Sgarbi, V., 'Aspetti della "Maniera" nel Veneto', *Paragone Arte*, 369, 1980, pp. 65–80.

Shapley, F.R., *National Gallery of Art Washington. Catalogue of the Italian Paintings*, 2 vols., Washington D.C., 1979.

Sheard, W.S., 'The Widener *Orpheus*', in Sheard, W.S. and Paoletti, J., *Collaboration in Italian Renaissance Art*, New Haven, 1978.

Sheard, W.S., *Antiquity in the Renaissance* (Exh. Cat., Smith College Mus. of Art), Northampton, Mass., 1979.

Shearman, J., 'Giulio Romano', *Burlington*, CI, 1959, pp. 456–60.

Shearman, J., 'The Chigi Chapel in S. Maria del Popolo', *JWCI*, XXIV, 1961, pp. 129–60.

Shearman, J., 'Die Loggia der Psyche in der Villa Farnesina', *JbKSWien*, N.f. 24, LX, 1964, pp. 59–100.

Shearman, J., *Andrea del Sarto*, 2 vols., Oxford, 1965.

Shearman, J., 'The "Dead Christ" by Rosso Fiorentino', *Bulletin: Museum of Fine Arts, Boston*, LXIV, 1966, pp. 148–72.

Shearman, J., *Mannerism*, Harmondsworth, 1967.

Shearman, J., *Raphael's Cartoons in the collection of Her Majesty the Queen and the tapestries for the Sistine Chapel*, London, 1972.

Shearman, J., 'Raphael, Rome, and the Codex Escurialensis', *Master Drawings*, XV, 2, 1977, pp. 107–46.

Sheenan, J.L. *see* Levenson *et al.*, 1973.

Shorr, D.C., 'The Mourning Virgin and St. John', *ArtBull*, XXII, 1940, pp. 61–9.

Sichtermann, H., 'Fluviali, Divinità', in *EAA*, III, 1960, pp. 715–17.

Sichtermann, H., 'Der Niobiden-Sarkophag in Providence', *JdI*, LXXXIII, 1968, pp. 180–220.

Sichtermann, H., and Koch, G., *Griechische Mythen auf römischen Sarkophagen*, Tübingen, 1975.

Sichtermann, H. *see also* Koch and Sichtermann, 1982.

Siebenhüner, H., *Das Kapitol in Rom: Idee und Gestalt*, Munich, 1954.

Sieveking, J., 'Zu den beiden Triumphbogensockeln im Boboligarten', *RM*, LII, 1937, pp. 78–82.

Simon, E., 'Zur Bedeutung des Greifen in der Kunst der Kaiserzeit', *Latomus*, XXI, 1962, pp. 749–80.

Simon, E., 'Polygnotan Painting and the Niobid Painter', *AJA*, LXVII, 1963, pp. 42–62.

Simon, E. *see also* Wester and Simon, 1965.

Simson, O. von, 'Gerard Davids Gerechtigkeitsbild und der spätmittelalterliche Humanismus', in *Festschrift Wolfgang Braunfels*, ed. F. Piel and J. Traeger, Tübingen, 1981, pp. 349–56.

Smart, A. *see* Kemp and Smart, 1980.

Smetius, M., *Inscriptionum antiquarum ... liber*, ed. J. Lipsius, Leiden, 1588.

Smith, A.H., *A Catalogue of Sculpture in the Department of Greek and Roman Antiquities, British Museum*, III, London, 1904.

Smith, C., 'Nike Sacrificing a Bull', *JHS*, VII, 1886, pp. 275–85.

Sotheby & Co. [J.M. Stock], *Catalogue of the Ellesmere Collection. Part II. Drawings by Giulio Romano. Sale 5th December, 1972*. Other Sotheby sales catalogues in London and Florence, as cited in entries.

Spencer, J.R., 'Volterra, 1466', *ArtBull*, XLVIII, 1966, pp. 95–6.

Spitzmüller, A. *see* Stix and Spitzmüller, 1941.

Spreti, Desiderio. *De amplitudine, de vastatione et de instauratione Urbis Ravennae*, Venice, 1489.

Spring, P.W.H., The Topographical and Archaeological Study of the Antiquities of the City of Rome, 1420–1447. Unpublished PhD thesis, Univ. of Edinburgh, 1972.

Stanford, W.B., and Luce, J.V., *The Quest for Ulysses*, London, 1974.

Stark, K.B., *Niobe und die Niobiden*, Leipzig, 1836.

Stechow, W., 'Lucretiae Statua', in *Essays in Honor of Georg Swarzenski*, Berlin–Chicago, 1951, pp. 114–24.

Stewart, A., *Attika. Studies in Athenian Sculpture of the Hellenistic Age*, London 1979.

Stix, A., and Fröhlich-Bum, L., *Beschreibender Katalog der Handzeichnungen in der graphischen Sammlung Albertina*, Vol. I: *Die Zeichnungen der venezianischen Schule*, Vienna, 1926; Vol. III: *Die Zeichnungen der toskanischen, umbrischen und römischen Schulen*, Vienna 1932; Stix, A., and Spitzmüller, A., Vol. VI: *Die Schulen von Ferrara, Bologna, Parma und Modena, der Lombardei, Genuas, Neapels und Siziliens*, Vienna, 1941.

Stock, J.M., *see* Sotheby & Co., 1972.

Strong, D.E., *Roman Imperial Sculpture*, London, 1961.

Strong, D.E., 'Some Unknown Sculptures: The first published account of the sculpture in William Waldorf Astor's Italian Gardens at Hever Castle', *Connoisseur*, CLVIII, April, 1965, pp. 215–25.

Strong, D., *Roman Art*, ed. J.M.C. Toynbee (Pelican History of Art), Harmondsworth, 1976.

Strong, D.E., and Ward Perkins, J., 'The Temple of Castor in the Forum Romanum', *PBSR*, XXX, 1962, pp. 1–30 including appendix by D.E. Strong, 'The Mantua Relief – A Note', pp. 28–30.

Strong, E., *Roman Sculpture from Augustus to Constantine*, London, 1907.

Strong, E., 'The Cook Collection', *JHS*, XXVIII, 1908, pp. 1–45.

Strong, E., 'Six Drawings from the Column of Trajan with the date 1467 and a note on the date of Giacomo Ripanda', *PBSR*, VI, 1913, pp. 174–83.

Strong, E., *Apotheosis and Afterlife*, London, 1915.

Strong, E., *La Scultura Romana da Augusto a Constantino*, 2 vols., Florence, 1923–6.

Strong, E., 'Sulle tracce della Lupa romana'. *Scritti in onore di Bartolommeo Nogara*, Rome, 1937, pp. 475–501.

Strong, E., 'Terra Mater or Italia?', *JRS*, XXVII, 1, 1937, pp. 114–26.

Stuart Jones, H., *A Catalogue of the Ancient Sculptures in the Municipal Collections of Rome*, I: *The Sculptures of the Museo Capitolino*, Oxford, 1912; II: *The Sculptures of the Palazzo dei Conservatori*, Oxford, 1926.

Stuveras, R., *Le putto dans l'art romain* (Latomus Collection, XCIV), Brussels, 1969.

Sutton, D., and Clements, A., eds., *An Italian Sketchbook by Richard Wilson RA* (Paul Mellon Foundation for British Art), London, 1968.

Szabó, G., *Sixteenth Century Italian Drawings from the Robert Lehmann Collection* (Exh. Cat., MMA), New York, 1979.

Tait, H., 'The Roman Lion-Hunt Dish, an early work by Xanto?', *The British Museum Society Bulletin*, XXI, March, 1976, pp. 3–6.

Tea, E., 'Le fonti delle Grazie di Raffaello', *L'Arte*, XVII, 1914, pp. 41–8.

Tedeschi Grisanti, G., *I 'Trofei di Mario'. Il ninfeo dell' acqua Giulia sull' Esquilino*, Rome, 1977.

Tedeschi Grisanti, G., '"Dis Manibus, pili, epitaffi, ed altre cose antiche": Un codice inedito di disegni di Giovannantonio Dosio', *Boll d'Arte*, XVIII, 1983, pp. 69–102.

Telpaz [Schulz], A.M., 'Some antique motifs in Trecento Art', *ArtBull*, XLVI, 1964, pp. 372–6.

Theocritus, *Idylls*, in *The Greek Bucolic Poets*, English transl. J.M. Edmonds (Loeb Classical Library), London–Cambridge, Mass., 1912.

Thode, H., *Die Antiken in den Stichen Marcantons, Agostino Venezianos und Marco Dentes*, Leipzig, 1881.

Thode, H., *Michelangelo und das Ende der Renaissance*, Berlin, 1902–13 (Vol. III, 1–2: *Der Künstler und seine Werke*, 1912).

Thomas, H., 'Antonio da Salamanca, printer of *La Celestina*, Rome, ca. 1525', *The Library*, 5th series, VIII, pp. 45–50.

Thomas, T.M., *Classical Reliefs and Statues in Later Quattrocento Religious Paintings*. PhD thesis, Univ. of California, Berkeley, 1980, Ann Arbor, 1984.

Tietze, H., 'Annibale Carraccis Galerie im Palazzo Farnese und seine römische Werkstätte', *JAK*, XXVI, 1906–7, pp. 49–182.

Tietze-Conrat, E., 'A Lost Michelangelo Reconstructed', *Burlington*, XLVIII, 1936, pp. 163–70.

Toca, M., 'Osservazioni sul cosidetto "taccuino senese di Baldassare Peruzzi"', *Annali Pisa*, I, 3, 1971, pp. 161–179.

Tolnay, C. de, *Michelangelo*, 5 vols., Princeton, 1943–60.

Tolnay, C. de, *Corpus dei disegni di Michelangelo*, Novara, 1975ff. (in progress; Vols. I–III published so far).

Tormo, E., 'Os Desenhos das antigualhas que vio Francisco d'Ollanda, Pintor Portugués (... 1539–1540...)', Madrid, 1940. See Appendix I: Francisco de Hollanda.

Toynbee, J.M.C., *The Hadrianic School*, Cambridge, 1934.

Toynbee, J.M.C., *Death and Burial in the Roman World*, London–Ithaca, N.Y., 1971.

Trachtenberg, M., 'An Antique Model for Donatello's Marble *David*', *ArtBull*, L, 1968, pp. 268–9.

Turner, A.R., *The Vision of Landscape in Renaissance Italy*, Princeton, 1966. (Paperback ed. 1974.)

Turner, N., see Gere and Turner, 1983.

Türr, K.M., *Eine Musengruppe hadrianischer Zeit. Die sogenannten Thespiaden* (Monumenta Artis Romanae, X), Berlin, 1971.

Uffizi, Gli. Catalogo Generale, Florence, 1979. (Illus. cat. of paintings.)

Ullman, B.L., *The Humanism of Coluccio Salutati* (Medioevo e Umanesimo, 4), Padua, 1963.

Vacca, F., *Memorie di varie antichità trovate in diversi luoghi ... di Roma. Scritte ... nell' anno 1594*, in F. Nardini, *Roma Antica*, 2nd ed., Rome, 1704, pp. 3–24 bound in at end of volume. Also in Schreiber, 1881, q. v.

Vaccaria, L., *Antiquarum statuarum Urbis Romae quae in publicis privatisque locis visuntur Icones*, Rome, 1584. See Appendix I: Vaccaria.

Vaccaro Melucco, A., 'Sarcophagi romani di caccia al leone' (Studi Miscellanei, XI–Seminario di archeologia e storia dell'arte greca e romana dell' Università di Roma, XI, 1963–4), Rome, 1966, pp. 9–60.

Valentini, R., and Zucchetti, G., *CTR* (Fonti per la Storia d'Italia. Istituto Storico Italiano per il Medio Evo).
Vol. I: *Scrittori Secoli I–VI*, Rome, 1940;
Vol. II: *Scrittori Secoli IV–XII*, 1942;
Vol. III: *Scrittori Secoli XII–XIV*, 1946;
Vol. IV: *Scrittori Secoli XIV–XV*, 1953.

Van Essen, C.C., 'Elementi etruschi nel Rinascimento Toscano', *Studi Etruschi*, XIII, 1939, pp. 497–9.

Varchi, B., *Storia Fiorentina*, ed. L. Arbib, Florence, 1838–41.

Vasari, Giorgio, *Le vite de' più eccellenti pittori scultori ed architettori* [1568], ed. G. Milanesi, Florence, 1878–85, 9 vols. Rpt. con nuove annotazioni e commenti di G. Milanesi, Florence, 1906.

Vasari, Giorgio, 'Anticaglie che sono nella Sala del Palazzo de' Pitti' (omitted from editions of the *Vite* except for those of 1568, Vol. III, unpaginated list in table of contents; Bologna, 1647; and Florence, 1772, pp. 471–2) reprinted in Bloch, 1892, pp. 81–2.

Vasari, Giorgo, *Le Vite de' più eccellenti pittori scultori e architetti* (ed. A. Venturi), Florence, 1896.

Vasari, Giorgio, *The Lives of the Painters, Sculptors and Architects*, 4 vols., transl. A.B. Hinds; ed. W. Gaunt, revised edition (Everyman's Library), London–New York, 1963.

Vasari, Giorgio, *La Vita di Michelangelo nelle redazioni del 1550 e del 1568*, 5 vols., ed. P. Barocchi, Milan–Naples, 1962.

Velde, C. van de, 'A Roman Sketchbook of Frans Floris', *Master Drawings*, VII, 3, 1969, pp. 255–86. *See* Appendix I: Frans Floris, Workshop.

Velde, C. van de, *Frans Floris (1519/20–1570). Leven en Werken* 2 vols., Brussels, 1975.

Veldman I. M., *Maarten van Heemskerck and Dutch Humani m in the Sixteenth Century*, Maarseen, 1977.

Veldman, I. M., 'Notes occasioned by the publication of the facsimile edition of Christian Hülsen and Hermann Egger, *Die römischen Skizzenbücher von Marten van Heemskerck*, 2 vols., Berlin, 1913–1916 (Davaco Publishers, Soest 1975)', *Simiolus, Netherlands Quarterly for the history of art*, IX, 1977, pp. 106–13.

Venturi, A., 'Di alcuni disegni di Giusto pittore tratti dall' antico', *L'Arte*, III, 1900, pp. 157–8.

Venturi, A., *Storia dell' arte italiana*, Milan, 1901–40. Vol. VII, 2, 1913; Vol. X, 2, 1936; Vol. X, 3, 1937.

Venturi, A., 'Gabinetto Nazionale delle stampe in Roma. Il libro dei disegni di Giusto', *Le gallerie nazionali italiane, Notizie e documenti*, V, 1902, pp. 391–392 and 32 facsimile plates.

Venturi, A., 'Romolo e Remo di Antonio Pollaiuolo', *L'Arte*, XXII, 1919, pp. 133–5.

Venuti, R., and Amaduzzi, R., *Vetera Monumenta quae in hortis Caeli montanis et in aedibus Matthaeiorum adservantur..*, 3 vols., Rome, 1776–9.

Verhayen, E., 'Jacopo Strada's Mantuan Drawings of 1567–1568', *ArtBull*, XLIX, 1967, pp. 62–70.

Vermaseren, M. J., *Cybele and Attis. The Myth and the Cult*, London, 1977.

Vermeule, C. C., review of A. Calò Levi, *Barbarians on Roman Imperial Coins and Sculpture*, Gnomon, XXV, 1953, pp. 471–7.

Vermeule, C. C., 'Notes on a New Edition of Michaelis: *Ancient Marbles in Great Britain*', *AJA*, LIX, 2, 1955, pp. 129–50; Part Two with D. von Bothmer, *AJA*, LX, 4, 1956, pp. 321–50; Part Three: 1–2, *AJA*, LXIII, 2, 1959, pp. 139–348.

Vermeule, C., 'The Dal Pozzo – Albani Drawings of Classical Antiquities: Notes on their Content and Arrangement', *ArtBull*, XXXVIII, 1956, pp. 31–46.

Vermeule, C. C., in G. M. A. Hanfmann *et al.*, 'A new Trajan. I: Interpretation, Typology and Date', *AJA*, LXI, 1957, pp. 229–47, esp. 235.

Vermeule, C. C., 'Hellenistic and Roman Cuirassed Statues', *Berytus*, XIII, 1959, pp. 1–82, and Supplements', 1964, 1966, 1974, 1978.

Vermeule, C., *European Art and the Classical Past*, Cambridge, Mass., 1964 (with useful appendix of artists, antiquarians and archaeologists, pp. 160–7).

Vermeule, C. C., 'The Dal Pozzo-Albani Drawings of Classical Antiquities in the British Museum', *TAPS*, n. s. L, 5, 1960; and 'The Dal Pozzo-Albani Drawings of Classical Antiquities in the Royal Library at Windsor Castle', *TAPS*, n. s. LVI, 2, 1966.

Vermeule, C., 'The Weary Herakles of Lysippos', *AJA*, LXXXIX, 1975, pp. 323–32.

Vermeule, C., and Neuerburg, N., *Catalogue of the Ancient Art in the J. Paul Getty Museum*, 1973.

Vertova, L., 'The Tale of Cupid and Psyche in Renaissance Painting before Raphael', *JWCI*, XLII, 1979, pp. 104–21.

Verzeichnis der Gemälde, Kunsthistorisches Museum Wien, Vienna, 1973.

Viatte, F., *Dessins de Stefano della Bella* (Inventaire général des dessins italiens II, Mus. du Louvre, Cabinet des Dessins), Paris, 1974.

Vicenzi, C., 'Di tre fogli di disegni quattrocenteschi dall'antico', *Rassegna di Arte*, X, 1910, pp. 6–11.

Vickers, M., 'The Source of the Mars in Mantegna's "Parnassus"', *Burlington*, CXX, 1978, pp. 151–2.

Vico, Enea, *Le imagini delle donne auguste...*, Venice, 1557.

Vierneisel-Schlörb, B., *Glyptothek München, Katalog der Skulpturen II: Klassische Skulpturen des 5. und 4. Jahrhunderts v. Chr.*, Munich, 1979.

Villefosse – *see* Héron de Villefosse, 1896.

Visconti, C. L., *I Monumenti del Museo Torlonia*, 2 vols., Rome, 1884–5.

Visconti, G., and E. Q., *Il Museo Pio Clementino* Vols. I–VII, Milan, 1818–22.

Visconti, P. E., *Catalogo del Museo Torlonia di Sculture antiche*, Rome, 1885.

Volaterranus [Raffaele Maffei], *Commentariorum Urbanorum Libri XXXVIII*, Rome, 1506.

Wace, A. J. B., 'Studies in Roman Historical Reliefs', *PBSR*, IV, 1907, pp. 258–63.

Wallace, R. W., *The Etchings of Salvator Rosa*, Princeton, 1979.

Warburg, A., *Gesammelte Schriften: Die Erneuerung der heidnischen Antike*, 2 vols. (Bibliothek Warburg), Berlin–Leipzig, 1932. Kraus rpt. ed. G. Bing, Nendeln–Liechtenstein, 1969.

Warburg, A., *La rinascità del paganesimo antico. Contributi alla storia della cultura*, transl. E. Cantimori, ed. G. Bing, Florence, 1980. (First ed. 1966; selections from *Gesammelte Schriften*, 1932).

Ward, R., *Baccio Bandinelli as a Draughtsman*. Unpublished PhD thesis, London Univ., 1982. (Not available in time to be used in our catalogue.)

Ward-Jackson, P., *Victoria and Albert Museum. Italian Drawings, Volume One: 14th–16th Century*, London, 1979.

Ward-Jackson, P., *see also* Regteren Altena and Ward-Jackson, 1970.

Ward Perkins, J. *see* Strong and Ward Perkins, 1962.

Waterhouse, E. K., 'A Note on British Collecting of Italian Pictures in the Later Seventeenth Century', *Burlington*, CII, 1960, pp. 54–8.

Watzinger, C., 'Theoxenia des Dionysos', *JdI*, LXI, 1946, pp. 76–87.

Waźbiński, Z., 'Daedalus and Icarus – two humanistic moral ideals', *ETYKA* III, 1968, pp. 98–114.

Weber, M., 'Die Amazonen von Ephesos', *JdI*, XCI, 1976, pp.28–96.

Webster, T.B.L., *The Tragedies of Euripides*, London, 1967.

Weege, F., *Etruskische Malerei*, Halle, 1921.

Wegner, M., *Die Musensarkophage* (*ASR*, V, 3), Berlin, 1966.

Wehle, H.B., *The Metropolitan Museum of Art. A Catalogue of Italian, Spanish and Byzantine Paintings*, New York, 1940.

Weigel, R., *Die Werke der Maler in ihren Handzeichnungen. Beschreibendes Verzeichnis der in Kupfer gestochenen, lithographierten und photographierten Facsimiles von Originalzeichnungen großer Meister*, Leipzig, 1865.

Weihrauch, H.R., *Europäische Bronzestatuetten, 15.–18. Jahrhundert*, Brunswick, 1967.

Weis, A., *The Hanging Marsyas*. PhD thesis, Bryn Mawr, 1976.

Weisbach, W., *Trionfi*, Berlin, 1919.

Weiss, R., 'Lineamenti per una storia degli studi antiquari in Italia dal dodicesimo secolo al sacco di Roma nel 1527', *Rinascimento*, IX, 1958, pp.141–201.

Weiss, R., *The Medals of Pope Sixtus IV (1471–1484)*, Rome, 1961.

Weiss, R., *The Renaissance Discovery of Classical Antiquity*, Oxford, 1969.

Weitzmann, K., *Greek Mythology in Byzantine Art*, London, 1951.

Weitzmann, K., ed., *Age of Spirituality. Late Antique and Early Christian Art. Third to Seventh Century* (Exh. Cat., MMA, 1978), New York, 1979.

Weller, A., *Francesco di Giorgio Martini 1439–1501*, Chicago, 1943.

Wester, U., and Simon, E., 'Die Reliefmedaillons im Hofe des Palazzo Medici zu Florenz', *JBerlMus*, VII, 1965, pp.15–91.

Wickhoff, F., 'Beiträge zur Geschichte der reproduzierenden Künste: Marcantons Eintritt in den Kreis römischer Künstler', *JAK*, XX, 1899, pp.181–94.

Wilde, J., 'Eine Studie Michelangelos nach der Antike', *MittFlor*, IV, 1932–4, pp.41–64.

Wilde, J., *Italian Drawings in the Department of Prints and Drawings in the British Museum: Michelangelo and his Studio*, London, 1953.

Wilde, J., 'Notes on the Genesis of Michelangelo's *Leda*', in *Fritz Saxl 1890–1948. A volume of Memorial Essays from his friends in England*, ed. D.J.Gordon, London, etc., 1957, pp.270–80.

Wilde, J. *see also* Popham and Wilde, 1949.

Wind, E., *Pagan Mysteries in the Renaissance*, London–New Haven, 1958; revised ed. Harmondsworth, 1967; New York, 1968; 2nd ed. Oxford: OUP paperback, 1980.

Winnefeld, H., and Rohden, H. von, *Architektonische römische Tonreliefs der Kaiserzeit*. Vol.IV (*Die antiken Terrakotten*), Berlin, 1911.

Winner, M., *Zeichner sehen die Antike. Europäische Handzeichnungen 1450–1800* (Exh. Cat., Berlin-Dahlem, Staatl. Mus., Kupferstichkabinett), Berlin, 1967.

Winner, M., 'Zum Apollo vom Belvedere', *JBerlMus*, X, 1968, pp.181–99.

Winner, M., 'Zum Nachleben des Laokoon in der Renaissance', *JBerlMus*, XVI, 1974, pp.83–121.

Winner, M. *see also* Dreyer and Winner, 1964.

Winter, F., 'Über ein Vorbild neu-attischer Reliefs', *BWpr*, 50, 1890, pp.97–124.

Winternitz, E., 'Musical Archeology of the Renaissance in Raphael's *Parnassus*', *Musical Instruments and their Symbolism in Western Art*, London, 1967, pp.185–201.

Witt, R. G., *Hercules at the Crossroads. The Life and Works and Thought of Coluccio Salutati* (Duke Monographs in Medieval and Renaissance Studies, 6), Durham, N. C., 1983.

Wittkower, R., 'A Symbol of Platonic Love in a Portrait Bust by Donatello', *JWI*, I, 1937–8, pp.260–1.

Wittkower, R., 'The Role of classical models in Bernini's and Poussin's preparatory work', *Studies in Western Art*, III: *Latin American Art and the Baroque Period in Europe* (Acts of the XXth International Congress of the History of Art), Princeton, 1963, pp.41–50. Reprinted in Wittkower, *Studies in the Italian Baroque*, London, 1975, pp.104–14.

Wittkower, R., 'L'Arcadia e il Giorgionismo', *Umanesimo Europeo e Umanesimo Veneziano*, ed. V.Branca, Venice, 1963, pp.473–84.

Wittkower, R., 'Hieroglyphics in the Early Renaissance', in Wittkower, *Allegory and the Migration of Symbols*, London, 1977, pp.113–28.

Wittkower, R., 'Transformations of Minerva in Renaissance Imagery', in Wittkower, *Allegory and the Migration of Symbols*, London, 1977, pp.129–42. (First published in *JWI*, II, 3, 1939, pp.194–205.)

Yuen, T.E.S., 'The Tazza Farnese as a source for Botticelli's *Birth of Venus* and Piero di Cosimo's *Myth of Prometheus*', *GazBA*, LXXXIV, September. 1969, pp.175–8.

Yuen, T.E.S., 'The Bibliotheca Graeca: Castagno, Alberti, and Ancient Sources,' *Burlington*, CXII, 1970, pp.725–36.

Yuen, T.E.S., 'Giulio Romano, Giovanni da Udine and Raphael: Some Influences of the Minor Arts of Antiquity', *JWCI*, XLII, 1979, pp.263–72.

Zampetti, P., *Mostra di Lorenzo Lotto*, Venice, 1953.

Zander, G., 'Le invenzioni architettoniche di G.B.Montano milanese', *Quaderni dell' Istituto di storia dell' architettura*, XXX, 1958, pp.1–21; XLIX, 1962, pp.1–32.

Zanetti, A.M. di G., and Zanetti, A.M. d'A., *Delle antiche statue greche e romane, che nell' Antisala della Libreria di San Marco, e in altri Luoghi pubblici di Venezia si trovano*, 2 vols., Venice, 1740 and 1743 with ills. of 100 Venetian antiquities. *See* Perry, 1972.

Zanker, P., *Klassizistische Statuen. Studien zur Ver-änderung des Kunstgeschmacks in der römischen Kaiser-zeit*, Mainz, 1974.

Zeri, F., *Italian Paintings in the Walters Art Gallery*, I, Baltimore, 1976.

Zerner, H., *École de Fontainebleau. Gravures*, Paris, 1969.

Zoega, G., *Li bassirilievi antichi di Roma, incisi da Tommaso Piroli*, 2 vols., Rome, 1808.

Zwirn, S., Glossary in *Age of Spirituality. Late Antique and Early Christian Art, Third to Seventh Century*, ed. K. Weitzmann. (Exh. Cat., MMA, 1978), New York, 1979, pp. 674–81.

GENERAL INDEX

All references in this Index are to page numbers in the book, except for numbers set in bold type, which refer to catalogue entries, and numbers in italics, which refer to illustrations. References for Artists will be found in Appendix I, and for Collections in Appendix II. Published Sketchbooks, Albums and Codices are always quoted in italics, while those as yet unpublished are given in ordinary roman type.